the
Village

the VILLAGE

400 YEARS *of*
BEATS *and* BOHEMIANS,
RADICALS *and* ROGUES

A History of Greenwich Village

JOHN STRAUSBAUGH

An Imprint of HarperCollins*Publishers*

HarperCollins books may be purchased for educational, business, or sales promotional use. For information please write: Special Markets Department, HarperCollins Publishers, 10 East 53rd Street, New York, NY 10022.

FIRST EDITION

Library of Congress Cataloging-in-Publication Data has been applied for.

ISBN 978-0-06-207819-3

13 14 15 16 17 OV/RRD 10 9 8 7 6 5 4 3

CONTENTS

INTRODUCTION

AMERICA WAS ONE THING AND GREENWICH VILLAGE
ANOTHER.

—*Ronald Sukenick*

"YOU COULD SIT ON A BAR STOOL AND LOOK OUT OF THE WINDOWS
to the snowy streets and see heavy people going by, David Amram
bundled up," Bob Dylan writes of his early '60s Greenwich Village
days in *Chronicles*. Half a century later, you can sit in one of the open-
front cafés along Cornelia Street and still see Amram, now in his
eighties and looking anything but heavy, striding up the middle of
the quiet block. Gray curls halo his face. He wears a dark suit, dark
shirt, and polka-dot tie, with rings on many fingers and a few pounds
of necklaces, amulets, and medallions dangling and clanging from
his neck. One of his daughters gave him the first few, and he added
more as talismans representing his travels. The overall effect is of a
hip Jewish shaman. He carries his French horn in one hand and in
the other cloth bags stuffed with more instruments—pennywhistles,
a tambourine, exotic flutes from China and the Native American
West, an Egyptian doumbek. When asked where his roadie is, he
says, "I'm my own roadie. It keeps me fit." Smiling, buoyant, full of
what they used to call pep, he radiates a kind of spiritual fitness as
well, an unalloyed joy to be in the world, making music in it, tending

the flame of jazz and Beat spontaneity. It's contagious. Just standing near him peps you up too.

He's got a gig tonight, down in the narrow basement cabaret of Cornelia Street Cafe. He's got a gig somewhere most every night; he's been in perpetual motion for decades. He returns to the café periodically to split whatever's collected at the door with his quartet because, he says, he wants to keep a connection alive, an ethos he remembers animating the Village in the mid-1950s. It's not about money. "I don't think Saint Francis had a big stock portfolio, but nobody would say he was a failure," he says. "It's about spirit and conduct and morality and standards."

Amram is a composer of jazz, orchestral music, opera, film, and theater scores (the original *Manchurian Candidate, Splendor in the Grass*). He's a multi-instrumentalist (piano, brass, reeds, flutes, percussion, much else) and comfortable in musical forms from many eras and cultures. The instant he arrived in the Village, in 1955, he started playing in the clubs. He soon met and befriended Jack Kerouac, who'd become one of its most famous, if only part-time, denizens. Amram's written three memoirs: *Offbeat, Upbeat,* and *Vibrations*. He has a genius for singing old-school scat and performing extemporaneous rap, both of which he and Kerouac performed together. Tonight's program is part concert, part history lecture. He calls it "55 Years in Greenwich Village," but it might also be titled "Around the World in Eighty Years." He and his combo play old standards in new ways—jazz pennywhistle, jazz glockenspiel. He sings a Native American song, then scats the theme song he wrote for *Pull My Daisy,* the 1959 film featuring Kerouac, Allen Ginsberg, Gregory Corso, Peter Orlovsky, and Larry Rivers. He turns his audience into a syncopated, hand-clapping rhythm section. Between songs he tells stories from the Village of the 1950s and from around the world. He explains how he sees all creativity coming from one great source, a world soul he believes can resist the deadening assaults of modern corporate conformism.

Amram knows this is an anachronistic message to deliver in the Greenwich Village of the twenty-first century, so different from the Village he first came to in 1955. Thanks to historic preservation, much of it *looks* more or less the same. Its famously meandering streets are still lined

with charming nineteenth-century homes and storefronts. Its night-life zone around the intersection of MacDougal and Bleecker Streets is still packed with young fun seekers every weekend. But much else has changed.

The Village in the mid-1950s saw an intense explosion of creative activity. It was a culture engine—a zone that attracts and nurtures creative people, radicals, visionaries, misfits, life adventurers. Coming together in one place they collide, collaborate, fuse, and feud like energetic particles in an accelerator, creating work and developing ideas that change the culture of the world. When the playwright Paul Foster speaks at the end of this book about a creative zeitgeist he means the same thing. Classical Athens was a culture engine, and Elizabethan London, and Paris and Berlin in the 1920s. Greenwich Village was a remarkably productive culture engine for as long as or longer than any of these fabled places.

From its start as a rural frontier of New Amsterdam in the 1600s, it was a place for outcasts. Among its first nonnative residents were "half free" African slaves whom the Dutch strung out on small plots of land as a buffer and early-warning system in event of an Indian attack. The Village would remain the center of the black community in Manhattan through the 1800s, home to the first successful black theater and black newspapers in the country. By 1800 it was the site of Newgate Prison, in effect the first Sing Sing, and a refuge when epidemics flashed through the city. Washington Square Park began as a burial ground for plague victims and a place to hang criminals. Tom Paine, the most effective rhetorician of the American Revolution, was an old and forgotten misfit when he died there in 1809. Edgar Allan Poe, misfit of all misfits, became famous for "The Raven" while living there. Walt Whitman's poetry was universally condemned and despised when he found his first sympathetic audiences in Greenwich Village in the 1850s, amid the first bohemian scene in the city.

The Village's "golden age" as the Left Bank of America flowered in the 1910s. Emma Goldman, Margaret Sanger, Eugene O'Neill, Djuna Barnes, Mabel Dodge, Edna St. Vincent Millay, Hart Crane, Theodore Dreiser, John Reed, Marcel Duchamp, Upton Sinclair, and Willa Cather were

among the set of remarkable individuals who put the Village on the lead-
ing edge of culture, politics, and social movements in those years. With
a speakeasy on every corner during the Prohibition 1920s, the Village
cemented its still active reputation as a party destination, as well as an
unusually tolerant zone for gays and lesbians. In the Red Decade of the
1930s the Village was a hotbed of leftist politics and culture.

New York City was on its way to becoming the culture capital of the
Western world when Amram arrived in the mid-1950s, and much of what
was lifting it to that position was happening in and around the Village:
Abstract Expressionism, Off- and Off-Off-Broadway theater, bebop, the
Beats, avant-garde filmmaking, the early glimmerings of the folk music
revival that drew Dylan and his cohort. The *Village Voice* appeared the
year Amram arrived in the neighborhood. Grove Press had recently pub-
lished the first U.S. edition of Samuel Beckett's *Waiting for Godot*. In 1955
Greenwich Village was a magnet for nonconformists, people who felt
like outsiders elsewhere in Eisenhower's America; it was one tiny corner
of American real estate where artists, writers, intellectuals, gays, lesbians,
and psychological and sexual adventurers could feel at home. It was the
bohemian capital of the East Coast. Amram and Kerouac shared it with
Pollock and de Kooning, Maya Deren and Anaïs Nin, Marcel Duchamp
and John Cage, Norman Mailer and Edward Albee, Charlie Parker and
W. H. Auden, Woody Guthrie and James Baldwin, James Agee and Wil-
liam Gaddis, Maurice Sendak and Dawn Powell.

In the 1960s the Village was the launchpad for Bob Dylan, Jimi Hen-
drix, and many other folk and rock acts, and in the early 1970s it was
the refuge to which John Lennon fled after the Beatles broke up. The
gay liberation movement simmered in the Village through the 1960s and
exploded with the Stonewall riots in 1969, making the Village the gay
and lesbian center of the world in the 1970s. It was also the East Coast
epicenter of the AIDS epidemic in the 1980s.

Greenwich Village was home to large working-class communities of
Italians and Irish as well. It was the site of the Triangle Shirtwaist fire
in 1911, one of the saddest events in the city's history. Three of the most
colorful mayors of the twentieth century came out of the Village: the

charming and lackadaisical Jimmy Walker, the indefatigable Fiorello La Guardia—both natives—and Ed "How'm I doing?" Koch, who moved to the Village as an adult. Heavyweight champion Gene Tunney, the Bard of Biff, was a Village native, as was Vincent "Chin" Gigante, the Daffy Don of the Genovese Mafia family, as were the gangsters who inspired *On the Waterfront*. This population coexisted with Henry James's genteel, patrician Greenwich Village, north of Washington Square, home to some of the oldest and richest families in the city.

The artists, radicals, and misfits drawn to the Village for all those years were always a small and transient minority, though a highly visible and vocal one. They could be as extremist in their behavior as in their art and politics, which didn't always endear them to their neighbors. They often came to the Village as "voluntary exiles," as Michael Harrington wrote, escaping what they felt were the restrictions and burdensome expectations of middle- or upper-class backgrounds. In the decades before every college campus was a node of an international counterculture, when gay and lesbian life was tightly closeted, when just wanting to make art or literature was a sign of abnormality, Greenwich Village was a crumb of the American social landscape where they felt free to live according to what they believed were their true natures. Inevitably some of them turned that liberty into libertinage. Exploring beyond the bounds of traditional social behavior and contemporary morals, they drank prodigiously, soaked up drugs, and threw nonstop orgies. William Burroughs once asked, "What happens when there is no limit? What is the fate of The Land Where Anything Goes?" Many, including Burroughs, sought the answers in Greenwich Village, the Neighborhood Where Anything Went, even though to do so was to court self-destruction. The history of Greenwich Village is littered with the corpses of those who drank themselves to creative ruin or death, overdosed on various drugs, committed alcohol- or drug-fueled murder or suicide, or partied themselves into oblivion. Their excesses could be heroic, despicable, or just ridiculous. In Village lore self-destruction was often revered as martyrdom. Though this seems misguided, we should resist judging the extremists too harshly by the very standards they intentionally, even conscientiously, flouted.

In the 1990s and 2000s Manhattan took the Village along when it renovated and repurposed itself as a magnet for wealthy tourists and residents. It is now more a place of recreation than creation, more occupied with preserving history than making it. The old Greenwich Village, the culture engine, exists now mainly in the memories of survivors such as David Amram. Many of them speak with bitter nostalgia about the changes. A few are more philosophical. The culture engine may return to the Village in some new form someday; the death of the arty-bohemian Village has been declared prematurely many times in the past. Indeed, every generation who misspent their youth there declared it over by the time they'd grown out of it. Today it does seem dead. There are various reasons for that, but one of the most significant, as in almost any story you can tell about Manhattan, is the price of real estate. Making culture and making a living rarely go together in America. The artists and bohemians who made the Village famous "came here," as Villager Floyd Dell wrote, "because the rents were cheap." Certainly not all of them fit the profile of the starving artist but many did. As a function of Manhattan's transformation in recent decades, the rents in Greenwich Village have soared. It's now a magnet for millionaires, not misfits.

A WELL-KNOWN CLICHÉ DURING ITS TWENTIETH-CENTURY HEYDAY was that Greenwich Village wasn't a place but a state of mind. For decades it wasn't even called Greenwich Village; it was known by its political divisions, the Ninth and Fifteenth Wards. Maybe that's why people have always been a bit vague about its geography and borders. Only its western border at the Hudson River waterfront is undisputed. (For convenience we speak as though Manhattan lies on a north-south, east-west axis, the way it looks on a subway map. In truth it leans distinctly to the right, with the southern tip pointing southwest and the northern tip northeast.)

Most people consider Fourteenth Street its northern edge, though Djuna Barnes, always good for an argument, insisted that the Village went no farther up than West Twelfth Street. Today, everyone considers Houston Street the southern border of Greenwich Village. But that's a

relatively recent development. Before the 1970s the area down to Canal Street on the Hudson side of Sixth Avenue was generally known as the South Village. (Barnes went to extremes here as well, claiming that the Village extended all the way down to the Battery, where it "commits suicide.") In the 1960s, artists began colonizing the abandoned cast-iron loft buildings along Broadway below Houston, an area that had been known as Hell's Hundred Acres for all the garment industry fires there. In 1968 they formed their own neighborhood association and named the area Soho (South of Houston). And so the South Village came to be considered part of Soho, even though it remained much more like the rest of the Village—narrow streets, older housing stock, and a largely Italian and Portuguese population. In the 2000s the Greenwich Village Society for Historic Preservation has campaigned to revive the name and idea of the South Village in an effort to get some of its buildings landmarked and preserved.

The Village's eastern border is the most vague. In his book *Republic of Dreams*, Ross Wetzsteon plotted the Village all the way over to Bowery/Third Avenue. At the opposite extreme, the ever feisty Barnes argued that "the Village does not run past Sixth Avenue." She considered only the bohemian and working-class areas, the old Ninth Ward, the true Village, with Washington Square and the streets above and below it a separate place. It wasn't a bad argument; physically and culturally there were notable differences between the patrician streets along lower Fifth Avenue and the more downmarket jumble west of Sixth. But most people include the Washington Square zone as part of Greenwich Village, and as the whole neighborhood has climbed upmarket over the last few decades the class separations of Djuna Barnes's time have disappeared.

For the past few decades the thin strip of mostly commercial stock between Broadway and the Bowery has been called Noho, forming a kind of buffer zone between the West and East Villages. That makes sense. So, in this book, Greenwich Village runs from the Hudson waterfront over to Broadway, and from Fourteenth Street down to Houston Street east of Sixth Avenue; west of Sixth, a bit of a South Village tail pokes down.

How did this tiny and vaguely defined corner of Manhattan come to play such a large and distinct role in Western culture? The history of Greenwich Village, like the history of New York City as a whole, is fantastically deep, layered, fragmented, and fractal. It goes back roughly four hundred years and starts before the Village was a village.

the
Village

From *the* Beginning Through *the* "Golden Age"

Bossen Bouwerie

Greenwich Village was a zone of rogues and outcasts from the start.

In 1640 the population of New Amsterdam, a rough outpost of the Dutch West India Company, was fewer than five hundred people, but it was astonishingly diverse, "the motliest assortment of souls in Christendom," including Dutch and Walloons, French, Swedish, English, Germans, "one Cicero Alberto (known around town as 'the Italian')," and a Muslim mulatto. The first Jews would arrive in 1654. Predominantly male, more employee than citizen, the residents were tough, contentious, and often drunk—drinking and whoring were the chief entertainments, and taverns occupied a quarter of the town's buildings. New York's enduring reputation as a wide-open party town goes back to its founding.

Today's Bowery follows the original track that ran out from the small settlement at the southern tip of Manhattan to *bouweries* (farms) like Peter Stuyvesant's on the east side. It remained an unpaved and lonely country turnpike into the nineteenth century. On the west side, roughly two miles north of town, was an area the Dutch called Noortwyck. It was

a mix of marshland, meadow, swamp, and woods, punctuated by a few
hills, its soil sandy and loamy. Through it wandered a trout stream the
natives called Minetta (Spirit Water), which to the Dutch became Mintje
Kill (Little Stream), to the English Minetta Brook. It wound a path down
through then-swampy Washington Square and took a downward diago-
nal to the Hudson.

Wouter Van Twiller, who succeeded Peter Minuit as director-general
of the Dutch settlement in 1633 (Minuit "bought" Manhattan from the
natives in 1626), was not a very diligent leader of the colony but he did
do well for himself in the new world. Taking advantage of the great dis-
tance separating him from his bosses in Europe, he appropriated for his
personal use two hundred acres of land in Noortwyck that Minuit had
mapped out as a future company farm. Van Twiller turned it into a to-
bacco plantation he named Bossen Bouwerie (Farm in the Woods). His
farmhouse is thought to have been the first built in the area. Late in the
1630s he transferred two parcels of the plantation to Jan Van Rotterdam
and Francis Lastley; the lane that ran between their farms would eventu-
ally come to be known as Christopher Street, the oldest street in the area.

So fair claim can be made for Van Twiller, Van Rotterdam, and Lastley
as the first European residents of what later became Greenwich Village.
They weren't there alone. A native settlement called Sapponckanican
lay near the intersection of today's Gansevoort and Washington Streets.
Gansevoort Street is believed to be laid out along the native trail to the
settlement, which was evidently abandoned in the 1660s, though for the
rest of the century European settlers continued to use the name Sap-
ponckanican for their own hamlet that grew up on the spot.

In 1644 the first black residents moved into the area, when New Am-
sterdam granted some of its slaves their "half-freedom" to grow food for
themselves and for the colonists on mostly tiny parcels of land between
today's Houston and Christopher Streets. Among them, the former slaves
Domingo Anthony, who farmed a plot at the southwest corner of today's
Washington Square Park, and Paul d'Angola, who worked a lot between
Minetta Lane and Thompson Street. A lane that followed the banks of

the Minetta Brook and connected the farms was called the Negroes'
Causeway in colonial times. It is today's Minetta Street.

Other so-called free negro lots were drizzled throughout present-day
Chinatown, Soho, and the East Village. The Dutch were not acting out
of altruism or good fellowship. Spread across the island, the black farms
were intended to act as a defensive barrier and buffer zone between the
town and the Lenape, the area's native population, who had been roused
to fury by Willem Kieft, New Netherland's director-general from 1638
to 1647. Hardheaded, tyrannical, and bloody-minded, Kieft had angered
the natives by trying to levy taxes against them. Violence ensued. Kieft
decided stern punishment was the only way to bring the unruly natives
in line. In February 1643 he led raids on two of their villages, one north
of the town (near the eastern end of the present Grand Street) and one
across the river in New Jersey. Kieft and his cohort massacred some 120
men, women, and children, triumphantly dragging mutilated bodies and
severed heads back to town. "Young children, some of them snatched
from their mothers, were cut in pieces before the eyes of their parents,
and the pieces were thrown into the fire or into the water," a shocked
townsman reported. "Other babes were bound on planks and then cut
through, stabbed and miserably massacred so that it would break a heart
of stone." The atrocities ignited a disastrous war that flared from New
Jersey to Long Island. A few thousand natives died, many outlying farms
were burned and abandoned, and New Amsterdam was brought close to
ruin by the time the conflict ended. Kieft was recalled and Peter Stuyve-
sant was brought in to restore order and rebuild.

In 1664 British warships sailed up to New Amsterdam and took it
from Stuyvesant without a shot fired, renaming it New York. (The Dutch
took it back in 1673 and renamed it New Orange but relinquished it
again, and for good, in a year.) At first, English colonial law continued to
allow black freemen to own land, and free blacks purchased sometimes
significant parcels of land through the seventeenth century. Meanwhile,
the English gradually tightened the reins on black slaves, requiring them
to carry passes, levying heavy punishments on escaped slaves and anyone

harboring them, and establishing, in 1702, the office of a Common Whipper of Slaves. A new slave market opened on Wall Street in 1711. The following year, a group of up to fifty black men and women "carrying guns, swords, knives, and hatchets" staged a rebellion, setting fire to a building on Maiden Lane (then on the outskirts of the city), killing or wounding some fifteen whites who rushed to put it out, including a few of their masters. Of those captured, "twenty were hanged and three burned at the stake. One, a pregnant woman, had her execution postponed" until after she gave birth. The incident was an excuse for a harsh new "Act for preventing Suppressing and punishing the Conspiracy and Insurrection of Negroes and other Slaves." This included a new prohibition against free blacks, mulattoes, or natives owning "any Houses, Lands, Tenements or Hereditaries." As a result, by the Revolutionary War most of the former Negro lots in Greenwich Village were in white hands.

UNDER THE ENGLISH, COLONIAL NEW YORK DEVELOPED FROM A frontier trading post into a port city. By 1700 its population was around five thousand, ten times that of 1640. It had expanded north almost to Fulton Street, packing in hundreds of new buildings on streets that were being paved with cobblestones. The decrepit defensive battlement at Wall Street was pulled down to make way for northward growth, although there wasn't much at first. The stone Great Dock was constructed on the East River in 1675, landfill widened the tip of the island all around, and stone bulkheads protected the new shoreline, which soon bristled with wharfs. The city grew and prospered through the first half of the 1700s, powered by shipping, riding boom markets in commodities such as sugar and slaves. By 1740 one in five New Yorkers was a slave. The city's numbers also swelled with new immigrants: Germans, Irish and Scots, many of them indentured (in effect, white slaves), and Jews.

The war of independence brought seven years of dislocation and disaster. Occupied by the British in 1776, the city was set alight, likely by Patriot saboteurs. After the British withdrawal on November 25, 1783, the burned-out zone west of Broadway was cleared for new construction. Wharfs that had deteriorated during the occupation were rebuilt, ship-

yards bloomed. Existing streets were paved and graded, new ones laid out. A flood tide of new immigrants brought the population to more than 120,000 by 1820.

For all its growth and busyness, however, the city was still packed tightly into a very small area at the tip of Manhattan. You could easily walk anywhere, as long as you minded the odd open sewer trench or the filled-in swamp where the ground was soft and still settling. A new housing development proposed in 1806 for up near the canal that ran west from the Collect Pond to the Hudson—filled in a decade later to form Canal Street—failed because nobody wanted to live "so far out of town." In his *Reminiscences of New York by an Octogenarian* published in 1896, the civil engineer Charles Haynes Haswell remembered that "As late as 1820 I, in company with an elder relative, occasionally practised pistol-shooting at a target on a fence on the south side in this open and unfrequented street." He also remembered hunting snipe on Lispenard's Meadow, south of the present Broome Street. When the new City Hall opened in 1812, three sides of the exterior were marble, but the north face was cheaper brownstone because there wasn't much of anyone north of Chambers Street to impress.

Still, some New Yorkers could already envision a much larger city. In 1811 the Commissioners of Streets and Roads in the City of New York published a map that planned for the Manhattan of the future. The commissioners' plan, sometimes referred to as the Randel Plan for its chief engineer and surveyor, showed a rectilinear grid of numbered east-west streets and numbered and lettered north-south avenues imposing machinelike order from Houston Street all the way up to 155th Street. As with so much else in New York City's history, real estate interests had top priority in the commissioners' thoughts. In the report published with the map, they noted that "one of the first objects which claimed their attention was the form and manner in which the business should be conducted; that is to say, whether they should confine themselves to rectilinear and rectangular streets, or whether they should adopt some of those supposed improvements by circles, ovals, and stars, which certainly embellish a plan, whatever may be their effect as to convenience and utility." (This is surely a disparaging ref-

erence to Pierre L'Enfant's more fanciful and, to this day, traffic-bedeviling plan for the new District of Columbia.) "In considering that subject they could not but bear in mind that a city is to be composed principally of the habitations of men, and that straight-sided and right-angled houses are the most cheap to build and the most convenient to live in. The effect of these plain and simple reflections was decisive."

From the day it was published the plan drew harsh criticism. Where were the utilitarian back alleys, the monotony-relieving plazas, the breath-taking hilltop vistas that befit a great city? "These are men who would have cut down the seven hills of Rome," one New Yorker griped in 1818. He was not far off; much of the once hilly island would be flattened as the grid marched inexorably uptown. In 1893 a *Harper's Monthly* writer complained:

> The magnificent opportunity which was given to the Com-
> missioners to create a beautiful city simply was wasted and
> thrown away. Having to deal with a region well wooded,
> broken by hills, and diversified by watercourses—where the
> very contours of the land suggested curving roads, and its
> unequal surface reservations for beauty's sake alone—these
> worthy men decided that the forests should be cut away, the
> hills levelled, the hollows filled in, the streams buried; and
> upon the flat surface thus created they clapped down a ruler
> and completed their Boeotian [i.e., dull-witted] programme
> by creating a city in which all was right angles and straight
> lines.

The writer summed up the plan as "a mere grind of money making in stupid commonplace ways."

One small area on the map bucked the precision-tooled order. Just above Houston Street on the Hudson flank of the island lay a maze of crooked, angled streets, a small eruption of eccentricity and disorder: the former Bossen Bouwerie, now called Greenwich Village.

A Magnet for Misfits

POOR TOM PAINE, THERE HE LIES;
NOBODY LAUGHS AND NOBODY CRIES;
WHERE HE HAS GONE OR HOW HE FARES,
NOBODY KNOWS AND NOBODY CARES!

—*Nursery rhyme*

EDGAR ALLAN POE IS DEAD. HE DIED IN BALTIMORE THE
DAY BEFORE YESTERDAY. THIS ANNOUNCEMENT WILL
STARTLE MANY, BUT FEW WILL BE GRIEVED BY IT.

—*Rufus Wilmot Griswold*

WHILE THE TOWN CROWDED INTO THE SOUTHERN TIP OF
Manhattan was going through all its growth, changes, and
catastrophes of the seventeenth and eighteenth centuries, the area
that became Greenwich Village remained quiet, bucolic countryside,

remote from the bustle and turmoil though not entirely isolated. In the 1650s "the few houses at Sappokanican" are mentioned in settlement records, an early indication that a small hamlet had grown up on Van Twiller's land. It's mentioned again thirty years later, when Jasper Danckaerts, a member of the Dutch Protestant sect called Labadists, came to the new world to scout out a location for a Labadist colony. In his journal entries for September 1679, he records setting out by foot to explore Manhattan, walking out of town on "the Broadway." On the way out of town along Broadway he passed "many habitations of negroes, mulattoes and whites." He found the island dotted with farms and small hamlets, both Dutch and English. Three hours' walk brought him up to the New Harlem settlement, where he spent the night in the home of the local *schout* or sheriff. "This house was constantly filled with people, all the time drinking, for the most part . . . execrable rum." He had also "the best cider we have tasted." Heading back down toward New York the next day, passing through large orchards where the peaches lay on the ground in such profusion that even the hogs had eaten their fill, he and his local guide Gerrit crossed the island and "came to the North River, which we followed a little within the woods," to the hamlet whose name he recorded as Sappokanikke. "Gerrit having a sister and friends there we rested ourselves, and drank some good beer, which refreshed us." Around the time of Danckaerts's visit, a Dutchman named Yellis de Mandeville, who lived near the village of Greenwijck on Long Island, bought some of Wouter Van Twiller's old Bossen Bouwerie and apparently named it Greenwijck. By the 1720s this had been anglicized to Greenwich. Because the settlements outside the city were called villages, Greenwich came to be known as Greenwich Village.

The farmland of Greenwich continued to be parceled out and developed in the 1700s. Small clusters of buildings sprouted at the crossings of country lanes and along the Minetta. Early in the century, the Crown gave Trinity Church two very large parcels of land that ran up the west side of the island all the way from the city to Christopher Street, forming Trinity Church farm. East of it lay the Elbert Herring and Thomas

Ludlow farms. In the 1740s Sir Peter Warren—whose home in the city was burned in a supposed Negro uprising in 1741—assembled a large estate running from the Hudson to around today's Sixth Avenue, and from Christopher Street up past Twenty-first Street. The Irish-born Warren cut one of the most gallant figures in colonial New York. He'd already demonstrated his daring and courage as a young captain in the British navy when he was posted to New York in 1728, where high society received him with all the honors and flirtations due a dashing officer. In 1744 he was appointed commodore of a squadron of British warships that preyed on French and Spanish booty off the Leeward Islands, taking two dozen prizes in just four months. Under the British naval system the commander shared the spoils with the Crown, so Warren became very rich, as well as earning an admiralty and a knighthood. He also married into one of New York's wealthiest families, the De Lanceys.

Warren was evidently the first rich man from the city to build a country place in Greenwich, a fine home to which he and his family could escape during the heat and stink of summer in the crowded city. On his death in 1752 Warren's estate was parceled out among three daughters, one of whom married the earl of Abingdon, namesake of the Village's Abingdon Square at Eighth Avenue between West Twelfth and Bleecker Streets. Another married a Colonel William Skinner, and Christopher Street was known for some time as Skinner Road. This land later fell to Charles Christopher Amos, and the three parallel east-west roads through it were named Charles, Amos, and Christopher Streets. Amos was later renamed West Tenth Street.

Other wealthy New Yorkers followed Warren's lead, so that "by the mid-1760s there was an almost unbroken line of great estates up the west side of Manhattan." It was lush countryside even then, and there was still good fishing in the Minetta Brook and plenty of small game to shoot. Haswell, in *Reminiscences*, records childhood memories of seeing men striding up Broadway and Greenwich Street with their guns on their shoulders and their dogs alongside, "on the way to the suburbs for the shooting of woodcock, English snipe, and rabbits." Captain Thomas Clark, a veteran of the French and Indian War, established a large estate

just north of Warren's in an area that still bears the name he gave it, Chelsea. Abraham Mortier leased a part of the Trinity Church farm called Richmond Hill, near today's Varick Street. He built a mansion on top of the promontory with a view of the Hudson. George Washington made it his headquarters at the start of the war; it's said that Martha enjoyed carriage rides up the Fitzroy Road, which ran north near today's Eighth Avenue, to the Chelsea and Bloomingdale estates (north of Chelsea in what became Hell's Kitchen). Abigail Adams, who moved there with her husband, John, when he became vice president in 1789, described the still rustic setting in a letter to her sister Elizabeth Shaw.

> The house in which we reside is situated upon a hill, the avenue to which is interspersed with forest trees, under which a shrubbery rather too luxuriant and wild has taken shelter . . . In front of the house, the noble Hudson rolls his majestic waves, bearing upon its bosom innumerable small vessels, which are constantly forwarding the rich products of the neighbouring soil to the busy hand of a more extensive commerce . . . On the right hand [uptown], an extensive plain presents us with a view of fields covered with verdure, and pastures full of cattle. On the left [downtown], the city opens upon us, intercepted only by clumps of trees, and some rising ground, which serves to heighten the beauty of the scene, by appearing to conceal a part. In the background, is a large flower-garden, enclosed with a hedge and some very handsome trees. On one side of it, a grove of pines and oaks fit for contemplation.

The Adamses hosted dinners at Richmond Hill that were long remembered for their elegance and opulence, at which Thomas Jefferson, foreign ambassadors, and local toffs feasted on lavish repasts of game and truffle pies, roast beef, lobster, and pâté. In the late 1790s Aaron Burr took over the house as his country retreat. It was from Richmond Hill that he left for his fatal duel with Alexander Hamilton in Weehawken, New Jersey,

on the morning of July 11, 1804. Returning to Richmond Hill later that day, he wrote to Hamilton's doctor, "Mr. Burr's respectful compliments. He requests Dr. Hosack to inform him of the present state of General H. and the hopes which are entertained for his recovery." Hamilton died the next afternoon and Burr fled to avoid a murder rap.

After that Richmond Hill's glory faded. By the 1820s the city was growing up around it. John Jacob Astor, who'd bought the property from Burr, had the house rolled on logs downhill to the southeast corner of Charlton and Varick Streets, then leveled the hill and laid out streets lined with modest row houses—now expensive historic homes on Charlton, King, and Van Dam Streets. The mansion, falling into dilapidation at its new location, housed the Richmond Hill Theatre and Miss Nelson's Theatre in the 1830s (50 cents for box seats, 25 cents for the pit) and a stable before it was torn down in 1849. A block of brick houses rose up on the site. In 1913, when the city widened Varick Street as part of the Seventh Avenue extension, these were torn down as well, and what was believed to be the foundation of the old house was uncovered.

To this day, in the Irish section of the Village, you can still hear an alternative version of this history, a legend that savors of Irish class warfare. In this telling, the regular folks who lived around Richmond Hill didn't like it that high and mighty types literally looked down on them from their big house at the top of the hill. And so they not only tore the house down, they flattened the hill.

A NEON SIGN HANGING FROM THE WALL OF THE TOWN HOUSE AT 59 Grove Street advertises the presence of Marie's Crisis Cafe, the small piano bar in the basement. Lower down on the wall, a plaque from 1923 explains that a contemporary of the Washingtons, Adamses, and Burr died there in 1809. The name "Crisis" is in his honor. The "Marie" is for Marie Dumont, the original owner.

Thomas Paine didn't die in the current building but in a wood-frame house that stood on the spot before it. In 1809 Greenwich was still largely the countryside Abigail Adams had described twenty years earlier, with large estates, farms, and some small hamlets stitched together by the

meandering lanes and paths that would become the Village's famously confusing knot of streets. Paine didn't do much in the Village except die there. As often happens to revolutionaries when their revolutions are won, he died impoverished and largely unloved by the nation he'd helped to create, his radical ideas having made him an unwanted outsider. Which is why it's fitting that he chose to end his days where he did.

Paine had arrived in Philadelphia from England in 1774, just in time to help light the spark of the American Revolution. He was in his late thirties, a man of restless intelligence who had not yet found his footing in the world. He'd followed his Quaker father into the corset-making business for a while, gone to sea, taught English, and importantly worked as a tax collector, where he saw firsthand the "numerous and various distresses" taxation imposed on the poor. He was also an amateur scientist and inventor, which led to his meeting Ben Franklin in London. With encouragement and a letter of introduction from Franklin, he left England for the American colonies, where he plunged straight into the independence movement. His *Common Sense*, the most influential pamphlet of its time, appeared in January 1776. It quickly sold an unthinkable one hundred thousand copies and was universally discussed and argued. William Blake cheered Paine as the man who could "overthrow all the armies of Europe with a single pamphlet." The Declaration of Independence came that July. Paine enlisted in the militia the following month and began writing *The Crisis*, his series of pamphlets written to rally support for the war. ("These are the times that try men's souls . . .")

When the war was won in 1783, however, his influence waned. Temperamentally unsuited to bureaucratic life, he held and lost a few minor positions in the new government. In 1787 he left for England and France. He was in Paris to rejoice when the revolution began in 1789. Back in England in 1791, he wrote his hot-tempered *Rights of Man* as a retort to "the nonsense, for it deserves no better name" of Edmund Burke's *Reflections on the Revolution in France*. Burke, fearing that the violence of the French revolt might ignite similar actions in England, argued that a people had no right to depose their hereditary monarch.

"All hereditary government is in its nature tyranny," Paine thundered

back. "To inherit a government, is to inherit the people, as if they were flocks and herds." The British Crown banished him for treason. He went back to France, where he was promptly invited to join the National Convention—and promptly imprisoned (gently, under house arrest in a former palace) for speaking out against Louis's execution. "Kill the King," he'd argued, "but not the man."

He worked on *The Age of Reason* during his ten months' confinement. "I do not believe in the creed professed by the Jewish church, by the Roman church, by the Greek church, by the Turkish church, by the Protestant church, nor by any church that I know of," he declares at the outset. "My own mind is my own church. All national institutions of churches . . . appear to me no other than human inventions set up to terrify and enslave mankind, and monopolize power and profit." This won him no new friends back in God-fearing America, where he returned, sixty-five years old and in fragile health, in 1802. "When President Thomas Jefferson invited Paine to the White House, one Federalist newspaper vilified him as 'irreligious, depraved, unworthy to associate with the President of the United States.' "

For his service to the new nation he'd been given a small, formerly Tory-owned farm in New Rochelle, but his neighbors despised him and possibly plotted to do him bodily harm. His health failing, in 1806 he moved to the city, where a friend, the painter John Wesley Jarvis, put him up in his home on Church Street. In 1808 Paine moved out to a house on Herring (now Bleecker) Street, then asked an old friend, a Madame Bonneville, to look after him. She rented for him the house at what's now 59 Grove Street and had the old man carried to it in an armchair. He died in a back room within a month, on June 8, 1809. Few noticed that a hero of the Revolution had passed. One of his few obituaries ran in the *New-York Evening Post*, founded by Alexander Hamilton and other Federalists for whom the post-Revolution Paine had been an irritant. According to the *Post* he'd "lived long, did some good and much harm." He was interred on his farm, with fewer than ten people in attendance.

The indignities didn't end there. In 1819 William Cobbett, a British radical and journalist, exhumed Paine's corpse and took it to England,

where he intended a proper memorial. He was refused permission and stored the remains in his attic. It's said that after Cobbett's death in 1835 his son sold Paine's remains, piecemeal—a hand here, the jawbone there— to fans in England and France.

PAINE DIED IN OLD, COUNTRY GREENWICH, BUT A PLAGUE, A PRISON, and a potter's field would soon help transform the village into a city.

All the hectic rebuilding in lower Manhattan after the Revolutionary War; the imperfect filling of former swampland and bog and waterfront; the increasing difficulties of drawing fresh water from overtaxed springs and streams; the metastasis of commercial activities into residential streets; the inadequate provisions for sewage and garbage disposal; and the huge influx of people into what was still a very small space combined to make New York in the last decades of the 1700s and first of the 1800s a noisy, stinky, soggy, overcrowded, often filthy hive of activity. Not surprisingly, deadly epidemics of smallpox, cholera, and yellow fever periodically broke out. A committee of citizens charged with determining the cause of the outbreaks cited the city's "deep damp cellars, sunken yards, unfinished water lots, public slips containing filth and stagnant water, burials in the city, narrow and filthy streets, the inducement to intemperance offered by more than a thousand tippling-houses, and the want of an adequate supply of pure and wholesome water."

Successive waves of yellow fever drove many New Yorkers to summertime residences in the countryside. Washington Irving, who made Sleepy Hollow and other Hudson River towns famous, was a Manhattanite who made his first trip up the river as a teenager when his parents sent him out of the city to escape a yellow fever epidemic in the summer of 1798. Many others escaped to the nearer countryside of Greenwich, a refuge from pestilence with its former swampland drained and its air fresh.

It was the especially virulent epidemic in the summer of 1822 that prompted the relocation not only of residents but of businesses and government offices to Greenwich, "which place," Haswell writes in *Reminiscences*, "became the scene of hurried building operations on a large scale." A local preacher spoke of seeing corn growing at the corner of today's

West Eleventh and Fourth Streets on a Saturday morning, and on the same spot, the very next day, a rough-hewn building "capable of accommodating three hundred boarders. Stores of rough boards were [also] constructed in a day." In one week in 1822 "the Custom House, the Post Office, the Banks, the Newspapers located themselves in the village or in the upper part of Broadway, where they were free from the impending danger," and these places "almost instantaneously became the seat of the immense business usually carried on in the great metropolis." The new buildings were thrown up along Greenwich's existing paths and lanes, making permanent the Village's jumbled street plan. The name of today's Bank Street derives from this period.

Some people returned to the city that fall, when the epidemic had passed, but others stayed. Brick row houses popped up all through the 1820s along the lines of Astor's development at the south end of Greenwich and along the north-south thoroughfares of Hudson and Greenwich Streets and Sixth Avenue. In 1825 the *Commercial Advertiser* noted that "Greenwich is no longer a country village. Such has been the growth of our city that the building of one block more will connect the two places; and in three years' time, at the rate building has been everywhere erected during the last season, Greenwich will be known only as a part of the city, and the suburbs will be beyond them." Between 1825 and 1835 the population of the Village doubled. It doubled again by 1850. New York grew and flowed around it and was so built up below Fourteenth Street by the 1850s that young New Yorkers scoffed at the idea that Greenwich Village had ever been a true, separate village.

NEWGATE PRISON OPENED IN 1797 AT THE FOOT OF CHRISTOPHER Street on what was then the waterfront at Greenwich Street. Greenwich was still far enough out of town in the 1790s to be considered the perfect site for such a facility, making Newgate the first penitentiary to which criminals from the city were sent "up the river" and predating Sing Sing by three decades. Newgate was a progressive institution aimed, under the influence of the city's Quakers, at reforming convicts by teaching them trades like weaving, cobbling, and blacksmithing. Its security was so lax,

however, that frequent riots and escapes forced it to close after Sing Sing opened to replace it in 1826. Jacob Lorillard, of the tobacco Lorillards, bought the buildings and converted them into a sanatorium and spa. The area had filled in during the prison's thirty years. The Greenwich Hotel was built nearby and tradesmen spread along Christopher Street. Greenwich Market on the south side of Christopher Street flourished from the 1810s into the 1830s; Christopher Street is still unusually wide past Greenwich Street because the horse-drawn wagons that used the market needed the room to maneuver. It closed in the mid-1830s when the new Jefferson Market, over at what's now Sixth Avenue and West Tenth Street, siphoned off its business. By 1820 a stagecoach was running between Christopher Street and the Financial District five times a day, helping to knit the city and Village together.

Christopher Street was the site of another very important development for both the Village and the city in 1807, when Robert Fulton's steamboat—originally simply called the *Steamboat*, later renamed *Clermont*—set out from the Christopher slip for Albany. A couple of thousand New Yorkers came out from the city to watch the launch, many expecting to see "Fulton's Folly" blow up. Fulton, a Pennsylvania-born inventor who'd previously experimented with submarines, was not, as legend often states, the inventor of the world's first steamboat. Inventors in the United States and France had successfully built versions some twenty years earlier. But the idea was still new and risible in New York, and several of Fulton's investors provided funding only under cover of anonymity to avoid being mocked by their friends. Local rivermen, who rightly saw steam power as a threat to their livelihoods, "accidentally" rammed their sloops into the *Steamboat* hoping to damage or sink it. But Fulton's ungainly, flat-bottomed, paddle-wheeled box survived, and steamboat service between Manhattan and upriver cities and towns was soon a booming business. Steamboats also took over the ferry services between Manhattan and New Jersey on the Hudson side. On the East River, Old Fulton Street still leads up into Brooklyn Heights from the Fulton Ferry landing in the neighborhood now known as Dumbo. Walt Whitman would often ride

the steam ferry from this Brooklyn landing over to Manhattan, and he wrote one of his best poems about it, "Crossing Brooklyn Ferry."

TWENTY-FOUR YEARS BEFORE THE PLAGUE SPURRED THE DEVELOPment of the western Village, it populated the eastern side of the Village, Washington Square in particular. During the epidemic of 1798, when a young Washington Irving was being spirited up the Hudson, the city sought a place far enough out of town to bury the glut of its dead. City government chose a swampy patch on the eastern side of Greenwich, which already hosted a few church graves. Over the next thirty years this soggy ground served as "our Golgotha," as one doctor called it, a potter's field for paupers and plague victims. Apparently duelists also used the land, and a wooden gallows for executions was sited roughly where the fountain is today. (The so-called Hangman's Elm or Hanging Tree, the three-hundred-year-old English elm in the northwest corner of the park, was never used for this purpose.) The last hanging from the gallows was that of Rose Butler, a black nineteen-year-old convicted in 1820 of arson after a fire in her master's house. Arson was a crime of gravest public concern in a city that had suffered several disastrous conflagrations. Since the slave revolts of 1712 and 1741, whenever anyone black was implicated in a fire, old fears of a Negro conspiracy were awakened. Thus Butler's conviction was relatively ensured, as was her death sentence. An enormous crowd gathered in the Square to watch it carried out.

By 1826 the ground was too crowded with corpses to take any more. The city created a new potter's field uptown near today's Bryant Park and converted the old one into the Washington Military Parade Ground. Opened on July 4, 1826, the fiftieth anniversary of the Declaration of Independence, the Square's inauguration was celebrated with "a great public barbecue for which two roasted oxen and two hundred hams were prepared." The wheels of cannons on parade sometimes broke through the ground and into the old grave pits, revealing corpses in yellow shrouds, which had designated them as fever victims.

Nevertheless, the Square was so popular a public space that people

began to build grand homes along its perimeter. Commercial buildings were quickly taking over lower Manhattan, making life increasingly uncivilized for the resident burghers and patricians. Around Wall Street and lower Broadway, tall buildings—five stories was the equivalent of a skyscraper then—reared up and overshadowed their homes. Seeking sunlight and fresh air, some moved across the East River to the brand-new suburb Brooklyn Heights, advertised to Manhattan's gentry in the 1820s as "the nearest country retreat." (Fulton's East River ferry service, launched in 1814, made it an easy commute.)

Others moved up to Washington Square. In the 1830s they lined the north side of the Square with fine brick row houses, including the Row, the block of Greek Revival town houses that still stands between Fifth Avenue and University Place. Some of the city's richest and oldest families lived there, including the Rhinelanders, Delanos, Coopers (as in Cooper Union on Astor Place), and Goulds, with staffs of up to sixteen chambermaids, butlers, footmen, cooks. In *Washington Square*, Henry James has Dr. Sloper move up to one of these homes from downtown in 1835. "[T]his portion of New York appears to many persons the most delectable," he writes from half a century's remove. "It has a kind of established repose which is not of frequent occurrence in other quarters of the long, shrill city; it has a riper, richer, more honorable look." James was born on Washington Place, which runs east from the Square, in 1843, but his family moved to Europe when he was still an infant. When they returned in 1847 he grew up on West Fourteenth Street near Fifth Avenue, though he spent many hours at his grandmother's home at 19 Washington Square North.

In 1832, the fledgling University of the City of New York (later New York University), founded a year earlier as "a nonsectarian training ground for the mercantile elite," went deeply into debt buying up properties on the east side of the Square for its first permanent building, a handsome Gothic hall "evocative of Oxford and Cambridge." Beginning an NYU tradition that continues into the twenty-first century, the construction of the building was fraught with controversy. Bitter faculty, teaching in temporary quarters downtown, often went unpaid. Parts of

the building expanded across property lines, causing legal problems. To cut construction costs, the university and the building's contractor arranged to use marble cut by prisoners at Sing Sing's quarry up the Hudson. This enraged local stonecutters, who attacked the contractor's office on Broadway in what came to be known as the Stonecutters Riot of 1834.

The streets on the south side of the Square were built up as well. A long block of what's now Washington Square South was lined with large, marble-front row houses for the burghers, advertised "To Capitalists" in the *New York Gazette*. More modest brick and wood-frame houses went up along Amity Street, now West Third Street. In the 1840s, Edgar Allan Poe lived, briefly, in two of them and enjoyed, briefly, the peak of his popular success while there.

From the start, Poe's life reads like one of his stories, a tale of constant wanderings, struggles, and self-defeat. He was born to poor traveling actors in Boston in 1809, roughly ten years ahead of Thoreau, Melville, Whitman, and Baudelaire. His parents separated, then died of tuberculosis within days of each other. The wealthy Allans of Richmond, Virginia, took him in when he was two but never legally adopted him. They took him to England when he was six, returning to Richmond five years later. Poe grew up a melancholic loner; his first known poem, written when he was fifteen, begins "Last night, with many cares & toils oppress'd, / Weary, I laid me on a couch to rest." Despite his desperate desire to please and impress John Allan, his foster father never approved of him; Allan would die in 1834 without leaving Edgar a penny. To be fair, Edgar made it difficult. He entered the new University of Virginia at seventeen, ran up an enormous gambling debt, and was forced to drop out when Allan wouldn't cover it. He left for Baltimore, enlisted in the army, and meanwhile self-published *Tamerlane and Other Poems*, the first of several books he'd publish himself at great cost with no appreciable returns in sales or critical esteem. He attended West Point in 1830, was bored, and got himself court-martialed in 1831.

Somewhere along the way he'd set his sights on becoming a professional writer, a characteristically self-defeating choice. The literary historian Sandra Tomc argues that Poe "selected a career almost guaranteed

not to issue in what antebellum society judged to be pecuniary or professional success." Writing was a marginal pursuit. Pay for all but the most popular writers and successful editors was abysmal, and no copyright laws protected work from piracy. The great mass of writers subsisted in dire poverty, unless they were "gentleman scribblers" of other means. But writing did hold out the possibility of those intangible rewards prestige and fame, which Poe, a rejected, orphaned outsider, might well crave.

He enjoyed some early successes. "MS. Found in a Bottle" won a small literary prize in Baltimore in 1833, and the Southern Literary Review, after publishing his "Hans Pfaall," brought him to Richmond as editor in 1835. He thrived there, greatly increasing the magazine's circulation while building his own repute as a wickedly sharp-tongued critic with the temerity to go after giants of the New England literary establishment the likes of Longfellow. (Boston, not New York, was still the capital of American literature at the time.) But he barely earned a living wage, drank heavily, and suffered black bouts of suicidal depression. In 1836, when he was twenty-seven, he married his thirteen-year-old cousin Virginia Clemm. After his drinking got him fired from the Messenger the following year, he brought his child bride and her mother to New York. Not a fan of city life, Poe set them up in a house in what was still, if barely, the suburbs: 137 Waverly Place in Greenwich Village. During their short stay he published The Narrative of Arthur Gordon Pym, then moved to Philadelphia in 1838 to edit a magazine, and it was here that he published most of the stories on which his reputation rests: "The Murders in the Rue Morgue," "The Pit and the Pendulum," "The Masque of the Red Death," "The Tell-Tale Heart," "The Black Cat," and others. But his salary never lifted him out of poverty, and his alcoholism and disputatious temper again got him fired.

In 1844 he brought the frail and tubercular Virginia back to New York. They stopped briefly in a boardinghouse on Greenwich Street adjacent to what would become the World Trade Center site. In 1845 they rented a small house at 15 Amity Street, and later number 85. While they were at this address, the New York Evening Mirror published "The Raven," and for the first time Poe achieved some of the popular success he'd craved.

It was an instant hit, widely reprinted, parodied ("The Pole-Cat" amused Abraham Lincoln), and translated into French by Baudelaire and Mallarmé. On the strength of its popularity, the firm of Wiley and Putnam quickly published his *Tales*, his first book in five years, and *The Raven and Other Poems*. It was also in 1845 that he briefly co-owned and edited his own publication, the weekly *Broadway Journal*, which debuted in January of that year and died for lack of funds in January 1846.

Despite his success, he remained a gloomy, high-strung, contrarian figure. Tomc speculates that although he certainly was all these things, he might have exaggerated his public persona. Many writers and editors of the period cultivated outré reputations as arrogant fops, decadent voluptuaries, immoral lechers, and pugnacious enemies of their contemporaries, hoping to stand out from the rest of the pack. Poe may have played up his glum demeanor as he fulfilled the many requests to read "The Raven" in public. In 1846, with Virginia fading away, the Poes moved out to the Bronx countryside, where in 1847, barely in her mid-twenties, she died. In 1849 Poe left New York for Richmond, where he wooed a widow. As they were making wedding plans, he took a train for New York but somehow ended up in Baltimore instead, where he was found lying on a street in a drunken stupor. He died there, a few months shy of forty-one, on October 7, 1849.

Poe was quickly labeled America's "first bohemian," not only here but in literary France as well. It is a reputation that's still attached to him today, but it's doubtful he'd be pleased. Unlike the bohemians, Poe never flaunted his poverty—it was a source of constant shame and misery to him. He didn't loaf and carouse like a bohemian; he worked himself to the nub trying to support himself, his frail wife, and his mother-in-law, and he drank alone, out of depression. He didn't reject mainstream values; he sought respect, approval, and success all his truncated life. If he was America's preeminent *poète maudit* of the time, it wasn't by his choice.

Poe's memory was insulted at the dawn of the twenty-first century, and another controversial New York University building was the source. In 2000 the university announced a plan to erect a new law school building, Furman Hall, on West Third Street between Sullivan and Thompson

Streets, the block where the small brick house once known as 85 Amity Street still stood and was cherished by Villagers as the Poe House. Of course, Poe lived in so many places that there are Poe Houses in several locations; the city of Baltimore, for instance, preserves its own little brick Poe House, as it happens on its own Amity Street, and the Bronx has the Poe Cottage. Nonetheless, NYU's plan to demolish this particular Poe House raised a furor of opposition among Village residents, preservationists, literary organizations, and celebrities from E. L. Doctorow to Lou Reed, who in 2003 released a two-CD collection of songs inspired by Poe, which he titled *The Raven*. Pressed on all sides, the university agreed to preserve and somehow incorporate the Poe House into its giant new building. The result is a reproduction brick facade bizarrely embedded in the West Third Street wall of the mammoth building. It looks like a skin graft that didn't take. The bricks, windows, and door appear to be brand-new. A plaque on the wall informs the passerby that this facade is an "interpretive reconstruction" of the demolished Poe House. The "Poe Room" inside is open to the public for exactly two hours per week, 9 to 11 on Thursday mornings. Furman Hall does salute Poe's legacy in one other, no doubt unintentional, way: it's grim as a mausoleum, and the color of dried blood.

Village lore tenuously connects Poe to one other building in the neighborhood, the appropriately odd Northern Dispensary, the brick triangle where Waverly Place splits and runs into Christopher Street, a few steps from where Poe lived in 1837. It was built in 1831 as the city's second clinic for the poor, and Poe, who certainly was that, is said to have stopped in with a head cold. As the city grew up around the Village the dispensary staff kept busy, writing more than twenty thousand prescriptions in 1886. Patients dwindled in the twentieth century as more hospitals appeared, and by the 1960s it was solely a dental clinic. In the 1980s it notoriously refused to serve HIV patients and shut down in 1989.

By 1850 Greenwich Village had been surrounded and engulfed by the city, yet it retained a distinctive character. It stood off to one side and at an angle. Its spaghetti of narrow streets west of today's Sixth

Avenue enforced a casual pace, its quaint houses and small shops calming. Until the Seventh and Sixth Avenue extensions, and the subway lines below them, spiked through the Village in the following century, the business and traffic of the city flowed around and past it. Its waterfront bustled, but otherwise it remained a bedroom community, largely free of industrial buildup. It was a backwater, an eddy. Still, it was part of the city now, a neighborhood rather than a village or suburb. Most people didn't even call it Greenwich Village: west of Sixth Avenue was now the Ninth Ward and around Washington Square and Fifth Avenue was the Fifteenth. Wards were political subdivisions. The Fifteenth Ward was nicknamed the Empire Ward for the high number of wealthy and powerful patricians who lived there. The Ninth came to be known as the American or Yankee Ward, because the wave after wave of new immigrants coming into the city from eastern and southern Europe largely flowed around it. In 1875 about one in three residents of the Ninth Ward was foreign-born, as opposed to areas such as the Lower East Side, its tenements bursting at the seams with new Jewish, Italian, Ukrainian, and other immigrants. The population would change. The immigrants and industry would come, as would apartment towers and tourist honky-tonk. Yet as the rest of Manhattan filled up with skyscrapers and giant apartment buildings, the Village's "quaint" and charming qualities ensured that it was never fully transformed and absorbed by the metropolis around it.

3

The First Bohemians

GIVE ME NOW LIBIDINOUS JOYS ONLY!
GIVE ME THE DRENCH OF MY PASSIONS! GIVE ME LIFE
 COARSE AND RANK!
TO-DAY, I GO CONSORT WITH NATURE'S DARLINGS—
 TO-NIGHT TOO,
I AM FOR THOSE WHO BELIEVE IN LOOSE DELIGHTS—
 I SHARE THE MIDNIGHT ORGIES OF YOUNG MEN,
I DANCE WITH THE DANCERS, AND DRINK WITH THE
 DRINKERS

—Walt Whitman

AT 643 BROADWAY BETWEEN BLEECKER AND WEST THIRD
Streets an upscale bar-lounge opened in 2011. Through a discreet entrance you descended a narrow stairway to a dimly lit basement. The walls were bare brick but otherwise the space was appointed to evoke sumptuous nineteenth-century indulgence: a long bar of carved oak, stuffed chairs, pleated leather banquettes,

carpeted floors, paintings of reclining nudes. It looked like a place
where diamond-studded robber barons of the Gilded Age might sit
with cigars and brandy between stuffing themselves full of oysters
at Delmonico's and sampling the ladies at the high-class bordello up-
stairs. Pretty young waitresses in corsets and fishnet stockings abet-
ted the anachronistically risqué atmosphere as they ferried trays of
high-priced cocktails to today's gentlemen and ladies of industry.

It was called the Vault at Pfaff's, from a line of Walt Whitman's, and
claimed a lineage to a subterranean Broadway rathskeller where Whit-
man and his friends quaffed and gabbed a hundred and fifty years earlier.
It's not unusual for bars in New York to adopt some historical theme in
their decor and promotion—or to fudge the history as needed. The origi-
nal Pfaff's was actually in the basement next door, under the deli and
shoe store at 645–647 Broadway. The building at 643 Broadway didn't ex-
ist in Pfaff's time. And Pfaff's famous clientele were both more boisterous
and less well heeled than the young urban professionals sipping concoc-
tions named the Leaves of Grass and the Smoking Revolver in today's
establishment. They were frayed-collar journalists and poets, struggling
artists, and actresses with somewhat salty reputations, and they created
New York's first celebrated bohemian scene.

THE TERM "BOHEMIAN" HAD FIRST BEEN APPLIED TO POOR ARTISTS
and poets on the Left Bank in Paris in the 1830s, but the idea was still
new enough in America twenty years later that the *New York Times* felt
obliged to offer a long and rather dismissive definition in 1858. To under-
stand how and why bohemianism came to New York when it did, it helps
to know something of its origins. Bourgeois culture and bohemian coun-
terculture were created at the same time, and by the same great force,
the industrial revolution. It was then, at the end of the 1700s, that the
economies of Europe turned away from peasant agrarianism toward ur-
ban industrialism. Cities swelled with the rise of the new middle class
and working class. (Both terms come to us from this period, along with
"industry," "factory," "capitalism," and "socialism.") Merchants became

captains of industry; peasants flooded in from the countryside to become the new urban proletariat. At the same time, waves of democratic revolt and reform, following the American Revolution of 1776 and the French Revolution of 1789, were dismantling the long-held powers of monarchs, feudal landlords, and the Church. The freethinking individual of the Enlightenment became the primary and ideal unit of the new social and political order.

The role of artists, writers, and other creative workers in this period was subject to these drastic changes as well. Until now, the arts had largely been created for and supported by either the Church or noble patrons. The masons who carved the great cathedrals, the painters who adorned them, and the composers who wrote the music for the Mass were all skilled artisans, usually guild members working collectively. They had a fixed place and purpose in the old social order. The idea of the individual artistic genius, free to follow his or her muse wherever she led, "would have been neither tolerated nor understood." The few insurgent spirits such as Michelangelo, Caravaggio, and Villon are exceptions who "stand out from the army of men with the standards of professional craftsmen and entertainers, the John Sebastian Bachs, Handels, Haydns and Mozarts, the Fragonards and Gainsboroughs." The poet Kenneth Rexroth, a godfather to the Beats, put it succinctly: "There were no Baudelaires in Babylon."

Now creative workers began (theoretically) to enjoy the same individual freedoms that everyone else (theoretically) did. Instead of obediently creating their works for the Church and the nobility, they were free to create whatever they wanted. But this meant competing for sales in a new marketplace, where the burgeoning middle class "required furniture, ceramics, paintings, ornaments, textiles and wallpapers for their homes, and formed a growing educated audience for literature, painting, music and the performance arts." To lessen the sting of having to sell themselves to the bourgeois philistines (another coinage from the period), artists began to define themselves as superior to their buyers. One of the seminal creations of this period is the idea of the artist as tortured genius,

in every way finer, braver, more sensitive, more angelic, and more satanic than those mere shopkeepers and merchants who had the privilege of consuming the products of his greatness.

With all these new freedoms came another: the freedom to starve. Without the support of the Church, noblemen, and the old guilds the creative worker was now "left to cast his soul upon a blind market, to be bought or not." Then as now, for every successful, celebrated creative worker there were many, many others who shivered and scrounged in obscurity. This is when the first identified "bohemians" emerge. In Paris by the 1820s young, hungry artists and intellectuals gathered together in the Latin Quarter on the Left Bank around the Sorbonne—the old student district, where Latin had been the common tongue of the international university crowd, and where, more to the point, the rents were very cheap. In many respects the lives they pursued there were indistinguishable from long-standing traditions in any university district in any city. Unencumbered by bourgeois concerns of getting and spending, they slept late and caroused early, clustered in cheap cafés to drink bad wine and shout lofty philosophies, experimented with drugs and with the occult, espoused free love, befriended the lower orders, developed an unhealthy fascination with romantic death and tragic suicide, and created art, literature, and ideas guaranteed to shock and confound their elders. The term "bohemian" was apparently first applied to them by a journalist named Felix Pyat in 1834. The French had long called Gypsies bohemians, because they were thought to come from the kingdom of Bohemia. (They were "gypsies" because they were thought to have come to Bohemia from Egypt.)

The inherent conflicts, confusions, and stresses that continue to dog the relationship of bohemian countercultures to their bourgeois markets were in place early. In rejecting the restrictions of capitalism and exploring the outer edges of individualism, bohemians were "essentially an oppositional fraction of the bourgeois class," "acting out the conflicts inherent in the bourgeois character . . . Many non-Bohemians experienced the same ambivalence" about their roles in the new social order "but they did not devote their lives to living it out." Writing about his Greenwich

Village years in *Exile's Return*, Malcolm Cowley points out that there had always been poor writers and artists, and they'd often clustered together in metropolitan ghettos, from ancient Rome and Alexandria to Grub Street, the shabby zone of hack writers and cheapjack publishers in eighteenth-century London. What was new about the bohemians, he argues, was their confrontational attitude and behavior: "Bohemia is Grub Street romanticized, doctrinalized and rendered self-conscious; it is Grub Street on parade."

Fifteen years after Pyat coined the term, another French writer, Henry Murger, went a long way toward romanticizing bohemia and thus launched it into international popular culture. Murger himself was a bohemian more by association and necessity than personal desire. Born into the lower end of the middle class, son of a tailor/janitor and a concierge, he decided not to follow his father's trade and pursued writing instead. He wrote as "Henry" rather than his given "Henri" because he thought the exotic English spelling would get him noticed. He was scrounging, doing hack work for various publications, when he began to write a series of feuilletons—brief sketches of everyday affairs, like the "Talk of the Town" pieces in *The New Yorker*—in a small newspaper in 1845, portraying the lives, loves, and carefree poverty of his bohemian friends. At first the public barely noticed, but when the sketches were reworked into a play, *Scènes de la vie de Bohème*, first produced in Paris in 1849, it was an enormous hit. Suddenly all Paris—then all France, then all of the Western world—was fascinated with bohemians. Riding the wave, Murger put out *Scènes* as a book in 1851 and it became an international best seller.

Bohemians fired imaginations everywhere—London, Berlin, Munich, St. Petersburg—and the wave hit American shores in the 1850s. One of the first American-born bohemians was James McNeill Whistler. He has come down to us as the painter of a dour, dark portrait of his mother, but Whistler himself cut an aggressively bright figure in the world. Born in New England in 1834, raised partly in Russia and London, the twenty-two-year-old moved to Paris in 1855, apparently under the spell of Murger's novel. He took a studio in the Latin Quarter and soon fell into the bohemian life, which almost killed him within a few years. He affected

flouncy, eccentric outfits and outrageous public behavior, while count-
ing Baudelaire, Théophile Gautier, Marcel Proust, and Édouard Manet
among his acquaintances. On returning to London, he continued to play
the oddly dressed, larger-than-life, two-fisted bohemian for the rest of his
days, attracting a lot of press, alienating a lot of fellow artists and wealthy
patrons, and inspiring a new generation of young aesthetes. Whistler
was the first notable American-born artist actually to settle in bohemian
Paris, as opposed to those who would make brief tourist pilgrimages be-
ginning in the mid-1850s.

JUST AS THE FIRST PARIS BOHEMIANS HAD EMERGED AT A TIME OF
huge social and economic changes, New York's first bohemians an-
nounced their presence when the young nation, not yet a century old,
was facing great internal crises. America had entered the decade of the
1850s with a booming economy, vigorously expanding across the con-
tinent, yet it had begun pulling itself apart along regional and factional
fault lines that pitted the industrializing Northeast against the plantation
South, the farmers of the Midwest, and the vast new territories farther
west. North, South, East, and West disagreed over much—over slavery,
over tariffs and taxes, over the rights of individual states versus the rule of
the union, even over the path of a proposed transcontinental railroad and
the need for coast-to-coast telegraph lines. Slavery was the touchstone is-
sue around which much of the conflict coalesced.

The country's economic boom ended in 1857 when a wave of bank fail-
ures rolled out from New York, followed by panic on Wall Street. Much
of the country plunged into a brief but steep depression, with the highest
unemployment in the North. In New York City the jobless ranks swelled
to as high as a hundred thousand in a city of eight hundred thousand.
Workers in factories and mines throughout the North, battered by wage
cuts and layoffs, organized strikes. The trouble spread to the Midwest,
where the value of farmers' crops plummeted. The plantation South, still
able to export cotton and tobacco, weathered the turmoil best. The fis-
sures deepened and the nation continued its slide toward civil war.

The Pfaff's scene appeared in the midst of all this turmoil, providing

some welcome distraction and a little comic relief. The restaurant saloon was in the cellar of the Coleman House, a small hotel on Broadway. The building still stands, showing its age. Broadway itself was in a state of great flux. From the 1820s through the 1840s, great homes and cultural institutions had spread up Broadway from the Washington Square area. Stuyvesants, Roosevelts, Lorillards, Astors all built mansions on or near Broadway above Houston Street. The wealthy importer Allan Melville built a grand house there when Herman was nine years old. The beautiful Grace Episcopal Church, the Gothic Revival masterpiece at Broadway and East Tenth Street, was consecrated in 1846.

Next door to Coleman House stood the grand Stuyvesant Institute, a Greek Revival palace of culture built in the 1830s that at various times was home to the New-York Historical Society, the Lyceum of Natural History, NYU's Medical College, and the National Academy of Design, the first professional association created by and for artists in this country. Young artists including the portrait painter Samuel Finley Breese Morse had started the academy in 1825 as a revolt against the older, hide-bottomed American Academy of the Arts (originally the New-York Academy of the Fine Arts). Morse was its first president, and he also taught painting and sculpture at NYU. In 1825 the city of New York sent Morse to Washington, D.C., to paint a portrait of Lafayette. While he was there news reached him that his wife, Lucretia, had taken ill in New Haven. By the time he got there she was in her grave. Already a sometime inventor, Morse started to think about faster ways to send messages over long distances. Through the 1830s he worked on what became the telegraph. It's an exaggeration to call him the telegraph's sole inventor—several others were working on the same principles, leapfrogging one another, and often disputing one another's claims—but he did invent Morse Code.

As the city surged up toward Fourteenth Street in the 1840s and '50s, Broadway developed into its chief shopping area, entertainment zone, and "sporting" (red-light) district. *Putnam's Monthly* declared the Broadway stem "the most showy, the most crowded, and the richest thoroughfare in America" during the day, and a "promiscuous channel of activity and dissipation" by night. Riding the pre-1857 boom times, shopping

was a popular new recreational activity in the city. Department stores like Lord & Taylor and A. T. Stewart, the jeweler Tiffany, dress shops, hat shops, and huge restaurants such as Taylor's, at Broadway and Franklin Street below Canal—where the stupefyingly opulent decor made up for the rude service and mediocre food—drew hordes of shoppers in the daytime. Not all that wide despite its name, Broadway was choked with the traffic of horse-drawn wagons, carts, carriages, and omnibuses, raising a terrible clatter. Shoppers darted from one side of the street to the other at some peril to their lives, not to mention their shoes and hems, since it was muddy in the rain, slushy in winter, and dusty when dry and the inadequate private garbage removal usually left the gutters choked. It was visually loud as well, with gaudy painted signs and advertisements festooning every spare surface of the buildings.

After dark, Broadway turned into the central nervous system of what the patrician George Templeton Strong called the city's "whorearchy." In the evenings Broadway was "always crowded," he complained in his diary in 1840, "and whores and blackguards make up about two-thirds of the throng." Upwards of a hundred brothels operated on and around Broadway in the 1850s; they were included in all the guidebooks. Whitman observed that "any man passing along Broadway, between Houston and Fulton streets, finds the western sidewalks full of prostitutes, jaunting up and down there." Broadway was lined with theaters, hotels, and saloons that also served as de facto whorehouses. The whorearchy worked generally unmolested in a city that was wide open and vice ridden. Prostitution was a huge industry—the second largest in the city, according to an 1855 census. Sex workers included both "she-harlots and he-harlots," as Whitman writes in his mad jeremiad "Respondez!" One guidebook remarked that New York out-Sodomed Sodom.

So it seems that Pfaff's was in the right spot at the right time to become a hangout for artists, writers, and newfangled bohemians. It had the vaulted, subterranean atmosphere of a rathskeller and was known for its beer selection, but it also maintained an excellent wine list and real silver and china service. Regular customers sat at small tables in the front, while a long table in the rear was reserved for the bohemian crowd.

Charles Pfaff was a German Swiss who, like all the best publicans, was a good-natured host to his colorful, eccentric clientele and shrewd enough to exploit their presence as a draw to student wannabes and gawkers. In its 1890 obituary for Pfaff, the *New York Times* recalled that in the late 1850s his establishment had been "the favorite resort of all the prominent actors, authors, artists, musicians, newspapermen, and men-about-town of the time. It was not an attractive-looking place, for it was on the floor below street level, and was fitted up in a plain, quaint fashion . . . but the service was clean and the cooking excellent." Pfaff's beefsteak and pfannkuchen were renowned, but most folks had come, the *Times* said, to "get a look at the lions of bohemia."

The core group at Pfaff's conformed closely to Cowley's notion that bohemia was Grub Street with an added layer of self-conscious ostentation. "Far from a pack of free-and-easy artistic vagabonds, the Pfaff's crowd consisted primarily of hard-working writers who made penurious livings from the penny press and magazines," the historian Christine Stansell notes. It was boom times for New York newspapers and magazines, and several founded in this era went on to great and long success, including the *New York Times* (founded in 1851), *Harper's Monthly* (1850), *Harper's Weekly* (1857), the *Atlantic Monthly* (1857), the *New York World* (1860), the *Nation* (1865), and *Harper's Bazaar* (1867). Most of them still paid their writers and illustrators abysmally, however, so Pfaff, who allowed them to loiter over their beers and run up tabs, was a godsend. Like media folks in any age, they wrote a lot about themselves, and Pfaff reaped the benefits of the free publicity. There were a couple of other venues where a nascent bohemian crowd hung out, including the saloon down at Taylor's restaurant, but Pfaff's was preeminent.

By January 1858 the *New York Times* felt moved to print a rebuke of the bohemian fad, observing that the term "is now heard almost as frequently as the once unknown term of loafer. But a Bohemian is not quite a loafer, though he is not far removed from one. The true Bohemian has either written an unsuccessful play, or painted an unsalable picture, or published an unreadable book, or composed an unsung opera." Bohemians "hold the finest sentiments, and have a distinctive aversion of anything

that is low or mean, or common or inelegant. Still, the Bohemian cannot be called a useful member of society." Disparaging bohemians as loafers or at best not-quite-loafers—loafing being a newly minted term when the *Times* and Whitman used it ("I loafe and invite my soul, / I lean and loafe at my ease observing a spear of summer grass")—became a standard put-down in work-ethic America still in use a century later.

Unhappy with writing for, and being written about in, stodgy papers like the *Times*, the "Pfaffians" created two short-lived papers of their own, the *Saturday Press* and *Vanity Fair*, which were in effect house organs for the scene. The founder and editor of the *Press* was a slight, perpetually pipe-smoking New Englander named Henry Clapp Jr. According to legend Clapp—a Sunday school teacher who by the 1850s had fallen off the temperance wagon and become a prodigious drinker—discovered one afternoon that the beers in Pfaff's were excellent and told all his writer friends, who made the place a boisterous scene and declared Clapp the king of Bohemia. The *Saturday Press* was a weekly broadsheet that sold for a nickel. It scratched out a chronically cash-strapped subsistence only from October 1858 into December 1860, later revived by Clapp for less than a year in 1865. The *Press* is best remembered in literary history for its relentless championing of Whitman's 1860 edition of *Leaves of Grass*, at a time when most critical responses were extremely negative, and for helping to kick off Mark Twain's career by first publishing "Jim Smiley and His Jumping Frog" in the 1865 reincarnation. Clapp set the irreverent, sarcastic tone of the *Press*. He was known for his pointed bon mots. When the *Nation* appeared in 1865, he gave it the nickname *Stag-Nation* for its lack of female writers. He called Wall Street Caterwaul Street and branded the *Tribune*'s Horace Greeley "a self-made man who worshipped his creator."

One of the most remarkable figures in Clapp's crowd was Ada Clare, born Jane McElhenney into a well-off Charleston family in 1836. She borrowed her nom de plume from Dickens's *Bleak House*, serially published in 1852–53, but she might also have been thinking of the southern belle's common exclamation "Ah declare!" Like Mabel Dodge Luhan in the following century, Clare spent much of her life in headlong flight

from her dull, respectable origins. By 1855 she was in New York and her first poems were appearing in the *New York Atlas*. She met and fell in love with the celebrated pianist and composer Louis Gottschalk, a notorious philanderer and ruiner of young women's reputations. (When he died in Rio de Janeiro in 1869, it was rumored that he'd been killed by a jealous husband. The cause of death was in fact malaria, of which he collapsed on stage in the midst of a recital.) Clare had a son by Gottschalk. Rather than quietly suffer the ruin of her reputation, as most young women of her time would have done, she boldly trumpeted it. She had calling cards printed up with the shocking announcement "Miss Ada Clare and Son," and the two of them traveled that way through Europe, out West, and as far as Hawaii.

In 1858 she returned to New York from Paris where, like Clapp a few months earlier, she'd enjoyed the bohemian milieu. The Pfaffians, already declaring Clapp their king, welcomed her back as their queen. The boys at Pfaff's were quite taken with her. Whitman called her "a perfect beauty" with "no inconsiderable share of intellect and cultivation." Stansell points out that the mere presence of Clare, an unrepentantly unwed mother, along with a handful of other single, unchaperoned women, was enough to give the scene at Pfaff's a risqué allure. In the mid-1800s, any woman seen alone in public—and certainly in a saloon—was presumed to be a prostitute.

Clare struggled with something of an acting career for much of her life (the *Times* described her performances as "erratic but gifted"), but her true forte was writing. She contributed funny, sharp-tongued theater and literary criticism to the *Saturday Press* and other publications. "I have finished reading 'Beulah,' " she wrote once in the *Press*. "Let the fact be recorded as a proof of my extreme pertinacity of purpose. 'Beulah' is another inane copy of 'Jane Eyre.' But it is a waxen, corky, wooden-jointed, leather-and-findings imitation of it." She used her *Press* column "Thoughts and Things" to comment on issues of the day, once lampooning the various causes then roiling the city and the nation ("Temperance, anti-asylumism, anti-slavery, anti-capital punishments") by declaring her own campaign—against pie.

Clare did not live in the city but out in what were effectively the sub-
urbs at 86 West Forty-second Street (Whitman jotted it down in one of
his notebooks), where developers had been building rows of modest town
houses, brownstones, and tenements for about a decade at this point.
Horse-drawn "street railroads" connected the new and still rather iso-
lated developments to the city. According to another actress friend, Rose
Eytinge, Clare held soirees on Sunday evenings for "men and women, all
of whom had distinguished themselves in various avenues—in literature,
art, music, drama, war, philanthropy. The women were beautiful and bril-
liant, the men clever and distinguished . . . This was Bohemia, and our
fairy-like, beautiful young hostess was its queen."

Another regular at Pfaff's, the Irish writer Fitz-James O'Brien (1828–
1862), came to America in 1852 from England, where he'd first tasted
the bohemian life while squandering a modest inheritance on immod-
est and intemperate pleasures. He earned the nickname Fist-Gammon
O'Bouncer for his tendency to escalate literary arguments into fistfights,
which often saw him remanded to the Jefferson Market jail. He was also
known for borrowing cash to throw dinners for his friends at Pfaff's or
Delmonico's, then not inviting the lender, on the presumption that any-
one holding that much cash to lend must be a bourgeois pig. O'Brien
wrote Gothic horror tales inspired by Poe for which he's best known
now, a column of theater criticism called "Dramatic Feuilleton" for
the *Saturday Press*, a "Man About Town" column for *Harper's*, and other
journalism. He wrote his best work when giving free rein to his raffish
sense of humor. His short story "The Bohemian" is a satire of the already
well-established stereotypes. A young, struggling lawyer and would-be
writer—he's working on an article for *Harper's*—looks up from his desk
one night to find a "seedy" man in his doorway, who proclaims himself a
bohemian. He explains:

"When I say that I am a Bohemian, I do not wish you to
understand that I am a Zingaro [Gypsy]. I don't steal chickens,
tell fortunes, or live in a camp. I am a social bohemian, and

fly at higher game . . . Have you read Henri Murger's *Scènes de la vie de Bohème?*"

"Yes."

"Well, then, you can comprehend my life. I am clever, learned, witty, and tolerably good looking. I can write brilliant magazine articles . . . I can paint pictures, and, what is more, sell the pictures I paint. I can compose songs, make comedies, and captivate women."

"On my word, Sir, you have a choice of professions," I said, sarcastically . . .

"That's it," he answered; "I don't want a profession. I could make plenty of money if I chose to work, but I don't choose to work. I will never work. I have a contempt for labor."

"Probably you despise money equally," I replied, with a sneer.

"No, I don't. To acquire money without trouble is the great object of my life."

Walt Whitman began frequenting Pfaff's in 1859, "sitting out the long period of critical silence that followed the second edition of *Leaves of Grass*," Stansell writes. "Pfaff's became, in these years, his chief source of social intercourse." A little older than most of the bohemians, he sat to one side and was amused by their high spirits. He was born near Huntington, Long Island, in 1819 and raised there and in Brooklyn, where he dropped out of school at twelve and became a printer and typesetter, a newspaperman, and a (largely self-taught) schoolteacher. He lived in Manhattan for several years in the 1840s, but was back in Brooklyn by the 1850s, though frequently crossing the river into the city for both work and play. He was attracted to Pfaff's—and to the attention its crowd was getting—at a time when he was avidly seeking attention for himself and for *Leaves of Grass*.

Four years earlier, he had self-published just under eight hundred copies of the first edition of *Leaves of Grass*, setting the type for some pages

himself in a Brooklyn Heights print shop. In every respect it was un-
usual. The author was unnamed but presumably portrayed in a fron-
tispiece engraving, looking more like a slightly dandyish workingman
than an aesthete. It opened with a prose prologue, a ten-page statement of
purpose that seemed to gush from the author in such a torrent he could
barely pause for punctuation: "The greatest poet hardly knows pettiness
or triviality. If he breathes into any thing that was before thought small
it dilates with the grandeur and life of the universe. He is a seer . . . he
is individual . . . he is complete in himself . . . the others are as good as
he, only he sees it and they do not." The twelve poems that followed were
untitled, without rhyme or meter or normal line breaks. The first one,
later titled "Song of Myself," flowed an astounding 1,336 lines, fifty-six
pages of "barbaric yawp." Later readers would recognize it as startlingly
modern free verse, exploding like an impatient supernova half a century
before its time. "I am the poet of the body, / And I am the poet of the
soul," Whitman announces. He declares his unity with everything and
everyone in the "kosmos." Nothing is too small or too large for him to
embrace ("I believe a leaf of grass is no less than the journeywork of the
stars"), and no human act is off-limits.

> *Through me forbidden voices,*
> *Voices of sexes and lusts . . . voices veiled, and I remove the veil,*
> *Voices indecent by me clarified and transfigured.*
> *I do not press my finger across my mouth,*
> *I keep as delicate around the bowels as around the head and*
> *heart,*
> *Copulation is no more rank to me than death is.*
>
> *I believe in the flesh and the appetites,*
> *Seeing hearing and feeling are miracles, and each part and tag of*
> *me is a miracle.*

Toward the end he hopefully projects, "The proof of a poet is that his
country absorbs him as affectionately as he has absorbed it." In this he

was sorely disappointed. Very few copies sold, very few reviews appeared. Of those that did, only the ones ghostwritten by Whitman himself were positive; the others denounced it as "a mass of stupid filth," "stupid and meaningless twaddle," or a "muck of abomination." One contemporary poet seemed to appreciate the work: Ralph Waldo Emerson. As a young newspaperman in 1842, Whitman had been terrifically impressed by an Emerson lecture called "Nature and the Powers of the Poet," in which Emerson declared that "New topics, new powers, a new spirit arise, which threaten to abolish all that was called poetry." Emerson called for an American poet who would capture "our log-rolling, our stumps and their politics, our fisheries, our Negroes and Indians, our boasts and our repudiations." Not outlandishly, Whitman thought he'd done that in *Leaves of Grass*, and he sent a copy to Emerson, who wrote back, "I find it the most extraordinary piece of wit and wisdom that America has yet contributed . . . I give you joy of your free brave thought. I find incomparable things said incomparably well, as they must be . . . I greet you at the beginning of a great career." Emerson came to New York to take Whitman out to dinner. Understandably elated, Whitman had Emerson's letter printed in the *New York Tribune*, reproduced it in his expanded 1856 second edition of *Leaves*, and had the words "I greet you at the beginning of a great career" emblazoned in gold lettering on the book's spine. Emerson, who hadn't been asked permission to make his private letter so very public, was taken aback by the brashness, but he got over it. Whitman took Emerson to Pfaff's, which he found too rough and noisy. Emerson's friends Henry Thoreau and Bronson Alcott (Louisa May's father) made their own pilgrimage to New York to meet Whitman; Alcott noted in his journal that Thoreau and Whitman were wary with each other, "like two beasts, each wondering what the other would do, whether to snap or run; and it came to no more than cold compliments between them."

For all that, the 1856 edition also went unread and unloved. Whitman was furiously writing new poems and planning a third edition when he came to Pfaff's. He wasn't much of a drinker. His first published book had been a temperance novel, *Franklin Evans; or The Inebriate*, published in 1842. At twenty thousand copies, it sold a lot better than *Leaves of Grass*

would. But he liked being around a jolly crowd, and he very much liked the respect and honors afforded him by Clapp and the *Saturday Press*. He and Clapp were kindred spirits, both lapsed temperance men with Quaker backgrounds and both older than most of the Pfaff's crowd. In its short existence, Clapp's weekly printed nearly fifty items about Whitman. Clapp helped broker the 1860 publication of the third edition of *Leaves*—vastly expanded to more than four hundred and fifty pages—with Whitman's first commercial publisher, Thayer and Eldridge in Boston. Whitman in turn brokered paid ads by the publisher in the *Press*. Not surprisingly, when the book was printed, the *Press* was an enthusiastic if lonely voice of huzzahs and kudos. "We announce a great Philosopher—perhaps a great Poet—in every way an original man," the review in the *Press* cheered. Scholars have debated whether it was Clapp or Whitman himself who wrote it. Clapp and Whitman were both believers that there's no such thing as bad publicity, and the *Press* reprinted some extremely harsh reviews of the new *Leaves*, including one that pleaded with the poet to commit suicide: "If Walt has left within him any charity, will he not now rid the disgusted world of himself?" Other reviews dismissed his work as "obnubilate, incoherent, overwritten flub-drub" and likened him to a gorilla.

Vanity Fair, begun in 1859 by three Pfaff's regulars, the brothers William Allen Stephens, Henry Louis Stephens, and Louis Henry Stephens, promoted the 1860 *Leaves* and its author in its own way—by poking gentle fun at them. Not the direct ancestor of today's glossy magazine, *Vanity Fair* was a humor and satire weekly modeled on London's *Punch*. All the Pfaffians wrote for it, though the blind items and pseudonyms make it hard to say who wrote what. Along with making sport of revered public figures such as Henry Wadsworth Longfellow, Abraham Lincoln, and the Reverend Henry Ward Beecher, *Vanity Fair* ran more than twenty humorous references to Whitman before it folded in 1863, presciently treating the little-known poet—the magazine's friend—as though he were as large a figure as those others, and as deserving of some satirical jabs.

The most famous *Vanity Fair* jape at Whitman's expense was a twenty-

five-line parody of "Song of Myself," published in the paper two months before the 1860 *Leaves* appeared, and thus serving as left-handed advance publicity. It was titled "Counter-Jumps" and subtitled "A Poemattina.—After Walt Whitman." The Pfaff's house jester Fitz-James O'Brien is a good candidate for its authorship. Besides being a brilliant parody of Whitman's style, it makes winking mockery of his homosexuality, which was well known to his comrades at the saloon. It was his other reason for frequenting Pfaff's: it was a hangout for "tall, strapping, comely young men" who were not averse to what he called "manly love," "adhesiveness," and "comradeship." In the 1840s and '50s—his twenties and thirties—Whitman cruised (he used the word) the streets of Manhattan and the Brooklyn waterfront to meet young workingmen, or "trade," with a special fondness for stage drivers, omnibus drivers, and ferryboat crews, once referring, in what must have been an unintended pun, to "all my ferry friends." His notebooks from these years are filled with entries like "Peter—large, strong-boned young fellow, driver . . . I liked his refreshing wickedness, as it would be called by the orthodox," and "David Wilson—night of Oct. 11 '62, walking up from Middagh [a street in Brooklyn Heights]—slept with me." At Pfaff's he met a group of young men who called themselves the Fred Gray Association for one of their members. He wrote of the Fred Gray group's "animation, hilarity and 'sparkle,'" and of joining them on their rounds of the "lager beer saloons" on the Bowery. It's believed that it was at Pfaff's that Whitman met Fred Vaughan, an Irish-Canadian stage driver who may have been the inspiration for a large new section of poems in the 1860 edition of *Leaves* known as the "Calamus" poems. Calamus is a figure in Greek mythology whose grief transforms him into a reed after his young lover Karpos dies; it's also the name of a plant with a distinctly phallic shape. The Calamus poems contain passages such as the following:

> *Here to put your lips upon mine I permit you,*
> *With the comrade's long-dwelling kiss, or the new husband's kiss,*
> *For I am the new husband, and I am the comrade.*

Or if you will, thrusting me beneath your clothing,
Where I may feel the throbs of your heart or rest upon your hip,
Carry me when you go forth over land or sea;
For thus merely touching you is enough, is best,
And thus touching you would I silently sleep and be carried eter-
 nally.

To Whitman's despair, Vaughan married and fathered four children. In cities like New York with huge populations of single working-class men constituting a "bachelor subculture," it wasn't uncommon for a young man to take his sex and romance any way he could find it and later settle down in a traditional marriage.

The Calamus poems were as close as Whitman came to outing himself. But his friends at *Vanity Fair* had beaten him to the punch. "Counter-Jumpers" was their joking term for "the well-dressed male clerks who worked in the fashionable stores catering to women," and "one way of speaking about the emergence of an urban homosexual culture." An accompanying illustration depicted the bearded poet looming over a smaller male. Associating Whitman with counter-jumpers was a clever way to tweak him on two counts, both for being gay and for being so un-bohemian in his lust for commercial success. It begins:

I am the Counter-Jumper, weak and effeminate.
I love to loaf and lie about dry-goods.
I loaf and invite the Buyer.
I am the essence of retail. The sum and result of small profits and
 quick returns.

It ends:

For I am the creature of weak depravities;
I am the Counter-jumper;
I sound my feeble yelp over the woofs of the World.

Whitman's sexuality was known not only to his friends but to at least one of his enemies. Five years before the Calamus poems, one of the reviewers of the 1855 *Leaves* attacked him openly for it. After expressing his "disgust and detestation" of the poetry in *Leaves*, the critic Rufus Wilmot Griswold, who had previously written a rather nasty obituary for Poe, dropped straight to his main point, resorting to Latin to expose the "vileness" of the poet: "*Peccatum illud horrible, inter Christianos non nominamdum.*" That is, "the horrible sin not to be named among Christians," later in the century known as the love that dare not speak its name.

IN 1861 THE ONSET OF THE CIVIL WAR BEGAN TO BREAK UP THE Pfaff's crowd. Some of them joined the army, while Whitman dallied at Pfaff's for a while, then went to Washington to volunteer as an army nurse. In the decades after the Civil War he finally achieved some of the respect he'd hoped for, developing a following as America's "good gray poet," acquiring fans including Oscar Wilde and Bram Stoker. To protect his reputation he dissembled and denied his homosexuality until his death in 1892, once angrily claiming to have sired six children.

Ada Clare traveled and continued to pursue both her writing and her acting careers. In 1866 her novel *Only a Woman's Heart*, based on her affair with Gottschalk, was published to harsh reviews, some from writers she'd previously panned. In February 1874, a small item in the *Times* reported that Clare "was some days ago nursing a pet dog which was ill, and while holding the animal in her lap the treacherous little beast, for some trivial cause or other, sprang at her, and, catching her nose between its teeth, wrenched and tore the unfortunate woman's face so severely that her countenance will undoubtedly be sadly disfigured for life."

It was worse than that: the dog was rabid. The following month she collapsed on a stage in Rochester, was carried off delirious, and died. In a letter to a friend, Whitman wrote that he was "inexpressibly shocked by the horrible and sudden close of her gay, easy, sunny, free, loose, but *not ungood* life."

Pfaff and Clapp tried to resuscitate the scene when the war ended in 1865, but its moment had passed. "The old Bohemian clique is smashed,

and Pfaff's has become a respectable and well-conducted lager beer saloon," an observer wrote. Clapp declined into drunken decay and died in 1875.

Pfaff closed the saloon and went into retirement for a while, then opened a new one farther uptown, on Twenty-fourth Street near Broadway. In the mid-1870s Whitman visited with him there, then wrote that the two old survivors sat and reminisced.

> Ah, the friends and names and frequenters, those times, that place. Most are dead . . . And there Pfaff and I, sitting opposite each other at the little table, gave remembrance to them in a style they would have themselves fully confirm'd, namely, big, brimming, fill'd-up champagne-glasses, drain'd in abstracted silence, very leisurely, to the last drop.

Pfaff closed the new place in 1887 and died a few years later.

4

The Restless Nineties

SO, TO QUAINT OLD GREENWICH VILLAGE THE ART
PEOPLE SOON CAME PROWLING, HUNTING FOR NORTH
WINDOWS AND EIGHTEENTH-CENTURY GABLES AND
DUTCH ATTICS AND LOW RENTS.

—O. *Henry*

THE UNION VICTORY IN THE CIVIL WAR ENDED THE ARMED conflict that had almost destroyed the nation, but war had left many rifts and fissures: between North and South, East and West, between the unimaginably wealthy and the unspeakably poor, between native-born and immigrant, rural and rapidly growing urban. In the following decades America surged into a period of dynamic growth and expansion. It completed its march across the continent, adding new states at a heady clip. Its victory in the Spanish-American War in 1898 gave it Cuba, Puerto Rico, and the Philippines—the start of a global empire. It urbanized and industrialized with breathtak-

ing speed. Cities grew in prodigious leaps, fed by millions of im-
migrants from abroad, as well as by a large-scale domestic migration
in from the farms and plantations. They flocked to work in the new
steel mills, textile mills, and factories, in shipping and logging and
railroading, in offices and shops. The rise of industry and the birth
of giant corporations made a tiny elite—railroad men, steel barons,
the Morgans, Rockefellers, Carnegies—stupendously wealthy, while
reducing most everyone else to either droning wage slavery or hid-
eous poverty. Middle- and working-class Americans learned how to
punch the clock, pass the exam, and meet the quota, while the new
mass marketing and merchandising encouraged them to devolve
from active customers into passive consumers. As early as 1873 Mark
Twain (an off and on Village resident) dubbed the era the Gilded
Age—gilded as in shiny on the surface, darker underneath. He also
called it "the great barbecue." At the other end of the era, the econ-
omist Thorstein Veblen, who would help found the Village's New
School for Social Research, coined the term "conspicuous consump-
tion." A vast social chasm opened between the very wealthy and the
hideously poor. The average American family lived on less than four
hundred dollars a year, while the richest capitalists and industrial-
ists bought their dogs diamond-encrusted collars. In New York City,
the rich competed with one another in building palaces on Fifth Av-
enue, while in the Lower East Side the poor were crowded beyond
overcapacity into disease- and crime-ridden ghetto tenements.

Cities became sinkholes of corruption as political machines exploited
the voting power of the new urban masses. In New York, that machine
was Tammany Hall. Opposition to all the bald-faced corruption and ex-
ploitation that characterized the Gilded Age ran from reformist to revo-
lutionary. It was the birth time of Marxism, socialism, and anarchism
in America, which would be pursued as viable alternatives to corporate
capitalism by many American workers and intellectuals well into the
twentieth century.

For much of the white Protestant middle class, meanwhile, this was
the Victorian era of prosperity, a time of stiff collars and tight corsets

and stuffy parlors where they obsessed over minutiae of etiquette and propriety while repressing and sublimating most desires. Some rebelled. Young, college-educated reformers went into big cities' poorer neighborhoods, including Greenwich Village, to document, as Jacob Riis put it, "how the other half lives," and to found settlement houses, offering various social services. The Progressive movement and a new species of journalist, the muckraker (an antiquated term revived by President Theodore Roosevelt, who was irked by what he felt was scandal-seeking journalists' meddling in government affairs), sought to expose the corruption in government and dismantle the big-city machines. Progressives pushed for the federal government to take a much more active role in curbing the seemingly limitless powers of the corporations and banks. Opponents mocked this Good Government movement as "goo-goo."

Another largely middle-class reform movement, feminism and women's liberation, grew as a force of change in this period. It comprised a range of issues, including prohibition and women's suffrage, which would culminate in the Eighteenth and Nineteenth Amendments to the Constitution in 1919 and 1920. Feminism would play a huge role in energizing the busy Greenwich Village scene of the mid-1910s.

The great barbecue came to an end with the Panic of 1893, a cascade of bank failures and Wall Street crash followed by a severe depression. Widespread unemployment and homelessness, as well as wage freezes for those who kept their jobs, sparked renewed labor unrest. Anarchism and socialism gained strength among workers despite all attempts to suppress them. Growing discontent and dissatisfaction characterized large sections of the working and middle classes in what is misremembered as the Gay Nineties. The Restless Nineties would be more apt. Into this milieu George du Maurier, a writer and illustrator for London's *Punch*, launched his 1894 novel *Trilby*, essentially an update of Murger's *Scènes de la vie de Bohème*, which was wildly successful in America as middle-class readers young and old, crammed into their high collars and tight corsets, bored with their office jobs and conventional marriages, responded to the call of the wild bohemian.

Curiosity seekers and wannabes looking for bohemia in Manhattan

got no end of advice from the guidebooks and magazines of the period. Any restaurant or tavern ever patronized by a writer or an artist, anywhere on the island, might be identified as a bohemian hot spot, especially if the cuisine and ambience were French, German, Italian, or otherwise exotic. Not all of the advice was bogus. There were enclaves of artists, writers, actors, and assorted bohemian types on the multiculturally bustling Lower East Side and up around the Art Students League near Columbus Circle.

Greenwich Village was the largest and most established of the city's bohemian zones. Although Pfaff's time as the first hot spot of New York bohemia was brief, it helped plant a seed that sprouted in the neighborhood in the years after the Civil War. South of Washington Square, once fashionable streets slid downmarket, with fine homes subdivided into rooming houses and bawdy houses. The cheap rents drew writers, painters, theater folk, and other potential bohemians. Before the Civil War the fine homes on Bleecker Street had rivaled those on the north side of Washington Square for elegance. They included Depau Row, a set of six handsome, upper-middle-class row houses on the south side of the street between Sullivan and Thompson, featuring airy front parlors that, with the connecting doors open, formed a block-long ballroom. As the city marched uptown the wealthy home owners left the street and it went into decline. An 1872 guidebook describes it as "a passably good-looking street going to decay . . . It was once the abode of wealth and fashion, as its fine old time mansions testify . . . Now a profusion of signs announce that hospitality is to be had at a stated price, and the old mansions are put to the viler uses of third-rate boarding houses and restaurants."

The author goes on to say that "In many respects Bleecker Street is more characteristic of Paris than of New York. It reminds one strongly of the Latin Quarter, and one instinctively turns to look for the Closerie des Lilas. It is the headquarters of Bohemianism." He portrays the denizens of a single house on the street.

> That long-haired, queerly dressed young man, with a parcel under his arm, who passed you just then, is an artist, and his home is in the attic of that tall house from which you saw

him pass out. It is a cheerless place, indeed, and hardly the home for a devotee of the Muse; but . . . so long as he has the necessaries of life and a lot of jolly good fellows to smoke and drink and chat with him in that lofty dwelling place of his, he is content to take life as he finds it.

If you look up to the second floor, you may see a pretty, but not over fresh looking young woman, gazing down into the street . . . Her dress is a little flashy, and the traces of rouge are rather too strong on her face, but it is not a bad face. You may see her to-night at the __ Theatre, where she is the favorite. Not much of an actress, really, but very clever at winning over the dramatic critics of the great dailies who are but men, and not proof against feminine arts . . .

In the same house is a fine-looking woman, not young, but not old. Her "husband" has taken lodgings here for her, but he comes to see her only at intervals, and he is not counted in the landlady's bill . . . Bleecker street never asks madame for her marriage certificate.

As the wealthy moved up and out of the area, bohemians commandeered the carriage houses behind their homes as living and working spaces. The rows of little carriage houses on MacDougal Alley and Washington Mews came to represent the height of boho charm. It was in just such a carriage house that, early in the twentieth century, Gertrude Vanderbilt Whitney would bring together the worlds of great wealth and artistic endeavor. Gertrude was born into extraordinary affluence and prestige, great-granddaughter of Commodore Cornelius Vanderbilt. At twenty-one she entered into a dynastic union with the also unspeakably rich Harry Payne Whitney, descendant of Eli Whitney. Shortly after the marriage she began studying sculpture at the Art Students League and then in Paris, where Rodin was her teacher. In 1907 she and Harry started buying pieces of property in the Village. They began with a small studio on MacDougal Alley, where she held exhibitions by contemporary American artists. Next they bought 8 West Eighth Street behind it,

knocking down the adjoining wall to make a larger space, the Whitney Studio. In the 1930s this evolved into the first location of the Whitney Museum.

BEFORE THE CIVIL WAR, FOURTEENTH STREET WAS THE FRONTIER of the built-up city. Above it, especially along Fifth and Second Avenues and around Union Square, was a kind of suburb for well-off New Yorkers in magnificent mansions and capacious brownstones featuring the latest in luxury conveniences: indoor plumbing, central heat, and gas light. After the war the rest of the city caught up and the wealthy fled still farther uptown. The area around Union Square and Fourteenth Street became a bustling zone of shopping, dining, and entertainments (licit and illicit) known as the Rialto. Theaters spread up Broadway; single-family brownstones became boardinghouses with street-level shops and mansions now housed private clubs; Tiffany, Brentano's, and other large stores moved up to Union Square; and Fourteenth Street was lined with Huber's Dime Museum, the popular German restaurant Luchow's, Delmonico's, F.A.O. Schwarz, the Hippodrome, Steinway Hall, the Academy of Music, Tammany Hall, and Tony Pastor's variety theater. The area was also well known for its brothels and gambling dens, and it drew hordes of slummers to the northern edge of the Village in search of the seedy underbelly of life. Decent middle-class folk in the Village below Fourteenth Street constantly complained they could barely walk home from work with their morals intact. Over time, the hookers and whorehouses spread down the once elegant Fifth Avenue to meet up with the hookers and whorehouses down around Washington Square Park, making the whole area feel like one giant red-light district, contributing to the Village's tawdry reputation at the turn of the century and forcing proper folks out.

Actors and all variety of entertainers hung out in Union Square and on Fourteenth Street, along with gamblers, bookies, "sporting youth," and moneyed, slumming libertines, who made the Rialto not only a happy hunting ground for female prostitutes but "a favorite promenade of fairies," according to one of them, the pseudonymous Ralph Werther. Werther's *Autobiography of an Androgyne* was published by something

called the *Medico-Legal Journal* in 1918, in an edition of one thousand copies available by mail order only to physicians, psychologists, sociologists, and others with a professional interest in the lives and habits of homosexuals. It earned no reviews or public interest. Werther, who also went by Earl Lind, Jennie June, and Pussie, laments, "I have been doomed to be a girl who must pass her earthly existence in a male body." Born around 1873 to a well-off, well-educated family in a town an hour's train ride from New York City, he says he dressed as a boy but in all other ways was a girl, and a nymphomaniac as well, with an intense and ceaseless craving to perform oral sex for boys. The other boys sometimes beat and humiliated him, setting a pathetic pattern for his life.

Coming to New York City to attend an unnamed university, he assumed a secret double life. By day he was an obedient, diligent student. At night he slipped off to join the ranks of promenading "fairies," as effeminate homosexuals had been known for some time. He calculates that in a twelve-year period he engaged in "approximately sixteen hundred intimacies with about eight hundred different companions." He insisted on being referred to as a female—not a woman, however, but a "baby-girl." Since wearing female apparel in public was illegal, he wore men's attire "in a distinctive manner, so as to be more readily recognized by my prey. Therefore unusually large neck bows and white gloves . . . The excessive wearing of gloves and the wearing of a red neck-tie are almost universal with high-class fairies." Because he, like Whitman before him, "much preferred the rough to the gentleman, and the profane boozing libertine to the morally upright," he started out slumming in the working-class immigrant areas of Hell's Kitchen, the Bowery, and Little Italy. He met other transvestites who'd grown up in the slums, who used names that sound oddly like Warhol superstars: Grace Darling, Jersey Lily, Annie Laurie. Poor young males in those neighborhoods had very little access to female companionship except on the rare occasion when they could afford a prostitute, so they sometimes resorted to these impersonators. Like Whitman, too, Werther enjoyed the company of young express-company wagon drivers. He'd meet them at a pool parlor at Thompson and Canal Streets and walk with them over to the Hudson riverfront, where they'd

climb into the back of a covered wagon parked for the night. (As we'll see, using trucks parked along the river for sexual encounters continued through the 1970s.) It was a very dangerous game. Werther was robbed and beaten countless times and more than once gang-raped. He sought the help of physicians, who prescribed useless drugs to "cure" him. Finally at the age of twenty-seven he had himself castrated, and his "craze for fellatio" gradually decreased. He was forty-five when his autobiography was published, a moderately successful businessman, and he said then that his sex life had dwindled to virtual inactivity.

Werther doesn't mention them but a few establishments in Greenwich Village were well known in the 1890s as spots where fairies plied their trade. The Slide, possibly the first drag bar in the city, was called "the wickedest place in New York" by the conservative *New York Press* in 1890. It was at 157 Bleecker Street between Sullivan and Thompson Streets, the site of the music club Kenny's Castaways. At the Slide, male prostitutes with names like Princess Toto and Phoebe Pinafore— "effeminate, degraded and addicted to vices which are inhuman and unnatural," according to the *Press*—sashayed around the bar and took their tricks down to the basement to service them. The authorities raided and shut down the Slide in 1892 due to "the unspeakable nature of the orgies practiced there," but the owners of the subsequent bars in the building preserved much of the interior. The novelist Edmund White, who later set part of his historical novel *Hotel de Dream* at the Slide, moved to the Village in 1962. "I'd go there all the time in the evening," he recalls. "It was always empty. It was this huge barn of place, and it had this staircase on the side going up to this very rickety balcony, which was condemned, but that's where the gay prostitutes would sit, up there. The owner once let me go down in the basement and see the little rooms that prostitutes used."

Nearby on West Third Street was the Golden Rule Pleasure Club. Charles Henry Parkhurst, the Presbyterian minister who in the 1890s was president of the reformist New York Society for the Prevention of Crime, visited the club on one of his fact-finding expeditions into the lower depths of depravity. Charles Gardner, the private detective who

served as Parkhurst's Virgil, recorded the evening in his 1894 book *The Doctor and the Devil.*

> We entered the resort through the basement door, and as we did a "buzzer," or automatic alarm, gave the proprietors of the house information that we were in the place. The proprietress, a woman known as "Scotch Ann," greeted us . . .
>
> The basement was fitted up into little rooms, by means of cheap partitions, which ran to the top of the ceiling from the floor. Each room contained a table and a couple of chairs, for the use of customers of the vile den. In each room sat a youth, whose face was painted, eye-brows blackened, and whose airs were those of a young girl. Each person talked in a high falsetto voice, and called the others by women's names.

Reverend Parkhurst fled in horror. Other Village hangouts for "male degenerates" in the 1890s included the Black Rabbit on Bleecker Street and the Artistic Club on West Thirteenth Street.

And then there was Murray Hall, who died in an apartment on Sixth Avenue just up from the Jefferson Market Courthouse in 1901. Hall was not a sex worker but he did have a sexual secret. For a quarter of a century he'd been a widely known and liked figure in and around the Village. He got out the vote for Tammany Hall on many election days. He ran an employment agency and a bail bond business and, according to a *New York Times* report on his death, "had a reputation as a 'man about town,' a bon vivant, and all-around 'good fellow.' " He could often be found playing poker and smoking cigars with his pals or drinking at the saloons. On one night of pub crawling around the Village he got out of hand and fought with a policeman. He spent a couple of hours in the MacDougal Street station before his politician pals sprung him. When he first showed up on the West Side he had a wife, who left him, complaining that he was always flirting with his female clients. He took a second wife, with whom he also fought about his roving eye. They had an adopted daughter, Minnie.

The kicker was, as the *Times* headline declared, "Murray Hall Fooled Many Shrewd Men." He was in fact a woman, as Dr. William C. Gallagher of West Twelfth Street revealed when Hall died. She'd been suffering from breast cancer for several years but didn't seek medical help for fear of outing herself. Dr. Gallagher first examined her about a year before she died. He and both of Hall's "wives" had kept her secret while she lived; even Minnie, who was twenty-five, was shocked to hear her father was female. "If he's a woman he's the wonder of all the ages, sure's you live," one of the Tammany b'hoys said on hearing about it, "for no man could ever suspect it from his habits and actions." Her real name, according to later reports, was Mary Anderson.

THE STUDENTS AND INTELLECTUALS ATTRACTED TO THE NEIGH-borhood by NYU—and, from 1860 on, by the new Cooper Union at Astor Place—continued to add to the Left Bank ambience. So did the French cafés, bistros, and brothels that surrounded the university, such that the area became known as Frenchtown and the Latin Quarter. In the last few decades of the nineteenth century, anyone looking for a taste of bohemia in New York made the pilgrimage to this area, to the Cafe de Paris, Au Chat Noir, the Taverne Alsacienne. West of the park, as Little Africa morphed into Little Italy, some restaurants there also promoted themselves, apparently with similar exaggeration, as prime spots for bohemian sightings.

Tourists would have had better luck up around Sixth Avenue north of Washington Square. Hunkered in the shadows and falling cinders of the Sixth Avenue Elevated from the late 1870s on, Sixth Avenue was one of the Village's more downmarket thoroughfares, lined with dive bars and rough saloons, slophouses and storefronts—all of which the area's artists and bohemians found a romantic attraction. The Tenth Street Studio, a brick barn of a building squatting in the middle of the block near Sixth Avenue, opened in 1858. Not a particularly attractive building, nevertheless it was a significant one. The first structure in America built specifically to house artists' studios, it was a major catalyst for the Village's growing reputation as an artists' neighborhood. It was built by

a wealthy Village banker and fan of the arts, and designed by Richard Morris Hunt, who also designed the Metropolitan Museum. Twenty-five studios surrounded a large central exhibition hall with gas lighting, sliding doors, and a glass skylight for a ceiling. Some artists lived and worked in their studios, some lived elsewhere. The building wasn't a philanthropic support-your-local-artists gesture. It was a business venture. Artists rented their spaces, taught students, showed and hoped to sell their paintings and sculptures there, and visitors paid twenty-five cents to see exhibitions in the large space. A few of the premiere and highest-paid artists in New York had studios in the area in its early years, including Frederic Church, Sanford Gifford, and John LaFarge (who painted the large altarpiece in the Church of the Ascension at the Fifth Avenue end of the block). Winslow Homer had a studio there in the 1870s. William Merritt Chase, one of the first American Impressionists, also had a studio there. In 1896 he founded the Chase School, where Edward Hopper studied, which later became the Parsons School of Design, now a division of the New School. Alexander Calder's sculptor father had a studio in Tenth Street for a brief time in the 1910s. One of its best-known twentieth-century tenants was also one of its most surprising. Kahlil Gibran, the Lebanese-born artist and mystically inclined writer, moved in around 1911 and most likely wrote *The Prophet* in his Village apartment. That slim volume of inspirational prose sold a little more than a thousand copies when Knopf first published it in 1923, but its repute grew year by year, and it's now said to have sold over one hundred million copies in forty-some languages, one of the bestselling books in history.

Tourists in the know might have spotted Village artists going in and out of a wicker gate at 58 1/2 West Tenth Street across the street from the Studio and down a short path to a small house in a courtyard. This was home to the Tile Club. Members ate, drank, gabbed, sketched, and painted here in an atmosphere of informal yet exclusive conviviality. Tile Club members included Homer, Chase, and Stanford White, the architect who designed both the Washington Square Arch at the north side of the park and the Judson Memorial Church complex at the south side. He also designed the second Madison Square Garden at Twenty-sixth Street

and Madison Avenue, on the rooftop of which he was shot dead by a jealous husband in 1906. (The New York Life Building has stood on the site since 1928.)

Nearby at what's now the southeast corner of Sixth Avenue and West Eleventh Street stood a venerable tavern called the Grapevine. It was a rambling clapboard house built in the eighteenth century near the Union Road, by which stagecoaches brought visitors from the city out to the country. Originally a home, it became a roadhouse named the Hawthorne, said to be frequented during the Civil War by Union officers and Confederate spies. From the end of the war through the turn of the century it was "known to all the artists, actors, litterateurs, and good fellows generally . . . as one of the pleasantest meeting places of its kind in the metropolis." Judges and lawyers from the Jefferson Market Courthouse a block south were also regulars, as was Murray Hall. The mix of clientele arguing politics and the news of the day apparently gave rise to the saying "heard it through the grapevine." In 1912 the *New York Times* reported that "In its palmy days the Grapevine was famous throughout Greenwich Village and the entire Chelsea section for its mutton pies." A hot pie and a glass of ale cost ten cents.

For much of its heyday the Grapevine was owned by a man named Alec McClelland. When McClelland started tending bar there in 1870 its origins were already shrouded in legend. He took over the place in 1883. The vine from which it took its name died around then, and patrons took pieces of the stump home as souvenirs. Teddy Roosevelt stopped in one night for an inspection during his time as a reforming police commissioner in the city. Effectively a teetotaler, he ordered a Vichy water, complimented McClelland on the place's cleanliness, and left. No women were served until after 1912, when a back parlor was outfitted for their use. And "no roisterers," McClelland told the *Times*. It was "a gentleman's cafe." He sold the bar in 1912 and it was torn down three years later to much nostalgic distress in the neighborhood. Today the site is occupied by an imitation bistro called French Roast.

By the turn of the century the Village's reputation as a place for artists and bohemians was well enough established that O. Henry, who lived

around and wrote mostly about Gramercy Park during his New York years, set one of his most widely read stories in Greenwich Village. In "The Last Leaf" he freely borrowed Murger and Puccini tropes about sickly, impoverished bohemians and added a distinctly American twist about the healing power of art.

THE OBSESSION WITH AND TOURISM SURROUNDING BOHEMIA show how bored some Americans were with the strictures of their lives and jobs at the end of the 1800s, and how much they yearned for something different. When the twentieth century arrived this desire surfaced in the cult of the new. The word was on everybody's lips. Everything in the new century was going to be *new*. Politicians spoke of a *new* age, a *new* millennium, and a *new* nationalism. Aesthetes believed America was primed for a *new* renaissance, which would bring with it new art, new literature, new theater. The new woman appeared as a subset of the women's movement. Where mainstream feminism centered on reforming marriage, "[t]he discussion among New Women," Christine Stansell writes, "focused rather on how women might live outside traditional domestic roles." Superficially there was something quite proto-hippie about the so-called new woman. She bobbed her hair for efficiency and threw away her corset. She wore loose, peasanty clothing in very non-Edwardian patterns such as batik and shucked off the high-button boots for sandals or moccasins. As part of her drive to achieve parity with males, the new woman dared to smoke cigarettes in public. But aside from that she was all business. At the turn of the century independent, well-educated single women were exploring freedoms that would have been almost unthinkable a generation earlier. They entered medicine, teaching, law, social work. The new women would drive much of the bohemian renaissance in Greenwich Village in the 1910s.

From Europe came the new psychology, Freud's shocking and for many Americans obscene theories of psychoanalysis. He published *The Interpretation of Dreams* in 1900, *The Psychopathology of Everyday Life* in 1901, and *Three Essays on the Theory of Sexuality* in 1905. The first International Psychoanalytical Congress was held in 1908. Freud, with Jung,

made his only visit to America the following year, arriving in New York Harbor and heading straight to Clark University in Massachusetts to give a series of lectures. In New York he visited Coney Island but not, apparently, Greenwich Village, where nevertheless his ideas got an early and enthusiastic reception. Although most Americans thought his theories on sexual repression perverse, Villagers would add Freud to free love and employed his ideas in their license for sexual promiscuity.

Nowhere in America was the *new* embraced with quite the ardor it was in Greenwich Village by the 1910s. All the movements, trends, and ideas coalesced there. But even as the Village hit its stride as the bohemian capital of America in the early twentieth century, Village artists and bohemians were a tiny minority in the neighborhood. Along with the moneyed WASPs who hung on in the North Village, the bohemian Village coexisted, often not happily, with the Irish West Village, the Italian South Village, and the black Village, all of whom made their own significant contributions to New York culture and history.

5
~~~~

# The Bohemians' Neighbors

A T SEVEN O'CLOCK ON THE EVENING OF JUNE 13, 2011, A BELL
at the Shrine Church of St. Anthony of Padua rolls its baritone
voice over the rooftops of Sullivan Street, across the river of buses
and cabs on Houston Street, and up over the heads of the couples
and gangs of tourists strolling toward the many restaurants, bars, and
clubs of Greenwich Village. The church, a street-sooted Romanesque
pile built by Italian immigrants and consecrated in 1888, dominates
the southeast corner of Sullivan and Houston Streets. Since the 1970s
this area has been known as Soho, but it used to be called the South
Village and it was part of a Little Italy much larger than today's.

Inside the church, several variations of the Virgin Mary gaze down
from wall pedestals as a High Mass for St. Anthony's feast day comes to
an end. People begin to work their way out of the long pews, and there
are many meetings in the aisles. Stout old workingmen, bowlegged in
their black trousers with black suspenders over crisp white shirts, shake
gnarled hands and lean their white heads together in murmured greet-
ings, grave and serious as cardinals. Their equally sturdy wives in dark

print summer dresses, some with St. Anthony medallions pinned on, with white shawls over their white hair, dip their fingers in the holy water and make the sign of the cross as they exit. Some conversations among these older parishioners are in heavily accented English but just as often it's Italian, Spanish, or Portuguese. (Sullivan Street historically has been home to a small Portuguese community, possibly drawn by St. Anthony's church. St. Anthony may have died in Padua but he was born in Lisbon.)

They step outside to a soft, springlike evening. The sun, setting somewhere across the Hudson in Jersey, angles long shadows down onto narrow Sullivan Street, where a crowd of a few hundred has gathered for St. Anthony's annual procession around the neighborhood. Not so many years ago the crowd would have been much larger, but in the twenty-first century this isn't the immigrant enclave it once was. A life-size statue of St. Anthony as a sweet-faced young Franciscan, tonsured, cradling the baby Jesus in his left arm, stands under a bower of white roses. Parishioners have pinned donations to his cassock and the hem of Jesus' frock, long trails of bills with portraits of Ben Franklin and Andrew Jackson hanging on them like vines. Fifty years ago, when the tenements along Sullivan Street were packed with Italian and Portuguese families, all the buildings on the block competed with one another for the honor of giving the year's largest donation.

Parish men once carried the statue on their shoulders, but tonight it stands incongruously in the bed of a silver Dodge Ram pickup truck with a CLERGY sign behind the windshield. A small brass band of gray-haired guys in Italian flag-striped caps warms up with a few classic Italian songs and a boisterous rendition of "New York, New York," at the end of which an older man in the crowd cheers, "Viva Sant' Anton'!" Priests in white Mass vestments and friars in Franciscan cassocks gather and the procession begins. St. Anthony and Jesus sway slightly in the back of the truck as it rolls through the wide Houston Street intersection, halting traffic, then leads the brass band and some few hundred of the faithful up into Greenwich Village. Tourists in the open-front bars and restaurants jump up to grab snapshots with their cell phones. Women on the fringes of the procession hand them little St. Anthony medallions and holy cards. One

older woman with a look of studious piety on her face and half a dozen rosaries hung over her breast distributes a card promising release from Purgatory and "the remittance of your sins" to anyone who completes three years of daily prayers in "Devotion to the drops of blood lost by our Lord Jesus Christ on his way to Calvary."

The procession turns onto Bleecker Street, where it passes more quizzical looks outside the rock and jazz clubs, turns again onto Thompson Street, and a few minutes later recrosses Houston Street and returns to the church. The crowd disperses, wandering up and down a Sullivan Street now in full twilight. The whole event has felt a bit compulsory and desultory, a fragmentary remnant of the rollicking celebrations, part festival and part carnival, that once took over Sullivan Street in the second week of June. Those were different times and that was a different Sullivan Street.

ALTHOUGH THE VILLAGE'S BOHEMIANS, ARTISTS, AND WRITERS would make it world famous, they always represented a small and transient minority of its residents. Much larger WASP, Irish, Italian, and, in the nineteenth century, black communities shared the neighborhood with them. "Shared" might not be the right word, since the arty Villagers and their neighbors usually had little contact with one another beyond each gawking at and grumbling about the other. On the whole, the Ninth Warders cursed the bohemians as unwanted outsiders who attracted even more unwanted visitors, dragging the neighborhood down as they pushed the rents up. The Empire Warders maintained their distance.

Today, Manhattan's Little Italy is a few blocks of tourist restaurants and shops surrounded by Chinatown. But a century ago it stretched from the Lower East Side west past Broadway, and from Canal Street up into Greenwich Village. Between 1880 and World War I waves of Italian immigrants increased the city's Italian population from fewer than twenty thousand to more than half a million. In Manhattan, this flood of immigrants mostly found themselves jammed into tenements on the Lower East Side and in East Harlem, which was known as Italian Harlem long before it was called Spanish Harlem. In the Village, they settled for the

most part in the south and east sections of the neighborhood. New six-
and seven-story tenements went up along Houston Street and on Thomp-
son and Sullivan Streets to its north and south. By the 1910s immigrant
Italians and first-generation Italian Americans were the dominant social
group in the Village. The South Village would continue to be considered
part of Little Italy through much of the twentieth century.

The first Irish in the Village came during the booming growth phase
in the 1820s, when they most likely worked as domestics and in construc-
tion of the new suburb. In 1829 the predominantly Irish Catholic parish
St. Joseph was founded, comprising all of Greenwich Village. The Church
of St. Joseph, on Sixth Avenue between Waverly Place and Washington
Place, was completed in 1834. (Singing the hymns at the dedication Mass
was the company of the new Italian Opera House down at Church and
Leonard Streets, founded by Lorenzo Da Ponte, Mozart librettist and
friend to Casanova, who had immigrated to America in 1805.) The Irish
Village was thus already an established community when the tsunami of
famine Irish came in the 1840s and '50s, and by the end of the century
they dominated the Hudson side of the neighborhood. New Catholic
churches and schools rose to serve the growing community—St. Veroni-
ca's on Christopher Street, St. Bernard's (now called Our Lady of Guada-
lupe at St. Bernard's) on the south side of Fourteenth. Middle-class "lace
curtain" Irish owned saloons, stables, blacksmith shops, feed stores. They
also owned the brownstones where they raised their families, sending
their boys to be educated by the Jesuits and keeping a very close watch on
their girls. Mayor Jimmy Walker grew up in such a home.

Working-class Irish families, headed by men who worked as long-
shoremen, janitors, mechanics, and teamsters, filled the new tenements
that sprang up along that side of the neighborhood starting in the 1880s.
The waterfront, from Canal Street up through Chelsea, became an almost
entirely Irish stronghold of work, power, and wealth. Ninety-five percent
of the longshoremen working this stretch of piers were Irish, as were the
stevedores, their foremen, the leadership of the International Longshore-
men's Association, the politicos "who made their fortunes from leasing,
contracting, and licensing fees relating to the piers," and the gangsters

who feasted on the whole system. Even after other immigrant groups, especially Italians, gained control of much harbor business in Manhattan, Brooklyn, and New Jersey, the Irish defended the West Side waterfront as a birthright. It was a tough, dark, dirty zone, made more dangerous by the largely Irish gangs of thugs the likes of the Hudson Dusters and the Gophers. There were many streets on the Irish West Side from the Village up through Hell's Kitchen where the beat cops, many of them Irish and very tough themselves, walked only in numbers, as a single officer was as likely to be mugged and robbed of his coat as any citizen. Not for nothing did mass brawls come to be known as donnybrooks and police vans as paddy wagons.

Through most of the 1800s there was also a large black community in the Village, concentrated on the streets to the south and west of Washington Square Park, the area first farmed by those "half-free" Africans in Dutch times. It came to be known as Little Africa, or less kindly as Coontown. By 1827 all black New Yorkers were legally free, yet a de facto state of half-freedom persisted. Slavery was abolished in gradual stages in the state of New York. At first, all blacks enslaved before July 4, 1799, remained in bondage, though now called "indentured servants." Children born to them from that date on would remain the property of their mothers' owners until the age of twenty-eight for males, twenty-five for females. For black New Yorkers it was an agonizing, maddeningly slow process. The long lag time was intended both to soften the blow for slave owners and to prevent a sudden glut of freed blacks competing with white workers for jobs. Some owners began to free (the old English legal term was "manumit") their slaves voluntarily; others sold off their slaves to new owners in the South. In 1817 the state legislature simplified things by stating that on July 4, 1827, all remaining slaves in New York would be manumitted.

During the decades of gradual manumission, many freed slaves left their former owners' homes down in the city and trickled out Broadway, settling in what was still sparsely populated countryside. By Manumission Day, July 4, 1827, more than ten thousand free blacks lived in Manhattan, and Greenwich Village was home to the largest population

of them. Few of them owned property but rented from white landlords. They were concentrated in the area around the Minetta Brook where those first black farms had been, encompassing a few blocks of Bleecker, Thompson, and Sullivan Streets; Minetta Street; Minetta Lane; and the now vanished Minetta Place—collectively known as "the Minettas."

Little Africa also drew free blacks and "mulattoes" who'd come to New York from the West Indies. Often better educated and with more skills than the city's freed slaves, some of them thrived, within the limits imposed on them. One started America's first black professional theater company in Greenwich Village in 1821. William Henry Brown had retired as a steamship steward in the West Indies when he moved to Manhattan in the 1810s. He bought a house in the city, on Thomas Street, where he held salons and teas on Sunday afternoons. Evidently his white neighbors complained, and in 1821 he moved out to a two-story house at the corner of Bleecker and Mercer Streets. He continued to hold teas and sell ice cream in the garden there, and he converted the second floor into a theater, the African Grove, with an all-black company. Brown would move the company to a few other sites in the city during its short life. Its first full-length production was Richard III. The company's principal actor, James Hewlett, was a tailor who is thought to have studied English Shakespeareans as he sat in the segregated Negro balcony at the Park Theatre, the city's premiere venue (on the block of Park Row below City Hall that today is dominated by J&R Music World).

As other productions followed—Othello, some farces and pantomimes, and most controversially Brown's own The Drama of King Shotaway, about a slave rebellion in the Indies—whites began to join blacks in the audience. They didn't sit in respectful silence. Black actors performing Shakespeare represented to them an amusing novelty. A newspaper from 1822 reports that "the audience was generally of a riotous character, and amused themselves by throwing crackers on the stage, and cracking their jokes with the actors." The seating policy at the African Grove, amazingly, instituted reverse segregation: whites were relegated to the back rows because, as a handbill stated, they didn't know "how to conduct themselves at entertainments for ladies and gentlemen of color." While having

rowdy hooligans in the audience was nothing new in New York theaters of the day—in the variety theaters on the Bowery it was common for audiences to interrupt performances, shout down actors, even jump on stage to join the action—one night in 1822 they got so out of hand the police shut the theater down. When the company attempted to perform again a few nights later the members were arrested. Brown gave up and closed the Grove for good in 1823. Another of the company's star actors, Ira Aldridge, moved to England, where he became renowned for his Othello, as well as his Hamlet, Macbeth, Lear, and Shylock, the latter roles sometimes performed in whiteface makeup.

Black New Yorkers may have celebrated July 4, 1827, with a Manumission Day parade, but their freedom came with restrictions. Although all white males earned the right to vote in New York State in 1821 (previously granted only to landowners), a crushing poll tax was imposed on freed black males, which only one in two hundred could afford. Women regardless of race would not get the vote for another century. White workers organized to bar blacks from jobs. Antagonisms between unions and black workers, who were often used as strikebreakers, continued into the twentieth century. Black New Yorkers who could find jobs did so almost exclusively as servants in white households, basically the same work they'd done as slaves. Nine out of ten employed black women and seven out of ten employed males did domestic work.

Housing was a chronic problem for black New Yorkers. Landlords routinely forced them into the most ramshackle homes and charged them more for the pleasure. "The Czar of all the Russias is not more absolute upon his own soil than the New York landlord in his dealings with colored tenants," the reformer Jacob Riis observed in his landmark book How the Other Half Lives, published in 1890. "Where he permits them to live, they go; where he shuts the door, stay out." He took grim photographs in Little Africa of its "vile rookeries," leaning, dilapidated wooden shacks, dark and dank, breeding grounds for tuberculosis, whooping cough, typhoid, and other infectious diseases.

Little Africa was also, to read the white writers of the time, a breeding ground of every crime, vice, and depravity known to man. Guidebook

writers recycled depictions of the Minettas as a no-white-man's-land where murder was a daily event and even the cops feared to tread. Even the sympathetic writers Riis and Stephen Crane described Little Africa in lurid language. In his 1896 article on Little Africa, young journalist Crane describes Minetta Lane as "a small and becobbled valley between hills of dingy brick," a vale of shadows with the Sixth Avenue horse cars jingling by at one end and "the darkness of MacDougal Street" at the other. Minetta Lane and Minetta Street, he notes, were "two of the most enthusiastically murderous thoroughfares" in the city. "The inhabitants for the most part were negroes and they represented the very worst elements of their race. The razor habit clung to them with the tenacity of an epidemic and every night the uneven cobbles felt blood . . . It was a street set apart, a refuse for criminals." Crane reports tales of legendary local killers with names like Bloodthirsty, Black Cat, and No-Toes Charley. He climbs "a flight of grimy stairs that is pasted on the outside of an old and tottering frame house" to visit with Mammy Ross, an old woman who regales him with stories of famous fights and quarrels. He descends to a tiny basement "restaurant"—a stove, a small table, two chairs, and a dusty sign offering "Oysters in every style"—to meet old Pop Babcock. "At this time Pop had three customers in his place, one asleep on the bench, one asleep on the two chairs, and one asleep on the floor behind the stove." Pop also tells him tales of the lane's violence. Those days are mostly now past, Crane reports, between the police cracking down and the Italians moving in, gradually pushing the blacks out. He ends the piece on a lighter note that could have come straight from a contemporary minstrel show: "Minetta Lane is a place of poverty and sin, but these influences cannot destroy the broad smile of the negro, a vain and simple child but happy."

The crackdown Crane mentions was the work of the new reform police commissioner who took over in 1895, Teddy Roosevelt. In his two years on the job Roosevelt tried to clean up the graft and corruption that were everyday business on the force. Riis guided him around the city's hot spots on midnight tours to sneak up on cops loafing and shirking. When Roosevelt replaced the captain of the Sixth Precinct and had his

new man bear down on the Minettas, life in Little Africa quickly got safer and quieter.

To whites, the most notorious institutions in and around Little Africa were "black-and-tans," low-class bars and clubs where blacks and whites mixed for drinking, dancing, and sexual assignations. The owner of the Slide ran one of the more notorious Bleecker Street black-and-tans. The threat of the "amalgamation" of the races through sexual union had terrorized white patricians since colonial days (John Quincy Adams thought *Othello* was about the evils of miscegenation), while poorer whites and blacks seem to have amalgamated with some abandon, judging from the plethora of laws the city fathers promulgated year after year to stem the practice. No image so titillated and horrified white New York in the 1800s as that of a white woman in a black man's arms. Black women in white men's arms were far less shocking, since it was considered common knowledge that black women were promiscuous and many were prostitutes. White women who frequented black-and-tans were presumed to have been turned to prostitution and other degradations by their black captor lovers.

Writing about Little Africa, Riis fulminated:

> The border-land where the white and black races meet in common debauch, the aptly-named black-and-tan saloon, has never been debatable ground from a moral stand-point. It has always been the worst of the desperately bad. Than this commingling of the utterly depraved of both sexes, white and black, on such ground, there can be no greater abomination. Usually it is some foul cellar dive, perhaps run by the political "leader" of the district, who is "in with" the police. In any event it gathers to itself all the lawbreakers and all the human wrecks within reach.

The historian Jamila Shabazz Brathwaite, program director of the CEJJES Institute, a cultural foundation in Rockland County, New York, points out that had Riis, Crane, and other writers been interested in any-

thing but sensational stories, they easily could have seen a very different side to black Greenwich Village. They might have noticed, for instance, the neighborhood's thriving black churches. Zion AME Church, aka Mother Zion, had begun down in the city in 1796 and moved to Bleecker Street in the 1850s. The Abyssinian Baptist Church went back to 1808, when black worshippers at the white First Baptist Church in the city withdrew in protest over being segregated in the balcony. This congregation also moved up to Greenwich Village in the 1850s. The black Catholic St. Benedict the Moor church was founded on Bleecker Street in 1883.

Brathwaite notes that Little Africa was home to several figures at least as notable as Black Cat and No-Toes, but for very different reasons. Bostin Crummell was captured as a child in West Africa and brought to New York, where he served in the household of Peter Schermerhorn, one of the richest men in the city. It's said that Crummell simply walked off the job one day—he "self-emancipated," as Brathwaite puts it—and, instead of running away, he remained in Manhattan and opened a successful oyster house. He and the freeborn Charity Hicks lived on Amity Lane (which became Amity Street, then West Third Street). Their son Alexander, born there in 1819, became an Episcopal priest in spite of opposition from white clergy. Alexander traveled extensively, earning a bachelor's degree from Queens College, Cambridge, living for a time in Liberia and lecturing around the United States, before founding the American Negro Academy in Washington, D.C.

Samuel Eli Cornish was a free black man from Philadelphia who moved to Little Africa in 1821, living on Wooster Street at West Fourth. He founded the first black Presbyterian church in the neighborhood, New Demeter Street Presbyterian. In 1827, apparently after a meeting at the Crummells' home, he and John Brown Russwurm started *Freedom's Journal,* the first black-owned and -run newspaper in the country. Henry Highland Garnet escaped slavery in Maryland and came to Little Africa in 1825. A Presbyterian minister and ardent abolitionist, he wrote often for the *Colored American,* the successor to *Freedom's Journal,* and delivered fiery speeches calling on slaves to free themselves by any means necessary. He later founded the African Civilization Society, which encour-

aged blacks in America to return to Africa. In 1865 he was the first black American invited to address Congress; in 1881 he attained a diplomatic posting to Liberia, where he died of a fever within three months. Garnet's second wife, Sarah, was the first black principal of African Free School No. 3 on Amity Street near MacDougal. African Free Schools were started by the Manumission Society in the late 1780s to educate the growing population of free black children. The intent was not just to teach reading and writing but to instill virtues such as industry and sobriety, diverting black youth from what was thought to be a natural inclination to vice. African Free School No. 3 was originally sited on Nineteenth Street in 1831, but after white neighbors complained it was moved to Little Africa.

Brathwaite has researched one Little Africa couple in particular who seem in every way the opposite of Crane's poor but happy-go-lucky Negroes. Edward Hesdra was born of mixed-race parents and was a practicing Jew. Cynthia was a slave who bought her freedom. According to an article in the June 8, 1890, *New York Times,* "Cynthia was an industrious, saving, and money-getting woman. She established a laundry and soon secured a large and profitable trade." She loaned money to neighbors to be repaid with interest. She bought the house she and Edward lived in on Amity Street and, eventually, as many as a dozen others in Little Africa. Cynthia and Edward left the city for Nyack, New York, where she died in 1879, leaving an estate valued at a hundred thousand dollars, more than $2 million in today's value. Childless, she apparently left a will dividing the estate among several charities, including the Jewish hospital where she died. Her widowed husband produced another version, in which she had left the money to him. Then there was a claim from Edward's adopted niece, who was white and, Brathwaite says, insane. The newspapers followed the story of "an ex-slave's fortune" with great interest as it wended its way through the courts for years and years. "It plays out like a soap opera," Brathwaite says. "The story just gets stranger and stranger." Not surprisingly, the attorneys ended up with much of Cynthia's money.

Greenwich Village remained the population center of black New York through the 1800s, though with changes. In the later decades of the century black Villagers of some means began moving up to the midtown-

west area then known as the Tenderloin (or, in the case of the wealthy Hesdras, out of town altogether). They would subsequently move farther uptown from there to San Juan Hill, in today's Lincoln Center area, and eventually to Harlem. In the Village they were replaced by blacks newly arrived from the South, mostly very poor and unskilled. At the same time, people of other ethnicities moved in, so that black Villagers shared the streets, buildings, and sometimes households with Irish, Italians, and other nonblacks. By the turn of the century the old "vile rookeries" were being torn down and replaced by new tenements that filled up with more Italian immigrants, until what had been Little Africa was considered part of Little Italy. In the 1910s, all that was left of the Little Africa Riis and Crane had visited were the Minettas, and they were still a sore point. Even the neighborhood's progressive social welfare volunteers threw up their hands. In 1912 Mary Kingsbury Simkhovitch, a founder of the Greenwich House settlement, recorded that there were still "three disorderly houses, two tough saloons . . . and prostitution" in the Minettas, and she suggested that the houses simply be razed. When the city proposed driving Sixth Avenue through the area, obliterating Minetta Place at least, she supported the plan.

Other Village streets apart from Little Africa were known for their black residents, Cornelia, Jones, and Gay Streets among them. The one-block Gay Street, connecting Christopher Street and Waverly Place, was just an alley lined with stables in the early 1800s. In the 1830s the stables were replaced by modest brick houses for black servants who worked in the wealthy homes that were then beginning to line Washington Square Park. Unlike Little Africa, Gay Street drew no attention to itself. After the Civil War, the wealthy families on Washington Square began replacing black servants with immigrant Irish, English, and German workers. Gay Street's black residents moved out and various artisans and workmen moved in, followed by artists, writers, and bohemians.

Gay Street is best remembered today for the basement studio at number 14 taken in 1935 by two sisters from Columbus, Ohio, Ruth and Eileen McKenney, who'd come to New York to start careers in journalism and acting, respectively. Ruth's series of articles for *The New Yorker* about their

colorful Village neighbors were collected in the book *My Sister Eileen*, adapted for Broadway in 1940. Eileen had moved to Hollywood by then, where she'd married Nathanael West. The two of them were killed in a car accident on December 22, 1940, four days before the Broadway show opened. The film version starring Rosalind Russell appeared in 1942, and in 1953 a new musical adaptation called *Wonderful Town*, written by Betty Comden and Adolph Green (to whom we'll return), with music by Leonard Bernstein, was a big Broadway hit.

Among the black families who moved out of the Village around the turn of the century were the Wallers. The baby of the family, Thomas, would become famous as the pianist Fats Waller. In his book *Black Manhattan*, published in 1930, the poet and memoirist James Weldon Johnson writes of his surprise to find a few "nests" of black residents still in the Village. "Scattered through Greenwich Village and 'Little Italy,' small groups of Negroes may be found who have never lived in any other part of the city. Negro New York has passed on and left them stranded and isolated. They are vestiges of a generation long gone by."

Nevertheless, for several decades following the publication of Johnson's book, the Village, with its jazz clubs and its bohemian and progressive residents, would continue to have a reputation as a small zone where blacks and whites met and mingled more freely than in most of the rest of the country—not a paradise of racial equality, maybe, but certainly ahead of the national curve on matters of race.

ONE OF THE SADDEST EVENTS IN NEW YORK CITY HISTORY OCcurred in 1911. It happened a short block east of Washington Square, next door to where Henry James was born. Visiting New York in 1904–5 after many years abroad, James was dismayed to find how built-up the area around his Washington Place birthplace had become in his absence. He deplored the marble Washington Square Arch, erected during his absence in 1892 (replacing a wood and plaster one constructed in 1889 for the centennial of Washington's inauguration). He called it a "melancholy monument" and "the lamentable little Arch of Triumph . . . lamentable because of its poor and lonely and unsupported and unaffiliated state."

He was even more saddened to discover his birthplace home had been torn down ("rudely . . . ruthlessly suppressed") to make way for NYU's Kimball Hall, "a high, square, impersonal structure, proclaiming its lack of interest with a crudity all its own." The shock he felt was like "having been amputated of half my history."

Across narrow Greene Street from Kimball Hall stood another new structure, the Asch Building, erected in 1901. The Asch was one of the "loft buildings" that started to rise all over lower and midtown Manhattan in the second half of the nineteenth century. Frames of steel up to twenty stories tall were curtained with facades of stone, brick, or cast iron, often with much larger and wider windows than older construction methods allowed. Inside, thinner columns meant open, sunlit loft floors eminently adaptable for a variety of uses. Lower floors might be warehouse space or house retail or wholesale commercial businesses. Floors above them, served by electric elevators, could be divided into offices. They would later prove equally eminently adaptable for loft apartments and condominiums. Because of their materials, these new buildings were said to be fireproof. Any building taller than seven stories had better be, because the fire department's ladders and hoses couldn't reach higher.

Around the turn of the century the top few floors of many of these buildings were taken over by the city's huge garment industry, the largest manufacturing business in the city, producing more than half the country's ready-made clothing. In 1910 it was estimated that there were 450 garment factories in the city, employing some forty thousand workers, the great majority of them Jewish and Italian women and girls as young as twelve. This made New York City the largest "factory town" in the country, though a visitor looking around the city's streets wouldn't even know they were there. In the 1800s, women and girls had done much of this work in their tenement homes on the Lower East Side and in Little Italy. New laws at the turn of the century forbade manufacturing work in residential spaces and prompted the industry's move. Loft buildings were never intended for this kind of manufacturing use, but neither landlords nor lawmakers made any fuss.

The Triangle Waist Company occupied the top three floors, eight

through ten, of the Asch Building. The company's founders, Max Blanck and Isaac Harris, had come to America as two poor immigrants among millions of others; now they were known as the Shirtwaist Kings, self-made men in the classic American mode. They'd built Triangle into the largest shirtwaist factory in the city, with five hundred to seven hundred employees, depending on the season. Workers cut and sewed on the eighth and ninth floors, with the bosses' offices on the tenth. The shirtwaist, a loose, simple blouse that had released women from the prison of stiff Victorian dress, had been all the rage at the turn of the century. As 1910 approached, however, the shirtwaist was looking old-fashioned, and sales and prices dropped. Manufacturers' attempts to attract shoppers by embroidering the garments with lace, much of it produced in the mills of nearby Paterson, New Jersey, were faltering. Competition for a dwindling market turned cutthroat, pushing wholesale prices lower and narrowing profit margins. A stock market crash in 1906 followed by a bank panic in 1907 had added to the pressures, prompting manufacturers of all kinds to tighten their belts, which often meant layoffs, pay cuts, and increased demands on workers to work longer and produce more. For the women and girls in New York's garment industry, conditions that were already barely tolerable worsened. At Triangle they worked twelve to fourteen hours a day, six days a week, seven at peak production times; in slack months they were apt to be laid off until business picked up again. They were paid by the piece, which amounted to two dollars a day at best, from which the bosses deducted the cost of the needles, thread, and even the power for the new electric sewing machines. Foremen patrolled the rows of workers, hollering at them, sexually harassing them, and docked their already pittance pay for the slightest mistake or perceived infraction. Blanck obsessed over the fear that workers were stealing needles and thread from him. At the end of every day, foremen searched their handbags as they filed out a single exit, the other exit door locked.

Twenty years of Progressive reformers urging more government intervention in the workplace had produced little regulation. The large labor unions, meanwhile, had concentrated their organizing efforts on skilled, "American" workers. That left the immigrant women of the garment in-

dustry to organize themselves, forming the International Ladies' Garment Workers' Union in 1900. In September 1909 one hundred Triangle workers met with ILGWU organizers. Blanck and Harris fired them all the next day. The entire Triangle workforce went on strike. Over the next six weeks as they picketed on the sidewalks below, Blanck and Harris allegedly hired thugs and prostitutes to assault them and paid the police to haul the strikers to jail for causing the commotion. In November, union organizers staged a huge rally at the Cooper Union a few blocks up Broadway from the Asch Building. Over the objections of the union leaders, the workers agreed to stage an industrywide walkout. The next day, in what came to be known as the Uprising of the Twenty Thousand, all the garment workers in the city walked off the job. The strike paralyzed the industry. Smaller manufacturers gave in quickly but Triangle held out. Ironically, the strike provided a unique opportunity for black women, who'd been kept out of the garment industry by both employers, who assumed them to be poor workers, and the white women workers themselves, who refused to work with blacks. As thousands of white women walked out, black women rushed into the lofts as scabs. Fearing they would derail the strike, union leaders invited black women to join but many refused. As the strike dragged on into the Christmas season, the workers gained important new allies: reform-minded society ladies, including Alva Vanderbilt Belmont and J. Pierpont Morgan's daughter Anne, who saw the garment workers' strike as part of the larger women's movement. The strike ended in February 1910, with most businesses coming to arrangements with the ILGWU. Triangle still held out, but the women went back to work anyway.

A year later, on the afternoon of Saturday, March 25, 1911, as the workers were lining up for their weekly pay envelopes, fire broke out on the eighth floor, possibly caused by a carelessly dropped cigarette. It quickly spread out of control, feasting on all the cloth and paper in the place. The 180 panicked workers on that floor raced for an interior stairwell or out to the fire escape. Up on the tenth floor the bosses and about fifty workers got word of the fire. Two of Blanck's daughters and their governess happened to be visiting that afternoon before a planned shopping trip.

Some escaped in the elevators, whose operators braved flame and smoke to save hundreds as long as the system operated. After the fire, the bodies of nineteen girls who'd fallen or jumped down the shaft were found on the elevators' roofs.

Blanck, Harris, and others made their way to the roof, where an NYU law professor and his students in the adjacent building saw them. They threw a ladder across the gap and all but one person from the tenth floor was saved. The 250 workers on the ninth floor got the worst of it. They were uninformed of the fire below them until it was too late. One exit door, as usual, was locked. Fire engulfed the other stairwell and the elevator shafts. Helpless firemen and a horrified crowd who'd been out strolling Washington Square watched women and girls so crowd onto the one rickety fire escape that it pulled loose from the wall and collapsed. Other girls clambered out to narrow window ledges and jumped, some with hair and clothes flaming. Falling nine stories, they punched right through the firemen's nets. In all, 146 women and girls died gruesomely. One of the Italian girls who died was a cousin of Jimmy Durante.

It was the city's worst workplace disaster before 9/11. When it was over, corpses littered the sidewalk, some too badly burned or mangled from the impact to identify. One girl's brother identified her by the buttons on her shoes. Seven bodies were never identified. Funeral processions for individual women and girls clogged the streets of the Lower East Side for days. On April 5 the ILGWU organized a massive funeral procession for those seven unidentified workers. The city of New York, fearing an open workers' revolt, would not permit release of the bodies from the morgue, so seven empty hearses led the solemn procession in a cold rain, with an estimated 120,000 silent marchers and another 300,000 viewers lining the streets. Marching up from Rutgers Street on the Lower East Side and down from East Twenty-second Street, two large columns under black umbrellas converged in Washington Square Park, then filed through the arch and up Fifth Avenue to Madison Square Park.

This huge demonstration, as much as the fire itself, startled the public, which had not been much moved by previous, frequent industrial deaths. Soon Village radicals would be deeply, passionately involved

in labor organizing and the women's movement. The city and the state passed a number of new fire safety laws over the next few years. Blanck and Harris, meanwhile, were found not guilty of manslaughter in the deaths caused by the locked exit door. They later paid seventy-five dollars per death to settle civil suits. The Asch Building itself turned out to be fireproof, as advertised. Firemen found the eighth through tenth floors essentially unharmed except for smoke damage. The building was easily refurbished, and in 1929 it was donated to NYU. It is now the Brown Building.

On March 23–27, 2011, for the hundredth anniversary of the fire, Judson Memorial Church hosted the premiere of *From the Fire*, a dramatic oratorio with music by Elizabeth Swados, produced by the New School and performed by a cast of students. Seated in the auditorium, one was acutely aware that the Brown Building was just a block away. Before the performance, a greeter wryly pointed out the four fire exits.

# The "Golden Age" Begins

THERE WAS A *GREENWICH VILLAGE* THEN—
A REFUGE FOR TORMENTED MEN
WHOSE HEADS WERE FULL OF DREAMS, WHOSE HANDS
WERE WEAK TO DO THE WORLD'S COMMANDS:
BUILDERS OF PALACES ON SANDS—
THESE, NEEDFUL OF A PLACE TO SLEEP,
CAME HERE, BECAUSE THE RENTS WERE CHEAP.

—*Floyd Dell*

BY THE EARLY 1900S THE VILLAGE HAD BEEN ATTRACTING ART-ists, writers, actors, intellectuals (a term coined around this time), and assorted bohemian types for decades. They had come together in small clusters at Pfaff's or the Grapevine or other popular saloons, in the French cafés and Italian restaurants, in private salons and clubs. In the 1910s certain people and institutions acted as magnets, drawing these disparate individuals and small groups together for the first time into a larger, bona fide Village scene. It's in this period, roughly

1912 through 1917, that the old Ninth and Fifteenth Wards become widely known as Greenwich Village; its artists, writers, bohemians, and political radicals become known (derisively to their Italian and Irish neighbors) as Villagers, and Greenwich Village becomes recognized around the world as the Left Bank of America. By the 1920s participants and chroniclers would already look back on this period, with premature nostalgia, as the Village's "golden age," a brief but shining time of intense social, cultural, and political radicalism and experimentation.

Malcolm Cowley didn't get to the Village until the golden age was over and many of its key figures had left, but he understood the bygone era well. "Greenwich Village was not only a place, a mood, a way of life: like all bohemians, it was also a doctrine," he writes in *Exile's Return*. That doctrine was a set of core values and beliefs carried over from the nineteenth century's liberal and radical movements, including, he thought, beliefs in self-expression ("Each man's, each woman's, purpose in life is to express himself, to realize his full individuality through creative work and beautiful living in beautiful surroundings."), personal liberty ("Every law, convention or rule of art that prevents self-expression or the full enjoyment of the moment should be shattered and abolished. Puritanism is the great enemy."), what he called paganism ("The body is a temple in which there is nothing unclean, a shrine to be adorned for the ritual of love."), and "living for the moment." In his time, the Greenwich Village of the Prohibition era, many of the behaviors associated with those beliefs— the drinking, smoking, eccentricities, and sex—would continue, but he felt the underpinning ideals had dropped away.

One of the magnets of the golden age who helped draw the scene together around these ideals was Henrietta Rodman, a New York City schoolteacher with militantly progressive ideas. Her pointedly new woman dress—bobbed hair, sandals, and loose shifts that looked to others like meal sacks—suited her blunt, confrontational personality. In 1912 she protested a Board of Education requirement that female teachers, but not males, report any change in their marital status. "The fight hit the newspapers," Stansell writes, "which were ever alert to controversies in-

volving New Women." Breathless rumors circulated that Rodman's own marital status was a free-love ménage.

Rodman was a member of the genteel Liberal Club that met near Gramercy Park. Floyd Dell, one of the Village's most enthusiastic boosters, quipped that it was "a respectable, well-meaning up-town club, composed mainly of polite old-fashioned believers in the gradual improvement of mankind by going to lectures." Rodman's strident advocacy of free love split the Liberal Club in half in 1913, with scandalized older members staying uptown and the younger, "ultra-liberal" ones following her en masse to a new location—in the Village, of course, at 137 MacDougal Street, between West Third and Fourth Streets. Where lectures and polite conversation had marked the old club, the new one, promoting itself as "A Meeting Place for Those Interested in New Ideas," was far more youthful and convivial. There were still lectures and talks; although Freud apparently never visited the Village, his pupil Carl Jung spoke at the Liberal Club. But along with talk it featured readings of the new free-verse poetry, "obscene" ragtime piano music, the racy new dances the shimmy and the turkey trot, and much drinking.

After events in the club the group would descend the stairs from their second-floor space to Polly's restaurant, well loved for its cheap meals, casual atmosphere, and a famous waiter named Hyppolyte Havel. Havel was a small, snarling anarchist who amused the bohemians by slapping their plates in front of them while growling, "Bourgeois pigs!" A genuine political radical, Havel considered many of his customers dilettantes. According to one Villager, he "was in a perpetual state of vituperative excitement." He was from the actual land of Bohemia where, he claimed, his anarchist rants got him confined to an insane asylum until the eminent psychiatrist Krafft-Ebing pronounced him sane, whereupon he was moved to a prison instead. The bohemians also loved the Washington Square Book Shop, next door, which they treated more like a lending library than a bookstore. The Liberal Club, Polly's, and the bookshop formed a symbiotic triumvirate and together became a neighborhood social magnet, with a continual flow from the poetry readings and dances upstairs to the eats and drinks below and on into the shop to

thumb through that new book on psychoanalysis or the latest anarcho-syndicalist tract.

Another of the scene-coalescing magnets, Mabel Dodge, arrived in the Village in 1912. She was not herself an artist or intellectual and became political only through her radical Village friends, especially her lover John Reed. But as a patron of the arts, a kind of collector of artists and intellectuals, and a catalyst—what the cultural historian Martin Green calls "a carrier of ideas, a *Kulturträger*"—she was hugely important to the cultural flowering of the Village and embodied its spirit as well as anyone on the scene.

She was born Mabel Ganson in 1879. The Gansons were a wealthy, stolid family in Buffalo, and Mabel spent much of her life escaping that heritage—not the wealth but the stolidity. "I felt I was made for noble love," she writes in her candid and garrulous memoirs (sixteen hundred pages published in four volumes in the 1920s, then handily edited down to some 260 pages in the 1999 edition entitled *Intimate Memories*). She was made "not for art, not for work, not for the life of the worldly world, but for the fire of love in the body, for the great furnace of love in the flesh, lighted in the eyes and flowing, volatile, between the poles." She admits she was no great beauty and had to exercise all her feminine wiles to distract the men she desired from her stumpy figure and plain face.

She was an innocent girl when she secretly married Karl Evans, from another wealthy Buffalo family, "and for the first time I experienced the amazing explosion of the internal fireworks." Their son, John, was two and a half when Karl was killed in a hunting accident in 1903. The following year her parents packed the distraught young widow and her son on a steamer bound for Europe. On the weeklong voyage she met Edwin Dodge of Boston, a wealthy architect, whom she soon married in France. "Between Edwin and me there was never a deep marriage relationship, although there was a great friendship," she writes.

From France they proceeded to Italy in 1905 and took a baronial Medici estate, the Villa Curonia, near Florence. With Edwin relegated more to friend and companion than husband and lover—he was "only the figurehead on my ship"—Mabel set about two great projects. On the one

hand, she sought to stoke the great furnace of love with a succession of men, from handsome, tragically fallen nobles to handsome, earthy chauffeurs, and with women as well. Her memoirs leave the impression that the passion was often more on her side than on theirs, and that there was more panting, overwrought Victorian melodrama in these relationships than explosions of fireworks. She writes that in one moment of despair over a failed romance she tried to commit suicide by eating figs packed with broken glass, which "for some miraculous reason" had no effect.

Meanwhile, she went to work on her aesthetic and intellectual improvement with equal verve. In Italy the vast storehouse of the Renaissance was at her fingertips. To educate herself about contemporary art, however, there was only one place to go: Paris. Art capital of the Western world, Paris in the early 1900s was where you went to learn about all the recent and exciting new trends—Impressionism, Post-Impressionism, Fauvism, Cubism, Futurism. She frequented the Montparnasse apartment of the brother and sister expatriates Leo and Gertrude Stein. Leo, the connoisseur and intense advocate of new art, introduced her to Picasso and Matisse and taught her to appreciate their work—work few people in America, still a fine art backwater, had seen. At the same time, the magnitude of Gertrude's life force fascinated and attracted Mabel, as though Mabel were a satellite held in the gravitational pull of a massive planet. "Gertrude Stein was prodigious. Pounds and pounds and pounds piled up on her skeleton—not the billowing kind, but massive, heavy fat . . . She had a laugh like a beefsteak."

Leo, Gertrude, and Gertrude's nearly silent partner Alice B. Toklas later visited Mabel at the villa. Mabel reports that Gertrude flirted with her so heavily that Alice began, in her quiet fashion, to engineer ways of keeping them apart. Edwin, the affable but boring Bostonian, faded further and further into the background of her life.

In 1912, wondering where to send John to school, Mabel boldly wrote to H. G. Wells in England, asking his advice. In today's pop culture Wells is remembered only as a kind of British Jules Verne, but in his lifetime he was highly respected as a public intellectual, a philosopher of science, politics, education, religion, and general civilization. She took his advice

that the best place to educate an American boy was America, and as their ship pulled into New York Harbor she warned John, "Remember, it is *ugly* in America." He gazed at Manhattan's spiked skyline and replied, "I don't think it's so ugly."

If Mabel had to be back in America, she wanted to be in the place that most reminded her of Europe: Greenwich Village. They took an apartment at 23 Fifth Avenue, on the northeast corner at Ninth Street, a short stroll from the Washington Square Arch. The house, which no longer stands, was a four-story brick box painted brown, the very image of stolid respectability, if somewhat gone to seed. The Dodges were on the second floor, a young lawyer's family was on the third floor, and on the fourth lived William "Plain Bill" Sulzer, a gaunt, sepulchral man who in photographs bears an unsettling resemblance to Lon Chaney unmasked in *Phantom of the Opera*. He'd just given up his seat in Congress in his quest to become New York's thirty-ninth governor, an office he would hold for less than a year before being impeached. On the ground floor was the owner, a grouchy one-legged Civil War relic, General Daniel Sickles, who once sent Mabel a thank-you note that ended with "Written in the 93rd year of my life without the aid of spectacles."

Mabel soon convinced Edwin to remove himself to rooms in the Brevoort House hotel just down the block. Built in 1854 and named for one of the oldest families in the city, who had owned a large tract of land north of Washington Square, the Brevoort was considered the best place to stay, short or long term, near the Square. Edwin's moving there seems to have been a relief to both him and Mabel and was a step toward their eventual divorce. She meanwhile did the apartment all in white, like an art gallery. What she exhibited there was not so much paintings as people. At a dinner party she met Carl Van Vechten, a music critic, author, photographer, voracious gourmand of the arts, and cultural provocateur. "He had nice brown eyes, full of twinkling, good-natured malice," she notes. He was already displaying a fascination with black culture that in the 1920s would make him one of the white aesthetes most involved in promoting the Harlem Renaissance—a "Negrotarian," in Zora Neale

Hurston's memorable coinage. He would be instrumental in finding white publishers for Hurston, James Weldon Johnson, and Langston Hughes, with whom he may have had an affair. In 1926 he would see the publication of his own very successful and controversial novel about Harlem, *Nigger Heaven*. (The unfortunate title has since doomed the novel to obscurity, but it was less scandalous in its time, when it was common slang for the racially segregated balconies in theaters. In the book it's a metaphor for light-skinned blacks trying to pass in white society.)

Soon Dodge also met Lincoln Steffens and Hutchins Hapgood, two of the older figures on the scene. Originally from San Francisco, Steffens was fleeing a wealthy family background of his own when he came to New York in 1892. He became the country's premiere muckraking journalist, exposing urban blight and municipal corruption in a series of articles collected in 1904 as the book *The Shame of the Cities*. As editor of the newspaper *Commercial Advertiser* and then *McClure's* magazine, he recruited so many reform-minded Ivy Leaguers to New York journalism that the zone of cheap rooming houses along the south side of Washington Square where they lived was referred to as a second Harvard Yard. When Dodge met him he was in his mid-forties and had recently moved there himself to be near the energetic and idealistic young people he liked to encourage and mentor. Hapgood was born in Chicago in 1869, son of a prosperous industrialist. He had gotten his master's degree and taught English at Harvard before moving to Manhattan in the late 1890s to take a job under Steffens at the *Advertiser*. He and his wife, Neith Boyce, who also wrote for Steffens, had lived on Washington Square for a while, but by the time Dodge came they'd long since moved up the Hudson River to Dobbs Ferry to find room to raise their growing family. Still, they had many friends in the Village and stayed active in its affairs. Hapgood was by his own admission a conventional man drawn to unconventional people; he titled his 1939 autobiography *A Victorian in the Modern World*. "I preferred for many years the society of outcasts, men and women, and the dreamshops of life to the respectable people and their social resorts," he writes. "I don't know why it was, entirely, but even from the beginning I

felt something limited and repressive in morality as it is ordinarily conceived. It seemed to say, 'Thou shalt not,' but only rarely, 'Thou shalt,' and then faintheartedly."

Hapgood writes that when he met Dodge "she was completely innocent of the world of labor and of revolutions in politics, art, and industry." She couldn't have been quite so culturally ignorant as all that, but Hapgood's condescending tone was not unusual when Dodge's male friends wrote about her. She records that it was Steffens who suggested she should host salons, because "men like to sit with you and talk to themselves! You make them think more fluently, and they feel enhanced."

She began to host regular Wednesday "Evenings." It was not the only salon in Manhattan at the time, but it became the most famous, and it was agreed she drew together the most interesting range of characters, whom she summed up as "Socialists, Trade Unionists, Anarchists, Suffragists, Poets, Relations, Lawyers, Murderers, 'Old Friends,' Psychoanalysts, IWWs [Industrial Workers of the World], Single Taxers, Birth Controlists, Newspapermen, Artists, Modern Artists, Clubwomen, Woman's-place-is-in-the-home Women, Clergymen, and just plain men." As many as a hundred of them would pack her bright-walled parlor. Some Evenings were organized, with a guest speaker followed by general discussion. Most of the topics, intensely interesting to Villagers, were of a type not openly broached in many other parlor rooms in 1913: trade unionism, socialism versus anarchism, "sex antagonism," birth control, free love, women's suffrage, psychoanalysis, eugenics. Poets read, often to the disgust of the other poets in the room, and one evening two editors of the magazine *Metropolitan* were rudely received by the crowd. *Metropolitan* was a very successful monthly that stood out on the newsstands with its pretty cover girls. It was the sort of well-heeled publication all struggling young Village writers professed to despise and any would give an arm to be seen in. As a result of this Evening, some would get the chance.

No direct records exist of the discussions, although many of Dodge's guests would write from memory about them. It was said that an experiment with a stenographer failed when the woman hired to record an Evening was both flummoxed by the big words bandied about and em-

barrassed by the subject matter. Dodge laid out a fine spread of food and liquor, such that her inner circle was at periodic pains to cull freeloaders. But everyone drank, many of them copiously. Other drugs were not unknown to them. One night, not an Evening but a small party, Dodge and a few select friends even tried peyote; Hapgood accidentally took more than the others and soon found himself over the toilet vomiting flames. But alcohol was the intoxicant of choice. Newspaper reporters came, indulged, and then wrote up the experience, often luridly and antagonistically. Mrs. Dodge, the society matron who invited bomb-throwing anarchists and sex-mad suffragettes to drunken revels in her Fifth Avenue home, was soon the talk of the town.

Among the notables crowding Dodge's parlor were the matronly Emma Goldman and intense Alexander (Sasha) Berkman. Goldman, born in the Russian (now Lithuanian) town of Kovno in 1869, had immigrated as a teenager to the United States, slaving away with other immigrant girls in Rochester's garment industry before moving to the Lower East Side in 1889. Anarchist meetings and rallies were practically daily occurrences on the Lower East Side at that point, and Goldman, in her early twenties, became known for her fiery speeches, delivered in both German and Yiddish. It was in this milieu that she met Berkman, another Russian immigrant whom Hapgood called "that very rare species of human being, a genuine fanatic." In 1892, during a bitter steelworker strike near Pittsburgh, Goldman and Berkman plotted the assassination of the industrialist Henry Clay Frick. Berkman pulled the trigger, failing to kill Frick, and was imprisoned until 1906. Through her writing and speaking Goldman was a huge figure not only in the anarchist movement but in trade unionism, women's rights, and among the bohemians. Together with Berkman, she edited and published the radical journal *Mother Earth*. Mabel Dodge found Goldman warm and motherly, while Berkman, with his hooded eyes and thick lips, seemed dark and troubling. "Sasha tried to kiss me in a taxi once, and this scared me more than murder would have done. I don't know why."

William and Margaret Sanger were also frequent guests. He was an architectural draftsman, failed painter, and lover of modern art. Despite

Margaret's soft, mild-mannered affect—"the Madonna type," Dodge calls her—she was by nature an extremist, and in some ways one of the most radical of Dodge's guests. She championed birth control at a time when just sending information about it through the U.S. mail was a felony and would go to jail when she opened her first birth control clinic in Brooklyn in 1916. She firmly believed that to achieve equality with men, women must enjoy equal sexual freedom. "Never be ashamed of passion," she would advise young married women in a 1926 book. "If you are strongly sexed, you are richly endowed." Acting on this belief, she would leave William in 1914 and take many lovers, including, it's said, H. G. Wells and Havelock Ellis. Dodge calls Sanger "the first person I ever knew who was openly an ardent propagandist for the joys of the flesh." In the 1920s Sanger's extremism would lead her well beyond promoting voluntary use of birth control to embrace eugenics and, if necessary, forced sterilization to solve "the menace of the moron to human society," as she wrote in 1922. She was hardly the only American of good conscience to promote eugenics and "racial hygiene" in the years before the Nazis put it into monstrous practice. A number of states practiced involuntary sterilization of the mentally ill or retarded, and the idea that certain races and ethnicities—including Asians, southern Europeans, and eastern Europeans—tended toward mental inferiority was behind the Immigration Act of 1924, which imposed strict quotas on newcomers from those regions.

For Theodore Dreiser, unlike many in Dodge's circle, poverty and working-class life were not noble abstractions but firsthand experience. Born the ninth child of a destitute German-immigrant mill worker in 1871 Indiana, he learned writing on the job as a poorly paid reporter in Chicago and elsewhere before coming to New York in the mid-1890s. He stayed for a while at the big new Mills House No. 1, which still dominates the south side of Bleecker between Sullivan and Thompson Streets, where Depau Row had been. By the 1890s those once fine homes had deteriorated into slum housing and sweatshops. The progressive millionaire banker Darius Ogden Mills had them torn down and replaced by the first of three model workingmen's residencies he built in the city, with clean rooms, baths, a library, and a dining hall in the basement. A room

and two squares cost fifty cents a night. Residents were locked out in the daytime to encourage them to find work.

In 1900 Frank Doubleday's editors had accepted Dreiser's *Sister Carrie* for publication while Mr. Doubleday was on vacation. Worried about its depiction of a country girl, "bright, timid, and full of the illusions of ignorance and youth," who goes to the big city and learns to survive by becoming a mistress and actress, Doubleday very reluctantly published only a thousand copies, without advertisement. It sold fewer than half of those. In 1912 Dreiser fell in with Dodge's crowd. He embraced their various political and social causes; by his own admission, he was especially interested in exploring the freedom to have sex with more than one partner, which he gave the unlovely name "varietism." In 1915 Anthony Comstock's New York Society for the Suppression of Vice would have Dreiser's autobiographical novel *The "Genius"* banned for its sexual frankness, resulting in a long court battle Dreiser eventually won in 1923.

The restlessly peripatetic Upton Sinclair flitted in and out of the Village at this time, drawn by the scene Mabel was generating. He was one of the most famous writers in America at the time, though in recent years he'd gotten more press as an excitable and eccentric socialist than as an author. He'd been born into relative wealth in Baltimore, but when his father's alcoholism dragged the family to ruin they fled in shame to New York City, where Upton grew up in shabby rooming houses. He struggled for years to find his literary voice before combining melodrama and muckraking in *The Jungle*, his gruesome 1906 novel exposing the unsanitary conditions and exploitive labor practices of the Chicago meatpacking industry. Jack London said it did for the modern wage slave what *Uncle Tom's Cabin* had done for black slaves in the previous century. Sinclair self-published a limited edition before it was picked up by Doubleday. *The Jungle* met with spectacular international acclaim and rang many bells for reformers. President Theodore Roosevelt read it carefully and sent Sinclair three pages of notes both praising and critiquing it, especially its propagandizing for socialism, which he rejected as "the pathetic belief that the individual capacity which is unable to raise itself . . . will, when it becomes the banded incapacity of all the people, succeed." Teddy the

relentlessly self-improving man's man believed in the strong individual over any collective of weaklings. Though *The Jungle* helped create a climate of public outrage that ensured the passage of a Pure Food and Drug bill Teddy supported, the president considered the author a "crackpot."

So did many others. No great literary success had followed *The Jungle*, and Sinclair's notoriety since had rested more on his exploits as a founder and member of various experimental communes; a sickly health nut susceptible to every quack and fad; and a proselytizer for socialism, free love, and vegetarianism. He made the front pages again when he angrily sued for divorce after his wife left him for his erstwhile friend Harry Kemp, the so-called Vagabond Poet, even while he, Sinclair, took up with an erstwhile friend of his wife's.

There was Max Eastman, who was just taking over the editorship of the radical monthly *The Masses*. Raised in Elmira, New York, both parents Congregationalist ministers, he studied philosophy at Columbia under John Dewey and was a poet and a critic who opposed the newfangled free verse. He was so handsome an admirer nicknamed him Apollo, "well dressed, well mannered, well connected, respected in academic circles." He had moved to the Village in 1907 and become passionate about the various women's liberation ideas circulating in the neighborhood, including suffrage and birth control.

*The Masses'* most fiery and popular writer, John (Jack) Reed, attended as well. Also from money, son of a prominent businessman in Portland, Oregon, Reed had graduated from Harvard and moved to the south side of Washington Square in 1911 with the goal of becoming a muckraking journalist in the Steffens mold. Boisterous, cheerful, and boyish, another writer of bad poetry, Reed was overflowing with infectious idealism. Apparently there was no one in the Village crowd, male or female, who wasn't at least a little in love with him. Mabel Dodge fell deeply and passionately for him. "He was young, big, and full-chested. His clothes wrinkled over his deep breast. He wasn't startling looking at all, but his olive green eyes glowed softly, and his high, round forehead was like a baby's with light brown curls rolling away from it and two spots of light shining on his temples, making him lovable." With Edwin out of the house she was free

to engage Reed in an affair she describes as both torrid and tempestuous, though once again much of the passion seems to have been on her end; he was more interested in roaming the world and writing in support of its revolts and revolutions. He moved in with her in 1913 but his constant ramblings provoked in her terrible fits of jealousy. With typically self-deprecating humor, she records that "When he came in one night and he told me he had walked and talked with a strange, beautiful prostitute on the street, had felt her beauty and her mystery, and, through her, the beauty and mystery of the world, I threw myself on the floor and tried to faint." They would break up and rejoin a few times before he left her for the younger Louise Bryant, a writer he met on a trip home to Portland.

Reed didn't have to go far for his education in radicalism, as not only Goldman and Berkman but Big Bill Haywood and Elizabeth Gurley Flynn turned up at the Dodge Evenings. Also from the West, though not by way of Harvard, Haywood was the one-eyed rabble-rouser for the IWW, aka the Wobblies. (According to the legend at the time, this nickname for the big union came from a striking Chinese worker who pronounced it "I Wobba Wobba.") Born in Utah, son of a Pony Express rider, Haywood had blinded his right eye "whittling a slingshot out of a scruboak," as John Dos Passos later wrote. As a young man he wandered the West of cowboys and miners, working various jobs, and once he tried to organize a bronco busters and range riders union. That he came to live in the Village is a good indication of what a magnet it had become for all kinds of radicals and rebels. Then, too, he may also have been attracted by the decadent bohemian lifestyle, which would have been wholly new to him. He lived with at least two Village women, a schoolteacher and then a well-off lawyer, and when the IWW began to founder in 1913, some would say it was because he'd lost his edge luxuriating in the warm bosom of the Village's free-loving atmosphere. Flynn grew up in the Bronx, the daughter of Irish immigrants. She gave her first public speech on the benefits of socialism at the age of sixteen. As a Wobbly she was an extremely effective speaker and strike organizer, known as labor's Joan of Arc. She was more successful than Haywood at resisting the Village's bohemian lure.

Haywood had helped to found the IWW at a "Continental Congress of the Working Class" in 1905; Flynn joined a couple of years later. The IWW was the most radical and confrontational of the era's labor unions, and the only one committed to out-and-out class warfare with "the capitalists." While the big labor unions such as the American Federation of Labor restricted their membership to skilled and overwhelmingly white laborers—steelworkers, machinists, and such—the IWW, under the banner of One Big Union, was open to any laborer skilled or unskilled, male or female, any race or ethnicity. On the East Coast, the Wobblies sought to organize the mostly Italian and Jewish immigrants in the big-city sweatshops and textile mills; out West they organized miners, loggers, sailors, and migrant workers.

The schism between the Reds of the IWW and the so-called American labor unions like the AF of L (The AF of Hell, the Wobblies joked) was also pulling apart the American Socialist movement just as it was reaching its peak strength. The Socialist Party of America (SPA) had been formed only in 1901, yet its presidential candidate Eugene V. Debs polled almost a million votes in 1912, and more than fifty cities and towns around the nation elected Socialist mayors that year. The key issue now was how radical the radicals wanted to be. "Socialists could not agree whether they wanted to reject . . . the whole of the dominant civilization or only its political forms," Henry F. May writes in *The End of American Innocence*. On one side of this rift were the reformist Yellows, also known as silk-stockinged Socialists, mostly middle- and upper-class WASPs who believed in all the traditional American values and merely sought to ease the working masses into that culture. On the other side, the Reds and Wobblies wanted full-on revolution, a stand that appealed to those Italian and Jewish workers. "The only question worth debating on the hot tenement roofs on summer nights was what kind of socialism should prevail in the whole world." Wobblies were noted for their rousing propaganda and sense of humor. Their *Little Red Songbook*, first published in 1909 and sold for a nickel, contained stirring anthems, such as "The Internationale" and "Solidarity Forever," but it was also filled with irreverent lyrics like "I pray, dear Lord, for Jesus' sake / Give us this day a T-bone steak."

By 1912 the Wobblies were organizing huge and successful strikes in mill towns such as Lowell, Massachusetts, Thoreau's "city of spindles." Wobbly leaders didn't openly advocate violence but sabotage was an approved negotiating tactic, and Wobbly-run strikes tended to be volatile. In Lawrence, Massachusetts, the workers destroyed equipment, threatened managers' lives, and went toe to toe with the police and state militia, who bayoneted one fifteen-year-old worker to death and shot and killed a woman worker. In a brilliant propaganda coup, the Wobblies gathered up the workers' children and sent them away "for their safety." Margaret Sanger paraded 120 of them off a train in Manhattan and through the streets to Webster Hall in today's East Village to meet the New York press. The ensuing articles helped convince the Lowell mill owners to give in to the Wobblies' demands.

ALTHOUGH RELATIVELY SMALL IN NUMBER, THE VILLAGE'S BOHEMIANs made themselves highly visible to their neighbors when they weren't holed up in Dodge's parlor or attending the Liberal Club. When they were feeling flush, or could put the bite on a publisher or art patron, they loved to party at two of the pricier cafés in the neighborhood, at the Brevoort and at the smaller Lafayette Hotel, behind the Brevoort at the corner of East Ninth Street and University Place. In fine weather the Brevoort put small tables out on the sidewalk, excellent for seeing and being seen. Originally the Café Martin, and later immortalized as the Café Julien in the novels of Villager Dawn Powell (who lived across the street), the Lafayette's café and restaurant were faux-French, complete with humorously snooty waiters, racks of French newspapers, French wines, and the latest French dishes. In the afternoons, artists and writers lounged at the marble-topped tables over checkers, dominos, and coffee; in the evenings the waiters spread tablecloths for dinner service. After dinner until midnight, the café bar with its aperitifs and cocktails was a destination watering hole where the smart set and slumming uptown swells came to meet up with their arty downtown pals. In her novel The Wicked Pavilion Powell would characterize it as a "procrastinator's paradise," a "union station" and "stationary cruise ship" where bohemians and the café set hid

from the world and its demands. It would remain so until the building was demolished in the 1950s.

More daringly—and more affordably—the bohemians infiltrated and colonized some of the old dive bars in the neighborhood. Bars were still almost exclusively male preserves, some refusing to serve women at all, others relegating females to a back room with a separate "ladies' entrance," as exemplified in Eugene O'Neill's *Anna Christie*, where the first act is played out in the separate ladies' room of Johnny the Priest's saloon. Village bohemians, however, shocked the neighborhood with their coed partying. They took over the Golden Swan at the southeast corner of Sixth Avenue and West Fourth Street. The Golden Swan was known as the Hell Hole from its use as a hangout by the Hudson Dusters. O'Neill, who felt more at home in tough dive bars than probably anyone else in his crowd, began frequenting the Swan and his presence drew other bohemians. The site is now a tiny city parklet, the Golden Swan Garden.

In her landmark study *Greenwich Village 1920–1930* the sociologist Caroline F. Ware writes of the "wide and virtually unbridged" cultural gulf between the Italian and Irish "local people" and the bohemian "Villagers." Her analogy is that the Villagers were like summer vacationers at a resort who maintain "a social existence wholly distinct from that of the natives." Irish and Italian Ninth Warders grumbled and stared at the bohemian men's loose, long hair trailing down to their open collars, which in an era of strangling high collars and pasted-down hair signaled their artistic and rebellious temperament. But it was the so-called new woman who most fascinated and scandalized the neighbors and the press. With her short hair and peasanty outfits, openly drinking and smoking in the company of men, she was the very embodiment of craven immorality.

Not every writer or artist drawn to the Village by the cheap rents and unhurried pace identified with the *new* crowd. Willa Cather and her longtime companion Edith Lewis, for instance, who'd been living in the Village for several years when Dodge arrived, kept pretty much to themselves. Born in Virginia in 1873, raised in Nebraska, Cather served a long apprenticeship writing journalism, poetry, and short stories before moving to New York in 1906 to work at *McClure's* with Lincoln Steffens and

Ida Tarbell, another older muckraker and author of the titanically controversial exposé *The History of the Standard Oil Company*. Cather took a studio in the cheap boardinghouse at 60 Washington Square South where Lewis also had a room, in the heart of the student and bohemian zone.

In her 1953 memoir/biography *Willa Cather Living* Lewis writes, "In 1906, Washington Square was one of the most charming places in New York," with "an aura of gentility and dignity . . . [I]t was a very sedate Bohemia; most of the artists were poor and hard-working." She fondly recalls the "youthful, lighthearted, and rather poetic mood of those days before the automobile, the radio, the moving picture—and before two wars." Lewis worked at *McClure's* as well. The two of them moved together to a boxy little apartment on Washington Place, then to a spacious seven-room apartment in a brick house at 5 Bank Street, near Greenwich Avenue, where they lived from 1912 to 1927. The heat was coal and the lights gas. They left only because the house was to be torn down for the large apartment building that stands on the corner to this day.

Cather wrote that *her* Greenwich Village was "a gentle spot of old Georgian red brick homes with brass knockers, filled with folks who like quiet and rest and mellow living." Even during the height of the Village's Left Bank heyday in the 1910s and through its wilder Prohibition party years in the following decade, she and Lewis lived sedately. She walked to Jefferson Market every day for fresh salad greens and cut flowers, worked diligently on her books, not participating in the bohemian and radical goings-on, arguing that "the business of an artist's life" is "ceaseless and unremitting labor." For socializing, she had small groups of friends, mostly from *McClure's*, over for Friday afternoon tea. On being forced to leave Bank Street she and Edith settled for a while at the old Grosvenor Hotel on Fifth Avenue at Tenth Street, across from the handsome Episcopal Church of the Ascension, and from there they moved up to Park Avenue, where Cather died in 1947.

A NUMBER OF THE GUESTS AT DODGE'S EVENINGS ALSO JOINED THE Liberal Club when Henrietta Rodman dragged it to the Village. With such personalities coming together not just in one neighborhood but in

one room, whether that was in Dodge's parlor, over the sixty-cent dinners at Polly's, or while downing the nickel beers at the Hell Hole, interesting events were bound to follow. In 1913 there were three: January's appearance of a newly reorganized, collectively run version of *The Masses*, edited, written, and illustrated by many in Dodge's circle; February's opening of the International Exhibition of Modern Art, known as the Armory Show, in which Dodge and her cohort were intimately involved; and the June pageant in support of the striking Paterson silk workers, which was conceived at one of Dodge's salons.

# 1913

MUCH OF THE EXPRESSION OF THOSE EXPLOSIVE DAYS
WAS THE SAME, WHETHER IN ART, LITERATURE, LABOR
EXPANSION, OR SEXUAL EXPERIENCE, A MOVING, A
SHAKING TIME.

—*Hutchins Hapgood*

SOME SAID IN THOSE DAYS THAT YOU COULD NOT GET
ANY NEARER TO ORIGINAL SIN THAN BY RENTING A
STUDIO ANYWHERE BELOW FOURTEENTH STREET.

—*Djuna Barnes*

*T*HE MASSES PLAYED OUT THE SCHISM BETWEEN YELLOWS AND Reds on a small scale. It was begun in 1911 as a Yellow periodical backed by Rufus Weeks, a vice president of the New York Life

Insurance Company and as silk stockinged as they came. It politely promoted workers' cooperatives. After a year of publishing. Weeks tired of supplying virtually all the funding for the magazine and announced he was closing it. Members of the staff, led by the illustrators John Sloan and Art Young, decided to continue the magazine as a collective. Max Eastman was vacationing in Provincetown when Sloan and Young informed him peremptorily that they'd chosen him to be their nonsalaried editor. He had never edited a magazine, but he was charming, charismatic, and intellectually flexible enough to ride herd on a collective of artists and radicals with big and usually contradictory ideas about sparking a cultural revolution.

They paid Floyd Dell twenty-five dollars a week to handle the daily editorial details, freeing Eastman to set the tone and raise funds. Dell had only just arrived from Chicago, where he'd edited the *Chicago Evening Post* books supplement and been a major figure in Chicago's own bohemian scene. It had developed in the South Side's Jackson Park, where artists and writers commandeered flimsy shacks originally built as souvenir and snack stands outside the 1893 World's Columbian Exposition. These spare, unheated spaces formed the center of a literary scene that included Ben Hecht, Sherwood Anderson, Vachel Lindsay, Carl Sandburg, Edgar Lee Masters, Maxwell Bodenheim, George ("Jig") Cram Cook, and the partners Margaret Anderson and Jane Heap (*The Little Review*). Feeling isolated in the Midwest from the larger bohemian scene, Dell, Cook, and Bodenheim fled to Greenwich Village and made themselves right at home. Dell would be the Village's most unabashed cheerleader and, later, its most nostalgic eulogist; Bodenheim became one of its most visible, and eventually caricature, bohemian poets; Cook would help pioneer its "little theater" movement.

Dell's assistant was a fledgling young journalist named Dorothy Day. Raised in a stolidly middle-class Episcopal household in Brooklyn Heights, she'd dropped out of college and thrown herself headfirst into the Village's bohemian milieu. She professed anarchist, pacifist, and suffragist politics, drank and caroused with the best of them at the Hell Hole, and was sexually free. Exhausted and disillusioned with the high

life by the mid-1920s she would undergo a spiritual conversion, embrace Roman Catholicism, and cofound the Catholic Worker movement in the early 1930s, dedicating herself to pacifism and to assisting the poor until her death in 1980. She has been proposed for canonization, something her pals in the Village of the 1910s could not have foreseen.

The new version of *The Masses* included a mission statement in its January 1913 issue that clearly said which side of the Yellow-Red divide Eastman believed the periodical was now on—"A REVOLUTIONARY AND NOT A REFORM MAGAZINE"—but hedged a bit by defining its revolution more in cultural than in political terms.

A MAGAZINE WITH A SENSE OF HUMOR AND NO RESPECT FOR THE RE-SPECTABLE: FRANK, ARROGANT, IMPERTINENT, SEARCHING FOR THE TRUE CAUSES: A MAGAZINE DIRECTED AGAINST RIGIDITY AND DOGMA WHEREVER IT IS FOUND: PRINTING WHAT IS TOO NAKED OR TRUE FOR A MONEY-MAKING PRESS: A MAGAZINE WHOSE FINAL POLICY IS TO DO AS IT PLEASES AND CONCILIATE NOBODY, NOT EVEN ITS READERS.

*The Masses* was published monthly, priced at ten cents an issue, one dollar for a year's subscription, so the working masses could afford to buy it. Apparently not many did—the circulation averaged around twelve thousand copies an issue—but the audience for its utopian socialist message was other artists and intellectual anyway, collectively known as the "lyrical left." Distribution was never easy. *The Masses* was banned from subway newsstands in New York, refused by distributors in Philadelphia and Boston, kicked out of the Columbia University library and bookstore, and not allowed into Canada. *The Masses* also started fights with other publications right away. It accused the Associated Press of slanting its reporting of labor disputes against the workers. The AP sued for libel but later dropped the suit.

In June 1913 the magazine moved the operation uptown to a combined office and bookshop at 91 Greenwich Avenue near Bank Street, just around the corner from Cather and Lewis's apartment. Being a Village publication now, *The Masses* took a clear stand against censorship,

sexual repression, and prudery. In one issue the illustrator Robert Minor depicted the recently deceased Anthony Comstock, prude of all prudes and bane of the Village during his lifetime, as a round-bellied, bald little man attacking an artistically reclining female nude with a broadknife. Comstock's successor John Summer responded by raiding the magazine's Greenwich Avenue bookstore and seizing a book on homosexuality that he said promoted sodomy. (In fact the book's author, like many of the men at *The Masses*, looked on homosexuality with tolerance but not favor.)

In addition to Reed, Eastman, and Dell, Dodge and Bryant contributed writing to *The Masses*, as did Sherwood Anderson, Carl Sandburg, Walter Lippmann (who helped found the Yellow *New Republic* in 1914), the cigar-smoking lesbian poet Amy Lowell, Upton Sinclair, Dorothy Day, the poet and Marxist Louis Untermeyer, race reformer Mary White Ovington, and James Oppenheim, poet and founder of the Village literary magazine *Seven Arts*. Women's rights, workers' rights, the plight of the Negro, the hypocrisy of established religions, and the war in Europe were frequent topics. Much of the writing has aged poorly. But the political cartoons and illustrations—by Minor, Sloan, Young, Hugo Gellert, George Bellows, Cornelia Barns, Stuart Davis, Boardman Robinson, Maurice Becker—remain beautiful, trenchant, and humorous, surviving not only as great political art but as some of the best works of the so-called Ashcan School of social realism.

ON FEBRUARY 17, 1913, JUST AS DODGE'S EVENINGS AND THE NEW *Masses* were getting up and running, the International Exhibition of Modern Art, casually known as the Armory Show, opened with great fanfare and ran for a tumultuous month. Although it happened outside the Village, Dodge and several from her circle played key roles in planning and promoting it. And by bringing an explosion of new art to the city (and America) for the first time, it provided a major early stimulus to a Village scene that would, a few decades later, come to dominate modern art.

American art in 1913 was stuck somewhere back in the nineteenth

century, if not the Renaissance. It had never been encouraged to develop. Americans devoured writing, music, and theater but they had not warmed to painting and sculpture. Every small town had its piano teacher but very few had an art teacher. To make change and growth more difficult, after the Civil War art was increasingly segmented into highbrow and lowbrow, an aesthetic divide along class lines. Lowbrow meant the popular culture that entertained the lower and lower-middle classes—minstrel shows, vaudeville, Currier & Ives. Fine art was reserved for those with the education, aesthetic refinement, and taste to appreciate it correctly, which restricted its appeal to small circles of wealthy patrons and cognoscenti in New York and a few other cities.

Even in those refined circles art, like all other endeavors in the land of the Protestant work ethic, was supposed to serve some pragmatic purpose. "For Americans an artist had always been valued for his functional role," the art historian Dore Ashton writes. Artists were thought to be not terribly different from artisans and craftsmen; a well-painted landscape was the functional equivalent of a well-constructed chair. Ideas about artists needing to express their personal vision or genius did not wash in America, and the story of the occasional idiosyncratic American artist who chose to follow his own muse "is a record of repeated cries of loneliness and despair, a story of flinty, determinedly reclusive eccentricity."

Beyond that, American painters and sculptors were still struggling to find an authentically American style, long after American literature and music (at least popular music) had established themselves. Educators, curators, and critics saw their role as preserving old forms and hallowed traditions from the debasing influences of modern Europe. Even many artists distrusted and spurned what they felt were decadent, effeminate, and immoral European tendencies. Winslow Homer grumbled that he wouldn't cross the street to see a French painting. All of these deeply conservative attitudes had obvious retarding effects on the development of a truly modern art in America. In 1913 sculpture was still largely neoclassical; paintings were mostly traditionally rendered portraits, landscapes, or historical scenes (preferably American subjects, scenes, and history).

By then, Samuel F. B. Morse's once renegade National Academy of De-

sign was a staunchly conservative defender of these old forms and a bitter enemy of the new. As early as 1875 disaffected artists had broken with it to form the Art Students League on West Fifty-seventh Street. Pointedly opposed to the academy's closed and elitist system of conferring favor on a handful of approved artists, it was an open atelier where anyone could study with any teacher they chose. In 1910 some artists associated with the league organized the large Exhibition of Independent Artists, presenting hundreds of paintings, drawings, and sculptures. A few of them were European-influenced Impressionists and Post-Impressionists. But the core of the organization called themselves New York Realists. Many of them came from backgrounds in newspaper and magazine illustration. They used traditional techniques of figurative and landscape art but applied them to a new, street-level realism, depicting bar rooms, diners, prizefighters, street urchins, wash hanging over tenement streets, the El. They were nicknamed the Ashcan School and it has stuck. In 1912 they formed the new Association of American Painters and Sculptors (AAPS).

It was members of the AAPS, determined to drag the American art world into the new century, who organized the Armory Show. They rented the 69th Regiment Armory, a barrel-vaulted hall on Lexington Avenue at Twenty-fifth Street, and began gathering what would be a giant exhibition of their own works alongside new works from Europe. Mabel Dodge and Alfred Stieglitz—whose small 291 art gallery on Fifth Avenue had previously been the only place in New York where one might see an occasional work of new art from Europe—were appointed honorary vice presidents of the association and helped strategize and publicize the show. So did Carl Van Vechten and, from Paris, the Steins. Even those who despised the work in the show agreed that the organizers pulled it off spectacularly. The exhibition was enormous, filling the cavernous hall with more than twelve hundred works by roughly three hundred artists, all offered for sale. The Americans included Edward Hopper, destined to be the most famous of them, along with several Ashcan artists who did illustrations for The Masses. There were a couple of American expatriates who were for all intents and purposes European artists, Mary Cassatt and (posthumously) Whistler. The Europeans, most of them shown in

America for the first time, included Picasso, van Gogh, Toulouse-Lautrec, Gauguin, Seurat, Roualt, Matisse, Braque, Munch, Leger, Redon, Duchamp, Brancusi, Cézanne, Daumier, Picabia, Kandinsky . . . an astounding explosion of the new.

The organizers promoted the show with an advance publicity juggernaut the likes of which had not been seen in New York since Barnum ballyhooed Jumbo the elephant thirty years earlier. This was no mere art exhibition for an elite of connoisseurs; it was a grand public spectacle, with admission set at a quarter in the day and a dollar in the evening to keep the show accessible to a wide audience. In its one-month run, some seventy thousand New Yorkers saw it, an astonishing turnout for its time. "It was the first, and possibly the last, exhibition of paintings held in New York which everybody attended," Van Vechten later wrote. He heard elevator operators, streetcar conductors, and other everyday New Yorkers going on about it. Overnight, looking at fine art was entertainment for the masses.

But if "everyone" in New York flocked to the show, not very many of them liked what they encountered there. "The thing is pathological! It's hideous!" the National Academy's Kenyon Cox huffed in the *New York Times*. "These men have seized upon the modern engine of publicity and are making insanity pay." Another disapproving voice in the *Times* issued the dire warning that "Cubists and Futurists are cousins to anarchists," all part of a general movement "to disrupt, degrade, if not destroy, not only art but literature and society too." The press and public singled out Marcel Duchamp's *Nude Descending a Staircase, No. 2* for particular notoriety. They seem not so much outraged or angered as moved to hilarity by it. They mocked it (the often repeated "explosion in a shingle factory"), parodied it, but generally admired what they took to be its brazen wackiness.

With the Armory Show, new art gained a foothold in New York. Duchamp followed his work to the city in 1915; for much of his life he would live and work in the Village. In 1916 he helped found the Society of Independent Artists, hosting large annual group shows where any artist who paid the six-dollar fee could exhibit, and the Société Anonyme in 1920, both dedicated to propagating the European avant-garde in America.

Gertrude Whitney was also a very important supporter of New York artists in the years after the Armory Show, showing both Ashcan School artists and European-inspired modernists (though preferring the former). In 1931 she and her husband would buy the two town houses next to 8 West Eighth Street and turn the three buildings into the Whitney Museum of Modern Art.

It would take until the 1940s, but when the seeds the Armory Show planted fully flowered, the Village would play a major role in making New York the modern art capital of the world.

In June 1913, Villagers organized and staged the Paterson Strike Pageant. Just fifteen miles west of New York City, the mills of Paterson, New Jersey, produced more than half the silk used by the garment industry. In a city of 125,000, some 50,000 nonunionized men and women worked in the mills. As mills elsewhere challenged Paterson's dominance, owners effectively doubled the workload without, of course, doubling the pay. The workers walked out in January 1913, shutting the mills. The IWW's Haywood and Flynn, flush from their victory in Lowell, swept into Paterson a month later to help run the strike. Newspapers in New York and New Jersey, solidly on the owners' side, barely covered the strike, even when two workers were shot and killed. That left it to *The Masses* to do the reporting, with Reed filing unabashedly pro-worker dispatches, for example, "War in Paterson," which began, "There's a war in Paterson. But it's a curious kind of war. All the violence is the work of one side—the Mill Owners." Reed was arrested while reporting on the strike. Several other Villagers went to Paterson to support the strikers and join in their demonstrations. They didn't all come back feeling quite the unalloyed sympathy Reed did. Harry Kemp was dismayed by the sight of thousands of workers "milling about like a great herd of restless cattle." In his 1926 autobiography *More Miles*, the sometime hobo hero wrote, "For the first time in my life, I had sensed directly that enormous, ruthless, unthinking and idiot power latent in masses of people . . . and it had appalled me."

With its tiny circulation, *The Masses* couldn't make a dent in the news

blackout. When Haywood complained to Dodge's circle that there must be a better way to make New Yorkers aware, Reed, Dodge, and John Sloan conceived the Paterson Strike Pageant. The theme would be radical but the form wasn't. Large-scale theatrical pageants were popular and familiar in America at the time. They were organized to celebrate history, mark centennials or other holidays, and teach civic, moral, or religious lessons. Haywood's Village friends imagined a giant pageant in which the Paterson workers themselves would act out the strike on the stage of some big hall in New York City, which would raise both public sympathy for the strikers and funds to help the strike continue. Haywood thought it was a capital idea. Flynn was less enthusiastic, concerned that it could distract the workers from manning the picket lines.

Reed, with Dodge's help, wrote the pageant and rehearsed the cast of more than a thousand workers. Sloan painted giant, realistic backdrops. New York City's garment workers, with the Triangle fire still seared in their memories, raised the funds to rent Madison Square Garden for one night. At that time the Garden was still at Madison Avenue and Twenty-sixth Street, its grand old edifice well worn and dingy, its tower topped with a statue of Diana, goddess of the hunt, drawing her bow.

On the morning of June 7, Reed led eleven hundred workers onto a train from Paterson to Manhattan, where they marched in a grand procession up Fifth Avenue and into the Garden. As dark fell, red lights on the tower—installed without permission—lit up, blazing "IWW" for everyone in Manhattan to see. Down on the street, the line for tickets stretched an incredible twenty-eight blocks. Box seats cost sympathetic toffs thirty dollars, but the great majority of the audience got in for the workers' price of a quarter, or free if they showed their union cards. A beyond-capacity crowd of fifteen thousand packed the arena, which was draped in red banners, and thrilled as troops of Paterson workers marched down the aisles to the huge stage, where they sang and acted out the heroic story of their strike in simple tableaux.

Like the Armory Show a few months earlier, the Paterson Pageant was an undeniable triumph of organization, but its outcomes ranged from disappointing to disastrous for its organizers. Reed, who'd thrown him

self into it with reckless gusto, was reduced to near complete exhaustion. Mabel Dodge seized the opportunity to whisk him off to Paris and Florence where, she confides rapturously in her memoirs, "at last I learned what a honeymoon should be." She was one of the few organizers to benefit. As a fund-raiser for the strikers the pageant was a bust. And, as Flynn had predicted, it distracted the strikers from the picket lines, allowing scab workers to filter into the mills. She and Haywood fell out over it; the strike foundered and collapsed by the end of July. It was a mortifying defeat for the IWW and the beginning of its decline.

On another scale, the pageant may have done its job all too well. Civic and business leaders read those big red IWW signs blazing from the top of Madison Square Garden as a dire warning. Coming on the heels of the outrageous Armory Show, the Paterson Pageant convinced them that dangerous radicals and extremists were attacking from all sides. The *Times* ran an editorial that began, "Under the direction of a destructive organization opposed in spirit and antagonistic in action to all the forces which have upbuilded this republic . . ." and went on to claim that the purpose of the pageant was "to inspire hatred, to induce violence."

It took a few years, but when the establishment struck back it did so in deadly earnest.

# The Provincetown Players

V ILLAGERS HELPED PIONEER ANOTHER NEW ART FORM IN THESE years, the "little theater" movement. American theater in the 1910s was as hidebound as American art. Theater owners and big New York producers like the Shubert family toured the same productions over and over for decades. They called it theatrical manufacturing. Audiences didn't care about the plays; they went to see stars, such as Sarah Bernhardt and Eugene O'Neill's father, James, who spent much of his career playing a single role, the Count of Monte Cristo. *Uncle Tom's Cabin* was still the most popular show in the country, touring endlessly in all sorts of productions. Young playwrights with fresh ideas need not apply. Susan Glaspell, a founder of the Village's theater movement, sighed, "We went to the theater and for the most part came away wishing we had gone somewhere else." Hutchins Hapgood and Neith Boyce thought they found that "somewhere else" in the ethnic theaters on the Lower East Side. They saw Shakespeare in Yiddish and Italian, serious German drama, Chinese plays serialized over weeks. To Boyce it felt nothing like the canned experience of a Broadway play; it was "a stream of life, rich, full, picturesque."

Another sort of inspiration came from Europe, where small art the-
aters had been experimenting with realistic, no-spectacle stagings of psy-
chologically rich dramas by Ibsen, Strindberg, Synge, and others since
the late 1880s. As with the new art, only glimpses of this new theater
were seen in America, but with profound impact. In 1911–12, Dublin's
Abbey Players toured works such as Synge's controversial *Playboy of the
Western World* in the United States. O'Neill and John Reed caught the
tour in New York, where hecklers, apparently outraged by the immorality
of a comedy about loose women attracted to a bragging patricide, threw
rotten vegetables and stink bombs at the actors. Soon-to-be Villagers Jig
Cook and Floyd Dell saw it in Chicago. Cook and Dell were still there
when the Chicago Little Theater opened in 1912. Both men brought to
the Village vivid memories of the Shaw and Strindberg plays they first
saw on a tiny, no-frills stage near the Chicago Art Institute.

The artistic, if not financial or political, triumph of the Paterson
Pageant also encouraged Villagers to continue do-it-yourself theatrical
experiments. Speaking about the birth of Off-Off-Broadway at the Vil-
lage's Caffe Cino half a century later, the playwright Robert Patrick has
remarked, "This was not a theater. It was almost like a clubhouse where
they said, 'Hey, let's put on a show.' " Much the same could be said of
Village theater in the 1910s. The Washington Square Players started out
in the back room of the Washington Square Book Shop, performing a
(bad) play by Reed and a few other new works, but from the beginning
the players dreamed of growing into a bigger and more legitimate theater
company. In 1915 they moved to a space well outside the Village, on East
Fifty-seventh Street. In 1917 they went to Broadway and hired profes-
sional actors. Straying so far so quickly from their amateur Village roots
caused dissension in their ranks, and the company disbanded and reor-
ganized as the Theatre Guild in 1918. In the 1920s the guild successfully
brought the new theater to Broadway with productions such as Shaw's
*Heartbreak House* and *Saint Joan* and O'Neill's *Mourning Becomes Elektra*
and *Strange Interlude*.

Meanwhile, Floyd Dell, inspired by the Chicago Little Theater, began
writing and putting on skits at the Liberal Club as soon as he arrived in the

Village in 1913. They were lighthearted satires of his new Village friends and their hot-button issues—women's suffrage, armchair anarchism, free love—produced without sets or lights, acted out by friends. Club members enjoyed laughing at themselves and soon many were pitching in. From this evolved the Provincetown Players. Mary Heaton Vorse, a writer for *The Masses* and many other venues, had moved to Provincetown, a tiny fishing hamlet on the tip of Cape Cod, in 1906. She was another wealthy radical, raised in an Amherst mansion surrounded by servants, who'd come to New York to study at the Art Students League before turning instead to writing. Along the way she got active in feminism and the labor movement and befriended Elizabeth Gurley Flynn. From 1913 on, "a social register of Greenwich Village Bohemia" vacationed in Provincetown, escaping the heat and stink that characterized summers in Manhattan before air-conditioning (while their Italian and Irish neighbors made do sleeping on the roofs and fire escapes of their tenements). They included Mabel Dodge, John Reed, Louise Bryant, Cook and Glaspell, Max Eastman and his wife, Ida Rauh, and Hapgood and Boyce.

In July 1915, on a lark, Hapgood and Boyce staged a pair of Dell-like one-acts in their rented Provincetown beach cottage. Both were slice-of-life commentaries on Village behavior, and like many of the group's early plays they reveal the doubts many Villagers harbored about one aspect or another of the "splendid plan." *Suppressed Desires*, by Cook and Glaspell, spoofed the Freudian fad through a Washington Square couple whose marriage almost founders on the shoals of fashionable psychobabble. It ends happily only when they agree to throw out the *Journal of Morbid Psychology*. Neith Boyce's more serious, semiautobiographical sketch *Constancy* filleted free love and open relationships in quick, deft strokes, suggesting that while these ideas meant freedom for men they were no-win propositions for women. Again there were no lights or stage, no set but the cottage's furniture. The evening went over in high style, and soon all the vacationing Villagers were writing plays about themselves and needed a larger space in which to perform them. Vorse gave them the use of a ramshackle shack on an old fishing pier she owned. It would become the Wharf Theatre.

The following summer Eugene O'Neill came up from Manhattan and met the group. Early legends, faithfully repeated for decades after, had it that O'Neill just happened to come to the beach with a friend where he ran into Cook and the others. Later research indicated that he arrived with every intention of showing the Villagers some of his trunkful of unproduced plays. Harry Kemp would later recall, "The young O'Neill was dressed slackly like a sailor who had just jumped ship. Dark and taciturn, he favored the portrait of Edgar Allan Poe. The same handsome moroseness was there." The youngest son of actor James O'Neill, Eugene was born in 1888 in a hotel favored by theater folk near Longacre Square (renamed Times Square in 1904) and spent his infancy on the road. The unhappy O'Neill household, which he would portray so bleakly in his plays, left him battling with rage and bottomless depression the rest of his life. He took to binge drinking early, went to sea, caught tuberculosis, and attempted suicide, all before turning to writing for at least some relief and release. He'd churned out more than a dozen one-act and full-length plays by the time he met the Provincetown group.

The old shack on Vorse's wharf was the perfect setting for one of them, Bound East for Cardiff, more a sketch or scene than a full play, about a young sailor dying in his bunk on a tramp steamer. Cook, Reed, and O'Neill himself performed in it. The group staged other plays that summer, by Reed, Bryant, Glaspell, and Boyce. They enjoyed themselves so heartily that when September came around they agreed to bring Provincetown back to the Village with them. Led by Cook, their most enthusiastic organizer, they rented the town house next door to Polly's and the Liberal Club on MacDougal Street, built a rough stage and bench seating, and opened a theater there that fall. O'Neill's Cardiff and another short one, The Long Voyage Home, were early hits, but it remained a communal effort, everyone writing, acting, taking tickets, sweeping the floor.

For a couple of years it seemed that all the Village—except, characteristically, Willa Cather—was joining in. Hutchins Hapgood brought Cook a manuscript of a play by Dreiser, The Hand of the Potter, about an East Side sex murder, which premiered at the theater. One day in December 1917 a petite, freckled redhead with large, luminously impudent green eyes

showed up to audition for a part in Floyd Dell's one-act farce *The Angel Intrudes,* in which a fashionably loose Village couple, Jimmy and Annabelle, are trying to decide whether to elope or break up when Jimmy's guardian angel appears. Annabelle falls for the angel instantly; despite his free-love cant Jimmy is jealous. "What good is he?" he asks Annabelle. "All he can do is sing hymns. In three months he'll be a tramp." The angel removes his wings for Annabelle. "Fool!" Jimmy cries. "You don't know what you are doing . . . Keep your wings, my friend, against the day of your awakening—the day when the glamour of sex has vanished, and you see in her, as you will see, an inferior being." The angel is outraged and goes off with Annabelle. A moment later he sneaks back onstage, collects his wings, and exits "with them safely clasped to his bosom."

The young redhead was Edna St. Vincent Millay. She had been writing and performing since she was five years old, both she and her mother unshakably convinced of her genius from early on. Luckily for them both, enough influential people were too. She was born in Maine in 1892 and grew up poor in a household of women—her mother, who left her father when Edna was almost eight, and her two younger sisters, Norma and Kathleen. Her middle name, presciently, was for St. Vincent's Hospital in Greenwich Village, where her mother's brother had been saved from death's door just as his niece was being born. Family and close friends called her Vincent. When she grew up, some large measure of the charisma she used to win lovers, fans, and devoted press would derive from her Edna–Vincent bisexuality, sometimes a frail and flirty girl in satin and curls, sometimes a boyish gamin in trousers, boldly smoking a cigarette like one of the boys. She'd arrived in the Village just a month before the audition, after graduating from Vassar, where she'd engaged in her first lesbian romances. Her star as a poet was on the rise and her first book of verses had just come out. She'd taken a tiny room on West Ninth Street and talked her sisters into coming to the city.

Dell not only gave her the Annabelle part but started an affair with her. It was clumsy at first—he was thirty and recently divorced, she was twenty and had only been with Vassar classmates—though eventually he found her passionate and uninhibited. He said she was part chorus girl,

part nun, and part Botticelli Venus. He couldn't keep her undivided attention for long. No one could. For some time she was more interested in attracting lovers than keeping them, and a cloud of suitors surrounded her, jockeying for position. For the press she became the free-loving Greenwich Village new woman personified, spokesperson for the new generation of "footloose girls," as The New Yorker put it in the mid-1920s, feted for burning her candle at both ends not only in her verse but in her life. Dell got the Millay girls better rooms on Waverly Place, helped with the rent and groceries, and squired them around the Village. Norma, the country mouse, took longer than Edna to acclimate herself to the Village, where she gaped as the women bobbed their hair and threw away their corsets, caroused with men in bars, openly smoking and cursing like stevedores. Decades later she told the biographer Nancy Milford that she and Edna "sat darning socks on Waverly Place and practiced the use of profanity as we stitched. Needle in, shit. Needle out, piss. Needle in, fuck. Needle out, cunt. Until we were easy with the words."

Edna wrote and directed one-acts for the Provincetown group. Her Aria da Capo was a sold-out hit for two weeks in December 1919. The Times's Alexander Woollcott raved that it was "the most beautiful and most interesting play in the English language now to be seen in New York." It was a harlequinade, a popular form of comedic nostalgia at the time, but she twisted it into lyrical high camp that began with Pierrot and Columbine as a lampoonish Village couple ("Don't stand so near me! I am become a socialist. I love Humanity; but I hate people.") and then darkened into a bitterly poetic antiwar commentary. Norma played Columbine.

Another young woman, a sharp-tongued journalist and poet named Djuna Barnes, also contributed plays. She'd arrived in the Village in 1915 but she didn't come to be a bohemian. She came from a family of bohemians and it had left her permanently damaged. Her paternal grandmother, Zadel, was a Victorian freethinker, free lover, abolitionist, suffragist, spirit medium, writer of stories and verse for Harper's, and, during several years she lived in London, a friend of both Lady Wilde, mother of Oscar, and Eleanor Marx, daughter of Karl. Djuna's father, Wald, seems to have

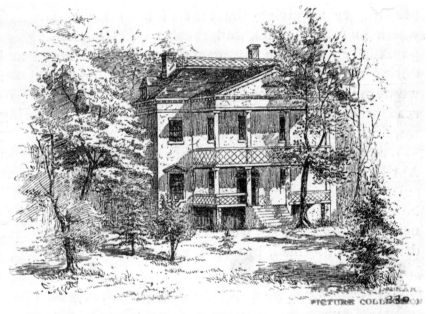

RICHMOND HILL HOUSE, VARICK STREET, BETWEEN CHARLTON AND
VANDAM STREETS

Before it was absorbed into the city, Greenwich Village was
noted for its country estates, including Richmond Hill.
(*New York Public Library*)

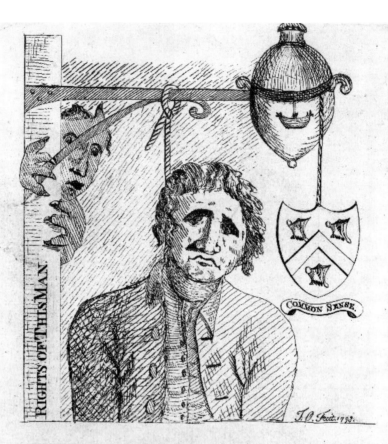

A pamphleteer imagines a fitting end for Tom Paine.
(*Library of Congress*)

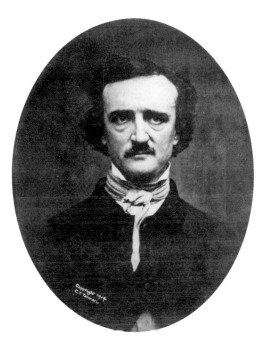

Edgar Allan Poe strikes a baleful pose.
(*Library of Congress*)

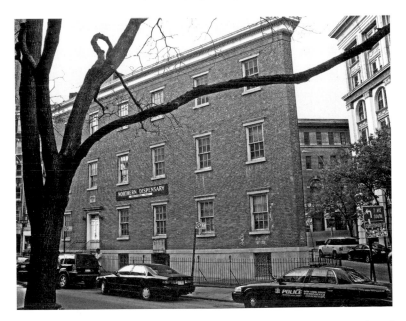

The Northern Dispensary, where Poe may have been treated and
HIV patients definitely weren't. (*Photograph by Christine Walker*)

MR IRA ALDRIDGE AS AARON.

"He dies upon my scimetar's sharp point,
That touches this my first born son and heir!"
TITUS ANDRONICUS.
Act 4. Sc 2.

Ira Aldridge, the star of the African Grove. (*Library of Congress*)

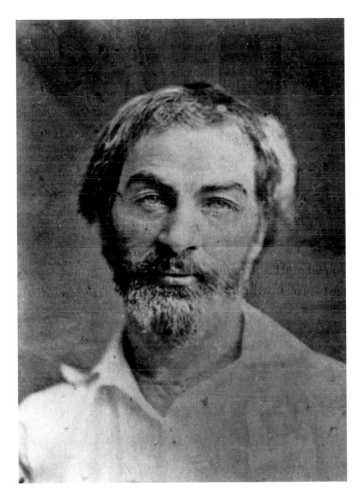

Walt Whitman.
(*Library of Congress*)

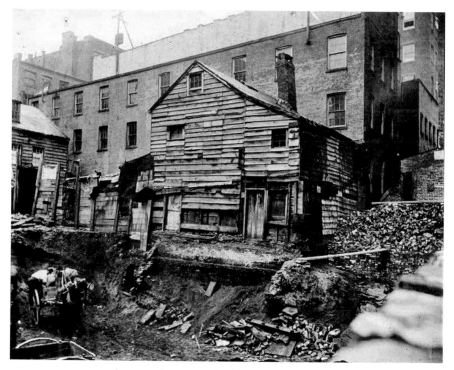

Jacob Riis photographed this "vile rookery" on
a back lot behind Bleecker Street, circa 1890.
(*Museum of the City of New York*)

Gay Street, once part of black Greenwich Village
and later the setting for *My Sister Eileen*.
(*Photograph by Christine Walker*)

Washington Square and Henry James's
"lamentable little Arch of Triumph."
(*Library of Congress*)

embodied the worst attributes of the bohemian. He was a shiftless ne'er-do-well who sponged off Zadel until she died (when he was fifty), and used his presumption of superiority to bourgeois morality as a rationale for immoral behavior, possibly including incest and certainly including child abuse. Djuna was born in 1892, the same year as Millay, and raised in a log cabin in Cornwall-on-Hudson and on a farm in Huntington, Long Island, in a household crowded with her grandmother, her mother, Elizabeth, her four siblings, her father's live-in lover Fanny, and their several children. Zadel paid the bills. As nonconformists among conservative country folk, the Barneses held themselves apart and mostly held the kids out of school, surrounding them with literature, art, and music but neglecting to teach them basics like spelling and arithmetic. Zadel doted on Djuna and encouraged her to write and draw. Both Zadel and Wald goaded the children to throw off bourgeois sexual restraints. For fifteen years Djuna and Zadel slept in the same bed, and their bizarrely bawdy letters, which Djuna saved, suggest they engaged in sexual fondling and play. Some feminist scholars would later attempt to interpret this activity, if in fact it happened, as the women's revolt against Wald's patriarchal hegemony rather than incest and child molestation. Wald certainly gave his daughter good reason to be revolted. Djuna later told and wrote conflicting stories about her first heterosexual encounter at the age of sixteen: her father initiated her entry to full womanhood by either raping her himself or bringing in a neighbor to do it. Whichever man it was, the experience left her with rage and humiliation that marked the rest of her life. When Djuna was eighteen, Zadel compounded the girl's sexual confusion by pushing her into the arms of Fanny's fifty-two-year-old brother.

When Wald's two families could no longer stand living under one roof, he kept Fanny and her children and banished Elizabeth and hers. They moved to the Bronx in 1912, and from there Djuna escaped to the Village in 1915, taking a room in one of the boardinghouses on Washington Square South. "In those days Greenwich Village was to the Bronxite just another name for hell and the devil," she later wrote, a place that would "get a girl by her back hair and sling her into damnation." She cut a striking figure, sometimes dressing all in black, with a black veil. She

was extremely bright and talented, with a knack for the killingly clever bon mot reminiscent of one of her role models, Oscar Wilde, and a luxuriously decadent style of drawing heavily influenced by another, Aubrey Beardsley. But her abusive and isolated upbringing had left its scars and skewed her dealings with the world. She flung herself at New York and Greenwich Village with reckless bravado yet at the same time held herself aloof. Her haughty attitude and sharp tongue fascinated and amused some Villagers, annoyed others; she had a gift for raising eyebrows and ires.

As Zadel had hoped, Djuna took up journalism, writing articles and drawing illustrations for almost every newspaper and magazine in the city, including *Harper's*. She wrote about boxers and dentists and Chinatown and the circus, interviewed Flo Ziegfeld and Mabel Dodge and Enrico Caruso. Yet she always felt journalism, and her readers, were beneath her, and many of her articles wore sardonic sneers. She wrote several tourists' guides to Greenwich Village that were prickly with a sarcasm that mocked both the rubes and the Village. The apex of scorn may have been an article she wrote for *Vanity Fair* (not the one from the Pfaff's era but the new magazine started in 1913), "What Is Good Form in Dying? In Which a Dozen Dainty Deaths Are Suggested for Daring Debutantes." Djuna confessed that it was the sort of cutting wit that's a front for deep insecurity and depression. As she wrote, "my upper lip . . . would persist in an attempt to curl, probably because I wanted to cry and wouldn't. I felt cold because I wanted so dreadfully to feel warm." Along the way she hurled herself into passionate romances with men and women that usually ended with her abandoned, enraged, and devastated. She got flinty with anyone who asked if she was gay, straight, or bi, once quipping that if she had sex with a horse it wouldn't make her a horse. Late in life, when she seems to have enjoyed playing the cranky old lady, she would perplex those who'd come to revere her as a lesbian heroine by snapping her low opinions of homosexuality male and female.

The Players produced a handful of her odd and unsettling one-acts, such as *Three from the Earth,* in which a trio of rough country brothers ("three columns of flesh without one of the five senses") confront a

haughty "lady of leisure" about her love affair with their father, who has recently committed suicide. As with all of her writing, it's easy to see autobiographical references embedded in its brief and jangling depiction of dysfunctional family life. Twenty years later Barnes would write of the Provincetown Playhouse, "Our destiny made us speak before we understood, write before we should and produce before we were able."

Still, by 1918 the theater was so successful, the houses so packed, that it moved to a larger space a few doors down the block, a converted stable that became its permanent home, called the Provincetown Playhouse. Barnes later quipped that it "was always just about to be given back to the horses." Uptowners joined the long ticket lines and theater critics wrote glowing reviews. In 1920 the premiere of O'Neill's The Emperor Jones was a giant, tumultuous success. As often happens in bohemia, mainstream success and popularity brought on a crisis of conscience within the group. Cook and others wanted to preserve the original amateur spirit, while O'Neill and younger members pressed for more professionalism. In 1922 Cook and Glaspell quit not only the theater but the entire country, moving to Greece, where Cook contracted typhus and died in 1924. Glaspell returned to Provincetown and continued to write novels and plays, earning a Pulitzer for her play Alison's House in 1931.

With the Cooks gone, O'Neill continued to drag the theater away from its bohemian roots. By the 1924–25 season the name had changed from the Provincetown Players to the loftier Experimental Theatre, Inc., and it was staging some plays, such as Desire Under the Elms, in the legitimate Greenwich Village Theatre near Sheridan Square. That season Paul Robeson starred in O'Neill's All God's Chillun Got Wings at the Playhouse, a succès de scandale about an interracial marriage that, as the Brooklyn Daily News quipped, earned "almost as much publicity as a murder." The mayor wouldn't allow black and white children to appear together in the opening scene, the theater got death threats, and a cordon of police ringed the entrance on opening night, which, in spite of everything, went off without a hitch. Newspapers around the country reported the story on their front pages.

By 1926 the company had lost the last vestiges of its casual bohemian

origins. O'Neill moved on to Broadway and his own Pulitzers, others also moved their works uptown, and it was over by 1929. But another little theater in the Village had started up in 1924. Vincent Millay and others took over a former brewery and box factory near the bend on narrow Commerce Street to create the Cherry Lane Theatre, the name a pun on London's Drury Lane. Through the rest of the century it would be an important incubator, hosting work by everyone from Dos Passos, F. Scott Fitzgerald, and Clifford Odets to Samuel Beckett, Edward Albee, and David Mamet.

By the end of the 1920s hundreds of little theaters around the country offered new American and European plays, while the infiltration of the Theatre Guild and plays by the likes of Glaspell and O'Neill had brought serious contemporary drama to Broadway. After World War II, the Village's Off- and Off-Off-Broadway theater movements would show obvious roots in those first Liberal Club skits of the 1910s.

# The Golden Age Wanes

WAY DOWN SOUTH IN GREENWICH VILLAGE
WHERE THE SPINSTERS COME FOR THRILLAGE
—*Bobby Edwards*

A NUMBER OF FORCES CONVERGED TO START CHANGING THE golden-age Village almost as soon as it got off the ground, scattering its players to the winds. Some were huge events outside the neighborhood: the start of the war in Europe in 1914, the United States's entry into it in 1917, the revolution in Russia that year, and the resulting Red Scare in the United States. Some changes were ones the bohemians had brought on themselves. And as so often in the history of Manhattan, the price of real estate played a hand.

MABEL DODGE'S EUROPEAN IDYLL WITH REED IN THE SUMMER OF 1913 was to be the last time she had him to herself. On their return to the Village, *Metropolitan* magazine surprised him with a dream assignment: covering Pancho Villa's guerrilla war against the government of Mexico.

Where most American newspapermen sat on the U.S. side of the border and filed boilerplate dispatches, Reed embedded himself, to use a term from a later era, with Villa's campesinos, marching and riding alongside the bandit hero. The twenty-six-year-old Reed found his writer's voice in Mexico, a clear and virile action prose.

> Then came yells and hoofs drumming in the rear. About a hundred yards behind ran little Gil Tomas, the ends of his gay serape flying out straight. And about a hundred yards behind him rode two black men with crossed bandoliers and rifles in their hands. They shot. Gil Tomas raised a ghastly little Indian face to me, and ran on. Again they shot. One bullet z-z-z-m-m-d by my head. The boy staggered, stopped, wheeled, and doubled suddenly into the chaparral. They turned after him. I saw the foremost horse's hoofs strike him. The *colorados* jerked their mounts to their haunches over him, shooting down again and again.

Reed's articles thrilled *Metropolitan*'s readers. The *New York World* and other newspapers picked them up. By the time they were collected and rushed out as the book *Insurgent Mexico* in 1914 Reed was a star, the most popular war correspondent in the country, hailed as America's Kipling. His days with Dodge, and his wild Village youth, drew to a close.

Dodge soured on the Village scene herself by the end of 1914. Reed had left her, and all the talk at the Evenings now bored her. During the next two years she was increasingly out of the city—in Europe, up the Hudson, in Provincetown. She met and married the artist Maurice Sterne, and in 1917 they left New York for good. They fled about as far away from the city and everything it represented as they could, resettling in what was then the tiny, isolated village of Taos, New Mexico. Sterne grew bored there after a while and returned east, but Mabel settled in and stayed for the rest of her life. Like some hippies later, she renounced modern society, got back to nature, and embraced Native Americans' traditional tribal culture, so different from the rampant individualism

of the Village. She divorced Sterne and married a Pueblo Indian, Tony Luhan, in 1923. This fourth marriage ended only in her death in 1962. She became the doyenne of the growing arts community in Taos. It was there that Willa Cather finally spent some time with her, but mostly with Tony, who drove her all over the desert, the two of them appreciating each other's quiet ways.

Relations between actual anarchists like Berkman and the Village's armchair radicals broke down in 1914. In Ludlow, Colorado, the Western Federation of Miners, supported by the IWW, struck against the Rockefeller family's Colorado Fuel and Iron Corporation. In an effort to break the strike, the Rockefellers threw the miners and their families out of their company-owned housing. They survived a bitter winter in a tent camp. In April, after a series of armed skirmishes, state militia and company-paid toughs mounted a full-scale attack, burning tents and firing machine guns at anyone moving. Nineteen men, women, and children—or twenty-two, or thirty-three, depending on the source—died. Back in New York, Upton Sinclair heard about the massacre and was outraged. He marched down to the Standard Oil offices at 26 Broadway intending to confront John D. Rockefeller Jr., but was refused entry. That evening he gave a fiery speech at the Liberal Club—though it's an indication of how the Villagers' radical ardor had cooled that few other than Lincoln Steffens attended—and was arrested the next day leading a picket line outside Standard Oil. A few mornings later, a young woman entered the building carrying a loaded pistol, shouting that she intended to assassinate Rockefeller. Now worried about what he'd started, Sinclair gave another speech entitled "Shall We Murder Rockefeller?" to an angry crowd at the uptown Socialist Club. Echoing Tom Paine's "Kill the king but not the man," he argued that the corporation, not the individual, was the enemy.

Berkman, the East Side anarchists, and the Wobblies in town disagreed. In June three anarchists died along with a tenement neighbor in Jewish Harlem when a bomb they were constructing, intended for the Rockefeller home, prematurely exploded. Berkman hailed the martyrs but shocked Village radicals distanced themselves from the workers' movement. Kemp later wrote: "I avowed revolutionary principles,

and wrote many poems for the Cause. But inwardly I was not so sure of the innocency of the proletariat . . . I was not so sure but that the regime of the Proletariat, when it had its turn, would not bring upon humanity abuses more atrocious than any that saw day under the present system of exploiters and exploited." Emma Goldman, who'd worked hard to be the personal bridge between the hotheaded anarchists and the Village intellectuals with their connections to funding and media, was disconsolate at the breakup.

The outbreak of war in Europe in August 1914 dealt a tremendous blow to the hopes and dreams that Dodge had called the "splendid plan." Rather than a new millennium, the world seemed to be sliding back into the barbarous nationalism and imperialism of the previous century. The Masses stood squarely against it. Long before the United States entered the conflict, the magazine's writers and illustrators condemned the Great War over and over as a territorial conflict fought by the young and poor entirely for the benefit of kings and capitalists. Reed went over as war correspondent for Metropolitan, reporting from the trenches on all sides and all over Europe. Asked what he thought the war was being fought over, he gave a one-word answer: "Profits." He saw nothing but misery and degradation for the working-class and peasant soldiers maimed and killed in utterly futile actions. When Metropolitan rejected some of his dispatches as too left wing, The Masses published them.

Woodrow Wilson kept America out of the war through 1915, despite 128 Americans dying when a German U-boat sank the British luxury liner Lusitania that May. Liberals and, more reluctantly, the farther left supported his successful reelection campaign in 1916, hoping he would stay the course. But in January 1917 Germany gave U-boats full rein to sink any ships in the Atlantic, including American commercial vessels. Wilson severed diplomatic relations and, in April, declared war on Germany. The staff of The Masses found themselves in a quandary. Some, like Reed and illustrators Sloan and Young, remained staunchly antiwar. Reed exhorted American workers not to fight this capitalists' war for them but to follow the lead of their Russian comrades. In the fall, he and Bryant, funded by Eastman, went to Petrograd to spend six months reporting on,

and becoming part of, the Bolsheviks' revolution. (Bryant's book *Six Red Months in Russia* would come out in 1918, but it would be overshadowed by Reed's hugely successful *Ten Days That Shook the World* in 1919.) Others at the magazine, however, concluded that now that America was in it, it was their patriotic duty to support the American boys being sent Over There. George Bellows even drew recruitment posters for the government.

With the U.S. entry into the war and the Bolsheviks' disturbing coup, the government moved to strike back against radicals and extremists in America. Congress passed the Espionage Act, making it a crime to interfere with war recruitment efforts, in 1917; in 1918 it added the startlingly harsh and broad Sedition Act, which made it a crime simply to criticize the government. In the summer of 1917 the U.S. Post Office seized the August issue of *The Masses* under the Espionage Act, primarily because of Reed's writings. The magazine took the government to court and the periodical's lawyers had the good fortune to argue their case before the liberal judge Learned Hand, who agreed with them that dissent was not espionage. He ordered the post office to mail the issue. The government instantly found a conservative judge to block Hand's ruling. Meanwhile, when the September issue was presented for mailing, postal service authorities informed the editors that their second-class mailing privileges were about to be revoked. Because the August issue hadn't been mailed, the argument went, *The Masses* was no longer a regularly distributed periodical permitted by law to use the second-class mails.

With two issues now held up, Eastman et al. decided that whatever they tried the government would figure out how to prevent them from selling their magazine, and they soon ceased publishing. The government pursued them even after the magazine died. In April 1918 it brought Eastman, Dell (with Vincent Millay at his side), Reed (still in Russia), and others to trial under the new Sedition Act. The judge summarily excused one young woman accused of sedition for writing a poem in praise of Emma Goldman. He read the free verse and decided it wasn't a poem at all; therefore she was innocent. For the others the trial ended in a hung jury, and so did the retrial several months later.

Eastman started up a successor to *The Masses*, called the *Liberator*, in 1918 and continued to publish Reed's overseas dispatches. In 1926 the *Liberator* would morph into the *New Masses*, with O'Neill, Dos Passos, Sinclair, and Hemingway as early contributors. It looked and read like the old *Masses* for a few years, then turned less literary and more doctrinaire as Eastman and other originators dropped out and hard-line Marxists took over. As the failures and horrors of Stalinism became known, Eastman's socialist ardor cooled. By the 1950s he'd completed a transit from the left to the right. He supported Joseph McCarthy, helped William F. Buckley Jr. start the conservative *National Review* in 1955, and wrote *Reflections on the Failure of Socialism*, published that year. He died in 1969.

The government moved against socialists, anarchists, and Wobblies on a broad front. Eugene V. Debs was arrested in 1918 for a speech exhorting workers to avoid the draft. He got an extraordinarily hard ten-year sentence and had his citizenship revoked. He would win almost a million sympathy votes running as the Socialist candidate for president from behind bars in 1920. The winner, Warren Harding, pardoned him in 1921. He died in 1926. The American Communist Party (CPUSA), founded in 1919, rented office space on West Thirteenth Street in the Village; over the next few years "too Thirteenth Street" became newspaper and magazine editors' code for articles they found too left wing to print. In the spring and summer of that year terrorist bombs, some sent through the mails, exploded all up and down the East Coast. One went off outside the home of Attorney General A. Mitchell Palmer in Washington, D.C., blowing out the windows of the house across the street, where Assistant Secretary of the Navy Franklin D. Roosevelt lived. Palmer retaliated with sweeping raids against leftist organizations, known as the Palmer Raids and the Red Scare. In a few months his agents arrested ten thousand leftists. Haywood, Goldman, and Berkman were all imprisoned. *Mother Earth* shut down. The government deported eight hundred foreign-born radicals, including Goldman and Berkman.

Reed and Bryant continued to speak in support of the Bolsheviks and continued to be charged with sedition by the government. Reed helped

form the splinter Communist Labor Party and sneaked back to Russia through White army lines to ask for the Comintern's official support; instead, Moscow directed the CLP and CPUSA to merge. Trying to get back out of Russia with this directive in early 1920, Reed was arrested, imprisoned, and tortured by the fiercely anti-Bolshevik Finns. On his release, a physical and emotional wreck, he returned to Petrograd. Louise meanwhile made her own extremely hazardous journey into Russia, joining him in Moscow. He died of typhus that October and was given a hero's funeral, the first American interred in the Kremlin.

Bill Haywood—or part of him—joined Reed there a few years later. Convicted and imprisoned under the Sedition Act, he escaped to Moscow while out on appeal in 1921. He served as an adviser to the Bolsheviks until his death in 1928. His body was cremated, with half the ashes buried near Reed and the other half sent home. Elizabeth Gurley Flynn, on the other hand, went on to a very long career as a political radical. She helped found the ACLU in 1920 and became prominent in the CPUSA in the 1930s, which led to her being ousted from the ACLU's board. During World War II she ran for Congress as a Communist but also supported Roosevelt in his prosecution of the war. In the mid-1950s she served two years in jail for her Communist activities, then emerged and became the party's national chairman, a position she held until she died in 1964 during a visit to Moscow. She was given a state funeral in Red Square.

Louise Bryant continued to write from Moscow after Reed's death. Her sunny views on the progress of the Bolshevik state, despite atrocities like the relocation and resultant deaths of millions of farm peasants, would prompt Emma Goldman, who was deported to Russia in 1919 and left it in dismay in 1921, to remark, "I do wish sometimes I were as shallow as a Louise Bryant; everything would be so simple." Goldman's own book on the Soviet state was titled *My Disillusionment in Russia*. She still believed in revolution but as an anarchist never abandoned the conviction that, as she once wrote, "all forms of government rest on violence, and are therefore wrong and harmful, as well as unnecessary." Except for a three-month speaking tour in 1934 she was never allowed back in the United States and died in heartbroken exile in 1940. By 1924 Louise had

left Russia as well. She married a diplomat, William Christian Bullitt Jr., and settled in Paris. He divorced her over an alleged lesbian affair with the artist Gwen Le Gallienne. Louise died in Paris in 1936.

Lincoln Steffens visited Russia in 1919 and again in 1921 and came back to utter the famously misguided line, "I have seen the future, and it works." By the time he died in 1936 he'd changed his mind about that.

OTHER FORCES BEGAN CHANGING THE VILLAGE FROM WITHIN AL-most from the moment the golden age started. One harbinger of the future, Guido Bruno, came to the Village around the same time Mabel Dodge did. He was a Czech émigré whose real name was Curt Josef Kisch, and he didn't really live in the Village, he just commuted there every day from Yonkers. It was said that he'd previously been a war cor-respondent in Turkey and a newspaperman in Chicago. An eccentrically flashy dresser known for his haughty manner, his glittering rings, and emerald-green fedoras, he came to be known as the "Barnum of Bohemia" and the "Czar of Charlatanism." He published a series of pamphlets and chapbook magazines—*Bruno's Bohemia, Bruno's Greenwich Village, Bruno's Weekly*—that he sold for a nickel or a dime and filled with his own feuil-letons about life around the Village, book reviews, occasional poems or stories by others, and a fair amount of self-promotion. At one point he claimed to have thirty-two thousand subscribers throughout the United States and Europe but, given the source and the fact that no one was au-diting his figures, there's plenty of room for doubt.

Bruno's true art, Harry Kemp sneered, was "the Art of Spectacularism." In 1915 he took the second floor in a ramshackle, forlorn-looking wood frame house at the corner of Washington Square South and Thompson Street. The gravedigger for the old potter's field once lived there, after which it was said to have been a stagecoach depot, roadhouse, saloon, and inn. More importantly for Bruno, it faced the spot where the Fifth Av-enue Coach line's double-decker buses dropped passengers from uptown before turning around and driving back through Washington Square. (The Square wasn't blocked off to vehicular traffic until the 1950s.) Fac-ing this entry point for tourists and curiosity seekers, Bruno slapped up

signs that announced GREENWICH VILLAGE and BRUNO'S GARRET, creating an eyesore that rankled neighbors. Inside he created what he called a "First Aid Station for Struggling Genius," which the historian Allen Churchill derides as "the layman's dream of the artist's life. Gaudy, dirty, crammed with easels bearing half-finished works of Impressionist art, the Garret was populated with artists'-model types of girls and hot-eyed young men who declared themselves poets, writers, and painters."

In staging poetry readings, tacking art to the walls, and peddling his pamphlets to tourists, Bruno helped to popularize many clichés that would soon come to be affiliated with the Village. He was of course a living cliché himself; he was even mentioned in a song on Broadway, with music by Jerome Kern and words by, of all people, P. G. Wodehouse (who stayed at the Hotel Earle in the Village during his long visits to America). In the 1910s Wodehouse was one of the writers who teamed up with Kern to renovate the Broadway musical, reducing it from giant, lavish spectacles to jewelbox shows with coherent stories and believable characters. Their 1918 Oh, Lady! Lady! featured the song "Greenwich Village," with the lines:

> Quite ordinary people who come and live down here
> Get changed to perfect nuts within a year!
> They learn to eat spaghetti (That's hard enough you know!)
> They leave off socks and wear greek smocks
> And study Guido Bruno.

But Bruno had a canny impresario's eye for talent. Along with the poseurs and amateurs he displayed as though in a bohemian dime museum, the young poet Hart Crane declaimed his work at the Garret. (He was seventeen and had just fled his upper-middle-class family in Cleveland, where his father had invented Life Savers candy.) So did the journalist and indefatigable bounder Frank Harris, then the editor of Pearson's Magazine, soon to be the author of the scandalous memoir My Life and Loves. So did Sadakichi Hartmann, whom Bruno declared "the King of the Bohemians." This must have come as a surprise to the rest of the Villagers, few

of whom had much to do with the flamboyantly eccentric Hartmann. Yet Hartmann certainly had the exotic pedigree and literary credentials of a bohemian. He was born in Japan in 1867 to a Japanese mother and a German father, who disinherited the rebellious adolescent and sent him to live with an uncle in Philadelphia in 1882. As a young man traveling around the United States and Europe he made the acquaintances of Liszt, Swinburne, the aging Walt Whitman (who fried him some eggs), Mallarmé, Stieglitz, Steichen, and others. At twenty-three he wrote "a dramatic poem in three acts," *Christ*, which was banned and burned in Boston as blasphemous obscenity. He also presented early incarnations of the psychedelic light show in the 1890s and "perfume concerts" in the the next decade, in which he used a machine to pump evocative scents into the concert hall. As an art critic he was an early and perceptive modernist.

Meanwhile he developed a bombastic, obstreperous, and often drunken public persona with a penchant for getting kicked out of museums and concert halls. Once, when he was having his bust sculpted by an artist whose studio was on Washington Square South, he fell out with her, took the bust, and carried it over to the Grill Room at the Brevoort. He sat it on a table, ordered two meals, and ate them both while having a lively discussion with the bust. On his way out he pointed to the bust and told the staff, "That gentleman over there will pay." Tall and thin as a stick, with a Eurasian mask of a face some people found mysteriously attractive and others frightening, he got to be known as one of the very worst spongers in the Village, a man who was absolutely convinced of his own genius and that the world owed him a living. Bruno recognized in him a fellow exhibitionist and crowned him king of a Village scene that wanted little to do with either of them. Hartmann soon left New York anyway; he went to Hollywood, where he generated many more tales of drunken misbehavior while proper acknowledgment of his talents continued to elude him until his death in 1944.

In May 1915 Bruno staged a big one-woman show of elegant, Beardsleyesque drawings by Clara Tice. Clara was born upstate in Elmira in 1888, after which her family soon moved to New York, where her father

became superintendent of the Village's Children's Aid Society. She studied at the Art Students League and helped organize the 1910 Independent Artists show. In March 1915 her career took off, thanks to Anthony Comstock. Seventy years old, retired as head of his suppression society, and less than a year short of expiring, Comstock had seen some delicate nudes by Tice on the walls at Polly's and sent his agents to confiscate them. In the ensuing uproar, *Vanity Fair* came to Tice's defense and boldly reproduced some of her offending works in its pages. When Bruno hastily tacked a large selection of Tice's work to his walls, the crowds and the press dutifully packed the Garret to see what all the fuss was about. Tice, like many other artists targeted by Comstock, called him her best press agent. She soon met Duchamp and through him became part of the New York Dada circle. She went on to a successful career as a book illustrator and died in Queens, at eighty-five, in 1973. Bruno also published a slim volume of illustrated lesbian verse by Djuna Barnes, freshly arrived in the Village and living down the block from the Garret. When *The Book of Repulsive Women*, which the author later disavowed, became a word-of-mouth hit he upped the price from fifteen cents to fifty and pocketed the difference.

Maybe the most surprising figure drawn to Bruno's Garret was Charles Edison, the wealthy teenage son of inventor Thomas Alva. Charles was enjoying a brief bohemian fling before settling down to a life of business and politics that would see him take over his father's empire and serve as governor of New Jersey. He wrote *vers libre* for *Bruno's Weekly* under the nom de plume Tom Sleeper ("A black crow flapped his wings in a dead tree. / At that moment I was born."). In 1915 he funded the Little Thimble Theater, a hundred-seat jewelbox at 10 Fifth Avenue, directly across the street from the Brevoort. Bruno served as the manager. Along with music recitals and free shows for young audiences, the theater staged credible productions of plays by Strindberg, Shaw, Gogol, and Chekhov. Tice designed some of the sets. When Charles's father dragged him back to New Jersey, Harry Kemp took over the theater as a venue for his own verse dramas.

Bruno lost the Garret in November 1916 and eventually faded away,

but he left his mark on a Village that many felt was rapidly being turned into one big Bruno's Garret—"a side-show for tourists, a peep-show for vulgarians, a commercial exhibit of tawdry Bohemianism," as Floyd Dell later put it. By 1915 many other Villagers, including Dell, were marketing and commercializing the Village, playing up both its quaintness and its pagan abandon for the tourist trade. Malcolm Cowley attributed it to most Villagers' innate bourgeois instincts. "Having fled from Dubuque and Denver to escape the stultifying effects of a civilization ruled by business, many of the Villagers . . . entered business for themselves," he writes in Exile's Return. "They would open tea shops, antique shops, book shops, yes, and bridge parlors, dance halls, night clubs and real-estate offices." Village women opened tearooms all over the place, with brightly painted decor, whimsical names, and Left Bank themes. The sculptor Edith Unger wrote the legend "ELOH TIBBAR EHT NWOD" over the door to the Mad Hatter, a basement space on West Fourth Street where a "giant stone fireplace and wooden benches added to the atmosphere." If you were lucky you might see Unger's friends Marcel Duchamp or the Gish sisters there. It was joined by the Purple Pup, the Mouse Trap, the Pig 'n' Whistle, the Crumperie (run by a Miss Crump), the inevitable La Boheme, Vagabondia, the Trilby Waffle Shop, Pollywogge, the Black Parrot, the Jumble Shop, the Vermillion Hound, Aladdin Attic, and others. The tearooms were very popular meeting places for Villagers, who loved to linger over their tea and cakes, talking Freud and feminism. Increasingly, as guidebooks touted tearooms as places for close encounters, the gawkers crowded the locals out.

Some Villagers took to marketing *themselves* as tourist attractions. One of the most popular and longest-running of the Village's characters was "Romany" Marie Marchand, who opened the first of her Gypsy-themed taverns in 1914 and closed her last in the 1940s. As the years rolled on and the tourists rolled in, Villagers smiled to see Marchand's Gypsy outfits grow more elaborate and hear her eastern European accent get more juicy and pronounced. Although she was born in Romania, she was not Romany but Jewish. She immigrated to the Lower East Side as a teenager in 1901 and did piecework in garment industry sweatshops. Legend had it

she learned English attending and ushering at Emma Goldman lectures. After her family moved up to the Bronx, their downtown friends—including Goldman and Berkman, Sadakichi Hartmann, and the historian Will Durant—came up for dinners and heated discussions. With a hundred and fifty dollars chipped in by these friends she opened her first Romany Marie Tavern in the Village, up three flights of rickety stairs on Washington Street. In 1915 she moved it to Christopher Street, where it stayed until 1923. The Metropolitan Museum of Art has an etching of this spot by John Sloan. Buckminster Fuller, in his mid-twenties, fresh out of the navy, met Romany Marie there in 1919 and they became lifelong friends. From Washington Street she changed locations nine more times over the decades, her one genuine Gypsy characteristic. Whatever the address, pretty much every Villager, wannabe, and tourist made it to Romany Marie's. She was a surrogate Jewish mother, feeding them soup and *chorba* (stew), listening to their troubles, letting them loiter endlessly over the Turkish coffee, and telling their fortunes from the grounds. Like Pfaff, she reserved the best tables for her favorite writers, artists, intellectuals, feeding them on the cuff when they were broke. She petted her arty friends and could be cool to outsiders in ways some of them—including Max Gordon, who founded the Village Vanguard—found snobby.

In the mid-1920s she took over the second floor of the old house on Washington Square where Bruno's Garret had been. After two years there NYU administrators evicted her and the ice cream parlor on the ground floor and tore the house down; the school's Vanderbilt Hall is there now. After that she moved in 1927 to Minetta Street, where Fuller designed the interior as an early showplace for his futuristic Dymaxion ideas. It was a disaster. Fuller's aluminum chairs with canvas seats and backs collapsed under her patrons, and his bright lights bouncing off all the shiny industrial surfaces blinded them. Fuller was still a struggling unknown then. A friend put him up in the Village and Romany Marie fed him. In return he drove her around in his three-wheeled Dymaxion car. Edgard and Louise Varèse were Romany Marie regulars throughout her reign. So were Isamu Noguchi, the Arctic explorer Vilhjalmur Stefansson, the folksinger Beryl (later Burl) Ives, William Saroyan, the roly-

poly artist Joseph Stella, and Clifford Odets, whom she later remembered as "just a kid hanging around to get a few words from Harry Kemp." Brancusi and the Russian mystic Gurdjieff came by when they were in New York. Through the 1950s, after losing her eleventh place, Romany Marie remained a fixture at other people's cafés and restaurants in the Village until her death in 1961.

Other enterprising Villagers opened bohemian-themed novelty and bric-a-brac shops, pushing "the gamut from gypsy beads, batik lampshades, and tin vanity cases" to "pre-dripped candles socketed in old beer bottles—a ubiquitous Greenwich Village item." By 1917 boutiques sprouted up to sell the visiting weekend bohemian the proper attire: artist's smocks, of course, peasant blouses, sandals and moccasins, slouch hats that sat nicely on bobbed hair, and berets. By then every restaurant, café, and bistro in the Village had adopted a bohemian decor, with those drippy candles in bottles, rickety wooden chairs and tables, peasanty throw rugs, and cobwebs in the corners. The bar Julius' would still be famous for its cobwebs into the 1960s, hanging ominously in the corners like threatening storm clouds. The Pepper Pot at 146 West Fourth Street near Sixth Avenue offered a bistro in the basement, a dance floor above, game and chess rooms above that (where chess fanatic Duchamp might also be found), and a novelty shop next door. (June Miller, Henry's second wife, would waitress there in the mid-1920s, by which time it had converted to a speakeasy.)

Crews from the city's still young film industry began to show up in the Village around 1916, hiring appropriately exotic-looking Villagers as extras to appear in comedies and farces about bohemian life, shot on location in the neighborhood's cafés and restaurants. The plot usually revolved around a good girl from uptown who runs away to Greenwich Village where her morals are tested. In the *Ziegfeld Frolic* on the rooftop of the New Amsterdam Theatre on Forty-second Street, Fanny Brice introduced a racy new song on the same theme in 1920, "Rose of Washington Square." Rose comes from the Bronx to the Village to be an art model, and the song suggests this entails more than posing. "I've got no future," Rose sings, "but oh what a past."

Guidebooks and tourist maps proliferated, all promising to lead the user to the real, the hidden, the hot spots. It was in this era that the first historical plaques began to appear on the walls where famous writers and artists once lived.

Nothing promoted to outsiders the idea that Greenwich Village was a fleshy Gomorrah so well as the "Greenwich Village balls," which were not actually held in the Village but over at Webster Hall on East Eleventh Street and Third Avenue. Built in the 1880s and expanded in the 1890s, Webster was one of the many rental halls around the city sited mostly in poor and working-class neighborhoods, where residents who were crammed into tenements needed spaces for wedding receptions, dances, political rallies, and other large functions. The halls were rarely fancy; as early as 1888 the Brooklyn Daily Eagle had characterized the Webster as "a big, bare, dingy place." By 1913 it was quite familiar to leftists. The Progressive Labor Party had been founded at a meeting there, and Samuel Gompers had rallied striking brewery workers there, both in the 1880s. Emma Goldman's Mother Earth held a masquerade in Webster in 1906, which was broken up by the police. Margaret Sanger had paraded those Lawrence children before the press there in 1912.

The first of the Greenwich Village balls were thrown as fund-raisers for The Masses and the Liberal Club in 1913. "Are You a Radical?" The Masses' ad for its first event asked. "Whether or Not, Come to the Greenwich Village Carnival Old Home Celebration Costume Dance." Admission was one dollar in costume, two dollars without, guaranteeing a lot of odd-ball and often impromptu outfits of the bedsheet-as-toga sort. The party, which rolled on all night with much dancing and drinking and necking, was a great success. Floyd Dell named the Liberal Club's fund-raisers "pagan routs," a name "potent in its appeal to the fevered imaginations of the bourgeoisie," he later wrote. Poster illustrations featured leaping fauns and nude models draped over the shoulders of husky, beret-capped artists. Revelers dressed as nymphs and satyrs and other pagan outfits and much tipsy, risqué merriment ensued. The Quill, a small literary and Village-gossip magazine, held its own "Dance of the Feathered Flock," the ad for which contained the silly verse "A flighty old bird is the pelican. /

He tries hard to dance, but the helican. / But he can drink, old red-eye, yep, quite welican." These early balls launched a tradition of Village and pseudo-Village balls at Webster Hall that escalated through the second half of the decade until the Webster was rocking to as many as two a week and came to be known as the Devil's Playground. They continued right through Prohibition and the Depression, the costumes waxing more fantastical and, for the ladies, revealing. Dell would watch with chagrin as the behavior grew rowdier and even "intolerably disgusting," and the link to anything like authentic Village culture or causes was lost. Cowley recalled Webster Hall events in the 1920s "attended by terrible uptown people who came to watch Villagers at their revels and buy them drinks in return for being insulted." In the mid-1920s Dell, who had left the Village and moved up the Hudson in 1919, rather disingenuously lamented that "we had something which it seemed all bourgeois America—sick to death of its machine-made efficiency and scared respectability—wistfully desired to share with us: we had freedom and happiness." Dell would later move to Washington, D.C., where he died in 1969, age eighty-two.

Just as the bohemians were attracting hordes of outsiders to the Village, the city made it easier for them to get there. From 1914 to 1918 the city and the privately operated IRT collaborated on extending Seventh Avenue through the Village, with a new west side subway line (today's 1, 2, and 3 trains) beneath it. Seventh Avenue had stopped at the spot where West Eleventh Street crosses Greenwich Avenue. Now it would plow down through the Village at an angle to meet up with the newly widened Varick Street below, making one continuous, though doglegged, thoroughfare from below Canal Street up to Central Park. The city condemned hundreds of homes and other buildings along the ten-block diagonal through the Village, evicted the occupants, and began demolishing buildings. Some weren't completely torn down, merely cut back to make room; houses and commercial buildings with wrong-looking angles still abut the avenue today. Oddly wedge-shaped buildings along the route, like the one that houses the Village Vanguard, were built later on the triangular lots created by the new road's slanting path. To lay the new subway line the IRT dug an immense trench, forty feet wide, that

locals nicknamed the Cut. For a few years it effectively isolated the Hudson side of the Village, making life miserable. As soon as it opened in 1918, the new subway's Christopher Street station disgorged crowds of visitors, while the new Seventh Avenue corridor boomed day and night with a glut of through traffic, which worsened a decade later when the Holland Tunnel opened. Lined with gas stations, tire shops, and garages, Seventh Avenue South looked more like a downbeat commercial strip somewhere out in the boondocks than a part of ye olde Greenwich Village. Sheridan Square around the Christopher Street stop bloomed with new tourist traps. Locals complained bitterly—not for the last time and not without cause—that the changes killed the Greenwich Village they'd known and loved. But they did get one benefit from it. The Cut prompted them to petition the city's new Zoning Commission for protection from further incursions. As a result, the city zoned the heart of the old Village for residential use only, an early example of historic preservation.

Beginning in the mid-1920s the city would also extend Sixth Avenue, while the IND built a new subway line (the A, C, and E) under it, even as the Sixth Avenue El continued to rumble above until 1938. The work brought five more years of destruction and dislocation to the Village, with more buildings demolished, more odd-shaped lots left over, and a few small streets, including Minetta Place, obliterated. Slicing through the heart of the neighborhood, Sixth and Seventh Avenues and their attendant subway lines definitively ended the old Village's long era of relative isolation and calm by 1930. They remain the two busiest, least lovable, and most un-Village thoroughfares in the heart of the neighborhood. They help explain why, when the city planner Robert Moses proposed further slicing up the neighborhood with highways and extensions twenty-odd years later, residents banded together to oppose him.

By 1917 the selling of the Village to tourists was so rampant that Sinclair Lewis wrote a satire about it, "Hobohemia," that ran in the *Saturday Evening Post*. He adapted it into a full-length play that premiered at the Greenwich Village Theatre on Sheridan Square in 1919. It's the story of a Mr. Brown, a Bruno-Babbitt who decides the only problem with bohemia is that the bohemians don't know how to make a profit from it. In

Greenwich Village he meets Mrs. Saffron, a parody of Mabel Dodge, and a famous artist who talks only about "Sex, with a capital S and four exclamation points after the word." He goes to see some inscrutable plays by the Hobohemian Players, discovers that free verse "was exactly like advertising, except that usually it was not so well done," and invents a Russian author, Zuprushin, whose novel *Dementia* all the pretentious Villagers he meets claim to have read. (As we'll see, a later Villager would put this ruse into actual practice.) As if proving a point, the first of the *Greenwich Village Follies* followed *Hobohemia* into the theater in 1919. A revue parodying every by now familiar stereotype and cliché of Village life, it was a smash hit and moved to Broadway. Subsequent editions played on Broadway through the 1920s, their connection to any Village behavior increasingly tenuous. For instance, Cole Porter wrote songs for *Greenwich Village Follies of 1924* while living in a palazzo in Venice.

VILLAGE ITALIANS, MOST OF THEM RENTERS IN TENEMENTS AND IN old single-family homes converted to hold multiple small apartments, now far outnumbered the neighborhood's other groups. As early as 1914 local property owners, middle-class families, and neighborhood merchants joined forces to form the Greenwich Village Rebuilding Corporation and the Greenwich Village Improvement Society. By improvement they meant both stemming the rising tide of bohemian shenanigans and redressing the overwhelming demographic dominance of the Italians. Collaborating with landlords and real estate developers, they launched a program to "re-colonize" the neighborhood with white, middle-class home owners and renters. Today we'd call it gentrification.

In 1915 the *New York Times* reported on the Rebuilding Corporation's buying old houses in the neighborhood to be "properly remodeled and equipped with some of the necessities of modern living comforts." In some cases remodeling meant as little as a fresh coat of paint and an icebox, after which rents doubled, tripled, quadrupled. Italians were evicted from tenements, bohemians and artists from their studios and carriage houses. Landlords and developers weren't above using the neighborhood's arty cachet to lure new, more affluent, art-loving tenants—profes-

sionals and office workers who liked the idea of living near artists and bohemians but, in most other respects, maintained their middle-class values and behaviors. By 1917 the *Times* noted a growing exodus of artists from the neighborhood, driven out by the rising rents the new tenants were able to pay. So many of the newcomers came from the Midwest that even *Ladies' Home Journal* could joke that Greenwich Village was becoming "the cob of the cornbelt."

Newspapers and magazine cartoonists depicted threadbare, starving artists being kicked out of places such as Washington Square Mews to make room for wealthy new tenants in top hat and ball gown with their chauffeured limos parked nearby. One began to hear the term "golden garret" used to describe such places. By 1922 the *Times* was reporting that artists were in full flight. "Studio rents have been multiplying chiefly, it is alleged, by the competition of bourgeois people who know nothing of art, but like to wear flowing ties and live in the midst of temptations. New York is being destroyed as an art centre by the usurpation of studios and the dispossession of artists, according to Frederick K. Detwiller, a well-known painter. 'Young artists are being forced out of the city by the hundreds,' he said . . . 'The struggling young fellow is finding it more and more difficult to get a foothold in New York City . . . He can't pay the studio rents in New York City because of the thousands of people in other walks of life who are taking the studios, either because they are cheaper or because they can be furnished easily or because they want to live in a section that has the reputation of being artistic."

By 1927 the news of the Village's demise as an "art centre" had spread so far and wide that the *Christian Science Monitor* ran an article with a headline and subheads that read like a death notice:

GREENWICH VILLAGE TOO COSTLY
NOW FOR ARTISTS TO LIVE THERE

*Values Increase So That Only Those Who Can
Write Fluently in Check Books Can Afford It*
ONE ROOM AND BATH COST $65

These reports betray a certain level of journalistic oversimplification and exaggeration. The sociologist Caroline Ware, closer to the ground, reports that while many of the 1910s wave of artists and writers did leave, not all were driven out by the rising rents and the hordes of tourists and wannabes. Some simply became successful enough to move uptown or out of the city altogether, either re-creating their Village youth in other settings—up the Hudson in towns such as Croton and Woodstock, for instance—or putting those days behind them. Others stayed and adjusted to the changes, although they uniformly groused about the new people and waxed nostalgic for the golden age. And although rents did go up all around the Village, second-wave artists and writers of Cowley's generation still found cheap places and settled down to lives of serious creative output. Ware describes a Village that grew more socially complex from the late 1910s through the 1920s. The two basic groups of the 1910s, "locals" and "Villagers," fragmented into subgroups that included artists and bohemians of the original type, the second-wavers they attracted (including the equivalent of today's hipsters and fauxhemians), and middle-class professionals (equivalent to today's yuppies) with little interest or involvement in the neighborhood's arty reputation. They were drawn to it instead by its old-fashioned charms and its location, conveniently near their places of work but still set off to one side from the hustle and bustle of the rest of Manhattan.

William Sloane Coffin—whose son would later be the ultra-liberal pastor of Riverside Church—made no secret of his intent to resettle the Village with this last group, advertising to white, middle-class Protestant families who would take back the old "Yankee Ward" from the Italians and bohemians. In 1920 his Hearth and Home Corporation evicted the mostly Italian tenants from the parallel stretches of Georgian row houses on MacDougal and Sullivan Streets between Houston and Bleecker, renovating them as deluxe single-family homes and combining all the backyards between the houses into a single, grandly landscaped garden completely hidden from street view. The idea was that the children of the white middle-class families to whom Coffin sold the remodeled homes could play in the garden, not out on the streets with the dirty Italian kids

from the surrounding "slum." Other interior gardens, like Bleecker Gardens, dotted the Village. Today the MacDougal-Sullivan Gardens development is an exclusive enclave that's on the National Register of Historic Places. The middle class can't afford it anymore; the town houses sell for $10 million and more now, and residents have included Bob Dylan, Anna Wintour, and Richard Gere. A pizza parlor on Bleecker Street has a fenced-in rear patio that abuts the secret, tree-shaded garden and offers a restricted glimpse.

Manhattan would go on a building spree through the 1920s and into the early 1930s culminating in the Empire State Building and the Chrysler Building, the world's two tallest skyscrapers for some time. But the boom's biggest impact was in the housing market. Apartment complexes rose all over Manhattan, adding as many as one hundred thousand units a year toward the end of the 1920s. It was in this decade that apartment living, previously relegated to the lower orders and the artists and bohemians among them, became acceptable to the middle and upper classes. Because of increasingly out-of-date city building codes, taller buildings for a while had to be constructed and marketed as "apartment hotels," with no kitchens or cooking allowed in the apartments. To this day, there are otherwise palatial apartments in older Manhattan buildings with strangely tiny kitchenettes squeezed in later when the codes changed.

Even in Greenwich Village, new apartment buildings like the one that ousted Cather and Lewis, some as tall as sixteen stories, sprouted. Lower Fifth Avenue was transformed into a "canyon" of tall apartment buildings. One of the most handsome went up at 1 Fifth Avenue, beside Washington Mews and right behind the town houses at the north edge of Washington Square. Known simply as One Fifth by locals, the soaring tower, an odd but happy mélange of deco and medieval touches, offered spectacular views of the Village and remains a poshly hip address to this day. Mabel Dodge's house came down for an apartment tower, as did the building across the street that held Harry Kemp's theater. Fine mansions the city's elite had built along the avenue in the 1800s were unceremoniously razed.

# The Next Wave

O N A COLD NIGHT IN JANUARY 1917 SIX VILLAGERS SNEAKED UP
to the top of the Washington Square Arch after noticing that
the door at the base was unlocked. They included John Sloan and
Marcel Duchamp, a trio of actors, and the ringleader, Gertrude Drick,
a vivacious young blonde recently arrived from Texas. Failing as a
musician, poet, and painter, she settled for being one of the Village's
colorful hipsters. Before this night she was best known for handing
out a black-edged calling card with "Woe" printed on it so she could
say, "Woe is me"—a fairly large step down on the social rebellion scale
from Ada Clare's "Miss Ada Clare and Son." They got a little camp-
fire going in a pot, strung Chinese lanterns and balloons from the
parapet, ate a picnic of sandwiches and wine, and then, as the oth-
ers fired off cap pistols, Drick read the Republic of Greenwich Vil-
lage's declaration of independence from the rest of the United States.
It consisted of a single word repeated over and over: "Whereas . . .
Whereas . . . Whereas . . ."

It's hard to picture the earnest radicals of 1913 issuing such a blank

declaration, perfect Dada gesture though it was. Nor would they have urged the withdrawal of the Village from the rest of the country. Their ideal had not been to remove Greenwich Village from the rest of America but to transform the rest of America into Greenwich Village. Drick and her pranksters were now declaring that experiment over, a failure. On the eve of America's entering the horrific Great War in Europe, with Russia plummeting into chaos and the anarchists at home making bombs, Drick and her crew seemed to be saying that Villagers just wanted to picnic and party. It was one thing for Duchamp to be part of this little scene. His whole life and art were about cool disengagement and intellectual distance. But for Sloan the socialist to be there suggests that a new mood was overtaking the Village.

"There were two sorts of people here: those who had lived in the Village before 1917 and those who had just arrived from France or college," Malcolm Cowley recalled. He'd left Harvard in 1917 to drive munitions trucks for the French army. He writes that he and the other young Americans serving around him—who included another Harvard man and future Villager, E. E. Cummings—had volunteered in someone else's war purely for the adventure of it and felt a "monumental indifference" to the cause for which they fought, a "curious attitude of non-participation, of being friendly visitors who, though they might be killed at any moment, still had no share in what was taking place." Carrying this experience of being uprooted and disconnected into the 1920s, they became the Lost Generation, a term Gertrude Stein applied to them after hearing a French garage owner yell it at one of his young mechanics. More worldly than the golden-age cohort, less idealistic and optimistic, in a sense they were expatriates wherever they went, whether that was Paris or New York.

> After college and the war, most of us drifted to Manhattan, to the crooked streets south of Fourteenth, where you could rent a furnished hall-bedroom for two or three dollars weekly or the top floor of a rickety house for thirty dollars a month. We came to the Village without any intention of being Villagers. We came because living was cheap, because friends of

ours had come already (and written letters full of enchant-
ment), because it seemed that New York was the only city
where a young writer could be published . . . [We] belonged
to the proletariat of the arts and we lived in Greenwich Vil-
lage where everyone else was poor.

Of the pre- and post-1917 Villagers Cowley writes, "I came to think of
them as 'they' and 'we.' . . . The truth is that 'we,' the newcomers to the
Village, were not bohemians . . . 'They' had been rebels: they wanted to
change the world, be leaders in the fight for justice and art, help to cre-
ate a society in which individuals could express themselves. 'We' were
convinced at the time that society could never be changed by an effort of
the will . . . We were content to build our modest happiness in the wreck
of 'their' lost illusions, a cottage in the ruins of a palace . . . We might act
like pagans, we might live for the moment, but we tried not to be self-
conscious about it."

Just as the counterculture of the 1960s would be dumbed down for
mass consumption in the 1970s as polyester bell-bottoms, "soft rock," and
Plato's Retreat, Cowley believed the ideas and ideals of the 1910s seeped
out of the Village in the 1920s, leaving only gestures. Female equality, he
argued, came to mean only the freedom to smoke (doubling the market
for the tobacco companies) and bob your hair; free love was reduced to
pure promiscuity, paganism meant hedonism, living for the moment was
interpreted as license to get as drunk as you want as often as you can. The
Village "was dying of success. It was dying because it became so popular
that too many people insisted on living there."

Margaret Anderson and Jane Heap came to the Village from Chicago
in 1917 hoping to participate in the golden age but quickly sensed they'd
come too late. Born in Indianapolis in 1886 to a middle-class house-
hold Anderson, like so many other eventual émigrés to the Village, had
known from early on that she was different, an outsider who would never
quite conform to bourgeois values. "I have never felt much like a human
being. It's a splendid feeling. I have no place in the world—no fixed posi-
tion. I don't know just what kind of thing I am," she writes in her first

volume of memoirs, *My Thirty Years' War.* She escaped to Chicago in 1908 and joined the Chicago Renaissance crowd. She started her own literary magazine, *The Little Review,* in 1914. In its fifteen years it was on the forefront of modern and avant-garde literature and art, American and European. Upton Sinclair canceled his subscription early on, claiming he couldn't understand a word in it. She started publishing work by her Chicago contemporaries and fanned out from there. As the third issue was being readied, "I heard Emma Goldman lecture and had just time to turn anarchist before the presses closed." Her pro-anarchist editorials lost her advertisers; in response, "I donated a page to every firm that should have advertised and didn't—a full page with a box in the centre, explaining why that particular concern should have recognized us." She and Goldman became friends. "Emma Goldman surprised me by being more human than she had seemed on the platform. When she lectured she was as serious as the deep Russian soul itself. In private she was gay, communicative, tender. Her English was the peculiar personal idiom favored by Russian Jews and she spoke only in platitudes—which I found fascinating." As the magazine reduced her to bohemian poverty, Anderson wrote bad checks at the grocer's—"But I didn't say it was good," she explained to the exasperated man—and once sent her printer, "in an elaborate envelope, all the money we had at the moment—five cents."

Jane Heap had fled Topeka for the Chicago Art Institute, where she had her first lesbian love affair and helped to start the Chicago Little Theater that so inspired Cook and Dell. She accentuated her stoutly masculine looks by wearing men's clothing. She and Anderson "formed a consolidation that was to make us much loved and even more loathed," Anderson writes. In 1917 they moved to New York, as all those other Chicago Renaissance figures had before them. After landing at the Brevoort they took a basement on West Fourteenth for their office and an apartment on West Sixteenth Street over an undertaker and an exterminator. After a few years they moved to West Eighth Street, above the Washington Square Book Shop.

Anderson reports being disappointed by the Village of 1917. Mabel Dodge's Evenings had ended; the Village's intellectual heyday seemed

over; the conversations at parties bored her. She met young Village new-comers who still spoke about politics and the revolution but to her it just sounded like they were parroting cant. She writes of "one young girl with gaunt eyes and the earnestness that would prevent anyone from achieving anything. She was writing stories about the miseries of miners and other tragedies of mankind in which she had never participated."

Anderson and Heap struggled to put the *Review* out monthly. "From this time (1917) until 1923 there was almost never a week when the morning coffee was assured," she writes. "As the *Little Review* became more articulate, more interesting, its subscription list became less impressive. It is much easier to find a public for ideals than for ideas." The magazine's New York contributor base expanded. Djuna Barnes got some of her work published in it. When Ezra Pound agreed to be the *Review's* "foreign editor" in 1917, the magazine stepped up to the leading edge of international literature, publishing contributions by Yeats, T. S. Eliot, Ford Madox Ford, and Wyndham Lewis. In October of that year it had its first brush with official censorship for publishing a chilly existentialist story by Lewis, "Cantelman's Spring-Mate." It was about an army officer who woos a country girl and abandons her pregnant. The U.S. Post Office found this obscene and seized and burned four thousand copies of the issue.

In 1918 Pound sent the *Review* a section from an unpublished novel he doubted it would publish because he was sure it would get the editors in trouble with the American censors again. Anderson loved it, and over the next three years *The Little Review* ran James Joyce's *Ulysses* in installments, its first appearance in print anywhere. Reactions were not positive. The critical establishment stood mute. Readers wrote furious letters complaining about the "filth." Four times over three years issues of the magazine were seized and destroyed. In 1921, in response to complaints from the New York Society for the Suppression of Vice, Anderson and Heap were brought to trial on obscenity charges over Leopold Bloom's erotic fantasies. The lawyer John Quinn agreed to represent them in court. Quinn was an enthusiast of avant-garde art and literature; he'd been involved in the Armory Show, was a friend and fan of Ezra Pound,

and had warned Anderson and Heap about publishing the potentially troublemaking sections of Ulysses. Villagers flocked to the courtroom to be amused by the stilted proceedings. The funniest moment came when the three judges refused to allow the defense to read the offending passage aloud, because there was a young lady present, that is, Anderson. "But she is the publisher," Quinn pointed out. "I'm sure she didn't know the significance of what she was publishing," a kindly judge replied. Not a single New York newspaper rose to the magazine's defense. The defendants were found guilty and fined a hundred dollars. Anderson later regretted not going to jail, which she felt might have been good publicity. She also rued that when Sylvia Beach published the first edition of Ulysses from her little bookshop in Paris the following year, the entire literary world acclaimed what it had ignored the three years it was appearing in the Review.

The Review also published several poems by one of the most strikingly odd characters in the Village, the Baroness Elsa von Freytag-Loringhoven. The Baroness's poems trampled the fine line between Dada and doggerel. The first one printed in the Review, dedicated to Marcel Duchamp, began:

> The sweet corners of thine tired mouth          Mustir
> So world-old  tired to nobility
> To more  to shame to hatred of thineself
> So noble soul  so weak a body
> Thine body is the prey of mice

Other poems freely mixed various languages real and invented, private puns, and raw sound. From a lament:

> Narin—Tzarissamanili
> (He is dead)
> Ildrich mitzdonja—astatootch
> Ninj—iffe kniek—
> Ninj—iffe kniek!

*Arr—karr—*
*Arrkarr—barr*

Readers were violently divided about them, some hailing the Baroness as an avant-garde genius, others begging the editors to stop printing her indecipherable gibberish.

For a few years the Baroness was a Village legend and fixture. Everyone wrote about her (she's Frau Mann, the Duchess of Broadback in Djuna Barnes's novel *Nightwood*), gossiped about her, drew and painted and photographed her. Since the 1990s feminist art scholars have been at some pains to renovate her reputation from that of a mere eccentric to a pioneering new woman and a neglected artist who played a pivotal role in the Dada movement. In her 2002 biography *Baroness Elsa*, Irene Gammel pieces together a portrait from numerous fragmentary sources. The Baroness married into the title. She was born Else Plötz in 1874 in a small German town. Her father was a master mason and an abusive drunk who drove her mother mad. As a teenager Elsa escaped to Berlin, a vibrant arts scene in the 1890s, where she studied art, cultivated androgynous fashions, posed in flesh-colored tights for racy vaudeville tableaux vivants, was a chorus girl, and threw herself into a whirlwind of sexual relations that left her with syphilis. Exploding on the avant-garde art and literary circles in Berlin and Munich as a model, mistress, and provocateur, she "exploited men financially, physically, and spiritually, and created a great deal of misfortune," an artist who knew her recalled. She and her second husband, the bisexual writer Felix Paul Greve, friend of Gide and H. G. Wells, lived and traveled on money given him by a former gay lover, who had Greve jailed for a year on fraud charges. On his release Greve's novels *Fanny Essler* and *The Master Mason's House*, both based on Elsa's life, were published. The former was a tell-all roman à clef about her sexual adventures among the aesthetes and literati ("very talentless and a bit mean," one of them sniffed), the latter a thinly veiled narrative of her earlier life. In 1909, to escape crushing debts, they faked his suicide and fled to America, ending up in rural Kentucky, where he abandoned her. He reemerged in Canada with a new identity, the novelist Frederick

Philip Grove, whose background wasn't uncovered until years after his death in 1948.

Elsa meanwhile made her way to New York City, where in 1913 she married the Baron Leo von Freytag-Loringhoven. She was thirty-nine, gave her age as twenty-eight on the marriage license, and concealed the fact that she was still married to Greve. Leo was twenty-eight, a former army officer and fallen scion of a noble Westphalian house. They honeymooned at the Ritz, then he returned to his job as a busboy. When the Great War broke out the following year he sailed for Europe to fight for the Fatherland, but his ship was taken by the French before it reached harbor and he sat out the war a prisoner. He never fired a shot until 1919, when he put a bullet through his brain.

When the Baroness moved to the Village her behavior became increasingly, often desperately, bizarre. Visitors to her tenement hovel on West Fourteenth Street described the filth and stench, with varying numbers of stray dogs and cats prowling among the clutter of objects she brought in from the streets to use in her sculptures and outfits. She also shoplifted art supplies from various department stores, resulting in several arrests. As her personal hygiene grew lax, "a reek stood out purple from her body," according to William Carlos Williams. Over time no soiree or Webster Hall frolic was complete without an appearance by the Baroness in one of her strange getups. When she first walked into the *Review*'s office she was wearing a bolero jacket, a kilt, spats, a multitude of dime store bracelets, two old tea balls hanging from her breasts, and a black tam-o'-shanter with ice cream spoons dangling from it. On that first visit the chronically impoverished Baroness stole five dollars in stamps. She later stole silverware from Jane Heap and raided the *Review*'s mail for subscription payments. For hats she wore peach baskets, wastepaper baskets, and, once, a wedding cake. She attended a costume ball at Webster Hall wearing parrot feather eyelashes and wouldn't leave the stage until she was awarded a prize. She carried small dogs and large sculpted penises as props. At a reception for the British opera diva Marguerite d'Alvarez, she "wore a trailing blue-green dress and a peacock fan," Anderson recalled. "One side of her face was decorated with a canceled postage stamp (two-

cent American, pink). Her lips were painted black, her face powder was yellow. She wore the top of a coal scuttle for a hat, strapped on under her chin like a helmet. Two mustard spoons at the side gave the effect of feathers." She greeted the famous coloratura with regal condescension. When d'Alvarez proclaimed that she sang "for humanity," the Baroness loudly scoffed, "I wouldn't lift a leg for humanity!"

Women on the scene tended to admire the Baroness's bold individuality and frank sexuality. The men tended to be traumatized by her feral advances. The artist George Biddle recorded that he fled from her in terror when she tried to kiss him, and the poet Wallace Stevens reputedly wouldn't venture below Fourteenth Street after she made a pass at him. Evidently only Williams, the hunky obstetrician and poet from New Jersey, was man enough to go toe to toe with her. He met her after she was released from the Jefferson Courthouse jail for shoplifting an umbrella. The Baroness conceived a ferocious desire for him, and when he demurred she stalked him in print, in New York, and in New Jersey, where she physically attacked him. On their next meeting, in Central Park, he punched her in the mouth, knocking her flat. Police hauled her away. Her heart broken, the Baroness shaved her head and lacquered it vermilion, then "stole the black crepe from the door of a house in mourning and made a dress of it," Anderson recalled.

JOE GOULD CAME TO THE VILLAGE IN THE LATE 1910S AND MATCHED the Baroness for ubiquity and eccentricity, like her providing Villagers with plenty of both amusement and annoyance. "Joe Gould was an odd and penniless and unemployable little man who came to the city in 1916 and ducked and dodged and held on as hard as he could for over forty-five years," The New Yorker's Joseph Mitchell writes in the opening of his famous profile "Joe Gould's Secret." Gould was a scion of the New England Goulds, a graduate of Harvard, but like so many who found their way to the Village he could not get by out there in the normal world. Years before Mitchell wrote about him he was a Village legend, a highly intelligent and impeccably educated bum who slept on park benches, cadged change in all the bars, appeared at all the parties to wolf down

the cocktails and canapés. At five-foot-four and a hundred pounds, with wildly frizzy hair (he looked rather like Larry Fine of the Three Stooges) and rumpled clothes, he was by turns elfin and silly or taciturn and imperious. He entertained Villagers for decades with a surprisingly small repertoire of parlor tricks, the two best known being his imitation of a seagull and his recitation of the couplet "In the winter I'm a Buddhist, / In the summer I'm a nudist." For a very long time he had the whole Village convinced he was a cracked genius in the rough, and that he was working on a gigantic tome, *An Oral History of Our Time*, written in scores of notebooks squirreled away in secret spots all over New York and New Jersey. Mitchell believed it when he wrote his first profile of him, "Professor Sea Gull," for *The New Yorker* in 1942. Gould's "secret," revealed by Mitchell after Gould's death in 1957, was that he was delusional, probably schizophrenic. The scant notebooks that turned up were filled with either endless repetitions of a few autobiographical anecdotes or mundane diary entries. Like the Baroness and some other Village fixtures over the years, Gould was the bohemian equivalent of a celebrity, famous for being infamous.

In 1918 twenty-one-year-old Dawn Powell arrived in Manhattan, another émigré from the small-town Midwest. She lived at first on the Upper West Side, cobbling together a small income writing for anybody who'd publish her. In those days, with the city's fifty daily newspapers in various languages, more than two hundred weeklies, and several hundred magazines, a writer who hustled and wasn't picky could get by. She would go on to write several plays and a few film scripts and more than a dozen novels, as well as keeping voluminous journals. She soon met and married another recent arrival, ad man Joseph Gousha (pronounced Goo-SHAY). They were never bohemians, but they lived just as unconventionally and often as impecuniously, and they never abandoned the Village the way some others did. They moved there in 1924 and were soon drinking and carrying on with Dell, Dreiser, Bodenheim, Cowley, and the rest. Joseph went too far with it and disappointed her by becoming, as she put it, a "crushed, hunted, half-defiant, half-cringing" drunk and depressive. They'd remain together through the rest of his life and most of hers, but

in a loose arrangement that allowed her many lovers and one best drink-
ing buddy, a bon vivant magazine editor named Coburn "Coby" Gilman,
who moved into their duplex at 35 East Ninth Street, a doorman building
across from the Lafayette Hotel, in the 1930s. This led to the impression
that they indulged in a ménage à trois—probably a misperception, accord-
ing to her biographer Tim Page, but not bad for her reputation among
Villagers.

For years Powell held court from a corner table at the Lafayette's café,
collecting the anecdotes, gossip, quips, and characters that went into the
series of witty New York novels she wrote from the 1930s on, including
*The Happy Island, The Wicked Pavilion,* and *The Golden Spur.* They weren't
always appreciated in their time, most sold poorly to moderately (al-
though *Pavilion* briefly made the best-seller list in 1954), and most were
out of print when she died in 1965. Starting in the late 1980s her friend
and fan Gore Vidal engineered a reappraisal, and the novels are back in
print, now enjoyed for Powell's unromantic, sometimes pitilessly satiri-
cal insights into her downtown milieu. Her characters might be bohemi-
ans or Babbitts, straight or gay, fresh newcomers or old hands. Some are
thinly veiled caricatures of actual people—Hemingway becomes a blow-
hardy author, Clare Boothe Luce a phony, Peggy Guggenheim a wealthy
art patron whose carefully doled out support "gave her a fine philan-
thropic reputation, dictator rights and the privileges of the artist's bed
and time." What marks them all as New Yorkers is the way every interac-
tion is some sort of transaction—for love or sex, for money or standing,
or just for a free drink or an invitation to a promising party. For all their
antic hijinks and drunken bonhomie they're often, as an unhappy *New
Yorker* reviewer once put it, "a pretty worthless and ornery lot of people,"
all loners and outsiders drawn to the Village like iron filings to a magnet,
misfits who seem incapable of dealing with the America outside their
little magic circle.

AFTER THE WAR, BETWEEN THE UPWARDLY CREEPING RENTS, THE
start of Prohibition, and the carnivalization of the Village, many artists
and writers, of both golden era and second wave, as well as many who

would have become Villagers earlier in the 1910s, headed not just uptown or up the Hudson but across the sea, to Paris. Some went for a few months or years, others stayed a decade or more, still others treated it as a kind of long-distance Provincetown, a place to spend their summers. What the Village had been to the 1910s, Paris was to the '20s, but on a grander scale. Parisians called the 1920s *les années folles*, the crazy years. Paris in the postwar years was hedonist and cosmopolitan and avant-garde and wide-open in ways even Greenwich Village couldn't match. It was an international free zone for sex in any flavor, liquor that didn't come from a gangster's bathtub, drugs of all kinds, and the leading edge of every art form. And given a marvelously favorable exchange rate of the postwar franc to the dollar, for Americans all the decadence and freedom came exceedingly cheap. Americans of small means—writers, painters, jazz musicians—could live like swells. You could rent a studio or romantic garret for three or four dollars a month. You could take your friends to dinner, party all night afterward, and not spend ten dollars. For wealthy, wild Americans, such as the seriously promiscuous Harry and Caresse Crosby, the lesbian Natalie Barney with her salons and backyard Sapphic temple, and the bisexual romantic Cole Porter, Paris in the 1920s was a moveable feast fit for kings. Berlin was just as wild and cheap during the same period—and more politically radical, more openly gay, and more intellectually bracing. It attracted its Audens and Isherwoods and Sally Bowleses. But Berlin was a bit too desperate and apocalyptic for most of the Lost Generation, who preferred the more genteel decadence of Paris.

Djuna Barnes left the Village for Paris in 1921. She held herself aloof and apart there too, never learning much French in almost a decade in the city and making friends only among other English-speakers: Gertrude Stein of course, and James Joyce, Mina Loy, Kay Boyle, Ezra Pound, T. S. Eliot, and Peggy Guggenheim. True to Powell's lampoon of her, Guggenheim was a Medici of modernism, surrounding herself with artists and writers to whom she doled out just enough favors and funding to keep them around, if grumbling. Barnes did plenty of the latter, exasperating her benefactress on numerous occasions. She wrote her first novel, *Ryder*, in Paris, the thinly veiled story of a supremely dysfunctional fam-

ily. It made the best-seller lists back home. She also created another il-
lustrated book about her lesbian friends, *The Ladies Almanack*, banned in
the United States. She met the love of her life, the sculptor Thelma Ellen
Wood, who eventually not only broke her heart but led her down a path
into alcoholism. Her novel *Nightwood*, on which her literary reputation
rests almost entirely now, revolves, in its highly elliptical way, around the
end of their affair. It was published in London in 1936 and in New York
the following year, and while many of the great writers of her time pro-
fessed to admire it, many also confessed to being confused by it. Barnes
remained in France and England until 1939. "By the late 1930s," her biog-
rapher Philip Herring writes, "Djuna Barnes was caught in a spiral down-
ward into alcoholism, self-deception, and continual illness . . . Soon she
would give up even the pretense of writing or painting or being sociable
and just drink alone in her room." She was prone to the usual drunkard's
list of illnesses, accidental injuries, and delusional outbursts. After Dju-
na's failed suicide attempt in 1939, Peggy Guggenheim in effect had her
kidnapped and thrown on a boat for New York, where friends and family
tossed her into a sanitarium for a drying-out cure that didn't stick. She
returned to the Village and would spend the bulk of the 1940s battling
alcohol, falling down, getting sick, writing little.

Edna St. Vincent Millay left for Paris in 1921 as well and spent a cou-
ple of years traveling around Europe, having more of her carefree affairs.
She returned to New York in 1923, in short order won a Pulitzer Prize for
poetry—the first woman to do so—and married the middle-aged Dutch
businessman and playboy Eugen Boissevain. They rented the miniature
town house at 75 1/2 Bedford Street, touted by every Village tour guide
as "the narrowest house in New York" at less than ten feet wide. They
weren't there much anyway. For their honeymoon they took an extended
trip around the world, after which they bought a farm upstate. They re-
mained together in an open marriage while he catered to her needs and
managed her career, which burned bright into the 1930s. (Djuna Barnes
once told Edmund Wilson a story in which Carl Van Vechten goes into a
bookstore in some provincial town and starts dropping the names of all
the famous authors he knows. When the dazzled bookman asks him who

he is, Van Vechten airily replies, "Oh, I am Edna St. Vincent Millay!") In the 1940s Vincent's health and her poetic voice slipped away. Eugen died in 1949 and she followed the next year.

Baroness Elsa also left New York bound for Paris in 1923. When she died in 1927, having left the gas on in her room as she went to sleep, it was not clear whether she'd intended suicide or was merely careless.

In 1923 Anderson and Heap joined the exodus. Anderson took a new lover and made Paris her home for years, while Heap returned to New York in 1925, where she continued to put out *The Little Review* more or less quarterly, publishing Gertrude Stein, some of Hemingway's first works, Gide, Cocteau, Picabia, Fernand Léger, Tristan Tzara. Heap made the magazine a New York outpost for European Dada, Mechanism, Futurism, and Constructivism and carried on the work begun at the Armory Show by organizing a Machine Age exhibition and "The International Theatre Exposition."

In 1929 Anderson and Heap decided to stop publishing the *Review*. "Our mission was accomplished; contemporary art had 'arrived'; for a hundred years, perhaps, the literary world would produce only: repetition," Anderson proclaimed. For the final issue they sent a questionnaire to contributors, asking, "What should you most like to do, to know, to be? (In case you are not satisfied.) Why wouldn't you change places with any other human being? What do you look forward to? What do you fear most from the future?" Many made conscientious efforts to reply. Djuna Barnes simply wrote:

> *Dear Little Review:*
> *I am sorry but the list of questions does not interest me to answer.*
> *Nor have I that respect for the public.*

While some Village expats to Europe, such as Anderson and Barnes, stayed away for many years, those like Heap—who filtered back in the early to mid-1920s, their Paris fling over—returned to a Village in its own *années folles:* the Roaring Twenties.

# PART II

## The Dry Decade,
## the Red Decade,
## World War II

# 11

## The Prohibition Years

IN 1929, WHEN THE MAYOR OF BERLIN VISITED NEW YORK CITY, he marveled at the skyscrapers, enjoyed tours around the various neighborhoods, then supposedly turned to Mayor Jimmy Walker and asked, "When does the Prohibition law go into effect?"

Prohibition had been in effect for almost a decade by then, but you couldn't blame the innocent visitor for not noticing. The nation's great urban and industrial centers had never enforced the law with anything resembling the hoped-for gusto. And no locale, not even Chicago, flouted Prohibition with quite the elbow-bending, nose-thumbing vivacity of New York City. Throughout the era, Americans and foreign visitors who wanted a drink in relative peace knew they could get one in New York. New Yorkers from top to bottom, from the mayor to the immigrant laborer, from its hoodlums to its largely Irish constabulary, were determined to ignore Prohibition, get around it, or profit from it in some way.

The legislatures in forty-six of the forty-eight states, including the state of New York, ratified the Eighteenth Amendment in 1919, to go into effect in January 1920. To give it legislative teeth, Congress passed the

Volstead Act. A federal Prohibition Unit, later renamed the Prohibition Bureau, was created to enforce the law. It was all the culmination of a temperance movement that went back to colonial times in its efforts to combat what were in fact ruinous levels of alcohol consumption in America. From the time of the first European settlers, America was, as a man remarked to Thomas Jefferson in the 1830s, "a nation of sots." The millions of German, Irish, and Italian immigrants who arrived in the nineteenth century added their own love of beer, whiskey, and wine. Temperance originally meant just that: modifying one's drinking. But by the 1840s it had come to mean total abstinence and prohibition. Among the drivers of the movement were the same aggrieved wives and mothers who steadfastly lobbied for women's suffrage. Susan B. Anthony, Elizabeth Cady Stanton, and Amelia Bloomer (whose name, yes, was applied to the women's garment) were all leaders in both movements. By the turn of the century temperance had also made strange bedfellows of rural conservatives and big-city reformers, Ivy League university presidents and tent revival preachers, steel barons and social workers, anti-immigrant groups in the northern cities and antiblack ones in the South, all brought together by the shared conviction that liquor was the source of the nation's worst social ills. Twenty-six states were already dry to varying degrees when Prohibition became law; part of the point of a national ban was to halt the flow of alcohol from wet states into those dry ones. There was so much smuggling on Highway 25 linking dry Toledo to wet Detroit, for instance, that it was known as the Avenue de Booze. While New Yorkers and residents of other large cities flouted the new law throughout the 1920s, drinking in fact declined sharply in the rest of the country during Prohibition. After Prohibition ended in 1933 Americans in general drank less than they had before. (Though in this too, as we'll see, Greenwich Village bucked the norm.)

In New York City, which had been a hard-drinking, hard-partying town since before it was New York City, anti-Prohibition sentiments ran high. Congressman Fiorello La Guardia, born in Greenwich Village, vehemently opposed the Volstead bill and predicted that Prohibition would do nothing to lessen Americans' drinking but much to promote criminal

activities and disregard for the law. The son of immigrants, La Guardia also pointed out, correctly, that Prohibition was in some large measure an anti-immigrant movement aimed at the saloons that were central to the social life of the urban working class. He was still against it in 1926, when he observed, "It is impossible to tell whether prohibition is a good thing or a bad thing. It has never been enforced in this country." In a city where twenty-three large breweries were steady employers, labor leaders threatened a general strike if beer was included in the new law. Governor Franklin D. Roosevelt believed in some government control of liquor but not an outright ban. After all, liquor taxes netted more than a quarter of New York's state budget.

Prohibition didn't go into full effect until January 1920 but a kind of practice lap, or dry run if you will, preceded it: starting on July 1, 1919, a Wartime Prohibition Act effectively barred the production and consumption of anything other than watery "war beer" that contained only about half the usual alcohol content. As the dreadful date loomed, New Yorkers went on a "liquor stampede." Liquor stores ran ads like "Protect Against the Dry Days." The night of June 30 was remembered as "New Year's Eve in June," as New Yorkers throughout the city crammed into every bar and saloon for a last night of full-bore whoopee. In the Village, the Brevoort opened its wine cellar at midnight and sold the contents at cost. Tipsy Villagers straggled across Washington Square cradling bottles in their arms. Some didn't make it all the way before falling into the fountain or flopping down on the benches and uncorking their booty right there. New Year's Eve proper six months later was said to be the wettest on record. Prohibition became law three weeks later.

All of New York City disobeyed the drinking ban but Greenwich Village, as one might expect, was one of the most openly defiant neighborhoods. On the very first day the Wartime Prohibition Act went into effect, the first person in the city, and possibly the country, to be arrested for disobeying it was Barney Gallant, co-owner (with Polly Holladay, formerly of Polly's) of the Greenwich Village Inn near Sheridan Square. A waiter had served a glass of sherry in full view of undercover lawmen and Gallant gallantly insisted on being the one punished. Like *The Masses* edi-

tors, he appeared before the lenient judge Learned Hand for sentencing. Judge Hand gave him ten days to get his affairs in order before serving a very brief sentence behind bars. Gallant returned from the hearing to a hero's welcome at the inn, where the liquor continued to flow. Twenty thousand New Yorkers signed a petition in his support, setting a New York tradition of insubordination that continued throughout the dry years.

Greenwich Village had always been a particularly wet neighborhood, with its more than fifty Irish corner saloons, its many Italian families who made their own wine, and its hard-drinking bohemians, wannabes, and tourists. Under Prohibition, the sociologist Ware wrote, "the principal industry of the Village . . . both in terms of the numbers of residents engaged in it and the income brought from it, was some form or other of bootlegging." Villagers turned to brewing, fermenting, and distilling their own liquor. Moonshine and moonshiners had been around forever, but Prohibition boosted the backwoods pastime into a national industry. Data suggest that the number of illegal stills around the country increased an astonishing thousandfold in the first six months of 1920. The market for both large, industrial stills and small home models boomed. A large still could make a hundred gallons of alcohol a day, produced at a cost of fifty cents a gallon and sold on the instantly bustling black market for three or four dollars. New York newspapers ran ads for one-gallon home stills and hardware stores in Greenwich Village displayed them in their windows. The shelves of any public library held books and even helpful government pamphlets on how to use them.

Early in 1920 the New York City administrator of the Prohibition Unit issued a call for all residents who owned stills to surrender them to his office, and when not a single citizen of the great metropolis complied he sent out his force of fewer than two hundred agents in a doomed search-and-seizure effort. Of course, as every backwoods moonshiner knows, stills sometimes blow up, making them dangerous appliances to have cooking away in apartments all over New York. Periodically through the 1920s a still explosion would make the news, including one in a West Eleventh Street kitchen that killed the owner's infant son.

In the Italian Village, people had always made wine for home use. Now they amped it up into a thriving cottage industry. "In the fall of the year, truckloads of grapes might be seen being unloaded in front of tenements or stores, the remains of mash purpled the gutters, and women grocery-store keepers apologized for the condition of their hands as they weighed their vegetables," Ware reported. Every Italian-owned business in the neighborhood—grocer, bootblack, cigar store, or barbershop—sold wine. Any New Yorker who wanted vino with dinner knew to shop in the Village.

As Prohibition shut down roughly four out of five of the city's fifteen thousand licensed taverns and saloons (the remaining few stayed open serving nonalcoholic fare), more than thirty thousand speakeasies took their place. Already a nightlife destination before Prohibition, Greenwich Village filled up with them. Toffs, tourists, and celebrities who could afford watery champagne at a hundred dollars a bottle patronized midtown clubs in and around Times Square, but the average citizen or college boy out for a ramble on a more limited budget headed to the less pricey Village. John Sloan commented that where there'd been a saloon on every corner of the Village in the 1910s, now there were ten speakeasies on every block. Many were dark hole-in-the-wall dives run by the neighborhood's Italian and Irish street gangs, who were taking their first steps to becoming full-fledged mafiosi. These tended to be like the classic speakeasy of lore, "stowed away with utmost secrecy," Ware writes, "and entered only with knock and password by those who were known." What they sold as gin, scotch, or bourbon was often just industrial or grain alcohol flavored and colored to a loose but potent approximation of the real thing. Patrons who drank too much of the swill were often poured into a waiting taxi at the end of the night, driven over to the dark waterfront, and rolled for their remaining cash. Poisoning from bad alcohol could be deadly; by the end of the decade more than six hundred New Yorkers a year were dying from it.

Classier speakeasies were more like cabarets or nightclubs, featuring a wide variety of entertainments along with the bad liquor. Some were so far from secret that they were world famous, their addresses listed in

every tourist guide, and the only people the lug behind the door refused to admit were those he had very good reason to suspect were law enforcers. Sheridan Square was thick with this type of speakeasy geared for the tourist trade, early examples of the theme bar. At the Pirate's Den a doorman dressed like a buccaneer let tourists in. Staff costumed as sea dogs staged mock battles with cutlasses in a warren hung with rigging and clanking chains, all dimly lit with ship's lanterns. Nearby were the zany Nut Club, something like a forerunner to today's comedy clubs; the Indian-themed Wigwam; and the Village Barn, a basement on West Eighth Street featuring square dances, hoedowns, and live turtle races. The Barn would long outlive Prohibition as a legitimate, if hokey, club.

In 1925 the perpetually broke and peripatetic Henry and June Miller moved to Greenwich Village to try running a speakeasy. It was in a tiny basement apartment they rented in the brick house at 106 Perry Street, where Henry had to make himself scarce when June brought her wealthy admirers over. June, the bisexual wild child, had been a taxi dancer when they met in 1923. It was at her prompting that he quit his job at the "Cosmodemonic Telegraph Company"—Western Union—to try to make it as a writer. In their time together they lived in, and were often thrown out of, numerous apartments in Brooklyn, Manhattan, and the Bronx. The speakeasy-and-sugar-daddies arrangement on Perry Street was one of their many failed moneymaking schemes. In *Plexus* Miller writes, "To run a speakeasy . . . and to live in it at the same time, is one of those fantastic ideas which can only arise in the minds of thoroughly impractical individuals." The apartment was two small rooms and a kitchen. One room held a pool table, with windows always shut and heavily curtained against law enforcement's prying eyes. By morning, when they tried to get to sleep, the stench of stale beer, spilled wine, and tobacco smoke was awful. "No doubt about it, if the enterprise proves a success we'll have tuberculosis." It wasn't a success. They thrived briefly at first, mostly because June's well-heeled admirers were customers. But they soon drifted off and within a few months the clientele was mostly Henry's impoverished bohemian pals. "On the kitchen wall is a long list of names," he records in *Plexus*. "Beside the names is chalked up the sums owed us by

our friends, our only steady customers." By 1926 they'd been evicted, the end of their brief Village fling. In 1930, deep in debt and driven crazy by June's affairs with men and women, Henry would leave for Paris. June would follow, and the two of them and Anaïs Nin would soon have their triangle. Henry and June separated in 1932 and divorced in 1934.

Leland Stanford Chumley opened one of the best-known and longest-lived Village speakeasies at the quiet, leafy corner of Barrow and Bedford Streets. Chumley came from Chicago with all the right bohemian credentials for the time. He'd been a stagecoach driver, a newspaperman, an artist, a hobo, and was now a Wobbly organizer. The building he bought had been a blacksmith shop and a dairy, and in converting it to the bar restaurant Chumley's he retained a comfortably rustic and woody atmosphere. He left the two entrances locked and unmarked—the back door at 86 Bedford Street and the front door, with a peephole, in Pamela Court off Barrow. (According to a disputable legend, the term "86'ed," meaning a quick exit or ejection, was coined at Chumley's. Patrons needing to beat a hasty retreat—for instance, Wobblies ducking a raid—or unruly guests being too noisy for the courtyard exit would "86 it" out the back door at 86 Bedford.) Wobblies held meetings and printed subversive literature upstairs, while Edna St. Vincent Millay read her poetry downstairs. Chumley's survived Prohibition as a legitimate establishment without ever putting a sign outside, although its location was perhaps the most open secret in the city. Over the years it acquired a reputation as a literary hangout; the long list of names associated with it besides Vincent's includes Dreiser, Cather, Cummings, Hemingway, Dos Passos, Bodenheim, Mailer, Maugham, Salinger, Ginsberg, Burroughs. Toward the end of the century, like the Village around it, Chumley's became a young professionals' meeting place trading on boho nostalgia.

Another Villager became maybe the most celebrated of all speakeasy proprietors. When twenty-three-year-old Mary Louise Cecilia Guinan, better known as Texas, came to Manhattan in 1907, she headed straight for the Village, where self-created larger-than-life characters like her belonged. Her first residence was a two-dollar-a-week room at 72 Washington Square South, but when she became rich and successful she moved to

a duplex at 17 West Eighth Street, filling it with antiques and bric-a-brac and bringing her parents to come live with her there. Brassy, ballsy, wise-cracking, and fun loving, Texas Guinan from 1922 on was the mistress of ceremonies at several Times Square clubs, where she was as much a draw as the chorus girls who kick-lined behind her.

Restaurants and legitimate clubs in the Village that did not serve liquor did provide ice and ginger ale "setups," and patrons were free to bring their own liquor in. Max Gordon, later the founder of the Village Vanguard, ran a dry club called the Village Fair on Sullivan Street; if a patron's personal bottle ran out while he was in the club, "There was always a guy in a doorway hanging outside Village joints who could get you one." You placed your order with this shadowy figure and went back inside. Your waitress informed you when he was back and you stepped outside to complete the deal. "The legal niceties were thus observed. The sale was made outside the premises and the joint was in the clear."

A number of tearooms and speakeasies in the Village catered to gay or lesbian clientele—the Black Rabbit, the Flower Pot, the Jungle, the Bungalow, Trilby's, the Red Mask. Paul and Joe's, on Sixth Avenue and West Ninth Street, was originally a tough dive bar trolled by prostitutes, but in the 1920s it evolved into a popular gay destination featuring drag and "pansy" acts. Eve's Hangout, a basement tearoom on MacDougal Street, was famous for the sign at the entrance MEN ARE ADMITTED BUT NOT WEL-COME. Attitudes among the straight bohemians ranged from tolerance to mild disapproval to outright hostility, a reaction shared by most of the rest of the neighborhood. Henry Miller, no slouch himself when it came to sex, writes in *Plexus*, "The Village had indeed deteriorated. There were nothing but dives and joints, nothing but pederasts, Lesbians, pimps, tarts, fakes and phonies of all description." He describes how Paul and Joe's had become "entirely dominated by homos in sailors' uniforms . . . Coming away from the place we had stumbled over two 'sailors' writhing on the floor of the balcony, their pants down and grunting like squealing stuck pigs. Even for Greenwich Village that was going pretty far, it seemed to me."

The disappearance of the old saloons and the birth of the speakeasy

had lasting effects on New York nightlife. It ended the era of men-only drinking establishments. Separate rooms and entrances for the ladies were too much trouble for speakeasy owners, and the coed carousing pioneered in the Village became the norm everywhere. In fact, Prohibition had a generally leveling effect on New York culture. New Yorkers of all strata found themselves thrown together in the speakeasies and clubs, all rebels, all drunk, everyone smoking, everyone flirting, rubbing elbows and other parts with people they never would have met otherwise, dancing wicked dances like the Black Bottom and the Charleston to the wailing Negro jazz band. Before Prohibition, men went to their local saloon or tavern after work and drank nickel beers and ten-cent whiskeys, smoked cigars, talked the news of the day, and went home to their families. Prohibition made drinking sophisticated, cosmopolitan, and "smart." Barkeeps transformed into mixologists inventing ever more exotic cocktails. Prices skyrocketed, but Wall Street was churning out paper millionaires anyway, and everyone was out every night spending it, whooping it up. Behavior one saw only in Greenwich Village in the 1910s spread throughout the whole city in the Roaring Twenties. Newspaper and magazine columnists cheered the democratizing effects of the new cabaret and nightclub culture, where, as one put it, "Woolworth money is quite as good as Cartier's." Of course, a great collective hangover was waiting at the end of the decade but nobody seems to have foreseen it.

THE FEDERAL PROHIBITION UNIT MANDATED WITH STOPPING ALL the illicit drinking in the nation of sots was chronically underfunded and understaffed. The agency fielded a mere fifteen hundred agents expected to watch the nation's vast borders, police its roads, find and shut down an expanding universe of illicit distilleries and breweries, go undercover into its thousands of speakeasies and clubs, and spy on the daily consumption habits of its one hundred and six million citizens. Many agents' hearts weren't in it from the beginning and corruption was rife throughout the unit's existence. An agent made under two thousand dollars a year in salary; he could make five hundred a day from his local bootlegger just for looking the other way when a shipment went out. In

New York City, the hiring of federal agents was just another Tammany patronage trough, and half the federal agents in the city had to be let go under accusations of bribery and extortion. Meanwhile, the police who were supposed to assist the feds were often on the take as well. In one instance, cops swooped down on federal agents who were preparing to bust a bootlegger's warehouse and arrested the agents as "suspicious characters," giving the bootlegger time to clear the place out. At the end of the workday many cops went off to throw around some of their ill-gotten gains at their own speakeasies of choice, including the one connected to Police Headquarters via a tunnel under Centre Market Place, where they bent elbows with judges, district attorneys, and other slack upholders of the new law. By the start of 1925 New York had bowed to the obvious and removed the police from Prohibition enforcement, leaving just the badly outgunned and graft-riddled feds.

Encouraged by the lazy enforcement, New York's Italian, Irish, and Jewish street gangs took to bootlegging, rum-running, and opening speakeasies with abandon. They became, in effect, an entire underground liquor industry. They imported enormous quantities of labeled alcohol from England and Canada (which encouraged, and happily taxed, its boom market for distilleries). Much contraband whoopee entered the city of New York through the Irish-run waterfront of Greenwich Village, Chelsea, and Hell's Kitchen. Gangsters built their own breweries and distilleries, ran their own trucking and shipping industries, figured out how to launder the cash and evade taxes, opened their own speakeasies, fought off competitors, and paid off everyone they had to. It was all a great learning opportunity for the neighborhood gangs, who grew into the organized crime syndicates that flourished in the 1930s and beyond.

In 1925, as though to flag their contempt for Prohibition, New Yorkers elected an Irishman from the Village to be their mayor. Central casting could not have sent them a better figurehead for the Roaring Twenties and the Prohibition years than the hard-partying, hardly working, and breezily corrupt Jimmy Walker, aka Beau James, the Night Mayor.

His father, William Walker, came from Kilkenny in 1857 and settled in the Ninth Ward, starting a lumberyard, marrying a neighborhood

saloonkeeper's daughter, and siring four children. James, the third son, was born in the family's apartment on Leroy Street in 1881. A few years later, the family moved to the handsome town house at 6 St. Luke's Place, where Jimmy would live for forty years. (Today it looks across the street at James J. Walker Park.) As a prosperous Irishman William Walker came to the attention of Tammany Hall in 1886. At the time, Tammany, the Democratic Party machine, ran virtually every politician, every department, judge, district attorney, and civil servant at all levels of city government. Despite its reputation, Tammany was not completely corrupt, and its effects on the city and state not always deleterious. (Al Smith, though a Tammany man, was a progressive reformer with the common touch and one of New York's most popular governors.) And though Tammany's leadership was generally quite crooked and self-serving, some relatively honest men served down at the level of the ward boss or ward heeler, "often a saloonkeeper who functioned as the local provider of patronage, dispenser of cheer and charity, and vote gatherer." One of their chief functions was to act as greeters of new immigrants in their neighborhoods, helping them fill out citizenship forms and peddlers' licenses, finding them jobs, negotiating with their landlords. In return, naturally, the grateful new citizens voted solidly Democrat. The ward heeler's job on Election Day was simply to see that Tammany's man won, by any means necessary.

Over the decades many a ballot box was stuffed, many Republican ballots were destroyed or lost down a coal chute, and many a dead Democrat was resurrected to do his duty at the poll one more time—or two or three, as needed. In the Irish Village, the building at 47 1/2 Morton Street was known as Little Tammany Hall, "because the voting rolls for the tenement listed far more registered Democrats than the number of people who lived there." With Tammany's support, William Walker served four times as alderman, once as state assemblyman, and finally as Manhattan's superintendent of public buildings, where he sponsored the city's first recreation piers.

Jimmy grew up affable, popular, bright but lazy, nicknamed Jimmy Talker in grade school. He attended New York Law School because his

father wanted it, but what Jimmy wanted was showbiz. He wrote his first hit song in 1905, the sweetly romantic "Will You Love Me in December As You Do in May?" (Later cited by Kerouac in *The Town and the City*.) He spent the windfall on spiffy new outfits, cranked out several more songs over the next few years, became friends with George M. Cohan and Ira Gershwin, and met his wife, the chorus girl Janet Allen. But though he loved show business the rest of his life and it loved him back, he obeyed his father and went into politics. In the state assembly he came under Al Smith's wing, and in 1925 Tammany made sure he was elected mayor.

He soon earned his reputation as the most lackadaisical mayor in the city's history. Instantly bored with his administration duties, habitually late for meetings, he let the Tammany hacks run things while he took off on lengthy and frequent vacations, almost 150 days in his first two years. When critics complained about a raise in his official salary to forty thousand dollars a year he quipped, "That's cheap! Think what it would cost if I worked full time." He happily assumed a purely ceremonial role, cutting ribbons, attending dinners, leading parades, handing the keys to the city to almost anyone who dropped by. He took up with a new chorus girl, Betty Compton, and installed her in the top-floor apartment at 146 West Fourth Street, above the Pepper Pot. Janet sat at home while Jimmy and Betty partied all over town. Eventually Betty forced him to choose between them; he left Janet and moved with Betty into a suite in a midtown hotel.

While Jimmy partied and traveled, Tammany ran the city into the ground. Just about everything a municipal government is supposed to be responsible for fell into neglect and rot—health, housing, education, sanitation, police, fire, roads, public transportation, the waterfront, the water itself. The city's payroll was outrageously bloated with patronage jobs handed out to Tammany hacks and nitwit nephews who were exempted from taking the civil service exam. A survey of one hundred lifeguards at city beaches in the early 1930s, for example, found that fourteen couldn't swim; another eighteen didn't even show up for the test. Mothers routinely warned their children to stay away from the beaches' first-aid stations, because that was where the prostitutes who'd come to service

the lifeguards hung around. As the gangsters who ran all aspects of the city's multimillion-dollar liquor industry warred among themselves in the later 1920s, the city became more violent and dangerous, murder rates climbed, and innocent victims, including children, died in the crossfire. Despite the occasional tough-talking police commissioner or district attorney, law enforcement in the city was simply too riddled with corruption to make a dent.

Through it all Jimmy sailed blithely on. One place you could always find him was at the Broadway musical revues, such as Ziegfeld's Follies, followed by a duck into one of the better speakeasies or nightclubs. Mayor Walker was as fond of speakeasies and nightclubs as anyone in the city. When the feds periodically leaned on him to make a better show of enforcing the law, his response was at best halfhearted. Pressed by the Prohibition Unit, his police commissioner once proposed a 2 a.m. closing time for nightclubs, which stayed open until 4 a.m. or later. New York was the city that never sleeps decades before Sinatra sang about it. During World War I a previous mayor had enforced a 2 a.m. curfew so young men wouldn't be too pooped if called upon to defend the city from the Hun, but as soon as the war ended the all-night whoopee started up again. Now club and cabaret owners, many of them personal friends of the mayor, howled. Mayor Walker offered a Solomonic compromise: a 3 a.m. closing time. Undercover federal agents tasked with infiltrating and observing the nightclubs became some of their best patrons. Buying champagne, cocktails, and orchids for their dates in their assiduous efforts to blend in with the crowd, they ran up a federal bar tab of seventy-five thousand bucks in 1928 alone, with no convictions to show for it. Mayor Walker cracked that it seemed a high price to pay "to learn facts which are known to virtually everyone."

Jimmy was a great fan of another Irish Villager who became a celebrity, controversial in his own way, in the 1920s: Gene Tunney, heavyweight boxing champion of the world. Born James Joseph in 1897 ("Gene" was a nickname that came from a younger brother's mispronunciation of Jim), he grew up in a cold-water flat above a general store at the corner of Perry and Washington Streets, one of seven kids born to a two-fisted

longshoreman who drank at Luke O'Connor's, one of the bars O'Neill and the bohemians colonized in the 1910s. Gene was quiet, polite, and bookish, considered "something of a prig" by other boys in the neighborhood, "almost a stereotype of the perfect altar boy. He didn't drink or smoke, and he regarded swearing as crude and sacrilegious." He took up boxing to defend himself from his brawling father and from bullies who thought him a sissy because he loved to read. Thoughtful and defensive in the ring as well, he was an undefeated amateur when he turned pro at eighteen, then enlisted in the marines during World War I. In 1926, at the age of twenty-nine, "The Fighting Marine" was 79–1 and ready to go up against "The Manassas Mauler," Jack Dempsey.

Tunney's celebrity stemmed from his still being a voracious reader of history, science, poetry, literature, and plays (he joined the Shakespeare Society and memorized *Hamlet*). He liked art and opera and used words of more than one syllable. He called boxing "the art of thinking as expressed in action" and said things like "I think of pugilism as a fencing bout of gloved fists, rather than an act of assault and battery." The newshounds and their readers, used to prizefighters being grunting pugs and lugs like Dempsey, couldn't decide if "The Boxing Savant" and "The Bard of Biff" was a pretentious freak, a joke, or a publicity stunt. Then, in Philadelphia's Sesquicentennial Stadium, before a crowd of a 145,000 that included his proud homeboy Jimmy Walker (and Astors and Vanderbilts and Charlie Chaplin and Tom Mix), plus a radio audience of fifteen million, he scientifically picked Dempsey apart for the championship. Dempsey, who'd been the five-to-one favorite, told his incredulous wife, "Honey, I just forgot to duck." Mayor Walker led a parade to welcome Tunney home, but Dempsey remained the fans' favorite. They fought again the following year in the still-discussed "Long Count" bout, when Dempsey, after knocking Tunney to the canvas for the first time in his career, took a long while getting to a neutral corner, delaying the ten-count and giving Tunney precious extra seconds to recover. Tunney got up . . . and won. He went on to enjoy a very successful post-ring career, marrying a socialite, lecturing on Shakespeare at Yale, sparring with Heming-

way, and becoming friends with his literary hero George Bernard Shaw, a fight fan.

WITH THE STOCK MARKET CRASH IN 1929 AND THE ONRUSHING Depression the party ended. Walker, the perfect man for leading the conga line in high times, proved perfectly incapable of dealing with the bread lines in hard times. Reformers and Republicans pounced. As new investigations and hearings made painfully clear what everyone had always known anyway—that Mayor Jimmy had presided over and handsomely profited from a Tammany-run government riddled with corruption—Governor Franklin Roosevelt convinced him to resign in September 1932. He finally married Betty and returned to his first love, music, heading up Majestic Records, which put out discs by Louis Prima and others in the 1940s. He died in 1946.

As one of his final acts in office Jimmy Walker left one last, dubious legacy to the Village, breaking ground in 1932 on the New York City House of Detention for Women, built on the site of the old Jefferson Market jail and colloquially known as the House of D. Like Newgate Prison back in the 1790s it was intended as a model of prison reform. Opened in 1934, the twelve-story monolith of brownish brick with art deco flourishes loomed behind the old Jefferson Market Courthouse on Sixth Avenue, looking more like a stylish, if somewhat cheerless, apartment building than a prison. Windows were meshed instead of barred, and the one sign on its exterior merely gave the address, NUMBER TEN GREENWICH AVENUE. There were toilets and hot and cold running water in all four hundred cells and, like Newgate, it was going to focus on rehabilitating its inmates—prostitutes, vagrants, alcoholics, and/or drug addicts—rather than merely punishing them.

From the start the reality was at variance with the intentions and the facility quickly became infamous as a combination of Bedlam and Bastille. Within a decade it was chronically overcrowded with a volatile mix of inmates: women who couldn't make bail awaiting trials that were sometimes months off, women already convicted and serving time, alco-

holics and addicts, the mentally ill, street gang girls, hookers and other lifelong multiple offenders, and teenagers spending their first nights behind bars. Tougher, more experienced prisoners brutalized and sexually assaulted the weak and inexperienced. So, of course, did the staff. The halls rang with the howls of inmates suffering the agonies of drug or alcohol withdrawal. There were cockroaches and mice in the cells and worms in the food. Village lesbians called it the Country Club and the Snake Pit. Elizabeth Gurley Flynn did time in the House of D, as did Ethel Rosenberg and Warhol shooter Valerie Solanas. In 1957 Dorothy Day spent thirty days there for staying on the street during a civil defense air-raid drill. Her ban-the-bomb supporters picketed outside every day from noon to two; the *Times* called them "possibly the most peaceful pickets in the city."

Despite its bland exterior the House of D made its presence very known in the neighborhood through the daily ritual of inmates yelling out the meshed windows or down from the exercise area on the roof to the boyfriends, girlfriends, dealers, and pimps perpetually loitering on the Greenwich Avenue sidewalk—a Village tradition for almost forty years. The filmmaker John Waters first caught the spectacle in the early 1960s. "It was amazing. No one can ever imagine what that was like. All the hookers would be screaming out the windows, 'Hey Jimbo!' And all the pimps would be down on the sidewalk yelling stuff." Jeremiah Newton, who would later produce a film about his friend Candy Darling, initially encountered the House of D at around the same time. "It was this huge, monolithic building, looking like the building the Morlocks dragged the Time Machine into, and the girls were always yelling down, screaming obscenities and throwing things out the window. It was the biggest building there. I sat on a stoop watching the people walk by. I'd never seen anything quite like it before." The Village writer Grace Paley lived near the facility in the 1950s and '60s and walked her kids past it regularly. She wrote that "we would often have to thread our way through whole families calling up—bellowing, screaming up to the third, seventh, tenth floor, to figures, shadows behind bars and screened windows, How

you feeling? Here's Glena. She got big. Mami mami, you like my dress? We gettin' you out baby. New lawyer come by."

All the while, the wonderful old Jefferson Market Courthouse itself soldiered on in the shadows. It was built in the 1870s and modeled on Ludwig II of Bavaria's fairy-tale castle Neuschwanstein. By the end of World War II it had ceased to be a courthouse and was temporary home to various city agencies before becoming a branch of the New York Public Library.

# The Coney Island of the Soul

AS THE 1920S ROARED ON, VILLAGERS CONSTANTLY COMPLAINED
of being overrun by barbarian hordes of outsiders who'd come
for nothing but a drunken debauch. "A den of iniquity, a sink of
perversion. In other words, the place to go," the bank robber Willie
Sutton calls it in his second ghostwritten memoir, Where the Money
Was. Among his many escapades, Sutton claims he was once taken
to a party on MacDougal Street where the hostess opened the door
topless, he saw a woman he knew performing oral sex on a man, na-
ked women danced together, and "before long I was corralled by a
lady poet who was down to her panties," which she soon stripped off
while reciting Ezra Pound.

Best representing that image of the Roaring Twenties Village was a
writer at least as well known for his drunk and dissolute behavior as for
his writing. Maxwell Bodenheim grew up poor and Jewish in small-town
Mississippi. He was bright but viciously boorish, physically handsome
yet repulsively slovenly, and argumentative to a fault, with a genius for
the insult that could end any argument, usually with his being punched

in the mouth. He desired more than anything to be taken seriously as a poet, and was for a while, yet he was best known as a writer of sleazy novels, an outrageous pain in the ass, and eventually a scary, shambling drunk. His friend Ben Hecht, in *Letters from Bohemia*, remembered him as "more disliked, derided, denounced, beaten up, and kicked down more flights of stairs than any poet of whom I have heard or read."

As young men he and Hecht were the pranksters of the Chicago Renaissance. According to Allen Churchill, they once filled a hall for a literary debate on the topic "Resolved: That People Who Attend Literary Debates Are Imbeciles."

> Hecht strode center-stage to announce that he would take the affirmative. Then he stated, "The affirmative rests." Bodenheim shambled forward, scrutinized his confident opponent, and said, "You win."

Bodenheim—Bogie to his long-suffering friends—was twenty-two when he blew into the Village with other Chicago émigrés in 1915 and instantly made a name for himself as a poet of great promise. Reading his facile, gaudy verses now, it's easy to think that it was the brute force of his sociopathic presence, rather than the poetry, that convinced the best poets in the Village at the time that he was one of them, potentially even the best of them.

> *You have a morning-glory face*
> *Whose edges are sensitive to light*
> *And curl in beneath the burden of a smile.*
> *Remembered silence returns to the morning-glory*
> *And lattices its curves*
> *With shades of golden reverberations.*
> *Then the morning-glory's heart careens to loves*
> *Whose scent beats on the sky-walls of your soul.*

Tellingly, those not directly in his orbit seem not to have been fooled by the clever romance-novel sham of such verses; neither, apparently, was Bodenheim himself, though he would go on roaring about his genius for decades. Hecht records that after entering 223 poetry contests and failing to win a single one, he took to signing his letters to editors "Maxwell Bodenheim, 224th ranking U.S.A. poet."

Bodenheim had a real talent for scandal, easy enough to generate during Greenwich Village's prolonged drunken orgy in the Prohibition years. His haughty, insulting demeanor and his habit of trying to steal other men's women right under their noses got him regularly socked on the jaw and thrown out of bars, soirees, and Webster Hall. Through the 1920s he wrote a string of best-selling, sensational potboilers: *Replenishing Jessica*, about a free-loving bohemian; *Georgie May*, about a fallen prostitute; and *Naked on Roller Skates*, about a middle-aged "onetime hobo, circus-pegger, doughboy, sailor, anarchist, con man, all-time sensationalist and wanderer of the world" who leaves a small town with a much younger woman who "wanted to try everything at least once." Hecht called them "hack work with flashes of tenderness, wit, and truth in them." When the Society for the Suppression of Vice brought Bodenheim to trial in 1925 on an obscenity charge for *Replenishing Jessica*, his defense lawyer used a by then familiar tactic of demanding that the prosecutor read the entire text aloud to prove his case. Judge, jury, and the reporters covering the trial dozed as the prosecutor droned on and on, and the unaroused jury voted Bodenheim not guilty. Jimmy Walker agreed with the verdict. "No girl was ever seduced by a book," he quipped.

For a bohemian poet, celebrity and commercial success could bring on a full-blown personality crisis (as it would to Jackson Pollock and Jack Kerouac). Bodenheim squandered the money he made from his novels on drink and gambling as though he couldn't throw it away fast enough. That way he could go back to demanding loans and cadging drinks from everyone around him, like a bohemian poet should. Meanwhile, his reputation in these years as a daring, risqué writer attracted a cloud of what we'd call groupies today, many of them the sort of teenagers from

the outer boroughs and the hinterlands who flocked to the Village in the 1920s to throw off the shackles of mainstream morality and abandon themselves to the neighborhood's nonstop pagan revels. He took his pick. One was Gladys Loeb, eighteen, from the Bronx. In 1928 he ended a brief fling with her, adding that her poetry was doggerel. Her landlady soon found her with her head in the gas oven, barely clinging to life, and to Bodenheim's portrait. A few weeks later he did the same thing to twenty-two-year-old Virginia Drew, who threw herself into the Hudson and succeeded where Gladys had failed. When police went to question Bodenheim about Drew's suicide, he'd slipped off to stay with Harry Kemp in Provincetown. Gladys, having recovered from her own suicide attempt, followed him there, trailing her irate father, cops, and reporters. Bodenheim talked his way out of their clutches but not out of the newspapers all over the country, which had a field day with lurid tales about the Greenwich Village Lothario.

Another of his conquests was Aimee Cortez, widely feted as "the Mayoress of Greenwich Village." She earned the title by stripping naked at private parties and Webster Hall shindigs and gyrating a wildly erotic dance. According to Churchill, this display sometimes ended with her going off with some lucky male, but other times she'd stop abruptly, with a look of terror and confusion, and run off. In a later era she'd be prescribed a drug for this clearly disturbed behavior, but in the Village of the late 1920s, where "a hideous lust . . . pervaded the air," as Bodenheim's *My Life and Loves in Greenwich Village* put it, she was merely celebrated as a queen of modern-day bacchantes. Not long after Gladys and Virginia made the papers, Aimee was found with her head in her own oven, also clutching Bodenheim's portrait. She was dead at nineteen.

Bodenheim was implicated in the sad end of another lover, a teenager from the outer boroughs with the improbable name Dorothy Dear. When she wasn't with him in his MacDougal Street apartment, he wrote her love letters that she carried in her purse. One afternoon she was aboard a rush-hour subway train heading from Times Square to the Village when it derailed at a faulty switch, killing sixteen passengers, including Dorothy. Bodenheim's love letters were found scattered around the wreckage.

By the end of the 1920s Bodenheim was a wreck himself. From the 1930s until his death in 1954 he was a fixture on the streets and in the bars of the Village, by turns annoying and sad making, decaying before his old friends' eyes into a stinking, toothless ghost, "tottering drunkenly to sleep on flophouse floors, shabby and gaunt as any Bowery bum," as Hecht put it. Still, Hecht gallantly added, "Bogie hugged his undiminished riches—his poet's vocabulary and his genius for winning arguments. He won nothing else." He cranked out more cheap novels, drank the money, and stooped to hawking his poems to tourists in Washington Square for a quarter each. Wiseacres in the bars fed him gin and laughed at his drunken mumblings and rants, which sometimes yielded a famous line, such as "Greenwich Village is the Coney Island of the soul."

Despite the frightening deterioration of his physical and mental state, not to mention his hygiene, Bodenheim still attracted a certain type of desperate woman, usually in decline herself. He met the last of them in 1951 when Ruth Fagan bought a poem from him with her last quarter. She was thirty-two, he was a fifty-nine-year-old derelict, and within a couple of weeks they were going around as Mr. and Mrs. Bodenheim, though it's not clear they ever bothered to make it official. Villagers said only a crazy woman would have taken up with him, and they may have been right. At fourteen "she had set fire to her parents' home in Detroit, had suffered several nervous breakdowns, and had been confined for several weeks to a mental institution in Brooklyn." They decayed together for the next couple of years, chronically broke and drunk, descending from cheap rooming houses to flophouses to sleeping in hallways and doorways. She turned tricks when she could, and he beat her when he found out. In 1952 they made a horrific spectacle of themselves at a fancy reunion for surviving members of the original Chicago Renaissance group, where he panhandled the guests while she propositioned them.

If the Bodenheim of the early 1950s was a frightening or amusing clown to the tourists, and an embarrassment and bother to his old friends, he was something of a martyred saint to the generation of bohemians who came to the Village following World War II. In his headlong descent into the abyss, his lust for the extremes of degradation, his lust

for lust itself, he was for them like a dark archangel of negative capability, representing the ultimate rejection of bourgeois virtue and mainstream values, even to the point of total self-destruction. He comes up several times in the published diaries of Judith Malina, cofounder of the Living Theatre, from this period. One night in 1951 she and her husband, Julian Beck, were in the San Remo, the dark and smoky bar at Bleecker and MacDougal Streets that Bodenheim often haunted.

> A ragged drunk approaches our table. In terrible shape. Ash blond hair askew. He lurches forward, his hands resting on the table. Directly to Julian: "What's your name?"
> "My name is Julian Beck."
> "My name is Maxwell Bodenheim. I'm an idiotic poet."
> And he turns and moves off before we can speak.

Roy Metcalf, who was a young newspaper reporter in the early 1950s, also encountered Bodenheim in the San Remo. "Bodenheim had a great face, an alcohol-ravaged face," he recalled in the 2010s. "Once a guy from uptown wanted to see Greenwich Village, so we went down to the San Remo. There was Bodenheim. He said, 'Bring him over, let's buy him a drink.' He expected Bodenheim to say something. Bodenheim by that time was so paralyzed by alcohol that all he could do was bray, 'Aaaaargh.' "

"Do we not idolize Maxwell Bodenheim although we are sometimes loath to talk to him and always ashamed of our condescension to him?" Malina wonders in another diary entry. "What we admire is Bodenheim's refusal to resist. We fight all the time, resisting temptation. We admire those who don't. Even if it's suicidal."

In 1953 Ruth Bodenheim took up with a violent, mentally unstable dishwasher named Harold Weinberg. One night in the winter of 1954 the three of them wound up in Weinberg's flophouse room off the Bowery. Bodenheim roused himself from a drunken stupor to see Ruth and Weinberg having sex. He attacked Weinberg, who pulled out a .22 and shot him through the heart. Then he stabbed Ruth in the chest.

Today, Bodenheim is remembered more for this tabloid end than for

any other achievement. Even his memoir was a dispiriting sham. *My Life and Loves in Greenwich Village*, published posthumously in 1954, was ghostwritten by a hack who, like everyone else in the Village, had bought him drinks to listen to his drunken ramblings.

EVEN AT THE HEIGHT OF ALL THE DRUNKEN WHOOPEE MAKING AND scandalous shenanigans, the Village still drew serious creative types. Marianne Moore and her mother had moved to 14 St. Luke's Place in 1918. Born outside St. Louis and raised in Pennsylvania, Moore was a poet's poet, a writer of intricately inventive verse highly admired by generations of peers from William Carlos Williams and T. S. Eliot to John Ashbery and Truman Capote. During the Village's wild and crazy 1920s she was likely to be found at the Hudson Park branch of the public library, where she worked. She's read now for her minutely observed nature poems such as the undulantly lyrical "The Fish" and "The Pangolin," in which she entwines poetic metaphors with the descriptive precision of an encyclopedia entry. In 1956 she suddenly vaulted out of poetry circles and into pop culture as the poet laureate of the Brooklyn Dodgers when the *Herald-Tribune* ran her paean to the team, "Hometown Piece for Messrs. Alston and Reese," on the opening day of the Dodgers-Yankees World Series. Unless you're an *otaku* of Dodgers history the poem is indecipherable today, and the Bums lost the series to boot. But for the rest of her life she was known as the sports poet. Branching out, she became a fan and friend of Cassius Clay, and in 1965 she was ringside at a Floyd Patterson bout with her pals George Plimpton, Philip Roth, and the ubiquitous Norman Mailer. By then she was a highly visible and feted character known for her witty banter and her eccentric quasi-colonial outfit, a cape and tricorner hat, her one bohemian indulgence.

Harvard classmates E. E. Cummings and John Dos Passos settled down in the Village in the early 1920s. Cummings, like Cowley and Dos Passos, had gone to France as a volunteer ambulance driver during the war. While there he befriended another American volunteer, William Slater Brown. When French troops, sick of the war, began to mutiny, censors found expressions of sympathy in some of Brown's letters and

interrogated both men. Cummings stood by his pal and was jailed along with him. After the war Brown and Cummings shared an apartment on West Fourteenth Street for a few years, after which Cummings joined the Lost Generation exodus to Paris in 1921. He returned to the Village in 1923, taking a studio at 4 Patchin Place, the gated mews off West Tenth Street, just across from the Jefferson Market Courthouse and jail. Originally built for the Brevoort's waiters, Patchin Place became known for the writers who lived there over the years, including John Reed, Theodore Dreiser, Djuna Barnes, Jane Bowles, and Cummings, who would reside there the rest of his days.

Dos Passos wandered around Europe and the Middle East after the war before moving to the Village in 1922, taking a small studio in Washington Mews. He and Cummings remained lifelong friends (although Cummings did make fun of the shy Dos Passos's stammer and lisp). Dos Passos had little time for "the nose in the air attitude that always bored me about Bohemians." They both leaned toward the left in their 1920s youth and both would become disenchanted in the Stalinist 1930s. Galvanized, like liberals and intellectuals around the world, by the Sacco and Vanzetti trials and appeals that dragged on into 1927. Nicola Sacco and Bartolomeo Vanzetti had been swept up in a wide manhunt and charged with murders committed during an armed robbery in 1920. Because they were anarchists their trial was a media sensation. The evidence against them was sketchy and most liberals feared they were being railroaded. In the end they were in fact convicted and executed. Dos Passos went to Boston to cover the case and interview the men for both the *New Masses* and the *Daily Worker*. "I even managed to get hauled in myself," he later wrote. Picketing outside the Boston statehouse at least once during the lengthy trials was considered de rigueur for all *bien pensant* Villagers, and Dos Passos was rounded up with a group of them one afternoon. "The ride in the paddywagon was made delightful by the fact that I found myself sitting next to Edna St. Vincent Millay. Outside of being a passable poet Edna Millay was one of the most attractive women who ever put pen to paper. The curious glint in her copper-colored hair intoxicated every man who saw her." Her husband bailed them both out. Dos Passos

and Cummings both traveled to the Soviet Union to see the Communist experiment firsthand, Dos Passos in 1928 and Cummings in 1931. The brutal repressions of the Stalin regime turned them away from the left, and they would share the distinction of being stalwart Republicans in liberal Greenwich Village, upsetting many of their cohorts. The relatively apolitical Dawn Powell would stick by them. In the 1950s Dos Passos wrote for the *National Review,* and both he and Cummings supported McCarthy.

Edmund Wilson, known to friends as Bunny, also arrived on the scene from serving in France. He was a short, plump, rosy-cheeked young man with the dolphin-browed dome of an intellectual and a high, thin voice, shy and aloof in manners and emotionally distant. Cummings called him "the man in the iron necktie," and his second wife's mother told him he was "a cold fishy leprous person." Growing up in the town of Red Bank on the New Jersey shore, he'd suffered through an affluent but bleakly WASPy youth. As a boy his knowledge of the greater world came largely through books. He studied at Princeton, where he met and became friends with F. Scott Fitzgerald, whose work he would critique for him. He believed, reasonably enough, that his friend had a great facility with words and romance but was an intellectual lightweight who drank way too much ever to think great thoughts. He nicknamed *This Side of Paradise* "This Side of Paralyzed." After Fitzgerald died in 1940, Wilson edited *The Last Tycoon* and *The Crack-Up* for posthumous publication.

He first moved to the Village in 1916, taking an apartment on West Eighth Street with two friends. His father supplemented the fifteen dollars a week he made as a cub reporter, so that despite the Grub Street job Wilson could cut a swell figure in the Village, always nattily dressed, carrying a stick, the visual antithesis of the bohemians around him. He and his roommates hosted genteel cocktail parties, complete with oboe music. Like many Village intellectuals Wilson was against America's entering the war in Europe, but when it did he volunteered and served with military hospital and intelligence units. He returned to the Village in 1919 and shared a place—and a West Indian cook—with two friends at 114 West Twelfth Street. He'd bounce around to various addresses in and out

and back in the Village through the 1920s, then move up and out, but still summer with the old crowd in Provincetown. After writing and reading all day, he launched himself into the drinking and carousing nightlife of the 1920s Village with the determination of a young man who had a very straitlaced background to overcome. Previously abstemious, he took right to drink; his sexual adventurism developed more slowly.

In the first volume of his journals, published posthumously as *The Twenties*, Wilson records slipping shyly into a pharmacy on Greenwich Avenue to buy his first condom. The helpful pharmacist blew one up like a balloon to show him how it worked. It burst, which he later—after suffering "many of the hazards of sex," including "abortions, gonorrhea, entanglements, a broken heart"—took as an omen. When he met Edna St. Vincent Millay in 1920 he was as dazzled as everyone else. According to his biographer Jeffrey Meyers, Wilson at twenty-five was still a virgin when Millay made him one of her many lovers. Wilson later wrote that she "ignited for me both my intellectual passion and my unsatisfied desire, which went up together in a blaze of ecstasy that remains for me one of the high points of my life." He notes his "subsequent chagrin and perplexity, when I discovered that, due to her extreme promiscuity, this could not be expected to continue." He proposed marriage—lots of men did—and forlornly dogged her to Paris, where he found she'd taken a new lover. His ardor dashed, he felt like he was "staring into the center of an extinct volcano." From the ashes of that dead affair rose what Meyers calls "one of the great literary fornicators of all time." Wilson astonished his contemporaries with the volume and variety of his conquests—actresses, poets, chorines, working girls, socialites—and writes in his notebooks with a sometimes giddy joy about his many sexual experiences. He'd go through four wives and cheat on them all.

For all that, Wilson possessed a disciplined mind and was a prolific writer, both as a journalist—at *Vanity Fair,* then the *New Republic,* and starting in the 1940s at *The New Yorker*—and as an author of many books. An astute and probing literary critic Wilson was one of the first in America to grasp the significance of Joyce, Eliot, and the other moderns; his *Axel's Castle,* published in 1930, was a seminal overview and analysis of

the movement. It came out just as the Depression and rise of fascism put the modern era on pause. He went on to be one of the century's preeminent men of letters, writing about the Depression itself (*The American Earthquake*), the history of socialism (*To the Finland Station*), the Dead Sea Scrolls, the Iroquois nation, the cold war, the injustice of the income tax—whatever inspired his catholic interests and curiosity.

Thomas Wolfe, twenty-three years old, came to the Village in the winter of 1924 to teach English at NYU. He'd grown up in Asheville, North Carolina, a town he would scandalize with his autobiographical novel *Look Homeward, Angel*, crowded with thinly veiled portraits of the citizenry. He started out writing plays and earned a master's degree in playwriting from Harvard. But when he showed his work around Broadway, producers told him his plays were just too long to stage. So in the mid-1920s he turned to writing novels, which also tended to be huge. But then so was Wolfe—six-foot-five and powerfully built—and so were his energies, neuroses, and appetites.

He took a room for twelve dollars a week at the residential Hotel Albert on University Place between East Eleventh and Twelfth Streets. It was not the cheeriest place. Most of the other residents, he would write in *Of Time and the River*, "were old people with a pension, or a small income, which was just meagerly sufficient to their slender needs. Some of them, widowed, withered, childless, and alone were drearily wearing out the end of their lives here in a barren solitude . . . [They] stayed in their rooms and washed their stockings out and did embroidery, or descended to the little restaurant to eat, or sat together in one corner of the white-tiled lobby and talked."

NYU was going through one of its growth phases when he arrived. From around four thousand students before the war it was up to sixteen thousand. Its main campus was actually not in the Village at this point: it had been moved to University Heights in the Bronx in the 1890s. (That campus would be sold to the City University of New York in the 1970s.) Downtown, the school demolished the original building and constructed a new one to house the undergraduate liberal arts program. There, Wolfe collided with a large influx of students, many of them Jewish and Ital-

ian boys and girls from the Lower East Side. The more Wolfe, still very
much a southern boy, struggled to repress an inbred and deep-seated
anti-Semitism, the more it expressed itself in tortured ways, including
an almost overpowering combination of lust and terror inspired by "the
proud and potent Jewesses with their amber flesh . . . skilled in all the
teasings of erotic trickery." He also developed a mighty grudge against
the college, blaming his crushing workload as a teacher for not getting
any writing done.

In 1925 he lit out for a trip to Europe. On the ocean liner coming back
he met his own personal erotic Jewess, Aline Bernstein. A New York na-
tive, she was the daughter of a respected Shakespearean actor and a suc-
cessful theatrical designer in her own right. She was also the wife of a
wealthy stockbroker, a mother of two teenagers, and twenty years older
than Wolfe. They began a powerfully sexual and emotionally tumultuous
affair. They rented a garret in the Village together, a dreary fourth-floor
walkup at 13 East Eighth Street, a block north of Washington Square Park.
She set up her drafting table in the front room and spent her days there
while, unbeknownst to her family uptown or to Wolfe's employers at the
university, he lived in the back, giving the Harvard Club as his address
if asked. They later gave it up for a larger, better-appointed apartment at
263 West Eleventh Street. With Aline playing a combination of lover and
mother (she cooked lunch for him, cleaned up after him, supported him
financially, and scolded him when he got lazy or undisciplined), he went
to work on what became Look Homeward, Angel. The longer he labored
over it and the longer it got, the more difficult he became. Sometimes
he'd fly into jealous rages, accusing her of being a whore and a sex-crazed
Jew; sometimes he'd beg her to get a divorce and marry him. He liked it
when she introduced him to famous writers she knew, including Carl
Van Vechten and, on a trip to Europe she financed, James Joyce, but he
could turn surly and pugnacious around her other friends. Sometimes
he proudly showed her off to his younger cohort, at others he wondered
if they mocked him as a middle-aged woman's boy toy. She stuck with
him and kept him at his work. When he finished the novel's enormous
first draft, Aline took it around to publishers, who rejected it as too prolix

and formless. When Charles Scribner's Sons published it in 1929, the editor Maxwell Perkins, who also edited Hemingway, Fitzgerald, and Dawn Powell, had cut it down by sixty thousand words.

Wolfe dedicated it to "A.B." Then he screwed every attractive literary groupie who gravitated his way once the favorable reviews came out, and he made sure Aline knew it. It was his way of beginning to extricate himself from the relationship, a process he dragged out over a few years. She didn't want him to leave and bore every cruelty and humiliation he doled out as he pried himself away from her an agonized bit at a time. When he finally moved to a place of his own, in Brooklyn in 1931, she responded with a suicide attempt. Even then the cruelties didn't stop. Once, he asked her to bring him five hundred dollars. When she got to Brooklyn she found his mother had come to visit him. Wolfe's mother, noting that Aline's daughters were closer to her son's age than Aline was, told her she considered any relationship between them other than a merely friendly one "illicit." Wolfe took his mother's side, and when Aline left in utter mortification the two of them sniggered anti-Semitic remarks.

Wolfe's sprawling second novel, the autobiographical *Of Time and the River*, took up where the first one ended. It was a best seller in 1935. He was widely feted as the country's new literary genius and enjoyed many more groupies. Few were unimpressed; one of them was Dawn Powell, whose skills as a wit and satirist were matched only by Dorothy Parker's at that point. She reduced the eight-hundred-page novel to a scathing eight-line ditty:

> *Oh Boston girls how about it*
> *Oh Jewish girls, what say*
> *Oh America I love you*
> *Oh geography, hooray*
> *Ah youth, ah me, ah beauty*
> *Ah sensitive, arty boy*
> *Ah busts and thighs and bellies*
> *Ah nookey there—ahoy!*

In 1938 Wolfe was diagnosed with tuberculosis of the brain and died
at Johns Hopkins Hospital in Baltimore, supposedly with Aline's name
on his lips. He left a vast store of manuscript materials; over half of his
published work, including the novel *You Can't Go Home Again*, appeared
posthumously. The year he died, Knopf published Aline's novel *The Jour-
ney Down*, based on their relationship. She died in 1955.

THE FRENCH-BORN AVANT-GARDE COMPOSER AND CONDUCTOR ED-
gard Varèse and his wife, Louise, a noted translator of Proust and Rim-
baud, arrived in New York in 1915, fleeing, much like Marcel Duchamp,
the war in Europe. By the mid-1920s he too was settled in the Village
where, except for a return to Paris from 1928 through 1932, he lived until
his death in 1962, much of that time at 188 Sullivan Street, one of Wil-
liam Sloane Coffin's MacDougal-Sullivan Gardens town houses. Con-
trary to later myths that would paint Varèse as a lonely avant-garde hero
who toiled in obscurity in culturally benighted America, he was received
in New York with open arms and adored by critics from the start. Fol-
lowing his American debut as a conductor in April 1917, at the gigantic
and gaudy Hippodrome auditorium in the theater district, critics hailed
him as a genius. Being French at a time when the Metropolitan Opera,
the New York Philharmonic, and other patriotic bastions of symphonic
music were cleansing their programs of German conductors and compo-
sitions didn't hurt. (President Wilson declared war on the Germans four
days after the concert.)

In the late 1920s one critic called Varèse a "new god" among modern
composers and compared his innovative genius to that of Leonardo da
Vinci. Although his celebrity in New York did dim in the 1930s and '40s,
partly due to his return to France in that period, an entire new genera-
tion of American composers and critics rediscovered him in the postwar
years and, as one music historian has put it, he "rose again as a well-
established deity." He was a well-liked presence in the Village through
the 1950s, especially admired by the jazzmen Charles Mingus, Charlie
Parker, and David Amram, who heard parallels between jazz and Varèse's
experiments with atonal and electronic sounds. Back in the 1920s Varèse

had disparaged jazz as "a negro product, exploited by the Jews," but bebop and free jazz appealed to him, and he'd go to Village clubs to hear it. He even conducted a free jazz workshop in 1957 with musicians including Mingus, Art Farmer, and Teo Macero. Free jazz is said to have inspired his *Poème Électronique*, an eight-minute tape of electronic whoops, bleeps, and whistles created for the Philips Pavilion of the 1958 world's fair in Brussels. He arranged for its U.S. premiere to be "not at Carnegie Hall but at the Village Gate," Amram recalls. "He said, 'I want to have it here where my friends can come and not have to take out a mortgage, and be able to see me afterwards and not have to break through a phalanx of guards.' He was the most genial, warm, hamische guy."

After Jane Heap returned to the Village in the mid-1920s, she was instrumental in bringing the Romanian avant-garde architect and designer Frederick Kiesler to the neighborhood. She'd seen an exhibit of his theater designs in Paris and teamed with the Provincetown Players, the Theatre Guild, and the Greenwich Village Theater to invite both the exhibit and Kiesler to New York. He was soon commissioned to design the city's first theater dedicated solely to film. At the time, movie theaters still featured live entertainment, so along with screens they had stages, curtains, and proscenium arches. The Film Guild Cinema opened in 1928 at 52 West Eighth Street, above the Village Barn and just down the block from where Gertrude Whitney was about to open her art museum. It was a dazzling wonder of the brand-new International Style, both the exterior, which looked like a Mondrian painting, and the ultra moderne auditorium, which had a screen that could dilate to different dimensions depending on the film to be projected. The coming of the Depression ended the experiment, but redesigned and reopened as the Eighth Street Playhouse it went on to be a cherished Village institution almost to the end of the century.

The Village got a larger International Style building around the same time, when the New School for Social Research moved there from Chelsea. A handful of progressive scholars uncomfortable with the militarist, nationalist trend at Columbia University left and founded the school in 1919. They included the historian Charles Beard, the economist Thor-

stein Veblen, and the philosopher John Dewey. They ran their New School as an academy, with lectures and free discussion, open to any interested adult, and no grade system. Reorganized along more traditional university lines in the 1920s, the school bought and demolished some old houses on West Twelfth Street near Sixth Avenue. In their place, Joseph Urban—previously known for creating the stage sets and theater for Ziegfeld's Follies—designed a new home, a modern banded box of a building, rearing up from the middle of a block of brick town houses, which startled the Village when it was completed in 1930. Thomas Hart Benton and José Clemente Orozco painted large, beautiful murals for inside. In one, Benton added the figure of a young man who was studying under him at the Art Students League named Jackson Pollock.

# The Red Decade

Before the crash of October 1929, national unemploy-ment stood at around 3 percent. By early 1930, according to some estimates, it had already increased tenfold. In New York City a million adults lost their jobs in the first few years of the Depression, and two hundred thousand a year were thrown out of their homes, some starving to death on the streets. In the Village and on the Lower East Side, the already crowded tenements got even more so as families doubled up and took in lodgers. Others built their own makeshift homes. By 1931, Greenwich House's Mary Simkhovitch recorded, the homeless had built shanty jungles, aka Hoovervilles, all over the city. One such jungle was near the waterfront, on a block of West Street the New York Central Railroad had cleared for its tracks, knocking down old houses to leave open, unfinished cellar pits. Several hundred homeless men threw tin roofs over these pits or built shacks above them. Only men lived there, those with families having sent them away while they stayed in the city and tried to find work. They grouped themselves by race, white men on one side of the tracks, blacks on the other, and a small Latino group off to one side.

Some of the men knew they were there for the long haul.

> The best house built above the ground was a two-room bun-
> galow with well-matched boards, good flooring, beams and
> doorjamb true, good roofing and a good window. Inside, the
> wall was wainscoted halfway up. The wood used for this pur-
> pose consisted of very narrow lathes carefully cut and fitted
> together and stained green. The upper part of the walls was
> lined with cardboard and papered with white wallpaper, as
> was the low ceiling. The main room contained substantial
> shelves, the bedroom firm bunks. An old coal range, secured
> in return for assistance to a man who was moving, had been
> installed in one corner. A piece of linoleum covered the floor.
> At the windows, over the shelves and over the door to the
> second room were curtains. The walls were decorated with
> pictures drawn by one of the neighboring shack dwellers.

A nearby gas station filled the men's water pails and let only the white
men use its restroom. They scrounged for food at the markets, worked
odd jobs along the waterfront when they could find them, and panhan-
dled.

Artists in and around the Village were already used to being broke
much of the time, but now the opportunities for work—illustrations for
magazines, portraits of rich patrons' children and pets—really dried up.
John Sloan drew a cartoon of a banker leaping into a hole labeled "De-
pression," only to find an artist already occupying it. Eleanor Roosevelt,
a New York native who would move to the Village after Franklin died,
held two benefit fund-raisers for artists at Romany Marie Tavern, and
Marie herself ladled out a lot of free soup and *chorba* to her artist friends
throughout the decade. In 1932 Gertrude Whitney and other well-heeled
art patrons formed the Artists' Aid Committee and organized a twice-
annual Washington Square Outdoor Art Exhibit at which hundreds of
downtown artists showed and hoped to sell their works for five or ten
bucks apiece. At the first event in the spring of 1932 a twenty-one-year-

old named Jackson Pollock exhibited still very traditional pictures, his first public showing. He didn't sell any.

It's no coincidence that the 1930s came to be known as both the Depression era and the Red Decade. The Great Depression and the international rise of fascism combined to make the 1930s banner years for progressives, from FDR to the American Communist Party. It reradicalized the Village. For many (though not all) Greenwich Village intellectuals and artists through most of the 1930s, the question wasn't Democrat or Republican, liberal or conservative, but Stalinist or Trotskyist, the *New Masses* or *Partisan Review*. Only at the end of the decade, when Stalin's barbarous excesses became public knowledge, would the infatuation fade.

Decimated by the Palmer Raids and marginalized by the giddy prosperity of the 1920s, the CPUSA entered the 1930s with fewer than ten thousand dues-paying members. Toward the end of the decade it peaked at around a hundred thousand, and untold thousands more Americans were fellow travelers, who sympathized without actually joining. For many it was just a youth-rebellion fad, functionally equivalent to hanging a Che Guevara or Angela Davis poster in your dorm room forty years later. But many New York artists and intellectuals in the 1930s sincerely believed they had a duty to create a new culture that reflected the reality of proletarian lives and inspired revolutionary zeal in the masses. They were less sure about how to do that. As we've seen, many were middle- and upper-class Ivy Leaguers and aesthetes with only the haziest ideas about who the proletariat was. Others were first- or second-generation American Jews who'd rarely set foot outside the five boroughs of New York City and were largely unfamiliar with the rest of America and its culture. As Kenneth Rexroth later japed, "Nothing was sadder than the 'proletarian novelist' . . . the product of a sociology course and a subscription to a butcher-paper weekly, eked out with a terrified visit to a beer parlor on the other side of the tracks and a hasty scurry past a picket line. Nobody read him but other Greenwich Village aesthetes like himself."

Those who were CPUSA members could at least take their cues directly from the Comintern (Communist International) in Moscow. The

party entered the decade with a hard-line policy condemning all other left and liberal movements as "socialist-fascist" and declaring itself the only true revolutionary party. It took a similar purist stand on culture, denouncing all arts and entertainments made by and for the masses as counterrevolutionary and hopelessly corrupted by individualist and capitalist ideas. To the party's *Daily Worker*, magazines like *Liberty* and *Collier's* were "flourishing weeds" and "dope-peddlers," and folk music was "complacent, melancholy, defeatist . . . intended to make the slaves endure their lot—pretty, but not the stuff for a militant proletariat to feed on." The *New Masses* tagged jazz "pseudo-music" and condemned Hollywood as "a gigantic propaganda factory for every feeble and vicious and half-false way of life." The *New Masses'* most vitriolic critic of American popular culture was the editor Mike Gold, born Itzok Granich on the Lower East Side. (Many radicals used pseudonyms, a tradition that went back to Vladimir Lenin, born Vladimir Ulyanov, and Leon Trotsky, born Lev Bronshtein.) Gold did his first writing for Max Eastman at *The Masses* in the 1910s, helped start up the *New Masses* in 1926, and pushed it toward the hard-liner stand it adopted in the 1930s. In 1929 he drummed Floyd Dell out of the publication for being too bourgeois and complacent. He targeted modern literature, charging Gertrude Stein with "literary idiocy," ridiculing Proust as the "master-masturbator of the bourgeois literature," and rebuking Carl Van Vechten's debasement of black culture into nothing but "gin, jazz and sex." He showed the way he believed proletarian literature should go in his autobiographical novel of the Lower East Side *Jews Without Money*, published to great success in 1930 and still in print today. Unlike many 1930s leftists, Gold would proudly retain his Communist Party membership right up to his death in 1967.

Not all efforts to create "Proletarian Culture" (or Prolecult) were as successful as Gold's. The CPUSA in New York sponsored a Workers Music Alliance and a Composers Collective, tasked with creating new, revolutionary "music for the masses." But the collective's composers Aaron Copland and Marc Blitzstein were academy-trained aesthetes (both had studied under Nadia Boulanger in Paris), modernists and avant-gardists with very vague ideas about what might inspire revolutionary zeal in the

masses, to whom Copland referred, with unconscious condescension, as "peasants." Their early efforts had no impact outside concert halls filled with like-minded aficionados.

At the same time that the hard-line Marxists were excoriating populist American culture, a few Village iconoclasts were championing it. John Hammond, the Yale-educated great-grandson of William Henry Vanderbilt, moved to Greenwich Village in 1931 and began avidly promoting, producing, and recording that most American of musical forms, jazz. In 1938 he would organize an immensely important concert at Carnegie Hall, "From Spirituals to Swing." He wanted to show that jazz was art, not just dance music—thus the Carnegie Hall setting—and that it had roots that went back through the blues and gospel to Africa. The concert was a great success, even though many of the performers were unknown in New York at the time. They included Lux Lewis, Sister Rosetta Tharpe, Lester Young, Sidney Bechet, James P. Johnson, Count Basie, Big Joe Turner, and Sonny Terry. Hammond became a legendary producer at Columbia Records, instrumental in the careers of many other artists, including Fletcher Henderson, Benny Goodman, Ida Cox, Big Bill Broonzy, and Bob Dylan.

In 1933 the musicologist John Lomax took his son Alan and an enormous disc-recording phonograph, then state of the art, on a tour of the South, recording the work songs, blues, and ballads of prisoners and field hands, mostly black. In Angola Prison in Louisiana they met Huddie Ledbetter, aka Leadbelly, serving time for murder. From him they first heard the songs "Goodnight, Irene" and "Midnight Special" and many others. When Leadbelly was released from prison the following year he joined the Lomaxes in Greenwich Village.

In 1934 the Comintern in Moscow abruptly announced a broad reversal in policy anyway. With Stalin's agrarian and industrial reforms failing miserably, and fascists taking over in Germany and Italy, the Soviet Union and international Communism needed all the friends they could get if they were to survive. The Comintern now directed Communist parties around the world to seek alliances with all left and liberal groups to present a united Popular Front. The new policy forced an overnight about-

face among New York's radical intellectuals. The Composers Collective disbanded and the Marxists now embraced folk music as passionately as they had been rejecting it the day before. Copland began incorporating traditional material like "Old Paint" and "Camptown Races" into his compositions. The party published *Songs of the People*, half of it devoted to approved popular tunes. Collective cofounder Charles Seeger, who'd written a piece damning folk music in the *Daily Worker*, now moved his family, including his sons Pete and Mike, to Washington, D.C., to work in building the Library of Congress Archive of American Folk Music.

Several key figures from the Popular Front folk music movement would settle in Greenwich Village. They included Pete Seeger, who dropped out of Harvard, joined the CPUSA, and devoted himself to music. He helped found a loose collective who called themselves the Almanac Singers. They lived and played in several houses in the Village; the best-known "Almanac House" was at 130 West Tenth Street, hard by the Women's House of Detention. At various points Almanac House was home to Leadbelly, Alan Lomax, Cisco Houston, Sonny Terry, Brownie McGhee, Burl Ives, the actor and activist Will Geer, and Woody Guthrie. They staged hootenannies and charged thirty-five cents admission. College kids gathered for sing-alongs on pleasant afternoons in Washington Square Park. What the Almanac Singers started at the end of the 1930s would blossom in the late 1950s and early '60s into the Greenwich Village "folk music revival" that produced so many stars including Bob Dylan and Peter, Paul and Mary.

Toeing the party line got more difficult as the decade wore on. News of the Great Purge, in which Stalin imprisoned and/or executed a million perceived enemies between 1936 and 1938, shook the faith of leftists worldwide. Max Eastman declared Stalin a "gangster god." Two young Village bohemians, William Phillips (originally Livitsky, born in the Bronx) and Philip Rahv (born Ivan Greenberg in the Ukraine), began as loyal party members and edited nine issues of *Partisan Review* as a party organ. Then they broke free and established PR as a platform for anti-Stalinist political theory as well as for modern literature and art, attracting many of the best writers and thinkers of the time: Delmore Schwartz,

Hannah Arendt, Edmund Wilson, James Agee, Lionel Trilling, Robert Lowell, Wallace Stevens, Randall Jarrell, Dwight Macdonald, Clement Greenberg, and Mary McCarthy, the sole female in the grubby Union Square office, who wrote caustic theater reviews.

It's an indication of how far PR drifted away from the party that its star writer was not a political figure but a literary one, Delmore Schwartz. His Romanian father, Harry, had sailed steerage to the Lower East Side, where he quickly got rich selling sometimes dubious real estate to his fellow immigrants. As an adult, Harry's firstborn son liked to spin alternate tales to explain how he got the goyish-sounding given name Delmore. The simple truth was that a neighbor named her son that, and Mrs. Schwartz liked it so much that she gave it to her boy too. The family bounced around to various Jewish neighborhoods in Brooklyn while the parents fought constantly and viciously, until Harry left. Mrs. Schwartz raised her two sons in the then-Jewish area of Washington Heights in upper Manhattan. By twelve Delmore was reading philosophy and sending poems to the best literary magazines of the day, once getting a kind rejection note from H. L. Mencken at the *American Mercury*. He was determined to become a great poet or philosopher, or both, and prone to the attacks of self-doubt and anxious melancholy such grandiose dreams are prey to.

In the summer of 1935, before going on to Harvard graduate studies in philosophy, he rented a gloomy room on Greenwich Avenue in the Village and wrote the short prose piece "In Dreams Begin Responsibilities." Highly modernist in structure, it occupies a gray area somewhere between a short story and autobiographical prose. Its emotional tone, meanwhile, is uniformly bleak. In a dream on the night before his twenty-first birthday he goes into a movie theater and watches a silent film of his parents in their youth, in 1909, on the day his father took his mother to Coney Island and proposed. Before the day is out they have a big fight, at which point Delmore jumps out of his seat and shouts at the screen, "Don't do it. It's not too late to change your minds, both of you. Nothing good will come of it, only remorse, hatred, scandal, and two children whose characters are monstrous."

At Harvard Schwartz got to be friendly with fellow students Leonard Bernstein and Robert Motherwell. But Harvard, like other Ivy League schools, had a quota on how many Jews could attend and he never felt comfortable there. In 1937 he left so abruptly he never returned the books he had out of the library or paid his university bills. He and his younger brother took a room in a Village boardinghouse at 73 Washington Place, half a block from the park. It sounds almost like a parody of the bohemian garret: "Their room," Schwartz's biographer James Atlas writes, "an attic loft with low rafters above Bertolotti's Italian Restaurant, could be reached only by climbing a ladder." In quick succession his poems and stories began appearing in the best literary magazines like *Poetry* and in the 1937 anthology from New Directions, the hot new literary publisher of the time, where he appeared alongside work by Cummings, Gertrude Stein, and Henry Miller. That same year Phillips and Rahv made "In Dreams" the lead piece in their first issue of *Partisan Review*. New Directions published a collection of his stories and poems under the title *In Dreams Begin Responsibilities* the following year. Just turning twenty-five, Schwartz was feted as "the American Auden" and as the preeminent voice of the young Jewish-American intellectual—a voice querulous with existential angst and historical melancholy, crying out for a generation steeped in "emptiness and depression," alienated from both the old world and the new, the Jewish and the American. (Woody Allen would later mine the same vein of anxiety for comic effect.) In his short verse play *Shenandoah*—Shenandoah was a name he gave his fictional alter ego—he portrays the striving, stultifying world of middle-class Jews who, for all their attempts at assimilation among Americans, remain outsiders.

> *O the whole of history*
> *Testifies to the chosen people's agony,*
> *—Chosen for wandering and alienation*
> *In every kind of life, in every nation.*

To the wider intellectual and literary world his was the voice of the despair and pessimism they were all feeling in 1938 as the Depression

dragged on and they saw the rising tide of Nazism and Fascism, on the one hand, while, on the other, the Soviet Union fell into its own brand of genocidal barbarism and a cataclysmic war loomed. No one was more of a pessimist than Delmore Schwartz. Even the high praise he was receiving from all quarters—from T. S. Eliot, William Carlos Williams, Ezra Pound, Vladimir Nabokov—depressed him; he worried that it was premature and he'd flame out early. Only when surrounded by fellow writers whom he liked and respected, drinking too much, did he momentarily brighten.

Another Village writer who was never swept up in the Marxist trend wrote what's now considered one of the classic descriptions of Depression hardship, *Let Us Now Praise Famous Men*. It wasn't so highly regarded in its time, however. Not published until the end of the era, it flopped and was forgotten until after the author's death.

James Agee grew up in suburban Knoxville, Tennessee. His mother's family was well-off, arty, educated, and piously Anglo-Catholic, a branch of Anglicanism with Roman Catholic leanings. According to family lore they were related to Walt Whitman, whose writing Agee would later dismiss as "generally half-assed." His father came from mountain folk, a nonreligious drinking man. He died when Agee was six, driving the family car off a country road at night, alone at the wheel, possibly drunk. Like his father, Agee would be a heavy drinker and die in a car. From his mother he inherited a preoccupation with sin and guilt that would often pitch him headlong into sloughs of suicidal remorse and self-hatred.

He arrived in New York City in 1932, the depths of the Depression, to write for *Fortune*, the magazine of big business that *Time*'s Henry Luce, with impeccably bad timing, had launched a few months after the crash of '29. Agee moved with his first wife to a basement apartment at 38 Perry Street in the Village. Over the next decade he would move around, with a second and then a third wife, finally settling on Bleecker Street in 1941. In *Fortune*'s offices high up in the dazzling new Chrysler Building he joined writers such as the Lost Generation poet Archibald MacLeish and the Trotskyist *Partisan Review* contributor Dwight Macdonald, gritting their teeth while penning paeans to capitalism yet grateful to have any job at all.

Even *Fortune* had to admit there were hard times out there and its editors sent Agee twice to the Deep South on Depression-related assignments. The first trip was to write about the Tennessee Valley Authority. Then, in the summer of 1936, the magazine sent him and the photographer Walker Evans to get a story on dirt-poor sharecroppers in Alabama. When he returned to New York Agee found it impossible to write about his experience in any way that *Fortune* would publish. He labored for the next three years on his book, a feverish prose poem with echoes of both Faulkner and Melville, almost hallucinatory in its physical descriptions of shimmering heat and sounds and smells, biblical in its surging bound-for-glory spirit.

By the time Agee delivered the manuscript to Harper & Row in 1939, Steinbeck's *The Grapes of Wrath* had told in effect the same story in fiction, the Depression was winding down, and the publisher, feeling the moment for Agee's epic and difficult tome had passed, rejected the book. Houghton Mifflin published *Let Us Now Praise Famous Men*, with Evans's stark and haunting photos throughout, in August 1941. But the Depression was now history, America's entry into World War II was just a few months off, and a harsh review in the *New York Times* ("arrogant, mannered, precious, gross") helped spike the book. The publisher sold just six hundred copies and remaindered the rest.

Agee's weeks-long benders became the stuff of legend. A chain-smoker all his adult life, he had persistent heart troubles. In 1955, in a cab from the Village to his dentist's office, he would suffer a fatal heart attack at forty-five. *A Death in the Family*, an autobiographical novel he'd worked on for years and not quite completed, was posthumously published to wide acclaim in 1957. That encouraged Houghton Mifflin to reissue *Famous Men* in 1960, when it was rediscovered as a lost classic.

WHILE JIMMY WALKER HID THROUGH THE EARLY YEARS OF THE Depression, in Albany the progressive governor Franklin D. Roosevelt took an active approach. He doubled the state income tax and gave the millions to Harry Hopkins, formerly a social worker at the Christodora House settlement in what's now the East Village, to start up relief and

jobs programs. When FDR went to Washington in 1933, he brought Hopkins down to run the Federal Emergency Relief Administration. FDR followed with a slew of other programs: the Civilian Conservation Corps, which hired young men to upgrade the national parks; the National Industrial Recovery Act; the Tennessee Valley Authority; the Public Works Administration; the Civil Works Administration; the Works Progress Administration. The federal government put millions of Americans back to work. Not everyone agreed this was a good thing. There were dire warnings that this was the prelude to American bolshevism and complaints that the programs generated useless make-work—the term "boondoggle" was coined in this era.

The WPA mostly focused on infrastructure, putting people to work building roads, highways, dams, airports (including New York's LaGuardia), schools, libraries, and firehouses. But Hopkins and his administrators treated bringing the arts and literature to the people as valid a civil works program as building roads and schools, and the WPA employed tens of thousands of writers, artists, musicians, and people in the theater as well. Many Village artists and writers kept body and soul together in the 1930s by working for the WPA. From early on, conservatives in Congress and the newspapers complained that it was a jobs program for a bunch of commies and bohemians. Which of course many of them were, and much of the work they produced for the program proved it.

The WPA's Federal Art Project had some five thousand visual artists and art teachers on its payroll. During the program's eight-year run they made an estimated two hundred thousand easel paintings, drawings, murals, prints, posters, and sculptures, usually displayed in public settings like schools, hospitals, and libraries. Working for the FAP in the 1930s had a huge psychological impact on the artists who would emerge as the so-called New York School in the Village and East Village after World War II—Pollock, Rothko, Lee Krasner, Ad Reinhardt, Louise Nevelson, Philip Guston, Arshile Gorky et al. For the first time in their lives they were paid to make art as a job, earning roughly twice what the average store clerk did, and working in the program created a sense of community among them that they'd carry on after the war. Also, on a superfi-

cial level, the murals program taught them to paint big, which became a hallmark of Abstract Expressionism. ("We are for the large shape because it has the impact of the unequivocal," a group of them would declare.) Congressional conservatives condemned the project as another WPA boondoggle; the conservative Hearst newspapers denounced the artists as "Hobohemian chiselers."

THE RISE OF FASCISM AND NAZISM IN EUROPE THROUGH THE 1930S had another effect on the intellectual and cultural life of New York and Greenwich Village, as many artists, writers, and scholars fleeing Europe arrived. Through the program termed the University in Exile and others like it, the New School brought in Hannah Arendt, the anthropologist Claude Lévi-Strauss, the psychologists Erich Fromm and Max Wertheimer, the extremely controversial psychiatrist Wilhelm Reich, the theater director Erwin Piscator, the economist Karl Brandt, the sociologist Hans Speier, the photographer Lisette Model, and scores of others. Some settled in the Village and on the New School faculty, others filtered out to other universities. Vladimir Nabokov and his family arrived in the city in 1940. Max Ernst, freed from the Gestapo, came with Peggy Guggenheim, whom he married. Duchamp came back. Piet Mondrian, André Breton, Salvador Dalí, Yves Tanguy, André Masson (whose bags, when inspected by customs men in the New York Harbor, were found to contain erotic drawings, which they ripped up before his eyes), Fernand Léger, and many others arrived. When Guggenheim opened her Art of This Century gallery on West Fifty-seventh Street in 1942, it "represented . . . a meshing of an entire international set of assumptions that flew, like so many iron filings, to the single magnet of New York," Dore Ashton writes. The gallery showed the European greats side by side with emerging New York artists. Pollock had his first solo show there in 1943, followed by Robert Motherwell, Clyfford Still, and Mark Rothko. To design the gallery Guggenheim hired Frederick Kiesler, who'd created the Film Guild Cinema in the Village. Mingling with all the European avant-gardists had a huge impact on Pollock and the other Americans. In a few years the drive to create their own American avant-garde would give birth to Abstract Expressionism.

14

# The Wrong Place
# for the Right People

O N ONE OF THOSE TRIANGLE-SHAPED LOTS CREATED BY THE EX-
tension of Seventh Avenue through the Village stands a low,
sharply pointed, wedge-shaped building constructed in 1921. In the
middle of the building, down a steep and narrow flight of stairs, is
a pie slice of a basement that originally housed a speakeasy called
the Golden Triangle. The Golden Triangle had been closed for a
couple of years when Max Gordon moved his nightclub into the
basement in 1934. The Depression and the end of Prohibition had
reduced the tsunami of whoopee-making college men and flappers.
Speakeasy culture had died. The Village, like the rest of the city, was
a harder, more sober place. In a journal entry for December 1931,
Edmund Wilson observed, "People looked whiter, more emaciated
than ever . . . the sky or whatever it was seemed to be shutting the
people down into the streets so that they crawled along them more
dismally, dumbly, ignobly, than ever . . . the life, the excitement had
partly gone out of the city—the heart had been taken out of it." But

people still needed a drink—now more than ever, maybe—and places to take a date, if on a nickel-and-dime budget. Village bars and clubs remained destinations.

Max Gordon's family had emigrated from Lithuania to Oregon in 1908. His father sold produce from a horse cart and made enough to put Max through college, where he majored in literature. On graduating in 1926 he headed for Greenwich Village, worked odd jobs, spent a lot of time in the all-night Stewart's Cafeteria at the corner of Christopher Street and Seventh Avenue on Sheridan Square, nursing a nickel coffee and making plans. With a friend named Ann, who waitressed at Paul's Rendezvous on Wooster Street, he made the rounds of Village clubs in the early 1930s.

> Romany Marie's, the Gypsy Tavern, the Black Cat. Ann hated all of them. Romany Marie was a snob; the two sisters in peasant costumes who ran the Gypsy Tavern were phony; the Black Cat was dark and full of menace. Then there was the Alimony Jail on West Fourth Street. Its high-backed booths were designed for necking and fornication.

Together they opened the tiny, threadbare Village Fair on Sullivan Street in 1932. Prohibition still had a year to run, so patrons brown-bagged their liquor and the club sold setups until a waitress who let an undercover cop buy liquor inside the club doomed the place. In 1934 Gordon tried again, opening the first Village Vanguard in a basement on Charles Street. He moved a year later to the basement on Seventh Avenue where it remains to this day.

Poets were the main entertainment at first. Gordon couldn't afford to pay them; they performed for whatever change the patrons tossed at their feet. The poet Eli Siegel, later founder of the Aesthetic Realism movement, was his emcee in the early years, but the crowd came to see three ghosts of the Village Past—Maxwell Bodenheim, Harry Kemp, and Joe Gould—who hung out there because Gordon tolerated them and his patrons were easy marks for a few free drinks. In his memoir *Live at the Village Vanguard*, Gordon describes how Siegel would call Gould out of

the crowd with the cry, "Ladies and gentlemen, the Harvard terrier and *boulevardier*, Joseph Ferdinand Gould!" Gould would shuffle up to the spotlight and do his shtick, while Bodenheim, tall and imperious, would stalk the shadows at the back, "point his finger, and shout, 'Eli Siegel! I hate you, Eli Siegel. You rat!' " Gordon continues:

> Eli would wait for Bodenheim to shape up so he could call on him to recite. But it was no use. Bodenheim, swirling crazily, eyes glazed, arms outstretched, would suddenly stop and point his finger at a frightened girl who had refused him a dance during intermission. "Rat!" he'd shout at her.

A teenage comedy and singing team called the Revuers got their start at the Vanguard in the late '30s airing "beefs" about life in New York City. In one sketch, they beefed about the Sixth Avenue El being dismantled and the steel sold to Japan; the sketch ended with Japanese bombs labeled "Made in N.Y." dropping on California. The Rainbow Room bought the Revuers away from Gordon. When one Revuer, Judy Holliday, was invited to Hollywood, she insisted the rest of the troupe appear in her first movie, which was, appropriately, the 1944 Technicolor musical *Greenwich Village*. The movie is more *Greenwich Village Follies* than Greenwich Village, rolling together every possible cliché about the Village of the 1920s—a speakeasy modeled on the Pirate's Den, a wild studio party, short-haired Jane Heap types in men's clothes, a man in woman's clothes, a writer rejoicing because he's been "banned in Boston," starving artists and their models, drunken poets, and a pagan revel at Webster Hall, including the number "It's All for Art's Sake," with lines like "That character in the lavender tuxedo / Is really a soda jerk from Toledo." Holliday et al. appear for a few seconds as extras. Holliday went on to be an Oscar-winning star, and Revuers Betty Comden (not to be confused with Jimmy Walker's Betty Compton) and Adolph Green wrote Broadway and film hits such as *On the Town*, *Singin' in the Rain*, and *Wonderful Town*, the stage adaptation of *My Sister Eileen*.

Professor Irwin Corey, "The World's Foremost Authority," got his start

as a nightclub comedian at the Vanguard in the 1940s. He was born in
Brooklyn in 1914 and later placed by his struggling parents, with all five
brothers and sisters, in the Brooklyn Hebrew Orphan Asylum. In the
late 1930s he performed in a Borscht Belt musical revue called *Pots and
Pans*, on Broadway in the long-running comedy revue *New Faces* (Mel
Brooks, Eartha Kitt, Imogene Coca, and Paul Lynde were later *New Faces*
alumni), and in the ILGWU's hit musical *Pins and Needles*, which ran
from 1937 to 1940 with numbers like "Sing Me a Song with Social Sig-
nificance" performed by an interracial cast. He perfected his signature
comedy routine at the Vanguard, the Copacabana, and on radio with the
ventriloquist Edgar Bergen and his dummy Charlie McCarthy. A small
man with messed-up hair, in a too-long frock coat and crooked string
tie, the Professor gave mock lectures on everything from Shakespeare
to religion to "sex: its origin and application," reducing it all to surreal,
extemporaneous gobbledygook that was a parody of the obfuscations and
doublespeak of scholars, experts, and authority in general. Buried in his
tangled skein of wordplay was the occasional one-liner that entered the
American vernacular—though often without his being credited as the
source—for example, "You can get further with a kind word and a gun
than you can with just a kind word" and the oft-repeated "Wherever you
go, there you are." Like most everyone in the Village at the time his poli-
tics were leftist, which got him blacklisted in the Red Scare after World
War II. He survived that and went on to be one of Johnny Carson's regu-
lar guests on *The Tonight Show*, run for president on the Playboy ticket in
1960, and perform on Broadway and in movies, including Woody Allen's
*The Curse of the Jade Scorpion*.

In 1943 Gordon and his partner Herb Jacobi opened a second club,
a very different club in a very different neighborhood: the Blue Angel,
on East Fifty-fifth Street. At the time, and for the rest of the twentieth
century, "uptown" and "downtown" weren't just geographical terms in
Manhattan; they described two distinct cultures. Uptown meant money,
power, breeding, class, chic, high society. Downtown was hip, arty,
scruffy, bohemian. Fourteenth Street was the accepted boundary line.
Uptowners who ventured below Fourteenth Street were slumming and,

as Ronald Sukenick explained a few decades later, "Village people might go Uptown but it was a kind of slumming in reverse." Gordon writes, "Everything above Fourteenth Street was another world." The Blue Angel was appropriately chic and swank. "Black patent leather walls in the bar, tufted grey velour walls with pink rosettes in the main room, banquettes of pink leather, a bright red carpet, black marbletop tables." Opening night the entertainment was "Mme. Claude Alphand, the wife of the French ambassador, an amateur chanteuse who preferred singing in a nightclub to living in the embassy in Washington; an Ecuadorian baritone who sang strictly Spanish; Brenda Fraser, an arch British comedienne; and Sylvia Marlowe on a harpsichord, playing Bach and boogie." Over the years Gordon and Jacobi experimented with swapping acts between clubs, a kind of cultural exchange program across the great divide of Fourteenth Street. The Vanguard sent the acts Barbra Streisand, Pearl Bailey, Corey, and Alan Arkin, then a young folksinger, uptown. The Blue Angel sent Orson Bean, Woody Allen, Mort Sahl, and Lenny Bruce (who bombed at the Angel) to the Vanguard. The Blue Angel would close in 1963 as the golden era of lavish nightclubs faded and a new generation of rock clubs and discotheques was coming on.

In 1948 Gordon met his future wife, Lorraine. She'd grown up a jazz fanatic in Newark and was married at the time to the German-born Alfred Lion, who'd fled the Nazis and arrived in New York just in time to be wowed by John Hammond's "From Spirituals to Swing" concert at Carnegie Hall. With another German escapee, Francis Wolff, Lion founded Blue Note Records. It was Lorraine who talked Gordon into booking his first jazz act at the Vanguard, the Blue Note recording artist Thelonious Monk. The pianist was unknown in the Village, the bebop he'd helped pioneer in Harlem a few years earlier still new and alien. "And nobody came," Lorraine recalls in her memoir *Alive at the Village Vanguard*. "None of the so-called jazz critics. None of the so-called cognoscenti. Zilch . . . And Max kept crying, 'What did you talk me into? You trying to ruin my business? We're dying with this guy.'" Lorraine left Lion and married Gordon, but it still took her some time to convince him to book more progressive jazz acts. Over time, though, the Vanguard became one of the

premier jazz venues in the city. Miles Davis performed there, as did John Coltrane, Charlie Parker, Dizzy Gillespie, Sonny Rollins, and Charles Mingus, among others. In 2009 Barbra Streisand, who'd first sung there as an ungainly bohemian teen from Brooklyn (when Miles Davis had refused to back her, growling, "I don't play for no broads"), gave a rare live performance at the club. Max Gordon had died by then, back in 1989, and Lorraine had taken over running the club. As of this writing she was still there most every night, walking the short distance from her Village apartment.

Cafe Society was another basement jazz club that opened in the Village in the 1930s. It had a shorter life span than the Vanguard but packed much historical significance into it. For most of the 1930s the basement at 1 Sheridan Square had housed one of that area's many themed clubs for the tourist trade, a former speakeasy called Four Trees that had a dungeon decor. In 1938 Barney Josephson, who worked in the family shoe business in New Jersey, came to the Village looking for a spot to open a new club—and a new *type* of club, the first one in the city where blacks, whites, and Jews would mix freely on the stage and in the audience. "I learned about prejudice when I was a kid in Trenton," he later told the neighborhood historian Terry Miller. "I had this idea that one day I'd open a club that would bring audiences and good music together and to hell with the racial barriers." He picked the Village because "I figured I'd have better luck finding an audience ready to accept what I wanted to do. Also, rents were low and I only had $6,000 in borrowed money."

He took over the recently closed Four Trees basement. It wasn't the most felicitous space. It was an odd shape, with large pillars blocking views. There were a few good tables around a small dance floor; otherwise, the best view was from a stool at the bar. Josephson got a trio of Village artists to paint murals on the walls in exchange for open bar tabs, and he borrowed more start-up capital from some progressively minded jazz people he knew, including John Hammond and Benny Goodman. The *New Masses* also backed the club. (Josephson was a supporter of the CPUSA.) Hammond helped choose the bill for the opening night in January 1939, which included a young singer named Billie Holiday, who

went on to a nine months' residency. Lena Horne sang there, as did Sarah Vaughan and Harry Belafonte; a young comic named Zero Mostel zinged the audience with leftist political satire, which would get him in trouble in the postwar Red Scare; the great stride pianist James P. Johnson organized boogie-woogie jam sessions. It's said that when the artist Piet Mondrian came to New York fleeing the Nazis, he first heard boogie-woogie played at Cafe Society and was inspired to paint his famous *Broadway Boogie-Woogie*. Liberal celebrities helped pack the joint and draw the gossip columnists for press.

The new club advertised its uniquely open audience policy with the slogans "The Wrong Place for the Right People" and "The Rendezvous of Celebs, Debs and Plebs." Not everybody got it. Once, a party at a table near the dance floor complained when Paul Robeson got up to dance with Hammond's white wife. Josephson showed them the door. On another occasion Josh White, the black folk and blues singer, was sitting at a table with Alan Lomax when Lomax suddenly jumped up and socked another man on the jaw. The man had complained about being shown a table near a Negro. Staff picked him up and threw him out. At a time when interracial acts were unthinkable, film director Nicholas Ray put White together at Cafe Society with the white torch singer Libby Holman, aka the Statue of Libby. She was already notorious. She'd gotten her first break on Broadway in *Greenwich Village Follies of 1926* and became known for the bluesy tunes "Moanin' Low" and "The House of the Rising Sun," a number she did with White. Scandalously, omnivorously bisexual, Holman took and tossed off numerous lovers, including Jane Bowles and Montgomery Clift; she married the fantastically wealthy R. J. Reynolds heir Zachary Reynolds, then made him so crazy with jealousy he blew his brains out. She was a goddess to the Village's gays and lesbians.

Cafe Society did so well that Josephson opened an uptown version in 1940. Then the Red Scare of the postwar years did him in, as it did many left-leaning people in the entertainment business. When his brother, a stalwart CPUSA member, refused to testify before the House Un-American Activities Committee in 1947, conservatives in the press, predominantly Westbrook Pegler and Walter Winchell, turned on

Josephson and his clubs. Business plummeted and he closed the clubs in 1950. But the racially liberal policy he'd pioneered was taken up by other jazz venues in and around the Village—the Vanguard was one of the first—and the basement of 1 Sheridan Square would continue to play a significant role in Village culture.

THE MAN WHO HAD SUCCEEDED JIMMY WALKER AS MAYOR OF NEW York was another immigrant's son born in the Village, Fiorello La Guardia. He was as fitting a mayor for New York's Depression and war years as Walker had been for the Roaring Twenties. They were opposites in just about every respect, and La Guardia would exert himself heroically to undo the neglect and corruption that had been standard operating procedure in the Walker years. As La Guardia's three terms rolled on, even Walker ended up working for him and admiring him as "the greatest mayor New York ever had." But for all the good he did he left a couple of legacies that had a questionable influence on nightlife in the Village and the city in general.

La Guardia's father, Achille, was a cornet player from Foggia who first saw America touring with the celebrated opera diva Adelina Patti in 1878. La Guardia's mother, from Trieste, was Jewish. They moved to the United States in 1880, renting an apartment in a town house at 7 Varick Place (which no longer exists) in the Italian South Village, where Fiorello was born in 1882. Unlike Walker, La Guardia didn't grow up in the Village. When he was three his father joined the army as a musician and band leader, and until 1898 the family lived on bases in South Dakota, Arizona, and other points west. Fiorello grew up in dusty cow towns where not many kids had names like his, and he did a lot of fighting with boys who gave him a hard time about organ grinders and their monkeys. As mayor he would ban organ grinders from the streets of New York. He was also commonly seen wearing a cowboy hat and a western string tie.

In 1898 the La Guardias left the United States for Trieste, and at eighteen Fiorello went to work for the American consulate in Budapest. He was fluent in five languages, including Yiddish, a skill that would do him well in New York City. He returned to America in 1906 and, after some

Henrietta Rodman.
(*Library of Congress*)

Neith Boyce.
(*Photograph by Frances
Benjamin Johnston.
Library of Congress*)

Mabel Dodge Luhan in a 1934
photograph by Carl Van Vechten.
(*Library of Congress*)

John Reed.
(*Library of Congress*)

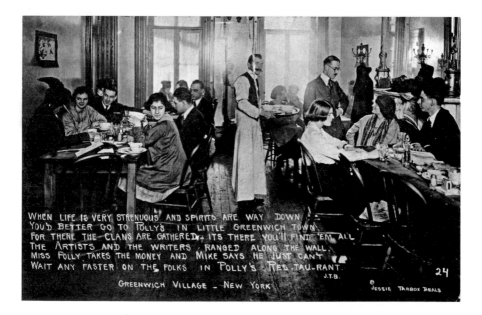

Polly's Restaurant. (New York Times)

Edna St. Vincent Millay and Eugen Boissevain at 75 1/2 Bedford Street.
(*Library of Congress*)

The Provincetown Playhouse today.
(*Photograph by Christine Walker*)

Sadakichi Hartmann, the "King of Bohemia."
(*Library of Congress*)

LEFT: Baroness Elsa and friend. (*Library of Congress*)

BELOW: Romany Marie. (*Photograph by Genevieve Naylor. Corbis Images*)

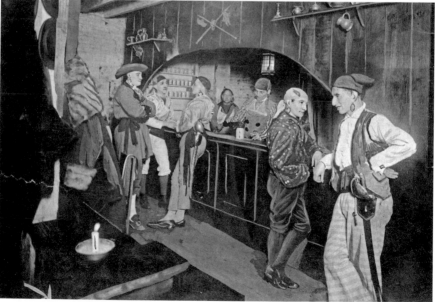

The Pirate's Den, one of the themed speakeasies around Sheridan Square in the 1920s. (*Corbis Images*)

One of Mayor Jimmy Walker's frequent photo ops. Here he poses with
Mr. Televox, a Western Electric "robot," in 1929. (*Corbis Images*)

Maxwell Bodenheim
in 1954, shortly before he
was shot to death.
(*Corbis Images*)

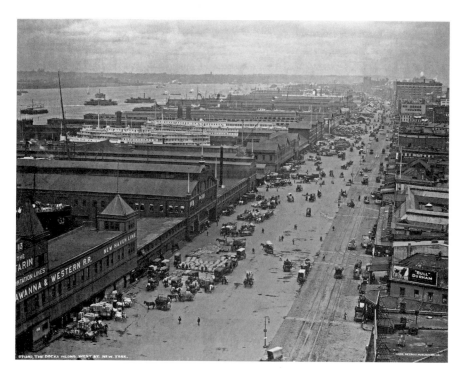

The West Side waterfront as it looked through much of the twentieth century, crowded with piers and "sheds." (*Corbis Images*)

Woody Guthrie, 1943. (*Photograph by Al Aumuller. Library of Congress*)

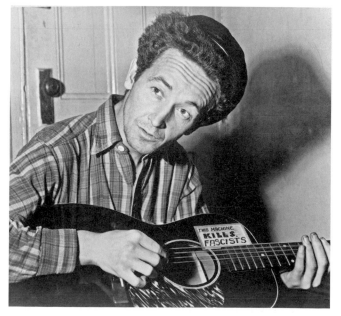

Alfred Leslie in front of one of his paintings at the Whitney Museum, 1959. (*Courtesy of Alfred Leslie*)

Frank O'Hara (*turning his head*) at the Cedar Tavern on a typically crowded night, 1956. (*Photograph by Fred W. McDarrah. Getty Images*)

W. H. Auden at work, 1946.
(Photograph by Jerry Cooke. Corbis Images)

moving around, he was back living in the Village, working as an inter-preter at Ellis Island while putting himself through law school. He joined the Village's Madison Republican Club and was elected to Congress in 1916. When America entered the Great War, Congressman La Guardia enlisted in the army air corps and was sent to Foggia, his father's home-town, where he trained with Italian pilots, flew some missions, and had a Flying Cross pinned to his chest by Italy's King Emmanuel III—whom La Guardia, never one to stand on ceremony, reportedly called Manny.

As mayor from 1934 to 1945 he was the hardest-working man in the city, a tireless micromanager who in every way was the antidote to Walk-er's lackadaisical stewardship. He rarely rested and grumbled about his staff's vacations and sick days. When he got antsy behind his desk he'd ride around town in a sidecar with the motorcycle cops. He chased any fire truck that crossed his path, sometimes plunging headlong into burn-ing buildings to lend a hand. When he saw a line moving too slowly at a city welfare office he fired the supervisor on the spot, promoted the next in charge, and promised to fire him too if the line didn't move a lot quicker. He removed armies of the Tammany clock watchers and shovel leaners from their city jobs and ended graft on city contracts. Between the Walker-era scandals and La Guardia's housecleaning, Tammany's long period as an Irish feed trough ended, though Tammany continued on through the 1950s, notably in Greenwich Village.

One of his more dubious legacies, though he shares the blame with a lot of others, was the Mafia's stranglehold on the city. By the end of Pro-hibition they were experienced racketeers. Corruption and ineptitude hampered law enforcement efforts against them on every level, from the beat cop and borough president to the FBI and the federal courthouse where, for example, the New York appellate judge Martin Manton, nick-named Preying Manton, made a habit of overturning mobsters' convic-tions until he was jailed for taking bribes in 1939. Despite some showy headline victories, the general weakness of the good guys allowed the mob to expand into virtually every corner of New York City life during La Guardia's tenure. They provided muscle for both unions and union busters, perverting huge sectors of organized labor. Through protection

rackets they shook down defenseless proprietors from mom-and-pop stores up to whole industries including the garment trade, trucking and hauling, the waterfront, the fish markets, and construction. They moved into slots, took over the numbers rackets they'd previously eschewed as "the nigger pool," and developed the constant corollary to gambling, loan sharking. They also got into prostitution, running an estimated three hundred whorehouses employing two thousand girls by 1936.

And they made New York City the hub of a global narcotics network. When legislation in the 1920s ended the legal production of heroin in the United States, the evil genius Arnold Rothstein adapted his international bootlegging operations to develop an overseas network that supplied heroin to New York's jonesing users. When Rothstein was rubbed out in 1928, his former associates Lucky Luciano, Meyer Lansky, Frank Costello, and Louis "Lepke" Buchalter took over and expanded the business. They made New York America's importing and distribution center for heroin from Marseilles—the infamous "French connection." Lansky and the rest continued the business even after the New York State special prosecutor Thomas Dewey put Luciano, who'd risen to first among equals of the Five Families' bosses, behind bars on a thirty-to-fifty-year sentence in 1936. (He'd be paroled after serving only ten.) Because New York, as the port of entry, had the nation's cheapest and most abundant heroin, it attracted junkies from around the country. By the end of La Guardia's tenure half of all the junkies in the country would be in New York City. Heroin use would be a scourge in the Village for years to come.

The mob also retained a deep and wide involvement in New York bars, nightclubs, restaurants, burlesque theaters, and other entertainment venues. State and city efforts to drive the mob out of these businesses ranged from the serious to petty harassment. As soon as Prohibition ended, the New York State legislature passed a raft of new laws about the sale and consumption of intoxicating spirits and created the State Liquor Authority (SLA) to enforce them. Along with wine shops and liquor stores any bar, club, restaurant, or hotel serving liquor now had to be licensed by the SLA, and any establishment violating any of the many pertinent laws risked heavy fines or even closure. This had a curious impact on the city's

gay- and lesbian-friendly establishments. Although homosexuals were not specifically cited anywhere in SLA regulations, police interpreted the rules against running a "disorderly" establishment to mean that "even the presence of homosexuals . . . in a bar made that place disorderly and subject to closure," David Carter notes in his book *Stonewall*. "Making it illegal for bars to serve homosexuals created a situation that could only attract organized crime." As licensed bar owners grew watchful of and hostile toward any sign of homosexual behavior on their premises, the Mafia stepped into the vacuum and ran many of the city's *illegal* gay and lesbian bars and clubs, selling "watered-down drinks at inflated prices, often made with ill-gotten liquor from truck hijackings," according to the journalist Lucian K. Truscott IV. To get around the SLA, the mob ran many establishments as "private bottle clubs" or after-hours places that were in effect latter-day gay speakeasies, ostensibly open to members only. It wasn't a question of mobsters being tolerant of homosexuals. Most mobsters despised them but were happy to exploit them, additionally using the bars and clubs as centers for gay prostitution and pornography rings, dope peddling, money laundering, and extortion rackets targeting wealthy closeted gays. In their lurid exposé U.S.A. *Confidential* from 1952, Jack Lait and Lee Mortimer claimed, "All fairy night clubs and gathering places are illegal, and operate only through pay-offs to the authorities. They are organized into a national circuit, controlled by the Mafia which also finds unique opportunity to sell dope in such dives." This tradition of gay and lesbian clubs with mob backers would lead directly to the 1969 Stonewall riots, the Bunker Hill of the gay liberation movement.

La Guardia meanwhile made a great symbolic show of cleaning up Forty-second Street and Times Square, which mob money was turning into a tawdry zone of burlesque theaters, strip joints, gambling dens, whorehouses, and clubs that featured drag performances or were known to cater to gay or lesbian clientele. Just as he had personally tossed the mob's slot machines into the harbor while newsreel cameras whirred, he padlocked some of these joints with his own hands for the cameras. And just as the mob simply trucked their slots to other cities with less hyperactive mayors, the gangsters relocated their clubs to other neighbor-

hoods. The drag clubs and gay and lesbian spots tended, naturally, to head for Greenwich Village or what's now the East Village.

• The Howdy Club, a cabaret bar with both lesbian and drag performers, relocated to West Third Street near Mercer Street. The Howdy was known for its lesbian staff and drag king performers and even fielded its own all-woman football team. In 1936 the *New York Post* called it "The Village at its strangest—and not for the squeamish." In 1938 three gunmen in the process of robbing the club got into a firefight with a police officer. He died from a bullet to the head. One of the robbers struck a young female patron, Norma De Marco, on the head with his pistol as she went to the patrolman's aid. The next night Norma committed suicide by leaping out of a twelfth-story apartment window. It's likely that she killed herself from extreme distress; the press coverage of the Howdy Club robbery had named Norma, effectively outing her.

Closer to MacDougal Street on West Third was Tony Pastor's Downtown, which, according to the drag performer and hustler Minette, was also a hangout for both lesbians and female impersonators. In his chapbook memoir *Recollections of a Part-Time Lady*, Minette recalls:

> The lezzies used to mix with the drag queens. The fairies and the lezzies didn't mix, but the queens did because we all used to hustle at Tony Pastor's on West 3rd Street. The johns would come in looking for something kinky or to try to convert a lezzie . . . So after a few drinks, the lezzies would turn them over to us and the john would end up with a queen. The queens looked so much prettier anyway, 'cause we tried.

Both clubs were raided on morals charges in 1944. According to *Variety*, the Howdy was padlocked for "presenting a show in which a male dancer, Leon La Verdi, gave a performance that 'exhibited feminine characteristics which would appeal to any male homosexual' present." Pastor's was found guilty of "permitting Lesbians to loiter on the premises and similar charges." The following year the jazz guitarist Eddie Condon reopened

the Howdy as a jazz club, retaining the old name. It was a popular spot through the 1960s. Pastor's also survived, apparently with mob backers.

In 1941 La Guardia introduced new cabaret laws that had little effect on the mob but made life miserable for everyone else in the business. The new laws required nightclub owners and all employees, from performers down to the hat check girl and the busboys, to get fingerprinted and carry picture ID cards. If you had any police record you couldn't have a card, which meant you couldn't work. Enforcement by the NYPD was haphazard and arbitrary, and charges of corruption and bias abounded. Mobsters easily got around it but it could be disastrous for performers. Billie Holiday, Thelonious Monk, and Charlie Parker would have their cards yanked for drug violations; Lenny Bruce would lose his because of an obscenity conviction; the exotic dancer Sally Rand, refused a card in 1947 because the cops thought her fan dance too risqué, would take the NYPD to court over it and win.

From La Guardia's time on, the mob would be an accepted presence in the Italian Village, an integral part of the social web, which functioned as a source of jobs and loans, a charitable organization, and a private security force that kept the blocks clean of anyone who looked like they "didn't belong." One of the most powerful and colorful of all mob dons, Vincent "Chin" Gigante, was born to poor Sicilian immigrants in the Village in 1928. He got his nickname Chin as a boy; it came from the way his mother pronounced Vincenzo, leaning out a window at suppertime and calling down to the street, "Chin-*chayn*-zo!" On his orders, wiseguys never said his name in public. They just pointed to their chins or made a C with thumb and forefinger. He dropped out of school at sixteen to begin his life of crime as a petty hoodlum on Village streets. By the 1950s he was the capo of a Village crew loyal to Vito Genovese. After Genovese died in federal prison in 1969, Chin eventually rose to be the boss of the Genovese family. He built it into the Rolls-Royce of Mafia families, with extensive and very lucrative operations in narcotics, loan sharking, extortion, trucking and shipping, construction, nightclubs and bars, the Fulton Fish Market, and the Jacob K. Javits Convention Center.

Through the 1970s and '80s Chin was a local landmark on the block of Sullivan Street between Bleecker and West Third Streets. Every morning he would visit his mother in her fourth-floor walkup on the east side of the street, then in the late afternoon or evening he'd cross to the Triangle Civic Improvement Association, a dumpy storefront with soaped-up windows at 208 Sullivan. It was his private "social club." He'd spend the evening in there playing pinochle, running the Genovese family business in whispered conversations. By then he'd developed the crazy act for which he came to be known as the Oddfather and the Daffy Don. To stay out of jail he pretended to be mentally incompetent. In public he always appeared in a ratty bathrobe, pajamas, and slippers, unshaven and unkempt, looking dazed, muttering. He teetered across Sullivan Street in tiny steps, with a couple of the boys at his elbows pretending to help him along. Sometimes he'd stop to urinate on the sidewalk. The FBI knew that a mental defective couldn't be running an empire as successful as the Genovese family's, but it took the Bureau decades to get the goods on Gigante. Agents tried to bug the Triangle, photographed the comings and goings, tapped phone lines, and even bugged the rearview mirrors of cars parked on Sullivan Street, hoping to snatch Chin's muttered conversations as he shambled past. Periodically over the years he would check into one psychiatric facility or another to shore up the ruse. It worked until his arrest in 1990. After years of legal maneuvering he was finally convicted of racketeering in 1997 and died in a federal penitentiary in 2005. The Triangle is now Sullivan Street Tea & Spice Company.

# Swag Was Our Welfare

WORLD WAR II ENDED THE GREAT DEPRESSION; AS A JOBS AND economic stimulus program it dwarfed FDR's New Deal. Several sectors of New York City's economy, licit and illicit, thrived. By midwar New York was at its "boomtown boomiest," *The New Yorker* crowed. There were jobs for anyone who wanted them, on the bustling waterfront, where the Brooklyn Navy Yard alone employed seventy-five thousand, in factories (New York City was still a major manufacturing center), and in offices. Women poured into jobs either newly created by the wartime boom or left vacant by men now in uniform. Toward the end of the war Rosie the Riveter held a third of all manufacturing jobs, more than double prewar levels. With money in their pockets for the first time in a decade, New Yorkers looked for ways to spend it. Between locals and the crowds of soldiers and sailors in town on weekend passes, the city's clubs, movie houses, and restaurants soared again. Broadway theaters were reborn; in the 1943–44 season alone they staged forty-one comedies, thirty dramas, and twenty-five musicals. *On the Town* and *Oklahoma!* both debuted

during the war, and both outlived it, inaugurating the golden age
of the Broadway musical. Historians credit the wartime boom with
expanding diversion-starved audiences for art museums, the sym-
phony, the ballet, and modern dance as well. The Village, crowded
with clubs, eateries, and cultural workers, shared the windfall.

Another by-product of that wartime boom would have a significant
effect on lifestyles in the Village, artificially extending its life as a place
of cheap rents and a magnet for bohemians and artists. To stem the rising
tide of inflation caused by the bustling economy, the federal government
instituted wartime price controls, including a freeze on rents. And when
federal rent control ended after the war, New York State enacted its own
programs, maintaining rents well below market rates in qualifying build-
ings. In New York, a city of renters, rent control and rent stabilization
were godsends to tenants lucky enough to be in the right units, but a
curse to their landlords. As real estate prices rose in Manhattan through
the rest of the twentieth century, lower-income tenants, including artists,
were able to stay in apartments they never could have afforded otherwise.

For Italians in the South Village, as for all Italian Americans, the war
exacerbated rifts between the older, immigrant generation and their
American-born kids. The older ones, conservative by nature and often
illiterate, tended to view Mussolini and the Fascists in terms of Italian
national pride. The federal government deepened their unhappiness
over the war against him by classifying many of them as "alien enemies,"
placing restrictions on their rights to travel and own property. For their
American-born children, on the other hand, the war represented escape
from the strictures of old-world family life. Young men went off to war
and to see the world; young women went off to jobs in factories and of-
fices. They now had independent incomes they could spend on enter-
tainment and clothes. Some became war brides, hastily marrying boys
in uniform who maybe weren't Italian and whom their parents might
not even have met, much less approved of. At Greenwich House, a group
called the Italian Mothers' Club met to fret about how to keep their
daughters down on Sullivan Street after they'd seen Times Square.

With their moms on the factory floor and their dads in uniform or

killed in action, the war also created a generation of latchkey kids and war orphans. Worries about these unsupervised children growing up into drug-taking, switchblade-flicking juvenile delinquents started during the war and amped up to levels of moral panic in the postwar years and through the 1950s. "No community, rich or poor, rural or congested, is free from the plague of juvenile delinquency," Jack Lait and Lee Mortimer warned. "Like a heathen religion, it is all tied up with tom-toms and hot jive and ritualistic orgies of erotic dancing, weed-smoking and mass mania, with African jungle background."

In the Italian Village, these fears had some basis in fact. By the mid-1950s young dope addicts and hoodlums were a major concern to the neighborhood's social workers and church leaders. When Howard Moody, an ex-marine veteran of Guadalcanal, took over as pastor of Judson Memorial in 1956, he told the new *Village Voice* that programs for young heroin users were his first priority. He was still trying to get local and federal governments to take the problem seriously a decade later. Reverend Moody would be at the Judson until 1992, transforming it into possibly the most progressive church in the country. Under his stewardship, with his assistant the Reverend Al Carmines in the 1960s and '70s, Judson resembled less and less a church and more an all-faiths community arts center leaning distinctly toward the bohemian, hippie, and avant-garde.

Though a contentious time for most Italian Villagers, the war was good to the mob. The servicemen flooding the city kept mobsters' clubs, gambling dens, and whorehouses busy while the city, state, and feds virtually suspended their racket-busting operations for the duration. Even the former mob-chasing prosecutor Dewey, now governor, was too busy prepping for his presidential campaign to think much about the syndicates. That same blind eye would be turned toward the racketeering on the Village's Irish waterfront for the duration of the war.

The Village in 2011 was much less Irish than it was during wartime, but some guys who grew up there in the 1940s and '50s were still around. A handful of them, now gray-haired men in their late sixties and up, met for lunch every week at the White Horse Tavern on Hudson Street. They

had names like Kelly, Mullens, O'Connell, McGee. They all grew up within a few blocks of the bar and had been pals since childhood. Virtually all of them were vets. They had worked as moving men, bartenders, security guards, and at the big Nabisco factory in Chelsea that now housed the Chelsea Market (and where the Oreo was invented). People said they were wild and tough boys in their younger days—drinkers, gamblers, brawlers. Now in retirement, they mostly drank juice or club soda, although one cracked the others up by ordering a nonalcoholic beer with a double tequila chaser. They scraped the butter off the rolls that came with the soup, speaking with fatalistic tough-guy shrugs about their last heart attack or their next trip to the cardiologist. And with almost no prompting they told stories about the Village and the West Side waterfront of their youth.

They remembered a neighborhood that was largely Irish, with pockets of Spanish, Lithuanian, Polish, Jewish, German, a few black families, later Puerto Ricans. "The prejudice was against the Italians," Tom Kelly said. "Not the blacks or Puerto Ricans. They were sort of accepted as long as they fought the Italians."

When they were kids the buildings were all still heated with coal. Coal ash and cinders from chimneys coated every outdoor surface in the winter. When they went up after playing in the street, their clothes were filthy with it and their moms gave them hell. In the summers they'd swim in the Hudson, jumping or diving off the piers. Just getting to the water took some doing. The waterfront was very different from the way it is now. From the Battery straight up the West Side it was crowded with working piers for cargo operations, transatlantic cruise ship companies, and Hudson ferries. Very few of them were open. Most had buildings on them called "sheds," a name that didn't do them justice. They were warehouses, loading docks, railroad barns, and passenger terminals—imposing brick and steel structures with footprints big as football fields and standing three or four stories tall. "You walked along West Street, you didn't see the river," Kelly recalled. Only a very few piers, like the one at Gansevoort Street, were open. "That's where we went swimming. Right next to the Department of Sanitation dump." There was so much trash

and garbage in the water "you learned how to do the breaststroke," pushing it out of your way.

In the hot weather "there was one fan in your mother and father's room—if they were still together and your father wasn't upstate. So you slept on the fire escape." Most of them grew up in tenement buildings, in railroad flats, with windows facing the street in the front room and windows on narrow air shafts in the back rooms. Kids got the back rooms. Kelly's bedroom window was directly above Tim Mullens's in a tenement on West Eleventh Street, just down the block from the White Horse. They hung a tin can and string communication system down the air shaft between them and later graduated to actual walkie-talkies. "We could've just talked out the window, but that was no fun."

Parents always took the front room, so all the moms could lean out the windows and keep an eye on the street. One lady was known as Elbows Smith because she was always leaning out, with a pillow under her elbows. "You couldn't get away with anything within eight blocks of your house without your mother hearing about it," Kelly said. Mullens recalled that when he played hooky he would run alongside the Hudson Street buses as they passed Eleventh Street, "so the neighbors—Mrs. Sherman, Mrs. Donovan—couldn't see me out the windows."

They were all working-class poor, their dads struggling to keep their large Irish Catholic families in food and clothes. Eight kids, twelve kids, thirteen kids was the norm. Supplementing the family income by illegal means was common practice, and trips to Sing Sing or Dannemora for Dad or his sons were regular occurrences. Kelly recalled a friend who was one of thirteen kids once telling him, " 'You know why there are only thirteen of us? There's two years between this one and that one, three years between those two. That's when my father was up the river.' Every family had somebody in trouble . . . It wasn't a stigma."

When these guys were growing up, the West Side waterfront, with its gangsters, crooked union bosses, and Tammany pols, was enjoying its last hurrah—the On the Waterfront years. (Budd Schulberg based his screenplay on Malcolm Johnson's eye-opening series of twenty-six articles for the New York Sun, "Crime on the Waterfront," for which he won a Pulit-

zer in 1949.) Much of the criminal activity in the neighborhood spilled out from the docks. "The waterfront was rough. It was bad," Kelly said. A lot of Irish men in the neighborhood worked on the docks. Longshoremen were what is euphemistically known as "casual labor," meaning they worked and got paid only when a ship was in. "You worked for that pier and that company. The Grace Line, the Holland American, whichever." When you had work, there was a whole system waiting to take your paycheck away. West Street, in the shadows of the elevated West Side Highway, was lined with "cheap lunchrooms, tawdry saloons and waterfront haberdasheries," according to the 1939 WPA *Guide to New York City,* which catered to the dockworkers, truck drivers, and thousands of sailors from around the world who came in on the cargo ships and ocean liners. "On every block you had at least one bar, some blocks two," Kelly said. "And every single bar had a bookmaker." On payday the moms in the neighborhood sent their oldest boys to look for Dad in the bars and try to bring at least some of his pay home before he drank and gambled it away. If he did, there was also a loan shark in every dive to help him out, at a crushing interest rate.

When there was no work at your pier, you tried to pick up some day work on a pier that was busy. This required showing up in the morning for the "shape-up," when union hiring bosses, either at the pier or at the union hall, picked extra hands as needed that day. "All the guys on your pier aren't working either, so you've got fifty to a hundred guys all looking to get in," Kelly explained. Maybe one in three would be picked; the rest returned to hanging out in the bars, hoping there'd be another shape-up that afternoon. It was a system obviously built for exploitation, graft, and bias. Irish workers got picked over men of other ethnicities. If black men got any work at all it was the lowest brute labor, jobs the white workers shunned. This is why, when waterfront unions called strikes, black workers were happy to act as scabs—they felt they owed nothing to the white union men. The longshoreman who got work was expected to kick back some of his pay to the hiring boss. The loan sharks had their own arrangement. For instance, if a man fell behind in his payments, he was told to wear a toothpick behind his ear at the shape-up. The hiring boss would

spot this signal and hire the man, who then had to kick some of his pay to the boss and some to his loan shark. Everyone came out ahead except the longshoreman. Waterfront gangsters and hoodlums, meanwhile, extorted the bosses for their own kickbacks or leaned on them to hire their men, who quite often never showed up at the dock except to collect their paychecks. The gangsters also made money by charging the shipping and trucking companies steep fees to move the cargo that came in.

The whole system was enforced with violence. Anyone who didn't play ball—longshoreman, hiring boss, truck driver—was beaten or killed. The threat of violence also ensured that everyone on the waterfront observed a strict code of silence, or "D and D" (deaf and dumb), that for decades stymied the law. The assistant district attorney William Keating, who prosecuted waterfront murders in the 1940s, called them "the most hopeless of cases . . . On the waterfront, to talk was to rat, and to rat was to stand exposed and unprotected." One man shot by his rivals and lying in the hospital snapped at detectives, "I don't know who shot me, and if I did I wouldn't tell you."

In 1947, Andy Hintz (rhymes with pints) stepped out of the door of apartment 3A at 61 Grove Street, next door to the spot where Tom Paine died, and headed down the stairs to the street. On the second-floor landing he came up against three men: the waterfront racketeer "Cockeye" Johnny Dunn, the gunsel "Squinty" Sheridan, and Dunn's gofer Danny Gentile. Dunn had an interest in the hiring and loading on all the piers south of Fourteenth Street—except on Pier 51, at the foot of Jane Street. As the boss stevedore there, Hintz refused to hire the men Dunn told him to or pay Dunn the kickbacks he demanded. This rare show of defiance could have only one end. Dunn put five bullets into the stout longshoreman before escaping across the rooftops. As he lay dying in St. Vincent's, Hintz refused for three days to rat to the law. Then, asked one last time who shot him, he is said to have uttered the immortal line, "Dunn. He done well too," and died. The Hintz case cracked the long-standing code of silence. Cockeye and Squint were convicted and died in Sing Sing's electric chair in 1949. Keating later cooperated with filmmakers on the 1957 dramatization of the story, *Slaughter on Tenth Avenue*.

Whitey Munson, grandfather of White Horse owner James Munson, "was a boss down at the docks," Kelly said. "Tough man. You didn't mess with him. He was well liked by some people because Thanksgiving and Christmas no family was ever without a turkey. If your husband was up in Sing Sing or Dannemora, you got taken care of." Like a lot of men in the city at the time, Whitey kept pigeons in a coop on the roof of his apartment building. In the Irish Village, "a big thing was stealing somebody's pigeons and then selling them to somebody else," Mullens said. Whitey once caught a friend of theirs up on the roof trying to steal some of his birds. "He says, 'I know your parents. I know your grandparents. You might as well go kiss them good-bye if you ever come up on this roof again.'"

"When we were younger the White Horse was considered a Communist bar," Kelly recalled. "A lot of the people that hung out here were merchant marine and dockworkers, but they were the radical left of the dockworkers. Old guys who'd been in the Abraham Lincoln Brigade were there too." Starting in the late 1930s and continuing in the 1940s, leftist unions such as the International Seamen's Union and the National Maritime Union, which were affiliated with the CPUSA and the upstart CIO, sought to break the stranglehold the corrupt International Longshoremen's Union and AFL had on the waterfront. Their organizing and strikes led to pitched battles in the streets, local against local, brother against brother. "Right out here," Mullens said, nodding at the tavern's wide windows. One guy they knew, "big guy, tough guy," kept his pockets full of marbles to throw under the hooves of the mounted cops' horses when they came to break up the fights. Dorothy Day's Catholic Worker House of Hospitality over on Mott Street housed and fed striking leftist union men. The loyalty oaths employers and unions started requiring during the postwar Red Scare put a lot of the leftist seamen out of work, so they had plenty of time to sit in the bars and sing "The Internationale." The writer and social activist Michael Harrington, who came to the Village from the Midwest in 1949, writes in his memoir that he was a nightly regular at the Horse from 1951 to 1961. He recalls that "on a number of occasions during the McCarthy years Irish working-class kids from the

neighborhood made fist-swinging, chair-throwing raids on the Horse. They used to scream that we were Communists and faggots." One night he and some of the waterfront radicals left the Horse and went down the street to the Paddock, another Irish longshoremen bar. When they got to singing some of their old workers' songs the manager had to call the cops to protect them from the other, solidly anticommie union men in the place.

The National Maritime Union survived the battles and by the 1960s was such an established presence that it hired an architect to design three of the oddest modern buildings on the West Side. The two seamen's dormitories up in Chelsea have round portholes for windows, making them look like giant wedges of Swiss cheese. The union headquarters and hiring hall in the Village, at Seventh Avenue and West Twelfth Street, is an upside-down ziggurat with the porthole shapes broken into wavelike overhangs, the exterior coated in small white tiles. The union built these flamboyant oddities just as the waterfront was dying; the Chelsea dormitories are now a hotel and St. Vincent's Hospital bought the hiring hall.

When Kelly and Mullens were young, some percentage of every cargo that came into the docks—fresh bananas, canned goods, clothes, shoes, cigars, appliances, whatever—was siphoned off by the gangs. The shipping lines treated it as a kind of unofficial added tariff, just another cost of doing business in New York. Kelly and Mullens said that pretty much everybody in the Irish Village accepted these stolen goods, aka swag. "When there was a couple of ships in, you could walk down Eleventh Street to West Street, and the people who had cars were parked all along there with the trunks opened up," Kelly said.

"Swag was our welfare," Mullens explained. "My mother paid thirty-two dollars and twenty cents for rent. When it went up to fifty she hit the ceiling. But swag was plentiful." He remembered once going down into a basement on Christopher Street where some guys were selling televisions stolen off a pier. "All of a sudden there's two cops standing behind me. They're waiting in line too."

Once, when Kelly was a kid, a shipment of Del Monte canned string beans pilfered off a dock made its way into all the tenements. He remem-

bered cartons stacked in the hall outside his family's apartment. His mother cooked string beans with every meal until they were gone. "To this day I cannot stand the smell of string beans," he said.

It all began to die out when the shipping companies switched to containerized cargo in the 1950s and '60s and transatlantic air travel began to replace cruise ships. The gangs and unions who ran the West Side docks resisted every effort by the Port Authority to modernize for the new container age. As a result, the shipping companies started using the upgraded Newark and Elizabeth, New Jersey, docks, throwing a lot of guys in the Irish Village out of work. By the mid-1960s the Irish were leaving the neighborhood in a steady stream, the once-bustling Village waterfront having crumbled into disrepair, abandoned and unused.

PART III

The Greenwich Village
Renaissance

# A Refuge in the Age of Anxiety

Aftan THE WAR Greenwich Village served again as a tiny speck of American real estate where nonconformists, individualists, bohemians, progressives, avant-gardists, experimenters, gays and lesbians could gather and feel at home. Bringing creative and iconoclastic individuals together in a small area stoked the Village's culture engine to a new level of productivity. If the 1910s were really Village bohemia's golden age, then this was the Greenwich Village Renaissance. New York City rose to be the cultural capital of the Western world in this period, and much of that rise was driven by the small community of self-exiled misfits who gathered in and around the Village.

They came to the Village to escape from an America that was suffering a kind of collective post-traumatic stress disorder. Following a decade of the Depression, the war had ripped an entire generation of Americans from family farms, small towns, and big-city neighborhoods and hurled them out to the wide world where they witnessed and often participated in the most shocking savagery and depravity humanity can display.

Along the way, they experienced cultures and behaviors that were entirely foreign to them. Military personnel saw liberal attitudes toward art, religion, and sex they probably never would have become aware of at home, while on the home front a nation of women and girls experienced the life of the independent wage earner for the first time.

Now that the war was over, millions of GI Joes and Rosie the Riveters were expected—and often wanted—to settle back into "normal" lives. Their latchkey kids, now "teenagers"—the term and the concept were invented at this time—were supposed to buckle down, shine their shoes, get good grades, and join the football team or the cheerleader squad. The daily threat of nuclear holocaust sent American society into full-scale withdrawal. White Americans retreated en masse to the suburbs; the corporate cubicle; the promise of consumerist prosperity; the lockstep patriotism of the loyalty oath; the sexless, nostalgic fantasies of Doris Day movies and Disneyland. In many ways, white America in the 1950s was stodgier, more conservative, less sophisticated, and less hip than it had been at any previous time in the twentieth century. Willfully so.

Norman Mailer described it as "the psychic havoc of the concentration camps and the atom bomb upon the conscious mind of almost everyone alive in these years." Anatole Broyard, who moved to the Village in 1946, later wrote, "The war had broken the rhythm of American life, and when we tried to pick it up again, we couldn't find it—it wasn't there."

The poet W. H. Auden, who moved to the Village the same year as Broyard, gave the era an enduring name. Auden and his friend Christopher Isherwood had arrived in New York from a Europe plunging into war in January 1939. Isherwood moved on to join Aldous Huxley's circle in California but Auden stayed in New York. Through Random House editions of his books he had already developed a cult following among New York poets, including Delmore Schwartz. Previously a somewhat lazy writer, he acquired a very New York City Benzedrine habit that powered him through his prolific next two decades. Right away he wrote the libretto for Benjamin Britten's *Paul Bunyan*, numerous book reviews and essays, and fine new poems, such as "September 1, 1939," commemorating the day Britain declared war on Germany.

In 1946 he took U.S. citizenship and settled in a tiny apartment on the fourth floor of 7 Cornelia Street, a charmless modern elevator building mashed between two tenements. Jug-eared, mule-faced, with large, raw hands and squinty eyes, limbs perpetually akimbo in corkscrewed clothes, not walking so much as gallumphing, he "looked exactly like a half-witted Swedish deckhand," according to one acquaintance. Auden professed to dislike the Village, but it refused to return the favor. He taught an evening class in Shakespeare at the New School that was so popular a faculty member joked you might have thought *Shakespeare* was teaching a course on *Auden*.

Visitors to his cramped Cornelia Street hovel were disgusted by the squalor. Tennessee Williams called it "fantastically sordid." Igor Stravinsky, for whom Auden wrote the libretto to *The Rake's Progress*, fearfully watched mice snack from dirty dishes piled in the sink. It was in this mess that he completed his longest and in many ways most elusive poem, *The Age of Anxiety.* He wrote it in the iron-clanging alliterative tetrameter of the Anglo-Saxon poetry he had first come to love at Oxford under a young professor named J. R. R. Tolkien. It's the narrative of four loners who meet up in a bar on Third Avenue and drunkenly reflect on many things, including an age "tamed by terror," a grim world "Of convulsion and vast evil, / When the Cold Societies clash / Or the mosses are set in motion / To overrun the earth, / And the great brain which began / With lucid dialectics / Ends in horrid madness." The book won a Pulitzer; it inspired Leonard Bernstein's second symphony, to which Jerome Robbins choreographed a ballet; and journalists and other writers began using "the age of anxiety" as an alternative term for "cold war era."

Refuges for self-exiled nonconformists were very rare in this era. There was not yet a globally connected counterculture with nodes in every city and on every college campus—that would develop in the 1960s—much less an Internet where far-flung misfits could gather in virtual communities. "Our generation in the fifties needed the Village and all it stood for as much as the artists, writers, and rebels of preceding generations—maybe even more," Dan Wakefield writes in *New York in the Fifties.* If everyone else was conforming, "surely it was all the more important to

have at least one haven where people were not only allowed but expected to dress, speak, and behave differently from the herd." The poet Edward Field, who had grown up in Brooklyn and navigated B-17s on bombing raids over Europe during the war, arrived in the Village in 1946 to attend NYU on the GI Bill. In his memoir *The Man Who Would Marry Susan Sontag* he writes, "If we were social outcasts, we were proudly, defiantly so. But back then, we were a pitifully small band in exile—homosexuals, blacks, sluts, psychotics, drag queens, radicals of all varieties, artists, ne'er-do-wells."

In the Village they felt free not only to be different but to flaunt it. At a time when mainstream American sexuality was being repressed and sublimated until it squeaked out in the depraved titillation of *Playboy* and Marilyn Monroe movies, the Village once again presented itself as a sexual playground, straight and gay, vanilla and kinky. People still called it free love, and it was still—now maybe more than ever—a rebellious act, a rejection of bourgeois inhibition. Young men flocked to the Village having read about the loose girls there in Bodenheim's novels, in men's magazines, in cheap pamphlets with titles like *Secrets of Greenwich Village*. ("You may think it daring, shocking—but its bold, intimate pages will leave you breathless. POSITIVELY NOT SOLD TO ANYONE UNDER 18!") Young women came to the Village to throw off their Freudian inhibitions and Reichian body armor. Previously in the century American women had freed themselves of their corsets and starched lace and floor-sweeping skirts. Flappers in the 1920s went braless in loose-fitting tops and their skirts rose above the knee. American women never before (or maybe since) looked as stylish as they did in the late 1930s. In the 1950s their bodies were reimprisoned in bullet bras and girdles, hidden under hoop skirts and petticoats, their feet trapped in murderous heels, their hair in elaborately stiff helmets encasing meticulously made-up faces. Village girls threw that all off. They let their hair down, wore dungarees, and, to the stupefied delight of the males, often wore no bras under their loose peasant blouses. Instead of garter belts and stockings they shopped at Goldin Dance Supply on West Eighth Street for simple black tights. In fair weather, they'd forgo heels in favor of that enduring symbol of the new woman, sandals.

Also, at a time when Eisenhower America boosted the Protestant work ethic to new heights, Village bohemians refused to enter the gray flannel rat race and proudly loafed like Whitman. David Amram says he earned his "PhD from the University of Hangoutology" in the mid-1950s, when everyone would go to the diners around Sheridan Square and sit until five in the morning eating hamburgers and shooting the breeze. A Village denizen named Anton Rosenberg became the icon of hangoutology. Although he was a painter and jazz pianist of some talent, he was a god to the Beats simply for his supremely cool loafing. In *The Subterraneans*, Kerouac based the character Julian Alexander on him. Hanging out, hanging around, doing nothing, in cafés all day, in the bars or lofts or diners all night—as much as anything else, their steadfast refusal to *appear* to be busy and productive, even though in fact many were getting an awful lot of painting and music and theater and writing done, scandalized the rest of America. Integral to the schtick of Maynard G. Krebs, the resident beatnik on *The Many Loves of Dobie Gillis*, was his panicked response whenever he heard the word "work"—or, as he pitifully yelped it, "wer-crk!"

A new kind of hangout came to the Village in the 1950s. Coffeehouses were to the Village of the 1950s what tearooms had been to the 1910s. At first there was only the Caffe Reggio, the granddaddy that had been there since the 1920s, followed by the Rienzi, started by a painter, David Grossblatt, in 1950, after enjoying those in Paris where he'd studied art after the war. They were both on MacDougal Street. By the end of the 1950s the streets around the intersection of MacDougal and Bleecker would be lined with them. They were popular with students, artists, musicians, and bohemians because they were cheap places where they could loiter, talk, and read Sartre. Like the tearooms, they were relatively inexpensive and easy for first-time entrepreneurs to start up.

And of course there were the bars. Virtually everyone on the scene drank, and bars were the nodes of much Village socializing. Many drank hard, drank daily, drank to excess, ended up damaging their careers or killing themselves with drink.

"Booze was a big deal," Roy Metcalf recalled in the 2010s. "It was con-

sidered almost an honor to get drunk." Born in the Bronx in 1927, he went to Rutgers on the GI Bill after the war and got a job as a reporter at the *Daily Mirror*. He never lived in the Village but did a good deal of drinking and hanging out there.

Metcalf saw two famous writers drinking themselves to death at the White Horse Tavern. Dylan Thomas "was always drunk, with his head on the table, surrounded by young people who, you know, wanted to hear something poetic." Thomas drank his last whiskeys at the White Horse early in his fourth visit to the United States in 1953. His volumes of collected poems and *Portrait of the Artist as a Young Dog* had earned him a growing following in the States through the 1940s. After his first long reading tour in 1950 he was one of the most popular writers in the English language, and on subsequent visits to America he was feted and celebrated like a rock star. Poetry and literature mattered to young people in the postwar years the way rock would in the 1960s. The shy Welshman, who had already been struggling with alcohol and failing health for years, responded to fame and success the way Bodenheim had, and his visits to America deteriorated into legendary nonstop benders. The White Horse was his watering hole of choice in New York. By that visit in the fall of 1953 he was a wreck. In November, after two nights of drinking at the White Horse, he sank into a coma in his room at the Chelsea Hotel. He died in St. Vincent's. He had just turned thirty-nine.

"The diagnosis was massive insult to the brain stem," Metcalf recalled. "You gotta drink God knows how much booze to do that. It's a damn shame."

In 1945 Delmore Schwartz returned to the Village from Harvard, where he'd taught English during the war. He'd found his students uniformly ignorant and that standing in front of a classroom full of them was torture, but at least it provided occasional comic relief, as when one coed he asked to read aloud from "The Love Song of J. Alfred Prufrock" misread a line as "Shall I part my bare behind?" He took rooms at 91 Bedford Street, conveniently just a few steps from Chumley's, and later moved to West Fourth Street, and later again to Charles Street. He met Elizabeth Pollet, a young writer as shy as he was, who had a cold-water

flat on Hudson Street. He married her in 1949. He edited poetry for the *Partisan Review*, which by then had dropped all pretense of political radicalism, and wrote intelligent book reviews and essays for other magazines. He lectured (shyly, haltingly) at the New School. Later he'd get a plum assignment to teach creative writing at Princeton but found it even WASPier and more uncongenial than he had Harvard.

The pit of depression yawned wider and wider. Despite the very high regard in which others held his writing, despite being one of the most anthologized poets of the era, he was terrified that he had in fact peaked at twenty-five and was on his way downhill. New Directions published a slim volume of his fiction in 1948. It was lavishly praised but sold poorly. A friend congratulating him on it at Minetta Tavern was shocked when Schwartz quietly burst into tears. He self-medicated with drinking at the Minetta, Chumley's, the White Horse, other bars. Then he added barbiturates. The drink and drugs aged him in his thirties, coarsened his once fine poet's features, bloated him, and contributed to his increasingly unbalanced mental state. The more he drank the more he lashed out at friends, colleagues, and wife—especially after her 1950 novel A *Family Romance* sold a quarter of a million copies. She left him in 1955.

By 1956 Schwartz was a shambling wreck, holed up in the Hotel Marlton, a dour eight-story fleabag at 5 West Eighth Street between Fifth and Sixth Avenues. Opened in 1900, its cheap rates had always made it a favorite residence of actors, artists, and writers, who at various times included Edna St. Vincent Millay, Lillian Gish, John Barrymore, and later Kerouac, Lenny Bruce, Mickey Rourke, and Warhol's would-be assassin Valerie Solanas. (In the late 1980s the New School took it over and cleaned it up as a dormitory.) By the end of the decade he was drifting from one fleabag to another; the one place he could usually be found was the White Horse, expostulating drunkenly, reading aloud from a tattered copy of *Finnegans Wake*. Metcalf used to see him there. "He was out of his mind by then, the poor guy. He lost hold of himself, I guess." While he deteriorated, he still managed to write fitfully, and his reputation continued to grow. A collection of old and new poems, *Summer Knowledge*, was widely hailed and won him the coveted Bollingen Prize. "The gift is loved but not the gifted

one," he wrote in one poem. Because he was wandering around so much he failed to be among the poets—including Auden and Robert Frost—at JFK's inaugural ceremonies in 1961. The invitation didn't find its way to him until four months after the event.

He went to teach at Syracuse, where the faculty warily avoided him, but some students, including Lou Reed, adored him. In 1966 he was incapable of much of anything, living at the Hotel Dixie and then the nearby Columbia, seeing almost no one, drinking alone in midtown and Chelsea bars. One night in July he lay for an hour in a hallway of the Columbia, dying of a heart attack at fifty-two. He had so distanced himself from everyone that he lay in the morgue for two days before anyone identified him. His canonization as yet another martyr to his art, murdered by an American culture that couldn't care less about its poets, proceeded apace and reached its apotheosis when Saul Bellow's novel *Humboldt's Gift*, based on his friendship with Schwartz, won raves and prizes in 1975.

WELL INTO THE 1950S, THE ARTS SCENE IN AND AROUND THE VILlage remained small and isolated. Everyone knew everyone else. Painters, poets, playwrights, musicians, filmmakers, composers, and dancers worked together, played together, drank together, lived together, slept together, and inspired one another. This promoted a milieu that was, as the poet Kenneth Koch put it, "fizzy with collaboration." Poets wrote plays, their painter friends designed and built the sets, their musician friends played the music, and they all acted in them, with their photographer and filmmaker friends documenting. Art galleries were often cooperatives funded and run by the artists themselves. Their poet friends wrote the exhibition catalogues and often the publicity copy and the reviews as well. In turn, the galleries published small literary magazines of their friends' writing, illustrated by the artists. The wild improvisation of bebop in the clubs inspired the free expression in Abstract Expressionist painting and Beat writing. Happenings drew together creative talents from across the disciplines.

The Off-Broadway playwright Jean-Claude van Itallie, who moved to the Village toward the end of the 1950s, recalls that "there weren't as

many artists as there are now. It was a smaller world and so the compartments came closer together in those days." David Amram put it this way: "Contrary to a lot that's been written, the folk musicians and the jazz musicians and the writers and the painters and the poets and the bartenders and the waitresses and the chess players all hung out together. There wasn't that subdivision of culture."

In their memoirs of the period, Anatole Broyard and the writer-composer John Gruen both describe a Village that was fizzy with collaboration indeed. Gruen and his wife, Jane Wilson, moved to the Village from Iowa in 1949. He was twenty and she was twenty-two. They took a one-room apartment at 319 West Twelfth Street, a brownstone near Hudson Street. They had no kitchen, and shared the bathroom with upstairs neighbors, for forty-eight dollars a month. The other tenants were an aspiring actress, a dancer with Martha Graham, an Italian man who drove a bakery truck, a gay couple who had loud sadomasochistic sex, and a fashion model "who was deep in Reichian analysis and could be found in her orgone box at all hours of the day and night." (Wilhelm Reich's idiosyncratic psychological theories, blending Marxism and antifascism while promoting the cosmic power of the orgasm, scandalized the rest of the world but found a natural home in the Village, where he joined the faculty of the New School in 1939. He believed his orgone boxes collected cosmic rays that could increase sexual potency, heal mental illness, shrink tumors, and cure cancers. This was not an avenue of research destined to go down well in repressed postwar America; from the late 1940s on Reich was hounded by the federal government and eventually died in a penitentiary in 1957.)

Looking for work, Gruen walked into the Fifth Avenue Brentano's, one of the very classiest bookstores in Manhattan, and instantly got a job selling art books to shoppers including Greta Garbo and Salvador Dalí. He also met the poetry anthologist Oscar Williams and his wife, the painter and poet Gene Derwood. Williams and Derwood threw parties at their apartment down in the Wall Street area, deserted and desolate at night. One night the guest of honor was Dylan Thomas. When the Gruens arrived he was on his back, snoring loudly, sleeping off the after-

noon's bender. Gruen met E. E. Cummings at one of these parties; when Gruen and Wilson moved to an apartment on West Eleventh Street—this time with a kitchen—Cummings and his third wife, Marion, would come by for dinner. Jane pursued painting, helping to found the artist-run co-operative Hansa Gallery on East Tenth Street, which launched her career and those of Allan Kaprow (organizer of Happenings), George Segal, and Ivan Karp, who went on to the Leo Castelli Gallery and then his own OK Harris. Meanwhile, offhandedly, the svelte and beautiful Jane became a fashion model. Her unusual dual career landed her in the pages of *Life* and *Glamour* and eventually led to her being a contestant on the popular CBS quiz show *The $64,000 Challenge*.

Gruen took a job at Grove Press, a small publishing house in the Village, which his erratic neighbor Barney Rosset had just bought. In 1962 Gruen became an art critic for the *Herald-Tribune*. On the side, with no formal training, he tried his hand at composing art songs, setting to music the writing of the downtown poet Frank O'Hara and others. Soon opera divas began performing his songs at Carnegie Hall and elsewhere, to rave reviews often penned by his friends and neighbors. After one concert he met Jac Holzman, who was starting an arty little record company. *New Songs by John Gruen* was the first LP issued by Holzman's Elektra Records, which went on to record the Doors, Roy Orbison, Phil Ochs, Judy Collins, Devo, Metallica, Ween, and numerous others. Gruen also wrote music for *8 x 8*, a 1957 experimental film by the German artist Hans Richter, who'd come to New York in 1940 fleeing the Nazis and taught film at the City College of New York. Duchamp, Max Ernst, Man Ray, Alexander Calder, Fernand Léger, John Cage, Josh White, and Libby Holman all worked on Richter's films.

Anatole Broyard moved to Greenwich Village as a twenty-six-year-old vet who as an officer in occupied Tokyo had made himself a tidy little nest egg hustling on the black market. Like so many others he came to the Village to escape his past and start over. Born in New Orleans and raised in Bedford-Stuyvesant, Brooklyn, he was a light-skinned, wavy-haired Creole who would pass for white from the day he set foot in the

Village to his deathbed confession. He had a black wife and child across the river in Brooklyn, and that's where he left them. His mixed-race heritage was a matter of rumor and speculation among white friends, though recognized easily by black ones, but he was evasive about it even with his second (white) wife and children—"a virtuoso of ambiguity and equivocation," as Henry Louis Gates Jr. puts it.

"The Village in 1946 was as close as it would ever come to Paris in the twenties," Broyard enthuses. "Rents were cheap, restaurants were cheap, and it seemed to me that happiness might be cheaply had." Like many Village vets he used the GI Bill to attend classes at the New School. "Education was chic and sexy in those days." The faculty was still full of German refugee professors; he studied anthropology with Gregory Bateson and psychology with Erich Fromm, who browbeat his students about how joyless, fearful, and boring America had become. He tried his hand at hip commerce, using his black market profits to buy out an Italian junk dealer at 20 Cornelia Street and open a small secondhand bookshop, where he displayed his erudition in literature and his lack of skills as a businessman. He turned to writing jazz reviews and essays on hip culture for *Partisan Review* and many other magazines and journals. Eventually he'd be an editor at the *New York Times*.

Meanwhile he made the rounds of postwar Village bohemian circles. He met—or perhaps "was granted an audience with" is more accurate— Anaïs Nin. Born in France, raised in the United States, she'd gone back to France in the 1920s and '30s, where she had her famous triangle with Henry and June Miller, then fled to the Village at the outbreak of the war. She was living on West Thirteenth Street with her husband, Hugh Guiler, a successful banker who as Ian Hugo made a few short experimental films. Very little of her writing was known yet in America beyond the self-published short story collection *Under a Glass Bell*, and that only because Edmund Wilson had extravagantly praised it in *The New Yorker*, not once but twice, hoping to get into bed with her. Evidently it worked, though she characteristically complained that he'd completely failed to grasp her genius. Her diaries wouldn't be published until the

1960s, her erotica in the 1970s. She was not yet a feminist hero and yet, in her mid-forties, was well into the process of self-mythologizing. Broyard found her disturbingly mannered and postured, like a silent movie vamp.

Around the time Broyard met her, Nin appeared in a short film by another self-mythologizing Village art-vamp and later feminist hero, Maya Deren. She was born Eleanora Derenkowsy to wealthy Jewish parents in Kiev, where her father was a successful psychiatrist. She was a child when they escaped the pogroms, settled in Syracuse, and shortened their surname. She came to the Village after college in the mid-1930s, and in the early 1940s she toured the country as personal assistant to the formidable Katherine Dunham, founder of a very successful black dance company. As a graduate student in anthropology, Dunham had done field work in the Caribbean, exploring the African roots of Caribbean culture and becoming a Vodoun priestess in Haiti. Deren was heavily influenced by her time working for Dunham; she would go on to do her own research into Vodoun, become a priestess herself, and write the 1953 book *Divine Horsemen: The Living Gods of Haiti*. While in Los Angeles with Dunham, Deren met her second husband, Alex Hammid, a Czech photographer who'd fled Nazi Europe, and they began to make short, black-and-white experimental films together. Their honeymoon project, *Meshes of the Afternoon*, shot in the Hollywood Hills in 1943, included among its surrealist techniques and Freudian symbols iconic footage of Deren looking like a wistful Botticelli angel, endlessly reproduced as a still. Hammid gave her a new first name, Maya—tellingly, Sanskrit for "illusion."

Deren's Village apartment, a small, sunny, fourth-floor walk-up on Morton Street, was an important node of downtown socializing. Over the years many cultural dignitaries would climb those stairs, from Duchamp and Dalí to Dylan Thomas and John Cage. Lithuanian-born avant-garde filmmaker Jonas Mekas, who came to New York as a war refugee in the late 1940s and later founded the seminal Anthology Film Archives, remembers Deren as "very composed, very intellectual and brainy, but also wild." Her New Year's Eve parties on Morton Street "were very famous." She'd lock up her "five or six cats" and invite the whole downtown

arts crowd, which he says could just about squeeze into one apartment, and things got "totally wild."

Like *Meshes, Ritual in Transfigured Time* was a silent, surrealist short, incorporating dance; it looks something like what might have transpired if Luis Buñuel or Jean Cocteau had collaborated with Dunham. It was maybe inevitable that Nin and Deren, competing self-made goddesses in the hothouse of Village mythology at a time when women artists and writers still had to work hard to be taken seriously, would pass from collaboration to feuding. When mythomaniacs collide they usually know precisely how to dismantle each other. It started with *Ritual*. Nin's ego was bruised by her not terribly flattering appearance in the film as a vulnerable older-woman figure, the opposite of the carefully preserved image she projected at Broyard. It did not escape her notice that Deren shot her in harsh light while always bathing herself in gauzy soft focus. She complained about Deren's "power to uglify." Deren shrugged and told her, "You will get over it." She never did.

Deren was forty-four when she died of a cerebral hemorrhage in 1961. Her completed film output totaled six shorts amounting to just over an hour. (*Divine Horsemen*, her abandoned documentary, was released posthumously.) Even so her legacy in film culture was extensive. The year Broyard met Nin, Deren began screening her films at the Provincetown Playhouse, the first time films had ever been shown there. In the audience was a young film fan who'd fled Nazified Vienna named Amos Vogel. Deren's films and lectures inspired him and his wife, Marcia, to start Cinema 16, a European-style film club that had a profound impact on New York's film culture into the early 1960s. One of Cinema 16's early programs was an October 1953 symposium on the topic "Poetry and the Film," where the speakers included Vogel, Deren, and Dylan Thomas. It turned out to be one of Thomas's last public appearances. Cinema 16 also distributed art films around the country, a business Vogel would sell to Barney Rosset and Grove Press.

These are more than anecdotes about small-world connections. They speak to an arts scene in which a small cadre of artists in all disciplines

collided and fused like subatomic particles in an accelerator, unleashing an explosion of creativity. Village artists advanced the avant-garde on several fronts simultaneously in these years. Abstract Expressionism was to art as bebop was to jazz, as the Beats and the New York School poets were to literature, as Off- and Off-Off-Broadway were to theater, as John Cage was to modern composing, as Grove Press was to book publishing. The intense activity in and around the Village in the postwar years helped make New York City the arts powerhouse it would become by 1960.

# The "New York School"

ARTISTS GET AWAY WITH MORE HUMAN NATURE THAN
ANYBODY ELSE.

—*Dawn Powell*

THE COVER STORY OF THE AUGUST 9, 1949, *LIFE* WAS ON FAIR-field County, Connecticut, "Country Home of Smart New Yorkers." The ads crowding the pages enticed readers to a postwar bounty of consumer luxuries: Jeris Antiseptic Hair Tonic and Chiffon Pure White Soap Flakes and Prince Albert's "P.A." (Pipe Appeal) and Dr. Hand's Teething Lotion and Stopette spray deodorant and Embassy cigarettes and Milk-Bone and Cheez-It and Kotex and the new wonder of the world Birds Eye frozen cod fillets, "Out of the package—Into the stove—On to the table!" One full-page ad intoned, "In this home-loving land of ours . . . in this America of kindliness, of friendship, of good-humored tolerance . . . perhaps no beverages are more 'at home' on more occasions than good American beer and

ale." The cover story describes how Fairfield County in rural cen-
tral Connecticut was becoming the commuter getaway of choice
for Manhattan's wealthy, its artists and "idea people." The painter
Arshile Gorky had been one of the pioneers. *Life* had done a small
photo essay on his converted Fairfield farmhouse in February 1948.
In July of that year, sick and depressed, he hanged himself in a shed
there. Nevertheless, the farms and fields of Fairfield would soon be
thick with the likes of Norman Mailer, Arthur Miller and Marilyn
Monroe, Richard Widmark, William Styron, Alexander Calder, John
Cheever, Van Wyck Brooks, Martha Clarke, Malcolm Cowley, and
Louis Untermeyer. Anatole Broyard, a successful and respected *New
York Times* editor by the early 1960s, would move there as well. As
would Maurice Sendak, who'd started out in Brooklyn and moved to
the Village in the 1950s.

In the midst of *Life*'s here-come-the-fifties prattle, pointedly juxtaposed
with the numerous photos of smart and successful New Yorkers on their
vast Connecticut lawns outside their dazzling white country homes,
was a photo of a balding man looking studiously louche and grubby in
a paint-spattered denim jacket and jeans, cigarette dangling from grimly
pursed lips, arms folded, legs crossed, scowling at the camera. He looks,
as a friend commented at the time, more like a gas station attendant than
a famous artist. Behind him is a horizontal banner of canvas spattered
and scrawled with black, yellow, and red.

The subhead of the two-and-a-half-page photo essay asks, "Is he the
greatest living painter in the United States?" Jackson Pollock's stony
expression replies, "Who wants to know?" "Recently," the short article
begins, "a formidably high-brow New York critic hailed the brooding,
puzzled-looking man shown above as a major artist of our time . . . Oth-
ers believe that Jackson Pollock produces nothing more than interesting,
if inexplicable, decorations. Still others condemn his pictures as degen-
erate and find them as unpalatable as yesterday's macaroni." It goes on to
describe the way he paints as "brooding and doodling," makes some sport
of the fact that no one can tell what his work "means," and explains, in a

tone of wonder, that the magnificent *Number Nine*, in front of which he posed, is eighteen feet long "and sells for $1,800, or $100 a foot." A 1949 dollar was worth roughly ten of today's.

It was not the first time *Life* had weighed in on Pollock. In its October 11, 1948, issue, the magazine had run a huge "Round Table on Modern Art: Fifteen Distinguished Critics and Connoisseurs Undertake to Clarify the Strange Art of Today." Aldous Huxley was the guest star and the critic Clement Greenberg was the only man (they were all men) at the table (they literally sat around a long table) with any close knowledge of the contemporary New York art scene. The rest were academics and museum curators, who spent the bulk of the sixteen-page article talking about such "art of today" as works by Picasso, Rembrandt, and Matisse. When the discussion got around to "Young American Extremists"—one painting each by Pollock, Willem de Kooning, William Baziotes, Adolph Gottlieb, and Theodoros Stamos—Huxley dismissed Pollock's *Cathedral* as "wallpaper," another said it'd make a nice silk tie, and another said he was suspicious of "any picture I think I could have made myself."

That year, Pollock had had his first solo show of the "drip" paintings at the small Betty Parsons Gallery in midtown Manhattan. The price tags were less impressive, as low as a hundred and fifty dollars for a smaller painting, and yet only one had sold. Pollock traded another for a sculpture and used a third to cover a sixty-dollar grocery bill. (The grocer's friends laughed at him for taking the painting; a decade later he sold it for seventeen thousand.) But that was all changing in 1949. Pollock's second solo show at Parsons also got mixed reviews from the critics—one wrote that his work looked like "a mop of tangled hair I have an irresistible urge to comb out"—but this time nine of the paintings sold. MoMA bought one for two hundred and fifty dollars, and the wealthy artist and collector Alfonso Ossorio bought another for fifteen hundred dollars, equivalent to fifteen thousand today. Other collectors and museums fell in line as the year progressed. Pollock stopped having to give away paintings to cover his grocery bills. When *Life*, with a national circulation of five million, ran its feature on him that August, the painter whom *Time* had

sniffed was "the darling of a highbrow cult" a few months earlier became a household name. The first of the Abstract Expressionists to experience celebrity, Pollock from now on was the one your Average Joe—and numerous comics and satirists—cited when scratching his head at the doings of those crazy New York artists and their "inexplicable" paintings.

NEW YORK WAS ON THE WAY TO SUPPLANTING PARIS AS THE ART capital of the Western world but most of the world hadn't noticed yet. The *New Yorker* art critic Robert Coates first applied the term "Abstract Expressionism" to Pollock's scene in 1946; it was also called the New York School. Neither was very accurate. "It is disastrous to name ourselves," Willem de Kooning declared. Although they did have a sense of being a community of artists they shared no one "school" of aesthetics or style. Their work ranged from pure abstraction to abstracted figures and landscapes, from "action painting" like Pollock's (a term he never liked) to color field to found-art assemblages to performances and Happenings to, eventually, Pop, Op, and Minimalism. They constantly argued about and sometimes punched each other over their aesthetic differences; Barnett Newman, shaking his head over all that discourse, once remarked, "Esthetics is for me like ornithology must be for the birds."

They came together less out of a shared aesthetic than out of the traditional bohemian artist's need for cheap rents. They congregated below Fourteenth Street, in Greenwich Village and in today's East Village. Spaces in Greenwich Village tended to be too small for them to work in, since paintings grew huge in this period, so they rented open lofts and empty storefronts mostly east of Broadway. But they studied and taught art in the Village, had important artists' clubs there, staged a seminal group show there, and ate, drank, hung out, and discussed the work there. Living, working, and playing in a relatively confined area, the artists on the scene developed a sense of belonging to a group. They encouraged and influenced one another, collaborated and feuded, partied and drank too much together, visited one another's studios, organized shows together, formed and broke romances and marriages among themselves. The lofts were perfect sites for parties and they threw lots of them: rent

parties, jazz parties, dance parties, pot parties. When it was time to party no one cared what kind of art you made or how well you made it, only how well you danced and kissed and held your liquor.

Marxism was on its way out. Younger artists still heard some Trotskyist rhetoric from the older ones, but it was increasingly just that. Downtown's arty bohemians still dressed and tried to drink like workingmen—a lasting legacy of the old American idea that only girly men would want to be artists—but for the most part they gave up trying to make art for them, or for the middle class, or for anyone else. "When those of us who were in the service came out of it, we were greeted with a world which we thought looked like the epitome of a kind of moral squalor," the painter Alfred Leslie has explained. "Everyone felt betrayed. Everyone felt this essential corruption of the politicians. As the rest of the world was picking up stones and sweeping up their cities, we had to, in a sense, sweep out our souls. We had to make a new art. We had to find a way to make an art that was consequential, and be outsiders and risk failure and believe that doubt was a positive thing and not make an art that would service the middle class."

At first it was a boys' club. It was Pollock and the others mentioned alongside him in Life—Gorky, Hans Hofmann, Ad Reinhardt, Robert Motherwell, Mark Rothko, Franz Kline, Philip Guston, Barnett Newman, Clyfford Still. Women became more prominent among the so-called second generation of younger artists who rose in the later 1940s and '50s that included Leslie, Larry Rivers, Joan Mitchell, Jane Freilicher, Nell Blaine, Grace Hartigan, and Helen Frankenthaler. They still had to fight their way through thick clouds of testosterone and much macho posturing, either by being even tougher and harder drinking than the boys, like the foul-mouthed, hot-tempered Mitchell, who sarcastically labeled herself a "lady painter," or by being very pretty and ladylike in a traditional way, like Jane Wilson.

Romantic ideals of bohemian poverty, alienation, and dedication to art for art's sake made a big comeback in this milieu. Explaining the downtown scene to the mainstream readers of the magazine Horizon in 1947, Greenberg used images that could have come straight out of Murger, describing "young people, few of them over forty, who live in cold-water

flats and exist from hand to mouth," who "show rarely on 57th Street, and have no reputations that extend beyond a small circle of fanatics, art-fixated misfits who are isolated in the United States as if they were living in Paleolithic Europe." In *Down and In*, Ronald Sukenick jokes: "The misunderstood genius starving in his garret was the role model for artists of all kinds at the time. I myself could hardly wait to start going hungry." De Kooning was the model of the downtown artist ferociously dedicated to the work and nothing but. He lived in abject poverty, sometimes painting in household enamels because he couldn't afford art pigments, but he could spend a year on a single painting, scraping and repainting and scraping and repainting. For all their poverty and angst, however, many of them still managed to get away in the warmer months. Provincetown filled up with an ever larger crowd of Manhattan aesthetes and intellectuals every summer—de Kooning, passed out drunk and nude on the beach, would be arrested for indecent exposure there—while the Hamptons became a destination or permanent home for many artists, writers, and their affluent patrons, and Fire Island bloomed as a nearer weekend resort, especially for the gay and lesbian members of the scene.

Until the media plucked Pollock from among them to be a star, the public and press had little interest in what President Truman dismissed as "that ham-and-eggs school of art," explaining that abstract art looked to him like someone stood back and threw eggs at the canvas. Asked how many people in America he thought liked modern art, Duchamp quipped, "Oh, maybe ten in New York and one or two in New Jersey." Even the art critics who wrote about Abstract Expressionism in its formative years generally despised it. Greenberg, Pollock's "formidably high-brow" champion, was among the few lonely cheering voices at first. Collecting and viewing modern art were not yet fashionably hip pursuits in New York, the way they would be by the 1960s. Guggenheim closed Art of This Century in 1947 and moved back to Europe, as did many of the refugee artists. There were only a handful of commercial art galleries in New York, all uptown, and into the early 1950s only a few small ones—Parsons, Charles Egan, Kootz, Tibor de Nagy—showed the downtown artists. So the artists started their own small collective galleries, where

they all paid monthly dues, five to ten dollars each, to cover the rent and lights. Most of these were on and around East Tenth Street. But the first was in Greenwich Village: the Jane Street Gallery, which opened in 1943. In 1949 it moved uptown to be near the commercial galleries. The best-known Jane Street member, Larry Rivers, who'd been painting only a few years, had his first show there of bright, cheery interiors heavily influenced not by Abstract Expressionism but by French post-impressionist Pierre Bonnard.

Eighth Street from Broadway over to Sixth Avenue was the artists' Village hub. Above the Eighth Street Playhouse and the basement Village Barn with its hokey hoedowns, Hans Hofmann had opened his School of Fine Arts in 1938. Hofmann was a living link to the European modern art of the early twentieth century. He'd worked in Paris when Fauvism and Cubism emerged and had been teaching art since the 1910s. Larry Rivers describes him as Santa Claus with a German accent. In both his color-rich paintings and what Rivers calls "his diatribes against all that was not inherently abstract" he was an obvious influence on the Abstract Expressionists, and on Greenberg too. Hofmann was the sole teacher at his school, and the idea of a school where a single instructor pounded home his dogma didn't appeal to everyone. In 1948 Motherwell, Rothko, Baziotes, and the sculptor David Hare rented a loft at 35 East Eighth Street near Broadway to start their own Subjects of the Artist school. The pay for guest lecturers was dinner and a bottle of their favorite liquor. It lasted only about a year before a group of teachers from NYU's art education program took it over as Studio 35.

Around the corner from Hofmann's school, on Sixth Avenue just below Eighth Street, the Waldorf Cafeteria opened early in the war years. Artists headed there after attending Hofmann's classes. The food was lousy, the lighting made people look so bad they nicknamed it the Waxworks, and the other patrons tended to be bums, drug addicts, tough guys, and cops. The staff was not particularly welcoming to arty boho types. In her diaries Judith Malina writes that Maxwell and Ruth Bodenheim celebrated his birthday there with a few friends, and assorted drunks and junkies, in 1953.

Seeking more amenable surroundings, artists again chipped in to rent an Eighth Street loft—this one near Fifth Avenue—that was called the Eighth Street Club or the Artists Club. Alfred Leslie says it happened simply because "everyone needed a place to sit and to hang out" when they weren't at work in their studios or out at the bars. "You needed a place to go, 'a social club.' " In addition to mounting some group shows, they held panel and roundtable discussions, sometimes with guest speakers, such as Hannah Arendt or E. E. Cummings. The four poets most associated with the New York School painters—and called, inevitably but just as inaccurately, the New York School poets—all read in public for the first time at the Artists Club: John Ashbery, Frank O'Hara, Kenneth Koch, and James Schuyler. At Friday night parties Larry Rivers and a pickup band would often play jazz.

Discussions at the club led to the members organizing a large group show, which they staged nearby in May 1951 at 60 East Ninth Street, between Broadway and University Place, in an empty, high-ceilinged storefront that had most recently been an antiques shop. It was the first show Leo Castelli curated. "He hung around," Leslie recalls. "He didn't have a gallery yet. He showed things in his home. I painted his apartment." The sixty-one artists who participated in the Ninth Street Show were a who's who of first- and second-generation New York School artists, from Pollock, de Kooning, Reinhardt, and Motherwell to Robert Rauschenberg, Mitchell, Frankenthaler, Hartigan, and Leslie. Everyone pitched in to rent the space for a month—Leslie remembers it was fifty or sixty dollars—and clear it out, whitewash the walls, promote the show among friends, and take turns sitting there when it was open. On opening night a big banner was stretched across the street. Despite an almost complete lack of interest from the press, the opening was like a scruffy downtown version of a Hollywood premiere, with a big crowd milling to get in and taxis jamming the street. Uptown art dealers took note.

Of all the sites in the Village associated with the painters, the best known and longest-lived was the Cedar Street Tavern, aka the Cedar bar, at 24 University Place just above Eighth Street. It was in the right spot to be their local, and they liked it because there was nothing quaintly Green-

wich Village-y or bohemian about it. University Place at the time was on the skids, dotted with flophouses, its sidewalks littered with bums, which put it well off the tourists' and slumming uptowners' path. John Gruen described the Cedar, named for the street farther downtown where it was originally located, as a "nondescript, ill-lit, more than slightly depressing place" with "drab naugahyde booths." Ruth Kligman, whose brief, tragic-romantic affair with Pollock began at the Cedar in 1956, described it as "a small, crummy-looking bar" with some booths in the back. "The walls were painted a pea-soup green. The place smelled faintly of stale urine." It had nothing to attract hipsters or tourists, at least not until all the artists and writers hanging out there became famous. Before that it was their spot and they kept it to themselves. "It became ultimately completely tribal, as all bars become tribal," Alfred Leslie recalled. "Everybody sleeps with everybody else, everybody knows each other, and basically strangers are not welcome unless they are brought in." But with *Life* and *Time* writing about them the mobs of gawkers, yahoos, aspiring youngsters, and art groupies on the make showed up, making it, as Rivers called it, "the G-spot of the art scene."

Like Pfaff and Romany Marie, the Cedar management enjoyed having artists and writers in the place to attract these crowds and was lenient about their running up tabs and knocking each other down. "We go there to meet the very people we hate most, the other painters," Reinhardt quipped. Many of them were bad drunks, and the psychodrama of numerous spats, feuds, and fallings-out of former friends got played out in the dark, noisy, smoky bar. Gruen was there one night when de Kooning and Pollock got into a drunken, heated argument that culminated with de Kooning punching Pollock in the face. When someone in the crowd urged Pollock to fight back, he gave the legendary reply, "What? Me hit an artist?" Pollock was briefly 86'ed for his own violent outbursts, which culminated in his kicking in a bathroom door. The painter Lee Krasner, his long-suffering wife, rarely accompanied him to the Cedar, later telling Pollock's biographer Deborah Solomon, "I loathed the place. The women were treated like cattle." Greenberg rarely went there either—it was too full of the drunken painters he'd written about.

They also liked another dive, Louis' Tavern, in a building no longer standing at the end of Barrow Street on Sheridan Square. Larry Rivers describes it as "a loud bar packed to its rafters with young bohemian heterosexuals lightly sprinkled with homosexuals." It was popular, he says, for "the excellent chances, after entering alone, of going home with somebody." It was often packed to overcapacity, the crowd spilling out to the sidewalk and the stone steps next door. Robert De Niro, the actor's painter father who had work in the Ninth Street Show, hung out there along with folks from the nearby Circle in the Square theater such as Geraldine Page, Jason Robards, and Steve McQueen. The Beats and later beatniks cruised the joint, as did Ashbery and O'Hara, while skeevier down-and-outers panhandled the crowd for a glass of beer or a twenty-five-cent shot of rail whiskey. Rivers says that by 2 a.m. everyone who was going to get laid that night had paired up and departed, and the deserted joint, as Ashbery put it, "looked like the bottom of a pocket."

POLLOCK'S DRUNKEN RAGES, AT THE CEDAR AND ELSEWHERE, WERE nearly as renowned as his paint-spattered canvases. The two were con-flated in his legend. Dawn Powell, who became a late-night Cedar regular in the mid-1950s and used it in her last novel *The Golden Spur*, has the bartender and a patron at the Cedar-like Spur discuss a Pollock-ish char-acter named Hugow. "A painter can't turn out the stuff they have to do now without being loaded," the patron argues. The bartender disagrees; "they got to paint sober," he says, "then they're so disgusted with what they done they got to get stoned." When the patron complains about how unruly they get when they're out drinking, the bartender replies it's only human nature. To which the patron grumbles, "Artists get away with more human nature than anybody else."

Whether or not he was the greatest living artist in 1949, Pollock was one of the most intense, tormented, and tormenting, a bad drunk who took swinish behavior to new lows and got away with it because he was the superstar of the scene. Born in cowboy country in Wyoming, raised all over the Southwest and Southern California, he'd first studied art in Los Angeles (with his friend Philip Guston), then followed his two older

brothers to Greenwich Village in 1930. Studying at the Art Students League and working for the WPA, he absorbed the influences of the Mexican muralists Orozco, Diego Rivera, and David Alfaro Siqueiros. He met Peggy Guggenheim during the war while working as a janitor at her uncle Solomon's new Museum of Non-Objective Painting on West Fifty-fourth Street, which later became the Guggenheim and moved to its iconic home on the Upper East Side. Peggy gave him his first show at Art of This Century, and helped him and Krasner buy the farmhouse out in Springs, near the Hamptons, where he could work in solitude and, they hoped, kick his alcoholism. It was there that he came up with the drip paintings. Like Bodenheim before him and Kerouac after, he suffered the joys and guilt of the successful bohemian. It exacerbated his drinking problem and led to many legendarily surly acts around his patrons, for instance the famous story of his pissing in Peggy's fireplace during a party. He and Lee spent much of the winter of 1951 in the carriage house at 9 MacDougal Alley, lent to them by Alfonso Ossorio. Pollock's carrying-on at the Cedar got particularly out of hand that winter—ranting, breaking furniture, pawing the young art groupies the bar attracted by then. Artist friends would drag him home at the end of the night, only to confront a screaming Krasner. In February 1956 *Time* ran its own largely negative and sometimes ridiculing overview of New York artists, calling Pollock "Jack the Dripper" and claiming that their work evoked "a mixture of puzzlement, vexation, contempt" in viewers. Yet just a few months later the Museum of Modern Art chose him to be the first in a new series of solo shows by artists in midcareer.

That spring Pollock met Ruth Kligman at the Cedar. He was forty-four; she was twenty-six and working as an assistant at an art gallery. In her memoir, she recalls how all heads in the crowded place turned when Pollock "came storming in . . . He looked tired out, sad, and his body seemed as though it couldn't stand up on its own. He was leaning against the bar as if for support." The writer and painter Fielding Dawson was in the bar one night that June when Pollock, after getting a stern warning from the bartender not to act up, did just that. Spying a pretty girl there with a date, he horned in on their table, started pawing the girl, and when

her date timidly objected he grinned evilly and swept his arm across the table, knocking their drinks, plates, and silverware into their laps. That summer, Krasner caught Kligman and Pollock sleeping together in the barn at Springs. When Krasner went to Europe to get away from him for a bit, Kligman moved in. On the night of August 11, 1956, after a long day of drinking, Pollock ran his Olds convertible off the road, killing himself and Kligman's friend Edith Metzger and seriously injuring Kligman. Already the biggest art star of his time, his suicide-by-Oldsmobile, like Dylan Thomas's suicide-by-whiskey three years earlier and James Dean's suicide-by-Porsche in 1955, secured his niche in the pantheon of martyred celebrities. He was far from the first artist killed by fame, and hardly the last, but he was maybe one of the last to be *surprised* by fame. By the Pop art, rock and roll 1960s, when the New York art market went on a bender that lasted into the 1980s, everyone would know if not understand that fame was integral to the game.

AT THE OTHER END OF THE SPECTRUM IN MOST EVERY WAY, LARRY Rivers was one of the younger, least pretentious, and most affable artists on the scene—a hepcat and party boy who appreciated the fame and money when they came his way. Born Yitzhok Grossberg in the Bronx in 1923, son of a man who had a garment industry trucking business, he didn't set foot in Manhattan until he was sixteen. He became Larry Rivers as a jazzbo playing baritone sax with touring big bands in the early 1940s. Through the jazzmen he became an avid pothead and a heroin user. At the end of the 1940s he'd voluntarily entered the same notorious drug rehab facility in Lexington, Kentucky, that Burroughs writes about in *Junkie*. He found Dexter Gordon, Sonny Stitt, and a few other jazz greats there already. In his witty, engaging autobiography *What Did I Do?*, he remembers himself as a young man during the war "walking all over Greenwich Village with his big horn slung over his shoulder looking for a joint where he could sit in and blow with a lot of other desperados." He studied music composition at Juilliard, where he smoked pot with fellow student Miles Davis. After the war he gave up trying to be a professional

musician, and the painter Jane Freilicher, then married to another jazz musician, inspired him to try his hand at art. Despite studying with Hofmann he wasn't one of the abstractionists; he started out imitating Bonnard and went on to prefigure Pop art. For a while he worked behind a counter at Bloomingdale's, doing quick-sketch caricatures for customers who bought a new type of ballpoint pen, still a novelty in the postwar years. His art and his career developed gradually; by his own admission he was at least as interested in sex (he was ravenously pansexual, and not above hustling gay male friends to advance his career) and drugs and music as in art. Once when he got a lover pregnant, they went to New Jersey, where Dr. William Carlos Williams performed the abortion. By 1960, a successful and comfortable art star, he'd rented a giant pied-à-terre in the Village to be near a current girlfriend, while keeping a place in the Hamptons as well. It was a huge duplex loft on West Third Street, a former film studio that cost two hundred and thirty-five dollars a month, far more than many artists could afford then.

In 1957 Rivers was invited to be a contestant on The $64,000 Challenge. Contestants, who over the years ranged from an eleven-year-old and a Bronx shoemaker to Dr. Joyce Brothers and Jane Wilson, were tested on the depth of their trivia knowledge in fields of their own choosing. The shoemaker, an Italian immigrant, won the top prize for his opera erudition. Rivers of course chose art and made it to the thirty-two-thousand-dollar level. He took the check straight downtown to the Cedar, where all his artist friends marveled and gnashed their teeth at it. He bought drinks for the house. "Between beer at fifteen cents and whiskey at fifty this gesture cost me a whopping $70," he recalled. Besides fattening his bank account, the show made Rivers a household name. This was the same year that resident Village intellectual Charles Van Doren, PhD, an assistant professor at Columbia and son of the eminent Village poet and Columbia professor Mark Van Doren, won the enormous sum of $129,000 on NBC's Twenty-One. Then the quiz show scandal broke and Van Doren admitted to a congressional investigating committee that the producers had fed him answers. Rivers was called to testify about his own experi-

ence. In his memoir he says that although the producers of The $64,000
Challenge didn't go so far as to feed him answers in advance, they did give
him really good hints about the questions so he could study up.

OF THE SIXTY-ONE ARTISTS WHO PARTICIPATED IN THE NINTH
Street Show in 1951, only one was still around, and still making art, sixty
years later. In a shotgun studio three steps down from the sidewalk in a
town house on East Sixth Street, Alfred Leslie sat at a bank of comput-
ers editing one of his films. Large panels for one of his comic-bookish
illustrated stories were tacked on one long wall. A teakettle burbled on a
hot plate next to a sink. Through a door in the back you stepped out to a
small roofed courtyard, where one of his giant Ab Ex paintings, much too
tall for indoors, leaned. In his mid-eighties he'd lost most of his once lush
curly hair, but he was still trim, looking fit, and very active. He attributed
his longevity to never being a big boozer as so many of the other New
York School artists were.

Like Rivers, Leslie came to the Village as a zoot suit–wearing young
hepcat from the Bronx. Born in 1927, son of an engineer, he was painting,
writing, and making his own 16mm films from when he was a boy. He
graduated from high school in 1945, studied and posed at the Art Stu-
dents League, and eventually began hanging out at the New School. "The
whole modernist enterprise was dropped into my lap."

He enlisted in the Coast Guard after the army and navy turned him
down for writing on the sign-up sheet that his religion was "deist." He
was in uniform only a few weeks when the war ended and was discharged
"exactly nine months and sixteen days" after signing up. He remembered
that because, in addition to a year's veteran's pay of twenty dollars a week,
under the GI Bill he was eligible for one year, nine months, and sixteen
days of educational benefits. He used this to enroll in NYU's art educa-
tion department, which he attended for precisely one year, nine months,
and sixteen days. He took a small apartment nearby on West Fourth
Street at Sixth Avenue. "It had no water. There wasn't any sink in it. It
was just a room at the end of the hall. And it had no toilet. So I would go

down and use the bathroom at the Waldorf." He showered at NYU. For extra cash he posed there, built shelves, and substitute-taught. In downtown studios and at parties he quickly met all the older Abstract Expressionists—some friendly and welcoming to younger artists, he recalled, and some not so much—and all the European-émigré surrealists, "all of the people that constituted the so-called current American avant-garde."

In his own work, Leslie would go on to range across the wide landscape of genres and media. Where the first generation of Ab Exers pursued the ultimate in aesthetic purism, he was a postmodernist before postmodernism; a fan of pop culture before Pop art; an enthusiastic explorer of all culture high, low, and in the middle who loved Hollywood movies and newspaper comic strips as much as museum art. He started out making enormous Ab Ex paintings but later became known for ultrarealist portraits and figure studies. He made films, drew his cartoonish illustrations and animations, built sculptures of junk and found objects, wrote poems and plays, and in 1960 edited and published a giant, one-off art "newspaper," The Hasty Papers, a kind of manifesto of his no-barriers, no-limits ideal, a words-and-pictures collage with contributions from the Beats and New York School poets, from Terry Southern and Billy Klüver (a Swedish PhD engineer at Bell Labs who collaborated with many artists on installations, sculptures, and Happenings), from Aristophanes and Fidel Castro.

A major catalyst in the budding careers of younger painters like Leslie was an unusual and colorful man named John Myers. A large, flamboyantly out gay man, he had fled Buffalo in his youth, studied art history at the New School, been an editor of the surrealist magazine View, and put on puppet-show versions of European avant-garde plays. In 1950 he convinced his friend Tibor de Nagy, a Hungarian banker, to back an uptown gallery that would show downtown artists. "John was an amazing man," Leslie recalled. "The most outrageous queen that one can imagine. He had created a self that was beyond imagining. It really took tremendous, tremendous courage to be able to do that" in the pre-gay-liberation 1950s. "He was as smart as anyone that I've ever known and a generous, trust-

worthy human being." With Greenberg as his guide, Myers gave shows at Tibor de Nagy Gallery to many of the second-generation painters, including Leslie in 1952.

There was one catch. "Because John Myers had no money, when an artist had a show they were asked to contribute two hundred and fifty dollars to help offset the expenses for the gallery. I had no money." He thought of the daytime quiz show *Strike It Rich*, on which hard-luck cases answered trivia questions to win the money they needed. Leslie was in fact the first of the artists to try the game show gambit. He went on the show, looking like an oddball bohemian artist, which perplexed the live audience but delighted the hipster staff, and won the needed money. At the end of their turn contestants were handed a few extra gifts from the show's sponsors. Among his was a giant box of Tide. When the show's host asked what he was going to do with his prizes, "I said, 'When I get home, I'm gonna have Tide for breakfast every morning.' " Everybody on the downtown art scene saw or heard about it. "It was a triumph. A triumph. But that was characteristic, because the art world was unknown, and what we think of as the scene today was not going to develop and not really clearly emerge until 1960."

In addition to running the gallery, Myers was an indefatigable booster of fizzy collaborations. It was Myers who named the quartet of Ashbery, Koch, O'Hara, and Schuyler the New York School poets, a label they tolerated at best. He published and distributed a newsletter, *Semi-Colon*, to promote their work, with illustrations by the downtown artists. In 1953 he and his friend Herbert Machiz founded the Artists Theatre to produce plays by O'Hara, Ashbery, Koch, Schuyler, and other poets with sets by Rivers, Leslie, Hartigan, Freilicher, and Elaine de Kooning. The poets and painters sometimes performed them as well. Staged at the Theatre de Lys and other spaces in and out of the Village, the productions revived the "Say, let's put on a play!" spirit of the early Provincetown Playhouse with, according to all involved, varying degrees of success.

Even when they failed, the collaborations made sense. The New York School poets were, in effect, the Abstract Expressionists of verse, rejecting and poking fun at the formalist rigors of the so-called New Criticism,

which dominated the poetry academy at the time. New Criticism taught that a close reading of the words on the page, analyzing a poem purely by its structure, yielded its absolute meaning, regardless of the poet's possible intent. Ashbery, Koch, and O'Hara all got bored and restless with it. Koch lampooned it in "Fresh Air," written in 1956, with lines like "Oh they are remembering their days on the campus when they looked up to watch birds excrete, / They are remembering the days they spent making their elegant poems." Ashbery's more experimental works went off like anarchist bombs inside the well-made poems of the academy. Inspired by the surrealists and dadaists, he deconstructed poetic forms, fragmented and jumbled lines until a poem made no conventional sense no matter how closely you tried to analyze it. He also satirized the well-made poem in such pieces as "Farm Implements and Rutabagas in a Landscape," which, instead of the pastoral idyll the title suggests, turns out to be an antic tale about Popeye and his friends. He wrote an ode to Daffy Duck as well.

Schuyler's poems were the quietest and most conventional. He was a midwesterner, not a Harvard man like the others, and had come to the city before the other three. For a few years he was Auden's secretary. When Ashbery and O'Hara came to the city in 1951 Schuyler moved into an apartment with them, becoming, as the literary historian David Lehman has put it, the Fourth Musketeer to the Harvard trio. Koch was the lone hetero of the four, but friends joked that he picked up so many mannerisms and attitudes from the others that he could easily pass as gay. Schuyler's link to Auden proved useful. In the 1950s the older poet assumed a role, apparently not intentionally, as what Lehman calls "the father (or, in camp slang, mother) figure for an entire generation of gay male poets." In 1955 Auden judged the prestigious Yale Younger Poets Prize. When Schuyler heard that Auden wasn't happy with any of the work submitted, he passed him manuscripts by his friends Ashbery and O'Hara. Auden wasn't terribly thrilled with their poetry either—it was too jokey and oddball for him—but he had to give the prize to someone, so he went with one of his friend's friends, Ashbery. Ashbery would return the favor in 1980, when as a judge for the poetry Pulitzer he successfully lobbied for Schuyler to win.

O'Hara's poems were the most casual and conversational. Edward Field describes them as "swishy, surrealist, almost zany." His "lunch poems," banged out on break time at MoMA, are slangy, jazzy, seemingly offhand, loaded with specific midtown Manhattan images; he jokingly yet aptly called them "I did this I did that" poetry. He could write high seriousness and deep sadness—they all could—but when O'Hara did it felt more like the aftermath of a broken affair or a crushing hangover than glum existential angst. He was also the most New York of the four. Ashbery left New York for Paris in the mid-1950s and stayed ten years. Koch went to Paris as well and Schuyler went out to the Hamptons. O'Hara stayed; propelled at breakneck speed through his own life, he was born for Manhattan and its constant busyness. From his arrival in New York in 1951 to his bizarre and untimely death in 1966, he was a ubiquitous downtown scene maker—with his broken nose and instamatic smile he seems to turn up in every photograph taken in the Cedar, the Five Spot, and every gallery and museum opening of the era. He also developed impeccable uptown connections. Born in Baltimore and raised in Massachusetts, after serving in the Pacific as a navy sonar operator, he went to Harvard on the GI Bill, where he became friends with Ashbery. His roommate was Edward Gorey. When he arrived in New York he got a job selling postcards and Christmas cards at MoMA, eventually charming his way up to the curator position he used to advance the careers of his downtown painter friends. He was a cultural omnivore, moving fluidly from art to literature to music to movies to dance, and making friends in all those circles. Like so many at the time, he was also an alcoholic, spritely and effervescent at cocktails but vicious and insulting by the wee hours. In one of the quintessential portraits of him by his friend, collaborator, and sometime sex partner Rivers, he's nude except for a pair of unlaced army boots, his arms raised to show off his wiry torso, one knee turned out to show off his penis. Over the years, pretty much all the artists would do portraits of him, and he'd write about them all.

O'Hara once said that the thing he feared most was to live past forty. In his late thirties, his alcoholism completely out of hand, he seemed to be willfully drinking himself into an early grave. In July 1966, a few months

after his fortieth birthday, he was out on Fire Island, the narrow scrawl of sand off Long Island's southern coast that had been a summer getaway for Village bohemians since the 1920s. By the '60s the hamlets of Cherry Grove and the Pines were gay resorts, with the wooded area separating them known among gay men as the Meat Rack for all the outdoor sex they had there. (The National Park Service rangers responsible for policing the island would generally turn a blind eye into the 2000s, when they'd begin handing out summonses for the most egregiously lewd behavior.) At 3 a.m. O'Hara and some drunken friends were in one of the little buses that drove along the beach, heading from the Pines to another hamlet where they were staying for the weekend, when it got a flat tire. As they all waited for a new tire, O'Hara teetered off a little way into the darkness. A drunk barreling past in a jeep ran him down. When Rivers and de Kooning visited him in the hospital, they "went white," Rivers writes, seeing the extent of his injuries. They weren't sure if O'Hara, in a heavily medicated fog, recognized them but instantly he began chatting away, dreamily dishing about some party. He died soon after. The New York art world, crowded with O'Hara's friends, lovers, enemies, and colleagues, went into deep mourning. Hundreds attended his burial in Springs's Green River Cemetery, where he was given a small plaque near the large boulder marking Pollock's grave.

# Duchamp, Cage, and the Theory of Pharblongence

R ESIDING IN GREENWICH VILLAGE FROM WORLD WAR II UNTIL 1968, Marcel Duchamp was a sort of living bridge between the New York avant-garde of the 1910s and the new avant-garde of the postwar years—but in a very particular and Duchampian way. He'd already given up on painting by the time of the Armory Show in 1913, and for decades he'd been more interested in and known for chess than he was for his art. When he originally lived in New York he could be found every night at the Marshall Chess Club, a private, members-only establishment then above the Pepper Pot on West Fourth Street. (The club moved around the Village before settling on West Tenth Street between Fifth and Sixth Avenues in 1931, where it remains today. Over the years, members have included Bobby Fischer, Stanley Kubrick, and Howard Stern.) Duchamp's friend Man Ray joined the club as well. "There were pretty girls who brought one coffee; the place was a mixture of sociability and serious players," he recorded.

After going back to Paris for *les années folles*, Duchamp returned to the Village permanently during the second world war, taking an apartment and studio on West Fourteenth Street, and cofounded the Greenwich Village Chess Club. "Chess is much purer than art," he declared more than once. He loved it because it had "no social purpose" and "you can't make money out of it." According to Man Ray, Duchamp's first wife (of less than one year) was so frustrated by his constant chess playing that one night while he slept she glued all his pieces to the board. He refused to have anything to do with the New York School painters and Abstract Expressionism, which he shrugged it off as mere "retinal" art. The downtown artists he did like were the composer John Cage and choreographer Merce Cunningham. Cage and Duchamp first met in 1942, and though Cage was already experimenting with making music using everyday utensils and sounds that was very like Duchamp's readymade sculptures in spirit, they didn't become friends for more than twenty years, and when they did it was through chess.

Cage was born in Los Angeles in 1912. His father, no one was later surprised to hear, was an eccentric inventor who produced a not quite successful submarine during World War I, the safety of which he liked to demonstrate by sailing it on Friday the Thirteenth with a crew of thirteen. He also developed a theory for space travel based on his "electrostatic field theory" of the universe, which he demonstrated in miniature to unconvinced scientists at Cal Tech. During World War II Cage was exempted from military service because he was helping his father research ways for airplanes to see through fog. He studied piano as a boy and played one on his own radio show on a local station in high school. By college he was also writing, painting, and composing. He made a living for a while during the Depression lecturing housewives about music, then worked for the WPA in San Francisco, teaching Italian, black, and Chinese kids about percussion. He studied composition with Henry Cowell at the New School and with Arnold Schoenberg in Los Angeles; Schoenberg later commented, "Of course he's not a composer, but he's an inventor—of genius." In 1942 Cage came to New York, penniless but with the rich and influential friends Max Ernst and Peggy Guggenheim.

Through them he met everybody on the New York arts scene. He later recalled that "in one fell swoop or series of evenings at Peggy Guggenheim's you met an entire world of both American and European artists. She was already involved with Jackson Pollock, and Joseph Cornell was a frequent visitor. Marcel Duchamp was there all the time, and I even met Gypsy Rose Lee. It was absolutely astonishing to be in that situation." He also met the dancer and choreographer Merce Cunningham, who'd come to New York several years earlier to dance in Martha Graham's troupe. Cage left his wife for Cunningham and the two men started a lifelong relationship. They gave their first concert together in 1944.

Within a few years Cage was immersed in Zen and the I Ching, which had lasting influences on his experiments with sounds and silence, and with introducing the element of chance in his compositions as a way to bypass the ego. Brion Gysin, William Burroughs, and the poet Jackson Mac Low made similar experiments with literature. Cage also gave lectures that were like the repetitive drone of Buddhist mantras. At the Artists Club in 1950 he rhythmically intoned his "Lecture on Nothing" for the first time. It was a seemingly rambling, remorselessly monotone meditation on being and nothingness, stillness and action. He began, "I am here, and there is nothing to say. If among you are those who wish to get somewhere, let them leave at any moment. What we require is silence; but what silence requires is that I go on talking." It went on that way for a long time. In his book *Silence* he recalls that the artist Jeanne Reynal, best known for the painstaking and repetitious art of the mosaic, "stood up part way through, screamed, and then said, while I continued speaking, 'John, I dearly love you, but I can't bear another minute.' She then walked out." When the "lecture" finally ended Cage invited questions; however, to illustrate his feelings about the pointlessness of discussion, he responded only with prewritten answers such as "That is a very good question. I should not want to spoil it with an answer."

While some artists found Cage's lectures maddening others were inspired. Alfred Leslie remembered a lecture he gave at Studio 35. "It was the summer, with the window open on the street. He stood behind the lectern there, and he paused, and he took out a watch, and he put his

watch down on the table, and just folded his arms and looked out and didn't say a word. And then he looked down and said, 'One minute has passed. Any questions?' Of course he was pointing out that you had an opportunity here, the window being open, you heard all the sounds, the music, the composition that he had just created." The courses Cage taught at the New School had a big impact on the avant-garde arts of the 1950s and '60s, including the Fluxus group, of which Yoko Ono was a member, and Happenings, which he helped to invent, and the improvisational stylings of Charles Ludlam's Theatre of the Ridiculous.

Like Leslie and Rivers, Cage also appeared on a game show, and it made for magnificent Dada television. In January 1960 he went on I've Got a Secret and performed "Water Walk," a short piece for grand piano, iron pipe, goose call, rubber duck, bathtub, five radios, ice cubes, steam cooker, and other objects. Today, you can watch the clip on YouTube. Everything about his appearance is a detour from the show's routine. To begin with, the host Garry Moore jettisons the usual process of having the celebrity panelists try to guess the guest's secret. He simply tells them what Cage is about to do, calling him "probably the most controversial figure in the musical world today," and adding that he teaches a course at the New School "on experimental sound." "Experimental *music*," Cage politely corrects him. Moore also explains that there's a hitch: two of the unions that work on the show, adding a perfectly Cageian element of chance, have gotten into a dispute about "who has jurisdiction over plugging in the five radios." Cage says that to compensate he'll hit the radios when he would have turned them on, and push them off the table when he would have switched them off. "I'm with you, boy," Moore replies. Interestingly, the studio audience responds more warmly to Cage's performance than some of his sophisticated downtown friends tended to do. They seem to get the Spike Milligan humor of it, laughing along with it, not at it, as Cage bangs pot lids, waters some flowers, squeezes the rubber duck, and shoves the useless radios to the floor. The audience heartily applauds when he's done.

In the mid-1960s Cage asked Duchamp to teach him chess; they played at Duchamp's home on Fourteenth Street at least once a week for the rest

of Marcel's days. Meanwhile, in his studio next door, Duchamp was secretly working on one last piece of art, the mysterious assemblage *Étant donnés*, not shown in public until after his death. It was only at the end of the 1950s that Duchamp's own art had been rediscovered and embraced by the new generation of Pop artists. Andy Warhol was among those who saw the first major retrospective of Duchamp's work at the Pasadena Art Museum in 1963, where Duchamp played chess with a nude woman. Chess was Cage's pretext for getting to know Duchamp but he was never any good at it. "Don't you ever play to win?" the exasperated older man frequently chided him. In 1968 Cage staged a performance in Toronto where Duchamp and his second wife sat on stage playing a game. Cage had wired the board so that the moving pieces signaled a group of musicians to play or stop playing, making accidental music. It cleared the space of the audience but became a legendary event in performance art history. Duchamp died soon after.

BORN IN COLORADO IN 1930 AND RAISED THERE AND IN LOS ANGELES, Robert Delford Brown studied art and devoured jazz as a teen. For a couple of his college years he lived above the merry-go-round on the Santa Monica pier in rooms filled until 2 a.m. with the relentless mechanical cheer of calliope music. He had his first solo show of abstract paintings in a small LA frame shop in 1952. When nothing sold, the shop owner took all his paintings out back and burned them.

"I came to New York in the spring of 1959, because this is where everything was happening," he recalled in a 1995 interview. "When I left LA, everybody said, 'Go jump in a lake. Next year LA is gonna be the art center of the world, and we won't invite you back.'" Brown arrived as the downtown art scene was going through a major shift. He'd come as a dedicated Abstract Expressionist but the work that had so bemused Truman's America a decade earlier was now old and familiar. The new shockers were Fluxus, Happenings, and the still-unnamed Pop art, exemplified by Jasper Johns's *Flag* and Robert Rauschenberg's *Bed* (both from 1955), with Andy Warhol soon to emerge as its Pollock. "Everything was up for grabs," Brown said. "You'd take a handful of something and throw

it on the floor, it was sculpture. You couldn't run fast enough to keep up." He bounced from one gallery to another, feeling that everything he had learned and practiced as art was being pitched out the window. "I was an impressionable hillbilly. I was really going nuts trying to keep up."

In 1963 he met Rhett Cone, who in 1957 had founded the Off-Broadway Cricket Theatre on Second Avenue. They married and became an insepa-rable art and life duo, known as "the Delford Browns," until her death in 1988. On a trip to Paris in 1963 they caught an Allan Kaprow Happening at a Bon Marché department store. "It was just incredible. Those French hated it. Nobody had seen a Happening. It was just the most exciting god-damned thing you ever saw. I figured, Jesus, this is where it's at."

In 1964 he participated in the New York premiere of the electronic music composer Karlheinz Stockhausen's *Originale*, in effect a Happen-ing, with a who's who of the New York avant-garde in attendance includ-ing Kaprow, Allen Ginsberg, Nam June Paik, Charlotte Moorman, Dick Higgins, and Jackson Mac Low. According to a head-scratching article in *Time*, it "featured two white hens, a chimpanzee, six fish floating in two bowls suspended from the ceiling," a guy covered in shaving cream, a pretty girl in her underwear, and Brown playing the Mad Painter. Wear-ing a hooded hazmat suit with an enormous phallus hanging from it, he dropped eggs from atop a ladder and punctuated the event with demonic howls and yolps.

He staged his own event, *The Meat Show*, in 1964. He and Rhett rented a refrigerated meat locker in the Meatpacking District at West Thirteenth Street and Ninth Avenue for a three-day weekend and artfully hung it with 3,600 pounds of butchered beef carcasses, pigs' heads, barrels of guts, and such. Chilled visitors pushed through yards of draped cloth painted with blood like giant intestines. A gallon of "Strange Moods" perfume added a weird olfactory signature. Because the environment was up for only three days, too quick for the art world to react, Brown figured that "if it was going to get any response at all it'd have to be through the me-dia." So he sent out a press release announcing that *The Meat Show* was the Grand Opening Service of a new religion. "I am attempting to bring religion, sex and art into the same vital relationship that existed prior to

the degenerative plague that Jesus Christ, Mohammed, Moses, Gautama Buddha, and Lao-Tse visited upon humanity," the press release declared. "The Meat Show will induce startling spiritual, sexual and aesthetic revelations in the viewer. It is my belief that even the most bereft wretch will be jolted into some kind of consciousness when confronted with the awesome sight of tons of meat, gallons of blood, hundreds of yards of lingerie fabric and other sights as yet undisclosed, which will be organized into a harmonious and inspirational work of art."

He called his new "Orthodox Pagan" religion the First National Church of the Exquisite Panic, Inc. "It has but one commandment: Live," he said. "It has but one prohibition: Do not eat cars." And it had but one god, named Who? "For example: Why is it not raining? Who? knows." The central concept was "the theory of Pharblongence. Pharblongence is a very ancient word of Yiddish origin, the most accurate translation of which is total confusion. We don't know where we're going, but Who? does. There are many religions which teach how to get to Nirvana. They all give very complicated directions. The First National Church of the Exquisite Panic, Inc. tells you how to get to Nevada. It's simple. You take a bus."

An international gaggle of newspaper stringers and television crews reported on The Meat Show in oh-those-artists tones. Brown had successfully established himself as the meat artist guy. People wondered what he'd do next. The chicken parts show? The raw fish show? "Back in the '60s, everybody accepted that if you painted stripes, you painted stripes for the rest of your life," he said. "If you painted squares, you painted squares for the rest of your life." He couldn't see himself hanging meat for the rest of his life. It would be the German Fluxus artist Joseph Beuys who ran with the idea, incorporating dead rabbits, live coyotes, and great slabs of fat into his work from the mid-1960s on.

Brown, like Alfred Leslie, pursued whatever kind of art struck his fancy and his dadaist sense of humor. In London he marched around the streets with his hair dyed a nuclear pink and his clothes festooned with buttons that declared, "I am a Young Jazz Immortal." He called that piece Free Stripteuse with Drum and Bugle Corps Accompaniment. In France

he and Rhett staged *Orgasm Event* in a hotel bridal suite. Guests walked from room to room with cocktails in their hands, viewing a replica Statue of Liberty holding sparklers, a woman in the bathtub who appeared to be a murder victim and was lit by highway flares, and a couple simulating sex in the bedroom. "It was a four-minute event," he later explained. "It lasted as long as the flares lasted." He did a series of hand-tinted, blown-up fetish and bondage photos. His series of "plagiarisms" anticipated postmodern appropriation. He published a very nicely printed pamphlet called *Ulysses*, made up entirely of early critical responses to Joyce's book but with Brown's name inserted every time Joyce had been mentioned. "This is instant gratification and energy conservation," he explained. "You don't have to write a big book—just get the reviews and stick your name in them." *Hanging*, another pamphlet, was a medical text describing the effects of hanging; Brown simply stuck his name on it as the author. When he gave away copies, he always signed them *Here's hoping the rope breaks*. Then there was the book about Duchamp in which he forged Duchamp's signature. Running into Duchamp at El Faro, he showed the book to him. Duchamp pulled out a pen and wrote under the forged signature *Confirmed: Marcel Duchamp '64*. Who? knows how long they could have gone on out-Duchamping each other this way.

In 1967 the Delford Browns bought the small, churchy-looking Victorian library building at 251 West Thirteenth Street just off Jackson Square, one of those confusing Village triangles where West Thirteenth, Greenwich Avenue, Horatio Street, and Eighth Avenue all manage to converge and go veering off in different directions. The library was designed by Richard Morris Hunt, who also did the Tenth Street Studio. The Delford Browns hired an architect to modernize the exterior and gut the interior, creating a high, open volume of light and air somewhere between an artist's loft and a Mondrian church, a jazzy collage of intersections in an upthrust tumble of airy spaces, with minimalist wooden stair blocks scaling exposed brick to shiny pressed-tin ceilings. Brown christened the renovated building the Great Crack-Up. He named one room the Temple of Hilarity and another the Chapel of Pharblongence. He hung two EXQUISITE PANIC signs out front, a pair of goony cross-eyed

faces with the motto *Who? Knows!* on them. In later years the lights of a disco ball would spill out at night through the big picture window next to the entrance. For the next three decades he would hold Exquisite Panic services there—always billed as grand openings—including "The Mr. Jesus Christ Contest" and a celebration for VD (Victory over Dumbness) Day. He would baptize people by silly string and get them to bake what he called Metaphysical Radio Cakes, "metaphysical radio" being his metaphor for prayer.

"I'm a religious leader. Somebody's gotta do it," he shrugged in 1995. "The great thing about being a religious leader is, anything I say is true. I'm an expert on all metaphysical matters."

# Bebop

BEBOP SUGGESTED ANOTHER MODE OF BEING. ANOTHER
WAY OF LIVING. ANOTHER WAY OF PERCEIVING
REALITY . . . STRANGENESS. WEIRDNESS. THE UNKNOWN!
—LeRoi Jones

SAY, YOU STILL SELLING GRASS IN THE VILLAGE? I BET
THE SPADES THINK YOU'RE A REAL BAD MAN.
—Panic in Needle Park

B EBOP BEGAN DURING THE WAR YEARS IN HARLEM. IT TOOK A
few years to make its way down to Greenwich Village, but when
it did it found a natural home there. Bebop was as much an expres-
sion of the postwar avant-garde as Abstract Expressionism and Beat
literature, and it inspired both painters and writers to be as freely,

spontaneously creative on the canvas and the page as boppers were in the air. Its influences are as obvious in Pollock's action paintings as in Jack Kerouac's "bop prosody." And as bebop begat the laidback cool jazz, the funkier hard bop, and the fiercely atonal free jazz—a boppier bebop, what Amiri Baraka calls "an atomic age bebop"—they all found attentive, even studious audiences in the clubs, bars, and lofts in and around the Village.

Bebop started as a revolt inside the big bands of the so-called swing era, which didn't have much swing left in it by then. Big band music "had passed completely into the mainstream and served now, in its performance, simply as a stylized reflection of a culturally feeble environment," as LeRoi Jones put it in *Blues People*. "Spontaneous impulse had been replaced by the arranger, and the human element of the music was confined to whatever difficulties individual performers might have reading a score." Younger musicians, bored to tears with tightly charted dance music, jammed this new, more freely improvisational and complex jazz. Jones and others saw this as not just a musical revolt but a political and social one as well. A new generation of black musicians was repudiating the way jazzmen had prostituted their creativity to entertain white audiences, he argued. They were taking back an authentically black cultural expression that had been commercialized and assimilated by a society that was thoroughly racist. In their way they formed a leading edge for the black nationalist and separatist movement of the 1960s that would turn LeRoi Jones into Amiri Baraka.

After hours at clubs like Minton's and Monroe's in Harlem, Dizzy Gillespie, Charlie Parker, Thelonious Monk, and others pioneered the new form. After the war it spread to West Fifty-second Street (aka Swing Street), Lincoln Square, and eventually to the Village and what became the East Village. Like any newly emerging art form it struck some early listeners as weird, ugly, and threatening. "The willfully harsh, *anti-assimilationist* sound of bebop fell on deaf or horrified ears," Jones recalled. Older jazzmen scoffed at it. "They flat their fifths," Eddie Condon once said, referring to the boppers' use of the somewhat menacing and discordant flatted-fifth scale later beloved of heavy metal guitarists. "We

drink ours." It was no coincidence that a revival of interest in old-school Dixieland jazz occurred around the same time, creating much heated debate between the bop fans and the old-timers, nicknamed "moldy figs." Dixieland was big in Village clubs through the 1950s. When Jones started hanging around the neighborhood toward the end of the decade, he got a part-time job at the *Record Changer* magazine, whose office on Sullivan Street was to moldy figs what Izzy Young's Folklore Center was to the folk music revival.

That bebop in its developmental years was considered a cult, a fad, the music of crazy outsiders only enhanced its esteem among hip young fans, black and white. "BeBop. A new language a new tongue and vision for a generally more advanced group in our generation," Jones wrote. Jazz had become dance music and entertainment; bebop musicians made the unequivocal statement that it was art. Like the Ab Exers they deconstructed the too-familiar forms to invent new ones. When Baraka writes about John Coltrane's solos "taking the music apart before our ears, splintering the chords and sounding each note, resounding it, playing it backwards and upside down trying to get to something else," he sounds much like Clement Greenberg describing the methods of Pollock or de Kooning. Among Village intellectuals, probably more than anywhere else at the time, the boppers' attitude that jazz deserved to be considered a serious art form was taken as a given. It was in the Washington Place apartment of the Hunter College English professor and huge jazz fan Marshall Stearns that the Institute of Jazz Studies started in 1952, with a board that included John Hammond and the avant-garde composer Henry Cowell, who taught at the New School. Robert Reisner, a curator of the institute's large archives, which started as Stearns's private collection, was an impresario who booked jazz acts in Village clubs. His ads included the only-in-the-Village tagline "Bob Reisner says: the three great life experiences are sex, psychoanalysis and cool jazz." It was in the Village that Charlie Parker knocked on Edgard Varèse's door and asked him to teach him composition. "I only write in one voice," Varèse later recalled Bird saying. "I want to have structure. I want to write orchestral scores. I'll give you any amount you wish. I make a lot of money. I'll be your servant. I'm a

good cook; I'll cook for you." Varèse was leaving for Europe. When he got back Parker had died.

Unlike Dizzy Gillespie, who was bebop's ambassador-at-large to mainstream America, Parker was bop's leading emissary downtown. Gillespie was flamboyant, affable, and easygoing, happy to promote the new music to broad audiences, even willing to play a bit of the (dizzy) clown in his campy look—a combination of clichéd arty-intellectual symbols including a beret, horn-rimmed glasses, a goatee, and ostrich-leather shoes. *Life* did a spread on him in 1948, with photos of hip Hollywood celebs Mel Tormé and Ava Gardner living it up in his audience.

Charlie "Bird" Parker, on the other hand, was the bop god to hipsters and fans, a jazzman for the cognoscenti. He was not even mentioned in that *Life* article, or in much other mainstream press during his lifetime. Growing up in Kansas City in the 1920s and '30s, he'd dropped out of high school, gotten married, developed a heroin addiction, and played his first professional gig all by the age of sixteen. As befits a bohemians' hero, he lived the rest of his short but action-packed life at full tilt. He matched his Promethean talent with prodigious appetites for everything—food, drink, drugs, sex, knowledge. He was as complex and mercurial as his solos, a tormented perfectionist whose moods veered from madcap antics to titanic rages to suicidal depression. After following other jazzmen to New York in 1939 he made it his home base. By 1949 he was so revered that he had a club named after him, Birdland, on Broadway near Fifty-second Street. It was a mecca for boppers, where of course he headlined. But he gravitated to the scene downtown and attracted other jazzmen there. In 1950 he moved his family to a brownstone on Avenue B near East Tenth Street, designated a historic landmark in the 1990s. When Reisner asked why he chose the neighborhood, he replied, "I like the people around here. They don't give you no hype." It also put him a short hop from Greenwich Village, where he did a lot of hanging out, partying, and playing. "He loved the Village more than any other part of town," the black Village poet Ted Joans said. Arthur's Tavern, which opened in 1937 next door to Marie's Crisis, still prides itself on having been one of Bird's haunts.

In 1951 Parker was banned from performing in New York when his cabaret card was revoked for drug violations. He wouldn't play in the city again until 1953, the year Reisner booked him for an extended engagement on Sundays at a club near Washington Square called the Open Door. By all accounts he was not at the top of his game by this point in his life. He had burned himself just about clean through, physically and emotionally. "The Sunday sessions were full of suspense and drama," Reisner writes. "Would he show? Was he well? Would he hang around or wander off?" One afternoon late in 1954 Parker was found lying unconscious on Barrow Street. His friend Ahmed Basheer brought him up to his apartment at 4 Barrow Street, where Joans also had a place. Parker crashed with them through that winter, which turned out to be the last few months of his life. Joans later recalled that he, Parker, and Basheer would sleep together in the same bed for warmth because the steam heat was so bad.

Parker died on March 12, 1955, at the uptown Stanhope Hotel, in the suite of Baroness Pannonica de Koenigswarter, the renegade Rothschild who was a patron to him, Thelonious Monk, and others. At thirty-four he'd lived fast and died young but did not leave a good-looking corpse—the coroner doubled his age in his estimate. As the word went out, Joans and a few friends from the Village fanned out by subway to scrawl the now familiar message *Bird lives!* in charcoal or chalk on walls around the city.

WHEN DAVID AMRAM HIT THE SCENE THAT YEAR, DOWNTOWN JAZZ was in its own golden era and he immediately found places to play in and around the Village. He had taken up trumpet as a kid growing up in rural Pennsylvania in the 1930s and then in Washington, D.C., during the war. He played his first professional gig while still in junior high, sitting in with an all-black jazz band. He got paid one dollar and a bucket of ice cream. He switched to French horn because it was easier to play with braces. From early on he was mixing jazz and classical music in his playing and composing. In the first half of the 1950s he played orchestral music in the army, then jazz in Paris. When he arrived in New York

in 1955 he got a place on East Eighth Street between Avenues B and C. Later he'd move to a tiny cockroach ranch of a sixth-floor walk-up at 114 Christopher Street. He headed straight for the jazz clubs in the Village and was soon playing with Charles Mingus at the Café Bohemia, a spot at 15 Barrow Street that since the late 1940s had been a bar, a restaurant, a lesbian hangout, and was now newly dedicated to progressive jazz; "No rock 'n roll, no vocalists, no big bands, no nuttin' except small jazz combos," the owner told the *Village Voice*. It was one of the coolest clubs in town. Miles Davis, Art Blakey, and other greats played there, all the other jazz musicians in town came to listen, and some landmark albums were recorded live there. "The Bohemia's audience reminded me of cafés in Europe, where people were serious and intense, and paid attention," the jazz record producer George Avakian recalled. "They regarded the music as an art form, and even acted a little superior about the fact that they were there and listening to Miles."

Amram also started to play at the Five Spot, a bar on Bowery below Cooper Square, which like the Cedar Tavern became a regular watering hole for the painters, the Beats, everyone on the downtown arts scene in the mid-1950s. Alfred Leslie credits the sculptor David Smith and the painter Herman Cherry, whose loft was across the street, with discovering it. Originally it was a family-owned dive where Bowery bums went for their morning "eye-openers." Then the owners, Joe and Ignatius Termini, allowed some neighboring jazz musicians to play there at night. Smith and Cherry told the other downtown artists, and since the Cedar was often three deep at the bar by then they began to peel off to the Five Spot just a few blocks south and east. It didn't take the Terminis long to see what they had going and soon they turned the bar into a regular venue for the newest jazz. Most of the downtowners preferred to hear jazz in bars rather than nightclubs; the drinks were much cheaper and the atmosphere looser. "The Five Spot welcomed everybody—artists, moving men, postal workers, winos, office workers, and off-duty firemen—and you could get a huge pitcher of beer for 75 cents," Amram writes in *Offbeat*, his second memoir. "The Five Spot is

darkly lit, has weird waiters, good music always," Kerouac wrote of it. "On weekends parties of well-dressed uptowners jam-pack the place, talking continuously—nobody minds."

"The outsiders were welcome to join us, even if they didn't want us to join them," Amram explained in 2011. "It wasn't an exclusive club. We were just hanging out." Any musician who wanted to jam with Amram's quartet was welcomed; he recalls one night when all eighteen members of the Woody Herman band sat in with his group. Thelonious Monk's quartet, with John Coltrane on tenor, played their first long-term engagement there. In 1959 Ornette Coleman's free jazz experimenting at the club would light a firestorm of jazz world controversy. One night Larry Rivers brought his friend Leonard Bernstein to the Five Spot to hear Coleman; Coleman invited Bernstein up to play. The Beats, the New York School poets, and their friends gave readings there, often backed by jazz. Langston Hughes came down from Harlem to read, backed by Charles Mingus; Kenneth Rexroth, the Beats' West Coast mentor, packed the house when he read to music by the hard bop Pepper Adams Quintet, who also recorded a live album there. In *Minor Characters* Joyce Johnson, who dated Kerouac for a couple of years, writes, "I remember one night when a middle-aged, sad-faced black woman stood up beside the table where she'd been sitting and sang so beautifully in a cracked, heartbroken voice I was sure I'd heard before." It was Billie Holiday. In the poem he wrote when she died in 1959, Frank O'Hara recalled hearing her at the club "and I stopped breathing."

In July 1957 *Esquire* ran a lavish photo essay, "New York's Spreading Upper Bohemia," a pseudosociological survey of places in the city where artists, musicians, and writers rubbed elbows with their well-heeled, well-connected patrons and collectors—businessmen, ad men, publishers, doctors, lawyers, society matrons. The article dubbed the artists Lower Bohemians and the wealthy patron an Upper Bohemian, who is "culturally hep, but he is not a cultural hepcat." In one photo, Amram blows his French horn on the Five Spot stage for a casually mixed-race crowd huddled at small tables. Another shows a booth crammed with the artists

David Smith, Larry Rivers, and Grace Hartigan and O'Hara and a pair of Upper Bohemians, one a neurosurgeon and the other an economist.

After his unhappy experience with Thelonious Monk early on, Max Gordon (with Lorraine's prodding) had warmed to progressive jazz, and many of the greats were playing at the Vanguard by the time Amram arrived. And when Art D'Lugoff opened the Village Gate on Bleecker Street in 1958, it became one of Amram's favorite places to play. "When you were there you just felt at home, more than where your home usually was," he recalled. "When I played there with Dizzy Gillespie, after the show was over we didn't want to leave. We'd sit in the back dressing room reminiscing and telling jokes. Finally about four o'clock in the morning the great big pipe [in the ceiling] started to drip. Dizzy said, 'That's the sign, fellas. We gotta split.' The bass player said, 'Why, man?' Dizzy said, 'Otherwise Art D'Lugoff's gonna charge us rent.'" Dizzy celebrated his sixtieth birthday there in 1977.

As that *ESQUIRE* photo of the Five Spot audience suggests, Village bohemians' enthusiastic embrace of progressive jazz can be seen as part of their ongoing efforts to be progressive about racial issues as well. It would be a gross overstatement to say that the bohemian Village was a little free zone of interracial harmony and equality, but black musicians, artists, and writers did feel somewhat more at ease mixing with the hip white people there than with whites elsewhere. The clubs and bars where progressive jazz was played were, as the jazz critic Nat Hentoff put it, "islands of at least acquaintanceship between Negroes and whites." The more thoughtful white jazz fans were aware that their enjoyment of this music in clubs where they mingled with black musicians and patrons didn't constitute great victories for racial understanding and equality but maybe small ones.

Gay black artists and writers found life a little easier among hip Villagers than in mainstream society, including black society. James Baldwin had started coming down to the Village from Harlem to work afterschool jobs in the 1930s. By the late '40s he was living there and working on his novel set partly in the Village, *Another Country*, about a bisexual

black jazzman who squires an emotionally battered white woman around the bohemian milieu. Baldwin met such black bohemians as Richard Wright, the novelist, and the artist Beauford Delaney, who painted several portraits of him. Born in Knoxville, Delaney had come to New York in 1929. He lived in Harlem, where he knew everyone on the Harlem Renaissance scene, but as a gay man he did his socializing in the Village, where he kept a studio. During the anything-goes Prohibition years Harlem's clubs and speakeasies had rivaled those in the Village for butch and pansy acts. But Harlem's dominant, churchgoing society remained very conservative on the issue, and what might be tolerated on a nightclub stage was soundly condemned in daily life. Even a star the likes of Langston Hughes kept it on the down low in Harlem. Bayard Rustin, the civil rights leader who was also gay, found his way to the Village in the late 1930s as well; he sang tenor in Josh White's group the Carolinians at Cafe Society and socialized at the White Horse and the Paddock.

Harry Belafonte came to the Village from Harlem after the war. His mother, Millie, of mixed-race heritage, had come from Jamaica to Harlem's West Indian section during Prohibition. She joined a sister who was already there and running a successful numbers operation with a white partner, a Tammany Irishman. His father, Harold Bellanfanti, also a mixed-race Jamaican, was a cook on United Fruit Company banana boats. Millie did domestic day labor. Harold Jr. was born in 1927. His childhood was divided between Harlem—where for a while the light-skinned boy hid his black heritage from the white kids around him, going by the nickname Frenchie—and long stays with his mother's family in Jamaica. He fell in love with theater and got a few acting parts with the American Negro Theatre, where he became lifelong friends with another young actor, Sidney Poitier. Following a stint in the military he used the GI Bill to study acting under Piscator at the New School. On his first day, the only dark face in his class, he introduced himself to the other young nobodies: Marlon Brando, Rod Steiger, Walter Matthau, Elaine Stritch, Wally Cox, Bea Arthur, and Bernie Schwartz, aka Tony Curtis. Brando was, not surprisingly, the coolest guy in class, but right behind him was his roommate Cox, whose entire career would be spent playing nerds and

nebbishes. He and Brando zipped around the Village streets on motorcycles. Brando had a thing for pretty black girls. He and Belafonte double-dated dancers from Katherine Dunham's company.

Although acting was Belafonte's first love, others convinced him that his true forte was singing. At twenty-one he debuted at the Royal Roost, a very popular midtown club, singing pop tunes like "Pennies From Heaven" with a pickup band that included Charlie Parker and Max Roach. He cut a few modestly successful records, toured East Coast clubs, and played an extended engagement at Cafe Society; then his pop career fizzled. In 1950, looking for more stable income, he threw in with two friends to start a tiny hamburger stand they called the Sage on Seventh Avenue near Sheridan Square. A burger joint run by three handsome black men was a novelty even in the Village, and it soon attracted a lot of Village girls, who attracted a lot of guys. This "began to cause some resentment among the Italians who ran most of the other coffeehouses and restaurants in the neighborhood," Belafonte recalls in his memoir. "We started hearing mutters, and caught some dirty looks." The trio managed to finesse their way out of paying local mobsters "protection" fees, but their own lack of business skills sank the place anyway. The Sage was right down Seventh Avenue from the Village Vanguard, where Belafonte heard Woody Guthrie, Leadbelly, Josh White, who inspired him to switch to folk music. He made pilgrimages down to the Lomax collection at the Library of Congress in D.C. and studied up, building a new repertoire. His agent convinced a reluctant Max Gordon to let him debut the new act at the Vanguard—a two-song tryout. He went over well and launched his new folksinging career there with a three-month engagement, followed by a run uptown at the Blue Angel. He soon took advantage of his Caribbean roots by adding calypso and mento songs to his repertoire, releasing the great single "Matilda" in 1953 and the smash hit LP *Calypso* in 1956.

LeRoi Jones moved to Manhattan in 1957. He'd grown up in the heart of the black middle class in Newark, attended Howard University, and done a tour in the U.S. Air Force, from which he was discharged on suspicions that he was a commie troublemaker, partly because he was

known to read *Partisan Review*. Now an aspiring writer and intellectual in his early twenties, he took a cold-water walk-up in the East Village. At twenty-eight dollars a month it was as near as he could afford to the Village proper. He haunted the Village coffeehouses—the Rienzi, the Figaro, Pandora's Box near Louis' Tavern off Sheridan Square. Applying for a job at the *Record Changer* he met Hettie Cohen, a Jewish girl from Queens. They were soon dating. "It seemed to me part of the adventure of my new life in the Village," Jones/Baraka later wrote. "The black man with the white woman, I thought. Some kind of classic bohemian accoutrement." They moved in together and on her second pregnancy decided to get married. According to Hettie, their Italian neighbors gave them cold stares, catcalls, and jeers when they walked arm an arm in the Village, but "we might have been hurt, or *killed*—and him more than likely—had we been out of New York City." Jones carried a length of pipe with him whenever he walked through the South Village, with or without his white woman on his arm. In Baldwin's *Another Country*, the black jazzman and his white woman are sitting self-consciously in Washington Square when an Italian youth from the neighborhood goes by. "The boy looked at him with hatred; his glance flicked over Leona as though she were a whore."

There was a bar on Minetta Lane in the mid-1950s where black men and white women went to meet—in effect a modern black-and-tan—called Romero's. Owner Johnny Romero was a handsome West Indian who was said to date only white women himself. He kept the jukebox stacked with calypso records, which Belafonte was then helping to make a big pop music fad. Romero's "had a smoldering kind of illicit sexual excitement about it," Dan Wakefield writes. Ron Sukenick records that white Village guys went there as a kind of political statement, a gesture of solidarity with black people, but often found the black men there intimidating. The black playwright Charles Gordone, who waited tables at Romero's, later set his Pulitzer-winning play *No Place to Be Somebody* in a fictionalized version of the bar. After a few years Romero abruptly closed the place and moved to Paris. There were rumors that he'd dated the daughter of Carmine DeSapio, the very powerful Village politico, and DeSapio's mob

friends had pressured him to leave. In Paris he opened a hip and very successful boîte, Les Nuages.

For all the interracial dating, Hettie Jones notes that there were never more than a small handful of actual relationships or stable interracial marriages in the Village at the time. Her own marriage would founder and break up in the mid-1960s, partly over Jones's many infidelities and partly because, as he became known as the angry black revolutionary and writer of such incendiary plays as *Dutchman* and *The Slave*, he eventually became embarrassed to have a white wife.

Although black men with white women were the more controversial, white bohemian guys of course also dated black women. Jack Kerouac's novel *The Subterraneans* is about an interracial romance he had in the Village, though he switched the location to San Francisco in the book. Relations between black and white bohemians are also at the center of John Cassavetes's writing and directing debut, *Shadows*, which premiered in 1958. The central characters are a struggling black jazz singer, his beatnik brother, and their innocent light-skinned sister who takes up with a white hepcat. He leaves her when he discovers she's black. Black and white hipsters drink together, dance together, and get in fights with Italian squares together, but the film says that race relations are a lot more difficult than the superficial bonhomie admits.

Actual events in the Village proved it. In the later 1950s Baldwin, by then a famous and successful writer, had an apartment on Horatio Street in the Irish Village, "a high-ceilinged studio that was clean and sparsely furnished—all I remember is a couch and a hi-fi set, bare hardwood floors and tall windows," Wakefield writes. He also drank at the White Horse and the Paddock, threw famous parties for his friends in his apartment, took them all to a nearby Spanish restaurant, El Faro at Horatio and Greenwich Streets (opened in 1927 and still in operation as of this writing), where he picked up the tab. He found it easier being black and gay in the Village than elsewhere, but not *easy*. "I do *not* like bohemia, or bohemians, I do not like people whose principal aim is pleasure, and I do not like people who are earnest about anything. I don't like people who like me because I'm a Negro," he wrote in *Notes of a Native Son*, published in

1955. He found out that the Irish Village could be as dangerous a place for a black man as the Italian Village. One night he took a booth in the Paddock with his friend the cinematographer Richard Bagley (*On the Bowery*) and two white women friends. The way it's told in the Irish Village to this day, a couple of young drunks, making their way past the booth to the men's room, made some nasty comment about seeing a black man sitting with a white woman. They either didn't know or didn't care that he was gay. Someone in the booth, it's said, was foolish enough to retort and the two exploded. They brutally beat Baldwin and Bagley. Baldwin left soon after for Paris, where he completed his Village novel *Another Country*, including a horrific scene based on his experience that night.

Another event signaling that the rapprochement of black and white bohemians in the Village—including Hettie and LeRoi Jones's marriage—could be fragile was the March 1964 production of Jones's play *Dutchman* at Cherry Lane. Written, he later recalled, in a single blazing night, the one-act portrays a sexually fraught encounter between a white female bohemian type and a young black man on the subway. She comes on to him and teases him in a half-crazy, half-mocking way, until he roars at her, "You great liberated whore! You fuck some black man, and right away you're an expert on black people. What a lotta shit that is." She stabs him to death, then calmly searches the subway car for her next victim. Jones followed it later in the year with *The Toilet* and *The Slave*. The latter is set in a near future when a black man formerly married to a white woman has become the leader of a violent black revolution. Hettie, and all their downtown friends, clearly saw herself and LeRoi in those two characters. *The Toilet* is about a gay white boy dragged into a men's room and beaten by a gang of black youth. Jones seemed to be working out some complex ambivalence in it regarding his relationships with friends like Frank O'Hara and Larry Rivers, who designed the set. On a larger scale, obviously, the white characters in these plays are all representatives of liberal white America, seducing black Americans and clasping them in an embrace that can be broken only by violence and revolution. Ironically, liberal white America hailed Jones as a new voice of black rage. *Dutchman*

won that year's Obie for best new play, and the author was showered with writing offers from mainstream media.

Jones's relationships with his white wife and friends continued to deteriorate. In a panel discussion with Rivers and others at the Village Vanguard in March 1965—one month after the assassination of Malcolm X—he shocked Rivers by accusing him of oppressing blacks both as a white man and as a Jew. They didn't speak for twenty years. A couple of weeks later Jones appeared on a panel at the Village Gate with D'Lugoff, Hentoff, the pianist Cecil Taylor, Congress of Racial Equality (CORE) leader Bob Gore, and Paul Krassner as moderator. With Jones leading the way the debate quickly descended into name-calling and insult, with much shouting, jeering, and cheering from the audience. Jones attacked the whites in the room at the root of their cherished belief, or hope, that as bohemians, jazz fans, liberals, outsiders themselves they were not part of the oppressive white establishment. He called D'Lugoff "just a shop-keeper in a very hip ghetto situation," told one white woman in the audience that she was "disqualified from humanity," and called another a "rotten fruit." D'Lugoff fired back that Jones was "a racist and bigot" and told Hentoff, who'd tentatively risen to Jones's defense, that he was an anti-Semite and a disgrace to Judaism. At the end of all the yelling, Jack Newfield wryly noted in the Voice, audience members were handed "leaflets written by Jones asking for contributions for his Black Arts Repertory Theatre." That same night the quintessential example of white people embracing black culture, the Paul Butterfield Blues Band, played a gig at the Gate. Jones left Hettie that year, left the Village for Harlem, and became the black revolutionary Amiri Baraka.

BESIDES COMPLETELY RENOVATING JAZZ, PART OF BEBOP'S LEGACY was the rise of heroin as the ne plus ultra of cool, outlaw hipster drugs. The previous generations of jazzmen had been pot smokers. They'd brought marijuana north with them from New Orleans and made it the hip drug of choice of the 1930s. Through the Depression pot was closely associated with jazz and vice versa. "Teaheads" and "vipers," as smokers were called, congregated where the jazz clubs were—in Times Square, on

Swing Street, and in Harlem's "tea pads." The boppers smoked plenty of tea themselves but many of them also turned to the hard stuff. Heroin use exploded at the same time that bebop did; in New York City, heroin busts increased tenfold between 1946 and 1950, clustered in the same neighborhoods where pot had been prevalent in the 1930s and for the same reason: it was where the jazz was. Smack was in effect the avant-garde of drugs, the ultimate high, the total rejection of the square world and its bustling work ethic. When Miles Davis came back to New York after a sojourn in Paris in 1949 he found that many of his jazz friends were "deep into drugs, especially heroin. People—musicians—were con-sidered hip in some circles if they shot smack." And since so many of the boppers, including Davis, did it, many of their fans, admirers, and wan-nabes did too.

It was no coincidence that jazz and heroin appeared in the same places. The common factor was the Mafia, who both ran the international heroin trade and owned or backed many of the jazz clubs. In the Village, where recreational heroin use ("joy bangs") had mostly been a working-class pas-time in the 1930s, it spread in the 1940s and '50s among the bop-loving hipsters, bohemians, and Beats. They in turn enhanced its allure among their fans. When LeRoi Jones came to the Village he was introduced to the speedball, a combination of heroin and amphetamines very popular with local hipsters. Heroin's reputation as the coolest complement to the coolest new music would carry through the rock and punk rock decades.

BY HAPPENSTANCE, ANOTHER ULTIMATE HIGH MADE ITS FIRST IN-roads into hip culture in the Village of the early 1950s. Years before Dr. Timothy Leary's name became synonymous with LSD, an obscure char-acter named George White was secretly dosing Villagers with it.

White had been a Federal Bureau of Narcotics agent since the 1930s and a spy during the war for the Office of Strategic Services, which later evolved into the CIA. As an OSS agent, White worked for a program to develop a "truth drug" that could be used on enemy spies. OSS scientists extracted THC, the active ingredient in marijuana, as a test truth serum; white went around New York City handing out THC-laced cigarettes to

suspected enemy agents, including scientists working on the Manhattan Project. In 1952, when the CIA wanted to test the mind-control potential of the relatively new drug LSD, White was given the job and a supply of the drug to use. White and his wife lived on West Twelfth Street and fit right in with the shadowy side of Village life. He was an alcoholic, and he was into kinky sex. He liked to be punished by women in stiletto heels, he liked to dish it out as well, and he and his wife liked to throw swinging orgy parties with friendly couples in their apartment. He was friends with Gil Fox, who published his fetishist Vixen Books (with titles like *No Holds Barred*, *Chains of Silk*, and *Carnal Cargo*) out of his apartment on Christopher Street, and the fetish artist John Willie, who put out a magazine called *Bizarre* and is best known for creating the bondage cartoon character Sweet Gwendoline. According to Fox, White showed his sadistic streak by secretly spiking friends' cocktails with LSD and coolly observing their confusion and terror. One young woman he dosed this way developed permanent psychosis and ended up in a mental institution.

In 1953 the CIA, convinced there was a mind-altering-drugs gap with the Soviets and the Chinese Communists, started the supersecret MKULTRA program "to develop drugs that would enable the CIA to discredit friends and foes alike, and that could be delivered clandestinely and kill without a trace." Using a CIA bank account and adopting a false identity as an artist, White rented an apartment in the nondescript building at 81 Bedford Street and outfitted it with an air conditioner, a two-way mirror, recording equipment, Toulouse-Lautrec posters, and a well-stocked liquor cabinet. Through 1955 he dosed unsuspecting people with LSD in this phony artist's pad and watched the results. Some were brought to him by hookers he paid for the service, others were acquaintances he or Fox lured there, an assortment of Village types—aspiring young actresses, young swinging couples, the occasional West Side hoodlum. It's unclear how much of this was useful research as opposed to White's simply entertaining himself at others' expense. The whole program almost blew up when a CIA scientist named Frank Olson was secretly dosed—not by White but by another MKULTRA researcher in a D.C. suburb. Olson went on a prolonged bad trip and was sent to New York City to see a CIA-

connected psychiatrist. Evidently the shrink was no help: Olson hurled himself out the window of his room at the Statler Hotel near Penn Station and died.

IN THE 1960S AND '70S FOLK AND ROCK DREW HORDES OF YOUNG listeners to the Village, much to the disgruntlement of some '50s holdovers. But even though the audiences for live jazz diminished, there was still a good deal being played in and around the Village. On a single weekend in the summer of 1963 you could hear Archie Shepp at the Take 3 on Bleecker Street, Herbie Mann nearby at the Village Gate, Gerry Mulligan at the Vanguard, Zoot Sims at the Half Note on Hudson Street, Steve Lacy at Phase 2, and Monk over at the Five Spot. Amram, the multi-instrumentalist and budding internationalist, loved the diversity of musical styles in the neighborhood. Within a few blocks' walk, he remembers, you could hear jazz in one spot, folk in another, Middle Eastern music at Cafe Feenjon on MacDougal Street, and Mongo Santamaria at the Village Gate. "That's how I learned so many different kinds of music and felt comfortable with them," he says. "I'd go sit in with Mongo, or play with Dizzy or my own group, then go down and play with Ramblin' Jack Elliott or Odetta, then sit in with the Middle Eastern guys all night. I was just an underground scholar with an open mind and an open heart. I've always been drawn to things of beauty. If something touched my heart I'd say, 'Man, I gotta get close to that.' "

# The Beat Generation

HOLD BACK THE EDGES OF YOUR GOWNS, LADIES, WE ARE
GOING THROUGH HELL.

—William Carlos Williams

I'M A RECORDING ANGEL. WE'RE ALL ANGELS . . . WE'RE
ALL IN HEAVEN *NOW*!

—Jack Kerouac

B EAT WRITING ENTERED THE POPULAR CONSCIOUSNESS WITH
the publications of Allen Ginsberg's Howl and Other Poems (by
City Lights in San Francisco) in 1956 and even more so with Jack
Kerouac's widely heralded and denounced On the Road (by Viking
in New York) in 1957, followed by a tsunami of Kerouac titles in the
three years that followed. Lawrence Ferlinghetti's Coney Island of the

*Mind* appeared in 1958 and William Burroughs's *Naked Lunch* (titled *The Naked Lunch* by its first publisher) in 1959. Ferlinghetti and Burroughs were older than Ginsberg and Kerouac, and neither ever called himself one of the Beats, but fans and the press did anyway. In 1958 the San Francisco columnist Herb Caen coined the diminutive "beatnik," combining Beat and Sputnik, and the Village, along with San Francisco's North Beach neighborhood and Venice Beach in Los Angeles, filled up with bearded, beret-wearing clones. By 1959 parodies littered the mainstream media, from countless editorial cartoons of stereotypical beatniks (the guys in berets and goatees, the girls all in black looking like Morticia Addams) to Roger Corman's genuinely funny *A Bucket of Blood*, a comedy-horror movie set in Venice Beach–style bohemia and advertised as "The Picture That'll Make You . . . sick sick SICK with Laughter!" That same year television got its first resident representative featured on *The Many Loves of Dobie Gillis*. Portrayed by Bob Denver, who would later play Gilligan, Maynard G. Krebs was all cliché, from his goatee and frayed sweatshirt to his hipster slang, his love of jazz, and his instinctive abhorrence of work and commitment.

Maynard may have been a stereotype, an exaggeration, but by 1959 Village coffeehouses were crowded with weekend and wannabe beatniks acting almost as ridiculously. The novelist Herbert Gold dismissed them with the nastily apt analogy that they were to the truly hip as a box of cornflakes was to a field of corn. David Amram likes to say that the beatniks had no more to do with Kerouac's work, his own, or their friends' "than *The Beverly Hillbillies* did with William Faulkner's writing." Tour buses clogged MacDougal and Bleecker Streets, packed with families hoping for "authentic beatnik" sightings, which local businessmen happily provided. That year the *Village Voice* photographer Fred McDarrah ran a small joke ad in the paper for a service called Rent-A-Beatnik. Surprised by the positive response, he enlisted the jazz poet Ted Joans, who made his rent money for a while going around to squares' parties and playing the role for them. In September 1960 came the inevitable MAD parody feature, "Beatnik: A Magazine for Hipsters." It offered a

glossary of square terms and a "Dear Daddy-O" column of "Advice for the Love-Bugged," and it took pokes at Kerouac (through a "part-time intellectual" named Kerr U. Ack) and others. An unintentional parody came out of Hollywood that year in *The Subterraneans*, a terrible film loosely based on the novel, with George Peppard as the Kerouac figure. By then many of the artists and writers who had generated all this interest had fled the Village and North Beach, abandoning them to the tourists and fauxhemians. The cycle from the original, "authentic" phenomenon to a crassly commercialized mass fad—one that bohemian enclaves go through so often it seems inevitable—was complete.

The Beat Generation, as Kerouac had almost inadvertently dubbed it, had been around for nearly twenty years by this time. In December 1943, Allen Ginsberg, a nerdy seventeen-year-old Columbia University freshman from Paterson, New Jersey, made his first trip to Greenwich Village where, as he wrote, "all the fairies were." His father, Louis, was a respected lyric poet and high school teacher. His mother, Naomi, was a card-carrying member of the CPUSA. He describes her long struggles with mental illness, culminating in the prefrontal lobotomy that reduced her to a zombie, in his elegiac "Kaddish." Worried that his homosexuality might be a symptom of inherited madness, Ginsberg remained a closeted virgin until he was twenty. For several years he tried to cure himself of it by dating women. He had come to Columbia and quickly fallen in love with Lucien Carr, a fellow freshman, originally from St. Louis. Falling for bright, handsome, and potentially dangerous straight males was to be a recurring theme of Ginsberg's romantic life.

Ginsberg met Burroughs through Carr. The history leading up to this meeting is serpentine. Back in St. Louis, a man in his early twenties named David Kammerer had become obsessively infatuated with Carr while directing the boy in an elementary school play. When Carr moved to Chicago and then to New York, in part, supposedly, to get away from Kammerer, Kammerer followed. By the time Ginsberg and Carr were students at Columbia, Kammerer had an apartment at 44 Morton Street in the Village. While Carr portrayed himself as the victim of Kammerer's unwanted stalking, the two of them frequently socialized and, a few days

before Christmas 1943, Carr took Ginsberg on that first trip down to the Village. They drank at the Minetta Tavern and went to meet Kammerer and his friend Burroughs. (Burroughs, who'd been friends with Kammerer in St. Louis, had also recently moved to the neighborhood, taking a room at 69 Bedford Street.) The four of them drank heavily that first night, and Carr's behavior soon turned bizarre. As Bill Morgan relates in *The Typewriter Is Holy,* Carr bit through his beer glass "and, bleeding badly, challenged David to do the same. That prompted Burroughs to bring a tray of razor blades and lightbulbs from the kitchen 'as hors d'oeuvre.'" It was not Carr's only bloody display. Around this time, he and Kammerer were drinking in the Village studio of a portrait painter when Carr became violent, trashing the studio, biting Kammerer on the shoulder, and biting off a part of the painter's earlobe.

Late on the night of August 13, 1944, Carr left a Morningside Heights bar where he'd been drinking with Kerouac. He ran into Kammerer, and the two of them took a six-pack into Riverside Park. According to Carr, Kammerer made sexual advances, and when Carr felt overpowered, he pulled out his old Boy Scout knife and stabbed Kammerer in the chest. He then bound the limbs with shoestrings, weighted the body with stones, and rolled it into the river. That morning he told Burroughs and Kerouac what he'd done, then gave himself up to the police. Burroughs and Kerouac were arrested as material witnesses. Burroughs and Carr were soon bailed out by their wealthy families, but Kerouac languished in the Bronx County jail. He was allowed out, in handcuffs, to marry Edie Parker at City Hall, after which she posted his bail. They later had the marriage annulled. At his trial, Carr's lawyers portrayed him as an innocent college boy who had simply defended himself from a predatory homosexual. The media ran with this version; the *Daily News* called Kammerer's murder an "honor slaying." Convicted of manslaughter, Carr would be out in two years, with even his friends conceding he'd gotten away with murder.

The incident shocked and atomized the group for a while: Burroughs went to stay with his parents in St. Louis, Edie and Jack with hers in Detroit. By 1945 they were all back in New York.

Their circle widened to include Joan Vollmer Adams, a bright and rest-less young war bride; her Morningside Heights roommate Edie Parker, a wild child who'd escaped a boring upper-middle-class suburb of Detroit; and Edie's boyfriend Jack Kerouac. Ruggedly handsome (Ginsberg fell for him), of French Canadian parents, Kerouac had grown up in Low-ell, still the working-class town where the Wobblies had organized mill workers back in the 1910s. He'd learned English as a second language and always spoke and wrote it with a musical lilt. He'd come to Columbia on a football scholarship, fought with his coach, and dropped out. He'd joined the Merchant Marine and then the navy, where he lasted only a week before getting a psychiatric discharge. He was by this time living with his parents, who'd moved to Ozone Park in Queens to be near him. His mother never liked his friends. "Don't let those bums in New York talk you into anything," he records her warning him. "They'll *destroy* you if you let them! I don't like the funny look in their face!"

The group shuttled between the bars of the Upper West Side and the Village. In the girls' fifth-floor walk-up they smoked pot and learned how to extract the Benzedrine-soaked strips from asthma inhalers for a speed kick, on which Joan got hooked. They talked long into the night about a "New Vision," which Ginsberg described in a journal: "Since art is merely and ultimately self-expressive, we conclude that the fullest art, the most individual, uninfluenced, unrepressed, uninhibited expression of art is true expression and the true art." This notion would become the driving impulse of the Beat lifestyle and literature. Defending Kerouac from his legions of critics in 1958, Ginsberg would explain his friend's writing as an attempt to "discover the rhythm of the mind at work at high speed in prose."

Burroughs was the old man of the group, eight years older than Ker-ouac and twelve years older than Ginsberg. His grandfather had founded the St. Louis–based Burroughs Adding Machine company, but his father had sold his stake and instead ran an antiques shop while the family lived a comfortable, coddled suburban life. William had been attracted to the outlaw underbelly of culture ever since he'd read hobo hero Jack Black's *You Can't Win* as an adolescent. "The author claimed to have spent a good

part of his life in jail," he writes in his semiautobiographical *Junkie*. "It sounded good to me compared with the dullness of a Midwest suburb where all contact with life was shut out." While studying at Harvard he made many trips to New York City to explore the clandestine gay scene. After Harvard he desultorily studied medicine for a year in Vienna, exploring the gay and drug scenes there. When the war broke out he enlisted in the army but was offended when not selected for officer training; his mother helped him get discharged. After he severed the tip of his left little finger to impress a man with whom he was infatuated, his parents, worried for his mental health, started giving him two hundred dollars a month to live on. It was plenty to cover a bohemian life in the Village but not enough for a junkie.

In *Junkie*, Burroughs describes scoring and selling heroin in the Village's addict subculture. "What a crew! Mooches, fags, four-flushers, stool pigeons, bums—unwilling to work, unable to steal, always short of money, always whining for credit." In 1946 he was arrested trying to pass a script on which he'd misspelled Dilaudid. He was given probation and sent home to his parents again. He was thirty-two. (With a stake from his parents, he would buy a citrus farm and a scorpion-infested ranch in Texas, where he tried to grow marijuana. Despite his homosexuality and his professed detestation of almost all women, he brought Joan and her daughter to live with him, and had his son, William Jr., with her in 1947. In 1951, he shot and killed Joan with a .380 handgun while they were performing a William Tell routine at a party in Mexico City. Burroughs fled Mexico and was convicted in absentia of homicide. He didn't return to New York until 1953 and didn't live in the city again until 1974.)

Meanwhile, his New York friends were having their own sometimes fatal misadventures. In 1949, just out from a short jail stint, perennial criminal and friend of the Beats Herbert Huncke moved himself and his petty thief friends Little Jack Melody and Vickie Russell into the sweet, hapless Ginsberg's apartment, which they used to store stolen goods. Driving Ginsberg out to his brother's place in New Jersey in a stolen car, Melody flipped it while trying to outrun some cops. He was arrested on the spot, Ginsberg and Huncke later at the apartment. The New York pa-

pers had a field day with the scandal of a bright Columbia student caught up in a web of drugs and crime. Huncke and his pals went back behind bars but Ginsberg went instead for a brief stay at the New York State Psychiatric Institute. There he started a lifelong friendship with a fellow patient, Carl Solomon, a brilliant but stranded young man from the Bronx who was in for electroshock treatments. Solomon, a dedicated fan of the surrealists and Dada, inspired Ginsberg's first great poem, "Howl." On his release Ginsberg went back home to Paterson for a short stay. While there, he made a pilgrimage to one of his poet heroes, William Carlos Williams, in Rutherford. Williams later wrote the introduction to Howl and Other Poems that ends with the line, "Hold back the edges of your gowns, Ladies, we are going through hell."

The group continued to befriend other petty hoodlums. Neal Cassady blew into town from Denver, and Ginsberg and Kerouac both fell for him in their different ways. A car thief and womanizer, he was Kerouac's model Beat, happily skirting the edges of society, morality, and the law, physically a man's man but psychologically boyish, an unscrupulous and irresponsible charmer. Then Ginsberg met Gregory Corso at the Pony Stable, a lesbian bar with a tough reputation on West Third Street. Corso was twenty and just out of the Clinton state prison in Dannemora, where he'd taught himself to read and write poetry. He was a Village native, born Nunzio at St. Vincent's to a teenage mother who abandoned him as an infant. Raised in foster homes, he'd hit the streets by twelve and was in and out of lockups ever since. He was not only Ginsberg's type—handsome, hetero, and macho—but recognizably a poet of promise.

Ginsberg, Kerouac, Carr, and Corso began hanging around with what Ginsberg called the subterraneans, which Kerouac later poached for his novel about the scene. (He reciprocated by giving Ginsberg the title for "Howl.") It was his term for the downtown crowd who drank and talked at Village bars like the dark and druggy Fugazzi's on Sixth Avenue and the smoky, livelier, but still rough San Remo, at the corner of MacDougal and Bleecker Streets. The San Remo was just another mob-backed Village bar when the bohemians and artists colonized it. "In the front they had booths," Roy Metcalf recalled. "The bar was always crowded. It was ex-

tremely clamorous. There were two very able bartenders," one of whom, Michael Conrad, went on to play Sergeant Esterhaus on Hill Street Blues. "In the back was a restaurant. You could go in there with a girl and get excellent prime ribs of beef. You could get a meal for two, martinis and everything, and pay ten bucks." Some of the staff were the kind of South Village thugs and semipro hoodlums Ted Joans called Minor Mafia.

To Sukenick, who first slipped into the Remo as an underage wannabe from Brooklyn, they projected "a leitmotif of fear." Like the bartenders and staff at tougher bars all over the city, they kept baseball bats ready behind the bar to use on anyone who got out of hand. And like all bars at the time, the San Remo had a "no fags" policy, even though everyone knew that some percentage of the hip colonizers on any given night was gay and lesbian. The playwright Robert Patrick, who got to the Village in 1961, remembers that the bars around Bleecker and MacDougal Streets were the worst. "One had a sign that said, 'If You're Gay Stay Away.' Another had a fire ax on the wall with the saying 'For Use On Queers.' You could go in, but you had to act straight, so why would you want to?" Eventually, Sukenick writes, the Remo got too unfriendly and dangerous, and the scene moved en masse to Louis' Tavern on Sheridan Square. But from the late 1940s into the '50s the Remo was one of the most popular boho hangouts in the Village, where one might encounter anyone from Jackson Pollock to Auden to the scarily life-battered Bodenheim. On and off the subterraneans included William Gaddis, Gore Vidal, Anatole Broyard, John Cage, Julian Beck and Judith Malina, Chandler Brossard, James Agee, Anton Rosenberg, and Bill Cannastra.

Unflattering portrayals of Anatole Broyard appear in the first novels of both Gaddis and Brossard. Well liked at first—he was best man at Brossard's wedding—over time he came to seem too much the hipster hustler, a guy too much on the make in his career, his social life, and his sex life. That's how Brossard, a writer for The New Yorker who had moved to the Village in the 1940s and was Burroughs's neighbor, depicted him in Who Walk in Darkness, published in 1952. Because some of the characters are based on the Beats it's sometimes called "the first Beat novel," which it's not. The central character, Henry Porter, is a smooth-talking hepcat who

in the original draft is rumored to be "a 'passed' Negro." He was so clearly based on Broyard that Brossard's publisher, New Directions, feared a libel suit and asked Broyard to sign a release. He refused and New Directions forced Brossard to change Porter's secret. In the published version, Porter is merely rumored to be a bastard. Broyard got his own back twenty years later, writing a vicious review in the *Times* of Brossard's 1971 novel *Wake Up. We're Almost There*, which he called "transcendentally bad." Another friend turned enemy, Gaddis used Broyard as the model for an oily Village character named Max in his first novel, *The Recognitions*, published in 1955. But then Gaddis mercilessly savages the whole Village scene. He describes the San Remo, which he calls the Viareggia, as "a small Italian bar of nepotistic honesty . . . taken over by the educated classes, an ill-dressed, under-fed, over-drunken group of squatters . . . all afloat here on sodden pools of depravity."

Cannastra, who was the Beats' guide to the Remo scene, was another wild man who briefly played a role as catalyst and inspiration for them. Born into a wealthy family upstate and educated at Harvard Law, he'd moved to New York the year before and was soon famous for throwing crazy orgiastic parties in his Chelsea loft with Joan Haverty, a pretty young woman who had met the bisexual Cannastra in Provincetown. Alfred Leslie recalled that you'd see everyone at Cannastra's parties—the subterraneans, the Beats, artists like himself, Maya Deren. He first met Kerouac and the others there in 1949. Cannastra, he says, was "an interesting guy" with "tremendous energy but he was fearfully self-destructive and was always doing wild, wild things." He'd lie down in front of traffic, dance on the edge of his building's roof, walk barefoot on broken glass, and compete with friends "to see who could hold his or her head the longest in the oven with the gas on." In October 1950, climbing out a window of a moving subway train, he fell and was crushed. He was twenty-eight.

Kerouac, who had left Edie, moved into Cannastra's loft with Haverty within days; in mid-November, on the spur of the moment, they got married. He was twenty-eight, she was twenty. When the rent on the loft came due at the end of November they decamped for Kerouac's mother's apartment in Brooklyn. Joan quickly realized this was a big mistake and

moved back into Manhattan. When Kerouac showed up unannounced with his typewriter and a roll-top desk, she reluctantly let him move in. In her apartment Kerouac began to bang out the first draft of what became On the Road, typing it single-spaced, unrepressed and unedited, on a 120-foot scroll. He was already a published novelist: John Kerouac's The Town and the City had been published earlier in 1950 by Harcourt, Brace, where his editor was Robert Giroux. It was a good, solid, traditional novel, clearly inspired, as everyone noted, by Thomas Wolfe, but it had gotten few reviews and sold poorly. John Kerouac was now trying something completely new, inventing Jack Kerouac and what Ginsberg called his bop prosody. As he banged away at it Joan, pregnant, kicked him out of her apartment. When she gave birth to the daughter she named Jan Kerouac, Jack refused to admit paternity. Six years later, his girlfriend Joyce Glassman saw a snapshot of the little girl and remarked on the resemblance to Jack. "Well, she's not my daughter," he snapped. "I don't care who she looks like."

He completed the draft novel while bunking with Carr. This is the experiment of which Truman Capote would later snipe, "That's not writing, that's typing." Kerouac unfurled the scroll in Giroux's office, insisting that it must be published exactly as is, with no edits. Giroux told him no editor in town would agree to that. He was right. On the Road wasn't published until 1957, after many rejections, and the version Viking put out was much revised by Kerouac and by Malcolm Cowley, Viking's editorial consultant. Ginsberg complained it had been "hacked and punctuated and broken—the rhythms and swing of it broken—by presumptuous literary critics in publishing houses." Over the decades as Kerouac's cult grew the original scroll would be preserved and revered as a sacred document, a kind of Beat Torah. It fetched a little over $2 million at auction in 2004. On the Road: The Original Scroll was published by Viking in 2007.

In 1952 John Clellon Holmes published his novel Go, about characters based on Kerouac and the others. Go is also sometimes cited as the "first Beat novel" but it's more a novel about the Beats, and a relatively conventional one. Holmes had first met Kerouac at a party in 1948. They were around the same age, but Holmes was a more conventional sort

than Kerouac and his pals. He was intrigued by them and was maybe the first to see them as representative of something larger than themselves— an Atomic Age nihilism, an insouciant rejection of postwar American values. Kerouac and Holmes became friends and drinking buddies. They attended literature classes at the New School together. After one of these classes they got to drinking and talking about the Lost Generation. Holmes asked Kerouac what he thought his generation should be called, and Kerouac casually responded with the term "beat generation." He later regretted ever uttering the two words together. Kerouac and the others had often heard "beat" used by hepcats to mean sad, dragged down, worn out; in his "A Portrait of the Hipster" in *Partisan Review* in 1948, Broyard listed it as an antonym for "solid, gone, out of this world." That was too negative for Kerouac, who decided it also meant upbeat, on the beat, beatific.

It was Holmes, not Kerouac, who first went public with the term Beat Generation. In 1952, the same year *Go* appeared, he wrote an article called "This Is the Beat Generation" for the *New York Times Magazine*. He credits "John Kerouac, the author of a fine, neglected novel *The Town and the City*," with coming up with the term, and explains, "More than mere weariness, it implies the feeling of having been used, of being raw . . . For the wildest hipster, making a mystique of bop, drugs and the night life, there is no desire to shatter the 'square' society in which he lives, only to elude it." The idea of the Beat Generation had been launched into the mainstream media but it didn't get much notice yet.

Burroughs was the next to get a book published. Ginsberg showed the manuscript for his autobiographical *Junkie* to Carl Solomon, whose uncle ran Ace, a paperback publisher that had recently begun to put out thirty-five-cent two-in-one "Ace Double" books of sci-fi, westerns, and mysteries. In 1953 Ace paid Burroughs an advance of eight hundred dollars and published *Junkie* (spelled *Junky* in later editions). It was nothing like the anti–dope fiend literature of the time but the publisher did a good job of disguising it as such. It was given a lurid cover and printed back-to-back with a more traditional exposé, Maurice Helbrant's *Narcotic Agent*, the "Gripping True Adventures of a T-Man's War Against the Dope

Menace." (A T-Man was a Treasury Department agent.) Burroughs used the pseudonym William Lee, partly for fear his parents would cut off his allowance. He returned to New York that year and stayed for a while with Ginsberg on East Seventh Street.

They all fled New York for the next few years. Burroughs lived in Tangier, Paris, and London until the 1970s. Kerouac, Corso, and Ginsberg wandered to San Francisco and Mexico City. They found San Francisco, which was in the midst of a poetry renaissance, more hospitable than New York. Ginsberg gave the first public reading of "Howl" there in 1955, at the Six Gallery, where he appeared with Gary Snyder, Michael McClure, Philip Lamantia, and Philip Whalen, while Kerouac, drunk on wine, cheered "Go!" from the audience. The next day, Ferlinghetti sent Ginsberg a telegram. He had opened the City Lights Bookstore in 1953 and just started publishing his Pocket Poet Series of books, beginning with his own *Pictures of the Gone World*. Hearing the unmistakable link between Ginsberg and Walt Whitman, he telegrammed, "I greet you at the beginning of a great career." He published *Howl and Other Poems* the following year. In 1957 U.S. Customs seized a shipment of the book coming into San Francisco from Ferlinghetti's British printer, then the police arrested Ferlinghetti for peddling smut. The ACLU argued his case, the judge found for the defense, and the national press covered it closely.

When Ginsberg, Kerouac, Ginsberg's San Francisco lover Peter Orlovsky, and Peter's fifteen-year-old brother Lafcadio hitchhiked back to New York late in 1956, they stopped first at the apartment of two friends of Ginsberg's on West Eleventh Street near the White Horse Tavern. Helen Elliott and Helen Weaver were known as the Helens. Elliott, who worked at the talent agency MCA, had come to the Village after her mother in Omaha had thrown her out. Weaver had grown up in Scarsdale feeling like an outcast. She'd followed a college lesbian affair with a quick marriage that had gone nowhere. In 1955 she found that the Village, "teeming as it was with artists, would-be artists, and oddballs like myself . . . seemed to represent the repressed unconscious—even the repressed sexuality—of Manhattan," she recalls in her memoir *The Awakener*. Their visitors unrolled their sleeping bags and slept on the floor. When the others

left, Kerouac stayed. In *Desolation Angels*, where he gives her the name Ruth Heaper, he describes Weaver's "brown sleek hair, black eyes, little pout," and "a strange boyish mischievous or spoiled plucky face but with rosy woman lips and soft cheek of fairest apparel of morning."

He and Weaver launched into a two-month affair. She writes that she was attracted to his extravagant good looks (Salvador Dalí proclaimed him "more beautiful than Mr. Brando") and his boyish ebullience but suspicious of his dark side: the abandonment of his wife and child, his old-fashioned ideas about women even as he sponged off them, the drunken binges, the immaturity, the way his high spirits periodically crumbled into surly brooding. She kicked him out after a late night when he and Carr, roaring drunk, refused to let her get to sleep. He spent a night or two at the Hotel Marlton before Ginsberg quickly hooked him up with the next in the line of women to take him in, the young writer Joyce Glassman. They were together, on and off, for the next two years, and Glassman, as Joyce Johnson, would write her own memoir, *Minor Characters* (where the two Helens are the two Virginias).

The Beats had returned from San Francisco buoyed and triumphant. Viking was getting ready to publish *On the Road* and Grove Press took *The Subterraneans*. The *New York Times*, *Mademoiselle*, and other publications were writing about them—principally Ginsberg at this stage. In a drunk, playful interview in the February 13, 1957, *Voice*, the trio of Ginsberg, Kerouac, and Corso called themselves "witless madcaps" who'd left New York "to get away from cliques and snobbery here," Corso said. "Too big, too multiple, too jaded," Kerouac agreed. "We were saints and Villagers and we're beautiful," he declared.

DAVID AMRAM REMEMBERS MEETING KEROUAC IN 1956, AT A BRING-your-own-bottle party in a painter's loft in what's now Soho. He forgets whose loft it was. There were a lot of lofts and a lot of parties. They jammed together, Kerouac reciting a poem and Amram improvising. "We kept running into one another and continued doing this wherever we were, often until we were asked to stop," he writes. "Eventually we formed a bond." The Kerouac he remembers was upbeat, openhearted, playful. Dan

Wakefield met Kerouac early in 1957 and remembers a darker, brooding one. They were introduced in Romero's. Kerouac, in a "rather grumpy, desultory way," was getting drunk on his thousand-dollar advance for *On the Road*, which Viking doled out at a hundred dollars a month. He "seemed more weighed down than elated" about the book.

"I foresaw a new dreariness in all this literary success," Kerouac wrote of this period in *Desolation Angels*. In that book, published in 1965, he looks back at 1957 and describes the months running up to the publication of *On the Road* as a time of world-weariness and foreboding. There had always been something forced about his garrulous carousing when drunk, his hitchhiking and tramp steamering around the map. It was a Neal Cassady impersonation. At heart he was a shy and withdrawn loner who was happiest at home with his mom. By 1957, the year he turned thirty-five, he'd been on and off the road for a decade. It was getting old. He was bored with himself, bored with his friends, and "wondering where to really go, what to do next—I suddenly realized I had nowhere to turn at all." *On the Road* now in the hands of his editors, he escaped New York, jumping on a boat for Tangier to visit with Burroughs. Ginsberg and Orlovsky followed. Even there Kerouac found himself in a roomful of hipsters: "And just like in New York or Frisco or anywhere there they are all hunching around in marijuana smoke, talking, the cool girls with long thin legs in slacks, the men with goatees, all an enormous drag . . . Nothing can be more dreary than 'coolness' . . . postured, actually *rigid* coolness that covers up the fact that the character is unable to convey anything of force or interest."

He was back in New York when Viking published *On the Road* in September 1957 and the *New York Times* launched him to stardom. It started with a fluke when Orville Prescott, the paper's conservative daily book reviewer, went on vacation and a freelancer, Gilbert Millstein, wrote the review instead. Millstein was a Villager and *Voice* contributor and he'd reviewed *Go* for the *Times* years before. He called *On the Road*'s publication "a historic occasion" and said that some of the writing was "of a beauty almost breathtaking" and the book is "a major novel." Prescott was incensed when he read it. But just three days later the Sunday *Times Book*

*Review* ran its own review, and though it was generally more muted in tone and suggested the book was a one-off, it did call the novel "a stunning achievement."

The phone at Joyce Glassman's apartment began ringing constantly the morning after Millstein's review appeared. Kerouac, after quickly downing three bottles of champagne almost single-handedly, gave his first interview that day. It was the start of a deluge of print and television coverage and commentary. After the *Times*'s positive reviews many other critics waded in to savage the book and its author as a "Neanderthal" and a "slob." The two-year-old *Village Voice* ran a very positive review, but over the next couple of years many *Voice* writers tended toward skepticism or dismay when addressing Kerouac and the rest of the Beats. "They've nothing to say and they say it badly" was a typical comment in 1958. In *Esquire* Norman Podhoretz, the same age as Kerouac, aligned the Beats with juvenile delinquents, warning that "we are witnessing a revolt of all the forces hostile to civilization itself—a movement of brute stupidity and know-nothingism." *Life* denounced the Beats as "talkers, loafers, passive little con men, lonely eccentrics, mom-haters, cophaters, exhibitionists with abused smiles and second mortgages on a bongo drum." The author bizarrely compared them to fruitflies feeding off America, "the biggest, sweetest, and most succulent casaba ever produced by the melon patch of civilization." James Baldwin rolled his moist eyes at the hype about the Beats. He didn't see much literary merit in their conversational writing style, didn't like their romantic ideas about blacks, and snickered at their infatuation with Zen Buddhism, calling them "the Suzuki Rhythm Boys."

Two older role models and early supporters of the Beats, Kenneth Patchen and Kenneth Rexroth, were driven to fits of bitter, probably jealous crankiness by all the hoopla. Both had been in effect proto-Beats some years before the Beats, both had spent time in the Village before moving to the West Coast, and both felt they'd pioneered and perfected jazz poetry before the Beats popularized it. Rexroth had been a central figure in the San Francisco Renaissance that warmly welcomed the East Coast Beats in 1956 and was the emcee at the famous Six Gallery reading.

By 1958 he was complaining that "incompetents looking for a fast buck" had turned jazz poetry into a fad, "a temporary social disease like pee-wee golf or swallowing goldfish." When *Time* declared him "the Father to the Beats," he snapped that "an ethnologist is not a bug."

Patchen was also an important figure in the San Francisco Renaissance. He'd been one of the most prolific and widely read authors in the Village during his time there between 1934 and 1946. His poetry and prose expressed a rebellious, visionary transcendentalism in the spirit of both William Blake and Walt Whitman. He was good friends with E. E. Cummings and did picture poems in a similar vein. He counted Henry Miller, Ferlinghetti, and Charlie Parker among his fans and collaborated with John Cage on the radio play *The City Wears a Slouch Hat* and with Charles Mingus on jazz-poetry performances that were considered paragons of the form. A committed, angry pacifist—Miller called him "the Man of Anger and Light"—he wrote some of his most striking work in the years around World War II, including his prose masterpiece, the apocalyptic anitwar novel *The Journal of Albion Moonlight.* After leaving the Village, he and his wife eventually settled in San Francisco, where Ginsberg, a huge fan, brought friends on pilgrimages to meet him. Patchen basked in their adulation then, but by 1959 he was disgusted with the media circus around them. In an interview in the *Voice* that year he railed against the Beats, calling them "the Brat Generation," "tenth-rate juveniles in their 30s," "irresponsible mountebanks in a freak show brought into existence through the agency of the greatest enemy of the arts and the artist in our time: the minions of *Time* magazine and all the rest of the mass-media distortionists."

Even Romany Marie piled on. Interviewed over coffee and cigarettes at the Rienzi by a reporter for the New York *Daily News* early in 1958, the seventy-two-year-old sighed, "This Beat Generation is truly sad. They have no dreams, no stars to follow and they live not to create but to destroy. They will soon destroy themselves. And there will be no one to take their place."

The ferocity of the attacks startled Kerouac, while the faddish adulation of fans and wannabes flabbergasted him. To Hettie Jones, who first

met him not long after *On the Road* came out, "he seemed bewildered by the ardent young crowd for whom he'd spoken." Amram has always insisted that the very idea of acting as a spokesman for a generation was antithetical to Kerouac. In *Offbeat* he writes: "We never dreamed that we ourselves would ever become labeled 'Beats,' emblematic of a nonexistent 'movement' whose presumed values were used to discredit us from having anything of substance to offer the world . . . [A]bove all, we were militantly free spirits who scrupulously *avoided* joining anything, or telling anybody what to do or how to think."

Kerouac drank more and more to cope and cover up. On TV he was shy and monosyllabic or drunk and incoherent, except on Steve Allen's show. Allen, the quintessential Upper Bohemian, sat at the piano and played bluesy jazz riffs as Kerouac read. An album of their collaborations, *Poetry for the Beat Generation*, would come out in 1959. Kerouac continued jamming with Amram, which he still clearly enjoyed. In October 1957 the two of them, with the poets Howard Hart and Philip Lamantia, staged a jazz-poetry reading at the new Brata Gallery on East Tenth Street. They advertised the gig entirely by mimeographed handbills and, given all the buzz about Kerouac, easily packed the place. A few months later they took the same show out to an auditorium at Brooklyn College, where it didn't go over so well. During a Q&A with the student audience Kerouac, drunk and high, proclaimed himself "a Zen Master" while refusing to give a straight answer to any of their questions. The students turned hostile. "Man, how come I like your book, but I don't like you?" one asked, to "loud jeering laughter."

In December, Kerouac accepted an invitation from Max Gordon to give short readings between the jazz sets at the Village Vanguard. It was a very different sort of gig for him and raised some eyebrows. The bohemians stayed away from nightclubs like the Vanguard with its dollar-seventy-five beers and four-dollar drink minimum, preferring the fifteen-cent beers at the Cedar and seventy-five-cent pitchers at the Five Spot. Dan Wakefield, covering the show for the *Nation*, met Joyce Glassman there. She explained that "Jack didn't like the idea of this nightclub business but thought it might help *On the Road*." Wakefield reported that

Kerouac "recited to a cold (as distinguished from cool) audience" made up of "one seaman, one poet" and a table of "what looked to be the leftovers of an office party from around Times Square." If Kerouac was playing the Vanguard, Wakefield mused, Ginsberg must soon "be opening at El Morocco." When Wakefield ran into Kerouac again a few months later, Jack was again drunk and moody. Wakefield assayed a no-hard-feelings rapprochement; Kerouac threatened to throw him out a window.

Covering another night that week at the Vanguard for the *Voice*, Howard Smith saw a very different show but his report was as skeptical as Wakefield's. He observed that Kerouac was fidgety as a cat, drinking, sweating buckets, and chain-smoking, painfully out of place. Yet the club was packed by "a few tieless buddies from the old days, a little proud and a little jealous, the fourth estate, the agents, the hand-shakers, the Steve Allens, the Madison Avenue bunch trying to keep ultra-current." They applauded wildly, and Kerouac "ate it all up the way he really never wanted to."

Pete Hamill, not yet the star novelist and journalist he'd become, caught one of the performances. Afterward he was in the Cedar Tavern, jam-packed as it usually was by then, when Kerouac and friends elbowed their way through the throng to the bar. "I said hello. He looked at me in a suspicious, bleary way and nodded." Kerouac bought drinks for all his crowd, "always polite, but his eyes scared, a twitch in his face and a sour smell coming off him . . . The painters gave him a who-the-fuck-*is*-this-guy? look."

Kerouac ended his appearances at the Vanguard after that one week. He happily rejoined Amram and the others to do Friday midnight shows at Circle in the Square, where the atmosphere was much looser and more fun. In January 1958, when the young newsman Mike Wallace interviewed him for the *New York Post*, Kerouac struck him as a "tattered, forlorn young man." Kerouac spoke a lot about death. "It's a great burden to be alive," he told Wallace. "A heavy burden, a great big heavy burden. I wish I were safe in Heaven, dead." *The Subterraneans* came out the next month, and *The Dharma Bums* the following fall, feeding the maelstrom

of press and public attention. Using the fifteen thousand dollars MGM paid him for the film rights to *The Subterraneans* he bought a small house out in Northport, Long Island, for himself and his mother, the first of several hideaways from which he made his forays into the city, where he'd drink too much, carouse, fall down, make a spectacle of himself, then go hide once more.

# Pull My Daisy

"DAVID'S WRITING A NEW NOVEL ALL ABOUT YOU, BEN."
"BETTER NOT BE ANY OF THAT BEAT GENERATION JAZZ
LIKE THE LAST ONE."

—Shadows

ON NOVEMBER 11, 1959, DEMONSTRATING AGAIN WHAT A SMALL world it was, Amos Vogel's Cinema 16 screened a double bill of John Cassavetes's feature-length *Shadows*, which had premiered the previous year, with the debut of a shorter film called *Pull My Daisy*, which Kerouac, Ginsberg, Corso, Amram, Orlovsky, Larry Rivers, Robert Frank, and a few others had all come together to make in Alfred Leslie's loft on Fourth Avenue near Twelfth Street. Avant-garde filmmaker and critic Jonas Mekas was in the audience and wrote a glowing review, cheering that it "reminds us again of that sense of reality and immediacy that is cinema's first property," and declaring that "I consider *Pull My Daisy* in all its inconsequentiality, the most

alive and the most truthful of films." Other critics wrote off Daisy as a frivolous trifle compared to the somber Shadows, which they hailed as the cornerstone of a new American underground cinema.

Different as they are in tone, Shadows and Daisy made a natural pair. Both attempted to present authentic portraits of Beat culture—or self-portrait in the case of Daisy—at a time when depictions in commercial film and television were typically sensationalist and exploitative. (For example, in the fall of 1959 Cassavetes was starring in the short-lived TV show Johnny Staccato, set in Manhattan. He played a private eye, who was also a beatnikish jazz pianist, in Greenwich Village.) Both films were shot low-budget with a black-and-white cinema verité look that was the antithesis of the Cinemascope and Technicolor epics Hollywood was making to lure viewers back from their black-and-white TV sets. Vogel screened them under the rubric "The Cinema of Improvisation," and that's how they were viewed for years. After all, Daisy looks like a group of Beats and artists clowning around one morning in front of a movie camera and Shadows ends with the announcement, "The film you have just seen was an improvisation." But Daisy actually took months to plan, weeks to shoot, and more months to edit, and Cassavetes labored over Shadows for three years. In the spirit of the time, the makers of both films put a lot of effort into making them look effortless.

Leslie and codirector Frank later had a bitter falling-out over ownership of Pull My Daisy and contesting versions of who did what. When explaining his version of how Pull My Daisy got made, Leslie starts back at the end of World War II, when he was a young painter-photographer-filmmaker freshly arrived in the Village. He would send cartons of cigarettes to a friend in occupied Germany, who sold them to buy cameras and equipment he then shipped back to Leslie. They made a film together, Directions, screened at MoMA. In 1949, feeling he had to concentrate on his painting, Leslie sold all the equipment, but by the mid-1950s he itched to make films again. His friend had died of cancer in his mid-twenties—and, in anger and despair, he had destroyed all but two frames of Directions—so, Leslie says, he invited his neighbor the photographer Robert Frank to go in with him. Frank had grown up in Zurich in a wealthy Jewish house-

hold and, after living out the war in the safety of neutral Switzerland, came to New York in 1947. He soon met and was mentored by Walker Evans, who helped him get work at some of the magazines. Bored and frustrated shooting commercial photography, Frank secured a Guggenheim grant in 1955 and spent two years traveling around the country, taking almost thirty thousand candid shots of an America that was rather more grim and bleak than most Americans liked to think of it in the patriotic 1950s. Eighty-three of them would go into his book *The Americans*, first published in France in 1958, then by Grove Press in New York in 1959, with an introduction by Kerouac and back cover art by Leslie.

Leslie and Frank formed a limited partnership, G-String Enterprises. They heard a tape Kerouac had made of himself reading all the parts of a never-produced play he'd written about the Beat Generation at the request of a Broadway producer. In the last act Kerouac tells of an afternoon in 1955 when he, Ginsberg, and Orlovsky went to Neal and Carolyn Cassady's house in Los Gatos to meet a Bishop Romano of the Liberal Catholic Church, a do-it-yourself spin-off of Roman Catholicism condemned as heresy by the Vatican. Romano was also a spirit medium who preached reincarnation. Drunk and high, the Beats went into their usual boyish hijinks, Romano and his companions were stiff and uncomfortable, and Carolyn was happy to clear the house. On the tape, as Kerouac read all the parts, Leslie and Frank could hear a radio in the background. It was Symphony Sid, the great jazz disc jockey. Listening to Jack do all the voices with jazz playing in the background, Leslie says, they conceived what became *Pull My Daisy*, a short loosely based on the play's last act, with Jack narrating it in voice-over while David Amram played.

Leslie and Frank raised fifteen thousand dollars, rented equipment, hired a small crew, did a script and storyboard that greatly reconfigured the story, and recruited the cast. Ginsberg, Corso, and Orlovsky played themselves; Rivers played the Cassady character Milo; Richard Bellamy, director of the Hansa Gallery (which had moved uptown by then), was the bishop; the painter Alice Neel was the bishop's mother; and Amram was added as the jazzbo Mezz McGillicuddy. The one professional was a beautiful French actress, Delphine Seyrig, the wife of their artist friend Jack

Youngerman, in the Carolyn Cassady role. They used Leslie's loft at 108 Fourth Avenue as the set, above the Emil Strauss Employment Agency. When Leslie moved there it was filthy and full of junk. He tossed out as much as he could, then had a commercial spray-paint crew come in and told them to spray everything—walls, floor, ceiling, and anything still lying around—white. "When I went in it looked like snow had fallen over a trash heap. There were mice frozen in place. It was beautiful. I mean it was majestic."

Amram recalls the shoot as three weeks of barely controlled chaos, as Ginsberg et al. got drunk and high and up to their usual antics—Ginsberg dropping his pants every time the camera started to roll, Corso jumping out the window, food fights, free improvisation, horsing around. Leslie and Frank had known them for years by then and knew what to expect, so they proceeded patiently, shooting every scene three times. Kerouac dropped by a few times, drunk, dragging Bowery bums up from the street with him. Seyrig, who spoke only French, was often confused and dismayed at the apparent anarchy, which actually helped her performance as Milo's exasperated wife.

Leslie spent a month or so cutting the film in an editing studio near the Brill Building. He and Frank rented a sound studio and put Jack and Amram in it. As the rough cut played they recorded Kerouac and Amram riffing the narrative to music in three takes. "Jack was a little bit high, which was good," Leslie says. "He was totally at ease." As Mekas puts it, "Jack rambled in the dark, drunk, and produced a masterpiece."

Not everybody agreed, including Jack. When the final edit was done, Leslie screened it for the cast and friends at MoMA, "and every single person there, except myself, hated it," Leslie says. They were disappointed, he believes, by "the fact that it was essentially about nothing, all these small moments, all the characteristics of its modesty, in the sense that it doesn't try to force you into believing anything, because it's all music from beginning to end. People were expecting something more like Shadows. They were all very unhappy with it." That's why, he says, he was shocked after the Cinema 16 premiere when it became "a cultural event."

\*    \*    \*

AFTER THE PREMIERE, LESLIE, KEROUAC, AND FRANK TOOK *PULL My Daisy* out to the West Coast, where they got strange and often hostile receptions. In LA Leslie visited his friend the Abstract Expressionist Bill Brice, who as the son of Fanny Brice was "part of old Hollywood royalty." At Brice's urging, he reluctantly screened *Daisy* in Brice's home for a few of Brice's friends: Vincent Price, Gypsy Rose Lee, André Previn, the screenwriter Jim Poe (*Lilies of the Field*), British poet turned screenwriter John Collier (he worked on *The African Queen* with James Agee), the novelist Harry Brown, and Brice's brother-in-law, the notoriously hardcase Hollywood producer Ray Stark. Stark would later produce the movie adaptation of *Funny Girl*, the musical based on his mother-in-law's life. He wanted a proven star like Edyie Gorme to play the part, but David Merrick persuaded him to try an unknown youngster he'd heard at Bon Soir in the Village. Stark hired Barbra Streisand only when she agreed to sign a crushing four-picture deal. "So we show the film, and there is complete silence, of course, at the end," Leslie recalls. Stark particularly seemed to hate it.

Pull My Daisy was scheduled to be screened at the 1959 San Francisco Film Festival. Leslie rendezvoused in Venice Beach with Kerouac and they met a dude ranch cowboy, "a nice guy, has this big beautiful white convertible, an Oldsmobile or something," who "drove us straight through to San Francisco. When we get to San Francisco early in the morning, the streets are all festooned, all the so-called beatnik bars have banners out, 'Welcome Kerouac,' signs put up, 'Beat Street.' Jack and I get a motel mainly for blacks, the motel that black musicians can stay in. We're the only two white people that come there. They're not too friendly, they're a little worried, but they're accepting, so we go in."

Barnaby Conrad, who'd written several books on bullfighting and owned a swank bullfight-themed bar called El Matador, had arranged a cocktail reception for Kerouac. "It was where all of the celebrities and literati or whatever meet. An upper-class, super-privileged scene bar." Leslie rented a tux but Kerouac wore his usual lumberjack outfit, which miffed Conrad, Leslie recalls. He abandoned them, unrecognized, at the bar. "One woman sidled up to Jack, but he was in sort of a disagreeable

mood—a very difficult situation for him. Because you never know who to trust, what people are trying to do at you, for you, against you, what they want. It was very tricky. So she left, and we're sitting there." Then David Niven swanned in, "with two or three beautiful dames on his arm, wearing a tuxedo, looks his most sparkling, wonderful self." It turned out that Niven was a Kerouac fan and Conrad had arranged the party at his request. Niven called Leslie and Kerouac over to his table. "Now everybody is in heaven, they love us because we are accepted, we have been given the olive branch, you know, the prize. So everybody is accepting and ecstatic. And the drinks are brought to the table, and Niven bangs his glass, everybody stands up and holds their glass out. He says, 'I want to propose a toast to Mr. Kerouac, striking a blow for freedom.' And at that point, I gotta tell you, the club went crazy. If Jack and I had told everybody to drop their pants and turn around, we could have fucked every living thing in that goddamned club. They were there in the palms of our hands. It was delightful. We went to Niven's house with this whole group of people. Jack had a liaison with somebody and went off to the right, I went off to the left."

The following night they met up with Frank for the festival screening. Shirley Temple Black, whose husband was the festival's president, introduced the film. "The audience was really hostile. We were supposed to talk. Jack had nothing to say, Robert had nothing to say, so it was all on my shoulders. There were just bad vibes." The film won the festival's first prize for "Best American Experimental Film" anyway.

BY 1959 THE BEATNIK INVASION OF THE VILLAGE WAS IN FULL force. The Bleecker-MacDougal fun zone was crowded with door-to-door coffeehouses and cafés. In the summer of 1959 the Cafe Borgia, the Figaro, the Rafio, the Flamingo, the Dragon's Den, the Cock and Bull (later the Bitter End), and the Take 3 were all operating on Bleecker, while the Rienzi, the Reggio, the Continental, Cafe Wha?, the Gaslight, and Playhouse Cafe lined MacDougal, with the Fat Black Pussycat around the corner on Minetta Lane. On weekends hordes of tourists strolled MacDougal Street past sidewalk pitchmen trying to lure them inside. The

crowds spilled into the street, blocking the path of the tourist buses and taxis.

A few weeks after shooting *Pull My Daisy*, Amram and Kerouac wandered into the Figaro for a disheartening lesson in what they, or the media, had wrought.

> We eased our way through to the back room of the Figaro. It was jammed with young people, many wearing black berets, all black clothes, the young men sporting glasses and goatees, some carrying what appeared to be recently purchased knapsacks. Most of the young men and women were carrying books, whose covers they displayed as they spoke to one another. There were copies of *On the Road*, a poetry anthology of Dylan Thomas, and books by Jean-Paul Sartre and Albert Camus. Most of the young women wore black fishnet stockings, black skirts, and tight-fitting black sweaters. Many of the young men carried brand-new bongos, some with the price tags still dangling from the tuning keys.
>
> "It's like Catholic school," said Jack. "Everyone's in uniform." For a place packed with young people, the atmosphere was remarkably tense. I felt a knot slowly developing in my stomach.

On the walls were photos of Amram and Kerouac, Charlie Parker, Monk, Miles. Kerouac remarked, "We're like tourists in a museum about ourselves." The beatniks glowered at them. "We weren't 'authentic,' " Amram recalls. "They thought Jack and I were two old unemployed dudes from Elizabeth, New Jersey, trying to score."

"It's a new scene," the manager explained to them. "The fun times are over. Business is booming all over the Village. More money than you would believe. Look at all these kids in their outfits. It's like a Shriner's convention. They all get dressed up and come down to the Village to be Beatniks. This is happening all over the country. You guys started a trend."

At the manager's request, Amram and Kerouac gave an impromptu performance, Kerouac reading something he'd just written over Amram's French horn. The beatniks were hostile and scornful. They refused to believe that Kerouac was Kerouac. He and Amram left, as a bus decanted a group of middle-aged tourists in front of the café. A guy from Ohio gave them the once-over and started advising them on how to dress and talk if they wanted to fit in with the Village scene. He'd read up on it in a how-to-be-a-beatnik book.

Three Kerouac books appeared in 1959, and four more in 1960. He'd written most of them years earlier but the appearance that he was churning the stuff out at such a furious pace confirmed for the public Capote's quip that he was just typewriting. Reviews tended to be harsh and dismissive and sales dropped off. He retreated farther, both physically and mentally. Kerouac was always a bundle of contradictions and confusions. There was the ebullient, spontaneous, fun-loving guy Amram knew, but also the suspicious, surly brooder many others saw. "Jack Kerouac was scary," Timothy Leary, who first met him in 1961, noted. "Behind the dark good looks of a burly lumberjack was a New England mill-town sullenness, Canuck-Catholic soggy distrust. This is one unhappy kid, I thought." He was the free spirit who never cut his mother's apron strings, the prophet of the open road who never learned how to drive, the avatar of a counterculture he never liked or trusted. By the mid-1960s he'd withdrawn completely and spent much of his last years holing up with his mother in Florida, in Lowell, and on Cape Cod, staying in contact with Amram and Clellon Holmes and other friends only through long, lonely, drunken telephone calls.

In 1968 Jack and his mother moved to his last little house in suburban St. Petersburg, Florida. He lay around in front of the television drinking beer, growing fat around the middle—becoming, in effect, the fat suburban slob the Beat Generation was supposed to have opposed. He watched from the wings as his books went out of print. He didn't get or like the hippies, even though so many of them cited him as an inspiration, and could get as angry as any World War II vet at the Vietnam war protests. In 1969 he wrote an article, "After Me, the Deluge," that appeared in vari-

ous papers around the country. It is a sad and presumably drunken rant in which he disavows his role as "the great white father and intellectual forebear who spawned a deluge of alienated radicals, war protestors, dropouts, hippies and even 'beats.' " Always more conservative, politically and socially, than his cultists admit to this day, he told a reporter for the *Miami Herald* that it was about "the Communist conspiracy," that the Communists "jumped on my movement and turned it into a Beat insurrection." He also said the New York Jewish literary mafia had conspired against him. One morning that October, as he sat watching *The Galloping Gourmet* on TV, already drunk before noon and eating tuna from a can, a vein in his abdomen burst. He was soon dead, at forty-seven.

# Village Voices

YOU HAVE NO *IDEA* WHAT A TERRIBLE LURE THIS PLACE
IS TO PEOPLE WHO LIVE OUTSIDE OF THIS PLACE.

—Jean Shepherd

GREENWICH VILLAGE IS ONE OF THE BITTER
PROVINCES—IT ABOUNDS IN SNOBS AND CRITICS.

—Norman Mailer

IN 2010 BARRY FARBER TURNED EIGHTY YEARS OLD—AND CEL-
ebrated fifty continuous years as a New York radio talk-show
host. With his wide-ranging knowledge, his gentle southern accent,
and his erudite political conservatism—much more like William F.
Buckley than Rush Limbaugh—he always stood out in New York
broadcasting. Liberal listeners often told him they hated his politics

but loved his show. John Lennon, during his New York years in the 1970s, was a fan. David Amram, who feels a kinship with Farber as a fellow Jew with southern roots in the biggest of northern cities, says he always admired Farber's courage and conviction.

Farber was born in Baltimore and raised in North Carolina. When he was in the army from 1952 to 1954, stationed near Washington, D.C., Greenwich Village was the favorite weekend pass destination for everyone on the base. "There was one hot spot after another," he recalled. He remembered strolling a West Third Street lined with nightclubs, and that the visible gay and lesbian presence in the Village was an eye-opener to a young man from North Carolina, where, he joked, there might be one known gay man per city and smaller towns had to share one.

He moved to New York in the mid-1950s to be a producer for the glamorous husband-and-wife team Tex McCrary and Jinx Falkenburg, pioneers of talk radio and the TV talk show in the 1950s. One of Farber's favorite memories from his first years in New York is the night he took a beautiful *Vogue* cover girl on a date to Rick Allmen's Cafe Bizarre on West Third Street. Cafe Bizarre opened in 1957 as a tourist trap, featuring "beatnik" poets and serving "Bohemian Burgers," but it also played a seminal early role in the Village's folk and rock music scenes. When Farber went there the star act was the glowering, growling Brother Theodore, who called his routine stand-up tragedy. Farber took his date backstage to meet Brother Theodore, who he recalls was very impressed with her.

Theodore Gottlieb was not, obviously, a monk and was, in fact, a wealthy German Jew who'd survived Dachau by signing over his family's fortune to the Nazis. After the war Albert Einstein helped him enter the United States. From the 1950s on Brother Theodore was a fixture in the Greenwich Village clubs the Village Vanguard, Cafe Bizarre, and the Village Gate, as well as playing a long residency at the 13th Street Theatre. He would also be a regular on Merv Griffin's TV show and, later, David Letterman's and do cameos in a few grade-Z drive-in movies. His act, no doubt reflecting his own grim experiences and taciturn nature, turned apocalyptic nihilism into absurdist comedy. He became famous for gloomy aphorisms like "I've gazed into the abyss and the abyss gazed into

me, and neither of us liked what we saw." Farber fondly remembered one of Brother Theodore's long-standing riffs, his campaign to have humans abandon bipedalism. ("Down, I say, down on all fours, and you'll have everything you want, be everything you want to be. Quadrupedalism is the key to every lock, the power that heals, the real McCoy.") Brother Theodore continued to perform sporadically almost until his death at age ninety-four in Mount Sinai Hospital in 2001.

In 1960 Farber got his own program at WINS-AM, where his first guest was a fellow southerner, an up-and-coming young civil rights preacher named Martin Luther King Jr. In 1962 he moved over to WOR, New York's talk radio giant, where he shared office space and airtime with Arlene Francis (maybe best remembered for her twenty-five years as a panelist on *What's My Line?*), Faye Henle, and Jean Shepherd. They innovated the talk format at a time when "radio was an adjunct of the music business," as Shepherd later explained, and most radio hosts just spun a set list of new 45s and cued commercials. "To this day I get asked by Jean Shepherd cult groups to talk about what it was like to share an office with him," Farber said. "Jean was the real article. Nobody is like Jean. He was a radio philosopher, but he was not dull and pedantic. He was very funny."

Shepherd was born in 1921—although when asked he often gave a later date, shaving several years off his age—and was raised in the small town of Hammond, Indiana. His bitterly comic memories of growing up in a small town as a boy named Jean inspired his friend Shel Silverstein to write the Johnny Cash hit "A Boy Named Sue." In 1955 he came to New York, which he called "the East of golden promise." He loved it right away. "Do you realize how—how *fortunate* we are?" he asked his listeners in 1960. "You have no *idea* what a terrible lure this place is to people who live outside of this place." He felt especially at home in Greenwich Village, among the jazzbos, Beat writers, and assorted eccentrics and misfits. His métier—long-form, extemporaneous storytelling—was akin to both jazz riffing and the Beats' love of spontaneous creativity. He started hanging out in the Village the instant he arrived and lived in the neighborhood from the 1960s into the late '70s.

In 1956 Shepherd hosted a late-late-night 1 to 5 a.m. program, which

he filled with long, wandering monologues, many of them very loosely based on his Midwest boyhood and others satiric observations of contemporary life in America and New York. "I used radio the same way that a writer uses a sheet of paper, to say what he has to say about the world," he explained. Some of this material appeared in his books In God We Trust: All Others Pay Cash and Wanda Hickey's Night of Golden Memories and Other Disasters and, later, in the movie A Christmas Story. Along the way he spun recordings of jazz and old-time music—his own selections, not from a station list—sometimes playing along on a Jew's harp or nose flute. He chatted with listeners who called, though with the technology at the time only his end of the conversation went out over the airwaves. He was inventing free-form radio before there was a term for it.

He quickly developed a small but devoted following. He described them as Night People—" 'soreheads,' 'eggheads,' 'long-hairs,' 'outsiders,' " he once wrote—as distinguished from the dull, conformist nine-to-five Day People. Unlike freethinking Night People, he believed, Day People were such sheep they'd clamor to buy any book, see any movie, or line up outside any restaurant that the media were somehow buzzing about. One night in the spring of 1956 he decided to test this hypothesis. He asked his listeners to help him invent a fictitious book. He and his callers came up with the juicy title I, Libertine and an author, Frederick R. Ewing, retired from the Royal Navy, gentleman scholar specializing in eighteenth-century erotica, currently residing in Rhodesia. They gave him a fictitious British publisher, Excelsior Press. Shepherd then asked all his listeners to go into a bookstore the next day and ask for a copy of I, Libertine. If the clerk asked who published it, they were to reply indignantly, "Excelsior, you fathead!" It became an enduring Shepherd motto (and the title of a 2005 biography).

His listeners did as he asked and the results exceeded his expectations. One listener, Shepherd later told fellow radio host Long John Nebel, called to tell him that when he went into the famous Eighth Street Bookshop and asked for I, Libertine by Frederick Ewing, the smug, all-knowing guy behind the counter ("He stands back of that cash register and you have a feeling that he wrote Kierkegaard.") sniffed, "Ewing. It's about time the

public discovered him." A woman wrote Shepherd that when she brought it up at her weekly bridge party, three ladies said they'd read it "and two of them didn't like it." Within a month, the syndicated gossip columnist Earl Wilson was claiming to have had lunch with Ewing and his wife, Marjorie, on their way to India. In two months hoaxers at various newspapers in the United States and Europe were slipping I, Libertine onto their best-seller lists. The Archdiocese of Boston banned the book sight unseen. By then Shepherd figured it had gone far enough. He cooperated with a Wall Street Journal reporter to expose the hoax in August. That only sparked a new round of articles worldwide, including one in Pravda.

Meanwhile, a friend of Shepherd's, the science-fiction writer Theodore Sturgeon, had told him that Ian Ballantine of Ballantine Books was frantically trying to secure the paperback rights to the nonexistent book. When Sturgeon and Shepherd had lunch with Ballantine and explained the hoax, he said he'd publish I, Libertine if they wrote it. They "banged this sucker out," Shepherd told Nebel, though apparently Sturgeon did virtually all of the actual writing, delivering the manuscript in a three-week marathon. Ballantine rushed it out in September as a thirty-five-cent paperback with a small run of hardcover review copies. Shepherd held the book signing in a Times Square drugstore. The cover art by Kelly Freas, an illustrator for MAD magazine (to which Shepherd would contribute "The Night People vs. 'Creeping Meatballism'" in 1957), shows a smirking eighteenth-century dandy in a tricorner hat and a wench displaying much cleavage, with the copy: "Gadzooks!" quoth I, "but here's a saucy bawd!" A banner across the top of the cover shouts Turbulent! Turgid! Tempestuous! As a final comeuppance to all those Day People who rushed out to buy the book—reportedly more than two hundred thousand in three months—the writing was in fact, and one suspects intentionally, Tedious! Torpid! Tiresome! The reader expecting a lusty tale of Ye Naughty Olde England must have been supremely disappointed by the resolutely unribald story of Lankford Higger-Piggott, a young swashbuckler working his way up the social ladder and through the ladies of London in the late 1700s.

Shepherd did the all-night show for less than six months before being

shifted to earlier, shorter slots, which cramped his storytelling style but earned him a wider audience, exposing his goofy humor and childhood stories to high school and college students, who became his most devoted fans. He liked to demonstrate his sway over them by staging impromptu gatherings he called "milling," a precursor to flash mobs. On his Friday night show he'd invite his audience to meet him in Washington Square Park the next day to "mill around." One Saturday in May of 1957, according to a *Voice* article, "several hundred young people, mostly in their teens, filled the circle yelling to one another cryptic slogans like 'Excelsior! . . . Let's mill!' . . . Finally, Jean Shepherd, in sports coat and open collar, appeared and mounted the ledge, and the throng, at least a thousand strong, closed in on him." Shepherd was apparently a bit alarmed at what he'd started. Cops arrived to break up the crowd, who booed and chanted "Excelsior!" As things looked to be getting out of hand Shepherd slipped away in a tiny red Isetta. He also solicited donations from his followers to help John Cassavetes raise the forty thousand dollars he needed to make his first film, *Shadows*. The opening credits declare that it's "Presented by Jean Shepherd's Night People."

In the summer of 1960 Shepherd narrated a twelve-minute short film, *Village Sunday*, shot by Stewart Wilensky as he strolled the Village with a three-person crew. It's charming and guileless as any travelogue. Artists hang their work on the Washington Square fence, while collegiate folkies gather around the turned-off fountain having a hootenanny with guitars, banjos, and fiddles. Guys doing their best to look like Kerouac glide by on motor scooters. Italian men in shirtsleeves play bocce (which Shepherd, showing his roots, murderously mispronounces as *bow-chay*). A hand-lettered sign announces a reading at the Village Gate by Lawrence Ferlinghetti, and Ted Joans declaims a poem in which he seems to be instructing chicks in how not to be uptight.

From 1964 through 1967 Shepherd broadcast a Saturday-night show live from Limelight, a popular nightspot at 91 Seventh Avenue South at Barrow Street. The original owner, Helen Gee, had opened it in 1954 as rather a different kind of place, a coffeehouse/restaurant with a photography gallery in the back. Born Helen Wimmer in 1919, she had run

away from home at sixteen to live in Greenwich Village with a man, the
thirty-year-old artist Yun Gee. An "Oriental" man and a teenage white
girl living in sin was barely tolerated even in the Village in the 1930s, and
in her 1997 memoir Gee remembers that when they left the safety of the
neighborhood they walked the streets at some distance from each other.
They were married in 1942, but after her husband was committed to a
mental institution Helen raised their daughter single-handedly, working
as a photo retoucher.

Limelight was a long, airy space, formerly a strip bar in the 1940s that
had been shut down after a shooting. The decor was white-walled and un-
cluttered with the bohemian kitsch typical of the Village. Coffeehouses
were new to New York in 1954. Photo galleries weren't new but still very
rare. Photography was still just coming into its own as art in the mid-
1950s, pushed along by the blockbuster "Family of Man" exhibition Ed-
ward Steichen curated for MoMA in 1955. It brought together more than
500 images by 273 photographers from 68 countries, a kind of United
Nations of images showing "the everydayness in the relationships of man
to himself, to his family, to the community, and to the world we live in,"
as Steichen wrote. A quarter of a million people saw the show at MoMA;
an estimated nine million saw it during its world tour over the next few
years. Still, Gee's backroom gallery, where she showed and tried to sell
work by Weston, Atget, Walker Evans, Moholy-Nagy, and others, took a
while to catch on. The front room was popular from the start, though
never a great financial success. "The only time I see one of those Beat
characters," Gee was quoted in a 1958 New York *Daily News*, "is when
there's a job open for a dishwasher. They'll come over for a few days to
pick up enough money to go back to their flats on the Left Bank." She
recalled that a group of them once walked into the gallery, "looked at the
pictures, couldn't raise enough for one cup of coffee—and left." Her regu-
lar clientele weren't much more well-heeled. It was a hangout for profes-
sors from NYU and the New School and actors from the nearby Theater
de Lys, Circle in the Square, and Cherry Lane. In her memoir, Gee jokes
that with so many of these actors hanging around, Limelight was "the
downtown Sardi's." The *Voice* held its first Obie awards ceremony there in

June 1956, with Shelley Winters as the mistress of ceremonies. It was also popular with the writers Lorraine Hansberry, James Baldwin, and Norman Mailer. Gee writes that "I was never too happy to see" Mailer, "never knowing what he'd do next. He'd stand on the stairs scanning the room then go weaving his way through, sometimes drunk, sometimes stoned, but always in great fighting form." Ed Koch came in three nights a week for the steak dinner. Jean Shepherd was a regular too.

Among the photographers who sat over coffee at Limelight were Weegee, Evans, Lisette Model, and Robert Frank. They were kindred spirits in that all four of them pushed photography away from art and glamour toward a more challenging or at least less happy-face realism. Frank and other edgy young photographers hated the feel-good blandness of "Family of Man," which he derided as the "tits and tots show." Weegee was the city's most celebrated crime-scene photographer, who in his ceaseless roaming around town had taken thousands of shots of "the Naked City" (his coinage) in all its rough, unvarnished, working-class diversity— Bowery drunks, tenement kids, hoodlums dead and alive, drag queens stepping daintily out of paddy wagons, strippers, "camera club girls" (including the not yet iconic Bettie Page), crowds packed like sea lions on the beach at Coney Island. He snapped thousands of pictures in the Village, and as an older man he loved to sit in Washington Square flirting with the pretty girls. Like Frank, Model had grown up in Europe in a wealthy Jewish household, in Vienna. She left Paris in 1938 in advance of the Nazi invasion of France. Her anti-glamour photography had a sideshow quality to it—she liked shooting fat ladies, midgets, transvestites. She lived in full-on bohemian poverty in a tiny basement apartment near Sheridan Square and taught at the New School, where she had a life-changing influence on Diane Arbus.

In 1961, facing mounting bills and pressure to unionize the staff (the AFL-CIO was aggressively organizing in Village clubs and eateries), Gee sold Limelight to Manny Roth and Les Lone of Cafe Wha? By the time Shepherd started broadcasting there in 1964 it had turned over again and was, in effect, just another Village tourist bar, which he filled up for a few hours a week with his loyal fans. Because it was a Saturday night and

those fans might get rowdy and shout out "improper speech," WOR pioneered the use of a seven-second taped delay for these broadcasts. Not a fan of Shepherd's antics, Gee saw it as a desecration, an invasion of yahoos into the place she'd founded for artists and intellectuals. She continued to live in the Village and represented photographers as an agent until her death in 2004 at the age of eighty-five.

Despite his adoring listeners, Shepherd increasingly chafed at the limitations of regional radio. After leaving WOR in 1977 he concentrated on film and television with some success; the bittersweet (mostly bitter) 1983 holiday film A *Christmas Story*, which he wrote and narrated, is considered a seasonal classic. But he never quite achieved the status he thought he deserved as a modern-day Mark Twain or Will Rogers and withdrew to Sanibel Island off the Florida gulf coast where, a self-professed sorehead, he lived in relative seclusion until dying of natural causes in 1999. No doubt he'd find some rueful satisfaction in knowing that today copies of I, *Libertine* are collectors' items going for as much as $350 for the hardcover and over $200 for the paperback.

IT'S AN OFTEN NOTED IRONY THAT THE *VILLAGE VOICE*, THE FLAG-ship of the beatnik-hippie-antiwar counterculture in the 1960s, was founded in the 1950s by World War II vets. Born and raised on the Upper West Side, Dan Wolf had fought in the Pacific during the war and was, in 1954, on Christopher Street, self-conscious about still living like a callow bohemian as his fortieth birthday loomed—he'd shave several years off when asked. Ed Fancher, another vet, had just turned thirty and lived upstairs. They met taking classes on the GI Bill at the New School. A friend in the Village, Jerry Tallmer, had enlisted a few days after Pearl Harbor and operated radio and radar in the army air corps. He watched the mushroom cloud bloom over Nagasaki from a nearby plane and didn't like what he saw.

They decided that the Village needed a hip new weekly, an alternative to the *Villager*. Founded in 1933, the *Villager* was a small-town paper in the big city, a prosperous weekly shopper filled with ads for local businesses, in which the news was mostly in-depth wedding announce-

ments and coverage of bake sales. "I always thought of it as a newspaper for little old ladies with cats," Tallmer later wrote, "and there was, in fact, a cat named Scoopy who conducted a chitchat column for the musty Villager from his vantage point, as I remember it, on a windowsill of The Villager's office." One of the side effects of the creation of the Voice was that it prompted the Villager to brush off the cobwebs and report more local news. When the Voice eventually outgrew the Village and became more of a national counterculture organ, the Villager soldiered on as the neighborhood's paper of record, a role it continues to fill to this day.

The three vets asked a fourth to throw in with them, Norman Mailer. Mailer, in his early thirties, was going through a prolonged rough patch. The Naked and the Dead had been published to enormous success in 1948, making him a star at twenty-five. It had been all downhill from there. After a disappointing year in Hollywood he returned to New York in 1951 and lived at various spots on the Lower East Side, at first down by the Brooklyn Bridge, later up in what would be called the East Village. He was with his second wife, Adele Morales, who had been Fancher's girlfriend when Mailer met her. His second novel, Barbary Shore, had been published to general disappointment in 1951. He then agonized over final edits to The Deer Park, rejected by several publishers before Putnam took it on. Drinking too much, smoking too much pot, and gobbling speed, Mailer often held court at the White Horse Tavern, but then he was an indefatigable scene maker and held court in many places.

The Wolf-Fancher-Tallmer trio got Mailer to invest five thousand dollars in their new venture, matching Fancher's initial investment, which bought him a 30 percent interest in the new company. Mailer's father, Isaac, became the paper's accountant. They rented an office above a bakery on Greenwich Avenue and assembled a tiny staff. Wolf would do the editing while Fancher ran the business side. Tallmer was associate editor and one of two drama critics—Vance Bourjaily came on board to cover "legitimate" uptown theater, while Tallmer presciently concentrated on and championed the small theaters downtown.

They put out the first issue of the Village Voice on October 26, 1955. It was a timid and inauspicious start, twelve pages that looked and read

like a do-it-yourself *Villager* with a five-cent cover charge and a circula-
tion of twenty-five hundred copies. But some people in the Village rec-
ognized its potential. A young man named Art D'Lugoff was one of the
first advertisers, taking out a one-inch ad for a midnight concert he was
producing at Circle in the Square. The performer was the blacklisted Pete
Seeger. D'Lugoff's friend Lorraine Hansberry (A *Raisin in the Sun*) helped
him distribute flyers all over the Village and the concert was a sellout.
D'Lugoff and Hansberry waited and bussed tables at the Potpourri, a res-
taurant on Washington Place that was another early *Voice* advertiser.

Other early advertisers included the Eighth Street Bookshop, local
productions of *The Threepenny Opera* and *The Cherry Orchard*, the Rienzi,
Tony Pastor's Downtown ("3 Revues Nightly"), Ernie's 3 Ring Circus,
a boxing tournament at St. Anthony's, and classifieds like "SPACE GIRL
WANTED—for vacancy in famous outer space corps. No experience nec-
essary, but dancer, mime or actress preferred; must be very extroverted.
Work fascinating, mostly evenings. If you qualify hail a flying saucer and
come to see." In June 1956 the Greenwich Village East Merchants As
sociation paid for a full page with the banner "VISIT THE BOOMING EAST
VILLAGE!"—an early use of that term.

Probably the most famous early advertiser was Mailer himself, who
ran a half-page for his new novel *The Deer Park* in the fourth issue. Critics
were savaging it and Mailer, who designed the ad himself, quoted all its
worst reviews: "Disgusting," "Nasty," "Silly," "Embarrassing," "Unsavory,"
"Moronic Mindlessness," and so on. Mailer was feeling "the empty winds
of a postpartum gloom," he writes in *Advertisements for Myself*. He decided
to help his *Voice* friends by writing a column. The first installment of
"Quickly: a column for slow readers" appeared in the January 11, 1956,
issue. Calling the Village "one of the bitter provinces," Mailer wrote to
his readers that "given your general animus to those more talented than
yourselves," he fully expected his column to be "actively disliked each
week."

The mail in the following issue indicates that he'd succeeded. "It cer-
tainly is so real kind and nice of the editor to hire you as a columnist," one
reader wrote. "My God, it is to be hoped so deeply this occupation will

keep you from writing another novel." Another wrote: "This guy Mailer. He's a hostile, narcissistic pest. Lose him."

Over the next few months the more readers howled, the longer and shaggier Mailer's column grew. He changed its name to the more Mailerian "The Hip and the Square." He fought with Wolf constantly, raging over every typo in his copy—and there were some lulus, as when "the nuances of growth" became "the nuisances of growth." Wolf in turn struggled to bring some order to Mailer's rambling, liquor- and speed-powered rants. In one column Mailer seemed to be writing in defense of rape. In another he went on at some length about *Waiting for Godot*, which he'd neither seen nor read. By May they'd all had it with one another. Mailer devoted much of his farewell column of May 2 to complaining about typos in the previous week's copy and poking fun at the editors. Then, being Mailer, he ran a full-page ad in the next issue, an apologetic "public notice" in which, having now actually read *Godot*, he corrected his previous opinions of it.

Mailer's direct involvement in the paper was brief and tempestuous but a significant influence. Mailer and his partners had "different ideas of how the paper should develop," he later wrote. "They wanted it to be successful; I wanted it to be outrageous." Wolf and Fancher thought the paper should establish itself in the community and with advertisers before it provoked any controversy. Mailer argued that being provocative was in fact the only way to establish the paper, give it an identity of its own. His instinct would prove to be right. The Village didn't need a second *Villager*. Had the *Voice* remained at that level of ambition it never would have become the paper of record for hip America. Mailer pushed Wolf and Fancher to develop a paper with a distinct personality. *Voice* writers would become famous, and infamous, for their distinctive voices, contentious opinions, and passionate interests. Paid little or nothing for the first eight years of the paper's existence, they came to it because it was a forum where they could express themselves freely.

Fancher, a Jean Shepherd fan, invited Jean to write for the paper, which he started doing in the spring of 1956—articles about hi-fi at first, then his own column, "The Night People." Fancher also bought a little advertising

time on Shepherd's show, and Shepherd, as a fan and contributor, gave the paper a lot more airtime than it paid for. Fancher credited him with selling many subscriptions at a time when the paper was struggling to get established. Over the years Shepherd would emcee a number of *Voice*-sponsored events, from jazz concerts to an annual *Village Voice* Washington Square sports car rally, which Shepherd, a car nut, and the paper's auto columnist Dan List invented.

The *Voice* distinguished itself from the start with its coverage of the arts, especially literature, music, and theater. Tallmer saw the significance of the Village's Off-Broadway theater movement; he and Fancher invented the Obie, the Off-Broadway Theater Award, in 1956. In the 1960s the *Voice* would similarly be out in front on the Off-Off-Broadway movement. Jonas Mekas began the *Voice*'s first film column, "Movie Journal," in 1958. "So much was happening in cinema," he recalls. "I kept looking in the *Voice*, which I liked because Norman Mailer was there," but he didn't see anyone covering movies. He went to the office to meet Tallmer and offered his expertise. At first he tried to cover everything from big Hollywood releases such as *Around the World in Eighty Days*, which he didn't like, to whatever was showing at Cinema 16 and European art movies, for example, *The Seventh Seal* by the new Swedish auteur Ingmar Bergman, which not surprisingly he liked very much ("There is more cinema in 'The Seventh Seal' than in the entire Hollywood production of 1958"). "But then it became so busy, the independent scene, that I could not see everything that was happening," he says. He called his friend Andrew Sarris and brought him to the *Voice* to cover commercial films while he focused on the art and avant-garde.

John Waters says that his becoming an underground filmmaker "was all because of Jonas Mekas and the *Village Voice*. The *Village Voice* was incredibly important to me as a beatnik paper and then a hippie paper." Growing up in a very mainstream suburb of Baltimore, a city that had "one bohemian" that he could recall, he might never have heard of Jack Smith, Kenneth Anger, or anything of the avant-garde movie scene had he not read about them in Mekas's column.

<div align="center">*  *  *</div>

IN 1951 BARNEY ROSSET PAID THREE THOUSAND DOLLARS TO BUY A tiny Village press that reprinted obscure vintage literature. He would turn Grove Press into the most influential publishing house of its time, certainly the most controversial. He helped change how Americans read, and what they are allowed to read. Like the *Village Voice*, Grove Press grew into a national presence, a pivotal force in the avant-garde, the counterculture, and the sexual and radical politics of the 1960s.

Rosset was born in Chicago in 1922, a combustible combination of half Jewish and half Irish, the only son of a prosperous banker. His parents sent him to a left-wing experimental school, where Dillinger was one of his heroes and the future cinematographer Haskell Wexler was his pal. In the eight grade they started putting out their own newspaper, which they called the *Communist*, then the *Socialist*, then the *Somunist*, and finally the *Anti-Everything*. At seventeen he protested *Gone With the Wind* for its racist content. He read a smuggled copy of Henry Miller's banned *Tropic of Cancer* and wrote a paper on it as a freshman at Swarthmore. During the war he learned photography and film in the army signal corps. After the war he came to New York, where he produced a documentary film, *Strange Victory*, about the persistence of American racism and anti-Semitism despite having just trounced the fascists abroad. He later explained it was about how he and other vets "came home from the war and took Hitler home with us." One theater, the Ambassador on Forty-ninth Street, showed it.

In 1949 he pursued the feisty painter Joan Mitchell, whom he'd known in Chicago, to France, where they married on impulse. Back in New York they took a small place near the White Horse and she plunged them both into the Ab Ex scene. "Very inarticulate people," he later said of the painters. "They didn't talk much." Nevertheless, Barney and Joan did a lot of drinking with them at the Cedar. Barney and Joan were big drinkers like everyone else, only more so. Rosset would remain a dedicated drinking man long after his contemporaries died from it or quit. Friends, employees, and the press marveled at the small man's ability to put it away. Into his sixties, seventies, and eighties his ever present rum and Coke, magically replenished from morn till night by silently gliding assistants or

wives, was his raffish signature, his set piece, like Hugh Hefner's pipes and bunnies. He also developed a taste for amphetamines that powered him through all the drinking.

Barney and Joan considered themselves free to pursue side affairs; given their combative temperaments and consumption habits, they inevitably became one of the most explosive couples on the downtown scene. They could be counted on for a screaming match at any party, with Joan throwing whatever she could put her hands on at Barney's head. Friends like John Gruen worried for the slight, wiry Rosset's safety when two-fisted Joan really got worked up. The marriage gradually unraveled and died in 1952. She moved to Paris and he would make and break a few more marriages. Kindred spirits, he and Joan remained friends and admirers until she died.

Before she left she told Rosset about a little Village publishing house that was failing after putting out just three volumes of public-domain literature, two from the seventeenth century (*The Verse in English of Richard Cranshaw* and *Selected Writings of the Ingenious Mrs. Aphra Behn*) and Melville's *The Confidence-Man*. Rosset was at loose ends, his filmmaking career a bust, taking courses at the New School. He borrowed some cash from his banker father and bought Grove Press, thinking that publishing might be his best avenue for shaking things up. The staff for the first few years was never more than five people (including Gruen for a time), and Rosset never let running his business get in the way of his drinking and partying all night. His half-Irish, half-Jewish, half-drunk, and half-speeding management style would go a long way to explain his erratically brilliant, periodically disastrous, and generally impulsive publishing career. In 1953 he read an essay about *Waiting for Godot,* which had just opened in Paris. He flew there, met Samuel Beckett, and paid him a two-hundred-dollar advance to publish an English translation of the play in the United States. It sold fewer than five hundred copies in its first year. Americans wouldn't get Beckett until later in the 1950s, and when they did it was through Rosset's publishing his books and through productions of his plays in Greenwich Village theaters. When New York's WNTA-TV televised a production of *Godot* starring Burgess Meredith

and Zero Mostel in 1961, Rosset gave the Rod Serling–esque stand-up introduction. *Godot* went on to sell more than two million copies by the 1970s. Beckett and Rosset were good friends until Beckett's death in 1989.

In 1957 Rosset started *Evergreen Review,* which began as both a literary magazine and a clever marketing tool, a way of hipping readers, through samples and excerpts, to the kinds of writers whose books he published. He also used it as a political platform. When U.S. Customs seized City Lights's shipment of *Howl and Other Poems* and Ferlinghetti went to trial, Rosset published "Howl" in the second issue of the *Review.* Since Ginsberg's book had been impounded, a lot of readers first saw the poem in Rosset's magazine. The magazine spun off a radio program where people could hear writers read their work. Through the books, the magazine, and radio Rosset introduced or helped introduce American readers to a very long list of avant-garde writers, cutting-edge intellectuals, and political radicals, who besides Ginsberg included Kerouac, Burroughs, Frank O'Hara, Nabokov, Borges, Havel, Susan Sontag, Julius Lester, Charles Bukowski, Robert Coover, Malcolm X, Jean Genet, Che Guevara, Ed Sanders, John Rechy, Eugène Ionesco, Harold Pinter, Alain Robbe-Grillet, Tom Stoppard, Michael O'Donoghue, and Hubert Selby. In the 1960s the *Review* would be as much a political as a literary magazine and, along with the *Voice* and *Rolling Stone,* a counterculture must-read.

When the judge in San Francisco found *Howl* not obscene, Rosset saw an opening. He'd itched to challenge censorship since reading that banned copy of *Tropic of Cancer.* He published an unexpurgated *Lady Chatterley's Lover* in 1959; since 1928 it had been available in the United States only in a bowdlerized edition with the sex cut out. Rosset didn't particularly like the book—the characters struck him as cold British snobs—but thought D. H. Lawrence made a better stalking horse than Henry Miller. The U.S. Post Office seized it, Rosset fought, and he won in the Court of Appeals. When he published *Cancer* in 1961 the Brooklyn district attorney instantly impaneled a grand jury, hoping for indictments against both Rosset and Miller (then living in Big Sur) on charges of conspiracy to peddle smut. The grand jury declined, but hundreds of jurisdictions all over the country brought their own charges. Rosset spent a fortune

over the next few years helping to defend bookstore owners who'd been arrested for selling the book. Richard Seaver, who came on as an editor in 1959, later said that 90 percent of Grove Press's energies and cash went into court fights during his first couple of years on the job. (Earlier in the 1950s Seaver had published the literary magazine *Merlin* in Paris and wrote the essay on Beckett that had sparked Rosset's interest.) Grove let copies of *Naked Lunch*, its next test case, sit in the warehouse while fighting the Miller battles one by one. In 1964 the Supreme Court found *Cancer* not obscene.

At the same time, Grove was publishing highly controversial political writing. When Rosset read that Doubleday had decided not to publish *The Autobiography of Malcolm X* he had to have it. White liberals turned on him for that. Then, after Che Guevara was killed in 1967, he bought a chapter of Che's much-sought-after diaries. One night in July 1968 a bomb went off in Grove's offices, which were then at University Place and East Eleventh Street. A right-wing Cuban exile group claimed responsibility but Rosset would always maintain it was CIA. He published the Che excerpt in the August *Review* anyway.

In 1969 Rosset brought the Swedish film *I Am Curious (Yellow)* to the United States and went into another round of fighting obscenity cases one jurisdiction at a time, up to the Supreme Court again, where this time he lost. Meanwhile, however, all the press covering the court cases made the rather dreary and not very sexy film a box-office smash. Block-long lines of curious-yellow Americans formed outside movie theaters, bringing millions into Grove while paving the way for "porn chic" and the massive success of *Deep Throat* in 1972. Rosset also bought and began reprinting a large library of public-domain vintage erotica including *My Secret Life*, *The Pearl*, and *A Man with a Maid*, which became another profit center.

Cash rolling in and his staff up to almost a hundred and fifty employees, Rosset bought the six-story brick building on the southwest corner of Mercer and Bleecker Streets, renovated it at great cost, and moved the company there in 1970. It was a very short-lived heyday. New York real estate went into freefall just as Rosset moved into the new building, which

was suddenly worth less than the cost of the renovations. Meanwhile he was hit by an attempt to organize the editorial staff by the Fur, Leather and Machinists Union. He rashly fired some pro-union staffers, including a militant young feminist who turned it into a women's liberation issue. She organized a takeover of Rosset's office while a larger group picketed down on the street, wearing "I Am Furious (Yellow)" buttons, protesting the misogynist erotica Grove distributed. As one of them told a television reporter, "What we want from Grove Press, in addition to the disclosure of the financial records, is fifty-one percent control of the editorship, so that we can determine what books and magazine articles are published."

Rosset, hurt and confused by this two-pronged attack from the left, managed to stave off both the union and the feminists but bankruptcy loomed. He sold the building, slashed staff, suspended publication of *Evergreen Review*, and began selling off pieces of the business to other publishers. By 1973 Grove was back down to about a dozen employees, operating out of Rosset's new home, a bunker-like blockhouse of a building at 196 West Houston Street. To some extent he fell victim to his own successes. As the 1970s rolled on, America was awash in erotica and porn, and the big commercial publishers were outbidding him for new, edgy books. Rosset's film distribution wing lost a bundle and he was forced to sell the rights to some of his bread-and-butter backlist titles. There's an old business joke that you can tell who the pioneers were because they're the ones with the arrows in their backs. Like other Village pioneers, Rosset lost the struggle to survive in the new world he'd helped to create. In 1985, desperate and deep in debt, he sold Grove to the West Coast socialite Ann Getty. The following year she fired him. He made some unsuccessful bids to buy Grove back in the following years, and he started a new line of erotica called Blue Moon Books. In 1993 Grove was merged with Atlantic Monthly Press.

Rosset was working on a long-promised memoir when he died in 2012 at age eighty-nine. David Amram played "Amazing Grace," a favorite of Rosset's, at a memorial service at Cooper Union.

# Standing Up to Moses
# and the Machine

O NE OF THE FIRST NEIGHBORHOOD ISSUES ON WHICH THE NEW
*Voice* took a stand was the grassroots effort to prevent the pow-
erful highway-building city planner Robert Moses from destroying
the Village. The battle would help spark the modern historic pres-
ervation movement and make a star of one of its participants, Jane
Jacobs. Born Jane Butzner in Scranton in 1916, she'd opted not to go
on to college after high school and moved, with a sister, to Brook-
lyn in 1935. Jane soon discovered Greenwich Village and they took
an apartment on Morton Street. She pursued a career in journalism,
married Robert Jacobs Jr., and then bought a three-story town house
at 555 Hudson Street in 1947. It had no heat, an abandoned candy
store on the ground floor, and a laundry and a tailor shop as next-
door neighbors.

In 1952, despite lacking a degree, Jacobs was hired by *Architectural Fo-
rum*, where she received crash courses in city planning, urban renewal,
and public housing. The prevailing wisdom among urban planners and

architects in the postwar years was that older cities from the East Coast through the Rust Belt were decrepit, dangerous, and dying. They were mixed up, a hodgepodge, disorderly, and dysfunctional. White flight was sweeping the middle class out to the *Leave It to Beaver* suburbs, abandoning urban centers to the poor. Inspired by Le Corbusier's geometric Radiant City, planners dreamed of knocking down all that mess and erecting a brand-new type of urban center, vertical and orderly, with neatly spaced towers lining multilevel highways, rationally segregated in discrete living, business, and recreation zones. They would be less like traditional cities than hives or nodes strung along bustling arterial roadways, operating with machine-like precision and order. They would impose order on their human inhabitants and if it looked like the mindless order of an ant farm, well, look at how efficient ants were.

Touring East Harlem, Jacobs saw some of that vision put into action. Block after block of old tenements and storefronts had been demolished to clear the way for more than a dozen towering public housing projects, grim brick monoliths standing back from the streets on plazas of sterile lawn where no one was allowed to walk or play or picnic. The people who inhabited these cheerless giants were no longer a community, no longer even neighbors, just hive dwellers. She began to form opinions distinctly counter to her employers. Jacobs thought cities were pretty much all right just as they were. To her a city was "an immense laboratory of trial and error," thriving on density and diversity, on mixes of people and businesses, even on chaos and mess. Attempts by planners and developers to impose neat order on urban life from above would always kill what makes it vital and successful, she argued. "There is a quality even meaner than outright ugliness or disorder," she would write, "and this meaner quality is the dishonest mask of pretended order, achieved by ignoring or suppressing the real order that is struggling to exist and to be served."

Few urban planners had such opportunity to impress their vision on their cities as Moses, the city's extraordinarily powerful public works caudillo. Since his start under La Guardia in the 1930s he'd met little opposition to his grand-scale planning that he couldn't overcome. In the 1950s Moses drove the Cross Bronx Expressway straight through the South

Bronx, displacing perhaps a hundred thousand working-class residents. In Brooklyn Heights, however, residents had the political and social clout to fight his plan to ram the Brooklyn-Queens Expressway straight through the old heart of their neighborhood. They forced an ingenious compromise, a two-tiered roadway along the neighborhood's Manhattan-facing bluff, with a pedestrian esplanade above. Moses still leveled a large section of the neighborhood—including the building where Whitman had helped set the type for the first edition of *Leaves of Grass*—to create Cadman Plaza, a soulless park lined with cheerless high-rises.

Greenwich Village, with demographics similar to those in Brooklyn Heights—a sizable proportion of white, well-educated, and well-connected professionals—fought him off as well, but it was a long battle and mixed victory. Moses had not only the city but the federal government behind him, in the form of Title I of the Federal Housing Act of 1949. It provided cities with massive amounts of federal funding to acquire and clear designated slum areas so that private developers could build on them. The law was generally interpreted as an aid to improving the living conditions of low- and middle-income city residents, and Title I money was in fact used to prepare the way for grim public housing blocks like the ones Jacobs visited in East Harlem. But Moses proved adept at interpreting the program more widely to fund other goals. He believed—and many political and business leaders agreed—that New York City's survival depended on halting the white flight to the suburbs by making the city's core borough, Manhattan, a more attractive and prestigious place. It meant creating a combination of new "luxury" housing, new amenities, and new prestige institutions in the borough. Two new prestige institutions he spearheaded were the United Nations complex on the East Side waterfront and the Lincoln Center arts complex near Columbus Circle, razing large areas of older housing and industrial stock to make way for them.

Closer to home for Jacobs, he also set his sights on Washington Square and the area of old housing and light manufacturing buildings below it. Over local protest Moses moved out a thousand small businesses and more than a hundred families and flattened the old buildings. He of-

fered some of the cleared ground to NYU for new facilities and the rest
to private developers, Tishman & Wolfe, for luxury housing towers to be
called Washington Square Village. To sweeten the pot for the developers
he promised them Washington Square Village would have a prestigious
Fifth Avenue address. To do that, he planned to drive a Fifth Avenue ex-
tension straight through Washington Square, obliterating the fountain
and cutting the park into two isolated strips.

Moses was stunned when Village residents—many of them "house-
wives" and mothers—got organized to oppose this proposal. It wasn't as
if the Square didn't already have traffic in it. Horse-drawn vehicles in the
nineteenth century and buses and cars in the twentieth, reaching the
end of Fifth Avenue, had always driven through or past the arch and into
the Square. But those who contested the idea of plowing Fifth Avenue
straight through the park set up card tables around the Square with peti-
tions, eventually garnering thirty thousand signatures, half the popula-
tion of the Village. When the *Voice* appeared in the fall of 1955 it took
on the controversy. Over the next three years, as opposition mounted,
the city considered a variety of alternative plans: to divide the road, bury
it under the Square, or lift it over the Square on stilts. Villagers coun-
tered with an idea that seemed radical at the time: close the Square to
all traffic and turn it into a proper park. Moses scoffed that this was "an
absurdity" and "completely unworkable." Where would the buses turn
around? Villagers didn't care. Eleanor Roosevelt personally led a delega-
tion to City Hall to support closing the Square. Carmine DeSapio, the
neighborhood's Democratic power player, and the up-and-coming John
Lindsay joined the fray. So did Jane Jacobs, who gradually emerged as the
movement's figurehead. In its March 12, 1958, issue, the *Voice* printed the
opinion of the eminent architecture critic Lewis Mumford that "the at-
tack on Washington Square by the Park Department is a piece of unqual-
ified vandalism," "an almost classic example of bad city planning" that
would "deface and degrade" the Square. He supported the idea of closing
it to traffic. In 1959 Moses's plan was finally abandoned and Washington
Square Park was closed to all traffic.

Washington Square Village was completed that year. A pair of mono-

lithic modern apartment blocks standing on stilts over manicured lawns, it was promptly nicknamed Tishman's Tenements. In the *Voice*, Eli Wilentz of the Eighth Street Bookshop called it "a prettily painted chicken coop enlarged to monstrous size." A few years later Tishman would run into financial difficulties and sell the complex to NYU.

Jacobs's increasing visibility as an advocate of preserving cities from the planners and developers brought her to the attention of both Mumford and William H. Whyte Jr., author of *The Organization Man* and an editor at *Fortune*. Whyte had her write an anti-redevelopment piece for *Fortune*, "Downtown Is for People," that outraged his fellow editors and drew bags of mail. In 1958 she took a leave of absence from *Architectural Forum* to start work on her book *The Death and Life of Great American Cities*, which Random House published in 1961. "This book is an attack on current city planning and rebuilding," she begins, then she lays out her core ideas about cities as living organisms that do best when least meddled with by the "experts." Urban planners and architects denounced her as an uncredentialed dilettante, a romantic, a myopic housewife whose entire understanding of urban life was based on her experiences in the utterly atypical hothouse of Greenwich Village. The book went on to be the bible of the anti–urban renewal and historic preservation movements anyway.

While Jacobs and other Villagers were busy fighting off Moses's large-scale public works plans, they failed to oppose the quieter, piecemeal incursions of private real estate developers, who through the 1950s were demolishing older buildings all over the Village for new high-rises. The old Brevoort on Fifth Avenue between Eighth and Ninth Streets was knocked down in 1954 to be replaced by the briskly moderne Brevoort apartment complex. The so-called Twain House next door at 21 Fifth Avenue on the southeast corner of Ninth Street (just across Ninth from where Mabel Dodge's Evenings had been) came down at the same time. Built in 1840 by James Renwick, whose son designed Grace Church on Broadway, it had actually housed *two* great writers—Renwick's friend Washington Irving predated Twain there by almost fifty years. Twain had been in and out of Manhattan since Clapp had published "Jim Smi-

ley," but his longest period of residence was from 1904 to 1908, when he rented the town house and installed a deluxe pool table in the master bedroom, moving his bed to the study. He and his men friends played so much pool his daughter Clara put up a sign by the door, NO BILLIARDS AFTER 10 P.M. The white-haired, white-suited, cigar-chewing don of American satire "gave lectures, attended luncheons, ambled around Greenwich Village, received so many visitors he had to hire a secretary to turn them away." Then he left New York for Connecticut, where he died. In 1925 the Greenwich Village Historical Society put a bronze plaque on the wall commemorating Irving and Twain. That same year the house was subdivided into apartments. The notice in 1954 that the Twain House was to be razed along with the Brevoort prompted a few halfhearted schemes to save it, perhaps by moving it and converting it into a museum. But on the whole Villagers, distracted by the fight to save Washington Square just two blocks away, failed to rally. The Historic Society's plaque is now stuck, ingloriously and incongruously, to the massive white flank of the Brevoort apartment building.

Nearby, the Lafayette Hotel also came down, replaced by another apartment building. Dawn Powell watched the demolition from her duplex across the street. Contemplating the destruction of the Café Julien at the end of The Wicked Pavilion, published in 1954, one of her characters wonders, "Where would they go to hide from their real selves when the Julien vanished?" In 1958 Powell and Gousha, splendid old landmarks in their own way, were uprooted as well. They had to leave their duplex when the building went condominium and they couldn't afford to buy in—he'd just been forcibly retired, a dipsomaniacal ghost, and Powell's income from writing had always been meager. Broke, old, and sickly they became gypsies, camping out in seedy residential hotels or with friends. He died in 1962, the year her last novel, The Golden Spur, was published to mediocre sales and reviews. She passed her last years in a small apartment on Christopher Street and died in 1965. Because she died broke, she was buried in an unmarked grave in New York City's potter's field on Hart (originally Hart's) Island, where the city has been laying its unidentified and indigent dead since 1869.

All over the Village of the 1950s blocks and half-blocks of old housing or commercial buildings came down and new apartment buildings went up. In 1956 the Tenth Street Studio, one of the more significant buildings in the neighborhood if not one of the most attractive, was demolished. It was replaced by a large, studiously bland brick apartment building. NYU knocked down the old boardinghouses on the south side of Washington Square where so many bohemians had lived. By 1960 the destruction of Village landmarks was so noticeable that a young Villager named Jerry Herman—who'd go on to write *Hello, Dolly!*, *Mame*, and *La Cage aux Folles*—included a song about it in his satirical musical revue called *Parade*. *Parade* started out at the Showplace, a club at 146 West Fourth Street (the Pepper Pot building), then moved to the Players Theatre on Mac-Dougal Street. The five-member cast included Charles Nelson Reilly and Dody Goodman, who sang "Save the Village," a mock-serious lament that included the lines:

> *Cease, oh cease the senseless demolition!*
> *Save, oh save our landmarks from this pillage!*
> *Won't you sign your name to our petition?*
> *Won't you sign your name and save the Village?*

By then preservation-minded Villagers were fighting a rearguard action to get at least the heart of the old neighborhood designated a historic preservation zone, which happened in 1969.

ANOTHER BIG ISSUE THE *VOICE* TOOK ON EARLY WAS HELPING TO unseat Carmine DeSapio. It was an epic battle that pitted the old Italian and Irish Village against the new, hip generation, and old-school machine politics against the liberal reformers. In the end it brought DeSapio low and raised up a new star, Ed Koch.

DeSapio was born in the Italian Village in 1908 to Sicilian immigrants. As a teen he ran errands for a Tammany wigwam called the Huron Club on Van Dam Street, delivering coal and Christmas turkeys to poor families who would vote Democrat when called on. By the late 1930s he'd

formed his own wigwam, the Tamawa Club (a name he made up, think-
ing it sounded sort of Indian), which met in a rented hall on the second
floor at 88 Seventh Avenue South, just north of the avenue's complicated
three-way intersection with Bleecker and Barrow Streets. Working-class
Villagers climbed the stairs several nights a week to seek Tamawa's help
with jobs or landlords in return for their votes. So did lawyers, because
the old-fashioned Tammany patronage trough remained the way to get
appointments and judgeships in the city's corrupt court system.

By the 1950s DeSapio wore a number of chief's bonnets. He was the
head of Tamawa and one of two elected Democratic leaders for the assem-
bly district that included Greenwich Village (each district had a male and
a female leader), and he was the Democratic chairman for all the assem-
bly districts of Manhattan and the grand sachem of what was left of Tam-
many, as well as the chair of the New York delegation to the Democratic
National Committee. In overwhelmingly Democratic New York, being
the party chief for Manhattan gave DeSapio tremendous clout and made
him something of a kingmaker. He'd helped get Robert Wagner elected
mayor in 1953 and Averell Harriman elected governor the following year.
In a long article about him in 1955 *Time* dubbed him "A New Kind of
Tiger" and a "Kitchen-Table Medici." He cut a grave and imposing figure,
a tall man with wavy black hair neatly coifed, eyes hidden behind dark
glasses, bespoke silk suits, nails manicured and polished, gold cuff links
flashing. In the neighborhood they called him the Bishop for his air of
gravitas, but to outsiders he looked more like the Godfather. DeSapio, of
course, denied any ties with organized crime, even though the Mafia's in-
filtration of Tammany was old news and mobster Frank Costello claimed
that he knew DeSapio "very well."

In the 1956 presidential elections two Democrats vied to be the one to
go up against incumbent Dwight Eisenhower. DeSapio, naturally, backed
Governor Harriman, which meant that most of the Irish and Italian Vil-
lage and most neighborhood businesses would too. But more liberal, re-
formist Villagers, including Dan Wolf at the *Voice*, backed the egghead
Adlai Stevenson, who'd already lost once to Eisenhower in 1952. No one
backed Stevenson more vociferously than Ed Koch, a thirty-two-year-

old struggling lawyer who had just moved to the Village that year. He shared an apartment with a friend at 81 Bedford Street—the same building where George White had been dosing people with LSD only a year earlier. Born to Jewish Polish immigrants, Koch had grown up in the Bronx, in Newark, and finally on the heavily Jewish Ocean Parkway in Brooklyn. As a kid he was, like Jimmy Walker, known as a motormouth, but he completely lacked Jimmy's bon vivant charm and was known to other kids as a loner, a geek, and an egghead. He served in the infantry during the war, entering Europe not long after D-day. He'd come to know the Village while studying law at NYU and had moved there from his parents' apartment. Tall, gangly, balding, with a face and a voice only a mother could love, he was and would remain a bachelor, with a male roommate, living in Greenwich Village, who showed greater interest in cooking and movies than in women. As he came to prominence in the city, most New Yorkers would assume this all meant he was gay. He denied it once on record, then stopped answering the question. All over the Village in 1956 he could be encountered handing out literature and soapboxing in his strident voice for his man Stevenson. He and Dan Wolf bonded. Stevenson won the nomination and lost the election. Outside of the Village, most Americans still liked Ike.

Wolf, Jane Jacobs, and other reformers then set their sights on unseating DeSapio as district leader, the linchpin of his empire; without it he couldn't be the party leader for Manhattan. They started an anti-Carmine group, the Village Independent Democrats. In his 1984 memoir *Mayor*, Koch wrote: "DeSapio was the boss of bosses, a backroom man, a cutter of deals. He was exactly the kind of politician who was unacceptable to my generation." But in fact, as the VID was forming, Koch went to where the power was and tried to ingratiate himself at Tamawa. He didn't fit in there. He waited a couple of years while the reformers' numbers and power grew before throwing his lot in with them. Wolf meanwhile was writing editorials calling for an end to DeSapio's reign. Carmine was unused to such criticism in his own district. The *Voice* alleged that he retaliated by pressuring neighborhood businesses not to advertise in the paper. It made the front page of the *Times*. Then, when a *Voice* staffer put a

VID poster in the window of her second-floor apartment on Christopher Street, a gang of Tamawa thugs showed up to threaten her and her landlady. It made big news and inspired Lorraine Hansberry's play *The Sign in Sidney Brustein's Window*.

Marky Iannello was just a child growing up in the South Village as all this was going on, but he remembered it well because his mother, Helen Iannello, was a key player—at some risk to her standing among their Italian neighbors. In February 1954, when Marky was five months old, his mother moved them into a third-floor apartment in the wide six-story building at the corner of Thompson and West Third Streets. He was still living in that same apartment more than fifty years later. His mother was not taking them into unknown territory in 1954. She'd been born in the building next door in 1922. His grandmother was the super of both buildings when he was growing up.

"My grandmother used to sweep and mop both buildings every day, and sweep and mop *the sidewalk*, every day," he said, chuckling with wonder. "And take out the trash. I look at the super now and I go, 'You fuckin' *jadrool*, how about cleaning the hallway?' " "Jadrool" comes from *cetriolo*, Italian for cucumber, and means a lazy bum.

Like most Italians in the Village, Marky grew up surrounded by extended family. He had aunts, uncles, and cousins in both buildings. Kids organized themselves in a hierarchy of zones. "We had a gang of all the kids who were on my floor. Then we had a gang of all the kids from my building. We'd fight all the other buildings' kids on the block. Then all the kids from my block would fight the kids from the next block. This was like a thousand kids fighting a thousand kids." As a child, he didn't stray far from his block. "I had to be nine years old before I crossed Bleecker Street," one block from his home. "And you *never* crossed Sixth Avenue. You got the shit beat out of you. You didn't go 'on the other side,' that's what they said."

There were still Italian pushcart men on the street when he was growing up. Ragmen and cardboard collectors and a watermelon man crying "*Watermelone!*" "Watermelon was big because it was cheap." The iceman still came around. He sold blocks of ice to the grocery stores and news

vendors, who'd buy watermelons from the watermelon man and display them for sale on the ice. And he shaved ice "in an old crank bucket" to make lemon ice. Was it good? "It was crack," Marky grinned.

People did very little shopping outside of the neighborhood, especially for food. Grocery stores were everywhere. Marky remembered one next door, another three or four buildings down, another one five buildings down from that. Across the street was a fourth and next to that was a candy store. "Candy store" is vintage Newyorkese for what today would usually be called a deli or a bodega, that is, a mom-and-pop shop that probably sold a miscellany of sodas, candy, newspapers and magazines, cigarettes and cigars, other daily necessities. In Marky's South Village candy stores were vital to kids' lives because they sold "spaldeens"—the street kids' pronunciation of Spalding. A spaldeen was a pink rubber ball, two halves glued together along the equator, with air pumped into it, kind of a naked tennis ball. Kids played stick ball, wall ball, and stoop ball with them. Candy stores stocked them by the box. The hardness and bounce of each ball depended on how much air was pumped inside. Neighborhood kids made a science of squeezing them to pick just the right one. "You wanted a ball that was hard, but not so hard that it would break easy. So when the guy in the candy store across Sixth Avenue had the good balls, you go there until he got balls that were bad. He opened the next box, they weren't as good. Then somebody would say, 'Go to the one down Thompson Street. He's got the good spaldeens.' In ten days they'd all be gone."

Boys played another game with deadly earnest: skelzy, known to kids in other parts of the city as skellsies or skully. They chalked a pattern of thirteen numbered boxes on a sidewalk or parking lot, like a more complicated hopscotch box, then flicked bottle caps around to all thirteen boxes following intricate and arcane rules. The girls played hopscotch. On the sidewalk near Marky's building the faintest ghost of a hopscotch box painted decades earlier could still be made out in the 2010s.

All the kids walked to school in the neighborhood. Marky attended nursery school at Greenwich House, and the Children's Aid Society on Sullivan Street offered after-school and summer programs. "Fabulous

setup. It was the real deal. They really cared about getting kids off the street, giving them a place to come, structure. You could learn how to play pool or you could learn woodworking, basketball. There was a little swimming pool, a little fountain. We played a lot of stickball."

Marky remembered the streets around his home thick with beatniks, folkies, and massive hordes of tourists. But the social separations that sociologist Ware had observed in the 1920s still largely applied. Clubgoers, folksingers, and beatniks shared the neighborhood with Italian families, often shared the same building, but they lived in different worlds.

"It was a heavy-duty Italian neighborhood. They knew their boundaries. It was painfully obvious. If you were a beatnik you were accepted by *your* people, but walking down the street you had to watch your Ps and Qs. I don't give a shit who the fuck you are."

It was also very solidly DeSapio territory. Helen Iannello was one of the few who bucked the tradition. After joining the fight against Moses, she served as president of the Village Independent Democrats, who worked against Carmine. Marky remembered that she "took a lot of grief from a lot of people in this neighborhood. They never really said anything to her, but they made her know just by . . ." He let the sentence trail off but made an eloquent, wordlessly Italian snubbing face.

In 1961 the VID candidate took the district leadership from DeSapio. In 1963 and again in 1965 Ed Koch, who by then was solidly with the VID, blocked Carmine's bids to get it back. A *Voice* headline cheered, "Last Hurrah for Tamawa! Village Is Reform Country!" It was Koch's start up the political ladder. Tammany as an entity faded into history, though the Tammany "clubhouse"–style of patronage and payoffs continued to be practiced by the city's Democratic machine. As for Carmine, he would be convicted of bribery and conspiracy charges in a scandal involving one of Mayor John Lindsay's commissioners in 1969 and serve two years in federal prison. He died a forgotten man in St. Vincent's in 2004.

# Off-Off-Broadway

IF YOU'RE GOING TO MAKE THE BIG BLACKOUT THERE
ARE WAYS THAT AREN'T QUITE AS MESSY.

—*Robert Heide*, The Bed

NOTHING WAS DONE BY THE BOOK. WE DIDN'T EVEN
KNOW THE TITLE OF THE BOOK.

—*Paul Foster*

O N A BITTERLY COLD WINTER'S EVENING, THE PLAYWRIGHT Robert Heide stands at the corner where the block-long Cornelia Street meets West Fourth. He gazes up through clouds of his own breath at the fifth-floor windows of the tall, narrow brick tenement at number 5. He recalls another night, almost half a century ago, when he stood on this same corner. It was October 27, 1964. A little

earlier, a naked young man had leaped from one of those fifth-floor windows and smashed to his death on the street.

"They were just cleaning up," Heide recalls, his voice going a bit dreamy with the memory. "I saw some blood and what must have been pieces of brain. I was like, 'Oh, that must be somebody I know.' "

It was. The dead man was twenty-eight-year-old Freddie Herko, a dancer and actor well known and liked in the Village. He'd leaped from the apartment shared by Johnny Dodd, the lighting designer for the theatrical performances at the Caffe Cino just down the block, and Michael Smith, a *Village Voice* theater critic and huge Cino booster. Opened in 1958, the Cino had quickly developed into a bustling hub of the exuberant Off-Off-Broadway theater movement. Several famous and very successful playwrights and performers started out or passed through there. But by 1964 hard drugs, decadence, and death were stalking Cornelia Street. By the mid-1960s a death like Herko's—maybe suicide, maybe a drug accident, no one was certain—was sad but not shocking.

GREENWICH VILLAGE WAS THE BIRTHPLACE OF BOTH OFF-BROADway in the 1950s and Off-Off-Broadway in the 1960s. During the war, the most notable new theatrical activity in the Village had been the New School's Dramatic Workshop. The workshop's director Erwin Piscator, whom the young Alfred Leslie met, had come to New York as part of the European exodus in the late 1930s. Piscator was a huge figure in the international theater community; a dadaist early on he'd then co-created epic theater with Brecht in the Weimar years. He'd fled Hitler in Germany and Stalin in Moscow before immigrating to New York. Because of his reputation his students had the opportunity to perform new work by important writers, including the U.S. premiere of Sartre's *The Flies* and the first staging of Robert Penn Warren's *All the King's Men*. Out of his classes would come a generation of stage and film stars of the 1950s.

A few new companies sprouted in the Village in the first years after the war. One called New Stages took over an abandoned movie theater at Bleecker and Thompson Streets and staged work by Sartre, García Lorca, and others. Another took over the Provincetown Playhouse and staged

works such as Cocteau's *The Infernal Machine*. In 1949 Broadway and Actors' Equity gave the nascent scene a boost. Broadway producers and investors "were caught in a two-way economic pinch," the theater historian Stephen J. Bottoms explains, as "a consumer-driven inflationary boom was driving the costs of production to unprecedented heights, while theater audiences were being seduced away" by film and television. Broadway producers turned increasingly to handsomely mounted musicals to lure audiences back; the 1950s would be the epoch of grand productions: *The King and I, The Sound of Music, Flower Drum Song, South Pacific*. There was some serious drama on Broadway but many producers didn't want to take the risk. Work abounded for the few actors who could hoof 'n' holler; less so for the rest. Actors' Equity, therefore, decided to let its members work in small theaters for reduced pay, restricting the size of the audience permitted and the number of performances.

With the promise of affordable legitimacy, new theater companies began to bloom around the Village. In 1950 the director José Quintero and others turned the former Cafe Society basement on Sheridan Square into the Circle in the Square. Their 1952 revival of Tennessee Williams's *Summer and Smoke*, which had flopped on Broadway a few years earlier, was a huge success, the first big hit of the new Off-Broadway. It made a star of Geraldine Page, who went on to do the filmed version as well. Quintero had another big hit with a revival of *The Iceman Cometh*. The new *Village Voice* handed out its first Obie awards that year to Quintero and the show's star Jason Robards Jr. The show then moved to Broadway.

In 1954 Marc Blitzstein's translation of *The Threepenny Opera* opened at the Theater de Lys (later the Lucille Lortel) on Christopher Street, with a cast including Lotte Lenya, Bea Arthur, and John Astin. It played ninety-six performances before it had to clear the stage for another show. Audience demand brought it back to the theater in 1955 and it ran for six years, with casts that included Ed Asner, Estelle Parsons, Jerry Orbach, and Jerry Stiller. That was nothing compared to another musical the young Orbach was in, *The Fantastics*, from which came the standard "Try to Remember." It opened at the Off-Broadway Sullivan Street Playhouse in 1960 and ran until the theater closed in 2002, an amazing 17,162

performances, said to be the longest-running musical in the world. It was there so long that for decades people referred to Sullivan Street between Houston and Bleecker Streets as "the *Fantastics* block." Not that anyone in the Village would admit to seeing the show, which they considered hopelessly middlebrow pap for the tourists. The poet and critic Alfred Chester lived in an apartment upstairs for years and never saw the show. After the show closed, the building was converted into luxury condos.

Reviving plays by Williams and O'Neill was "not particularly daring," Bottoms argues. "In effect, the serious drama being squeezed off Broadway by economic forces found an alternative home in these smaller theaters." For really new and challenging work, there were the haphazard collaborations of John Myers and Herbert Machiz's short-lived Artists Theatre, and there was Julian Beck and Judith Malina's Living Theatre, both closer in spirit to what came to be known as Off-Off-Broadway than Off-Broadway. In 1959 the Living Theatre produced a kind of junkie *Godot*: Jack Gelber's *The Connection*, the most controversial Off-Broadway play yet and its biggest succès de scandale.

Beck and Malina had founded the Living Theatre in the postwar years and from the start had charted a singular course for it. Malina was born in Germany and came to New York with her Jewish parents in 1929, when she was three. In 1943 she met Beck. She was seventeen and an aspiring actress; he was eighteen, a painter, and had just dropped out of Yale to be part of the downtown art scene. She studied theater under Piscator. Inspired by his approach to theater as a political art form, and by Antonin Artaud's extremist Theater of Cruelty, she and Beck founded the Living Theatre in 1947. Because Malina was pregnant with the first of their two children—to whom they gave the venerable theater name Garrick—they got married that year. It was an open marriage, both of them free to pursue other men.

Chronically broke, they staged their first performances in their apartment before renting Cherry Lane in 1951 to produce Gertrude Stein's *Doctor Faustus Lights the Lights*, which John Ashbery called "one of the most beautiful things I've ever seen on the stage." In 1952 they presented an evening of one-acts: Stein's *Ladies' Voices*, T. S. Eliot's *Sweeney Agonistes*,

and Picasso's surrealist *Desire Trapped by the Tail*, best known for Gertrude Stein's remark on first encountering it that the painter should stick to painting. Ashbery and Frank O'Hara played dogs in it. A scoffing reviewer for *Billboard* wrote that if such work "must be done, an off-Broadway theater . . . is the best place for it . . . It's like nothing seen before. Even Bohemia was never like this." A double bill of Alfred Jarry's *Ubu Roi* with Ashbery's mildly homoerotic *The Heroes* the following year got Beck and Malina into their first of many scrapes with the authorities. The fire department shut it down after three nights, citing the gauzy *Ubu* set as a fire hazard. They were shut down again for building code violations in 1956 and spent the next few years finding and then outfitting a beautiful space in an old storefront at Fourteenth Street and Sixth Avenue. In the interim they became increasingly involved in radical politics, participating in, and getting arrested at, a number of antinuke, antiwar protests. Their thinking about theater evolved in the same direction, away from poetical European texts and arty sets to something more confrontational and topical. They wanted, as Beck later put it, to "be real on stage, without feigning realism."

In 1959 they did just that with Gelber's *Connection*, about a group of heroin addicts waiting for the Man. Everything about the production obscured the lines separating theater and reality. The set re-created a scummy Lower East Side pad. The audience was told that the performers weren't actors but actual junkies, including the jazz band on stage, some of whom occasionally appeared to nod off. The action, much of it improvised, happened in real time, not theatrical time. The performers fidgeted like jonesing addicts, mumbled junkie small talk, spatted, and for long stretches did nothing at all but wait, while the audience took over the fidgeting. Finally the dealer arrived, they all shot up, and one of the junkies overdosed as the band wailed bebop. The End.

The daily newspapers' critics despised it, the *Voice* loved it, and no self-respecting downtown type failed to see it at least once. Larry Rivers, who turned down an offer to play/be one of the junkies, says it "reflected the avant-garde conceits of that period . . . one of which was to be sure their audience found something in the production annoying." He calls Beck

and Malina "violent pacifists . . . Whatever they and their productions were, they gave you the feeling you were witnessing something important." They followed The Connection with The Brig, an even grimmer, more "realistic" production set in a U.S. Marine prison compound, where the actors suffered physical and psychological brutalities. During the run of The Brig in 1963 the IRS seized the Living Theatre's space for nonpayment of roughly twenty-eight thousand dollars in back taxes. Agents chopped up the set and put whatever they could find in the building on auction. It netted less than three hundred dollars.

Locked out at Fourteenth Street, they remounted The Brig in a space on Forty-second Street near Tenth Avenue, where they were soon shut down again. Jonas Mekas, who'd known the Becks and followed their work since the early 1950s, caught one of those last performances and decided he had to film The Brig. He persuaded the company to "do one more performance, just for me." To capture the sense of reality the Becks were going for onstage, he decided to rent two Auricon single system sound-on-film cameras, used by news agencies because you could very quickly print, edit, and project what you shot. Since the Forty-second Street space was now closed he, his crew, and the company sneaked in through a coal chute. While lookouts kept watch for the cops, they shot the performance in one take, pausing only to reload film. The performance "was so precisely orchestrated that my being there disrupted it completely. The actor had to be there, but I was there with my camera," so the cast had to think on their feet and work around him. "That made it [a] very, very special performance. It became much more real. Those little changes made a big, big difference. Two days later I projected it at the Bridge Theatre on St. Mark's Place for like ten people, fifteen. The Living Theatre, Andy Warhol came, a couple more. And Andy went gaga. 'This is it! This is it!' So I feel guilty. He was doing such good work in silent cinema, and I infected him with Auricon. So that's how Andy's sound period begins, because it was so easy."

In their subsequent trial on the tax charges, Beck and Malina were given short, symbolic jail sentences, which they appealed. Many saw it all as a government crackdown on Beck and Malina for their peacenik

activities. The two agreed that America wasn't going to let them do their kind of theater anymore. They took the Living Theatre into a long exile in Europe, during which they created *Paradise Now*, a highly improvised audience-participation spectacle that included, like many avant-garde performances of the time, nudity. Touring that piece in the United States in 1968 resulted in numerous arrests for indecent exposure; performing it in Brazil in 1971 got them imprisoned for months and deported. Beck and Malina's marriage and theatrical partnership lasted until he died in 1985, shortly after the filming of *Poltergeist* II, one of his very rare forays into the commercial sphere. (He was also in *Candy* and *The Cotton Club*.) Malina soldiered on, back in New York. In 1993 the Buildings Department closed yet another Living Theatre space, this one in the East Village, for code violations. In 2006 Malina signed a ten-year lease on an intimate, spare space in a basement on Clinton Street on the Lower East Side.

WATCHING ALL THE NEW THEATERS CROPPING UP IN THE VILLAGE in the 1950s was a young failed poet and novelist who'd moved there at the start of the decade. He later told an interviewer he'd sometimes go to two plays a day. He saw *Iceman*, the Picasso, the Beckett, the Tennessee Williams. In 1958, as his thirtieth birthday loomed, he decided to write a play of his own. His name was Edward Albee.

He'd come, in a way, from a theater background. Shortly after his birth in 1928, he was adopted by the wealthy Reed Albee, whose father had made a fortune from the Keith-Albee vaudeville chain. Growing up in Westchester and on Park Avenue, he was often taken to the theater as a child. As parents the Albees were cold and distant, magnifying his sense of being alone in the world. He went to, and did poorly at, the finest private schools, including Choate and the Valley Forge Military Academy, where, he later joked, they taught only two subjects, sadism and masochism, and where he discovered his attraction to other boys. In 1949 he broke with the Albees. "They were deeply bigoted, reactionary, materialistic," he wrote in *Time* in 2002. He spent the next decade moving around to various apartments in the Village and Chelsea, working odd jobs, in-

cluding delivering telegrams for Western Union, to supplement a small stipend from an adopted grandmother and quietly soaking up culture. He met his lover, the wickedly smart, handsome, and self-destructive composer Bill Flanagan, and, like most everyone else in the Village in the 1950s, they did a lot of drinking together. They drank with the painters at the Cedar Tavern, with the composers Aaron Copland and Elliott Carter up at the Carnegie Tavern next to Carnegie Hall, and in the still largely clandestine gay meeting places in the Village: Goody's (which had been one of the bars where Joseph Mitchell met up with Joe Gould in the 1940s); Mary's on Eighth Street; Julius's on West Tenth Street; and Lenny's Hideaway, a basement dive on West Tenth Street between Seventh and Eighth Avenues (now the jazz club Smalls). Robert Heide met them there in the mid-1950s, along with the composer Ned Rorem, the playwright Tom Eyen, and composer Jerry Herman. "It had a kind of artistic and pretentious aura about it," Heide recalls. He remembers a "surly German bartender," a former ballet dancer, who "served a special deadly drink he called 'der clinker,' " a mix of brandy and vodka. Flanagan and Albee lived together in a tenement on West Fourth Street and dressed and acted so alike that friends called them clones. They also fought fiercely; Heide maintains that some of Martha and George's verbal battles in Who's Afraid of Virginia Woolf? come verbatim from Albee and Flanagan's arguments. Albee got the title from graffiti he saw in a West Tenth Street bar, the College of Complexes (later the Ninth Circle).

In 1958, his poetry and fiction going nowhere, Albee sat down at an old typewriter he'd lifted from the Western Union office and spent three weeks banging out his one-act The Zoo Story. Jerry, a probably gay loner, confronts Peter, a married and possibly closeted middle-aged man in Central Park, and goads Peter into stabbing him to death, in effect sacrificing himself to shock Peter out of his complacent torpor. The story reflected some of the sad, solitary New Yorkers Albee had met on his Western Union job. The seedy Upper West Side boardinghouse where Jerry lives, for example, was inspired by Albee's regular delivery of telegrams to the gruff actor Lawrence Tierney, then down on his luck and living in a run-down place in that neighborhood.

The Zoo Story didn't premiere Off-Broadway but *way* off Broadway. Albee sent it to a friend in Rome, who showed it to a friend in Berlin, where it was translated into German and double-billed with Beckett's Krapp's Last Tape in 1959. Meanwhile the Actors Studio staged a reading, at the end of which Norman Mailer jumped up and in his blustery Mailerian way proclaimed The Zoo Story "the best fucking one-act play I've ever seen." In 1960 producer Richard Barr brought the double bill to the Provincetown Playhouse. It began a long collaboration between Albee and Barr, who had been Orson Welles's assistant at the Mercury Theatre in the late 1930s. Despite mixed reviews from newspaper critics The Zoo Story was a big success, and subsequent productions spread around the country and the world. It vaulted Albee to overnight celebrity as America's hottest new playwright. Heide remembers a night soon after the play opened when the San Remo was crowded with big names—Tennessee Williams, Simone Signoret, Leonard Bernstein, Malina and Beck. When Albee walked in and stood alone at the end of the bar every head in the place turned. He had arrived.

Albee's Who's Afraid of Virginia Woolf? exploded on Broadway in 1962, with Uta Hagen, Herbert Berghof's wife and partner at the Bank Street acting school HB Studio, playing Martha. Some critics failed to get it, denouncing it as "a sick play for sick people" and "for dirty-minded females only," but it proved to be a gigantic success anyway. Albee was hailed as the new O'Neill, won prizes, and made the cover of Newsweek. Fitting the downtown pattern, fame sat uneasily with him. He lashed out at the critics, was surly and peckish in interviews, and made no effort to hide his contempt for Broadway and its audiences. He was another downtown celebrity the media loved to hate, the quintessential angry young man. While Albee's career soared, Flanagan's remained earthbound. Albee eventually left him for the young playwright Terrence McNally. "As Ed became a celebrity he distanced himself from everybody," Heide says. Battling alcoholism and depression, Flanagan deteriorated mentally and physically through the 1960s. He was found three days' dead in his apartment in 1969. He had just turned forty-six.

As Albee's star continued to rise he moved to fancier digs on Fifth Av-

enue and a place out at Montauk, then bought a loft in Tribeca. Through the 1970s and '80s his own alcoholism derailed his career and badly damaged his writing. In his Albee biography, Mel Gussow describes a dinner party he and his wife gave in their Village apartment in 1977 for assorted great names of New York theater, at which a drunk Albee and Joseph Papp, founder of Shakespeare in the Park and the Public Theater, flew into a vicious shouting match that began with insults about each other's work and descended to ad hominems, Albee needling Papp about his former CPUSA membership and Papp attacking Albee's homosexuality. Albee finally got his drinking under control and made his comeback in the 1990s with the Pulitzer Prize–winning play *Three Tall Women*.

WHERE MUCH OF THE EARLY RISE OF OFF-BROADWAY HAD BEEN driven either by revivals like *The Iceman Cometh* or imports from Europe, Albee's triumphs signaled to producers and investors that they could actually make money presenting new plays by young writers. Off-Broadway theaters sprang up everywhere in the early 1960s, and investors poured money into productions. Everybody from theater owners to the unions put their hands out. Ticket prices rose. Inevitably the vastly greater sums being risked made producers more cautious about the plays they put on. Off-Broadway's shining moment as an incubator of new talent and ideas seemed to be ending almost as soon as it had begun. By 1964 Albee himself was noting how "greedy landlords, union demands, costs" were ruining it. He had decided to do something about that. With Barr and their producing partner Clinton Wilder, he'd used some of the handsome profits they were making to start the Playwrights Unit theater, in the Village South Theatre on Vandam Street. They nurtured the development of playwrights including Sam Shepard, LeRoi Jones, Lanford Wilson (Lance to his friends), Paul Foster, Jean-Claude van Itallie, and of course McNally, among others. "It seems to me that if one finds oneself with the cash it's one's responsibility to do a thing like that," Albee said in a *Paris Review* interview in 1966. "The plays we've put on . . . are primarily plays that I wanted to see: other people weren't putting them on, so we did."

In that interview, Albee said that "Village coffeehouses have taken over the job of putting on the furthest-out, most risky plays of young writers." He named only one, the Caffe Cino, maybe because it was the most active, the most unusual, and the most gay. Probably for those same reasons it went down in theater lore as the birthplace of Off-Off-Broadway, which isn't precisely accurate—the movement sprang up in a few spots more or less at the same time—and its proprietor, Joe Cino, as the accidental midwife, which is closer to true.

Cino was born in 1931 to Sicilian immigrants in Buffalo, which he, like gallerist John Myers, found not a great environment for a young gay man. When he was sixteen he fled to New York City, where he worked odd jobs while studying performing arts at the Henry Street Playhouse. His dance ambitions were hampered by his weight (his friends called him Porcino, or Little Pig). "Joe was short and he always smelled," playwright Robert Patrick remembers. "I don't mean he was dirty, but he had a virile, male smell. He was short and plump and got plumper. He had eyes like Hedy Lamarr. His eyes could just transfix you. And he was so kind that it almost seemed like a character flaw." Similarly, Heide cites Cino's "abundant, humanistic, and all-embracing hopeful attitude." In 1958 he and a couple of friends rented the empty storefront at 31 Cornelia Street, site of the restaurant Po today, and opened the Caffe Cino.

At the time, Cornelia Street was a little backwater of the Italian Village—the landlady at 31 rented to Cino because he was Sicilian. Tucked behind an always busy and crowded stretch of Sixth Avenue, it's only a block long, running at an angle from West Fourth to Bleecker Street. Because it doesn't really go anywhere it gets little traffic to this day. Still, this out-of-the-way block saw a surprising amount of activity. Auden had lived there, Broyard had opened and closed his bookstore there, Agee had worked in a studio there in the 1940s. The Phoenix Bookshop at 18 Cornelia Street printed and published works by the Beats and LeRoi Jones. New Directions, which published so many downtown writers, was in the triangular building at the West Fourth Street end of the block. Across the street from the Cino was the bar restaurant Mona's Royal Roost, a

popular gay destination. It looked like a New Orleans whorehouse inside, ruled by the portly, eponymous Mona. Since the Cino had no liquor license there was a fair amount of foot traffic back and forth.

A short way up the block the floridly out queen Frank Thompson had an art gallery that was notorious in gay circles. "He was a little buxom and short, and I think he got premature gray hair, but his skin was always smooth," recalls the performer Agosto Machado, who first happened on the Cino in 1959. "He looked like if he did drag he would be like Mrs. Santa Claus." Thompson lured a constant procession of young and sometimes underage males up to his shag-carpeted apartment for drugs and sadomasochistic sex. Cino playwright Robert Patrick remembers pretty constant foot traffic between the Cino and the gallery. At the gallery "you could drop in and get laid any hour of the day or night. If there was nobody else around, Frank would do you."

The Cino began mainly as a hangout for Joe's theater friends, with some small, mismatched tables and wooden chairs strewn around the narrow storefront and a big coffee machine on a counter in the back, which held pastries and snacks. Art by Joe's friends, posters and flyers for their events, Valentine hearts, crumpled silver foil and glossies of hunky movie stars like Rock Hudson and Tab Hunter went up on the walls. Over time more and more layers were added, with twinkling Christmas lights strung everywhere, until the walls were encrusted and barnacled. Many patrons found the effect charming, an enchanted grotto; others thought the room looked diseased. For entertainment at first there was "dance" (a friend of Joe's gyrating suggestively to records), poetry readings, and music—Tom O'Horgan, who'd later direct *Hair* and *Jesus Christ Superstar* on Broadway, told jokes while playing the harp. In 1959 came readings of plays, then primitively staged performances. At first they were unauthorized productions of works by established playwrights like Williams, Genet, and Sartre, making the Cino in effect just an extremely low-budget and semi-amateur version of an Off-Broadway theater. Gradually, young writers started bringing their own new work and the Cino came into its own as an Off-Off-Broadway house.

At first tables and chairs were simply pushed back to clear a small

space on the floor. Then a low platform of wooden milk crates, eight by eight feet, became the stage. The tiny space enforced minimal sets—a ladder, a couple of chairs, a sofa, often dragged in off the street. Lights were stolen from established theaters. For power, Cino's then lover, an electrician named Jon Torre, ran cables out to a nearby streetlamp to siphon off free juice from the city grid. Given the minimal sets, lighting designer Johnny Dodd, who had apprenticed with the Living Theatre, became adept at sculpting space and mood with light. He would go on to work with everyone from La MaMa to Robert Wilson to the New York Dolls.

The audience, which sometimes included the Albee-Barr-Clinton trio and sometimes Tennessee Williams (whose last plays show a discernible Cino influence), clustered around the tiny performing area at their tables, the actors sometimes literally in their laps. Pretty soon the Cino was hosting a full-on schedule of fourteen performances a week, by far the most regular and busy of the Village's coffeehouse theaters. There were no tickets; like Village folk music venues at the time, the Cino passed a hat after performances. The take was sometimes zero dollars, since in the early years, especially at late-night performances, there was no one in the audience. Without a cabaret or a theater license, with power boosted from the city, and with audiences later filling the narrow space beyond capacity once word got around, the Cino was violating numerous city codes, which meant fairly constant visits from cops and building and fire inspectors. They never shut Cino down, which his friends say was due to his innate Sicilian understanding of which pockets to line and palms to grease. Still, he was broke from the day he opened the place, working odd jobs in the days and running the café every night; toward the end he lost his apartment, slept at the café, and showered at friends' apartments.

But then poverty was endemic. When Edmund White arrived in the Village in 1962 he got a job as a staff writer for Time, Inc., and his first apartment on MacDougal Street between Houston and Bleecker. "My first lover was in Caffe Cino plays," he remembers. Cino playwright Lanford Wilson "would come to our house for dinner, because he was so poor he was starving. I was one of the few in our crowd who had a job. I made a hundred dollars a week, but that was enough to buy spaghetti for

people." He remembers that during performances at the Cino "Joe Cino was always in the back making the coffee with a very loud machine, and oftentimes there weren't more than ten people in the audience. Like all these things that you hear about that are 'historical,' it was a pretty shabby little scene at the time. But life was cheaper then."

Not everyone participating in the shows was gay, but a gay aesthetic certainly prevailed. In a *Voice* review of an early Cino production, *No Exit* in 1960, Seymour Krim noted the "incense burning and faggots camping." Some of the camp was playful and silly, as in the retro musical *Dames at Sea*, one of the Cino's last productions and one of the few financial successes. But it could also be bizarrely surrealist, as in the work of Haralambos Monroe ("Harry") Koutoukas. Born in 1937, he grew up in the tiny village of Endicott in western New York State. According to Agosto Machado, Koutoukas's inspiration for moving to the Village came from a chance encounter in his teens with Minette, the legendary drag performer and author of the pamphlet *Recollections of a Part-Time Lady*. As Machado tells it, Koutoukas's family, Greek immigrants, ran a roadhouse in Endicott, a combination motel and diner. "It's not the place the average person would go to, because it's sort of a drinking place and single women did not go. And they had entertainment on weekends to attract some customers. They would advertise at the diner, 'This weekend we're having female impersonators.' " Koutoukas's parents would tell him to avoid the women staying at the motel, which only made him curious. "He knew there was something different about these women. They were very nice and friendly, but if you saw them in the morning, they looked a little slept-in." One of the ladies he met in the motel in his teens was Minette, on one of the tank-town road trips she describes in her book. "She said, 'Oh New York City, there's no place like it in the world. Get away to the big city. Because this burg, if you're gonna spend your life here, what is there?' " When he graduated high school, Koutoukas followed Minette's advice and moved straight to Greenwich Village. It's just one example, Machado says, of Minette acting as "the fairy godmother" to the Village.

Koutoukas studied under Piscator but despised mainstream theater and expressed his singular vision Off-Off-Broadway. On the surface his

scripts and productions could seem a rummage sale of classical theater, surrealism, jokes, puns, high-flown verse, glitter and glam, but a fine if not quite balanced intelligence knit it all together. His *Medea in the Laundromat*, performed at the Cino, was an adaptation from the ancient Greek where the tragedy was played straight but Medea was played in drag, and the setting was a Laundromat while the language was a warped classical-sounding verse: "Must you always gather like maggots / At tragedy's door— / Or do you free yourself from guilt / By coming here to bleach your clothes." Another of his plays was called *Awful People Are Coming Over So We Must Be Pretending to Be Hard at Work and Hope They Will Go Away*. A loose-knit but faithful sort of repertory company formed around him, which he called the School for Gargoyles. Machado was a Gargoyle, along with O'Horgan, Harvey Fierstein (who performed and hung out all over the Village without ever living there), and *Hair* writers Gerome Ragni and James Rado. Koutoukas went on to write nearly two hundred plays, mixing all styles and genres, for which the *Voice* gave him an Obie in a new category, Assaulting Established Tradition. He would be a presence in downtown theater for decades while being just too extreme and strange ever to emerge from the underground. In an interview he asked to be buried on a spit "so every time there's a bad theater production I'll turn automatically." He died in 2010.

The fanatically perverse director Andy Milligan, who passed through the Cino in its early years, brought a whole other kind of weirdness. As Jimmy McDonough relates in his biography *The Ghastly One*, Milligan was born in 1929, an army brat. He told McDonough that his mother was neurotic and overbearing ("Oh, she was sick, sick . . . She was an awful mother.") and his father weak and suicidal. Whatever the causes, he emerged cynical, misogynist, sadistic, and gay. He left home for the navy, after which he toured the country with "two crazy lesbians" in a puppet troupe, doing marionette versions of *Aladdin*, *Pinocchio*, and, he told McDonough, "*Emperor Jones*—about a nigger who sets himself up as a *king*. In Augusta, Georgia! All puppets. Of course, nobody came." In the early 1950s he came to New York and acted in some live television dramas before switching to fashion, designing and fabricating haute couture at his

own shop, Ad Lib, first on the Upper East Side, then on West Fourth Street in the Village.

Milligan walked around the corner and into the Cino sometime in 1960, and he began directing plays there in 1961. He was one of the first with an actual background in theater, but his most authentic addition to the Cino mix, McDonough notes, was "a certain depravity." Milligan's productions of Genet's *Deathwatch* and *The Maids*, an adaptation of Tennessee Williams's *One Arm*, and other one-acts put Antonin Artaud's then fashionable ideas about a "theater of cruelty" into serious practice. Milligan brought his own predilections for sadistic sex to his fast, loud, and violent shows, as much S&M exhibitions as theater. Audiences gaped in mesmerized shock or fled in revulsion as his actors and actresses assaulted one another with a brutality that looked real because it often was. Milligan found a kindred spirit in Frank Thompson up the street. Thompson and Milligan staged many drug-fueled S&M scenes with young males both in public at the Cino and in private at Thompson's apartment. One of their young victims overdosed on heroin one night; Thompson found his corpse the next day while waiting for a visit from Walter Chrysler Jr., the millionaire scion of the automobile family and a heavyweight art collector. Thompson hid the dead body until Chrysler left and managed to evade prosecution.

Extremely argumentative and abusive to friends and colleagues alike, Milligan soon fell out with Cino. No one could decide if Milligan's productions were so psychotic and awful they were good or just plain awful. Playwright Paul Foster, who "stumbled into" the Cino around then, recalls that as a director Milligan "could hold your attention. There was something about it that drew you in. It wasn't a lack of talent, but it was talent that was all fucked up. It totally disregarded what the audience might think of this. He had so many contradicting psychological problems that I couldn't sort it out. I was twenty-two, twenty-three at the time, and this was a new animal form for me."

Not long after Foster met him, "Andy said, 'I want to start a theater myself.' Cino rolled his eyes, like lots of luck, kid." Milligan enlisted Foster and a few other innocent Cino figures as investors. "We chipped in two

thousand bucks apiece. I borrowed the two thousand from my brother. Andy said, 'Great, now we have a theater.' " He rented "the old Russian Bear restaurant on Second Avenue just south of Fourteenth. It was full of rats. They never cleaned it. So first we killed all the rats." Milligan's first and last production there was George Bernard Shaw's *Mrs. Warren's Profession*. A *New York Times* reviewer wrote that police should cordon off the street "so nobody goes in there by misadventure. That's how bad it was. Andy's response was, 'Oh, what do they know?' "

Milligan and Foster helped Ellen Stewart start La MaMa in 1961, but he soon fell out with her as well. He moved on to film, cranking out no-budget grindhouse horror movies in the 1960s and '70s, such as *The Ghastly Ones*, *Bloodthirsty Butchers*, *Gutter Trash*, and *The Rats Are Coming! The Werewolves Are Here!* Each is a perfectly ugly storm of apparent insanity and maybe willful incompetence, motivated by what seems to be a malignant contempt for anyone who might be stupid enough to watch it. John Waters is a fan; on the other hand, Stephen King summed them up as "the work of morons with cameras." Milligan died of AIDS in 1991 in Los Angeles and was buried in an unmarked grave.

Less depraved young playwrights used the Cino as a rare venue in the city where they could try out new work. Among them were future stars Sam Shepard, John Guare (*Six Degrees of Separation*), Tom Eyen (*Dreamgirls*), and Lanford Wilson (*The Hot l Baltimore*). Wilson had come to New York from the Midwest specifically to be a playwright, but like Koutoukas he had hated everything he saw on Broadway. He dove right into the Cino, eventually having nine plays produced there. The most notable was *The Madness of Lady Bright* in 1964. Where Cino productions had always flaunted the gay aesthetic, *Madness* came all the way out as an extended monologue by an aging drag queen. This was four years before *The Boys in the Band* presented openly gay characters to Off-Broadway audiences. *Madness* ran a remarkable two hundred performances and encouraged other Cino playwrights to start creating openly gay characters. Both Heide and Patrick insist, though, that they were not making "gay theater" the way that was soon to be construed. They had no gay political or social agenda. "We didn't think of ourselves as writing gay theater," Patrick

said. "We were just writing the life around us. We were more interested in the fact that it was experimental theater than that it was gay." In *States of Desire*, his 1980 insider's guide to gay culture, Edmund White says that he and his friends would have considered labels like "gay writer" or "gay artist" "limiting, irrelevant, even humiliating."

The Cino stage was open to first timers who had never written and sometimes never even thought of writing for the theater until they caught the bug there. "Joe was a very special person," Heide recalls. "The doors were always open. And he himself was open—perhaps too open in the end. Joe would say, 'Oh just do it. Here's a date.' So you just did it."

Robert Patrick was one of the first timers. Geographically and psychologically, he'd grown up about as far from Greenwich Village as a kid could. He was born Robert Patrick O'Connor in 1937 in Kilgore, Texas, "in the shadow of somebody else's oil well." His dad was an oil rig worker, a drunk who "beat us like crazy." He dragged the family around the Southwest following the jobs, from one tent camp to another. Patrick says he was an adolescent before he lived in his first home with a solid roof on it. "Our family moved so much looking for work that I never went to one school for a whole year until my senior year in Roswell. So I still call Roswell my home town." They moved around so much that he and his two sisters "never got socialized." They made up stories, acted out comic books, and that was "as near to a background in theater as I had." He remembers seeing his first movie—appropriately, it was *Boom Town*, about wildcat oilmen—at a makeshift outdoor screening in a Louisiana tent camp. "The government, I guess, threw some park benches in a clearing, and there on a bedsheet stretched between two trees were Claudette Colbert and Clark Gable. I never forgot it." He first saw images of Greenwich Village in movies and first looked at modern art in other people's copies of *Look*.

"I was a horrible, misfit kid," he recalled. "Completely detached . . . Where I came from they hated gay people, they hated artistic people, and they hated intelligent people. Being all three, all I could think to do was skulk in the corner and read my comic books. You can always tell what anybody in my generation was like in high school by which role they played in *Our Town*. I played Simon Stimson, the drunken outcast artist."

In the summer of 1961, at the age of twenty-three, he headed east for the first time, to take a job washing dishes at the Kennebunkport Playhouse. "It was summer stock theater and I learned everything. We did twelve, fifteen shows in three months. I didn't care if I was only backstage with a towel to dry Nellie Forbush's hair in *South Pacific*. I was in theater."

Heading home at the end of that summer he got a ride as far as New York, left his bags with a friend's landlady, and asked her how to get to Greenwich Village. When he came up out of the subway he "followed a boy in the street who obviously wasn't wearing underwear. He had long hair. I followed him into a little café. His name was Johnny Dodd, lighting genius of all time, and that café was the Caffe Cino. They were having a rehearsal at the time. I didn't know it was a rehearsal. I thought it was a show. They kept stopping and starting again. If they made a mistake they'd back up a few lines and start again. I thought it was brilliant theater."

He decided to stay in New York, moved in with his friend—"a two bedroom apartment a block from the Museum of Natural History for a hundred and forty dollars a month"—got a job as an office temp, "and started hanging around the Cino. After a while they'd say, 'Would you go pick up pastries?' or 'Would you go pick up these flyers at the printer?' Soon I was just there. Ultimately Joe bought me a West Point cadet's jacket and a sombrero and I was the official doorman."

He met Lanford Wilson and the actor Michael Warren Powell at the Cino. "They were so scruffy and hopeless-looking I said, 'You can move in with me if you want to.'" They alternated, one of them working a month to pay the rent and utilities while the other two worked on plays. "Lanford would write days, and when I came home he'd clear his stuff off the kitchen table and I'd write at night." It didn't last long. After the two months off Patrick spent to write his first play, The Haunted Host, "I came home one day to find an eviction notice on the door. Lanford and Michael had not been working at all. They had an absolute allergy to work."

When he handed Joe the *Host* manuscript, Joe threw it in the trash can. "He said I was too nice a person to be a playwright." Wilson, Eyen,

and others said they wouldn't write any more plays for the Cino unless
Joe produced Patrick's. He did. It premiered in 1964, with Patrick and
the playwright William Hoffman in the two roles. Surprisingly assured
for a first effort, The Haunted Host is set in a Village apartment, where Jay,
a bright, bitter gay man, locks horns with Frank, an innocent-seeming
playwright manqué from the hinterland. They both fling Oscar Wildean
bon mots like daggers. Frank asks Jay, "What's life like in Greenwich
Village?" He fires back, "Nothing's very lifelike in Greenwich Village."
Having the play staged opened a floodgate for Patrick, who went on to
an extraordinarily prolific career. His Kennedy's Children, a mournful
epitaph for the 1960s set in a Lower East Side bar, was a surprise hit on
London's West End in the mid-1970s, had a brief run on Broadway, and
went on to performances around the world. A revival of Host in the 1970s
featured Harvey Fierstein in his first role as a male—that is, not in drag.

Paul Foster was another first timer. He grew up in New Jersey, where
his dad was a patent lawyer for DuPoint, and went into corporate law
himself, working for a firm called Combustion Engineering. "They man-
ufactured the atomic cores for the first atomic submarines, the Savannah
and the Nautilus." The job took him to Paris, where he started to write
fiction. After a term in the navy he moved to the East Village, met Cino
and Stewart and their crowds, and "decided to give up being a lawyer.
I just fell out of love with it. It pissed off my parents mightily. My dad
said, 'You'll see. You'll starve. You'll be on the Bowery.' As it so happened
I was damn close to the Bowery. I had saved up my money carefully and
had enough for a down payment on a town house on Fifth Street just off
Bowery." His first play, the Beckett-inspired Hurrah for the Bridge, opened
at the Cino in 1963. After the fiasco with Milligan's theater on Second
Avenue he helped Ellen Stewart start up La MaMa, where a number of
his plays were presented. One, called Balls, featured two swinging Ping-
Pong balls and recorded voices. His Tom Paine, directed by O'Horgan,
premiered at La MaMa in 1967. The Times's Clive Barnes hailed it as "alive
and vital," and its meditations on revolution and anarchy struck a chord
with younger audiences. Grove Press published it that year.

The Village's long reputation as a sexual playground continued after World War II.

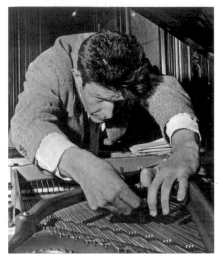

Maya Deren, 1959.
(Photograph by Fred W. McDarrah.
Getty Images)

John Cage, 1957.
(Photograph by Fred W. McDarrah.
Getty Images)

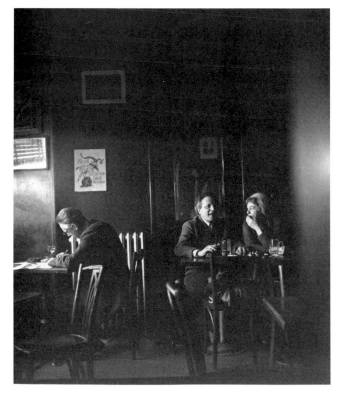

Delmore
Schwartz at the
White Horse
Tavern, 1959.
(Photograph by
Fred W. McDarrah.
Getty Images)

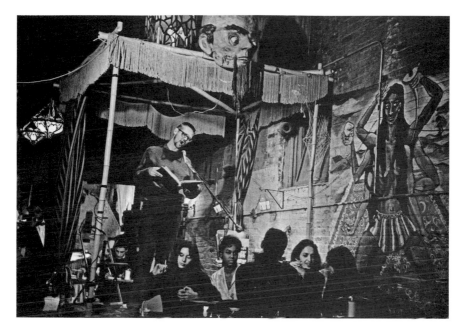

A poetry reading at the Cafe Bizarre.
(New York Times)

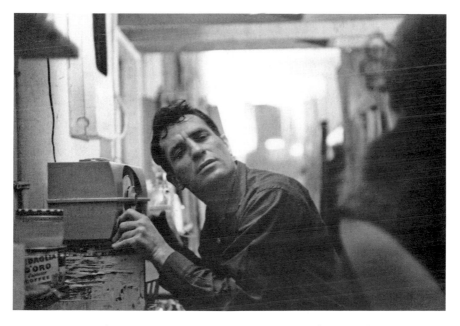

Jack Kerouac, maybe listening to Symphony Sid.
(Photograph by John Cohen. Getty Images)

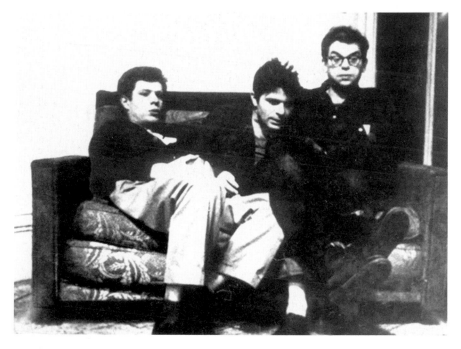

Peter Orlovsky, Gregory Corso, and Allen Ginsberg in *Pull My Daisy*.
(*Courtesy of Alfred Leslie*)

Jane Jacobs at the Lion's Den in 1961.
(*Photograph by Phil Stanziola. Library of Congress*)

Doc Humes arrested at the "3000 Beatnik Riot." A still from
Dan Drasin's documentary film *Sunday*. (*Courtesy of Dan Drasin*)

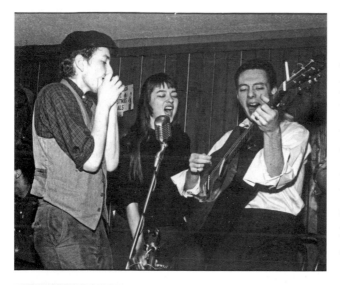

Bob Dylan with Karen Dalton and Fred Neil performing at Cafe Wha? in February 1961, shortly after Dylan's arrival in the Village.
*(Photograph by Fred W. McDarrah. Getty Images)*

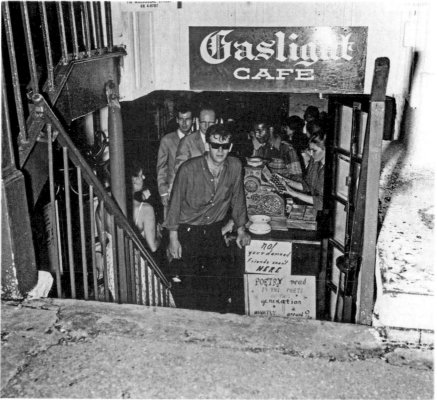

The Gaslight Cafe, 1960.
*(Photograph by Fred W. McDarrah. Getty Images)*

Edward Albee.
(*Corbis Images*)

Rosalyn Drexler as Rosa Carlo, the Mexican Spitfire.

LEFT: LeRoi Jones at the premiere of his play *The Toilet* in 1964. (*Photograph by Fred W. McDarrah. Getty Images*)

BELOW: The Mattachine Society "Sip-In" at Julius' on West Tenth Street, April 21, 1966. Randy Wicker is at the far right of the group. (*Photograph by Fred W. McDarrah. Getty Images*)

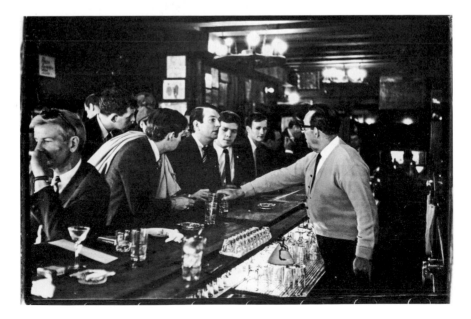

Robert Heide came to the Cino with a couple of plays already produced Off-Broadway. As a kid growing up across the Hudson in suburban New Jersey in the 1940s, he'd climb a hill and gaze over at the spires of Manhattan. "I always used to think, 'I'm going to live there someday.' That was my escape plan." He'd come over to the city with his family sometimes to Radio City Music Hall or Broadway shows. He loved the Automat on Times Square. "They had a second tier and you could look out at the Camel sign, all the neon. One day when we were there a woman came in wearing a black Persian lamb coat with peaked shoulders. She had black hair in a pageboy and full-face theatrical makeup on. Two guys were with her who I would now identify as gay chorus boys. She looked out at the lights and said, 'Yeah boys, it's good to be back in li'l old New York.' "

His first trip to the Village was with a high school class tour in the 1950s. After that he and friends would drive in or take the Hudson Tubes (now called the PATH) and hang out at Lenny's Hideaway. When he finished college in 1959 he moved to the Village permanently. He eventually settled in an apartment on Christopher Street that he shared with his longtime partner John Gilmore. He studied acting with Uta Hagen and Stella Adler, and he hung around with downtown theater people at the Village Drugs soda fountain on Seventh Avenue and at Mother Hubbard's on Sheridan Square, famous for its apple pie, where Harry Belafonte briefly waited tables. Among his neighbors were Zal Yanovsky, who'd cofound the Lovin' Spoonful, and actress Sally Kirkland, who was waiting tables at Le Figaro Cafe, and Dick Higgins, who'd help found the Fluxus art movement. He "vaguely remembers" an all-night pub crawl with Albee and the Irish playwright Brendan Behan, which started at the White Horse and ended at Julius' with Behan, shades of Dylan Thomas, roaring incoherently.

Heide first went to the Cino in 1960, where he was the sole person in the audience at one performance of that infamous production of No Exit. Meanwhile, he was writing his first one-acts. Hector played at Cherry Lane on a bill with plays by Kenneth Koch and Cocteau; West of the Moon, "an encounter between a hustler and a religious fanatic" set in a rainy

doorway on Christopher Street, appeared at the New Playwrights theater on West Third Street. The mainstream critics were appalled by its frank homosexuality—one suggested that Heide "break his typewriter over his hands." Joe Cino liked it and asked him to write something for the Caffe. So *The Bed* premiered at the Cino in 1965. It presented the foundering of a young gay couple's relationship, sinking into existential boredom and ennui. (Heide, like so many Villagers' at the time, read a lot of Sartre and Heidegger.) Because of the rep Heide had after *West of the Moon* as a writer of troubling homosexual content, a pair of FBI agents took in one performance. Cino stuffed them full of pastries and cappuccino and they left peacefully. Andy Warhol also came and later filmed a version of the play in a loft on the Bowery.

In 1965 the first one-act play by Jean-Claude van Itallie, the surrealist *War*, was produced at the Cino, with Gerome Ragni in the cast. There was only one performance: the next morning the Cino was a charred husk. It was March 3, 1965, Ash Wednesday. In the *Voice* Michael Smith wrote that it was an accidental gas fire but among themselves the Cino crowd said that Cino's lover Torre had torched the place in a jealous rage.

The scene was unraveling. "It wasn't Wonderland," Robert Patrick says wryly. "It was a gay, drugged theater in Greenwich Village in the sixties." Freddie Herko had taken his swan dive the previous autumn. He was strung out on speed, his longtime lover had left him to marry his close friend the writer Diane di Prima, and at twenty-eight he felt the end of his dance career looming. Broke and effectively homeless, he'd come to Dodd and Smith's fifth-floor apartment to use the shower. He came out of the bathroom nude and started dancing around the room. The impromptu performance climaxed with a beautiful leap out the open window. "Maybe thought he could fly," his friend van Itallie says. "Maybe was afraid he couldn't fly."

After the fire in March, the downtown theater crowd instantly organized benefits, for instance, a performance of Maria Irene Fornés's one-person *Dr. Kheal* at the Village Gate, and Ellen Stewart gave Cino use of La MaMa. The Cino reopened in May. The *Times* ran its first features on the scene that year, one in April, a long if rather arch and condescending

overview, and a more enthusiastic one at the end of the year. The second featured a photo of Patrick and declared Sam Shepard the "genius" of Off-Off-Broadway. Patrick later recalled that it sparked bruised egos and jealous rage at the Cino. One playwright "almost physically attacked me," another threw the newspaper in his face. "[W]e had all laughed about this sort of thing, but then we had never been in the *Times* before."

In 1966 the director Robert Dahdah rummaged through a stack of old scripts Cino had tossed in the trash. Early on Dahdah had brought his repertory company to the Cino for an extended stay; it was his production of *No Exit* that Krim reviewed. The play he found was a few years old, a campy homage to Busby Berkeley movies called *Dames at Sea*. It was a light, frothy musical revue with some winking gay-sailor innuendo, like a pre-echo of Village People schtick—not really the sort of thing that happened at the Cino but Dahdah convinced Joe to let him stage it. He designed a production that was all in black, white, and silver, like an old movie, and reworked the script so a cast of six could play it on the tiny stage. He cast a sixteen-year-old singer-dancer, Bernadette Peters, in her first leading role. It opened in May and was a smash hit, bringing in the Cino's first uptown, mainstream audiences. It moved later to the Theatre de Lys. There would be a London production and a small-screen adaptation starring Ann-Margret as well.

Among the new audiences the *Times* and *Dames* drew were people from Warhol's crowd. Cino regulars, maybe a bit disingenuously, say it was the Warhol crowd, especially Ondine, who introduced the hard drugs that were the Cino's undoing. "We all took drugs," Patrick says. "It was the sixties. We all took acid and pot, and played a little bit with speed. But when the Warhol people came down they brought drugs like you never saw in your life. I'm lucky I didn't wind up hooked on something." It wasn't just the Cino or the Warhol crowd, Paul Foster cautions. "Drugs and alcohol ruined a generation. The box office staff at La MaMa? *Gone*. Some of them died with the needles still in their arms. Drugs and booze, that was the dark underbelly of Off-Off-Broadway theater. But that's a dog with a very long tail," he adds, citing all the drinking that had marked Village life since the 1910s.

The Cino took on a crazy speed-freak intensity. Joe, who'd been work-
ing seven days and nights a week since opening the place in 1958, got
hooked on meth. "That was when I think Joe started his decline," Pat-
rick says. Old hands like Foster and Dahdah dropped away. In January
1967 word came that Jon Torre, who had left New York, had electrocuted
himself. Some suspected suicide but the official verdict was that it was
accidental. Cino, by then mixing acid and meth, fell apart. At dawn one
morning he phoned Dodd and Smith from the café to say good-bye.
Smith ran in to find Cino covered in blood on the floor. He'd mutilated
himself with a knife. He died at St. Vincent's on April 2.

"There was a great deal of that, of tragedy," van Itallie recalls. "And this
was pre-AIDS. I have no scientific analysis for it, for why particularly sen-
sitive, gifted gay men ended up tragically. It's a question. Sometimes I feel
that we made a pact with our mothers, if ever we emotionally grew out
of the nest, either the mother or the son had to die. Literally. I have no
scientific basis for telling you that, but there are many friends with whom
I feel that's the case."

Smith and others kept the Cino open for another year before it closed
for good in March 1968.

ALONG WITH THE CINO AND LA MAMA, JUDSON MEMORIAL
Church, on the south side of Washington Square Park, was a major center
of Off-Off-Broadway theater in its early years, as well as an important pre-
senter of avant-garde art, music, and dance. Howard Moody, the marine
vet, had come on as pastor in 1956 with the intention of continuing and
extending the church's missionary work in the neighborhood by getting
the church involved in Village politics and culture. He put the Judson
on the forefront of the liberation theology movement, which would push
the Roman Catholic Church toward the liberalizing reforms of Vatican
Council II in the early 1960s. The Judson being a Village church, the
reforms Moody oversaw there, with the backing of the church board,
were sweeping and radical. As symbols of those populist and seculariz-
ing changes, Moody and his assistants stopped wearing clerical outfits,
the cross and pews were removed from the church, and the altar became

a stage. Moody recruited the Village arts community to help develop services that grew less like liturgy and more like Happenings or hippie pagan celebrations. Writing for Esquire, Murray Kempton witnessed one service where a man, naked to the waist, stood on the altar and poured blue paint on himself while others sang a Bessie Smith song. Agosto remembers one where the muscular actor-dancer Eddie Barton, a Cino favorite, twirled down the center of the nave wearing only glitter, "then up on the stage as a glorification of God created man and Mother Nature and all this thing. And I thought, 'Golly, where in the world? Aren't we the blessed people? Nowhere is this freedom. Only New York City.' Because I had traveled a little in the other parts, so-called liberal San Francisco or what have you, you still had to mind your Ps and Qs."

The Judson Gallery, organized by an assistant minister and a few students and artists, including Jim Dine, started in 1959. It was in the basement of Student House, aka Judson House, the church's residential building on the corner of Thompson and West Third Streets, later demolished by NYU. Ray Gun Specs, an early Happening, took place in the gallery in 1960, created and performed collaboratively by Claes Oldenburg, Allan Kaprow, Jim Dine, Red Grooms, Dick Higgins, and others.

Judson Poets Theater and Judson Dance Theater followed in the early 1960s. The director Lawrence Kornfeld and Moody's assistant the Reverend Alvin Carmines oversaw the theater program and collaborated on many of the performances. Carmines, who grew up in Virginia, was from a musical as well as a religious background. He'd come to New York to attend the Union Theological Seminary and seen both Living Theatre productions and the Judson House Happenings. In all probability he was the only openly bisexual minister serving at a Baptist church in the country at the time. Over the years he would write thousands of songs for both performances (comprising, by his own count, scores for eighty musicals) and services at the Judson. Kornfeld came to the Judson from several years with the Living Theatre; he told Bottoms that producing The Connection was initially his idea. Although it was home to a variety of plays in a range of styles, the Judson became best known for a species of joyfully experimental musical theater. The congregation, being a

Greenwich Village congregation, backed them, including voting never to censor any performance in the church for its language or ideas. Performances were in the church itself, either up in the choir loft, which could fit an audience of about a hundred, or down in the sanctuary for larger productions. Budgets were minuscule: the church put up two hundred dollars a year, which was supplemented by small donations from the congregation and often the performers as well. The first production, a double bill of the Village poet Joel Oppenheimer's *The Great American Desert*, a send-up of cowboy lore, with Apollinaire's surrealist *The Breasts of Tiresias*, cost all of $37.50 to put on. Production budgets rarely topped a hundred dollars. The spirit was as communal and everybody-pitch-in as at the Cino. Casts included Village poets, painters, and bartenders as well as actors, and everyone was welcome to bring bits of costumes and sets in from off the streets.

Playwright, novelist, and artist Rosalyn Drexler fell right in with the Judson's everything-goes spirit. She'd grown up in the Bronx, married the painter Sherman Drexler, and for a few months in 1951 had performed on the professional women's wrestling circuit as Rosa Carlo, the Mexican Spitfire. She later explained she did it on impulse. She heard about a promoter while working out at a gym on Forty-second Street used by pro wrestlers, tumbling midgets, other carny and circus acts. She met the promoter around the corner at the notorious fleabag Hotel Dixie (later the Hotel Carter and still a fleabag), and "the interview with me consisted of me trying on a bathing suit." She performed in a wig and heavy makeup, with audiences "yelling things at me in Spanish, which I didn't understand." Lady wrestling was "poor people entertainment," presented in airplane hangars, and once, she recalled, in a graveyard. She left when the tour hit the South, where the segregated facilities upset her.

In the early 1950s, when Norman Mailer and Vance Bourjaily organized Sunday-afternoon writers' get-togethers at the White Horse, Drexler was the only woman they invited. "I went there really happy, and looking forward to a literary salon with beer," Drexler recalled. "Norman as usual challenged people to arm wrestle, or was it thumb wrestling? I placed my crumpled handwritten stories on the table, ready to read

and hoping to receive the benefit of what these brilliant men would say. Turned out I was disappointed. All they wanted to hear was what my experiences had been like as a professional wrestler." Warhol would do a series of Rosa silkscreens, and Drexler later wrote a novel about her, To Smithereens.

Drexler wrote Home Movies to amuse herself when she was home with her children. "I didn't even know it was a play!" she told Bottoms. "Like an amusement." Her friend Richard Gilman, a Newsweek theater critic, took it to the Judson, where Kornfeld and Carmines reworked it into a hilariously bizarre musical. In this and her subsequent early plays Drexler created an alternate, purely invented lampoon universe somewhere east of Alfred Jarry, south of Koutoukas, north of Krazy Kat, and west of the Marx Brothers. (As it happens, she was related to Chico.) In Movies, characters like the homosexual Peter Peterouter (played by Freddie Herko), the lascivious priest Father Shenanigan (played by Carmines), and "the colored maid" Violet speak and sing total nonsense to one another while working themselves up into high dudgeons of lust, outrage, and other cartoonish emotions. It was hard to say exactly what Drexler's preposterous characters were getting so worked up about. Nothing they said or did made much conventional sense. Yet on some intuitive level audiences and critics got it. Gilman called Movies "the first musical of the absurd." Writing in the Times, Christopher Lehmann-Haupt later dubbed Drexler "the first Marx sister." Movies won an Obie and went on from the Judson to seventy-two performances at the Provincetown Playhouse. Drexler wrote more plays, including the also magnificently wacky The Line of Least Existence; earned more Obies; and wrote novels (including a novelization of Rocky) and material for an Emmy-winning Lily Tomlin special. At the same time, her paintings and collages, appropriating pop culture and commercial imagery, made her one of the very few females in the first generation of Pop artists.

Sam Shepard's Red Cross was produced at the Judson, as was Koutoukas's Pomegranada, Maria Irene Fornés's Promenade, Rochelle Owens's Instanboul, and some of Carmines's own works, such as The Sayings of Mao Tse-tung, a cantata that put Mao to music a couple decades before Nixon in

*China.* In what surely rates as an only-in-Greenwich-Village event, Reverend Carmines's gay musical revue *The Faggot* opened at the Judson in 1973, got rave reviews even in the mainstream press, and continued Off-Broadway. Matching *The Faggot* for provocative bravado, Carmines and Kornfeld staged *Dracula: Sabbat,* in effect a satanic Black Mass, on the altar. Carmines suffered an aneurysm in 1977 and had to quit his post in 1981, ending the era of the Poets Theater, though the church continues to host performances to this day, well after his death in 2005.

Judson Dance Theater, which operated from 1962 to 1964, has been cited as the birthplace of postmodern dance. The work tended to be highly experimental and Cage-inspired, redefining dance, movement, gesture, and ritual. Freddie Herko, Meredith Monk, Yvonne Rainer, Lucinda Childs, and Carolee Schneemann were among the performers and choreographers. Drexler told Bottoms about one performance where dancers threw sticks at the audience from the balcony, "and somebody in the audience took one of the sticks and tied a handkerchief on and said I surrender because it was so awful, but it was like, avant-garde dance!"

# The Folk Music Scene

3000 BEATNIKS RIOT IN VILLAGE

—New York Daily Mirror

IT'S KIND OF AMUSING TO REALIZE IT WAS HISTORY. I
WAS JUST LIVING MY LIFE.

—Suze Rotolo

IN 1950 IT SEEMED FOR A MOMENT THAT FOLK MUSIC WAS ACHIEV-
ing the mass appeal of pop music. The group that made that hap-
pen was from Greenwich Village: a folk act called the Weavers, which
Pete Seeger and others had spun out of the Almanac House. They
made a number one hit record out of "Goodnight, Irene," a waltz that
the Lomaxes had first heard Huddie Ledbetter sing in prison. The
moment was brief. *Red Channels,* a pamphlet listing a hundred and

fifty-one writers, directors, and actors who had been CPUSA members or fellow travelers back in the 1930s, came out that summer with Seeger and other folksingers on its list of reds, and the Weavers were blackballed from radio and the big concert halls. Folk music all but vanished from mainstream entertainment for most of the 1950s, unless you count folkish pop like Patti Page's "Tennessee Waltz" (which she followed up with "(How Much Is) That Doggie in the Window") or Tennessee Ernie Ford's "Sixteen Tons." But it didn't go away. It spread through a growing national network of coffeehouses, college campuses, and church halls. In 1954, when a thirteen-year-old Joan Baez first heard Seeger, it was in a California high school auditorium. An older kid named Dave Guard who was also in the auditorium that night would later be a founding member of the Kingston Trio, who brought folk back to the top of the charts in 1958. By 1959 folk was once again the next big thing in popular music. When the Newport Jazz Festival spun off the Newport Folk Festival that summer, it was a big enough deal to make a star of Baez, an unscheduled performer who mooched her way onto the stage. Her debut album, released just one year later, would go gold.

In Greenwich Village, folk music had continued to thrive, if not prosper, through the Eisenhower years. Earnest, well-scrubbed college kids with guitars singing plaintive English ballads and old Wobbly songs could be found in Washington Square Park any weekend, weather permitting. In the mid-1950s, when coffeehouses began to spread around the Bleecker-MacDougal axis, folk music spread with them. One of the first coffeehouses to host folk music was the Caricature, a tiny place on MacDougal Street where folkies were allowed to play quietly in a back room as long as they didn't disturb the bridge players in the front. That's where Dave Van Ronk, later dubbed "the mayor of MacDougal Street," got his start. Van Ronk was a big, bearded bear whose voice was gruff, his delivery full of heart. He was a soulful singer of sea shanties and old English ballads who could also rock and swing and sing credible blues and pluck a ukulele Arthur Godfrey–style. He was born in Brooklyn and

grew up in the "paralyzing boredom" of Queens. He got his first guitar in a school yard swap for a stack of Captain Marvel comics. His Irish grandmother belted out old tunes like "The Chimes of Trinity," which he later played for Bob Dylan. Dylan adapted it into "Chimes of Freedom." "Her version was better," Van Ronk observes wryly in his posthumously published memoir *The Mayor of MacDougal Street*.

He took his first subway ride to the Village as a teen. He expected to see an old-fashioned village "inhabited by bearded, bomb-throwing anarchists, poets, painters, and nymphomaniacs whose ideology was slightly to the left of 'whoopee!' " He was disappointed to find it looked "just like fucking Brooklyn." By the mid-1950s he'd learned fingerpicking from a guy in Washington Square and was playing folk music in venues including the Caricature. He was among the artists who played the opening night at the Cafe Bizarre in 1957, with Odetta headlining.

As folk spread to more coffeehouses, clubs, bars, and restaurants in the second half of the 1950s, they arranged themselves in a food chain from the less prestigious venues to the most. Manny Roth's Cafe Wha?, the liquorless club in the basement at the corner of MacDougal Street and Minetta Lane, was an entry-level spot. In the afternoons a parade of wannabe folksingers, amateur comics, weekend poets, drag queens, magicians, show-tune belters, and sadsack troupers of all sorts performed short sets there. Like many places in the Village it was a "basket house": there was no cover charge to get in but on your way out someone at the door, often a pretty and persuasive young woman, shoved a basket at you and asked for a buck or two donation for the performers. On a Saturday night in one of the more popular basket houses a performer could actually make decent money, but not on weekday afternoons. In the evenings more polished acts took over at the Wha?—Richard Pryor, Lenny Bruce, Woody Allen, and folksingers such as the deep-voiced Fred Neil, who also served as the emcee. Neil was a MacDougal Street legend, a musician's musician who never chased a larger spotlight but influenced a lot of sixties folk rockers and wrote songs for Roy Orbison ("Candy Man"), Jefferson Airplane ("Other Side of This Life"), and Harry Nilsson ("Every-

body's Talkin'," a Top 10 hit). Shackled with a heroin addiction, he would leave the Village for Woodstock and then Coconut Grove, Florida, spend decades in semiretirement, and die quietly in 2001 at the age of sixty-five.

Across the street and down a few doors from Cafe Wha?, the Gaslight Cafe was in the basement of the Italian tenement at 116 MacDougal Street. John Mitchell had already opened and lost Le Figaro Cafe when he started the Gaslight in 1958 as a basket house where Beat poets, including Ginsberg and Corso, read. It had once been a speakeasy and, after that, the tenement's coal cellar, leaving it with a sooty patina that couldn't be scrubbed out. Small, dark, and funky it was also afflicted with cockroaches and the occasional rat. The ceiling pipes leaked. On crowded summer nights it could get so hot that the fire sprinklers went off, drenching the audience and performers. The upstairs neighbors didn't much care for the beatniks, folksingers, and blacks the Gaslight attracted. When they complained about the noise coming up the airshaft, Mitchell asked audiences not to applaud the acts but to snap their fingers instead, helping to promote the enduring cliché of the finger-popping beatnik.

Mitchell warred with the fire department over what he felt were nuisance code citations and balked at paying off the cops and local mobsters. With no liquor license, he overcharged for bad coffee and food few dared to eat in the grungy space. But despite all that the Gaslight became one of the premiere folk venues in the Village. It featured up-and-coming and established professionals who made sixty dollars a week there, a decent wage when even in the pricey Village your rent was likely a hundred dollars or less a month, and a couple of bucks bought you a mediocre but filling meal in one of the diners or spaghetti houses. Among the folk, blues, and comedy acts who crossed its stage were Richie Havens, Phil Ochs, Buffy Sainte-Marie, John Lee Hooker, Mississippi John Hurt, Tom Paxton, Carolyn Hester, Bill Cosby, Lord Buckley, Artie and Happy Traum, Hugh Romney (later known as Wavy Gravy), John Sebastian, Flip Wilson, and Fred Willard. Van Ronk emceed Tuesday-night hootenannies. Between sets they all went upstairs for drinks at the Kettle of Fish, another tough Village bar the poets and folkies colonized at some peril. Mitchell would sell out in the early 1960s and leave town—according

to rumor, one step ahead of unhappy creditors and wiseguys. The Gaslight fell into the hands of Clarence "Papa" Hood, an irascible, bourbon-drinking southerner who dropped his whole family into a Village they knew nothing about. His son Sam managed the day-by-day chores, while Papa, unlike his predecessor, wisely paid off the protection rackets and city inspectors.

Art D'Lugoff, who'd been producing concerts around the Village for a few years by then, opened his club, the Village Gate, in 1958. It went on to be a Village flagship, home to folk, blues, jazz, rock, experimental music, cabaret, musicals, poetry readings, and anything else D'Lugoff felt like booking. National Lampoon Lemmings ran there for two years and graduated its star performers John Belushi and Chevy Chase to Saturday Night Live. Jacques Brel Is Alive and Well and Living in Paris debuted there, as did the political satire MacBird, the jazz revue One Mo' Time, and the sex musical Let My People Come. (The SLA revoked his liquor license for that; he took the agency to court and won it back.) The Gate was in the former Mills House No. 1, the big workingmen's residence on the south side of Bleecker Street between Thompson and Sullivan. By the time D'Lugoff looked at the building it had deteriorated into the Greenwich Hotel, a flophouse. D'Lugoff's daughter Sharon Blythe remembers him telling her of residents peeing out the windows and throwing bottles at the street. In her own memories, "There were still a lot of bums. It was scary. Bleecker Street wasn't as gentrified then. There'd be people passed out with their heads in the gutter, smelly bums, and then the Gate right there." Before D'Lugoff created the Gate, the building briefly housed a coffeehouse, Jazz on the Wagon. The Beats took it over as a place for readings. The hotel's echoing, paint-shagging atrium was sometimes used for larger events, such as a 1962 symposium on sex.

The Allan Block Sandal Shop at West Fourth and Jones Streets was an early magnet for folkies. Block's sandals, handmade right there in his small shop, were de rigueur Village footwear from the 1950s into the '60s. But he was just as well known as a folk music fanatic—his daughter Rory became a well-respected folk blues performer—and his shop was often so crowded with people jamming and gabbing that no sandals got made that

day. Then twenty-nine-year-old Izzy Young started his Folklore Center in 1957, and in no time it was a mecca for folkies from around the country. The Folklore Center was up a flight of stairs in the tenement at 110 MacDougal Street, a few doors down from the Gaslight. For folkies it was "like an ancient chapel, like a shoebox sized institute," Dylan writes in his memoir. It was packed with musical instruments, antique sheet music, hard-to-find 78s, old Wobbly song pamphlets, and out-of-print music books. Fans and musicians went there to meet, gab, thumb the books, even pick up their mail.

More than a shopkeeper, Young was a godfather to the scene. It was Young who in 1960 brought folk music to Gerde's, an Italian restaurant on the northeast corner of West Fourth and Mercer Streets, in a building later torn down and replaced by the Hebrew Union College. It was just another red-sauce spaghetti house that catered to a lunch crowd of workers from the nearby Broadway loft factories. With those businesses dwindling, it was easy enough for Young to talk owner Mike Porco into trying folk music at night to draw a new crowd. Young called it the Fifth Peg (standard banjos have five tuning pegs). It was the first regular, non-coffeehouse folk club in the Village. After a few months of good business Porco cut out Young and renamed it Gerde's Folk City. Playing there meant you'd made it.

Half a century before Occupy Wall Street, Young helped gather a few hundred young protesters to occupy the fountain in Washington Square Park. Like OWS they ended up clashing with the police. It started in the spring of 1961, when the Washington Square Association, made up of home owners around the park, appealed to the city's Department of Parks and Recreation to do something about the hundreds of "roving troubadours and their followers" playing music around the park's turned-off fountain on Sunday afternoons. The practice had started in the postwar years and grown through the 1950s until both the police and the neighbors found the "troubadours"—mostly college kids—a nuisance. Van Ronk recalled that there were various cliques in the park: a Zionist group singing and dancing "Hava Nagila," the Stalinists, the bluegrass fans, the folk traditionalists. The journalist John A. Williams reported that the lo-

cals' complaints were not really musical but social: "In the ensuing meetings with city officials, it became apparent that what was opposed was not so much folk singing as the increasing presence of mixed couples in the area, mostly Negro men and white women." The parks commission began issuing permits to limit the number of musicians, allowing them to "sing and play from two until five as long as they had no drums," Van Ronk writes. This "kept out the bongo players. The Village had bongo players up the wazoo . . . and we hated them. So that was some consolation." According to Hettie Jones, those bongo players were often black; in Stewart Wilensky's *Village Sunday* short, the bongo players in the park are indeed all young black men. (This racial aspect actually had an old historical precedent in the Village. In 1819, white residents of the area complained "of being much annoyed by certain persons of color practising as Musician with Drums and other instruments through the Village.")

In 1961 the parks commissioner responded to the complaints by refusing to issue any permits at all. Young and others organized a peaceful protest demonstration. On Sunday, April 9, 1961, a few hundred young people, few of them actual Village residents, gathered, attracting a few hundred more spectators. Among them was eighteen-year-old Dan Drasin, a mild-mannered kid who liked to hang out in the park. He brought one of the big, boxy film cameras of the era and documented the afternoon in a short black-and-white film, *Sunday*. The film shows clean-cut college and high school kids, many of the girls in Jackie O hairdos and heels, many of the boys looking like young Allen Ginsbergs with serious, sensitive, owlish faces behind heavy black-framed glasses. They carry handwritten placards and cardboard guitars and argue with the dozens of beefy, florid-faced cops who've shown up. Izzy Young, also bespectacled and in jacket and tie, lectures the cops about the constitutional right to make music as the kids sit in a circle in the dry fountain and sing "This Land Is Your Land" and "The Star-Spangled Banner." So does Art D'Lugoff, telling them they ought to be out "chasing criminals" instead of "stopping free speech." As protests go it all looks low-key and polite. Then paddy wagons arrive and the cops haul off one nebbishy young man cradling an autoharp, pushing him into a prowl car. According to Drasin,

most of the singers and musicians had left the park, leaving the few hundred spectators loitering around the fountain, when the cops' tempers finally boiled over. They waded into the crowd, shoving boys and girls to the ground, mauling them, dragging a handful into the paddy wagons. Reportedly they knocked some heads with their clubs, although it's not shown in the film. The whole event, Drasin says, lasted maybe two hours. (Jonas Mekas was also there that day, filming from up in a tree until cops pulled him down out of it.)

The next day, the *New York Daily Mirror*, the conservative Hearst tabloid, ran a giant war-is-over front-page headline, "3000 BEATNIKS RIOT IN VILLAGE." That week's *Voice* scoffed at the *Mirror*'s "hysterical" coverage, wondering if there were three thousand beatniks in the entire country that Sunday, let alone in Washington Square Park. By May the outrage caused by the cops' overreaction forced the city to back down and issue permits, a practice that continues to this day.

Among the protesters hauled off that afternoon was the Village character H. L. "Doc" Humes, identified in the *Mirror* as a "scofflaw" and the "mob leader." Humes was a gregarious polymath, a novelist and raconteur, cofounder of the *Paris Review*, designer of cheap housing made from old newspapers, director of a lost film updating the Don Quixote story as *Don Peyote*, LSD pioneer with Timothy Leary, later helper to Norman Mailer when he ran for mayor in 1969, and later still a paranoid drug casualty who believed UFOs, the CIA, and the pope in Rome were out to get him. He would not have been a stranger to the cops in the park that day. Just a few months earlier he'd had a very public spat with the police commissioner Stephen Kennedy. In October 1960 cops had shut down a performance by Lord Buckley at the Jazz Gallery in the East Village. Lord Buckley was a stately man with sleek gray hair and a pointy Dalí-esque mustache, who often performed in a tux and orated in a plummy, faux-British voice, seeming every bit the vaudeville and burlesque master of ceremonies he once was. But what came out of his mouth was pure hepcat jive he'd learned from the jazz musicians and pot smokers with whom he'd associated since the 1930s. In the 1950s he started to recast biblical stories, historical texts like the Gettysburg Address, and Shakespeare in

White Negro proto-rap: "Hipsters, flipsters, and finger-poppin' daddies, knock me your lobes. I came here to lay Caesar out, not to hip you to him." It sounds like novelty schtick today but in Eisenhower's America there was something inherently subversive about a man who looked like the maître d' at a fancy restaurant jiving like a viper. "His Royal Hipness" had a lot of fans and friends downtown, where he performed and hung out whenever he was in New York. David Amram remembers jamming with him many times at Village parties or after-hours in some club.

The cops halted Buckley's gig because of a problem with his cabaret card. He'd failed to report a pot bust that went back to the 1940s. Without the card he couldn't perform in New York City, including a scheduled appearance on his old friend Ed Sullivan's show (they'd toured together with the USO during the war). Despondent, Buckley called his friend Humes. In news reports about the Buckley affair Humes was often referred to as Buckley's manager, but Amram says, "To the best of my knowledge, Doc was not ever Lord Buckley's manager per se. Doc was one of Buckley's admirers and always a supporter of free speech. And Doc was openhearted and exceedingly generous. But Doc was not noted for his business acumen, and most of us who were Village denizens weren't either. We were barely able to manage our own daily lives. Like myself and so many others, Doc needed a manager himself."

Humes talked his *Paris Review* friend George Plimpton into letting Buckley give a little performance at a party in his Upper East Side apartment, with the idea that Plimpton's influential crowd might help get Buckley's card reinstated. With Amram at the piano, Buckley went into his schtick. The response was cool. Plimpton's literary swells had come to sip cocktails and talk about themselves, not listen to Village-y jazzbo jive. Buckley the old vaudevillian worked hard to win them over, pulling out bit after bit, overstaying his unwelcome. As the crowd grew increasingly bored and angry, Norman Mailer started heckling. Amram remembers that Buckley finally gave up, then "came over to the piano and whispered in my ear, 'Let's split and get out of here, man.' "

It turned out to be Lord Buckley's farewell performance. He died of a stroke shortly afterward, age fifty-four. Art D'Lugoff offered the use

of the Village Gate for a memorial service, at which Ornette Coleman and Dizzy Gillespie played for a large crowd of Buckley's friends and admirers. He was laid out at the Frank E. Campbell Funeral Chapel on the Upper East Side, New York's funeral home to the stars. Humes, Mailer, Amram, and others then started a public campaign to end the cabaret card system. Humes charged that police harassment had killed Buckley and claimed that if Buckley had only slipped the right cop a hundred bucks the whole thing would have been settled under the table. That enraged Commissioner Kennedy, who retaliated by tossing Humes in jail for unpaid parking tickets and ordering up the biggest crackdown on cabarets and nightclubs in years, sending cops to more than twelve hundred venues looking for non–card carrying workers. But this protest worked as well. Kennedy was sacked for his overreaction, and though it took another seven years the cabaret card system was eventually abolished.

TWO RECORD LABELS WITH VILLAGE CONNECTIONS WERE IMmensely influential to the folk music revival. Vanguard Records was an independent label with tiny, cluttered offices at Fourteenth Street near Eighth Avenue. The brothers Seymour and Maynard Solomon started it in 1950 with ten thousand dollars borrowed from their father. They put out classical recordings at first, then John Hammond brought them jazz, including recordings of his historic "Spirituals to Swing" concerts. Next they branched out to albums by the blacklisted Weavers and Paul Robeson. In 1960 they hit pay dirt with Joan Baez's first LP. She'd record with them into the 1970s.

The other was Moses "Moe" Asch's Folkways Records. Folkways' extraordinarily broad catalogue reflected Asch's international upbringing. He was born in Poland in 1905, eldest son of the Yiddish writer Sholem Asch. From there the family moved to Berlin, France, and New York, where they bounced around from Greenwich Village to the Bronx, Brooklyn, and Staten Island. Then he spent a couple of years in Weimar, Germany, studying radio electronics, returning to Brooklyn in the mid-1920s to begin a career in radio and sound engineering. Along the way

he pieced together an idiosyncratic self-education in a variety of international folk music. He first saw John Lomax's landmark anthology *Cowboy Songs and Other Frontier Ballads*, for example, in a book stall on a street in Paris.

During the Depression his company Radio Laboratories installed speaker systems for ILGWU rallies and for Yiddish theaters on the Lower East Side, equipped sound trucks for Franklin Roosevelt's electioneering in New York, and built a transmitter for the *Forward*'s Yiddish radio station ẆEVD. The call letters of the unabashedly Socialist station stood for Eugene V. Debs. In the mid-1930s he worked with a guitarist on developing electric guitars and amplifiers; that guitarist, who originally performed "hillbilly" music as Rhubarb Red, later became famous as Les Paul. Asch helped the ILGWU produce *Pins and Needles*. One member of the cast had recently arrived from Louisiana: Huddie Ledbetter.

Asch began making records as the Asch Recording Studios in 1939; he followed that with Disc Records and, in 1948, with his famous Folkways label. His first recording was of Yiddish singers too aptly named the Bagelman Sisters. He also trucked a mountain of field equipment out to Princeton to record his father interviewing Albert Einstein. His biggest early success was an album of children's songs performed by Leadbelly. Woody Guthrie first recorded with him in 1944; it's said that 80 percent of Guthrie's recordings were with Asch. In 1952 Folkways issued a six-disc collection that changed the course of American popular culture: *The Anthology of American Folk Music*, compiled by a bona fide crazed American genius, Harry Smith. Ethnomusicologist, anthropologist, filmmaker, record producer, alchemist, drunk, mooch, psychedelic adventurer, speed freak, and self-defeating crank, Smith died, poor and obscure, in the Chelsea Hotel in 1991. Since then a boatload of books and conferences have been devoted to analyzing the fractal web of ideas and influences connecting him to the entirety of downtown and underground culture in New York City in the second half of the twentieth century. As a musicologist he made field recordings of everything from Kiowa peyote songs to the street sounds outside Allen Ginsberg's window to his friend Lionel Ziprin's grandfather Rabbi Naftali Zvi Margolies Abulafia lying in his

bed on the Lower East Side singing ancient Hebrew songs he'd learned growing up in Galilee. The melody of one, startlingly, is recognizable, note for note, as Dick Dale's 1962 surf guitar classic "Misirlou." Dale had heard it played on an oud by his Lebanese uncle, who knew it as a popular Greek song about a beautiful Egyptian girl (*misir lou*) from the 1920s.

Those kinds of elaborately, mystically improbable linkages abound in Smith's work. It was only natural that he should meet Moe Asch shortly after moving to New York from San Francisco. Always broke, Smith offered to sell Asch his large collection of old, obscure 78s. Asch had the idea for the *Anthology*, for which Smith selected eighty-four tracks of blues, Cajun, jug band, bluegrass, gospel, and "race" records released in the 1920s and '30s and little heard since. Because these musical styles are so well known now it's almost impossible to imagine what a treasure trove of shattering revelations the *Anthology* was for the young listeners of Bob Dylan's generation. Dylan memorized every song on the six records and continues to perform them today. Van Ronk and all the other Village folkies were just as steeped in it.

Because of the Guthrie records, the *Anthology*, and other recordings, Folkways had colossal prestige in the Village, and just about every folk performer on the scene wanted to record his or her own record with Asch. Through the '50s and into the '60s Pete Seeger, Ramblin' Jack Elliott, Cisco Houston, Van Ronk, Phil Ochs, Mike Seeger's New Lost City Ramblers, Janis Ian, Richie Havens, and others would do so, some of them many times. But marketing and sales were never Asch's strong suits. Some Folkways albums sold well but most did not, and very many sold fewer than two hundred copies. What little artists got paid for recording with Folkways they had to pry out of the notoriously tightfisted Asch who, to be fair, was perpetually strapped for cash.

In addition to American folk, jazz, and blues Asch released an enormous catalogue of world music brought to him by the ethnomusicologist Harold Courlander; classical and avant-garde music; poetry and other spoken word recordings, from Langston Hughes and Eleanor Roosevelt to Timothy Leary and Ho Chi Minh; plays and musicals, holiday records, humor records, educational and instructional records, natural sound and

sound effects records. When he died in 1986 the Folkways catalogue was up to 2,186 albums. The Smithsonian bought the label and kept every single Folkways album, including the *Anthology*, in print, even *Speech After the Removal of the Larynx*, *Sounds of the Junkyard*, *The International Morse Code: A Teaching Record Using the Audio-Vis-Tac Method*, and *Corliss Lamont Sings for His Family and Friends a Medley of Favorite Hit Songs from American Musicals*. Lamont, a well-known Marxist professor who taught at Harvard, Columbia, and the New School, was seventy-five when he sat down at the piano and belted out an LP of songs including "I'm Forever Blowing Bubbles" and "Drink to Me Only with Thine Eyes."

SUZE ROTOLO (PRONOUNCED SU-ZEE ROE-TOLO) WAS AN INTIMATE of the scene as all this was going on, though she was not a performer and never famous. For decades, outside her circle of friends and some co-gnoscenti, she was the anonymous yet universally recognized "chick on the Dylan cover." Just that pretty girl trudging up a slushy Village street with him on the cover of his landmark second album, *The Freewheelin' Bob Dylan*. For all most people knew, she might have been a model hired for the shoot.

She was in fact Dylan's girlfriend at the time, his first love in New York. It wasn't until the 2000s that her significant role in his life and career was made general knowledge, in his 2004 memoir *Chronicles* and in her own *A Freewheelin' Time*, published in 2008. Her anonymity was largely her own doing. She had never wanted to ride his coattails, neither during nor after their relationship, and rejected on principle the empty fame that accrues to people simply for having known some celebrity back when.

"It's kind of amusing to realize it was history," she said in 2011. "I was just living my life."

Rotolo was a red-diaper baby, born in 1943 into an artistic, progressive, working-class family in Queens. Both her Sicilian immigrant father and her Boston-born mother were members of the Communist Party; he was a union organizer and an artist, she edited and wrote for the Communist newspaper *L'Unità del Popolo*. They named her sister Carla Maria in honor of Karl Marx. They'd lived in the Village before moving out to Sunnyside.

"I was lucky," Rotolo recalled. "Some people have to find their way and rebel and all that. I was brought up with books and music and all sorts of stuff at my fingertips, so it was always a lot easier for me than other kids who had to really fight tooth and nail to get away from their parents' ideology."

Suze and Carla, who would become an assistant to Alan Lomax, naturally gravitated to the Village as teenagers in the late 1950s. "The path that drew me here was my crush on Edna St. Vincent Millay and the earlier things that I read about the salons and all these people who put on plays, all these writers," she said. "That was the old attraction to this place—the Village as a place for artists. There was the folk music in Washington Square Park. The Beats were close. We were reading and discovering their poetry."

After Suze's father died, her mother moved back to the Village, renting the small penthouse at the top of 1 Sheridan Square, the building with the basement space that had been Cafe Society and was now Circle in the Square. The penthouse had a separate bedroom with its own entrance, and Suze, who'd been subletting and staying with friends, moved in. She got a job working the concession stand in the theater and Carla ran the lights.

She first saw Dylan performing in April 1961, though it would be months before they actually met. He had arrived in the Village on January 24 and had instantly begun to burrow his way up the folk scene's food chain. No one becomes a major celebrity by accident. Like Baez, who'd eventually be sharing her spotlight with him, he was a driven, ambitious young comer with his eyes on the prize from the minute he set foot in Greenwich Village. In a BBC Radio interview that aired in 2011, Chip Monck, a lighting designer at the Village Gate in the early 1960s, recalled his impression that Dylan "knew exactly what he was going to do from, obviously, the moment of birth."

Born Robert Allen Zimmerman in 1941, Dylan grew up in the small town of Hibbing, Minnesota. He played rock and roll, like many teenage boys in the 1950s, before discovering Woody Guthrie. He switched to folk music, closely patterning his style on Guthrie's, and chose his stage name

after Dylan Thomas. When he arrived in New York in January 1961, having hitched a ride with another folk hopeful from Madison, Wisconsin, he told fanciful tales about himself to sound more like Guthrie than a nineteen-year-old Jewish kid from the upper Midwest. He told Nat Hentoff in *The New Yorker*, for instance, that he'd run away from home as an adolescent to join a traveling band. Hentoff was not pleased when he later learned it was a lie. He told different stories whenever asked, covering up his past by mythologizing it. Rotolo learned his real name only when his draft card fell out of his wallet after they'd been living together for months.

The day he arrived in the Village he went to the Cafe Wha? and played a little harmonica for Fred Neil at the afternoon session. Neil invited him to play with him that evening. He hadn't been in the Village twenty-four hours before his first gig. The next day he went out to Queens to visit with Woody Guthrie's family. Guthrie himself was in a psychiatric hospital in New Jersey, wasting away from the Huntington's disease that would finally end his life in 1967. But Dylan did meet the thirteen-year-old Arlo, who'd grow up to perform in a style very reminiscent of both his father's and Dylan's. A few days later Dylan went to New Jersey to meet Guthrie himself.

Dylan quickly put himself next to all the most influential figures on the Village folk scene. John Hammond Jr. heard him play and told his father about him. Hammond Jr. had grown up in the Village and was a regular performer there, one of the most credible white bluesmen of the 1960s. Dylan met Hammond Sr. not long after that, at a party on West Tenth Street. He made a point of sitting next to the Columbia Records producer and playing him a few songs. He met Van Ronk at the Folklore Center, and Van Ronk took him under wing, squiring him into the Gaslight, where he was performing within a couple of weeks of arriving. Around the same time he started playing at the Monday-night open-stage hootenannies at Gerde's. He also met Ramblin' Jack Elliott, who had just returned to a hero's welcome in the Village that year after several years of touring Europe and being a huge star on the folk-revival scene in England, where it was called skiffle music. Elliott had been Guthrie's side-

kick and protégé in the early 1950s after meeting him at a house party on University Place, where Guthrie was playing songs for a nickel a pop. He'd lived with him for a year in Coney Island and was considered the world's leading interpreter—some said imitator—of Guthrie's songs. Elliott and Dylan crossed the Hudson to visit Woody. Dylan even took the room next to Elliott's at the Hotel Earle. He added to his instant cachet in the Village by palling around with Elliott and imitating his style. Elliott later said he didn't mind the imitating at the time, but a couple of years later, when Dylan was a huge international star, he would chafe when young people called him a Dylan imitator.

Dylan's Guthrie by way of Ramblin' Jack sound didn't appeal to everyone. Some of the older hands on the scene openly mocked him for it. When he auditioned for Art D'Lugoff at the Village Gate, D'Lugoff turned him down, commenting that if he wanted to hear Woody Guthrie he'd listen to Woody Guthrie. Vanguard producers were making a series of compilation albums of young folksingers they thought had promise but weren't yet ready to record whole solo albums. They declined to record Dylan. So did Jac Holzman's Elektra.

Dylan didn't gravitate to Van Ronk and Elliott purely out of ambition. He was on their side of the great divide in the way folksingers approached and performed the music, separating the ones who prettified and cleaned it up for broad popular appeal from those who tried for an authentically raw and rough sound. The first group could sound studied and clinical—the squeaky-clean Pete Seeger, the operatic Joan Baez—or fluffy and pop like the Kingston Trio and the Village's folk super group Peter, Paul and Mary. They were the ones the college kids preferred and the record labels wanted. The more raw-sounding folkies included Van Ronk, Elliott, and Mike Seeger, Pete's half brother, a supple multi-instrumentalist whose banjo playing and smoky voice sounded convincingly southern and downhome. Ultimately their interpretations were just as much northern, urban re-creations as those of the more pop performers. All three were born in New York City, after all. Ramblin' Jack was in fact Elliot Adnopoz, son of Dr. Abe and Flossie Adnopoz of Brooklyn, who saw his first cowboys at a touring rodeo show in Madison Square Garden. But

they tried to get to the marrow and mystery and strange humor of folk music, instead of just singing the pretty melodies and harmonies, an approach Elliott derided as "sissy." Van Ronk sneered at the Kingston Trio as "Babbitt balladeers" who "threw me into an absolute ecstasy of rage."

With the backing of local legends, married to his own single-minded drive and focus, Dylan conquered the Village scene with startling speed. He'd been there only two months when Porco booked him to play a short set, second on the bill to blues legend John Lee Hooker, a prestigious booking in what turned out to be a very successful extended engagement, April 11 to April 25.

Joan Baez first heard him the night before that gig, April 10. She'd headed to New York to be part of the Sunday-afternoon Washington Square rally but arrived too late. Sticking around the city, she went to Gerde's that Monday night for the hootenanny, where many of the local folk acts, Dylan among them, took turns performing in a post-rally celebration. Dylan made sure he met her. He didn't care for her music but he liked what she could do for his career. Just a few months older than Dylan, she was already folk music's reigning queen. As ambitious and focused as he was, she'd conquered Boston's Harvard Square coffeehouse scene as quickly as he was rising in the Village, wowed the crowd at the first Newport Folk Festival, and put out her first album on Vanguard, the 1960 *Joan Baez*, which went gold. Most everybody on the folk scene wanted some of that gold to rub off on them. Dylan had the chutzpah to make it happen. By summer he was in negotiations with the man who got Baez her record deal, Albert Grossman.

Grossman was the sharpest businessman in a field admittedly not crowded with them. He was one of the founders of the Newport Folk Festival. Originally operating from Chicago, he relocated to New York to get involved in the burgeoning Village scene. It was Grossman who put together three Village folk veterans to create Peter, Paul and Mary. Peter was Peter Yarrow; Mary was Mary Travers, a Village native; and Paul was Noel Stookey, whose name Grossman changed. In *Positively 4th Street*, David Hajdu reports that although Grossman was not yet representing Dylan he greased the wheels of a triumphal, career-making

return to Gerde's that September. He threw some money at Porco and, according to rumors that quickly spread among the other folkies, threw some more at the *New York Times* folk reviewer Robert Shelton. Shelton, whose real name was Shapiro, was a proofreader who got to cover the folk music scene because no one else on staff cared about it. He rarely wrote a negative review and moonlighted writing pseudonymous liner notes for albums. If Grossman did pay him to write something positive about Dylan—it's possible, given that payola in many forms was standard practice in the music business—it was money very well spent. When Dylan returned to Gerde's for a two-week run that September, second on the bill to the Greenbriar Boys this time, Shelton raved about the unknown twenty-year-old, "a bright new face in folk music," "one of the most distinctive stylists to play in a Manhattan cabaret in months." Dylan and Shelton went on to have a long and mutually profitable friendship until the latter's death in 1995.

The day Shelton's article appeared Dylan was playing harmonica at a Columbia recording session behind folksinger Carolyn Hester, produced by John Hammond Sr. At the end of the session, Hammond—who, to his chagrin, had passed on recording Baez—took Dylan into his office and signed him to a five-year contract. Nine months after the whey-faced nineteen-year-old Woody imitator arrived in the Village he was a Columbia Records recording artist. The whole Village scene buzzed with excitement, and also jealousy. Hammond had Dylan in a recording studio by November. That month, responding both to the buzz and to Grossman's behind-the-scenes urging, Izzy Young booked one of Carnegie Hall's small spaces, Chapter Hall, and promoted it as "The Folklore Center Presents Bob Dylan in His First New York Concert." Despite a two-dollar ticket price it was too much too soon. Dylan's Village friends, gnashing their teeth, stayed away. Only fifty-three people showed up. A few nights later, Baez gave her first big New York concert nearby at Town Hall for a sold-out audience of seventeen hundred adoring fans. Shelton raved. Vanguard released *Joan Baez, Volume 2* that month. It went gold, almost cracked the *Billboard* Top 10, and stayed on the charts for two years.

Dylan and Rotolo had met that July, when she attended a hootenanny

at the Riverside Church on the Upper West Side. She was seventeen, he was twenty. "She was the most erotic thing I'd ever seen," he writes in *Chronicles*. "We started talking and my head started to spin . . . I felt like I was in love for the first time in my life." They were soon an item, hanging out together in all the clubs, hiding from Suze's mom in her bedroom with its separate entrance. With some money in his pocket that fall from the Columbia signing, Dylan rented his first New York City apartment, a top-floor walk-up at 161 West Fourth Street, a nondescript brick building around the corner from 1 Sheridan Square. Rotolo waited for her eighteenth birthday before moving in with him. Her mother was not at all pleased and never took to Dylan, whom she called a "scruffy beatnik." Carla didn't approve either, considering him an ambitious schemer who would leave her sister behind as he scrambled up the ladder of success. He didn't much like Carla in return. "For her parasite sister, I had no respect," he snarls in "Ballad in Plain D," in which he recalls "the screaming battleground" of his and Carla's arguments over Suze.

Dylan writes in *Chronicles* that Rotolo was his muse as well as his girlfriend. Her work for CORE and SANE (the National Committee for a Sane Nuclear Policy) educated him about social issues he hadn't been much interested in previously. She took him to see Picasso's *Guernica* for the first time and the work of East Village artists such as Red Grooms. She introduced him to the poetry of Arthur Rimbaud and shared her interest in theater with him, bringing him to the Caffe Cino, the Living Theatre on Fourteenth Street, and to the Theater de Lys. Suze was also working backstage at the Sheridan Square Playhouse, which was producing the musical revue *Brecht on Brecht*. Dylan writes that he was thunderstruck by Brecht and Weill's songs. He got the genius of what they had done, the elemental rattle and bang of Weill's tunes, so simple yet so sophisticated, flawlessly suited to Brecht's characters and their tough views of the world. It wasn't anything like American folk music yet it had a similarly raw and chthonic feel, as if it were coming from the roots of the world. It protested everything but it wasn't protest music.

A young folksinger who came to the Village at this point acted as Dylan's foil, his greatest fan, and his friendly competitor. When Phil Ochs

quit college and came to the Village in 1962 he quickly emerged as one of the most earnest and personally committed of protest singers. He wrote and sang the timeliest and most topical songs of the day—his first Elektra LP was titled *All the News That's Fit to Sing*—a handful of which rank among the best ever recorded, including the anthems "I Ain't Marching Anymore" and "The War Is Over" and the satirical "Outside of a Small Circle of Friends" and "Love Me, I'm a Liberal." Songs like the latter, an attack on limousine liberals, helped to ensure that he never quite won over the Peter, Paul and Mary audience, despite his clean-cut tenor. He would stick with his uncompromising political views well into the 1970s, long after many of the others drifted away. He was associated with the Youth International Party, aka the Yippies, the political pranksters who proposed running a pig for president at the 1968 Democratic Convention and tried to levitate the Pentagon.

Ochs idolized Dylan in 1962, suppressed his own vaulting ego when in Dylan's presence, and called him "the man I most respect in the world." As can happen in that kind of relationship, Dylan was far less respectful of Ochs, treating him like a groupie. They often tried out new songs on each other. When Dylan harshly critiqued Ochs's music, Ochs would go into a period of deep self-examination and self-criticism. The one time Ochs is known to have criticized Dylan, they were together in Dylan's limousine in 1965. Dylan played him a new song, "One of Us Must Know," which would appear on *Blonde on Blonde*. Ochs expressed his regret that Dylan was no longer writing the kind of topical songs he had when they first met. Dylan flew into a defensive rage and threw Ochs out of the limo. "He was such a prick," the late Sam Hood says in the 2010 documentary film *Phil Ochs: There But for Fortune*.

*Bob Dylan* came out in March 1962. It did poorly on the charts—around Columbia it was known as Hammond's Folly—but by the time it was released Dylan had already moved well past the young Woody wannabe it documents to the songwriter of genius who appeared on his next LP.

Rotolo's mother, anxious to break the two of them up, convinced Suze to go along with her on an extended European trip that June. Suze didn't return to the Village until December. Dylan seems to have been

genuinely lovelorn during her absence, writing her many love letters and some songs that would appear on his next album. For her part, she was considering her own art career and having second thoughts about being a celebrity's "old lady." Still, they happily reunited on West Fourth Street, and that winter the two of them strolled arm in arm up nearby Jones Street for the *Freewheelin'* cover photo. Released in May 1963, *Freewheelin'* was Dylan's breakthrough LP, revealing him as an extraordinary writer with the songs "Blowin' in the Wind," "Masters of War," "A Hard Rain's a-Gonna Fall," and "Don't Think Twice, It's All Right." But it didn't catch on right away. The month it was released he performed at the Monterey Folk Festival. The crowd, used to the more prettified type of folk, appeared bored and restless. Then their queen strode onto the stage, gave them a stern talking-to, and Baez and Dylan sang their first public duet. That summer Peter, Paul and Mary's cover of his "Blowin' in the Wind" rose to number two on the charts and Baez brought him out for some more duets at the Newport Folk Festival. He had arrived.

Rotolo was in the Newport audience. "Their convergence was predictable; for folk music, it was a mandate," she writes. She didn't know yet that Dylan and Baez were becoming a romantic duo as well, but not long after Newport she moved out of Dylan's apartment "because I could no longer cope with all the pressure, gossip, truth, and lies that living with Bob Dylan entailed." They continued to see each other, but it was unraveling, and by 1964 his skyrocketing fame, her knowledge of his affair with Baez, and her own determination to craft a life for herself ended it. She moved to Italy to study and make art, and in 1967 she married an Italian film editor. She moved back to the Village with her husband in the 1970s and was still living there when interviewed in January 2011, just short of fifty years after she first saw Dylan perform. She had kept silent about her time with Dylan, pursuing her own artistic and family life, into the 2000s, when she finally assented to some interviews and then wrote her memoir. She said she was suffering "a miserable cold" when the interview took place. A month later she died of lung cancer. She was sixty-seven.

# From Folk to Rock

FOLK MUSIC GOT ITS OWN TV SHOW, ABC's *HOOTENANNY*, IN the spring of 1963, around the time of the release of Dylan's *Free-wheelin'*. Jean Shepherd hosted the pilot but was replaced by the time the show aired. Because ABC continued to blacklist Seeger—who, ironically, had originally popularized the term "hootenanny" with Guthrie and the Almanac crowd in the 1940s—a number of folk music's stars, including Baez and Ramblin' Jack, boycotted the show. Folksingers in the Village held a meeting at the Village Gate and organized a telegram protest campaign. Many of the acts who did appear on the show were of the squeaky-clean pop folk sort: the Chad Mitchell Trio, the Limeliters, the Brothers Four, Judy Collins, and the Smothers Brothers. *Hootenanny* represented folk music's peak as a popular music fad. When the Beatlemania tsunami hit American shores at the end of 1963 *Hootenanny*'s ratings immediately plummeted. It was canceled in the summer of 1964 and replaced with a new rock show, *Shindig!*

In the fall of 1963 Dylan had recorded his last album of protest songs,

presciently titled *The Times They Are a-Changin'*, released early in 1964. By the time the recording was done he was already starting to disavow his role as protest singer, much to the consternation of Baez, Seeger, and the whole folk scene. He later confessed to never being comfortable in the role, and to feeling especially out of place singing with Baez, Seeger, and other earnest white northerners at civil rights rallies in the Deep South. Brilliant as the songs were, it's hard not to see his protest period as another canny career move, one calculated to ingratiate him with the most powerful figures in folk music and their large reservoir of fans. As soon as he felt powerful enough on his own, Dylan moved on to his next phase, the visionary poet-singer.

In December 1963 he met someone in the Village who'd help steer him down that path: Allen Ginsberg. It happened at a party in the apartment of Ted Wilentz, proprietor with his brother Eli of the celebrated Eighth Street Bookshop, in the antique-looking storefront on the corner of Mac-Dougal and West Eighth Streets. A Chinese restaurant called Bamboo Forest had previously occupied the space, then a Womrath's, a store featuring calendars, greeting cards, and a book rental club. The Wilentzes, brothers from the Bronx and World War II vets, bought the Womrath's in 1947, changed the name, and threw out the calendars and frippery. In one of their first canny moves they latched on to the still new format of the paperback, which had been introduced in the United States by Simon and Schuster's Pocket Books in 1939 but was still looked down on by the "finer" bookstores in the city. (When Ferlinghetti's City Lights bookstore, in some ways the Left Coast cousin of the Wilentzes' shop, opened a few years later it also specialized in paperbacks.) Ted, an erudite bibliophile who was dubbed "the bourgeois bohemian," filled the shop with an eclectic, with-it selection of books, so that in the 1950s it became well known as a hip, arty literary mecca—and, as Jean Shepherd sarcastically noted, a sometimes snooty one.

Wilentz also started his own Totem Press/Corinth Books, which published Ginsberg's *Empty Mirror*, Frank O'Hara's *Second Avenue* with cover art by Larry Rivers, Kerouac's *The Scripture of the Golden Eternity*, and books by Michael McClure, LeRoi Jones, Diane Wakowski, Rochelle

Owens, Gary Snyder, and the undersung Gilbert Sorrentino and Paul Blackburn.

Over the years, employees included Peter Orlovsky and the Fugs' Ken Weaver, both as janitors, LeRoi Jones, Andrei Codrescu, and the poet A. B. Spellman. The North Carolina poet Jonathan Williams, founder of the wonderfully iconoclastic small press the Jargon Society, worked there for a while in 1959–60. Alger Hiss sold the store its stationery. Regular customers included a Greenwich Village who's who for the period. In his memoir *Early Plastic*, Bill Reed, who worked there in the 1960s, recalled being awkwardly shy meeting Neal Cassady in the store, and a late night when actress Shelley Winters called from her Upper West Side apartment asking him to ship her some books on "this Emma Goldman dame" she'd been asked to play in a movie.

Another time an old and frail Djuna Barnes stopped in, to everyone's amazement. She'd been living in the Village, not quite a total recluse but certainly an elusive and often hostile figure, since her return to the United States in 1940, when she moved into a tiny one-room apartment at 5 Patchin Place, with E. E. Cummings across the way in number 4. She stayed there for the next forty-two years. For a brief time she read manuscripts for Henry Holt and Company, but her notes were so viciously negative they fired her. By 1950, after a mighty struggle, she had conquered the alcoholism, but she never regained her health and was still so accident prone that Cummings would periodically throw open his window and yell across to her, "Are you still alive, Djuna?" She worked on a biography of the Baroness Elsa that she never finished and a number of poems she endlessly drafted and redrafted. A couple were published in *The New Yorker*, and others became the illustrated bestiary *Creatures in an Alphabet*, published in 1982, the year she died. She did manage to complete one last extremely difficult and obscure work, *The Antiphon*, a verse play that's like the bastard offspring of a Jacobean tragedy ("Would you propose a beggared silk-worm draw / From out her haggard poke so brave a silk / Could card a paragon?") and one of O'Neill's bleak family dramas. Like most of her work, it's a bitter rebuke of her family, thinly disguised.

Ted Wilentz lived with his family in an apartment above the book-

shop, where his parties "were the closest thing to a literary salon in the Greenwich Village of the 1950s," according to the longtime *Voice* photographer Fred McDarrah. In December 1963, when Ginsberg and Orlovsky returned to the Village from extensive world travels, Wilentz put them up. The day after Christmas Al Aronowitz, a journalist who was obsessed first with the Beats and then with Dylan, brought Dylan to a party at Wilentz's to meet Ginsberg. He later recalled that the two giants talked poetry and Ginsberg made an unsuccessful pass. Dylan and Ginsberg went on to have a long and complex friendship with, as the historian and Dylan scholar Sean Wilentz (Eli's son) describes it in *Bob Dylan in America,* "mutually exploitive elements." Just as Dylan was the Village folksinger most driven to fame and success, Ginsberg had always been the most fame-hungry of the Beats. Neither was above using the other to boost his image. Ginsberg was Dylan's conduit to the Beats, a cool association for him to make at a time when he was starting to distance himself from the folk crowd. The Beat poetry influences are evident in the more personal and nonpolitical turn his lyrics took on his next LP, the pointedly titled *Another Side of Bob Dylan.* (The album did contain one leftover protest song, the beautiful, Van Ronk–inspired "Chimes of Freedom.") Like the Beats a decade earlier he now wrote his lyrics as spontaneous riffs, free form, increasingly drug inspired. By *Bringing It All Back Home* and *Highway 61 Revisited,* both released in 1965, there's more than a hint of Ginsberg, Ginsberg's visionary hero poets, and Ginsberg's psychedelic drugs in Dylan's lyrics, along with general observations and evocations of a Beat-ish bohemian life in songs such as "On the Road Again."

In 1965 the Wilentzes moved their bookstore across the street to number 17. It gave them even more space to fill with an estimated sixty thousand titles, though old-timers missed the atmosphere of the original, funkier location. Ted sold out his interest in the store to Eli in 1967 but continued a long career in selling and publishing books almost up to his death in 2001. In the 1970s escalating rents forced out many older establishments on and around Eighth Street, often to be supplanted by chain stores of one sort or another, from Blimpie to B. Dalton Bookseller. Eli Wilentz hung on despite pressures to move and to unionize his staff;

when a fire gutted the store in 1976, rumors of arson circulated. He re-opened it that year, then closed it for good in 1979.

A CENTRAL TENET OF DYLAN LORE FOR YEARS WAS THAT HE SIN-gle-handedly rang the death knell for acoustic folk music with his electri-fied set at the Newport Folk Festival in July 1965. It's true that Newport was the debut of yet another new phase, Dylan the folk rocker (a term he hated but it fits), and that he did shock and dismay the folk purists in the audience, including Pete Seeger. But he'd been upsetting the purists for over a year by then with his turn away from protest songs. And it was 1965. The ascendancy of rock was a given everywhere in the Western world *except*, perhaps, at the Newport Folk Festival. And even there, two of the acts that preceded Dylan's set that summer were the Chambers Brothers and the Paul Butterfield Blues Band, both of whom went over very well with the younger people in the audience. Young listeners had been rocking to the electrified "Subterranean Homesick Blues" and "Mag-gie's Farm" since *Bringing It All Back Home* came out that spring. "Like a Rolling Stone," which had been released as a single a few days before the festival, would soon be a huge hit. Despite its then outrageous six-minute length it would be ubiquitous on pop radio for the rest of the summer and reach number two on the charts (just behind the Beatles' "Help!").

It was another smart career move for Dylan, and again Grossman had a behind-the-scenes hand in it. The Paul Butterfield Blues Band hadn't shown up at the festival uninvited: their manager, like Dylan's, was fes-tival honcho Grossman. Alan Lomax, who was on the festival's organiz-ing committee, had preceded them with an introduction so patronizing and insulting that he and Grossman came to blows backstage. When it was his turn to go on, Dylan appeared with members of Butterfield's band—but not, tellingly, the star Butterfield himself—to play ragged, ef-fectively unrehearsed renditions of some of his new electrified songs, including the interminable-seeming "Rolling Stone." The purists in the audience booed the songs, but it's said that many of the younger people in the crowd were in fact booing the sound system, which wasn't set up to handle rock, and the loosey-goosey performance. Still, Seeger, Lomax,

and the other, older purists had good reason to be upset. Dylan was making it very clear that he was done with the whole folk scene. Their golden
boy was thumbing his nose at them at their most hallowed event.

Dylan was far from the only former Village folksinger who went electric in 1965. At the same time that *Bringing It All Back Home* was released,
the Byrds released an electrified version of his "Mr. Tambourine Man,"
which became a chart-topping hit, as did their debut album that summer.
Members Jim McGuinn and David Crosby had been Village folkies. The
Lovin' Spoonful also emerged from the Village. The quartet was two guys
from Long Island, Steve Boone and Joe Butler, and two Village folkies,
Zal Yanovsky and John Sebastian. Sebastian had grown up in the Village,
with Woody Guthrie and others dropping in on his parents. They honed
their act playing regularly at the Night Owl on Bleecker Street, a narrow
space with a stage so tiny Butler had to set up his drums on the floor. In
August 1965 the Spoonful released its first Top 10 hit, "Do You Believe in
Magic?" Paul Simon and Art Garfunkel, boyhood friends from Queens,
had been on the Village folk scene since 1963. In the fall of 1965 a mildly
rockish rerecording of their Dylanesque folk song "Sounds of Silence"—
which had flopped when released in a straight acoustic version the previous year—became a smash hit. The Mamas and the Papas released their
first records in 1965 as well. Three of the four—John Phillips, Cass Elliot,
and Denny Doherty—originally met while living and making folk music
in the Village.

This helps explain why Dylan exasperatedly threw Ochs out of his
limo that year. By 1965 it was a little late to expect Bob Dylan to go back
to singing one of his Baez-era civil rights songs like "The Death of Emmett Till." Ochs himself would soon change his style anyway, recording
lush folk pop with orchestral arrangements by Van Dyke Parks and others. They were some of his best studio recordings, but the folk purists,
still reeling from Dylan's defection, were disappointed in him. In 1970
Ochs bizarrely appeared to embrace rock and roll, wearing an Elvis-
tribute gold lamé suit onstage before hostile audiences who missed the
irony. By then he was in serious personal crisis, an alcoholic caroming
through the wild mood swings of a manic depression he inherited from

his father. He was disillusioned with the country and disappointed that he never achieved the stardom he felt he deserved. In the end he sank into madness and black depression and hanged himself in 1976 at the age of thirty-five.

The photographer Bob Gruen (no relation to John Gruen) took his first official concert photos at Newport in July 1965. He'd grown up on Long Island and had just made his first move into the Village that June at the age of nineteen. Despite having no professional credentials, he talked the festival into a press pass and had worked his way to the front of the crowd when Dylan came on stage for his electric set. Looking back, Gruen has said that this was one of the days that changed not only his own life but all of pop culture.

Gruen and a friend shared an apartment in the Italian South Village, on Sullivan Street just down the block from the Shrine Church of St. Anthony of Padua. Their first night in the apartment was the start of the annual St. Anthony's festival, then a rollicking ten-day street party and carnival that ended with the procession. "I thought it was a great way to welcome the new neighbors," Gruen recalled. "The next ten days we just ran outside with plates and got clams and sausages and sat on the fire escape and watched the bands playing across the street."

Gruen remembers that there was still a lot of folk music in the Village that summer of 1965. His favorite acoustic group at the time was the Holy Modal Rounders, the duo Peter Stampfel and Steve Weber, who made a raucous brand of folk and jug band music with humorous lyrics. "They played the Gaslight all the time. They were outrageous." Once he was walking down MacDougal Street, having just bought the latest Dylan album on Eighth Street, when he bumped into Dylan himself, who was getting into a waiting limo outside the Kettle of Fish. Gruen was excited; Dylan "looked perturbed."

Robert Heide witnessed a tense scene inside the Kettle of Fish that year, a confrontation between a characteristically grumbly Dylan and a characteristically passive Andy Warhol over the poor little rich girl Edie Sedgwick. She came from New England aristocracy that went back to the Revolution but had grown up on a vast ranch in California where her fa-

ther psychologically brutalized his offspring; she went through a couple of mental institutions, and a brother, also institutionalized, hanged himself. She'd come to New York in '64 with a huge inheritance to burn and an inchoate notion of becoming a fashion model. Pretty in a perfectly sixties pixie way, broken and born to be wild, she captivated Andy at a party. She was soon appearing in Andy's films and on his arm constantly in public, his beard against the homophobia that was still rife in the media. It didn't last long. The more bored and frustrated she got with Andy's filmmaking style and Factory life in general, the more of an irritating and emotionally explosive handful she became.

Then Bobby Neuwirth, Dylan's right-hand man, arranged for him to meet Edie one night at the Kettle of Fish. For a short time they were an item, though evidently more a business union than a romantic one. From "Just Like a Woman," thought to be about her, it's not clear he ever even liked her. Dylan and Warhol used Edie as a fragile bridge between their giant egos, while she had an agenda of her own. Dylan mulled over borrowing some of Andy's art world cachet; Andy thought it would be great for his film business to put Dylan in a movie; and Edie wanted Albert Grossman to manage her. None of them got what they wanted, although Dylan, typically, got more out of it all than the other two.

Heide was at the Factory the day Dylan showed up for a screen test. After three minutes of fidgeting and glaring peevishly into the camera he got up, walked over to one of Warhol's *Double Elvis* silkscreens, and said he'd take it as payment. As the infamously stingy Warhol cringed and blushed, Dylan and Neuwirth hauled the large work into the Factory's elevator and vanished with it. He later traded it to Grossman for a sofa.

Andy had asked Heide to write a screenplay for Edie, *The Death of Lupe Velez*. One night Heide went to meet Andy at the Kettle of Fish to talk about it. Edie was there alone when he arrived. Then Andy showed up, acting shy and nervous as always. It seemed that Andy was hoping for a rapprochement with Edie, using Heide as a buffer. But when Dylan appeared, looking sullen and unhappily surprised to see Warhol in "his" bar, a tense and almost silent contest of wills ensued. Dylan and Warhol were crossing swords over Edie. Dylan as usual played the aggres-

sor; Warhol was his usual public self, passive and wilting. After a short while Dylan stood up and growled to Edie, "Let's split." She left with him. She'd made her choice, though it wouldn't do her much good. Dylan soon dropped her, Grossman never picked her up, and she and Andy drifted apart as well.

Heide walked out with Andy, and at Andy's request they strolled over to Cornelia Street to look up at the window where Freddie Herko, who'd appeared in some of Andy's early films, had done his swan dive. Standing on that corner more than forty-five years later Heide, imitating Warhol's breathy vocal flutter, recalled that Andy said, "Gee, I wonder if Edie will commit suicide. I hope she lets us film it." She didn't. She died of an accidental overdose in 1971, at the age of twenty-eight.

By 1966 Bob Dylan had left Greenwich Village, and left as well a lot of grumbling former friends and colleagues behind. They felt that he'd used them as stepping-stones on his scramble to the top and dropped them as soon as he'd gotten what he needed from them. He retorted with the put-down of "Positively 4th Street." By then he'd been distancing himself, physically and psychologically, for a couple years at least, on the road, out in California with Baez, and up the Hudson in and around Woodstock, a country outpost for Villagers since the golden age. Grossman had introduced him to it, and in 1966 he found a home there for his family. For the next few years he'd hole up in Woodstock with his wife, Sara Lownds, whom he'd met while breaking away from Baez. But he'd be back.

ROCK WAS THE REASON GRUEN'S TIME ON SULLIVAN STREET LASTED only a few months. "We met a couple of guys on the street who started rehearsing with my roommate and formed a band called the Justice League. They used to rehearse in the apartment during the day. The Italian neighbors greatly resented that we weren't working and were making noise day and night. We had a big party on our last night—we were moving out in September because we hadn't paid the rent since moving in. Unfortunately the party was the last straw for the neighbors. They burned down my car. I remember the firemen and the landlord coming up to my door at two in the morning."

As the 1960s progressed, music in the Village was less and less folk, more and more rock. Sometimes it was a unique hybrid. The Village Fugs, soon known simply as the Fugs, were not quite folk, not quite rock, not quite even a band, more an anarchic hippie-Yippie-beatnik-peacenik jug band carnival and Happening. In a sense they were a bridge, albeit a crooked one, linking the folk 1950s to the rock 1960s. The poets Ed Sanders and Tuli Kupferberg began forming the group in the East Village late in 1964. Kupferberg was forty-one and already a Beat hero, publisher of the poetry magazine *Yeah* and a figure in Ginsberg's "Howl"—the one who "jumped off the Brooklyn Bridge this actually happened and walked away unknown and forgotten." In truth it was actually the Manhattan Bridge Tuli jumped off in a failed suicide attempt in 1945, and it left him severely injured and hospitalized. Sanders was twenty-five and publisher of his own magazine, *Fuck You: A Magazine of the Arts*, for which he was unsuccessfully tried on obscenity charges. Kupferberg borrowed the group's name from the euphemism Norman Mailer had been forced to invent in *The Naked and the Dead*, which struck him as funny in a mordant way. A lot of things struck Kupferberg funny that way, as was evident in his songs, his poetry, his cartoons, and his deadpan wisecracks in person. Where the younger Sanders was the quintessential East Village hippie peacenik, Kupferberg was a Greenwich Village bohemian and closer to Brother Theodore in his deeply Jewish, balefully humorous nihilism; two of his best songs were titled "Nothing" and "Defeated."

The two Holy Modal Rounders joined them, along with Ken Weaver, who, according to legend, had been the first bearded, long-haired proto-hippie in the East Village, before the word "hippie" had any currency on the East Coast. Weaver had previously been kicked out of the army for writing a poem about wanting to have sex with Jackie Kennedy.

The Fugs played their first gig at Sanders's Peace Eye Bookstore, a former kosher meat shop on East Tenth Street, in 1965. When they recorded their first album that year it was, fittingly, with Moe Asch and Harry Smith. Asch, by then sixty years old and broke as always, had just signed a licensing agreement with MGM's Verve label to form Verve/Folkways. For MGM it was an entrée to the exploding folk-rock scene and for Asch

a way to release potentially commercial records that might not have fit in the Folkways roster. Smith brought the Fugs to him. They recorded *The Village Fugs Sing Ballads of Contemporary Protest, Point of Views, and General Dissatisfaction* in two long, anarchic sessions, with Smith as producer. Kupferberg would later remember Smith going into drunken rages as the sessions rambled on and smashing liquor bottles against the studio walls. Kupferberg dedicated "Nothing" to him.

As the counterculture and antiwar movements spread through the rest of the decade, the Fugs served, as Kupferberg later put it, as "the USO for the left. We played more benefits than any band I know." When the Yippies tried to levitate the Pentagon in 1967 the Fugs were there to provide the soundtrack. Surprising even them, their records became hits. When they toured Europe, Fleetwood Mac opened for them. Ed Sanders graced the cover of *Life* in 1967 and was invited to be a guest on Johnny Carson's show, but he turned it down when the network wouldn't allow the Fugs to perform "Kill for Peace" on the air. Like so many bohemian heroes before them, the Fugs experienced the downsides of their brief fame and success. Sanders received death threats and was once mailed a fake homemade bomb because he had sold out "The Revolution." The FBI investigated them. Atlantic Records, which had signed them in a heady fit of experimentation that included releasing an LP of Ginsberg reading "Kaddish," abruptly dropped them and shelved an album they'd recorded. Feeling that their cultural moment was passing, Sanders broke up the band at the end of the 1960s.

Through it all the Fugs had remained hometown heroes in the East Village and in Greenwich Village, where they played the short-lived Café Au Go Go on Bleecker Street and the opening of Izzy Young's newly relocated Folklore Center on Sixth Avenue; most notably, the group enjoyed a long and very successful run, more than seven hundred performances, at the Players Theatre on MacDougal Street beginning in the summer of 1966. Jimi Hendrix was playing downstairs at the Cafe Wha?, the Mothers of Invention were up on Bleecker Street, and the Fugs' audiences were peppered with theater and film stars such as Peter O'Toole, Kim Novak, Tennessee Williams, and Richard Burton.

The Fugs periodically regrouped from the mid-1980s on and per-
formed up until Kupferberg suffered two strokes in 2009 that laid him
up in his Sixth Avenue apartment. He died, at age eighty-six, in 2010.

ANOTHER NEW BAND IN 1965 WAS FUSING GENRES, CREATING A
sound like no other band playing in the Village or anywhere else at the
time. The Velvet Underground, named for the 1963 book about wife-
swapping, key clubs, and other underground sex practices in America,
was a jarring mash of screeching rock, highbrow avant-garde drone
music, S&M references, and heroin chic. At the end of 1965 they were
about to add Pop art to the mix. Lead singer and songwriter Lou Reed
was born in Brooklyn in 1942 and grew up on Long Island loving rock
and roll and R&B and hating the suburbs. As a teenager he was such a
malcontent and misfit his parents tried electroconvulsive shock therapy
to straighten him out. He spent his college years at Syracuse University,
where Delmore Schwartz took him under his wing, and then moved to
a tiny apartment on Ludlow Street and got a job writing and recording
novelty songs for the budget record label Pickwick, fronting knockoff
bands with names like the Roughnecks and the Beachnuts.

When Pickwick threw together a band called the Primitives, John
Cale was recruited mainly on the basis of his long hair. He was a Welsh
musician who'd come to New York to study minimalism with downtown
composers John Cage and La Monte Young. Reed's songs were minimal-
ist ditties in their own way, and since he and Cale were both twenty-two,
living on the Lower East Side, and into heroin, they bonded. Inspired by
Bob Dylan's new mix of poetry and rock, Reed started writing dark, seri-
ous songs about street life and junk. With the rhythm guitarist Sterling
Morrison and the resolutely deadpan Maureen "Moe" Tucker on drums
they became the Velvet Underground. In December 1965 they started
what was supposed to be a two-week run at the Cafe Bizarre. The harsh
wall of noise they generated drove most customers out and got them
fired, but not before Andy Warhol's friend Gerard Malanga caught their
act and was moved to jump up and do an impromptu "whip dance" that
became a regular feature of their shows.

Malanga and Andy's filmmaking partner Paul Morrissey brought Andy to the Cafe Bizarre. Having struck out with Dylan, Andy was convinced to invite the Velvets up to the Factory, where he could film them rehearsing. In 1966 he added the statuesque German goddess Nico for visual appeal and a hint of Weimar decadence and installed them at his Exploding Plastic Inevitable on St. Marks Place. They went on to be one of the most influential bands in rock history.

PERHAPS THE GREATEST ROCK GUITARIST OF ALL TIME WAS DISCOVered at Cafe Wha? in 1966. Named Johnny Allen Hendrix by his mother at birth in 1942—his father legally changed it to James Marshall later on— Jimi Hendrix grew up in Seattle, learning to play guitar left-handed, before enlisting in the 101st Airborne. Discharged in 1962, he went straight into music, touring the chitlin' circuit with Little Richard and the Isley Brothers, learning stage gimmicks from other guitarists, playing with his teeth or behind his back. He settled in New York in late 1964, living in fleabag Times Square hotels, working odd jobs, selling drugs, hocking his Stratocaster and amp when he couldn't pay his bills, and haunting clubs from Harlem to midtown to the Village. He was impressed with the way Dylan had risen from the Village folk clubs to international stardom and encouraged by the fact that Dylan was, like he felt himself to be, a "sloppy" singer.

In 1966 Hendrix wandered into a club near his Times Square hotel called the African Room, on West Forty-fourth Street. On stage he saw a tall, muscular black man in a black leotard, boots with eight-inch heels, and a spider monkey on his shoulder, doing a voodoo-inspired dance in front of a rock band. Mike Quashie had come to New York from Trinidad in 1959, earning brief but heady fame as the Limbo King. He performed at parties for Jackie Kennedy and appeared on Ed Sullivan's show. *Life* ran a photo of him limboing under a pole held just seven inches above the floor. But by '66 limbo was long dead and he was now blending exotic dancing, voodoo, and fire eating as the Spider King. He was also a fixture in Greenwich Village, where he would occupy a one-bedroom apartment on Bedford Street from 1966 until 2009, when he moved to an assisted

living facility in the Bronx. As an idol and mentor to young rockers, he's been credited with influencing the stage acts of KISS, Alice Cooper, the New York Dolls, and David Bowie and opened for Led Zeppelin at Madison Square Garden in 1970.

When they met, Jimi was still going as Jimmy James. "I teased him about his vaselined hair," Quashie told the Hendrix biographer Jerry Hopkins in the 1980s. Hendrix was wearing it long, straightened and conked in an old-fashioned Little Richard pompadour. "Sometimes I'd call him J.C., for Jimmy Coon." Under Quashie's tutelage, Hendrix let his hair grow out in an afro, started wearing big jewelry and Gypsy scarves, and incorporated voodoo and fire in his act. Hendrix would often sleep on Quashie's couch, using his apartment as a Village anchor and, later, as a place to hide from groupies and hangers-on.

In the summer of 1966 Jimmy James and the Blue Flames played an afternoon audition at Cafe Wha?, the same basement where Dylan had first played five years earlier. His band wasn't much but Jimmy's playing impressed the owners, and he was soon gigging there five nights a week. Chas Chandler, the Animals bassist who was quitting the band to become a producer, caught Jimmy's act on a visit to New York. He was so impressed that he whisked Hendrix to London almost overnight. In a whirlwind few months Chandler and his partner Mike Jeffery introduced Jimmy to all the British rock royalty, changed his name to Jimi, put together his new band the Experience, and had his first single, "Hey Joe," on the British charts by January 1967. Are You Experienced was released in May, and Hendrix wowed the Monterey Pop Festival that June, less than a year after the afternoon audition at Cafe Wha? Following a disastrous but at least brief tour opening for the Monkees, Jimi released his second album, Axis: Bold As Love, toward the end of 1967, toured England and Europe, and headlined his first U.S. tour in 1968.

New York became his home base again that spring. He drifted like a Gypsy from his suites in midtown hotels to Quashie's couch to various girls' apartments. Meanwhile, he began the laborious process of piecing together his third album in the brand-new Record Plant recording studio on West Forty-fourth Street. In his mid-twenties, Hendrix was living his

rock godhood to the hilt, indulging in innumerable girls and massive quantities of drugs and alcohol. But he was already bored with performing his hits and stage gimmicks of the previous year, and the demands of superstardom depressed him. At Record Plant he noodled for weeks and weeks, with many guest musicians, gradually creating the sprawling, messy double album *Electric Ladyland*, released in the fall. The album was a musical and commercial triumph, greeted with a level of fanfare usually accorded only new albums by the Beatles, the Stones, and Dylan. *Ladyland* included his cover of Dylan's "All Along the Watchtower," which as a single became his only Top 20 hit in the United States.

As brilliant as much of it was, *Ladyland* is also the sound of a young man lost in a fog of drugs. Hendrix drove both Chandler and his bandmates Noel Redding and Mitch Mitchell away in the process of making that album and ran up a crushing bill besides. Mike Jeffery suggested that in the future it might be cheaper for Hendrix to record in a studio of his own. They chose a spot in the Village, in the basement at 52 West Eighth Street between Sixth Avenue and MacDougal Street. Upstairs was the Eighth Street Playhouse. The Village Barn, with its square dances and hoedowns, had been in the basement from the 1920s through the '50s; in the 1960s a rock club Jimi liked, the Generation Club, replaced it. Generation had just closed when Jimi and Jeffery took the spot for his new studio. Flooding from the Minetta Brook and the vibrations from the subway station just half a block away slowed the construction, which took thirteen months and cost a million dollars.

Without doubt the strangest story told about Jimi and the Village starts a few blocks away, in the legendary 1 Sheridan Square building. In 1967 the club impresario Bradley Pierce opened a disco there, Salvation. Pierce had previously run several very hip clubs around Manhattan, including the midtown spot Ondine, at the foot of the Fifty-ninth Street Bridge, where Jimi had briefly worked as a busboy when he first moved to the city. Like Ondine, Salvation attracted the crème of hip café society, including the Beatles and the Stones, and swinging foreign royalty such as King Hussein of Jordan. Richard Roundtree, aka John Shaft, was a doorman there. So was Mike Quashie. By the time Jimi started hanging

out in Salvation in 1969 Pierce had sold the club to a wealthy but inexperienced new owner from Queens, Robert "Bobby" Woods. Woods floundered. He somehow lost his liquor license, the celebrities moved on, and drug dealers moved in. As happened in so many Village clubs, the mob came calling, forcing Woods to hire a couple of their boys. They showed up at the club only to collect their paychecks, so Woods had to hire other help to cover for them.

Hemorrhaging cash to the mob, Woods decided a switch from disco to live music might save the club. With the help of Mike Jeffery, he convinced Jimi to play a gig there one night in September 1969 with his new post-Experience trio. Though the 250-seat crowd responded lukewarmly to Jimi's set of all new material—no pyrotechnics or flash, just the more serious jazz-funk vein he was then exploring—Jimi enjoyed himself. He also, according to Hopkins, enjoyed all the free-flowing cocaine Woods made available to him.

Different versions of what happened that night after the gig have circulated over the decades since. In Hopkins's telling, Jimi left Salvation with a couple of guys looking to score some coke, which makes little sense since apparently it was very easy to get inside the club. His companions were reputedly unconnected young wannabe gangsters out to prove themselves to the mob, which they tried to do by kidnapping Hendrix. They held him first in a Little Italy apartment and then moved him to the country house he'd rented upstate—near Woodstock, as it happens. They demanded that Jeffery and his new partner Jerry Morrison sign over management of Jimi to them or they'd kill him. Several days passed before Jeffery and Morrison, with the backing of the Mafia, secured Jimi's release. He was unharmed. No report was ever filed with the NYPD or the FBI. A rumor spread that the weird affair was a hoax staged by Jeffery and Morrison to appear as heroes in Jimi's eyes.

Whether or not it's true, the story has a sad factual coda: Bobby Woods closed the club that November. The following February he was found in a street in Queens, with two bullets in his head, two in his chest, and one in his jaw.

Electric Lady Studios was completed in the summer of 1970. Mike

Quashie played host at the opening press party in August while Hendrix, increasingly drug-addled and depressed, mostly hid in an office. Hendrix flew the next morning to England to play the Isle of Wight rock festival and some dates in Europe. Before he went, he left a couple of trunks of his things and a bathrobe at Quashie's apartment.

He never came back for them. He died of an apparent drug overdose in London on September 18. Electric Lady is still in operation on Eighth Street as of this writing.

# Lenny Bruce and
# Valerie Solanas

LENNY BRUCE IS A DISEASE OF AMERICA . . . A PEARL
MISCAST BEFORE SWINE.

—*Kenneth Tynan*

IN APRIL 1964, LENNY BRUCE MANAGED TO GET HIMSELF BUSTED
for obscenity twice in one week, and in one location: the Café Au
Go Go, Howard and Ella Solomon's new coffeehouse in the basement
at 152 Bleecker Street, across from the Bitter End. He got the Solo-
mons busted as well. Getting arrested was almost routine for Bruce
by 1964. He'd been doing it regularly since 1961. His comedy had
made him, effectively, an enemy of the state.

Born Leonard Alfred Schneider on Long Island in 1925, he was raised
by his divorced mom, a dance instructor and performer, and by various
relatives. He ran away from home at sixteen and volunteered for the

navy at seventeen, in 1942. After three years of action in the Atlantic he'd had enough war; he dressed up in a female officer's uniform to get a psychiatric discharge. He got his start in showbiz in 1947, emceeing for his mother and appearing in rigged amateur-hour shows at clubs like George's Corner in the Village, earning two dollars a night plus carfare. In 1951 he married Honey Harlow, a redheaded stripper he met in Baltimore. While they were both performing in Miami he came up with a scheme to earn enough cash so that she might quit the business. He created a legal foundation and, dressed as a priest, went door to door in Palm Beach soliciting donations for a leper colony in British Guiana. He later joked that he first considered bronchitis, cholera, and the clap before reading an article about lepers. After a week he had raised eight thousand dollars. He was arrested but since the foundation existed on paper, and he had in fact sent twenty-five hundred dollars to Guiana—pocketing the rest as administration fees—he was found not guilty.

After a terrible car accident that nearly killed them both, he gave up the priest gag and they headed for Los Angeles. Honey went back to stripping while he worked as a comic and emcee in what he called "burlesque shithouses" and "toilets." It was in these joints that he started going to any excess to get a rise out of his audience, "working blue," as comedians said back then, adding sex jokes and profanities to his routines, once throwing a whipped cream pie in the face of a heckler, on another occasion strolling out on stage dressed only in socks and shoes. Meanwhile his behavior offstage got out of hand. Bruce loved partying with the guys in the band, he loved his hookers and strippers, he loved his drugs, and he indulged himself fully. A bit like Elvis, he found doctor fans who willingly gave him prescriptions for uppers and painkillers and his jazz musician pals hooked him up with junk.

Bruce and Honey's tumultuous, drug-impaired marriage split up shortly after the birth of their daughter, Kitty, in 1955. In 1957 he moved up the coast to North Beach, the Left Coast's Left Bank, and graduated from burlesque to legitimate nightclubs. He debuted a new act at Ann's 440, a cabaret popular with gays and lesbians, where Johnny Mathis got his start. It happened to be just around the corner from City Lights. The

same year that Ferlinghetti was winning his *Howl* trial Bruce began push-
ing his own free speech rights, becoming the man *Time* dubbed "the high
priest of the sick comedians." Other satirists of the late 1950s—Mort Sahl,
Jean Shepherd, Tom Lehrer, Nichols and May—teased Americans about
their shortcomings and foibles. They kept their patter light and their
jokes clean. Bruce not only used forbidden language, he pushed Ameri-
ca's buttons about sex, race, religion, violence. He tipped sacred cows all
over the cultural landscape. He made fun of the pope and Oral Roberts,
observed that Eleanor Roosevelt had nice tits, depicted the Lone Ranger
wanting to schtup Tonto *and* Silver, conjugated the verb "to come" to a
jazz beat, and interrupted his routine to ask the audience "Are there any
niggers here tonight?" He declared that two people having sex was never
obscene; Hiroshima was obscene. He poked liberals and conservatives,
squares and hipsters. He made some people laugh but he made a lot of
others uncomfortable and angry. "Constant, abrasive irritation produces
the pearl: it is a disease of the oyster," the theater critic Kenneth Tynan
wrote in his foreword to Bruce's autobiography, *How to Talk Dirty and In-
fluence People*, published by Playboy Press in 1965. "Lenny Bruce is a dis-
ease of America . . . a pearl miscast before swine." It's no coincidence that
Bruce emerged at around the same time as Elvis, the Beats, and Sputnik.
Like Elvis, he represented a rebellion against sexual repression and was
seen as dangerous and "dirty." Like the Beats, he loved jazz, spontaneous
riffing, and lots of drugs. And like Sputnik he startled the government
into hostile reaction.

In 1961 police working a tip entered his hotel room in Philadelphia,
saw a fair amount of drugs and syringes lying around, and arrested him.
A week later, out on bail, he was back in San Francisco, at a club called the
Jazz Workshop, where he was arrested for using the word "cocksucker."
He was hauled to jail, saw the night judge, the club owner posted his bail,
and he was back onstage in time for his one a.m. show. A jury later found
him not guilty but it was just the beginning. Between then and his Cafe
Au Go Go gig in 1964 he was arrested four times on obscenity charges
in Los Angeles, where one of his lawyers was Melvin Belli and one of
his prosecutors was Johnnie Cochran; once for possession of narcotics in

LA; and once for obscenity in Chicago. He was also refused permission to perform in Canada and in Detroit, banned from Australia (after he walked on stage in Sydney, declared, "What a fucking wonderful audience," and was instantly arrested), and turned away from England. With a few exceptions—Ralph Gleason in San Francisco, Nat Hentoff in New York—the media portrayed him as a dirty-mouthed drug addict. Club gigs began to dry up, his record sales slumped, and his bills escalated, as did his drug use. By the time he opened at the Café Au Go Go at the end of March 1964 he was broke, paranoid, exhausted, strung out, and his health was failing.

The Solomons had only just opened their Parisian-themed coffeehouse that February. He was a stockbroker and she was a fashion designer. Booking Bruce was a bold act. In advance of the 1964 World's Fair in Flushing, New York City had launched extensive campaigns to clean itself up for the tourists. The NYPD executed Operation Pornography and arrested more than one hundred and fifty sellers of pornographic materials, mostly in and around Times Square. The city's clergy pitched in; Operation Yorkville, a movement founded by a priest, a rabbi, and a minister (which sounds like the start of a Lenny Bruce routine), organized sting operations against sellers of lewd reading materials to minors, which included sending a sixteen-year-old girl into a bookstore, where she was allowed to buy a copy of Fanny Hill, classed as obscene at the time. Her mother filed a complaint and the bookstore was prosecuted. At one point the founding priest went on a fast to pressure Mayor Wagner to pursue obscenity violations more vigorously. Cardinal Spellman got into the act. The mayor appointed an antipornography commission. The city bore down on strip clubs, nightclubs, cabarets, and bars, with a special emphasis on those believed to cater to gay or lesbian clientele or featuring drag shows. There was even a new coffeehouse law enacted with the specific purpose of reining in those scruffy bohemian enclaves of Greenwich Village and the East Village. Under this law, poetry readings were defined as entertainment, which required the hated cabaret license. While the Solomons were opening their coffeehouse in February, the Cafe Le Metro over in the East Village was being issued a summons

for hosting unlicensed literary events. Allen Ginsberg led a protest and in March a judge overturned the law.

The Manhattan district attorney had his man in the Au Go Go audience furiously taking notes when Bruce opened on March 31. He caught a lackluster performance. Bruce, as he would for what was left of his career, spent much of it obsessing over the minutiae of his court cases, interspersed with some of his raunchy old bits. One new routine of note was about JFK's assassination the previous November. *Time* had claimed that when Jackie scrambled out of the limo after the shots, she was courageously seeking help for her stricken husband. "That's bullshit," Lenny said. "That's a dirty lie. [She] hauled ass to save her ass." He said he hoped his daughter would do the same. A few nights later, cops entered Bruce's dressing room before his show and arrested him and Howard Solomon for violations of Penal Code 1140-A, which prohibited "obscene, indecent, immoral, and impure" entertainment that might "tend to the corruption of the morals of youth and others." Out on bail, Bruce went onstage the following night. This time he and Ella Solomon were arrested.

At Ginsberg's request, Helen Elliott and Helen Weaver, big fans of Bruce's, wrote and circulated a petition against his "censorship [and] harassment." Dan Wakefield and Lucien Carr helped. Nearly one hundred cultural heavyweights signed, including Arthur Miller, Woody Allen, Norman Mailer, Lillian Hellman, James Baldwin, Bob Dylan, Paul Newman, Henry Miller, Dick Gregory, Liz Taylor, Richard Burton, Gore Vidal, Malcolm Cowley, Nat Hentoff, and Irving Howe. Kerouac, who never dug Bruce's act, refused. The venerable theologian Reinhold Niebuhr signed, never having caught Lenny's act. He later asked for his name to be removed. Many of them were the type of liberal do-gooders Bruce despised. Contrarian to the bitter end, he quipped: "The problem of people helping you with protest is that historically they march you straight to the chair." Privately, however, he called Weaver to thank her, and when he visited her in her West Thirteenth Street apartment, she writes, "His aura struck me almost like a physical blow when he walked in. It was a strange aura, almost repellent: very sexual, but like both sexes at once, like half man half woman. He reminded me of Di Angelo, my

lesbian lover, that slightly sinister quality she had." They had sex, napped, cracked some jokes, then he was gone.

The trial began that June. Protesters showed up to denounce the "Courtroom of the Absurd." Bruce fans (Ginsberg, Weaver, Jules Feiffer, Philip Roth) packed one side of the courtroom, opponents the other. The testimony of the inspector who'd taken notes at Bruce's show amounted to a terrible Lenny Bruce impersonation. Bruce complained that the guy was not only flagrantly misquoting him but murdering his act. Both sides trotted out expert witnesses; Dorothy Kilgallen and Hentoff appeared on Bruce's behalf. Weaver remembers the prim, devoutly Catholic Kilgallen saying, "They're just words, Judge." Mort Sahl, who'd followed Bruce at the Au Go Go, turned down the defense's request to speak out for him. America's *other* leading satirist, Sahl had always envied Bruce's notoriety. Weaver visited Bruce once in his room at the fleabag Hotel Marlton, where Kerouac had holed up after Weaver tossed him out of her apartment years earlier. Bruce's room was like a representation of his mind by that point, a manic clutter of law books, legal briefs, and his personal trial tapes, "a very sad spectacle," Weaver writes.

As the trial dragged on, Bruce fired his lawyer, whom he couldn't pay anyway. He proceeded to make a pitiable shambles of defending himself, at one point pleading with the three judges, "Don't finish me off in show business!" They did. They pronounced him guilty and sentenced him to four months in the workhouse, which he never served. More damagingly, his cabaret card was revoked, ending his career in New York City. But his career was all but dead everywhere by then. Almost no club owner would touch him. He found some work in San Francisco, but—again, one thinks of Elvis—he was a distracted, drug-addled ghost onstage. His final performance was at the Fillmore, with the Mothers of Invention opening for him. He was like Elvis in one last way: he died on the toilet in his home, of an overdose, in August 1966. He was forty. He joined Ferlinghetti, Rosset, and a few others as a pioneering saint (and in his case martyr) of the postwar free speech movement. In 2003 New York governor George Pataki granted him a pardon for the 1964 conviction, the first posthumous pardon in the state's history.

The Café Au Go Go went on to be one of the great rock, folk, and blues clubs in the city. The list of acts who played and jammed there before it shut its doors in 1969 includes Jimi Hendrix, the Fugs, Cream, the Blues Project, the Grateful Dead, Joni Mitchell, Tim Buckley, Muddy Waters, Howlin' Wolf, Lightnin' Hopkins, the Chambers Brothers, the Young-bloods, Richie Havens, and a band called the Company that morphed into Buffalo Springfield. Professor Irwin Corey, of whom Lenny had been a big fan, also performed there, as did George Carlin, who'd carry on Lenny's anticensorship challenges in his own way.

BY THE MID-1960S THE VILLAGE'S PERIOD AS A RELATIVELY ISO-lated and exclusive enclave of outsiders had ended. Disaffected baby boomer youth around the country read On the Road and Howl and the Village Voice, listened to Dylan and Hendrix, and fled from whatever boring suburb or dysfunctional home where they were feeling alienated to Greenwich Village and the East Village, the hip meccas of the East Coast, or to Haight-Ashbury in San Francisco (where the population jumped from fifteen thousand in 1965 to a hundred thousand in 1967). The Village that had been a rare sanctuary in the 1950s was now just one node in an international chain of counterculture centers that included every decent-sized city and college campus. The weekend beatniks with their price-tagged bongos were replaced by weekend hippies—"plastic hippies," Villagers called them—wearing the brand-new headbands and love beads they bought in Bleecker and MacDougal Street boutiques.

Edmund White, who moved to MacDougal Street from the Midwest in 1962, remembers, "There were so many people . . . It was really a mob scene. Cars couldn't get through the streets. I mean like a car could never get down MacDougal." A lot of the crowd, he remembers, were what Manhattanites call B & T (bridge and tunnel) kids, in from New Jersey and the outer boroughs to party, "who would come over and be belligerent to everybody." It got so bad that one Friday night in March 1966 the NYPD tried barring all nonneighborhood vehicles from the entire "café area," the zone from West Fourth Street down to Houston. Only drivers who could prove they resided in the Village were allowed past the barri-

ers, a clear attempt to discourage the B & T crowd. It didn't quite work as planned. Some fifteen hundred youths took advantage of the trafficless MacDougal Street to stage an impromptu protest, chanting "Up with the Village and down with the police" and "Stop the fuzz," according to the next day's *Times*. Club owners in the zone complained that their business fell way off that night. The experiment was not repeated. Still, police kept up a heightened presence in the "cabaret and coffeehouse district" that Saturday night, and teenagers continued to resist. Groups of several hundred of them marched down MacDougal Street chanting "We shall overcome" and tussled with mounted cops, with some arrests for disorderly conduct. After ending the crackdown, a beleaguered police spokesman insisted "heatedly" that "At no time did we surrender to beatniks." Meanwhile the long block of West Eighth Street connecting Fifth and Sixth Avenues, where the painters had hung out in the postwar years, was now "All neon and noise, crowded with peddlers competing for a few feet of sidewalk . . . a vivisected slice of 42nd Street transplanted downtown, where drag queens, drug freaks, and mobs of gawking tourists promenade."

Although still fantastically low by today's measure, Village rents kept climbing. Until 1969, when the city designated most of the central Village a historic preservation district, developers continued to knock down the tenements and older buildings where apartments were cheapest to build new high-rises and fill them with middle-class tenants. "Today," one guidebook published in 1966 sniffed, "most of Greenwich Village provides a charming, interesting backdrop for thousands of unctuous middle-income urbanites bottled into prosaic, but artfully titled apartment buildings." It was becoming "little more than an offbeat shopping and modern-living center." That was an exaggeration—the Village still had some years to go as a place that pioneered and influenced American culture before it turned into the affluent bedroom-and-boutiques community of the twenty-first century. Still, it's an indication that the trend was already quite evident in the rising rents, crowded streets, and increasing commercialization of the 1960s.

The avant-garde zeitgeist that had resided almost exclusively in Green-

wich Village through the 1950s began to look for cheaper places to live. Artists colonized the former garment industry lofts along the Broadway stem south of Houston Street, creating what came to be known as the Soho art district. The East Village became the epicenter of the new counterculture. Soon people would begin referring to Greenwich Village as the West Village. From the 1970s on, much—though not all—of the new art, music, dance, film, theater, and so on that was made and presented below Fourteenth Street was outside the Village. In 1965 the East Village got its own alternative to the *Voice*, the *East Village Other*. Hippie, psychedelic, anarchic, and sexed-up, it made the *Voice* look like a middle-aged "bo-lib" (bohemian-liberal) spinster, lasted a respectable six years, and achieved a circulation of around forty thousand before it ran out of gas and closed up in 1971. Meanwhile the *Voice* itself was becoming less identified with the Village. By 1967 it was a national presence, the largest-selling weekly in the country, the hip paper of record. It topped a circulation of a hundred thousand, yet its readership in the Village was still around thirteen thousand, where it had been for years. The new readers were elsewhere. In recognition that it was outgrowing its neighborhood roots, it changed its logo that year, downplaying the *village* and magnifying the VOICE. From then on, although a square like Vice President Spiro Agnew might still misidentify it as "the *Greenwich Village Voice*," it was more commonly known simply as the *Voice*. It would keep various Village offices until the late 1980s, when it moved to Cooper Square, but the lower-case *village* in its name was increasingly vestigial.

Middle-class residents began to feel they were under siege from outsiders in the mid-1960s. The Washington Square Park they had fought only a decade earlier to save from Robert Moses's bulldozers was now overrun in a different way. In 1964 the neighborhood's two Democratic district leaders, Carol Greitzer and Ed Koch, asked the NYPD to bear down on the park's "alcoholic derelicts, narcotic addicts and sexual perverts." The park also filled up with more "troubadours" than ever, few of them the well-scrubbed college kids as before; political radicals of every type and cause; and religious prophets of every calling, from Hare Krishnas to Jesus freaks to the Gandalfian character with the long white beard and

white robe who warned that a new flood was coming because his listeners had been drinking and dancing and fornicating. "Oh, how you love to fornicate," he intoned. Meanwhile, gang kids and other hoodlums and junkies roamed the Village streets in predatory packs, mugging and robbing with something close to impunity. "I was robbed on the street, on Bleecker," Edmund White recalls. "It was around six o'clock, and there were tons of people around. These guys had hollowed out the pockets in their overcoats, and they had guns there but the coat was sort of covering it unless you were standing directly in front of them. But nobody wanted to be bothered, get involved with that, you know. I guess you could definitely say from '67 on it was very edgy."

It wasn't just college kids and young adults coming to the Village anymore. From the mid-1960s on an epidemic of underage runaways flooded both the West Village and East Village and created a whole other set of conditions and problems. Too young to get legitimate work or sign a lease, they lived on the streets, floated between friends' pads, got rooms in cheap and dangerous flophouses, dodged cops, and often found themselves forced to hook and hustle to get by. They were easy prey for the muggers, rapists, drug dealers, and pimps who were also a growing presence. By 1968 Judson House was operating a crisis center for runaway minors. At first it offered them "a place to get their heads together" for a few nights while counselors from the church contacted their parents and tried to arrange for the kids to go home. But it soon developed into a long-term residence for more than a dozen kids, average age fifteen, who couldn't or wouldn't leave. A few years later, Father Bruce Ritter opened the first Covenant House shelter for runaway minors on La Guardia Place. Through the 1970s and '80s Covenant House grew into a huge multicity program. In 1990, facing numerous charges of sexual and financial misconduct that were tabloid fodder for months, Ritter was forced to resign.

VALERIE SOLANAS WAS THIRTY BY THE TIME SHE ARRIVED IN THE Village in 1966, and she fit right in with the new outsiders crowding its streets. She'd been a teenage runaway and a drifter for some time, and like Djuna Barnes decades earlier she was quite damaged by the time she

appeared. Born in 1936, she grew up in New Jersey, where, according to a sister, their bartender father regularly molested her. Later, when her mother and a despised stepfather couldn't handle her rebelliousness, they sent her to live with her grandfather who, she said, tried to beat it out of her. She ran away at fifteen and would profess a hatred of men for the rest of her life. Over the next few years she had a married sailor's child who was taken away from her for adoption, but she still managed to graduate high school and do well at the University of Maryland, earning honors in psychology. After adding a year of grad school at the University of Minnesota she hit the road again, a hobohemian tomboy waif who panhandled and hooked her way to Berkeley.

She continued to turn tricks and bum change when she reached the Village, staying in the run-down Marlton while trying to make it as a writer. In the February 9, 1967, issue of the *Voice* she ran two small ads. One was for readings, at the Directors Theater School on East Fourteenth Street, of her play, which had one act but four titles:

*Up Your Ass*

or

*From the Cradle to the Boat*

or

*The Big Suck*

or

*Up from the Slime*

It also had three dedications: one to Me, one to Myself, and the third to I. The other ad was for her mimeographed pamphlet, SCUM *Manifesto*, which according to the ad was available for a dollar fifty at the Eighth Street Bookshop and other venues. SCUM stood for the Society for Cutting Up Men. The pamphlet begins, "Life in this society being, at best, an utter bore, and no aspect of society being at all relevant to women, there remains to civic-minded, responsible, thrill-seeking females only to overthrow the government, eliminate the money system, institute complete automation, and destroy the male sex." It goes on to describe all the ways

males are deficient and depraved, as are all women who aren't SCUM. It explains how SCUM will wipe most of them off the planet and create a utopia for the free, courageous, wise, and groovy SCUM sisterhood.

Up Your Ass delivers the same basic message in satirical dramatic form, as the Solanas-like character Bongi Perez—described forty years later in the Voice as "a wisecracking, trick-turning, thoroughly misanthropic dyke"—matches wits with variously loathsome men, a couple of them designated only as White Cat and Spade Cat, and street queens and the straight women who distress her the most, who are willing to "eat shit"—literally—for their men. Both the manifesto and the play can be seen as early examples of the extremist feminist-separatist tracts that became more familiar in the 1970s.

With its eccentric ideas about the future, SCUM Manifesto can also be read as a distant cousin to William Burroughs's mad sci-fi visions. That's evidently how Maurice Girodias, publisher of the Olympia Press, read it. Effectively Barney Rosset's opposite number in France, Girodias published a mix of pornography and literature, the latter including works by Beckett and Henry Miller, Burroughs's Naked Lunch and Nabokov's Lolita. After several prosecutions on obscenity charges in France, he had moved himself and his press to the Chelsea Hotel in 1966 and was seeking edgy new writers to publish. They didn't come with more edge than Solanas, who responded to an ad in the Voice and showed him the manifesto. He liked its bizarre sense of humor and gave her a five-hundred-dollar advance to write a novel on a similar theme. Solanas, with her long-ingrained mistrust of all males, immediately decided he was out to cheat her and never delivered the novel.

By then she had focused her fiercely obsessive attentions on another male, Andy Warhol. She took a copy of Up Your Ass to the Factory. Warhol liked the title but apparently never read the play. Solanas began to hound him, in person and through innumerable phone calls, demanding the manuscript back, but it had been lost in the clutter at the Factory. (It wasn't rediscovered for decades and is now archived at the Warhol Museum in Pittsburgh.) Trying to placate her, he let her do a small scene in the movie he was then shooting, I, a Man. It didn't help. She continued

to stalk both Warhol and Girodias, demanding thousands of dollars she was convinced they owed her, working herself up with the idea that they were conspiring together to keep her down. She became a familiar crazy on the streets of the Village and East Village, hawking the manifesto, harassing male passersby, trying to recruit women for SCUM, fitting right in with the increasingly sideshow milieu of speed freaks, flower children, acid casualties, religious nuts, and street queens. "For a while she was hanging out on St. Mark's Place," Agosto Machado recalls. "People would say, 'Just leave her alone.' She'd be picked up making threats and brought back in. I met her briefly, but I was so shy and she was a pretty strong person, even when she wasn't talking . . . You'd choose your words carefully around her, because what would come out of her could lacerate."

She got herself booked onto Alan Burke's late-night TV talk show. Burke was an abrasive conservative host who booked guests such as an abortionist or a nun turned go-go dancer solely to harangue them. Solanas proved too much for him. She started cursing the minute she opened her mouth, and when she wouldn't stop he stalked off the set in frustration. Sadly, the show never aired.

In 1968 she approached Paul Krassner, founding Yippie, editor of the East Village–based underground paper the *Realist*, sometime hip standup comedian at the Village Gate, and collaborator with Lenny Bruce on *How to Talk Dirty*. She got a fifty-dollar loan from him and used it to buy a .32 caliber handgun. She already had a .22. On the morning of June 3, 1968, she went to the Chelsea looking for Girodias. Instead of her normal tomboyish attire she was dressed for business in a nice turtleneck and raincoat, with her hair done and wearing makeup and carrying the pistols in a brown paper bag. After waiting around in the Chelsea lobby for a few hours she headed for the Factory, which Warhol had moved six months earlier from its original midtown space to 33 Union Square West, just across the park from his favorite hangout, Max's Kansas City, the coolest club in the city at that point. Solanas sometimes went to Max's stalking Andy, but then so did every other wannabe in the city. Where the original Factory, known as the Silver Factory, had been a cross between an art studio, a clubhouse, and a drug den, the Union Square space signaled a new

businesslike Warhol, organized like an office with a reception area and desks. The first time Solanas rode the elevator up to the sixth-floor space that afternoon she encountered Warhol's filmmaking partner Paul Morrissey who, like most of Warhol's crowd, had long ago decided she was a nut and a pest. He shooed her out. She rode the elevator up and down several more times that afternoon, until Morrissey threatened, ironically, to beat her. Then Andy arrived. He was his usual passive, placating self, telling her how nice she looked. When Morrissey went to use the bathroom, Solanas pulled out the .32 and started shooting. Andy screamed and crawled under one of the desks as her first two shots missed. She calmly squatted, stuck the gun into his armpit, and fired again. The bullet ripped through both lungs, his liver, and spleen. She then put the gun to the head of Fred Hughes, Warhol's manager, who had dropped to his knees. As he begged her not to shoot the elevator arrived. Solanas rode it down to the street.

Warhol was rushed to nearby Columbia Hospital, where the paparazzi were already magically waiting, and where he was initially pronounced dead before a surgical team went to work saving his life. Solanas wandered up to Times Square, where she handed her pistols to a rookie cop, telling him she'd shot Warhol because "he had too much control over my life." By the time she was brought in for booking at the Thirteenth Precinct, a few blocks from where Warhol lay on an operating table, an enormous cloud of paparazzi had descended there too. "I was right in what I did!" she shouted to them. She was remanded to the House of D and from there to a psych ward. From behind bars she sent Jonas Mekas ranting letters to pass along to the *Voice*, where Ed Fancher declined to print them. "So she blamed me for it all and threatened me in typical Solanas fuming language," Mekas said.

Three days later in Los Angeles, a little after midnight on June 6, Sirhan Sirhan upstaged Solanas by shooting and killing Robert F. Kennedy. In the shadow of that national tragedy, Warhol didn't get much sympathy in the press; the general tenor was that his shooting was comeuppance for his amoral, decadent lifestyle. Some feminists championed Solanas as a hero. She was in a psychiatric facility that August when Girodias pub-

lished SCUM *Manifesto*, with a commentary by Krassner entitled "Wonder Waif Meets Super Neuter." She pleaded guilty to reckless assault in 1969 and was locked up until 1971. She was arrested again that year for making new threats to Warhol and others. In and out of psych wards, she drifted to the Tenderloin in San Francisco, where she lived in relative obscurity in the 1980s, turning tricks again. She died in a welfare hotel there in 1988.

It wasn't until 2000, more than three decades after she first tried to get it produced, that *Up Your Ass* had its world premiere, in a theater just a few blocks from where she'd lived in San Francisco. It had its New York premiere the following year at P.S. 122, in a rapidly gentrifying East Village that was going through a wave of nostalgia for the hip, crazy downtown Manhattan of the 1960s.

# The Radical '60s

IN WHAT AT LEAST
SEEMED ANGER THE AQUARIANS IN THE BASEMENT
HAD BEEN PERFECTING A DEVICE

FOR MAKING SENSE TO US
IF ONLY BRIEFLY AND ON PAIN
OF INCOMMUNICATIONS EVER AFTER.

—James Merrill

THE BIG POLITICAL BATTLES IN THE VILLAGE OF THE 1950S HAD
been about local issues, chiefly defeating Robert Moses and
Carmine DeSapio. In the 1960s the Village became one node in a
national network of youth rebellion, racial upheaval, and the anti-
war movement. American politics turned harder, more violent, more
deadly earnest through the 1960s, driven by the construction of
the Berlin Wall, the Cuban missile crisis, JFK's assassination, and
LBJ's massive escalation of U.S. involvement in Vietnam. By 1967

the United States had committed more than half a million troops to the war and protest rallies were regular occurrences. The murders of Medgar Evers and other blacks and civil rights activists had set a grim tone for the decade. By the mid-1960s many black Americans were frustrated with the slow progress of the nonviolent civil rights movement. Riots broke out; the Black Panthers were formed. On April 4, 1968, Martin Luther King Jr. was assassinated. America, along with much of the rest of the world, seemed to be pulling itself apart along political, racial, class, and generational fracture lines.

In Greenwich Village antiwar sentiment ran very high. The Washington Square United Methodist Church on West Fourth Street, nicknamed the Peace Church, became a nerve center of the city's antiwar movement. It was home to the Greenwich Village Peace Center, where volunteers counseled young men facing the draft, and a station for the War Resisters League's "underground railroad," which helped draft resisters relocate to Canada. Antiwar groups from the Catholic Worker to the Trotskyist Spartacists met there, as well as the antinuke groups the National Committee for a Sane Nuclear Policy and Women Strike for Peace.

Women arrested at antiwar rallies in the city found themselves locked up in the House of D. On Saturday, February 20, 1965, two eighteen-year-old college students, Lisa Goldrosen and Andrea Dworkin, found themselves in the D after being arrested during an antiwar protest at the UN. They later testified that they were brutally mistreated and humiliated by male doctors "examining" them for venereal diseases and forced constantly to fend off the rough advances of other prisoners. They were not allowed to use a telephone until Monday. That March, the *New York Post* ran an exposé based on their testimony. They didn't experience anything other women hadn't for thirty years by then, but in the 1960s those other inmates were overwhelmingly poor black and Hispanic women. Dworkin and Goldrosen were white, middle-class college coeds. As so often happens that's what it took to generate public outrage.

When Grace Paley was arrested at another war protest some months later and detained in the facility, conditions had slightly improved in light of the outcry the *Post* had stirred up. Paley had been arrested be-

fore at antiwar protests, but it had always resulted in overnight stays at worst. This time a judge threw the book at her and gave her six days. "He thought I was old enough to know better," she later wrote, "a forty-five-year-old woman, a mother and teacher. I ought to be too busy to waste time on causes I couldn't possibly understand." At least she could look out her cell window and watch her kids walking to school. She was a Villager, her apartment just a few minutes from the jail.

Born in 1922, she grew up speaking Russian and Yiddish in the Bronx, the youngest child of Russian Jewish immigrants. Her father, Isaac Goodside (anglicized from Gutseit), had started out poor on the Lower East Side when he reached America but was a comfortably well-off neighborhood physician by the time she was born. Both parents were Socialists, and Grace grew up surrounded by arguments between hard-liners and progressives, Trotskyists and Leninists that left her, she later wrote, "neurotically antiauthoritarian." As a young woman she took Auden's Thursday-evening class at the New School. "It was my life, my whole life in that Thursday night," she later told an interviewer. "I came down to this fascinating place, and I sat in the back of this class with those other two hundred people, and he talked." Coming from the Bronx, she'd never encountered an upper-crust British accent before. "I couldn't understand him. Not only was there this very strong accent, but he used to lisp a great deal. It was *impossible*. But I didn't miss a class." Although she was writing poetry from the age of five, it wasn't until the mid-1950s, a single mother in her early thirties living in a basement apartment in the Village, that she began writing fiction. When she'd written three stories a neighbor, Ken McCormick, told her that if she wrote seven more he'd publish them in a book—he was an editor at Doubleday. It took her a few years, but in 1959 Doubleday published The Little Disturbances of Man. Two more slim collections came out in 1974 and 1985. She wrote in the voice of the postwar American Jew, the generation after Delmore Schwartz's. Hitler had proved Schwartz right, and Paley's characters could still be heavy with historical sorrows, but they also said things to each other like, "As you know, I grew up in the summer sunlight of upward mobility. This leached out a lot of that dark ancestral grief." It earned her a loving

following. From the early 1960s on she taught writing at Columbia, City College of New York, and Sarah Lawrence.

At the same time she grew increasingly active in the antiwar movement. She could often be found on a corner of Sixth Avenue—a friendly, gum-cracking neighborhood mother, handing out antiwar, antinuke, and women's lib literature—or at the Peace Center, where as a member of the War Resisters League she helped to organize the protest rallies in which she regularly participated. Her week in the House of D did not deter her. In 1969 she was one of a small group of peace activists who traveled to North Vietnam and came back with three American POWs, a small goodwill gesture from the government there at a time when the Nixon administration seemed amenable, briefly, to such overtures.

IN 1970 RADICAL POLITICS TURNED DEADLY IN THE VILLAGE. BORN in 1945, Cathy Wilkerson grew up in haute bourgeois comfort in Connecticut. When her parents divorced she stayed with her mother; her father, an executive at the ad agency Young & Rubicam, remarried and in 1963 bought the sumptuous Greek Revival town house at 18 West Eleventh Street, just off Fifth Avenue, in the "nicest" part of the Village. That year Cathy, a sophomore at Swarthmore, was arrested while picketing outside a dangerously decrepit and overcrowded black school in Chester, Connecticut. A few years later she was in Chicago editing the newsletter New Left Notes for the Students for a Democratic Society. When SDS began in 1962 it was mainly involved in civil rights issues, but from the mid-1960s on it grew increasingly active in the antiwar movement. In 1969 SDS claimed a hundred thousand members on college campuses nationwide, the same level as the CPUSA in its heyday in the 1930s. Wilkerson attended the national convention in Chicago that June, when SDS burst apart at the seams. Fed up with the organization's policy of nonviolent protest, which seemed to be having little effect, a faction calling itself Weathermen from the line in Dylan's "Subterranean Homesick Blues" essentially hijacked and later dismantled SDS. Among its leaders were Mark Rudd, who as chairman of the SDS chapter at Columbia had led the 1968 student uprising there, and Bernardine Dohrn. Wilkerson

went along with them. The Weathermen group styled itself as a cadre of the world armed revolt against U.S. imperialism and as a corollary to the Black Panther Party. They adopted Fred Hampton and Mark Clark, two Panthers killed in a police raid, as role models and patron saints. Never more than a thousand committed members nationwide, Weathermen set themselves the goals of radicalizing the nation's working class, disrupting government and corporate operations, and bringing about the revolution in America by any means necessary. Attempts to organize the working class and to align with the Panthers would fail miserably: workers beat them up and the Panthers rejected them as "scatterbrains." Meanwhile their advocating violence alienated the rest of the antiwar movement.

Weathermen's first public action was a demonstration in Chicago that fall that came to be known as Days of Rage. They'd expected tens of thousands of protesters but only a few hundred showed up. From its starting point in a park the march flowed out into the streets and soon got out of hand, with protesters breaking car and shop windows. Cops chased them through the streets, shooting at a few, bludgeoning and arresting others, including Wilkerson. She was out on bail two weeks later. Having proven to themselves the futility of public demonstrations, Weathermen now turned to direct action. "We will loot and burn and destroy. We are the incubation of your mother's nightmare," one of them orated. Looking back on this moment forty years later in her memoir *Flying Close to the Sun*, Wilkerson writes, "Now it seems fantastic that I responded to the clear signs of political idiocy" by going along.

Breaking up into small cells in secret locations around the country, the group members went into an intense period of self-indoctrination, hoping to transform themselves from middle-class college kids into "more effective tools for humanity's benefit," Wilkerson writes. Through grueling, humiliating group interrogations they attempted to purge themselves of personality and individualism in order to create a faultlessly doctrinaire and obedient collective that was as much cult as communist, the Borg of the revolution. Because traditional relationships might weaken members' bonds with the collective, they were supposed to have sex only with randomly assigned partners or in cheerless-sounding group orgies.

In the winter of 1970 Wilkerson was attached to the cell in New York City. Because the cell needed a safe place to hide and work, she went to visit her father at 18 West Eleventh Street. She hadn't seen much of her Nixon-voting father in recent years but was able to convince him to let her stay in the town house while he and her stepmother were on a Caribbean vacation; she told him she had the flu and had nowhere else in the city to stay. She and a handful of other revolutionaries moved in as soon as her father left. It was plush digs for a gang of Marxist terrorists, one of four spacious town houses Henry Brevoort Jr. built in the 1840s for his children. Later, Charles Merrill, founding partner of Merrill Lynch, lived there; his son James, the poet, was born into wealth there in 1926. Cathy's father had handsomely furnished the house and the pantry was well stocked.

One member of the New York cell, Kathy Boudin, was actually a Village native with family roots in the Village's left-intellectual history. Her father, Leonard Boudin, was a well-known civil liberties lawyer. He represented Dr. Spock and William Sloane Coffin in their case and also Daniel Ellsberg when he was tried under the old Espionage Act for leaking the Pentagon Papers. Leonard's uncle Louis Boudin, a Russian Jewish émigré, was a labor lawyer and Marxist writer. An aunt of Kathy's was married to the liberal investigative journalist I. F. Stone. Kathy went to Bryn Mawr with another member of the cell, Diana Oughton, daughter of a wealthy Illinois Republican.

Weathermen collectives around the country had set off a number of firebombs by this time, targeting military recruitment centers, campus ROTC centers, courthouses, and the offices of corporations doing business with the military. The devices they used were basically Molotov cocktails—glass bottles filled with gasoline and ignited by a lit rag—and did not do much damage, if they even went off at all. Wilkerson's group decided, despite a nearly perfect lack of demolitions knowledge, to step up to pipe bombs filled with dynamite and nails, detonated with blasting caps on electronic timer fuses. They set to work constructing them in the town house's unfinished subbasement. They chose Fort Dix in New

Jersey for their target. They didn't want to harm regular soldiers, who might well be draftees from lower-income communities, so they decided to detonate the bombs during a dance in the officers' club.

Just before noon on March 6, 1970, Wilkerson was ironing sheets in the kitchen when a series of explosions burst up from the subbasement and splintered the kitchen floor. Smoke, splinters of wooden beams, and shards of brick roared up from the crater where the floor had been, followed by a rush of flames. The explosions blew out a two-story section of the front wall of the house, shooting glass, bricks, and tongues of flame clear across the street. The shock wave rocked the entire block and shattered windows up to the sixth floor in the apartment house across the way. Down in the subbasement Terry Robbins, Ted Gold, and Oughton had made a fatal error in hooking up the blasting caps and timers to their pipe bombs and were blown to pieces when the exploding bombs set off three cases of extra dynamite. Wilkerson and Boudin, who'd been taking a shower upstairs, stumbled outside, blinded by smoke, through the gaping hole in the front wall. Boudin was miraculously unharmed; Wilkerson was bleeding from numerous small cuts, her clothes in shreds. Behind them, the entire interior of the house collapsed into the crater, where a huge fire roared and belched black smoke through the blown-out windows.

Neighbors gathered instantly, thinking it had been a gas main explosion. A news photo shows Dustin Hoffman, who lived next door at 16 with his wife and kids, having a most Greenwich Village reaction: he is racing out of his house with a painting he saved. Hoffman was a movie star by then—*The Graduate* had come out in 1967, *Midnight Cowboy* in 1969—but New Yorkers were famously blasé about celebrities living among them. The theater critic Mel Gussow also lived at 16; he and his wife were in the crowd as well. None of them ever slept another night in the structurally compromised 16. A neighbor let Wilkerson and Boudin use her shower and gave them some of her clothes to wear. As cops and fire trucks arrived, Wilkerson and Boudin slipped out of the neighbor's house, walked away from the crowd, and went down into the nearest sub-

way station. They and other Weathermen members went into hiding, be-
coming the Weather Underground and finding themselves on the FBI's
most wanted list.

On April 30, President Nixon went on national television to announce
that he had sent troops into Cambodia, Vietnam's neighbor. The purpose
was to cut off North Vietnamese supply routes through the country. Just
ten days earlier Nixon had announced that 150,000 American troops
would be pulled out in the coming year. Now he suddenly seemed to
be expanding the war again. In the following days, protests erupted at
hundreds of colleges around the country, while Nixon groused about
"bums blowing up campuses." Protest rallies were practically everyday
occurrences by the spring of 1970—the giant march on Washington in
1969 had drawn an estimated quarter of a million protesters—but this
time things turned deadly. On May 4, National Guardsmen opened fire
at Kent State in Ohio, killing four students and wounding nine others.
Reacting to this "massacre," students went on strike around the coun-
try, and there was another huge march on Washington. Beginning on
May 4, NYU students occupied the Loeb Student Center on the south
side of Washington Square Park (torn down in the 2000s and replaced
by the much bigger Kimmel Center), Warren Weaver Hall on Broadway,
and Kimball Hall near the Asch Building. They were especially inter-
ested in the university's print shop in Kimball, which they used to crank
out strike pamphlets and revolutionary literature, and in the Atomic En-
ergy Commission's multimillion-dollar computer center in Weaver. The
university's administration was particularly anxious to coax them out of
Weaver before they vandalized or destroyed those computers. When the
students voluntarily left the building after two days, cops and university
workers entered it and immediately smelled smoke. Racing up to the sec-
ond-floor computer center they found jug-sized Molotov cocktails with
long rag fuses burning, which they stamped out. It took two weeks of
negotiations to pry the students out of Loeb and Kimball. While all this
was going on, a few thousand college and high school students, including
some of the NYU strikers, gathered outside Federal Hall down on Wall
Street for a rally on May 8. Cops and a few hundred construction work-

ers, organized by local union bosses, attacked the kids, chasing them through the streets of the financial district in what came to be known as the Hard Hat Riot. For the Old Left it was a terrible vision, the workers rising up to attack kids.

The turmoil continued. From the underground Dohrn issued a tape-recorded "declaration of war." Three weeks later a bomb went off at NYPD headquarters. The organization followed it with a number of actions over the next few years, bombing military buildings, corporate headquarters, courthouses, even the U.S. Capitol building and the Pentagon. They also helped Timothy Leary break out of a California prison where he was serving time on a pot bust, smuggling him and his wife out of the country to Algeria, where they met up with the self-exiled Black Panther Eldridge Cleaver.

Wilkerson remained in hiding through it all, changing her locations and using assumed identities, lying low, working as a waitress, a secretary, a nurse's aide. When Nixon resigned in disgrace in 1974 and the last American troops left Vietnam in 1975, the revolutionary moment passed. The Weather Underground dissolved amid doctrinal squabbles in 1976 and members began turning themselves in to the authorities. Dohrn and Wilkerson remained in hiding until 1980. After giving herself up, Wilkerson served a year for illegal possession of explosives. On her release she moved to Brooklyn and became a public school math teacher.

Boudin was arrested in 1981. After the breakup of the Weather Underground she'd become involved with a radical black organization, the Family, which included Doc Shakur, Tupac's stepfather. She participated with them in a botched holdup of a Brinks truck in Rockland County, New York, in which they shot and killed a Brinks guard and two policemen before being apprehended. The Family's motive wasn't political; they wanted the money to score drugs. Boudin became a poet in prison and won a PEN prize. She was paroled in 2003.

The 1970 explosions and fire had completely gutted the Wilkersons' home. It stood an abandoned and boarded-up husk for eight years. Someone scrawled the graffito Weatherman Park on the plywood. Some neighbors thought the house should be reconstructed to match the original

design, but when it was finally rebuilt in 1978 an architect gave it a new facade, which stands at a sharp, punched-out angle to the flat fronts of its stately neighbors, a silent but striking visual reference to the explosion.

James Merrill wrote a poem about it all, "18 West 11th Street," which includes the lines, "The point / Was anger, brother? Love? Dear premises / Vainly exploded, vainly dwelt upon."

IN OCTOBER 1970 ANGELA DAVIS WAS ARRESTED IN THE HOWARD Johnson Motor Lodge at Eighth Avenue and Fifty-first Street and taken to the House of Detention. It was not her first time in Greenwich Village. She was born in 1944 in Birmingham, Alabama, where her father was a car mechanic and her mother was a teacher and a civil rights activist. They lived in a black neighborhood called Dynamite Hill, so named because the Klan often firebombed homes there. With help from the American Friends, she and her mother moved to New York, where her mother studied for her master's at NYU while Angela attended Elisabeth Irwin High School in the Village. She went on to study philosophy at Brandeis, the Sorbonne, and at the University of California, earning her PhD. One of her teachers was the neo-Marxist Herbert Marcuse, whose book *One-Dimensional Man* was a must-read for the New Left. By the late 1960s she was an avowed Communist, a member of the Student Nonviolent Coordinating Committee, and affiliated with the Panthers. She lectured in philosophy at UCLA until 1969, when her Communist and radical affiliations got her fired.

In August 1970 a black teen named Jonathan Jackson took over a Marin County courtroom with a machine gun and demanded the release of his older brother, Panther member George Jackson, from nearby Soledad prison. He took the judge, the district attorney, and three jurors hostage. In the attempted getaway Jackson, the judge, and one other person were shot and killed. When police discovered that Davis, who knew George Jackson, was the registered owner of Jonathan's weapon she was charged as an accomplice to murder, a capital crime in California. She fled the state, which put her on the FBI's most wanted list. A beautiful twenty-six-year-old with a huge and magnificent Afro, she became a global pop star

of the revolution à la Che Guevara. Before the FBI arrested her she'd spent a few days walking openly in Times Square, unrecognized because she'd slicked down the Afro and dressed like an office worker.

Within thirty minutes of her being locked up in the House of D a crowd of protesters began to gather outside the monolith, chanting; prisoners stood in their windows and chanted along, their fists raised. The NYPD sent a Tactical Defense Force—riot police—and House of D officials turned off all the lights inside, hoping to quiet things down. Women set small fires in their cells and demonstrators cheered the flickering in the windows. They eventually dispersed without major incident. Placed in isolation, Davis went on a ten-day hunger strike. She spent nine weeks in the facility while fighting extradition to California, where, she was quite convinced, she'd be convicted and put to death. In fact she would be acquitted of all charges in a San Francisco courtroom in 1972, after spending eighteen months behind bars. She went on to write about the terrible conditions in the House of D for the Village Voice.

Davis was the facility's last celebrity tenant. Through the 1950s and '60s Village civic and neighborhood groups had continually called for the facility to be removed to some location more appropriate, which is to say far away from where they lived and walked their children to school. More liberal souls in the neighborhood thought it should stay, fearing that if the women were shifted to some more isolated location they might be all the more easily mistreated. Jerry Herman satirized the controversy in "Save the Village":

> Don't tear down the House of Detention
> Keep her and shield her from all who wish her harm
> Don't tear down the House of Detention
> Cornerstone of Greenwich Village charm . . .
>
> So I say fie, fie to the cynic
> Know that there's love in these hallowed walls of brown
> There's love in the laundry, there's love in the showers,
> There's love in the clinic

*'Twas built with love, my lovely house in town*

*Save the tramp, the pusher and the souse*
*Would you trade love for an apartment house?*

Dworkin and Goldrosen's testimony before a commission studying conditions at the House of D helped lead to its being shut down altogether in 1971. Inmates were moved to a new facility on Rikers Island. After some debate about possible new uses for the Village monolith it was simply torn down in 1973. The site is now a small, fenced-in garden. In 1975 Tom Eyen's spoofy play *Women Behind Bars*, set in the House of D in the 1950s, premiered. The John Waters star Divine performed in a later production.

# The Lion's Head

$I$T WAS NOON ON A FALL WEEKDAY AND THE WHITE HORSE WAS very quiet. A few gray-haired topers at the bar, no lunch crowd yet at the tables or booths in the back room. A photograph of Dylan Thomas with the postmodern novelist David Markson (*Wittgenstein's Mistress*) gazed down at Dermot McEvoy. McEvoy was an infant when Thomas drank his last at the White Horse, but Dermot and Markson, who died in 2010, were longtime pals and drinking buddies. Not at the White Horse but at another Village writers' bar, the Lion's Head. Compact and gray-haired, a bit on the high side of sixty, McEvoy had worked in publishing for twenty-five years. He'd written two novels set in Greenwich Village, *Terrible Angel* and *Our Lady of Greenwich Village*, and was working on a third. Though born in Dublin he'd lived in the Village most of his life. He had the very slightest hint of an Irish accent, saying "em" when an American would say "um," an Irish love of funny stories, and the passing storms of an Irish temper.

"My family came to this country in 1954. I was three and a half. My parents were in their forties. We were poverty-stricken in Ireland, so we

came here to be poverty-stricken. The only thing that saved us was a rent-controlled apartment." The family first lived at West Tenth and Bleecker Streets. "My father was the super there, and he used to get in arguments with the owners all the time, very hot-headed Irishman, with red hair. So we moved almost every year until we finally settled at 25 Charles Street.

"My father being a super and a plumber, I've been inside most of the buildings in the Village. He was a super originally on Horatio Street, and he was a plumber in almost every building in the Village, putting in boilers and doing stuff like that. I got to see a lot. He had four buildings on West Eleventh between Fifth and Sixth, one of the most beautiful blocks in the Village." McEvoy's father and mother both worked for Osmond and Helene Fraenkel, who had the town house at 25 West Eleventh Street. Osmond was a civil rights lawyer who helped found the ACLU and was on the defense teams for Sacco and Vanzetti and for the Scottsboro Boys. Helene had been one of the screenwriters for the 1944 Dick Powell movie It Happened Tomorrow. She had a writing cabin in the backyard. "A wonderful woman, and even in her eighties and blind, she was an extraordinarily beautiful woman with brilliant white hair. Her battles with my hot-tempered father still bring a smile. My father would be cursin' and swearin' and Mrs. Fraenkel would calmly say, 'Nevertheless, Mr. McEvoy!' I used to type her manuscripts and read the Times to her each day." In March 1970 he was relieved to hear that the Fraenkels were unharmed when Cathy Wilkerson and her friends blew up the town house across the street at 18.

Dermot went to the elementary school at St. Bernard's on West Thirteenth Street, now closed. "It was great. It was a real neighborhood. The three ethnic groups that made up St. Bernard's parish were Irish, number one, maybe Spanish number two at that point—they lived in the projects up on Fifteenth Street—and maybe Italian was the third one. But it seemed like it was mostly Irish. You played in the street. I just marvel at guys who make playdates for their kids. We came home, we put on our dungarees, and went out and played ball until five-thirty or whenever. I never understood why you have to worry about your kids so much. There were probably just as many perverts wandering then as there are now."

He remembered playing stickball between St. Luke's, the beautiful Episcopal church at Hudson and Christopher Streets, and the Archive Building, a massive redbrick warehouse on Greenwich Street, near the site of the old Newgate Prison, which stored documents for federal archives until it was converted into apartments in 1988. "That block of Greenwich, between Christopher and Morton, we used to play football there in the winter because it was empty at the weekends, you never get a truck. They were all bays down there for the post office, which was located on Christopher Street then. So that was empty, no traffic, and that's where we all played ball."

As a kid he encountered some of the Village's bohemians. His mother cleaned a rooming house at the corner of West Fourth and West Twelfth Streets that "was full of artists. I remember one fellow used to be sketching there, and to keep me quiet he'd give me a pad and some crayons. This is '54 maybe, '55? There were still guys with the dream. What was he renting for, maybe ten bucks, with the bathroom in the hall. Every time I pass that building I remember that fellow."

McEvoy's working-class Irish neighbors began to flee the Village in the mid-1960s with the dockworkers exodus. "St. Veronica's school closed, so half the kids went to St. Bernard's, half went to St. Joseph's. That was the beginning of the end of the Village as a working-class neighborhood. The Italians were leaving to go to the suburbs, which is an Italian instinct, not too much of an Irish instinct. There were tenements on Thirteenth Street which were torn down and replaced by apartment buildings. One of my playmates' father was a fireman, another was a detective, another drove a truck. Things like this. So you had blue-collar stuff, and people worked very hard." The death of the waterfront had a ripple effect through the community. "It slowly began to die off as the kids grew up, went away, went to college, whatever. So that's when the Village started changing, in '64, '65." The mom-and-pop shops that served the community—the grocer's, the butcher's, the shoe repair and barbershop and candy store—began to vanish one by one as well.

McEvoy's family, not dependent on the waterfront, stayed. He went to high school at La Salle Academy over on Cooper Square. From there

he went up to Hunter College, and from there he went into publishing, rising to a senior editor position at *Publishers Weekly*. And as he got old enough he began to go into the neighborhood bars.

"We used to drink at a place called the Cookie Bar," now Dublin 6, on Hudson Street. "A great place. A lot of guys from the HB Studio went in there." He remembered William Hickey, the Brooklyn-born character actor who played Don Corrado Prizzi in *Prizzi's Honor*. "Guys you would see on TV all the time, they used to go in the Cookie Bar."

As a young Villager and aspiring writer, McEvoy read the *Voice* religiously. His favorite *Voice* writer, no surprise, was Irish: Joe Flaherty. Born in Brooklyn, Flaherty was seven when "the body of his murdered dockworker father [was] fished out of the Gowanus Canal," Kevin McAuliffe writes in *The Great American Newspaper*, a history of the *Voice*. No doubt Mr. Flaherty had gotten on the wrong side of the mobsters who ran the Brooklyn waterfront. Joe was trying to be a writer while working as a longshoreman himself when the *Voice* ran his first piece in 1966. Dan Wolf soon had him writing regularly and wittily on sports and politics, and he was one of the stars of the paper into the mid-1970s. He also contributed to the *Times* and all the other New York papers, as well as to magazines, including *Penthouse*. He never lost his big, burly longshoreman's appearance or his habit of drinking like one.

"Joe always used to mention going into the Lion's Head," McEvoy recalled. Opened in 1966, it was a few steps down from the sidewalk at 59 Christopher Street near Sheridan Square. Like a lot of bars mythologized by those who drank away their youths or lives in them, there was nothing special about the Lion's Head space. The bar ran down the right side of the narrow front room. Small windows in the front let in sunlight and views of pedestrians' ankles for the afternoon drinkers. Over time the wood-paneled wall to the left as you entered was covered with the dust jackets of books written by the regulars. In the back, to the right, was a larger room with tables where food was served. There was no jukebox early on—it was a serious drinkers' and talkers' bar.

Because it was a few steps away from the offices at the time, it was a *Voice* hangout. For thirty years it would be the destination Village water-

ing hole for journalists from the other papers and magazines in the city as well, and for a sizable literary crowd, and for local politicians, and for assorted neighborhood characters. Along with Flaherty, Mailer, Jimmy Breslin, Frank McCourt, and Pete Hamill were regulars. When Hamill was dating Shirley MacLaine, he'd sometimes bring her there. Jessica Lange waited tables there; she quit to go star in *King Kong*. David Markson, who'd come to the Village in the mid-1940s, had switched from the White Horse to the Lion's Head by the time McEvoy started drinking there. "Markson was a heavy drinker. He would drink a couple bottles of vodka a day. His first shift would be at noon. At noontime in the Lion's Head in the old days, noon to two or three, there'd be a lot of writers in there, you'd have five or six guys at the bar, steady drinkers. Then David would come back at cocktail hour, and he'd come back at around eleven o'clock at night and drink for an hour or two, and then he'd pick up a bottle of vodka on his way home to put on his cornflakes in the morning. And this guy lived to be eighty-two and had all his faculties at the end."

Other novelists McEvoy met there included Vince Patrick (*The Pope of Greenwich Village*), Martin Cruz Smith (*Gorky Park*), and the damaged Fred Exley, whose *A Fan's Notes*, published to positive reviews in 1968, is a semiautobiographical novel about struggling with acute alcoholism, trips to mental institutions, and electroconvulsive therapy. Jerry Orbach would play the Exley character in a 1972 film adaptation. "Exley's was the first jacket up on the wall, as far as I remember. He lived upstate mostly. He'd always show up once a year or something, and he'd be fairly soused every time I saw him." Exley died of a stroke in 1992.

The veteran character actors Val Avery and Jack Warden were also regulars. "Val Avery lived right across the street. He was in *Columbo*. We used to have great conversations in Gristede's on Sheridan Square, because he was a gourmet cook, and we'd chat in front of the meat counter." Warden lived on Sheridan Square, "above what's now a Starbucks, which used to be the bar Jack Delaney's. Extremely regular guy. I never saw an entourage. None of these guys had personal assistants or anything."

In 1969 the big round table in the dining room of the Lion's Head became one of the unofficial campaign headquarters for Norman Mail-

er's quixotic run in the Democratic mayoral primary. Jimmy Breslin ran
with him for city council president and Gloria Steinem was persuaded
to run for comptroller; Doc Humes, the Voice's Flaherty, Jack Newfield,
Peter Maas (the Times crime reporter who wrote Serpico and The Valachi
Papers), and the activist Yippie Jerry Rubin all pitched in. Announcing
his candidacy, Mailer called New York City "a cancer and leprosy ward
that has infected the rest of the country" and called for a "hip coalition
of the right and the left." In a long piece for the magazine New York, Bres-
lin wrote that "this city is cut and slashed and bleeding from somewhere
deep inside." It was no time for politics as usual, he declared. "The City of
New York either gets an imagination, or the city dies." Their platform did
not lack for imagination. Under the slogans "No More Bullshit" and "Vote
the Rascals In," they resurrected an old notion of making New York City
the fifty-first state, proposed decentralizing political power to the neigh-
borhood level, and called for, as Mailer put it, "a day set aside, perhaps the
last Sunday of the month, when nothing would move or operate in the
city—no vehicles, no ships, no trains, no planes, and no electric power but
for places of dire emergency."

A Mailer-Breslin ticket might seem preposterous on the face of it. Local
media certainly thought so. When New York ran Breslin's piece, which he
titled "I Run to Win," it put a photo of him and Mailer on the cover with
a huge headline, "MAILER-BRESLIN SERIOUSLY?" Coverage in the dailies was
slight to mocking. Mailer, always trigger-happy when there was an oppor-
tunity to shoot himself in the foot, lashed out at the press, which didn't
improve the coverage. Yet most New Yorkers shared Mailer's and Breslin's
low opinion of the city's health. When John Lindsay was elected mayor
in 1965, he was seen as a kind of local version of JFK—young, handsome,
relatively hip for a politician, and a liberal reformer. He was the first Re-
publican mayor since La Guardia, elected on the good government prom-
ise that he'd clean up the corruption and ineptitude that afflicted the city
under the Democrats and what was left of Tammany Hall. But his own
term was so riddled with problems that Time would run a story in 1968
with the headline "John Lindsay's Ten Plagues." Crime and drugs were
rising, the middle class and businesses were fleeing, the Mafia was thriv-

ing, the cops were on the take, race relations went from bad to worse, the city's youth were in open revolt. Striking transit workers brought New York to a standstill on Lindsay's very first day in office, striking sanitation workers let mountains of garbage pile up on the streets, and teachers went on a long and bitter strike of their own that pitted black school administrators against the mostly Jewish union.

Campaigns were shorter in those days. The Mailer ticket announced its candidacy in April and the voting was in July. Breslin began to take it seriously. Mailer did, too, but he couldn't resist being Mailer. His biggest gaffe was at a fund-raiser at the Village Gate in May, where he got "dead drunk," he later admitted, and railed at his own would-be supporters, calling them "nothing but a bunch of spoiled pigs" and repeatedly telling them, "Go fuck yourselves." *That* the media covered. Meanwhile, a citywide poll indicated that 60 percent of voters had never even heard of Norman Mailer.

On primary day Mailer poled 41,000 votes. Breslin beat him with 66,000 and quipped, "I am mortified to have taken part in a process that required bars to be closed." (The city's voting day blue law was repealed a few years later.) Lindsay pasted together a third-party fusion ticket and managed to save his job that fall.

Everybody went back to drinking as usual at the Lion's Head. Flaherty wrote a book about the campaign, *Managing Mailer*, and a couple of New York novels, before dying in 1983 at the age of forty-seven. "Flaherty would drink a bottle of Remy Martin a day," McEvoy said. "But he died of prostate cancer, after he gave up drinking. He was clean and sober, lost fifty pounds and everything."

The Lion's Head went through a few owners and managements before running out of steam and closing in 1996. "It was kind of heartbreaking," McEvoy said. "You never thought the Lion's Head would ever close." The Kettle of Fish took over the spot. The interior is basically unchanged, just somewhat cleaner. Stock photos of sports stars replaced the wall of dust jackets, and big new flatscreens and dart boards went up. But the clientele is very different. During football season it's the premiere spot in the city for Green Bay Packer fans, who line up for hours outside on Sunday

afternoons in green jerseys and cheese hats. It's hard, McEvoy said, not to see the shift from writers' bar to sports bar as a metaphor for the changes Greenwich Village has undergone since the heyday of the Lion's Head. He said that the new owner was "a good guy" and liked having old Lion's Head regulars come in. "But if I recall the old days, the only time Wisconsin was mentioned was in political terms: 'Hey, Flaherty, who's gonna win the fucking Wisconsin primary?' "

## PART IV

## The Last Hurrah

# Prelude to the Stonewall Uprising

"GAY POWER COMES TO SHERIDAN SQUARE," THE *Voice* FRONT PAGE
declared on July 3, 1969. "Sheridan Square this weekend looked
like something from a William Burroughs novel as the sudden spec-
ter of 'gay power' erected its brazen head and spat out a fairy tale the
likes of which the area has never heard."

The writer Lucian Truscott was one of two *Voice* writers who hap-
pened to be nearby when the Stonewall riots erupted. He was in the
Lion's Head at the time, just two doors down. Howard Smith was work-
ing late in the *Voice* offices across Sheridan Square. Neither was a likely
candidate to cover the birth of gay liberation, though Truscott was by far
the less likely of the two. Smith was one of the *Voice*'s old guard. He'd
started out as office boy and gofer soon after the paper began and wrote
his first article in December 1957, covering one of Kerouac's appearances
at the Village Vanguard. By 1969 he was a well-known photojournalist
and radio personality who made the counterculture his beat; a couple
months after Stonewall he'd be doing live national radio reports from the

Woodstock festival and a few years later he'd produce and codirect the
Oscar-winning documentary *Marjoe*.

Lucian K. Truscott IV is a descendant of Thomas Jefferson who in the
summer of 1969 was a brand-new lieutenant in the U.S. Army. He comes
from a line of military men. His grandfather was the general Lucian
Truscott who served with Patton. His father was a colonel who served in
the Pacific and met Lucian's mom, a Red Cross nurse, in the Philippines.
Lucian was born in Occupied Japan, grew up on army bases in Europe
and America, and followed the Truscott tradition by going to West Point.
But even as a youngster on an army base he was reading the *Voice*, and
he started writing letters to Dan Wolf while a nineteen-year-old cadet at
West Point in 1965. A lot of cadets subscribed to the *Voice* for its events
listings and ads so they could plan their weekend trips to New York.

"I think my first letter to the editor attacked Abbie [Hoffman] and
Jerry [Rubin]," he recalls. Staff writers "all went through the roof," which
is probably why Wolf ran it. In 1967 Truscott got an invitation in the
mail to attend the *Voice*'s Christmas party. He took a train down from
West Point and showed up at Ed Fancher's West Tenth Street apartment
in his cadet's dress grays with an overnight bag in his hand. He learned
that night that Fancher had served under his grandfather, while Wolf
had fought in the Pacific. His first article for the *Voice* was about "some
Christmas be-in at the Electric Circus, with Wavy Gravy and the Hog
Farmers, and it was the *biggest* crock of shit I ever came across." He con-
tinued to write contrarian articles for the paper, guaranteed to draw the
angry letters Wolf liked.

Sometime after 1 a.m. on Saturday, June 28, 1969, he was drinking in
the Lion's Head with other writers when they noticed a commotion out-
side through the low windows. Cops were raiding the Stonewall again.
Nothing new about that. Cops regularly raided gay and lesbian hangouts.
They'd roust the patrons, arrest a few, and the place would reopen, often
that same night.

What was new this time was that the patrons weren't going quietly.
They were fighting back. As the night progressed toward dawn it turned
into a full-scale street battle. It happened again the following night, and

again a few nights later. What Truscott saw as he went out the Lion's Head door and up the steps to the crowded street was the start of the Stonewall riots, referred to as the Stonewall Rebellion or Stonewall Uprising. As the New Left was to the old Marxists, and the Black Panthers were to the civil rights movement, Stonewall was to gay rights—a louder, angrier, more militant new phase of a movement that by then had been around for a long time.

THERE WAS NO GAY PRIDE BEFORE STONEWALL, EDMUND WHITE has written, "only gay fear and gay isolation and gay distrust and gay self-hatred."

The conservative cold war swing in American culture during the post-war years and well into the 1950s came with a renewed animus toward homosexuals. Equating homosexuality with treason, the Red Scare search for Communist spies and sympathizers in every corner of American life included a push to expose suspected homosexuals in government and the military, because they were presumed to be easy targets for blackmailing by Soviet agents. New York State's antisodomy law made consensual oral or anal intercourse between unmarried persons, hetero or homosexual, misdemeanors punishable by jail time and fines. (The New York court of appeals would rule this unconstitutional in 1980 yet it remained on the books until 2000.) Many states stiffened old laws or passed new ones that were much harsher than New York's, with jail terms, mandatory psychiatric incarceration, even forced castration.

In this period, the Village's role as a relative haven for gay men and lesbians was maybe more critical than ever. This is the Village Joseph Touchette, known to everyone as Tish, moved to in 1952. He was still living there in 2012, turning eighty-eight in the rent-controlled one-bedroom apartment on Bank Street where he'd been since the end of 1955. He sat on the couch in the living room, a slight man, his hair dyed blond, trim in slacks and a bright yellow sweater, his face smoothed by a recent botox treatment, eyebrows plucked, wearing what appeared to be a little makeup. His voice was gravelly and bore a trace of an accent. The wall behind him was covered with framed black-and-white publicity

photos of what looked to be glamorous showgirls from the 1950s and '60s, in sequined gowns and beehive hair and Cleopatra makeup. They were all, in fact, female impersonators, all friends and colleagues of Tish. A few of the photos were of Tish himself.

Tish was born in 1924 in Connecticut. His was one of the many French Canadian families, like Jack Kerouac's, drawn to the New England mill towns. As a child he was affectionately known as Ti-Boy. In 1952 he and a friend took a tiny basement apartment on MacDougal Street. Later they moved to 146 West Fourth Street, the old Pepper Pot building, and then to Bank Street. Tish had been singing in New England clubs for a few years by then—standards, Edith Piaf songs, jump numbers the likes of Louis Prima's and Louis Jordan's—but never in drag until he went to audition at the Moroccan Village, a basement nightclub at 23 West Eighth Street known for its lavish female impersonator shows. In the dressing room, all the other performers were getting dolled up in their wigs and gowns. "You walk in as a boy and an hour and a half later you're a woman." His audition went well. The manager said, " 'Look, you can start Tuesday. But you gotta wear women's clothes. You gotta get a wig.' " That's when Tish became a full-fledged female impersonator. From then on, he said proudly, "The only time I didn't work is because I didn't want to."

Nightclub entertainment was still elaborate in the early 1950s. Tish's first year at the Moroccan Village, "It was like a Broadway show." There were twenty-five to thirty performers, a mix of chorus girls and boys and elegant female impersonators, with a band onstage behind them. Their shows were large productions. A comedian/emcee opened the show, followed by "an encapsulized version of Guys and Dolls." Solo acts followed—a singer, a dancer. Then the whole troupe was back on the floor for a medley from Chicago. Then solo acts again, then a grand finale, from The King and I, with the impersonators in full frills.

"Every night was Saturday night," Tish recalled. "We would get the proms. We would get the straight people. They're from, say, Idaho. They're walking down the street." They see the promotional photos outside the club. "They say, 'Is that a man or a woman?' . . . This is 1952, '53. Guys wearing women's clothing, Jesus Christ. And they're coming into this

place, they don't know if they should be there or not. I could see them from the stage. Especially the girls—'Oh my God, that's a man.' "

Tish eventually formed a small troupe, usually five or six performers, called the French Box Revue. (The name was a nod to the most famous and luxurious female impersonator troupe of the 1940s through the 1960s, the Jewel Box Revue, a complement of twenty-five female imper-sonators, with one female dressed as a man in a tux and paste-on mus-tache: Stormé DeLarverie, who would become a hero of the Stonewall riots.) From 1963 to 1967 the French Box Revue played the Crazy Horse on Bleecker Street, next door to the Bitter End. The Crazy Horse, named after the club in Paris, was a coffeehouse, no alcohol served. Tish's group did five or six quick shows a night, six nights a week. The owner charged two dollars to get in and split it with the performers.

On his nights off Tish would go dancing, partying in bars and after-hours clubs around the Village. "I used to go walking, in full drag, to Ar-thur's Tavern," the piano bar next door to Marie's Crisis on Grove Street. Beat cops, bar owners, and bartenders all knew he was a man in drag, he said, but they never hassled him about it. He believed it was because he was polite and respectful with them, and they returned the favor. He carried himself according to a motto he sought to pass on to the Village's next generation of more outrageous transvestites: "You are never going to be a lady if you weren't a gentleman first."

IN 1950, IN THE DEPTHS OF THE RED SCARE'S HARSH ATTITUDES toward homosexuals, two gay males in San Francisco founded a homo-sexual rights organization they gave the intentionally obscure name Mattachine Society, from a medieval term for masked jesters who were allowed to criticize the king. They coined the term "homophile" as an alternate to the more loaded "homosexual," held meetings and lectures, and published *Mattachine Review*. A lesbian counterpart to Mattachine with the equally recondite name Daughters of Bilitis, from Pierre Louÿs's 1894 book of pseudo-sapphic erotica *The Songs of Bilitis*, started up in San Francisco in 1955. They published the first lesbian magazine in the coun-try, the *Ladder*. Reflecting members' tightly closeted lives, both organiza-

tions were virtually secret societies at first; DOB members didn't even know one another's real names.

In 1958 twenty-year-old Randy Wicker saw his first copy of *Mattachine Review* on a Greenwich Village newsstand and went uptown to a meeting of the New York chapter on Sixth Avenue near Forty-eighth Street. He'd soon help prod the organization to become more visible and vocal. His Hoboken apartment today is crammed with files, photos, news clippings, and memorabilia documenting half a century as a political activist and social gadfly.

Born Charles Gervin Hayden Jr. in Baltimore, he grew up there and in Florida. His father was a corporate accountant, his tubercular mother spent several of his childhood years in a sanitarium, and his grandmother helped to raise him. He says his mother was "really a rather dreadful person" and "extremely puritanical," and remembers watching his father slave away at the office to buy her fancy clothes while "he himself was wearing dollar ties and fifty-dollar suits." So he grew up believing that "all women were extremely puritanical and antisexual like my mother. For that reason I really began life as a misogynist, which I now view as a mistake, because I missed out knowing half the human race. I believed all women just lived off men and used men. So when I found out I was gay my emotional reaction was, 'Oh thank God, I won't be a slave to women all my life.'" As a kid he made a pact with the other boys in his neighborhood that when they grew up they wouldn't spend their whole lives working for some girl. "Everyone agreed. Then when puberty set in I was the only one who kept the true faith," he says with a laugh.

"I knew I was gay from the age of fourteen or fifteen, but I had no sexual contact with anybody." At Washington and Lee and the University of Texas he studied psychology and sociology, partly to try to figure out the meanings of sexuality and sexual social norms. At eighteen years old, on a break from school, he decided to seek out other homosexuals. "I had read that Greenwich Village was a gathering spot." He came to New York and headed for Washington Square Park. "I put on bright red socks, which I thought was very obvious. I sat there in the park, and sure enough this balding, beady-eyed guy, around thirty-two—some 'old man'

of thirty-two—came up and started talking to me. He took me back to his place," on MacDougal Street, "and seduced me." He later took Wicker to his first gay bar, Lenny's Hideaway. "Here I entered this world that was just filled with these gorgeous, normal-looking, normal-acting young men, boys from Yale and Brown and young lawyers who were starting their careers. Young, upper middle class. That was probably what fueled my identity as a gay activist. I said, 'My God, this is what gay life is like? This is nothing like I read about in the paper, with lisping queens and Communists and child molesters and everything.' "

Most of the gay men he met "lived a dual life. They were not so open to their straight friends as they are today." Or at work. He knew one man who "had worked for AT and T for something like twenty years. He got a little tipsy at an office party and it became obvious that he was gay. His promotion was dependent on his immediate boss, and his immediate boss he knew was homophobic. He said, 'I can't quit. I have twenty years invested in this. In ten years I'll have a pension. But I know my career is doomed because my boss knows I'm gay. I have no chance of ever being promoted.' " At the first Mattachine meeting Wicker attended, "there were only eighteen, twenty members. Middle-aged men, not firebrand people at all. A couple of midlevel executives who would print the newsletter on the mimeograph machine at work without anyone knowing, things like that."

Wicker "became kind of a proselytizer." Promoting the society's monthly lectures, he got the attendance up from thirty to three hundred—and got the group evicted, because there was a bar on the ground floor and the landlord worried it would be busted for serving homosexuals. They wound up renting space above the Lion's Head and were still there when the Stonewall Uprising took place on the street below. Meanwhile Wicker's involvement in the organization led to an uneasy agreement with his father. "My father had read my diary. He'd told me he wanted me to be the best-adjusted homosexual I could be. He didn't tell my mother because she'd never accept it." When Wicker showed him some Mattachine literature, "He said, 'I don't think you're going to get very far with this. Just do me one favor, don't involve my good name.' " In

corporate America at the time, having a homosexual activist son would not have been good for a manager's career. "So my father gave me his name on the one hand and took it away on the other." Wicker invented a new name for himself. Randolfe was for the handsome, rumored-to-be-gay actor Randolph Scott. A girl he worked with told him that if she had a son she'd name him Wicker and he borrowed it. He kept Hayden as his middle name. He'd make it legal in 1967.

In 1962 Wicker went public in a big way. He was angered by a program on WBAI-FM, the city's public affairs radio station, on which a panel of psychiatrists claimed they could "cure" homosexuals through therapy. He marched to the station and harangued the manager. "I said, 'How can you put those morons, those frauds, on the air? We homosexuals are the experts on homosexuality. You should have us talking about our own situation.'" At the station manager's invitation, he put together a group of eight gay men willing to talk, anonymously, about their lives. Before the show even aired a columnist for the conservative Journal-American railed against the station for "scraping the sickly barrel-bottom," called Wicker an "arrogant and card-carrying swish," and suggested the station change its call letters to WSICK. When the program—the first such show on American radio—aired, conservatives called on the FCC to revoke the station's license. The agency ruled instead that homosexuality was a legitimate topic for discussion. Newsweek and the Times agreed. Although it would be another decade before the American Psychiatric Association took homosexuality off its list of mental illnesses, Wicker had forced the first step in that direction.

"Once that ruling was made, the phone was ringing off the hook at Mattachine," he says. He was, as it happens, editing the men's magazines Jaguar and Photo-Rama and others like them at the time. Without an uptight corporate job to lose, like most other Mattachine members had, he became a spokesman. In 1964 he appeared on The Les Crane Show, a regional TV talk show, taking calls from viewers, another first.

Wicker joined the New York League for Sexual Freedom, founded in 1963, whose members were male and female, gay, straight, and bi. Ginsberg and Julian Beck were early members. They advocated legalizing

abortion and abolishing censorship and argued for the rights of homosexuals and nudists. In September 1964 Wicker and maybe a dozen other league members picketed outside the U.S. Army induction center at 39 Whitehall Street downtown to protest the military's ban on homosexuals. The men wore jackets and ties, the women looked prim and proper as librarians. They weren't rebelling against American society, Wicker says, they just wanted to fit in and be treated as equals. The following spring there'd be larger, also peaceful demonstrations outside the White House and the UN.

In 1966 Mattachine turned its attention to the state liquor authority and the difficulties gay men had getting served in bars, even bars in the gay Village like the venerable Julius', the former speakeasy at the corner of West Tenth Street and Waverly Place. Since the 1950s it had been "known as a gay subculture bar because a lot of gays went there, but it was mixed," Wicker says. "Julius' didn't want to have any trouble with the police. They weren't paying them off. They were a legitimate bar. But they didn't want to become a gay bar either. So they had a doorman who stood there. If it got over a certain percentage of men to women, you couldn't go in unless you had a woman with you. That's the way they kept Julius' from becoming a gay bar." Once gay men got inside, Edmund White recalls, "Julius' had weird rules imposed on it." To prevent gay drinkers from cruising each other on the premises, "you'd have to be facing out. You couldn't look into the bar, but you'd have to look out through these big plate-glass windows that are still there, facing the street. It was so crazy." "It was the kind of gay bar that didn't want a certain element," Agosto Machado says. "It was khaki, loafer, button-down shirt. Or you could get away with an angora sweater."

Mattachine staged a demonstration the *Times* dubbed the Sip-in. After sending a press release to the local news, Wicker and three other members went around to bars, identified themselves as homosexuals, and asked to be served. They were hoping to be denied. The first bar they went to, informed by reporters that they were coming, simply closed down for the day to avoid the publicity. They proceeded to the Howard Johnson's on West Eighth Street at Sixth Avenue, where they were served, and a

Sixth Avenue bar called the Waikiki, where they were served, and finally to Julius', where one of them, Craig Rodwell, had recently been 86'ed for wearing a button Wicker made that declared "Equality for Homosexuals." There were gay men drinking inside when they arrived. Desperate, they appealed to Julius' manager, who played along and pretended to refuse them drinks. It got them the press they'd hoped for and was another first step, this one in a long march to legalizing gay bars. In 1967 Rodwell opened the Oscar Wilde Memorial Bookshop, said to be the first bookstore in the country dedicated to gay and lesbian literature. It started on Mercer Street and later moved to Christopher Street, where it would remain until 2009.

BY THE 1960s THE MAFIA INVOLVEMENT IN GAY BARS AND CLUBS that had started in the 1930s amounted to a nationwide stranglehold. In New York, Vito Genovese backed such mainstays of Greenwich Village gay socializing as the Bon Soir, which gave the teenage Barbra Streisand her first big push, and the Moroccan Village. Several other gay-friendly bars and restaurants in the Village of the 1960s allegedly had mob backing.

In the spring of 1967 mob owners took over the Stonewall Inn. In his book *Stonewall*, David Carter explains that the place already had a long history. In 1930 Mary Casal's lesbian autobiography *The Stone Wall* was published. The following year, two former stables at 51 and 53 Christopher Street were joined and opened as the tearoom Bonnie's Stone Wall, the name probably "a coded message to lesbians that they would be welcomed there." In the 1940s it "lost its rebellious edge" and became the Stonewall Inn, a popular restaurant for wedding receptions. In the 1960s, gutted by a fire, it stood boarded up and rotting for several years. Then the Genovese mobster Fat Tony Salerno and some partners, including Matthew "Matty the Horse" Ianniello, occupied the abandoned space. They laid black paint over the charred wood and painted the windows black too, common practice in gay and lesbian places. They also boarded and barricaded them and installed heavy steel doors with speakeasy-style peepholes. They brought in a few tables and chairs, a jukebox and ciga-

rette machine, hung a few lights, and left the big, rusting sign hanging out front. Later they'd add black lights and go-go boys in cages.

In March 1967 they reopened the Stonewall as a "bottle club," an old mob ruse to get around serving liquor without a license. Ostensibly they were members-only clubs, where the members brought and drank from their own bottles. As practiced at the Stonewall and other mob joints, it just meant that a bouncer sat inside the door with a sign-up book; you handed him a dollar to buy your "membership," signed a fake name, and you were in. The doormen also used a "Sorry, members only" pretense to keep out straight-looking people and, they hoped, undercover cops. The liquor was all hijacked swag, which didn't prevent the owners from watering it down and overcharging for it. Staff also peddled uppers and downers. Because the mobsters despised their gay clients they made no effort to keep the joints clean. Robert Heide and his friends dubbed the Stonewall the Cesspool. The bathrooms were dark and the glasses so dirty that activists blamed the joint for an outbreak of hepatitis.

Despite it all, the Stonewall was a huge hit from the night it opened. Its location just off Sheridan Square made it a destination. And there was dancing to the jukebox in the large back room, virtually unheard of at a time when gay men at Julius', only about a block away, couldn't even look each other in the eye. Carter reports that the mobsters made back their minimal initial investment on the very first night, and after that "it was essentially pure profit every day for nearly two and a half years."

"Stonewall was a sleazy lowlife bar that any self-respecting gay would not go to," Agosto Machado says. He proudly adds that he went there often.

ALONG WITH THE STREET KIDS AND RUNAWAYS WHO FLOODED THE Village in the 1960s were a number of effeminate gay youth who dressed in partial or full drag. They came from places where dressing that way in public would get them arrested or institutionalized, if they weren't beaten to death first. Some came to stay. Arriving with no money, contacts, or prospects, many of them soon fell to hustling, dealing dope, rolling bums, and shoplifting. Others were New York or New Jersey kids

who came to dress up and party on the weekend, often changing into their drag clothes in the car or subway, and changing back into male clothing on the way home.

Agosto was born in Hell's Kitchen of Chinese and Spanish parents, orphaned, and lived in foster homes around the city. Interviewed in the 2010s he declined to state his age—"just say thirty-nine," he suggested. He began hanging around the Village in the late 1950s and was in early audiences at the Cino, Judson, and La MaMa. Jackie Curtis "dragged me across the footlights." Curtis knocked on Agosto's door in his East Village tenement building one day looking for Agosto's neighbor, a Broadway actor. Eyeing Agosto, Jackie asked, " 'Can you sing?' And I said, 'No.' 'Well, can you dance?' I said, 'No.' 'Can you act?' 'No.' 'You wanna be in a show?' And I said, 'Yes.' " Curtis cast Agosto in her farcical drag musical *Vain Victory*, where he shared the stage with Warhol superstar Candy Darling. He also performed with John Vaccaro's Play-House of the Ridiculous, Koutoukas's Gargoyles, the San Francisco–based gender-bending troupe the Cockettes, and the Cockettes' New York counterparts the Hot Peaches and Angels of Light. "So I always say opportunity didn't knock, Jackie Curtis did."

In the mid-1960s Agosto joined the contingent of street queens who had become a large and increasingly visible presence on Christopher Street, along the waterfront, and in the meatpacking district. Officially Gansevoort Market, the meatpacking district is tucked in the northwest corner of the neighborhood, from Fourteenth Street down to around Gansevoort Street and the waterfront to around Hudson Street. What started out a produce market in the 1800s had grown by the 1960s into the country's third-largest slaughterhouse and packing zone, with as many as two hundred and fifty meat companies lining its streets. During business hours its extrawide cobblestone streets were filled with trucks, racks of hanging beef, the smell of offal, and the sight of butchers in bloody aprons taking smoke breaks on the loading docks. At night it turned dark and deserted, as did the waterfront that ran the length of the Village. West Street lay desolate under the crumbling hulk of the elevated West Side Highway. (A death trap from its start in the 1920s, the highway

would be closed to traffic below Eighteenth Street in 1973 when a large section collapsed. Most of it was taken down in the 1980s.) Among the dark warehouses stood a few once respectable hotels including the Keller, by the 1960s a decrepit flophouse inhabited by drug addicts, winos, and gay hustlers. The hotel's bar, opened in 1956, is said to have been the first gay leather bar in New York City. The Village People got publicity photos taken there in the 1970s. Other tough waterfront bars had long served a mixed clientele—dockworkers and truckers by day, sailors and gay men at night. West Street was also lined with parking lots for tractor trailers that stood empty and unlocked all night. And as the shipping companies fled the West Side for New Jersey through the 1960s, one by one the shedded piers stood dark and abandoned as well.

In the 1960s and '70s gay men turned this area into a public sex zone. Men from the era explain that much of their romantic and sexual activity happened in public places because it was so hard for them to go out on dates like other young couples. Before Stonewall, a gay man couldn't be seen out in most places with another man. Two young men or women couldn't hold hands across a table in most restaurants or slow-dance in most clubs (even though a New York court of appeals judge ruled in 1968 that "close dancing" by same-sex couples was not in itself illegal). Even in many bars like Julius' they risked being kicked out by watchful management or entrapped by undercover cops if they made or responded to obvious advances. If they met someone they liked and were feeling sexy, they couldn't get a room in most hotels like hetero couples could. Many of them lived with one, two, three roommates, which made bringing a date home difficult.

So they took it to the streets. "I cruised the streets constantly," Jean-Claude van Itallie recalls. "You didn't have to be circumspect about cruising. They couldn't arrest you for eyeing somebody." And they headed for the dark and desolate waterfront to have sex in the dingy flophouses and even in those parked trucks. Walking over to the waterfront late at night for some quick, anonymous sex in a dark and usually stinky truck was nicknamed "taking the express." Often multiple partners would cluster in the dark for orgies lit only by the glow of an occasional cigarette or

joint. By 1968 the trucks scene was well known enough to be included in the mainstream Sinatra movie *The Detective*, which has a gay subplot. It was also well known to the NYPD, whom gays called Lilly Law. Officers would stop by a few times a night to chase the gays out and make a few arrests. And it was familiar territory to gay-bashing thugs who'd have sex with the locals and then rob them, beat them, or push them off the edge into the filthy river, which usually meant they drowned. These thugs included gangs of what were known as "banjee boys," ultra-macho black or Latino gay or bi youth who came to the waterfront to prey on more effeminate men. Gay bathhouses represented a safer alternative to the waterfront, but there weren't any in the Village. The nearest were the St. Marks Baths in the East Village and the Everard Baths on Twenty-eighth Street. The swanky new Continental Baths, where Bette Midler would get her start with Barry Manilow on the piano, was on the Upper West Side.

Dark and out of the way, the meatpacking district and waterfront were prime strolls for hustlers—female, male, and in between. Agosto did some hustling in drag but says he was never very good at it. "I was a little timid, and I didn't feel that I was that attractive. When it got dark, I could roll up my pants, put on a skirt and what have you, stroll Christopher" and the waterfront. Like a lot of other younger, inexperienced drag hustlers, he was taken under wing by Marsha P. Johnson. Marsha was born Malcolm Michaels in Elizabeth, New Jersey, in 1944, and said she started dressing as a girl by age five but had to give it up when a neighbor boy raped her. In the Village of the mid-1960s she became one of the most outrageous and flamboyant queens on the streets and piers, "the ultimate and original low-budget drag queen," her friend Randy Wicker says. A tall, muscular black man, clearly male, clearly at least half mad, she wore cheap wigs, often with things like a stuffed bunny or a Valentine chocolate box as a hat, and ensembles pulled together from thrift shops and trash bins, draped in plastic beads and flowers, Christmas ornaments and lights, sometimes in big sneakers, sometimes on roller skates. She impressed people less as a typical drag queen than as a gender-bending, mind-bending sport of nature. A number of people, not all of them gay, treated her as a holy

madman, or madwoman, and called her Saint Marsha. Agosto calls her "a bodhisattva." She amended her given name from Michael to Marsha, took Johnson from the Times Square Howard Johnson's, and said the P stood for "Pay It No Mind."

She panhandled, hustled, sometimes waited tables, slept on the streets and in fleabags like the hotel Keller until Wicker took her in in 1980. She was arrested often, beaten several times, at least once pushed into the river, and once shot in the back by a cabdriver on the West Side Highway after giving him oral sex. She was also periodically in and out of mental institutions. Once, after Wicker took her in, he left her in his apartment while he went on vacation. She had an episode, spray-painted the walls and kitchen cabinets with silver graffiti and pulled the fire alarm. When firemen arrived she said God had told her to do it. On the Village waterfront, she would sometimes strip and throw her clothes into the Hudson as offerings to Neptune, then stroll naked up Christopher Street until the cops grabbed her. She would tear other people's clothes off and throw them in the river too. "I may be crazy, but that don't make me wrong," she used to say.

Through it all she remained a kind of half-crazed den mother to younger queens like Agosto and Sylvia Rae Rivera, born Ray Rivera in 1951, also a New York native and orphan, of Puerto Rican and Venezuelan descent. He began wearing drag in grade school and was on the streets hanging with the transvestite hustlers by adolescence.

"Marsha did try to help me get into the business, but it was really, really too tough," Agosto says. "She said that you don't drink and you don't do drugs when you're working the street. If a car drives by and stops you don't lean in. Because often for kicks the people will have a brick in their hand and smash you in the face. Or you could get robbed. Marsha was trying to teach me. And after a while she said, 'I've got to make a living too.' I'm not the smartest person, I'll admit that. I blew a guy, and at the time, what did I get, like twenty dollars or something. And he said, 'Oh, do you have change for a fifty?' And I said no. He said, 'Why don't I let you off, I'll go up to the store, buy something and come back.' And of course he never came back. But it's not like really being beat up and so

forth. Many of the girls were knifed. Or you sort of wait for the money, and he'd say, 'Get out of my car, faggot,' and you got out of the car. We were all flexible to the game. We were outsiders, we were gay, we were underage or a little over. The law wasn't going to work for us. And so if we were victims of anything, there was no one to go to."

He also worked the "tearooms," gay slang for the public men's rooms in the subway stations and parks. "You'd say, 'Oh, I did the BMT today.' And your friend would say, 'The whole line? Or just express stops?' " The tearoom in the Christopher Street station at Sheridan Square was extremely popular. Late on weekday afternoons men heading home from downtown offices, in suits and carrying briefcases, many with wives and kids waiting for them, would stop off "for a little entertainment." Agosto once took an innocent lady friend down there to catch a train and the platform was mobbed with men. "She said, 'Gee whiz, are they only running express trains?' She didn't know that it was so crowded because they had to wait to get into the tearoom." For years NYPD vice cops routinely raided tearooms and shook down these businessmen for payoffs in return for not arresting them on morals charges. Mayor Lindsay put an end to that.

When the Stonewall opened, drag queens and hustlers became regulars, in full or partial drag. Skull Murphy and the other doorkeepers kept a limit on how many full-on drag queens they'd let in at any one time; the Washington Square Bar, at West Third Street and Broadway, was more amenable to them but not as much fun. Nevertheless, by 1969 the Stonewall had developed a reputation, and older white gay men rarely went there. The Stonewall was for a clientele not welcome in the more mainstream gay bars. The crowd was young, many below drinking age and flashing fake IDs, many of them black or Latino. "It was not a bar I went to any longer," Edmund White recalls. "It had become pretty much a black-and-tan drag queen bar. We called them A-trainers because they came down from Harlem."

It was common knowledge in the neighborhood that cops from the local Sixth Precinct took payoffs from mob-owned bars and clubs in return for turning a blind eye to numerous infractions, ranging from selling

liquor without a license to providing entertainment without a cabaret license to operating a "disorderly" establishment because they allowed gays and lesbians in. Gay men called crooked cops "the Mafia in blue." At some places in the Village, Friday was known as "brown bag" day because the cops often made the rounds for their cash on Friday. According to one of David Carter's sources, the Stonewall handed cops twelve hundred dollars a week. Still, they had to make periodic raids to keep up appearances; they also did it when they needed to beef up their arrest numbers, because gay men tended to be easy collars who rarely put up a fight. When they were planning to raid a place they'd usually let the mob owners know in advance. The owners would make themselves scarce and wouldn't leave much cash or illegal liquor on hand for the cops to confiscate. At the Stonewall, there was no cash register for the cops to haul out; cash, as well as drugs, were kept in cigar boxes the staff could try to hide when a raid was on. The cops obligingly scheduled raids for early in the evening, when the place wasn't filled, so that business could resume later at night when the crowds showed up. It worked out for everybody except the staffers on duty during the raid, who had to take a collar for their bosses, and any patrons who were underage, in drag, or holding drugs, who'd get hauled off as well.

"You must remember, everybody was doing drugs back then," Sylvia Rae Rivera later explained. "Everybody was selling drugs, and everybody was buying drugs to take to other bars."

Sylvia described a typical raid at the Stonewall. The lights would come on, the jukebox was turned off, and the cops would stride in to divvy up the patrons. "Routine was, 'Faggots over here, dykes over there, and freaks over there,' referring to my side of the community. If you did not have three pieces of male attire on you, you were going to jail." Cops would arrest the staff and a few patrons who weren't observing the dress code or didn't have valid ID and push the rest out to the street. Those among them who were closeted in daily life would quickly slip away into the darkness, greatly relieved not to have been arrested and revealed as homosexuals. Others would go to one of the Sheridan Square coffee shops

for a while. The cops would padlock the door and depart with the cash and liquor—which rarely made it to the precinct house—and their collars. An hour later, "You come back, the Mafia was there cutting the padlock off, bringing in more liquor, and back to business as usual."

The Friday night of June 27, 1969, nothing was business as usual.

# Stonewall

D EPUTY INSPECTOR SEYMOUR PINE WAS A GOOD COP AND A NICE guy, a Jewish veteran of World War II who after joining the NYPD had done exemplary work against the mob in Brooklyn. In 1969 he was transferred to lower Manhattan's morals unit, where he was told to continue to harry the Mafia, including Mafia-owned porn shops and gay clubs. That year Interpol asked the NYPD to look into large numbers of negotiable bonds flowing illegally into Europe. The investigation indicated that the mob was blackmailing closeted gay men in the financial industry into stealing the bonds. One focus of the investigation fell on the Stonewall, where the known blackmailer Skull Murphy worked.

The NYPD executed a rash of raids on mob-run places in the weeks preceding the Stonewall flare-up, hitting the popular Checkerboard and a couple of after-hours clubs, the Snake Pit and the Sewer. Pine's unit, operating independently of the Sixth Precinct, raided the Stonewall on Tuesday, June 24, confiscating the liquor and arresting staff. When it re-opened the next night, Pine got a search warrant authorizing him not

only to toss the place again and remove any liquor but to chop up the wooden bars and confiscate the cigarette machine and jukeboxes.

The mood in the Village was unsettled that week. The weather was oppressively hot and muggy, fouling tempers. A lot of the older gay men escaped the city that Friday for Fire Island or up the Hudson. The recent raids had left the street kids sick of being ripped off in the clubs run by the mob only to be rousted out of those clubs by crooked cops.

After midnight that Friday night Pine sent four plainclothes officers, two male and two female, into the crowded club. Their job was to case the goings-on and identify the staffers. When they hadn't emerged after an hour he grew concerned. With two uniformed patrolmen and another detective he burst in. The lights went up, the music shut off, and cops barred the exit. Now eight cops had to deal with a very large and unhappy crowd. They separated the staffers and the more obvious drag queens from the pack, then had everyone else line up and produce identification. Rivera was there, under eighteen and carrying a fake ID. The crowd was surlier than usual, talking back, resisting. Pine called the Sixth Precinct for backup. A few uniformed patrolmen arrived outside on foot and in a couple of patrol cars. Pine requested paddy wagons to haul off the arrested staff and drag queens, along with the cases of liquor and vending machines. The precinct took its time sending only one, leading later to speculation that the cops at the Sixth were unhappy about Pine's independent unit messing with their turf.

As Pine let patrons file out the door they didn't slink away into the night as usual. They gathered on the sidewalk and in the little park, waiting for friends, watching. That crowd and the added spectacle of the police vehicles soon attracted a larger crowd as word flashed through the Village that something unusual was happening on Christopher Street.

"I had done an early session in the trucks," Agosto says with a bit of a wink. He was heading toward Sheridan Square when he ran into Marsha. She'd heard something was going on at the Stonewall. "Timid person that I am," he tended to avoid cops and think "they're right, we're wrong." But curiosity drew him into the growing throng.

Looking out a window on the west side of Sheridan Square, Howard

Smith saw the crowd metastasizing by the minute. He put on a press badge and headed over. He met up with Lucian Truscott, who'd come out of the Lion's Head. At first, they would both write, it was like a street party. "Cheers would go up as favorites would emerge from the door, strike a pose, and swish by the detective with a 'Hello there, fella,' " Truscott observed. "The stars were in their element. Wrists were limp, hair was primped, and reactions to the applause were classic." When the paddy wagon arrived, "three of the more blatant queens—in full drag—were loaded inside." When the handcuffed Mafia staff, including Skull Murphy, were led out, the crowd jeered. (At some point in all the ensuing tumult Murphy would manage to slip away, elusive as ever.)

The mood started to sour when a cop shoved a queen, the queen hit him with her purse, and the cop used his club to get her into the paddy wagon. But the real turning point, everyone agrees, was when a butch lesbian in men's clothing gave several cops a wild ten-minute fight before they could wrestle her into a patrol car. Watching her fight back, the crowd's mood grew angry and violent. The identity of this legendary "Stonewall lesbian," an Unknown Soldier of Stonewall, has been debated ever since. A candidate favored by many is Stormé DeLarverie, of the Jewel Box Revue. She had a reputation for being tough and was reputedly at the Stonewall that night. Later she marched in every Gay Pride parade until 2010, when at age eighty-nine she was moved to a Brooklyn nursing home. In an interview that year she seemed to confirm that she was the so-called Stonewall lesbian but her mental state at that point left the question open.

Seeing the Stonewall lesbian's heroic fight with the cops emboldened the crowd. They began to throw pennies at the cops—"coppers"—shouting, "Here's your payoff, you pigs!" Agosto, who'd found himself surrounded by the crowd, joined in. "That isn't so brave. You lob pennies at the police from a little distance. At a certain point I said, 'Oh my God, I'm out of pennies. I'm not going to throw quarters.' " Then the first beer bottle was hurled.

Folksinger Dave Van Ronk was celebrating his birthday in the back room of the Lion's Head when he heard shouts and a siren outside and

went to investigate. He told David Carter that he'd never thought much about gay rights before, but he'd seen cops rough up enough antiwar protesters to know he didn't like it. He joined the crowd in throwing change and apparently hit one cop just under the eye. Seymour Pine rushed out of the Stonewall and tackled him around the waist. Van Ronk was a very big man, well over six feet and beefy. It took a few other cops to knock the singer to the street. They dragged him into the Stonewall, handcuffed him to the radiator, and barricaded the door.

The party was over. Truscott reported the crowd began throwing bottles and paving stones; someone pulled a parking meter out of the sidewalk and used it to batter the Stonewall door. Others tried to set the place on fire. Howard Smith, who had flashed his press card to get in, was now locked inside with Pine and his small contingent of cops. He reported that they were very frightened and edgy, fingering their weapons, as the crowd outside roared and battered at the door and barricaded windows. "It was terrifying," Pine later said. Slowly, reinforcements from the Sixth and other precincts arrived in patrol cars, sirens wailing and red lights spinning. They pushed the crowd away from the front of the building so those inside could get out. Pine hustled Van Ronk and others into waiting vehicles that sped away. The crowd dispersed. The sun rose soon over a Christopher Street that looked like a full-scale battle had been waged. It was strewn with broken glass and bottles, twisted trash cans, stones, and that uprooted parking meter.

Nobody had ever seen anything like it before. Edmund White, who'd been passing by when it all erupted, credits the "A-trainers." "They were the ones who actually fought the police," he says. "I don't think the white middle-class queens like me would have ever done anything."

SATURDAY WORD FLASHED THROUGH THE GAY COMMUNITY THAT the revolution was on. The Stonewall's owners reboarded the smashed windows and chalked messages on them, including We are open and There is all college boys and girls in here. Gay men added their own messages: Support Gay Power and Gay Prohibition Corrupt$ Cop$ Feed$ Mafia. The Stonewall did in fact reopen that night but, as Truscott wrote, the

"real action . . . was in the street." A much larger crowd than the previous night's, some two or three thousand, choked the street and held a demonstration. They chanted "Gay power!" and other slogans. "Hand-holding, kissing, and posing accented each of the cheers with a homosexual liberation that had appeared only fleetingly on the street before," Truscott wrote. The street queens were out in force. A group of them formed a chorus line, kicking and chanting to the tune of the *Howdy Doody* song:

> *We are the Stonewall girls*
> *We wear our hair in curls*
> *We have no underwear*
> *We show our pubic hairs!*

Despite the hilarity of such "gay tomfoolery," as Truscott called it, the mood was angry and rebellious. The crowd blocked Christopher Street to traffic, attacking one taxi that innocently turned onto the block, rocking it back and forth, scaring the wits out of the passengers.

The NYPD showed up in full force as well, busloads of helmeted, baton-carrying Tactical Patrol Forces, sore about the previous night's rout and ready to crack some heads. Another full-fledged riot, actually larger and more violent than the first, ensued. The crowd threw barrages of bottles at the cops, lit trash can fires, smashed car windows, and slit tires. Phalanxes of TPF rushed into them, smashing heads. The crowd retreated down Christopher Street, only to race around the block and reenter the street "*behind* the cops," Truscott recalls. "So every time the cops were ready to catch a guy, suddenly there's fifty, sixty guys behind them going, '*Woo hoo!*' And they turn around and head in that direction. They just kept them running." The battle surged up and down Christopher and adjacent streets for hours. Cops fired tear gas into the crowd; Truscott wrapped a wet towel borrowed from the Lion's Head around his face so he could keep reporting. It finally died down around 3.30 a.m., once again leaving Christopher Street looking like a war zone.

Sunday was quieter. Many felt they'd made their point and it was time for the next steps. A group called the Homophile Youth Move-

ment, founded by Mattachine's Rodwell, distributed a typed, mimeographed leaflet, "Get the Mafia and Cops Out of Gay Bars," calling for a boycott of all mob-run establishments, including the Stonewall. The older men who'd missed it all came home from their weekend away. A lot of people had to get up for work the next day. The NYPD, exhausted from two nights of chasing rioters around and around, used a new tactic, quietly flooding the area with a large enough force to dissuade a third night of mayhem. Their actions Sunday night were "controlled and very cool," Truscott reported. After 1 a.m. he ran into Allen Ginsberg and the diminutive Warhol star Taylor Mead. "It was a relief and a kind of joy to see [Ginsberg] on the street." The trio went into the Stonewall, a first for both Ginsberg and Truscott. The mood there was a peaceful victory party. After Ginsberg danced for a while, he and Truscott walked toward Ginsberg's East Village home. "You know, the guys there were so beautiful—they've lost that wounded look that fags all had ten years ago," Truscott reported Ginsberg saying. He ended his long piece with "Watch out. The liberation is under way."

The Village was quiet the Monday and Tuesday that followed. Then, Wednesday evening, the Voice hit the streets with Truscott's and Smith's articles running off the front page. Their liberal use of terms like "the forces of faggotry" and "dancing faggots," and Truscott's descriptions of limp wrists and primped hair, stirred everyone up again. It's an indication of how marginal homosexuals still were in 1969, even in the Village, that even hip and generally sympathetic writers like Truscott and Smith blithely used such language. As did Allen Ginsberg, and Larry Kramer, who titled his first novel Faggots. "I was utterly clueless," Truscott says now. "Nobody [at the Voice] had any prejudice against any gay people. The Voice was fifty percent gay." It's worth remembering that politically correct speech codes were not yet in effect. Rock critics at the time referred to Jimi Hendrix as "Super-Spade" and meant it as a compliment. And the Voice's Stonewall coverage was far less outrageous than the daily papers'. On July 6 the Daily News ran a story headlined "HOMO NEST RAIDED, QUEEN BEES ARE STINGING MAD."

Then again, the Daily News offices weren't right on Sheridan Square. By

ten o'clock Wednesday night several hundred younger men were battling cops on and around Christopher Street again, hurling bottles, smashing windows, lighting trash can fires, and threatening to burn down the *Voice*'s offices as well. The cops swung their clubs freely this time, leaving streets all around Sheridan Square strewn with young people bleeding from head and face gashes. It was the most intense night of fighting yet, and the last.

STONEWALL REVEALED A GENERATION GAP IN THE GAY COMMUNITY as real and as wide as the one in the rest of society. Ginsberg, who had just turned forty-three that month, heartily approved of the younger people demanding their rights, but as a guru of flower power and Buddhism he also said he considered the rioting and destruction of property "bitchy, unnecessary, hysterical." On Sunday a hand-lettered sign had appeared outside the Stonewall: "WE HOMOSEXUALS PLEAD WITH OUR PEOPLE TO PLEASE HELP MAINTAIN PEACEFUL AND QUIET CONDUCT ON THE STREETS OF THE VIL-LAGE—MATTACHINE."

Randy Wicker admits he was typical of Mattachine's attitude. He was by 1969 a small businessman—he had a thriving little shop on St. Mark's Place, Underground Uplift Unlimited, where he sold slogan buttons like the one that had gotten Rodwell kicked out of Julius', other hip accoutrements, and underground publications such as the SCUM *Manifesto*. When Al Goldstein started publishing his sex tabloid *Screw*, Wicker was one of the first shopkeepers to sell it. At Goldstein's invitation he wrote an article for the May 23, 1969, *Screw*, its fourteenth issue, about anal sex. Al titled it "Up the Ass Is a Gas." It got *Screw* busted for promoting sodomy. Wicker was also a coeditor, with Ginsberg and others, of the pro-legalization *Marijuana Newsletter*. His name was at the top of the masthead. "I guess they figured if someone was going to get busted, it was better to have Wicker take the fall," he later quipped to an interviewer. For all that, he still believed in changing the system through nonviolent protest, the way he'd been doing with Mattachine for years, not in revolution. He'd had a falling-out with the more hotheaded Abbie Hoffman, a St. Mark's neighbor, who accused him of being a "hippie capitalist."

On Sunday, July 6, the weekend after Stonewall, Wicker gave a speech at the Electric Circus, right across the street from his shop. In the previous few years the Fugs had played there when it housed Stanley's bar, then Warhol turned it into the disco Exploding Plastic Inevitable and installed the Velvet Underground as the house band. Then a man named Jerry Brandt, a rock promoter who worked with acts from Sam Cooke and Chubby Checker to the Rolling Stones and Carly Simon, turned it into the Electric Circus in 1966.

Hearing about Stonewall, Brandt and his partners invited Wicker and Mattachine to host a night for gay men and women that Sunday. The club quickly distributed a flyer, "Oh Boy!," inviting gay people tired of being "packed into over-crowded, over-heated, over-priced, Mafia-controlled sewers" to come. The night started out peacefully, with gays and straights dancing. Then Wicker got up to give a talk, in which he voiced his concerns that if the younger gays got too out of hand "homosexuals would be the bogeyman of the '70s." He quoted Jesse Jackson's line that rocks through windows don't open doors. Among the fired-up younger crowd it marked him as out of touch or, as he put it, "the numbnuts of Stonewall. I went from being the spokesman of gay civil rights to the trash can of history that night." It also provoked a fight when a guy who apparently hadn't been informed that he was at a gay event freaked out and began to beat a young gay man standing next to him. He was dragged out, raving about "queers and fags." Wicker gave the bloodied young man a ride home. "He told me, 'I've been in the movement a week and beaten up three times.' I said, 'That's amazing. I've been in the movement for eleven years and haven't been beaten up yet.'" Wicker felt it confirmed his fears that the new militancy would dismantle all the work he and Mattachine had been doing.

In the immediate wake of Stonewall, Agosto says, "The talk on the street was a little more militant, collectively. 'They can't treat us this way anymore.' That's when the various gay lib organizations and factions started meeting . . . Then, due to the press and worldwide attention, suddenly there was a platform." The short-lived Gay Liberation Front started with a flyer that declared:

*Do you think homosexuals are revolting?*
*You bet your sweet ass we are*

Before the end of the year the GLF broke up in a flurry of leftist policy disputes. From its ashes came the more focused Gay Activists Alliance. Agosto, Marsha P. Johnson, Sylvia Rae Rivera, and even Wicker joined the GAA. Agosto was on the committee that found GAA its headquarters, a decommissioned FDNY firehouse at 99 Wooster Street below Houston, in what was coming to be known as Soho. The rent was cheap and there was space for offices, meeting rooms, and large social gatherings. Soho was still dark and deserted at night and felt remote from the Village. But those were its selling points. "We could make all the noise we wanted," Agosto explains. "We would really be left alone. We wouldn't have neighbors. We could have dances and meetings all the time." The GAA's Saturday-night dances became hugely popular. In 1974 the building was gutted by fire, believed to be arson; suspected perpetrators ranged from disgruntled former GAA members to homophobic neighbors, but no one was ever tried.

The Stonewall Inn closed in October 1969. It was said that it had just become too visible and hot for its Mafia owners. The big rusty sign came down and various shops occupied the space over the next couple of decades. It became a gay bar again in the early 1990s and has gone through a few managements since. The current Stonewall, like much else in the Village, is a kind of historical re-creation of a more heroic past.

On June 28, 1970, the first Christopher Street Gay Liberation Day march took place. It started as a few hundred nervous young gays and lesbians marching up Sixth Avenue with handmade banners and signs. By the time they reached Central Park, supporters had swelled the ranks to thousands. It was the start of the Gay Pride parade that has been held every year since.

The organizers of the early marches were as concerned as Mattachine had always been not to present too flamboyant or stereotypical an image of gays and lesbians. For that reason they decided to bar transvestites like Marsha and Sylvia from marching with them. They worried that if

drag queens marched every camera would focus on them and they'd be all you'd see in the news. Marsha and Sylvia's response was to make their own banner, gather some other drag queens, and march *ahead* of the parade. "So they ended up leading the whole parade!" Wicker says with a laugh. After that, they were officially included. "Those two lived their lives the way they wanted, and to me, they *were* Stonewall and the liberation," Agosto says.

Skull Murphy went on to a curious second life after Stonewall. He worked with mentally challenged kids, was a Santa at Christmastime, and, maybe oddest of all, emerged as a controversial leader of the gay pride movement. He was chairman of the Christopher Street Festival Committee created in 1972 as a way for local businesses to capitalize on the parade. At Murphy's urging, the parade altered its route; instead of marching up to Central Park, the parade now began there and ended on Christopher Street where the bars, shops, and outdoor festival were waiting to entertain the growing crowds with drinks, food booths, and tables loaded down with T-shirts and other gay-themed tchotchkes. Arthur Bell, who covered gay issues for the *Voice*, speculated that Skull was trying to make up for the sins of his earlier life. Others saw it as yet another ploy by the Mafia, or at least a questionable guy with Mafia ties, to skim profits from the gay community. As the 1970s progressed Murphy styled himself more and more a gay activist and rode as a marshal in the annual parade. Marsha rode with him one year. After Murphy died of AIDS in 1989 associates took over the festival.

For a brief time after Stonewall, Marsha and Sylvia, getting a cold shoulder from the more mainstream gay activist groups, started one of their own, Street Transvestite Activist Revolutionaries, or STAR. Along with a few other drag queens with names like Bambi, Bubbles, and Andorra, they ran STAR House in what Bell called a "dilapidated hellhole" of a tenement building in the East Village. A notorious Village figure named Mike Umbers rented it to them. Though straight, Umbers managed a number of mob-backed gay establishments in the Village, including a gay porn shop called Studio Book Store and a call-boy service. Marsha and Sylvia hoped to create a halfway house for homeless younger

drag queens but they couldn't quite match their street hustling lives to their good intentions and Umbers soon evicted them.

Randy Wicker closed his East Village button shop and in 1973 opened an art deco lamp shop, Uplift Lighting, on Hudson Street near Christopher. Sylvia worked there and Marsha often stopped by to get made up for her evening's stroll. From 1980 on Marsha lived with Wicker in his Hoboken high-rise apartment. His one stipulation was that she couldn't come and go in drag, so she'd carry her outfits in a shopping bag and change at the shop.

Marsha's body was found floating in the Hudson off the Village piers shortly after the Gay Pride march of 1992. Many friends were sure she was murdered—she'd had those numerous run-ins with violent tricks and gay bashers over the years—but police recorded it as suicide and did not investigate. Wicker and Marsha's family pressed for the case to be reopened, which it was, though with no results. After the funeral the large crowd of mourners marched over to the river, where they spread her ashes and tossed in flowers. The Marsha P. Johnson Center for gay and lesbian youth in Harlem was named for her, as was the band Anthony and the Johnsons. A few years later Sylvia, forty-four and homeless, tried to drown herself in the Hudson; she was hauled out and taken to Bellevue. She continued to feud for years with mainstream gay activists who, she felt, were selling out transvestites to get gay rights legislation passed. She died of liver cancer in 2002.

32

# Village Celebrities of the 1970s

WHEN WE FIRST MOVED HERE WE ACTUALLY LIVED IN
GREENWICH VILLAGE, WHICH IS SORT OF THE ARTSY
FARTSY SECTION OF TOWN, FOR THOSE WHO DON'T
KNOW, WHERE ALL THE STUDENTS AND THE WOULD-BES
LIVE, AND A FEW OLD POETS AND THAT.

—*John Lennon*

BY MOST MEASURES NEW YORK CITY HIT A LOW EBB IN THE 1970s. Economically, the city had reached its twentieth-century peak from the postwar years into the 1960s. It's strange now to think of New York as a major manufacturing center, but in the 1950s there were a million light manufacturing jobs in the city, roughly a third of its total job pool. The port was still busy and midtown bristled with shoulder-to-shoulder corporate headquarters. While downtown Manhattan gave birth to the first American avant-garde, the mainstream music industry, movies, publishing, television and radio,

advertising, Broadway, the nightclubs, and the fashion industry all
added to the city's unrivaled reputation as the glittering, bustling
capital of the world.

It started to slide downhill in the 1960s, pushed along by Mayor Lind-
say's ruinous combination of borrowing and taxing to buy off his con-
stituents with social services the city couldn't afford. It came crashing
down fast in the 1970s. The recession and "stagflation" that shoved the
nation's economy into a tailspin hit the city especially hard. The shipping
business that had been the lifeblood of the city for centuries had van-
ished, leaving the greatest port in the world to rot. From the mid-1960s
to the mid-1970s the city's light manufacturing shrank by more than half
and kept dropping. The exodus of corporate headquarters that began in
the 1960s grew to a flood in the '70s. Between 1960 and 1990 the num-
ber of Fortune 500 corporations maintaining headquarters in Manhattan
dropped an amazing two-thirds. Large portions of the music, film, and
television industries left as well. The white middle class and profession-
als went with them, nearly a million strong, their place taken by new
immigrants, many of them poor. The city government was borrowing
two-thirds of its budget by 1975 and would have lapsed into bankruptcy
had President Gerald Ford actually refused the request for a federal bail-
out as he'd threatened. The city cut more than fifty thousand jobs, froze
wages, hiked bus and subway fares, and ended free tuition at City Uni-
versity. As a result, basic services dropped to Walker-era lows. Trash piled
up and potholes yawned. Crime skyrocketed while the NYPD put too
few officers on the streets. Curtis Sliwa and his Magnificent 13, later the
Guardian Angels, began policing the streets for themselves. City schools
spent $3 billion a year to graduate illiterates. Parks deteriorated into
litter-choked rat warrens where only criminals and bums dared tread.
The Mafia-riddled unions were bleeding the city dry. New York felt ever
darker, dirtier, more dangerous and dysfunctional. Times Square contin-
ued its slide from being the Crossroads of the World to a frighteningly
sleazy zone of peep booths, grindhouses, pimps, hookers, and dope ad-
dicts. Whole areas of the South Bronx, Harlem, eastern Brooklyn, and the
Lower East Side looked like bombed-out war zones as slumlords aban-

More rockers, including Hendrix, began taking homes in the area, forming the kernel of the Woodstock festival, originally planned as a relatively small concert to raise funds for a recording studio in the town. At the last minute the organizers were forced to move the festival to another county. Dylan chose not to attend.

He decided life might be easier back in Greenwich Village, and toward the end of 1969 he bought 92-94 MacDougal Street, two town houses fused into a mini-mansion in the MacDougal-Sullivan Gardens row. In *Chronicles* he admits it was "a stupid thing to do." You can't go home again. The Village of 1970 was nothing like the Village he'd come to in 1961. It was much more crowded, especially in the heart of the MacDougal-Bleecker fun zone, and much crazier. And the Dylan of 1970 was a global celebrity, not the unknown kid he'd been in 1961. The town house was a far more accessible magnet for goons, moochers, loonies, and tourists than his Woodstock home had ever been.

None was more obsessed with Dylan than self-proclaimed Dylanologist and garbologist A. J. Weberman. Alan Jules Weberman was born in Brooklyn and by the later 1960s was a pot-smoking, acid-dropping East Village hippie and member of the Yippies. He'd been a huge fan of Dylan in the early 1960s and like many others was hugely disappointed when Dylan stopped being the protest-singing Voice of His Generation. Believing, not entirely without cause, that Dylan had sold out to the corporate entertainment establishment—and had become a heroin addict to boot—Weberman began scrutinizing Dylan's lyrics like a Talmudic scholar, searching for messages and meanings hidden under the surface of the words that might explain his hero's puzzling defection. With the help of another Dylan fan at NYU's computer center he entered Dylan's lyrics on punch cards and fed them to a computer, producing a massive printout he called the Dylan Word Concordance, published forty years later as the *Dylan to English Dictionary*. It proved to be even more inscrutable than Dylan's original lyrics, so he tried a new tack.

Learning Dylan's MacDougal Street address, Weberman noted the family's garbage cans next to the front door, a couple of steps down from the sidewalk level, behind a wrought-iron fence. Anthropologists ana-

doned or burned down thousands of buildings and the city's bankers, declining to throw good money after bad, practiced a policy of "benign neglect." Many of the abandoned buildings became heroin shooting galleries; on the Lower East Side self-described anarchist squatters took over others. Where the city had calmly endured its first blackout back in 1965, in seemed to fall into total anarchy in the widespread looting and vandalism of the great blackout in July 1977. Son of Sam ruled the night that spring and summer.

BY THE 1970S RENTS IN THE VILLAGE WERE GETTING HIGH ENOUGH that the flow of arty young hopefuls it had been attracting for a good one hundred and fifty years by then was diminishing to a trickle. Some still came, but from now until the end of the century, if you were a young person from the hinterlands coming to New York to start your career as a painter, a filmmaker, an actor or writer or rocker, you were more likely to start out in a tiny cockroach farm on the Lower East Side, which was cheaper and had succeeded the Village as the happening neighborhood. From now on, when arty people moved into Greenwich Village, they tended to be older and already successful arty people who could afford it.

Like Bob Dylan. After his mysterious motorcycle accident near Woodstock in 1966, which some speculated may have been a cover story for a period of heroin withdrawal (his heroin use was confirmed in a BCC report in 2011), Dylan hid out upstate for a while, recording what came to be known as *The Basement Tapes* with the Band and reappearing with yet another new style, the country sound of *John Wesley Harding* and *Nashville Skyline*. Before it was synonymous with the counterculture, Woodstock had a year-round population of about three thousand that swelled in the summer to twenty thousand, mostly vacationers from New York City. At first Dylan was left in relative peace there, but gradually the groupies, crazies, and fans (he calls them "goons," "moochers," "druggies and dropouts" in *Chronicles*) zeroed in on his home, making life hell for him and his growing family. He kept a couple of pistols and a rifle in the house to scare off the more persistent house crashers.

lyze refuse for insights into the daily lives and habits of ancient cultures. Weberman applied the same methodology to his study of the mysterious Dylan. Rooting around in the Dylan family's garbage cans he found, among the soiled diapers and rotting vegetables, such possibly meaningful clues as a handwritten letter from Dylan to Johnny Cash and June Carter Cash, a thank-you letter from the Little Red School House for a donation, a birthday card from Dylan's mother, fan mail, and hate mail. He wrote an article for the *East Village Other*, "Dylan's Garbage's Greatest Hits." Soon there were stories about Weberman in *Rolling Stone*, *Newsweek*, and *Time*. *Esquire* hired him to root through other famous people's garbage. He would claim to have analyzed the garbage of Jackie Kennedy, Bella Abzug, Joe McCarthy's assistant Roy Cohn, Gloria Vanderbilt, Dustin Hoffman, and, inevitably, Norman Mailer.

He began teaching an evening course in Dylanology at the Alternate University, a kind of hippie-radical continuing education center and meeting place on Sixth Avenue near Fourteenth Street that offered free courses on Marxism and community organizing along with his. Post-Stonewall it was a meeting place for newly radicalized gay activists such as the GLF. After one class Weberman led about thirty students down Sixth Avenue and through the Village to 92-94 MacDougal. He was going through Dylan's garbage cans, his students milling around, when they noticed Dylan standing across the street, arms folded, glaring. "He was so mad it looked like smoke was coming out of his head," Weberman said at the time. Dylan crossed over, Weberman put his garbage bags down, and the two of them walked down MacDougal Street to the storefront rehearsal studio Dylan was renting at Houston and Sullivan Streets. " 'What's this about?' " Weberman remembers Dylan asking him. "I said, 'Well, man, you know, it's about you and how you dropped out of the movement and how you're using heroin.' " Dylan rolled up his sleeve to show he had no tracks, Weberman says. He claimed that when he got home later that night Dylan called and tried to bribe him by offering him a job as his chauffeur.

Weberman, Abbie Hoffman, and the street singer David Peel formed the Dylan Liberation Front to free Dylan from his decadent stardom so

he could return to "the movement." For Dylan's thirtieth birthday on May 24, 1971, they gathered a crowd the *Voice* estimated at around three hundred in front of the town house, chanting "Free Bob Dylan! Free Bob Dylan!" Dylan was in Israel that day. By the time Weberman produced a birthday cake with candles painted to look like syringes, Dylan fans on the scene tried to break things up. Among them was Al Aronowitz, who despised Weberman despite having concluded that Dylan was, in his words, "a prick." The pro- and anti-Dylan factions scuffled; someone smashed the cake and knocked Weberman's glasses off. Cops showed up and arrested a guy as the crowd now chanted "Pigs! Pigs!" The birthday party was the last straw for Dylan. Weberman claims that sometime after that Dylan rode up to him on a bicycle on Elizabeth Street, tore his "Free Bob Dylan" button off his jacket, and knocked him to the sidewalk. Weberman admits he had it coming.

It didn't knock the obsession out of him. As late as 2009 Weberman was still hounding Dylan with books like *RightWing Bob*, in which he accuses Dylan of being anti-Semitic, a Holocaust denier, and racist. As a cofounder of an entity called the Jewish Defense Organization, he lobbed similar accusations at other Jews. He also cowrote *Coup D'Etat in America*, a Kennedy conspiracy book, and wrote a diatribe against former New York mayor Rudy Giuliani with the entertaining title *Homothug*, accusing him of being a closeted homosexual whose longtime lover was "a defrocked Catholic cleric and child rapist."

In the early 1970s Lucian Truscott was renting a second-floor loft at Houston and Sullivan Streets for two hundred dollars a month. "When I got this place people said to me, 'God, how are you going to make the rent?' That was considered outrageous. Most of my friends lived in forty- and fifty-dollar-a-month rent-controlled apartments on the Lower East Side. Or there were people who had been in New York longer who were in rent-controlled Village apartments, and they're paying less than a hundred dollars. And I went, 'Yeah I know, two hundred dollars is a lot. I'm gonna have to hustle.' "

Dylan's practice studio was on the ground floor next door. "There was this uninsulated Sheetrock wall between the first-floor lobby of my

building and his studio, and he had his piano right up against that wall. He used to sit down at that piano and write. I'd get up at around eleven in the morning and go across the street to the newsstand, which was next to Joe's Dairy, and get the *Times*, and I'd come back and hear him tinkling away on the piano. You could hear every word. I kept a folding chair down there and I would go back under the stairs, pull that chair up, and have my cup of coffee and read the *Times* and listen to him write. I heard him write songs for like three or four albums."

Dylan gave up on trying to live in the Village in 1973. He leased a secluded and secure complex in Malibu, where he could hide from his public in style among the movie stars and other celebrities. So he generated quite a buzz in the Village when he showed up again in June 1975, being driven around in a limo. Word spread that he was seeking musicians for a new touring ensemble. That June he caught his old pal Ramblin' Jack Elliott at the Other End on Bleecker Street. Originally the Bitter End, a no-alcohol coffeehouse, it had recently gotten new management, a liquor license, and a new name. (It would later switch back to its old moniker.) Truscott wrote a *New Yorker* "Talk of the Town" about it. The first night Dylan sat quietly through Elliott's set, then the two of them hung around together reminiscing until closing time. The second night was a nostalgic hootenanny. Dave Van Ronk, Bobby Neuwirth, and Dylan himself shared the stage with Elliott.

Dylan also caught a performance by a newcomer, Patti Smith, at the Other End that month. They met backstage and he invited her to go on his planned tour with him. She had just put her band together and was planning to record her first LP in a couple of months, so she turned him down. In her 2010 memoir *Just Kids*, Smith recalls the first time she saw Jim Morrison and the Doors at the new Fillmore East, formerly the Village Theater, when it opened in 1968. Of Morrison she writes that she "observed his every move in a state of cold hyperawareness . . . I felt, watching Jim Morrison, that I could do that." Smith was twenty that year when she stepped off a bus in New York with a copy of Rimbaud's *Illuminations* in her suitcase. She'd grown up working class outside of Philadelphia—her mom a waitress, her dad a factory worker, both Jeho-

vah's Witnesses—and came to New York to find the bohemian dream. She stayed at first with friends in Brooklyn, where she met Robert Mapplethorpe, a boy from Queens who was trying to make it as an artist. They were lovers until he realized he was gay, and they remained friends until he died. Together they prowled Greenwich Village, the East Village, the Chelsea Hotel, CBGB, and Max's Kansas City. Smith met Ginsberg when he tried to pick her up at a Horn & Hardart automat, thinking she was a skinny boy. She met Harry Smith in the Chelsea and Bobby Neuwirth; Neuwirth suggested turning her poems into songs over a drink at El Quijote, the Spanish restaurant and bar next door. She met Jimi Hendrix at the opening of Electric Lady and the Warhol crowd at Max's. She and Sam Shepard became lovers, cowriting and performing the play *Cowboy Mouth* together. She met the guitarist Lenny Kaye when he worked behind the counter at Village Oldies, the record store on Bleecker Street (later Bleecker Bob's). He began backing her up at poetry readings and the band evolved from there.

In September 1975 Smith and her band went into the studio to record their first LP with Smith's producer of choice, another hero, John Cale. As it turned out they didn't get along well. Cale's heroin use was out of control at the time. He nodded out early into one of their gigs and spent the remainder of it throwing up. Another time, when Smith explained to him her lofty vision for the album, he reportedly replied, "Patti, you're full of shit."

Dylan, meanwhile, had used the Other End as an informal after-hours spot to put together some of the caravan-load of musicians he'd gathered for what became the Rolling Thunder Revue. (Operation Rolling Thunder had been the official name of the sustained bombing campaign against North Vietnam during the war.) Truscott, who was friendly with the Other End's house band Jake and the Family Jewels, has fond memories of hanging out there after closing time and listening as Dylan, the Bowie guitarist Mick Ronson, T-Bone Burnett, and others jammed and rehearsed.

*    *    *

IN 1971 JOHN LENNON AND YOKO OKO MOVED TO THE VILLAGE too. They took a small basement apartment at 105 Bank Street, a nondescript cube of a house near the corner of Greenwich Street. Yoko had come to New York after World War II, attending Sarah Lawrence College, then becoming part of the downtown arts scene, participating in Happenings, working with John Cage and La Monte Young. In 1965 she and Lion's Head regular Val Avery starred in a no-budget B movie called *Satan's Bed* about an innocent Japanese woman who comes to New York and gets caught in a drug war. She met Lennon in London and they married in 1969. When the Beatles broke up she took an awful beating from the British fans and press and longed to return to New York, which she referred to as "the motherland." Evidently the change of scenery suited Lennon as well. The whole neighborhood buzzed about the ex-Beatle moving in, and at first no one intruded. "I'm just known enough to keep me ego floating, but unknown enough to get around, which is nice," Lennon said of his life in New York.

Photographer Bob Gruen lived a two-minute stroll away. After being kicked out of his Sullivan Street apartment in 1965 he'd bounced around various parts of the city, then moved back to the Village with his wife in 1970. He was still living in the same building in the 2010s. He'd stayed all those years because it was the Westbeth Center for the Arts and, as the saying in the Village goes, once you get an apartment in Westbeth the only way you leave is feet first.

Westbeth is a giant compound of five former industrial buildings, thirteen stories high in places, taking up a square block from West to Washington Streets between Bethune and Bank. It was Western Electric/Bell Laboratories' headquarters from the 1920s into the '60s. When Bell left the Village as part of the general exodus of industries from Manhattan in the 1960s, the newly created National Endowment for the Arts and a private foundation acquired the site. Rents were subsidized at below-market rates. The original plan was for Westbeth to give struggling artists a foothold in the city; tenants would cycle out of the complex as their careers developed and they could afford other, nonsubsidized housing. But as real estate prices in the Village soared in subsequent years,

Westbeth tenants held on to their spaces for dear life, while a long and fabled waiting list formed, with applicants waiting ten or fifteen years to get in. Westbeth has become what's known in the elder care industry as a NORC—a Naturally Occurring Retirement Community—with an estimated 50 percent of the original tenants, now in their seventies and eighties, still in their spaces in 2011.

On December 17, 1971, Gruen was at the Apollo Theater in Harlem to shoot a benefit concert for the families of the thirty-nine inmates and hostages killed in the Attica Correctional Facility riots of the previous September. John and Yoko made a surprise appearance; Gruen photographed while Lennon sang "Imagine" and "Attica State," written not long after the riots. Lennon asked to see Gruen's photos, so a few days later Gruen walked some of them over to 105 Bank Street and knocked on the door. He was surprised when Jerry Rubin answered and took the photos. Not a security guard, not a staff assistant, but the famed revolutionary. Rubin and Abbie Hoffman were acting, in effect, as the Lennons' political advisers at the time, pushing them into radical and revolutionary causes and taking advantage of their celebrity status to give those causes more presence in the media. A week before their Apollo appearance, at Rubin's urging, the Lennons had gone to Ann Arbor, Michigan, to headline a benefit concert for John Sinclair, founder of the White Panther Party and manager of the rock and revolution band MC5. Sinclair had gotten a ten-year jail sentence for carrying two sticks of marijuana. The Lennons' very visible and vocal involvement in these events had the ill effect of making them targets of the FBI, as Gruen later experienced firsthand.

David Peel, A. J. Weberman's friend, was also an influence on the Lennons' politics at the time. He and his generally out-of-tune acoustic guitar had been ubiquitous on the streets and in the parks of Greenwich Village and the East Village for a few years by the time the Lennons moved in. More a roving jester than a troubadour, he'd recorded a couple of albums with Jac Holzman's Elektra Records, featuring rangy, goofy songs such as his paean to the Village, "I Do My Bawling in the Bathroom." The Fugs' Tuli Kupferberg later suggested an alternate version, "I Do My Bathing in the Ballroom."

The Lennons became enamored of Peel the first time they heard him singing in Washington Square Park in 1971. He, John, and Yoko remained close friends for the rest of Lennon's life. He appeared onstage with them at the John Sinclair benefit, and Lennon references him in the song "New York City." Peel's exuberantly loose-limbed approach to writing and playing music was a clear influence on the raw, very un-Beatles sound of Lennon's early New York recordings. Lennon signed Peel to an Apple Records contract and produced his LP *The Pope Smokes Dope*, banned around the world on its release in 1972.

In February 1972 Gruen photographed Lennon's recording sessions with a Greenwich Village band, Elephant's Memory, for what became the album *Some Time in New York City*. The sessions were at the midtown Record Plant, where Hendrix had labored over *Electric Ladyland*. He was soon hanging out at 105 Bank Street and became John and Yoko's friend and in-house photographer through the 1970s, taking roll after roll of candid shots. The front room at Bank Street was an office but the Lennons spent most of their time in the back bedroom, taken up by a giant bed where they held court and a large television Lennon watched nonstop.

The far west Village was still remote and quiet in the early 1970s. "When I moved here it was west of nowhere," Gruen says. "I remember the first time I came trying to find the place, you go over to Sheridan Square and you start walking west, and you get to Eighth Avenue and there's nothing except a couple of empty blocks, a few town houses or something. I couldn't believe it was even farther, because the waterfront in those days was pretty deserted." Tourists rarely ventured west of Seventh Avenue. For their first year or so in the Village, the Lennons luxuriated in the casual atmosphere and their semireclusive status. "What he liked about New York was people didn't bother him as much as they did in other places," Gruen recalls. "Like in England, with Beatlemania and the intense crush of press. Living in New York gave him a little break from that. If you live in New York you're going to see a lot of celebrities, but that doesn't mean you're going to let them take your taxi. You're busy too. You get where you're going and say, 'Hey, guess who I saw today.' You

don't waste your afternoon trying to chase the guy. I think he really enjoyed the fact that he could rent a bicycle and go for a ride down Bleecker Street, walk over to Washington Square Park." There were some restrictions on Lennon's freedom. He'd draw a crowd if he went to a movie or grocery shopping, "but he thought that was okay. He could afford a servant to do his shopping for him." Like Hendrix before him, Lennon built himself a recording studio in the Village, Butterfly Studios, on West Tenth Street near West Street, a quick four-block stroll south of Bank Street.

As 1972 progressed, the Lennons' address on Bank Street became more widely known and less viable as a home. "It was a nice apartment, but after they'd been here about a year it was way too public. People would just come up and ring the bell. I was visiting one time when an assistant came in and said, 'There's somebody at the door.' They said, 'Who is it?' The assistant goes, 'Well, it's Jesus.' And then he clarified, 'Jesus from Toronto.' John said, 'We don't know that one.' "

And then there was the FBI. In 1972 the Nixon administration sought cause to revoke Lennon's visa and deport him. Eighteen-year-olds had gotten the vote and Nixon, up for reelection, didn't relish facing millions of radicalized Lennon fans that fall. Gruen remembers unmarked cars tailing him and Lennon all over Manhattan, and guys in fedoras and trench coats standing across the narrow Bank Street watching who went in and out. "They looked like G-men. It's really kind of corny how typical it was and how easy to spot." Still, Gruen says, "The fact the government would be looking at him just didn't seem plausible. John and Yoko said, 'We're hearing clicks on the phone, we think the phone line is being tapped.' People said, 'Yeah, yeah, sure. What did you smoke?' But in the '60s we used to say that just because you're paranoid doesn't mean you're not being followed."

By 1973, the same year Dylan left, life was no longer tenable for the Lennons in the Village. They moved up to the Dakota, the massive Victorian apartment building on the Upper West Side, with security, doormen, and a drive-in courtyard. Even there, Lennon couldn't resist going for walks in Central Park, being polite to the gaggles of autograph hounds

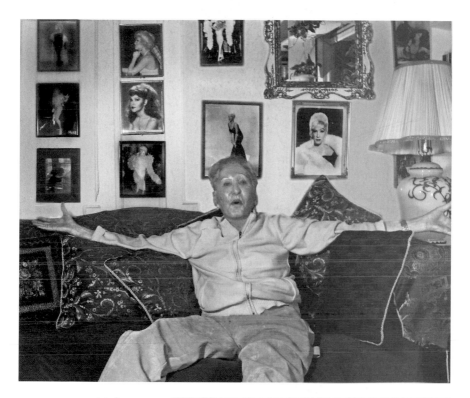

ABOVE: Tish, 2012. The two photos behind his head and left shoulder are of Tish as a performer. (*Photograph by Christine Walker*)

RIGHT: Barney Rosset. (*Photograph by Arne Svenson*)

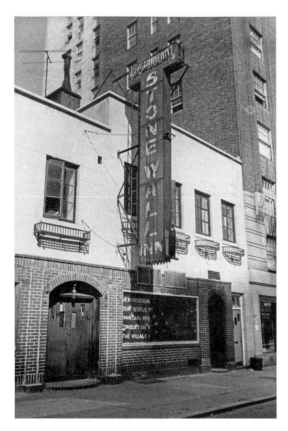

LEFT: The Stonewall Inn,
September 1969.
(*Diana Davies photographs,
Manuscript and Archives
Division, The New York Public
Library, Astor, Lenox,
and Tilden Foundations*)

BELOW: The first Gay Pride
march up Sixth Avenue,
June 1970.
(*Photograph by Fred W.
McDarrah. Getty Images*)

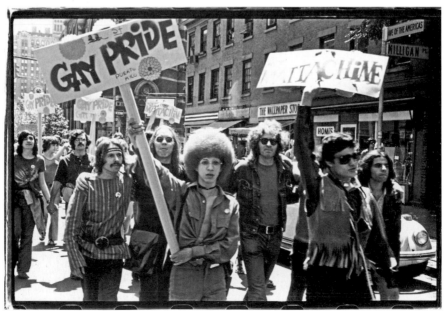

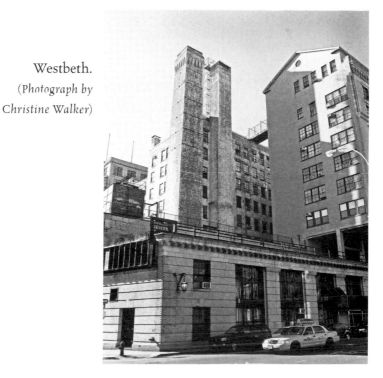

Marsha P. Johnson leading a STAR demonstration, 1970.
(*Photograph by Fred W. McDarrah. Getty Images*)

Westbeth.
(*Photograph by
Christine Walker*)

Jimi Hendrix during the construction of his West Eighth Street
recording studio, Electric Lady, in June 1970. He died that September.
(*Photograph by Fred W. McDarrah. Getty Images*)

Dustin Hoffman saves a painting from his home at 16 West
Eleventh Street after the explosion next door, 1970. (Getty Images)

John Wojtowicz on the real Dog Day Afternoon, August 22, 1972.
(New York Times)

The Village People's outfits were inspired by gay club fashions. (*Robert Heide & John Gilman Dime-Store Dream Parade Collection*)

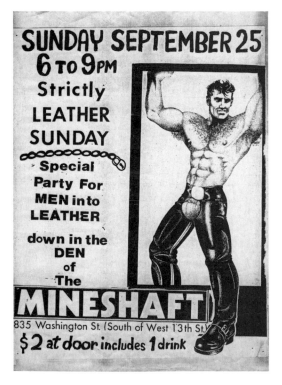

ABOVE: Quentin Crisp, the British monologist who often performed in the Village, strolls out onto a pier in 1978. A shed crumbles in the background.
(Corbis Images)

LEFT: Looking like a visitor from the past, on West Street in 2012.
(Photograph by Christine Walker)

David Amram at Cornelia Street Cafe in 2012.

(*Photograph by SashWeight*)

Washington Square today.

(*Photograph by Christine Walker*)

When she was thirteen she met nineteen-year-old Allan Arbus, an aspiring actor who worked for Russeks Furs. Despite her parents' desire that she marry someone closer to her social standing, the two were wed when Diane turned eighteen. After the war they became a fashion photography team, first for Russeks ads and then for the big fashion magazines. They never much liked it, and by 1956, bored and depressed, she quit the business. He kept at it while she went to study photography with Lisette Model at the New School. "Three sessions and Diane was a photographer," Allan later said. Model, who'd taken her own freakish portraits over the years, encouraged Arbus to seek out her subjects without qualms and to shoot them without arty pretense. In time it became her signature—foursquare portraits of people standing or sitting in the center of the image, staring directly and openly into the lens. The Arbuses moved to the Village, with Allan running the photography studio, at 71 Washington Place, next door to where Delmore Schwartz and his brother had rented their little attic in the late 1930s. The model and actress Ali MacGraw lived upstairs from them. In 1959 they separated and Diane moved into a former stable in a courtyard at 131 1/2 Charles Street, taking their daughters, Doon and Amy, with her. They grew up as Village girls; Doon acted in a couple of Caffe Cino productions and would become a journalist. Amy became a photographer.

Diane began to prowl all over New York and New Jersey looking for her unusual subjects. She hung around Washington Square Park in the mid-1960s and observed how its different users held on to their territories, "young hippie junkies" in one area, "amazingly tough, hardcore lesbians" in another, the winos in the middle. She haunted Coney Island, Hubert's Dime Museum in Times Square. Shy and petite, she used her unthreatening presence as a way to ingratiate herself with her subjects. She was searching for "the gap between intention and effect," she later explained, trying to ease her subjects to a place where they revealed the difference "between what you want people to know about you and what you can't help people knowing about you."

While she was developing that work she supplemented her income doing portraits of celebrities, including such Village figures as Auden and

at the building's entrance. That's what he was doing on the night of I cember 8, 1980, when Mark David Chapman, for whom he'd autographe a copy of his new album *Double Fantasy*, shot and killed him.

David Peel's LP *John Lennon for President* had come out earlier that year. Thirty years later he and his battered guitar could still be found on the streets of the unimaginably upscaled East Village, where he served, not unlike David Amram in Greenwich Village, as a living link to the neighborhood's rowdier, more rambunctious past.

ANOTHER PHOTOGRAPHER MOVED INTO WESTBETH AT THE SAME time Gruen did but she wasn't there nearly as long. When she moved into Westbeth in 1970, Diane Arbus (pronounced Dee-ann) was the toast and the scourge of American photography. Her portraits of midgets, giants, fat ladies, tattooed ladies, transvestites, winos, nudists, corpses, identical triplets, bottled fetuses, and other "freaks" (her term) polarize viewers and reviewers to this day, some seeing them as compassionate and revelatory, others as exploitive and ghoulish.

Her roots in the Village went back to her mother's father, Frank Russek, a penniless Polish Jewish immigrant who sold peanuts on trains, ran a bookmaking operation, and then in 1897 opened a tiny fur shop at Fourteenth Street and University Place. By the 1910s Russeks Furs had grown to a posh shop on Fifth Avenue and made the family millionaires. Diane's father, David Nemerov, married into the family business. Born in 1923, Diane grew up on the Upper West Side surrounded by maids, nannies, and chauffeurs. She went to the finest schools and most exclusive summer camps wealthy Jews could get their daughters into at the time. From early on she was aware that she lived in a bubble of privilege, "immune and exempt from circumstance," isolated from the world where most other people lived and struggled. She took to wandering around the city, staring at people, especially those who were somehow impaired or crippled or in other ways marked by life. Later she'd use the camera "as a kind of license" to stare, she said. From early on she was also prone to bouts of deep melancholy that in adulthood manifested as manic-depressive mood swings.

Marianne Moore. She took a fantastically Freudian photo of Mailer wearing a natty three-piece suit, sitting in a stuffed chair with one leg thrown over the arm to show off his crotch, the very embodiment of cockiness. "Giving a camera to Diane Arbus is like giving a hand grenade to a baby," he grumbled on seeing it.

In the 1967 "New Documents" show, MoMA exhibited a big selection of her work along with two other edgy photographers, Lee Friedlander and Garry Winogrand. It was seen as the opposite of Steichen's "Family of Man" exhibition in the 1950s. Where that had tried to show the inherent beauty and nobility of all humanity, "New Documents" seemed to imply that we're ugly, goofy, lonely oddballs. It made Arbus a star, though one critic singled her out as "the Wizard of Odds."

After ten years apart she and Allan got an amicable divorce in 1969 so he could remarry. She even threw a small reception for the newlyweds. Her bouts of depression grew increasingly deep and long, exacerbated by some physical deterioration from the hepatitis she'd contracted in 1966. She spent long days just sitting in Washington Square Park, unable to lift her camera, watching the stoned hippie kids panhandle, getting to know some of the tough street kids from the Bronx and New Jersey who came to hang out and sell dope in the Village. She moved herself and the girls from the Charles Street stable to a duplex on East Tenth Street. She was still working, more in demand than ever after the "New Documents" show, but sliding deeper into an unrelieved melancholia. She moved into the new Westbeth in January 1970, renting a ninth-floor duplex with excellent views of the Hudson. She began to teach a master class for young photographers in an empty apartment there.

In 1971 Westbeth developed a gruesome reputation as a place where arty people went to die. Residents nicknamed it Deathbeth and Westdeath. A woman was raped there that spring; the new Westbeth Playwrights Feminist Collective's first production that year would be called *Rape-In*. A woman who didn't live there walked in off the street, got up onto the roof, and jumped, smashing into the courtyard. Her mangled corpse lay there almost all day under a sheet before authorities removed it. Later, a Westbeth resident went up to the roof and jumped as well.

Some residents with kids who'd only just moved in moved right back out. Some people on the list dropped off. In repurposing the complex, the architect Richard Meier hadn't done much to brighten up its glum industrial interiors. It remains an infamously confusing rats' maze of long, narrow hallways, looking as much like a prison or mental hospital as an artists' community. To add to the bleakness, the hallway to Arbus's apartment had been painted black. In 1971 the streets around Westbeth could get quite lonely and grim after dark. It probably wasn't the best environment for a chronic depressive. Arbus's friends began to detect signs early that summer that she might be wrapping up her life. On July 27 her telephone rang unanswered. The next day a friend and sometime lover let himself in. He found her in the tub, her wrists slit, her body already starting to decompose. In the open journal on her desk her entry for July 26 was "The last supper." She left no other explaining note. Just another Westbeth suicide.

In 1971 Allan Arbus was in Los Angeles, finally pursuing the acting career he'd always wanted. He's best known for his work in the TV series M.A.S.H. but he got his start in two brilliant cult films, *Putney Swope* (1969), a satire about race relations on Madison Avenue in which his character is named Mr. Bad News, and the psychedelically weird *Greaser's Palace* (1972), in which he plays a zoot-suited Jesus who drops into a surrealist Wild West. Other characters include the eponymous Seaweedhead Greaser, Lamy Homo, the bearded prairie drag queen Spitunia, and a villain with possibly the most preposterous name in the history of filmmaking, Bingo Gas Station Motel Cheeseburger With A Side Of Aircraft Noise And You'll Be Gary Indiana.

Both films were written and directed by Robert Downey Sr., a Villager. Born Robert Elias in 1935, he was fifteen when he dropped out of the ninth grade and used his stepfather's surname Downey to enlist in the army. During his time in uniform he managed to get himself thrown in the brig three times, once while stationed in Alaska, for getting drunk with a buddy at their radar scopes and faking a Soviet missile attack. By 1960 he was in the Village writing Off-Off Broadway plays. When he read a *Voice* column by Jonas Mekas in which Mekas declared that anybody

could be a filmmaker, he rented a camera and started making low-budget underground films. He hung out with Mekas and other filmmakers at the Charles Theater on Avenue B, where one night a week anyone could screen his or her work. From the start he combined avant-garde technique and do-it-yourself impudence with a wild sense of humor, suggesting more than a few hours spent at the Caffe Cino and Judson. In the 1964 *Babo 73* he cast Taylor Mead as an addled president of the United States, with scenes shot guerrilla-style during a tour of the White House. The 1966 *Chafed Elbows* combines film and still photos to tell the ludicrous tale of Walter Dinsmore, a young man who wanders aimlessly from the New School to the Hotel Dixie like a Candide adrift in the Pop art world. In one scene, a man on the street paints him with the initials AW, declares him a work of art, and escorts him at gunpoint to the Washington Square Gallery, where "you'll be sold right away, because you're very pretentious." In another he records a gibberish pop song, "Hey Hey Hey," flip side to "Yeah Yeah Yeah." Tom O'Horgan did the music.

*Putney Swope* was his first commercial release. He followed it with *Pound*, adapted from a play of his that he later said was "done Off-off-off-off Broadway at a movie house at midnight." It's about a bunch of stray dogs waiting to be adopted or put down, played by actors. It's remembered today for the acting debut of Downey's five-year-old son Robert Downey Jr., born in the Village. A reporter for the magazine *Show* who spent time on the set during the filming noted a lot of pot smoking; Downey Jr. has said that his problems with drugs go back to his childhood, when his father gave him his first puff on a joint. He plays a puppy in *Pound*. His first recorded line of dialogue, addressed to the bald actor playing a Mexican hairless, is "Have any hair on your balls?" *Pound* was rated X for its foul language, and the United States Conference of Catholic Bishops denounced its "gross crudities played simply for irreverent and tasteless humor in a style that is more asinine than canine." It premiered on a double bill with Fellini's *Satyricon* and then vanished. Meanwhile Downey was directing plays for Joe Papp's Public Theater; when he directed David Rabe's antiwar play *Sticks and Bones* for a planned CBS broadcast, the sponsors backed out at the last minute. After *Greaser's*

*Palace,* Downey went on to a fitful, iconoclastic Hollywood career. In the 2000s Mekas's Anthology Film Archives worked with Martin Scorsese's Film Foundation to restore, screen, and archive some of Downey's earliest underground films, which hadn't been seen for decades.

ON THE OTHER SIDE OF THE VILLAGE, ANOTHER SORT OF ARTS CENter got up and running around the same time as Westbeth. It didn't last as long, however.

The eight-story, mansard-roofed Broadway Central Hotel, known as the Grand Central when it opened in 1870, hunkered at the northern end of the Pfaff's block, on the west side of Broadway between Bleecker and West Third Streets. In its heyday it was renowned as one of the largest and most luxurious hotels in the city. While high society moved uptown and the area slid downmarket, the Broadway Central stood through the decades, genteelly moldering and crumbling. In the 1960s street hustlers both straight and gay took their johns there. By 1970 it was a hulking eyesore that had fallen into severe dilapidation and, renamed the University Hotel, was run by the city in partnership with the owners as housing for around three hundred welfare recipients. (At the time, the city partnered with owners of many crumbling old buildings to convert them into "welfare hotels," a highly controversial idea.) The hotel's residents complained of rats, leaking pipes, crumbling walls, gaps in the floors, and exposed wiring. It was also filled with drug addicts, drunks, hookers, and thieves, according to the longtime state attorney general Louis Lefkowitz, who called it a "squalid den of vice and iniquity . . . an open and notorious public nuisance and a den of thieves." In one six-month period he counted one murder, three rapes, forty-nine burglaries, and assorted muggings and drug busts on the premises.

In 1966 Art D'Lugoff had come up with an ambitious plan for the back of the old building, the Mercer Street side, where the Winter Garden had been. He envisioned a multiuse performance center, "a kind of downtown Lincoln Center," as the *Times* later put it. Never in the chips himself, he talked a man named Seymour "Sy" Kaback into putting up the money to lease and convert the space. Kaback ran an air-conditioning business but

had a taste for showbiz; after installing the a/c in the Village Gate he had become a silent partner and financial backer to D'Lugoff. By the time the Mercer Arts Center was fully operational in 1971 D'Lugoff had moved on to other projects and Kaback was the sole owner and proprietor, with an artsy board of directors that included Viveca Lindfors and Rip Torn.

When it had its official opening late in 1971, the Times called the Mercer "the closest thing yet to a theatrical supermarket." Into its two-level, thirty-five-thousand-square-foot space Kaback had stuffed two large Off-Broadway theaters, the Hansberry and the O'Casey, the smaller Shaw Arena, a cabaret called the Oscar Wilde Room, another cabaret, rehearsal and workshop spaces, a film screening room, an experimental video lab called the Kitchen (in the hotel's former kitchen), a bar restaurant, and a hip boutique called Zoo. All of it was, of course, air-conditioned. Its theaters hosted successful productions of One Flew Over the Cuckoo's Nest, The Effect of Gamma Rays on Man-in-the-Moon Marigolds, The Proposition, and Macbeth, starring Rip Torn and Geraldine Page.

To subsidize the theaters the Mercer opened its doors to rock bands. It was a major incubator of downtown's proto-punk glam and glitter rock scene. Although inspired by British glam stars like Bowie and Roxy Music, New York's version was, naturally, harder, funkier, druggier. The Mercer's various spaces hosted acts such as the Magic Tramps, Suicide, Teenage Lust, Ruby and the Rednecks, Tuff Darts, Wayne (later Jayne) County's Queen Elizabeth, and, best known today, the New York Dolls. The Dolls were five rockers from various points around the city who hung out in the Village. Musically they were the Rolling Stones' bratty, cheeky little brothers, a loud, raunchy, and barely held together sound that was punk before punk. Their name was inspired by a doll repair shop on the Upper East Side called the New York Doll Hospital. Their trashy transvestite look—clunky heels, messily poofed hair, pounds of cheap jewelry, and clownish makeup—was inspired by the outrageous street queens in the far west Village. The Dolls' first public performance was at another notorious welfare hotel, the Endicott, on the Upper West Side, at the end of 1971. One of their first paying gigs was in a western-themed gay bar in Brooklyn Heights, which like Greenwich Village was not then the gen-

teel bedroom community it is today. Along with the Magic Tramps, the Dolls were in effect a Mercer house band.

Coming on the heels of the hippie 1960s, glam's raunchy street-slut aesthetic took some getting used to. "The first night I went there I was really shocked," Bob Gruen recalls. "I saw some men in makeup and ran out the door. Second time I noticed all the girls in miniskirts, and that was more like what I wanted to see. It was a really eclectic scene. The bands were wild and young and different." In the Kitchen he was introduced to the brand-new, smaller video cameras that artists were just then beginning to experiment with. He soon shot now classic videos of the Dolls. Zoo sold glam fashions from England, plastic miniskirts and platform boots, "things that had never been seen here. So it was really an influential space, with music and art and fashion all mixed together."

The grand Mercer experiment was sadly short-lived. It all came tumbling down, literally, on Friday, August 3, 1973. At around three in the afternoon the building's walls and ceilings began to make odd popping and crackling sounds. Cats and dogs in the building became skittish. Then residents in the front and a few bands and actors rehearsing in the back felt the walls and floors begin to shake. Loose sections of plaster fell from ceilings as wooden beams cracked. The whole building groaned and swayed. Residents, many of them elderly, some in wheelchairs or on crutches, fled screaming out the front, rockers and actors out the back. Cops and firemen gathered on Broadway, along with a crowd of gawkers. At around five o'clock the top floors of the hotel crashed down onto the lower levels, shooting loose bricks and clouds of dust out over Broadway. Then the building's facade fell in a thunderous roar, hurling a massive pile of rubble onto the street under a gigantic, dirty cloud.

Luckily, the building's creaking and groaning had given hours of warning before the collapse, allowing almost everyone to escape; four residents died and a handful of others received minor injuries. In the ensuing city investigations the hotel's owners were accused of having ignored signs of structural stress, as well as having removed load-bearing supports in the basement. Vibrations from the BMT subway line under Broadway probably precipitated the final crash. The back part of the building, where the

arts center was, came out relatively undamaged, and there was talk for a while of reopening it. But in the end NYU bought the property and cleared it for the big dormitory that stands there now. One survivor of the disaster, the Kitchen, relocated to Chelsea, where it became a flagship of avant-garde performance art.

As a band the New York Dolls didn't outlive the Mercer by much. Outside the hothouse of downtown New York City their look and sound were, as they titled their second LP, *Too Much Too Soon*. In London, where they disgusted the straights but were hugely influential on the coming generation of punks, their original drummer died of drugs and alcohol. The group continued to shed members and tour with not much success until finally collapsing themselves in 1976. In the late 1980s the singer David Johansen found commercial success when he transformed himself into Buster Poindexter and had a big hit with his cover of the soca song "Hot Hot Hot."

# After Stonewall

WE HAVE THE ULTIMATE IN FREEDOM—WE HAVE
ABSOLUTELY NO RESPONSIBILITIES!—AND WE'RE
ABUSING IT.

—*Larry Kramer*

IN THE WEDDING PHOTO, THE GROOM IS A SMALL YOUNG MAN IN an army uniform, his chest covered in medals and ribbons, one hand inserted in the uniform jacket like Napoleon, looking off to one side and smiling proudly. The bride looms over him, a head taller, thin and gangly in her white gown and veil, bouquet held down at her side, gazing off in the same direction and not looking particularly happy. In fact she looks like she'd rather be somewhere else.

Maybe she knew the trouble she was getting herself into. The groom was John Stanley Wojtowicz (WOY-towich). His bride was Ernest Aron, a pre-op transsexual. According to Randy Wicker, their "wedding" was held in their rooms at 250 West Tenth Street between Hudson and Bleecker

Streets in December 1971. A handsomely restored town house today, it was a gay rooming house nicknamed Boystown in 1971. The wedding was a mock Roman Catholic service, with a priest, whom Wicker believes had been defrocked, officiating. Wicker was there. So was Wojtowicz's mother, Theresa. She attended, Wicker says, because she adored her son and anything he wanted to do was okay with her. Same-sex marriages wouldn't be legal in New York State until June 2011, and even then they remained forbidden by the Catholic Church.

Wojtowicz was a New York native of Polish and Italian descent, a Vietnam vet who'd worked a number of low-end and dead-end jobs since mustering out. In 1967 he married Carmen Bifulco, with whom he had two children before leaving her in 1969. By 1971 he was a familiar figure at the GAA's Soho firehouse, where he went by the name Littlejohn Basso (his mother's maiden name). The *Voice*'s Arthur Bell called him "pleasant, spunky, a little crazy, and up front about his high sex drive." Wicker remembers other members thinking of him as a "crazy, obnoxious, unlikable bisexual." He met Ernest that year. Wojtowicz later wrote to the *Times*, in a letter the paper did not publish, that Ernest "wanted to be a woman through the process of a sex-change operation and thus was labeled by doctors as a Gender Identity Problem. He felt he was a woman trapped in a man's body." In 1971 Wojtowicz asked the GAA for permission to use the firehouse for a wedding. It prompted a fierce debate among the membership over whether gay marriage was good or bad for gay liberation. Deciding that the drag and fake-Catholic aspects would make it "a freak show," they declined, and Wojtowicz went on with it at his apartment instead.

Late on the night of August 22, 1972, Arthur Bell and Wojtowicz had a remarkable telephone conversation. Bell was in his Manhattan apartment. Wojtowicz was in a bank in the Gravesend area of Brooklyn—and all over the local television and radio news. Earlier in the day he and two accomplices, all armed, had walked into the bank and attempted to hold it up. Cops had arrived, followed by the FBI, news crews, and a crowd that swelled to thousands. As Bell and Wojtowicz spoke, Wojtowicz and one of his young accomplices, the nineteen-year-old Sal Naturale, were holed

up with seven bank employees as hostages, negotiating with the cops and FBI.

If that sounds familiar, it's because it was the basis for the film Dog Day Afternoon, directed by Sidney Lumet and released in 1975.

Two days before the bank heist, Ernest had swallowed sleeping pills in a suicide attempt and was taken to the psychiatric ward at Kings County Hospital in Brooklyn. In Wojtowicz's version, Ernest tried to kill himself because they couldn't come up with the money for his sex-change operation and he didn't want to live any longer as a man. That's why, Wojtowicz claimed, he attempted to rob the bank on August 22: he was desperate to get Ernest the cash he needed for the operation. "I did what a man has to do in order to save the life of someone I loved a great deal," he wrote to the Times. This is the tragic-heroic version of the story told in Dog Day Afternoon. But Bell's version, which appeared in the Voice the week after the event, added a darker, more complex background. Wojtowicz had actually planned the heist for months, Bell claimed, with help from the Mafia. In the spring, Wojtowicz told Bell, he'd met a Chase bank executive in Danny's, a gay bar on Christopher Street, and for some reason this man explained to Wojtowicz that on a specific Tuesday in August the Gravesend branch would receive a shipment of as much as two hundred thousand dollars in cash that could easily be snatched. Over the summer Wojtowicz recruited Naturale, who was a friend of one of Danny's bartenders, and another young man, Robert Westenberg. Sometime during the summer, Bell believed, Wojtowicz told Mike Umbers about his plan. Bell theorized that Umbers, manager of all those Mafia-backed businesses, supplied at least one of the weapons. In return, Wojtowicz was supposed to split the take with the mob fifty-fifty. (Speaking in 2012, Wicker declared the late Bell "full of shit" about this mob connection, claiming Bell was merely repeating scuttlebutt he'd heard on the street.)

At three in the afternoon on Tuesday, August 22, Wojtowicz, Naturale, and Westenberg marched into the Gravesend bank with guns waving. Then their problems started. First, they'd missed the shipment and there was only a little less than thirty thousand dollars cash in the bank. Then the cops showed up outside, and Westenberg bolted, leaving Wojtowicz

and Naturale with seven hostages. The famous standoff developed. As the crowd and the media grew, Wojtowicz played to them, ordered pizzas, camped it up, and gave several interviews to the press on the bank's telephones.

Bell heard about it around 10 p.m. that night, got the number at the bank, called, and was amazed when his old friend Littlejohn picked up. Wojtowicz, afraid that things were going to end badly, asked Bell to hurry out there and act as his mediator with the law. When Bell said it might take him a while, Wojtowicz replied, "Grab a cab. I'll throw a few hundred-dollar bills out the window." When Bell got there the officers in charge wouldn't let him speak to Wojtowicz. He did meet up with Ernest, who'd been brought from the hospital, looking wan in a housecoat and slippers. Ernest explained that he'd actually taken the sleeping pills in a melodramatic attempt to stop Wojtowicz from carrying out the planned heist. He said Wojtowicz had never told him that some of the take would pay for his operation. Ernest told Bell that the marriage had been rocky and unhappy, and that Wojtowicz "was sadistic in his sex habits" and "terrified" him. Bell also met up with another of Wojtowicz's lovers, who claimed that Wojtowicz planned to use the money to run away with *him*.

At around 4 a.m. the two bank robbers and their hostages filed into a waiting vehicle, arranged for them by negotiators, which sped off toward Kennedy airport, where a plane supposedly waited to fly Wojtowicz and Naturale to freedom. At the airport the FBI sprang, killing Naturale and arresting Wojtowicz. While the GAA debated whether or not to embrace the event as a revolutionary act—there was a lot of that going on at the time—Naturale's bartender friend asked them to help fund Sal's burial. They did not, and Naturale joined Dawn Powell and hundreds of thousands of others in the potter's field on Hart Island.

*Life* did a spread on the event that September. A Hollywood producer read it and paid Wojtowicz $7,500 for the film rights. At his court-appointed lawyer's suggestion, Wojtowicz set aside five thousand for a defense fund; he ended up being sentenced to twenty years in prison. He gave the remaining twenty-five hundred dollars to Ernest to pay for his sex change. On a Sunday afternoon in the spring of 1973, Wicker says,

he picked up Ernest at a gay rooming house in Brooklyn run by a man named Frank, who preferred to be called Franny. Wicker drove Ernest, who by then had been taking female hormones and was calling himself Liz Eden, to a doctor's office in Yonkers for the first step in the sex-change process: castration. All the other gay men in the house either begged Liz not to go through with it or taunted him about it. One told him to "go ahead and cut them off, baby. I never thought of you as really having balls anyway." Liz replied, "Even with no balls, I'll still have a cock a lot bigger than yours." From behind bars, Wojtowicz had promised Ernest/Liz that if he became a woman they'd get married again, legally this time. In the Yonkers doctor's office, Liz waited forlornly for a promised call from Wojtowicz, which never came. However, Carmen, Wojtowicz's legal wife, did call. She and Ernest had become friends after the failed robbery. The operation was agonizing; Ernest was so nervous and tense that his testicles withdrew into his abdomen and the doctor had to search for them. After the operation, a butch young lesbian came to the office to discuss a sex-change with the doctor. She offered to take Ernest's testicles. Wojtowicz had asked for them to be sent to him in a jar. The doctor refused both requests. Liz later completed the process to become a fully transgendered woman. Wojtowicz divorced Carmen but never married Liz.

Wojtowicz and thirteen hundred other inmates at the federal penitentiary in Lewisburg, Pennsylvania, watched a special screening of *Dog Day Afternoon* when it came out in 1975. His unpublished letter to the *Times* that year was largely a critique of the film, which he complained was "only 30% true." He loved Al Pacino's portrayal of him, of course, and thought Chris Sarandon was excellent in the Ernest role. However, he noted that "the actress playing my mother overdid her role, especially the overprotective Mother type baloney in it." She was Judith Malina.

Wojtowicz was released in April 1987. Liz Eden died of AIDS in Rochester that September. Wojtowicz lived quietly with his mother in Brooklyn until he died of cancer in 2006. "He wasn't mean or anything," Theresa told the *Daily News*. "He was very, very good to me." Refused the military burial he'd wanted he was cremated instead.

\* \* \*

"Stonewall was pretty amazing," Edmund White recalls. "I moved to Rome shortly after it happened, and when I came back a year later, everything had changed. There were suddenly lots of gay bars, including back-room bars, and giant discos in the meatpacking district that were on several floors. All that was just totally new to me. Lots of go-go boys, all that kind of stuff."

The Stonewall Rebellion had transformed the gay Village. The neighborhood had always been a magnet for gay men but now they were conscious of themselves as a community—or a "gay ghetto," many said—and a rapidly growing one, as men flocked to the Village from all points to be part of it, to party, or just to see it. Agosto remembers gay tourists flooding the west end of the Village. "People were paying homage," he recalls. The reverberations quickly spread across the country. Gays and lesbians came out en masse and started hundreds of organizations and publications. Through the 1970s they won new acceptance from much, though certainly not all, of mainstream society. Americans expressed a new tolerance for, even fascination with, gay and lesbian cultures. Some young people who weren't gay wished or pretended they were. Suddenly many of their rock stars were gay or bi or pretending to be—Bowie, Jagger, Lou Reed, Freddie Mercury, the glitter and glam bands.

And then there was disco, not exclusively a gay phenomenon but widely associated with gay culture. Different cities (Philadelphia, New York) and subcultures (black, Latin, gay) claimed credit for originating disco, but it's uncontested fact that one of the very first discos, and some argue *the* very first, started in the Village in 1970. It was not in a commercial club but in David Mancuso's loft at 647 Broadway—the old Pfaff's building, a few doors down from the Mercer Arts Center. Mancuso, fed up like so many other young men in the Village with mob-run gay clubs, equipped his loft with a state-of-the-art sound system and began hosting private Saturday-night parties for his friends and their friends, spinning records nonstop all night. A bit of a hippie, he called it "Love Saves the Day," but as word spread it became known simply as the Loft. It was soon the hottest Saturday-night spot in the Village, and imitators both private and commercial sprang up all over the neighborhood. Where Mancuso's

parties were alcohol- and drug-free, copious drinking and consumption of energy-enhancing drugs, from amphetamines to alkyl nitrite "poppers," were the norm in most other venues. (Doctors prescribed alkyl or butyl nitrites for heart patients, who broke (*popped*) small capsules and inhaled the vapors, providing quick relief of chest pain. They became very popular in gay culture in the 1970s, both as a stimulant on the dance floor and as a muscle relaxant aiding anal sex.)

One of the most popular discos for a few years, the Flamingo, was a members-only all-night party in a loft down the block from Mancuso, on the second floor above the Chase Manhattan Bank at the corner of Broadway and Houston Street. In *States of Desire*, his 1980 travelogue of gay communities in America, White described "hired musclemen garbed as centurions or deep sea divers or motorcyclists" striking poses on a raised platform as shirtless men on the crowded dance floor gyrated and groped from midnight until ten in the morning. By the mid-1970s disco dominated pop music, and the largest, most posh Manhattan discos attracted huge crowds, straight and gay and undecided, every weekend.

The gay Village of the 1970s was also the center of a cabaret revival. Nostalgia for the elegance and sophistication of the 1920s and '30s nightclub era helped launch acts such as Peter Allen and Manhattan Transfer to national stardom. Reno Sweeney's Paradise Room looked like a small-scale reproduction of a Busby Berkeley set, with art deco and potted palms. Operating on West Thirteenth Street from 1972 (the year the movie *Cabaret* was released) to 1979, the nightclub named for a character in *Anything Goes* hosted intimate performances by Allen and the Transfer, Karen Akers, Diane Keaton (who was just then a rising movie star as well), Baby Jane Dexter, Marvin Hamlisch, and Nell Carter. Some odder acts were mixed in with the more straightforward cabaret revivalists, including Patti Smith and the post-Velvets Nico. When Holly Woodlawn brought her drag chanteuse act there in 1973, FBI agents showed up and hauled her off the stage. A few years earlier she'd gotten arrested for impersonating a French diplomat's wife and cashing a two-thousand-dollar check. She was rearrested at Sweeney's for failing to make restitution. A few weeks later the club hosted a fund-raising benefit for her. In 1977

Charles Ludlam, founder and star of the Ridiculous Theatrical Company, performed his show The Ventriloquist's Wife with Ridiculous regular Black-Eyed Susan and a dummy he named Walter Ego. Maybe strangest of all, in January 1978 Edith Beale—Little Edie of Grey Gardens (1975)—made her debut there as a cabaret singer. Big Edie had died in 1977 and Little Edie felt she was now free to live out one of her life's dreams. In a red dress and signature snood with a crown of silk leaves, the sixty-year-old sang "Tea for Two" and other standards and bantered, crazily and winningly, with the packed house.

THE INCREASING ACCEPTANCE OF HOMOSEXUALITY OCCURRED IN the context of greatly relaxed attitudes toward sexuality in general, the sexual revolution that swept mainstream America of the 1960s and '70s. Made possible by the Pill, cheered on by Barney Rosset and Al Goldstein and Cosmopolitan and The Joy of Sex and Deep Throat (the latter two in 1972, the same year the Pill became universally legal and available), the 1970s was the Sex Decade, the porn chic decade, the decade when everybody in America was supposed to be having it, experimenting with it, doing it in hot tubs and Plato's Retreat (the hetero swingers club that replaced the gay Continental Baths in 1977), doing it with one another's spouses and strangers, doing it in groups, doing it with a lot of drugs, doing it without guilt or shame, or love or affection. Dozens of movie theaters in the city now screened gay and straight porn. Conservative political leaders including Ronald Reagan, religious leaders from the pope to Jerry Falwell, and spokespersons such as Anita Bryant rallied the resistance.

In the Village, true to tradition, the sexual revolution took on some of its most extreme expressions. Because gay men were identified and stigmatized on the basis of their sexuality, a sexuality they'd hidden all their lives, many of them now equated sexual liberation and political liberation. Gabriel Rotello has written that the more radical among them argued that "if liberation meant rejecting constraints, then to be more liberated meant to reject even more constraints, and the most liberated (meaning the most gay) were those without any constraints whatsoever."

"Gay liberation began about men loving men," the activist and writer Richard Berkowitz says. "But it became about so many men, so little time."

The activist and club promoter Jim Fouratt recalls, "It wasn't about changing the world. It was about getting laid." Many gay men were having sex with one or more strangers every week. For some men it was many more than one stranger and much more often than once a week. Life for the most active gay man in the 1970s was a nonstop orgy in the baths, the clubs, the backs of gay bookstores, the trucks, and the piers. In the early 1980s Berkowitz's friend Michael Callen, then twenty-seven, calculated that in nine years of active gay life he'd had sex with about two hundred men a year in the baths alone. When he added sexual activity in clubs, bars, and other venues, "I estimate conservatively that I have had sex with over three thousand different partners."

Some gay men began to explore consensual S&M, bondage, and ritual humiliation. Where there had been a few leather bars, such as the Keller, in the 1960s, now there were many full-on bondage establishments, where sadomasochism and ritual mortification became full public spectacles. In their role playing, gay men assumed the costumes of the male figures who had traditionally dominated and oppressed them: cops, bikers, blue-collar workers, Nazis. The Village People would soon adopt similar costumes as kitsch. According to Berkowitz, it was all a way of expressing and maybe purging "a lot of self-loathing, a lot of insecurity, and a lot of the culture's contempt."

Whatever the reasons, the era of "Macho Man" had arrived. Gay Villagers pumped up. Gyms became favorite cruising spots. The new uniform when cruising in the neighborhood consisted of tight jeans, tight white T-shirt, engineer boots, and leather jacket. In a back pocket they wore a bandanna, color-coded to flag the wearer's sexual preference. Relatively simple at first—black for S&M, green for prostitution, and so on—the code grew bewilderingly long and specific over the years, adding more shades and patterns to signify very precise tastes, until vendors took to giving away helpful cards listing all the many current variations.

In his memoir *Stayin' Alive*, Berkowitz writes that after moving to Manhattan from New Jersey in 1979 he found a huge and very ready mar-

ket for his services as a freelance S&M hustler. Born in 1955, he'd grown up in a working-class environment where homosexuality was a hidden shame. He learned to hustle at the highway rest stops and Howard Johnson's parking lots where men furtively met. He came out and became a gay activist as a student at Rutgers when frat boys hung an effigy from a tree in front of their house with the sign, "The only good gay is a dead gay. Back to your closets homos." Berkowitz helped organize a protest rally at which the Voice's Arthur Bell was a speaker. A lesbian friend introduced Berkowitz to gay Manhattan, taking him to Le Jardin, a midtown disco popular with the Warhol crowd, and to stroll Christopher Street. By the time he moved across the river the Village was such a mecca that he couldn't find an affordable apartment and took one on West Fifteenth Street, which was close enough. He arrived "a take-charge twenty-four-year-old with an ample supply of anger." His submissive clients taught him "how to channel that hostility," and bought him the leather outfits and S&M accountrements until "my apartment started to look like a sex shop."

Gay entrepreneurs opened businesses all over the West Village in the 1970s, and the mob was only too happy to pitch in. By the end of the 1970s gay bars would be legalized and more than a hundred, mostly gay-owned, were operating legitimately around the city. The Mafia's stranglehold was finally loosened but throughout the decade mobsters kept a hand in the gay after-hours clubs, sex clubs, prostitution, porn shops, and drug dealing that flooded the Village west of Seventh Avenue. In 1971 the Voice's Mary Perot Nichols wrote that the Village, "once a relatively harmless coffeehouse scene with some narcotics available," had seen "an influx of after-hours clubs, pornography shops, prostitutes . . . and an extremely heavy supply of heroin." That much of this commercial activity targeted a newly emerging gay clientele she left unstated. That the mob was behind most of it was a given. Nichols reported that many Villagers believed the mobsters were acting as shock troops for powerful real estate interests, who hoped that if the neighborhood deteriorated far enough it would empty out and be ripe for new development.

That summer a joint organized crime task force of NYPD and federal

agents executed a sweeping raid of gay after-hours clubs in the Village, all reputedly mob-run. Among the clubs they shut down was Christopher's End (later the Cock Ring), known for its nude go-go boys. It was run by none other than Mike Umbers and was located in the frighteningly sleazy Hotel Christopher, with tiny, filthy rooms rented by the hour for sex and drugs.

"The city was exploding with sexual playgrounds," Berkowitz says. "There were places to go have sex morning, noon and night." The nerve center of gay sex clubs was the meatpacking district. In the post-Stonewall 1970s this tiny corner of the Village, along with lower Chelsea and the waterfront, saw an explosion of sex clubs and leather bars with names like the Mineshaft, the Anvil, Ramrod, the Spike, Crisco Disco, the Cock Pit, the Toilet, and Hellfire. Many hosted special theme nights. Mineshaft had a night when you got in free if you were circumcised. There were also parties that happened weekly or monthly. One, for Latino men, was called Papicock. Clit Club was one of the few lesbian parties. Jackie 60, one of the most popular and successful, happened every Tuesday night. It wasn't exclusively gay and it wasn't about sex, or at least not as overtly as other places in the neighborhood.

The Anvil occupied two floors of the old Strand Hotel, later known as the Hide-A-Way, at Fourteenth Street and Tenth Avenue. A low, triangular brick building stranded between the booming traffic of Tenth Avenue and the West Side Highway, the hotel had long offered hourly room rates to dockworkers, truckers, and their dates when the Anvil took over two floors in 1974. The main dance floor featured a runway where drag queens lip synched and naked go-go boys "pranced up and down the bars, fucked each other with chains, lit themselves on fire and performed aerial gymnastics on trapezes dropped from the ceiling," White records. Jacques Morali and Henri Belolo spotted Felipe Rose dancing on the bar there in an Indian costume and asked him to join the disco group they were forming, the Village People. Anvil patrons went down to the dim, stone-walled grottoes of the basement for sex.

A couple of blocks away at Washington and Little West Twelfth Streets was the Mineshaft, a gay S&M club opened in 1976. Before the Mine-

shaft the building had housed a series of gay bars, including the Den, the O.K. Corral, and the popular after-hours club the Zodiac, one of the spots raided in 1971. White describes the scene one night in the dim back room. Couples had sex in flimsy cubicles, men suspended from the ceiling submitted to anal fisting, others knelt in a bathtub to be urinated on.

"I went to the Mineshaft, I went to all those places, but I never fit in that well with gay culture," John Waters recalls. "I wasn't butch enough. I didn't have a leather outfit."

Enticed by his reading of the *Voice*, Waters had started hitchhiking from suburban Baltimore to Greenwich Village in 1962, when he was sixteen, a sophomore in high school. "I would go on weekends, or tell my parents I was going somewhere else. I used to go with my girlfriend—it was that long ago. I remember once sending her parents phony permission slips to a sorority weekend that was completely fictitious. They had to sign all the papers *and* give money so we could go to New York." Waters and the girl were so green that "we used to try to hitchhike in Manhattan, which is impossible. Even at the height of the hippie era, just cabs pulled over. I don't know how I ever pulled it off. We would just go. We didn't have anywhere to stay sometimes. We would just ask people and they would say yes. We were young. A lot of bad shit could have happened, but it never did. Except at the Earle, but we stayed there anyway. It was the only place that would let us because we were underage and had no money."

With an 8mm camera his grandmother had given him for his sixteenth birthday, Waters and his friend Glenn Milstead, who became Divine, began making movies. On his trips to New York in the 1960s Waters haunted Jonas Mekas's Film-Makers' Cooperative, saw Warhol and Jack Smith films, took in a talk by Weegee in the East Village, caught low-budget grindhouse movies on Forty-second Street. He was in the Village for the blackout of 1965. "No one knew what a blackout was, so it was really scary at first. You don't realize how many planes are flying over New York at night until you turn out the lights. But there was no rioting. Everybody just went to bars. I went to the Ninth Circle." Opened by Mickey Ruskin of Max's Kansas City, the Ninth Circle, in the old College of Com-

plexes spot at West Tenth Street near Greenwich Avenue, was originally a steakhouse and bar. Ruskin sold out in the 1970s and it switched to a gay disco. By the mid-1970s it really did feel like a region of hell. Warhol and Lou Reed visited it in 1974, and its "ugly, bearded, painted, bruised, bandaged, strange" patrons put them in mind of Weimar-era Berlin at its lowest ebb.

In 1966 Waters was a film student at NYU "for five minutes. I went to one class." He was more interested in smoking pot, dropping acid, eating speed, and going to four movies a day, his real film education. He stole books from the campus bookstore and then returned them for the refund. When he and friends were reported for smoking pot, "They locked us in our room and said we were expelled from the dorm. Six or eight of us were thrown out and our parents had to come get us." By the 1970s he was the cult auteur of the movies *Multiple Maniacs*, *Pink Flamingos*, and *Female Trouble*, an underground celebrity in the Village. "They once did a study. Every one of my movies, every theater it ever played in the world, where did it do the very best? It wasn't Baltimore. It was Greenwich Village."

Of the Village sex clubs he saw in that period, Waters says that the Toilet, at Fourteenth Street and Ninth Avenue, was "the most shocking. I used to go with Fran Liebowitz and all our friends. That was scary. It was so illegal. There were no bathrooms. People just pissed on people. You just didn't look." The club Waters liked best was Hellfire, another S&M club, in a basement on Ninth Avenue, "which we all went to, straight, gay, men, women. That had one bathroom where you pissed on people and one where you didn't. So at least you had a choice." Clubs called the Sewer and the Catacombs had preceded it in the dirt-floored basement. "You think back on it and wonder how did it exist?" Waters says. "But you saw famous people in those places. I saw Jerzy Kosinski *every night* in Hellfire."

Waters got mugged one night in the area. "I didn't even see the person. They just waited until everybody got let out and whacked me on the head. I woke up covered in blood and went to Fran Liebowitz's house," on Bethune Street. "She answered the door and I said, 'I murdered five people and came to involve you.' " She took him to St. Vincent's.

He was lucky it wasn't worse. When the Al Pacino movie *Cruising*, some of which was filmed on location in the clubs, came out in 1980 gay rights groups protested what they said were its exploitive stereotypes, and deplored whatever influence it might exert in an America where conservatives were vigorously opposing gay liberation. At greater distance it can be seen as a rare mainstream attempt to portray the meatpacking club scene at its height. It's not a good movie, but if it seems lurid so was reality. It's the story of a cop who goes undercover in the clubs in search of a serial killer targeting gay men. There was such a cop, and there were at least two serial killers, along with other violent predators, stalking the Village. Through the 1970s the mutilated torsos of men presumed to frequent the clubs kept turning up in the Hudson. Those murders were never solved.

In 1985, at the tail end of the meatpacking scene, a young man named Eigil Vesti, a Norwegian fashion student and masochist, left the Hellfire with a man named Andrew Crispo. Crispo had allegedly been a gay hustler in Philadelphia when he came to New York in the mid-1960s and, after serving a few years of apprenticeship in the art world, opened his own gallery on East Fifty-seventh Street. Crispo developed a client list that included wealthy European nobility, while, according to the *Times*, he personally earned a reputation for Caligula-like scenes of cocaine-fueled S&M parties and surrounded himself with thuggish young "bodyguards" like Bernard LeGeros, troubled scion of a wealthy upstate family. Vesti willingly went home with Crispo for an S&M session. He was never seen alive again. Several weeks later some kids on the LeGeros family estate in Rockland County found his corpse, burned, mutilated, with two bullets in his brain and still wearing the leather masochist's hood that gave the case its tabloid title, the Death Mask Murder. LeGeros, who testified that Crispo ordered the killing, was convicted and sentenced to twenty-five to life; Crispo was never charged for lack of evidence, though he later served time for tax fraud. Strange tales continued to circulate about Crispo and LeGeros in the following decades. Soon after his release from prison in 1989, a gas-leak explosion demolished Crispo's Southampton mansion

and multimillion-dollar art collection, but he escaped injury and won a huge lawsuit against the gas company. And in 2007 LeGeros, still in prison, sued for custody of a son conceived by his estranged jailhouse wife during a conjugal visit. In 2010 he was denied parole.

ALONG THE WATERFRONT, HUNDREDS OF GAY MEN STILL MET FOR anonymous sex in the trucks most nights. And increasingly in the 1970s they "took over the abandoned piers," Agosto recalls. Through the '60s the piers and their cavernous sheds had moldered, rotted, and crumbled. A few had burned and stood as charred, twisted ruins. But they were not unused. All sorts of West Siders appropriated them as makeshift, dilapidated beaches—lower Manhattanites' first access to the water in generations. Breaking through flimsy chain-link fences, they went out onto the piers to sunbathe, roller skate, smoke pot, walk their dogs. Homeless people squatted in the sheds. A few of the piers, including Pier 45 at the foot of Christopher Street and Pier 46 between Perry and West Tenth Streets, were known as gay piers. On good summer days men sunbathed nude and had sex on the open spaces out near the end of the piers, to the point where Circle Line cruises directed tourists' attention to the New Jersey side of the river when passing them. They also met for quick sex in the dark, stinking, rubble-strewn, and rat-infested sheds.

"It was open enough, you saw who was coming and going, they weren't going to arrest you, and it was twenty-four-seven," Agosto explains. Cops didn't care because "there's no reason to protect an empty pier that's full of queers. What damage could they do?" Crowds would peak in "that desperate time" of the wee hours, after the bars closed and you hadn't made a connection. "You could smoke weed, you could bring your poppers, and you could find somebody or a group to have sex with." The sheds were unlit but light came in from out on the street and across the river, "and believe me, more people were attractive without direct lights . . . We could see the lights of the World Trade Center being built as it went up. It was like Christmas lights year-round." The piers were crumbling underneath them. In the dark you had to be careful of the holes and rats

underfoot. You also had to beware of muggers and gay bashers. "But the scary thing was seeing bodies of cats. Of course they weren't well cats, but rats really attacked them and ate part of them."

The art historian Jonathan Weinberg, who grew up in the Village, points out that artists gay and straight also appropriated the piers in the 1970s. Conceptual artists including Vito Acconci and John Baldessari used them as apocalyptic settings, and numerous photographers prowled them. Filmmakers shot documentaries and gay porn on the piers. The crumbling blank walls attracted muralists and graffiti artists including Keith Haring and Gustav von Will, aka Tava, whose cyclopean, priapic figures at the ends of the piers also caused the Circle Line tourists to turn their heads. The Soho artist Gordon Matta-Clark cut large geometric shapes out of the walls of Pier 52's shed at the foot of Gansevoort Street to create his environmental piece *Day's End*. That pier was demolished in 1979. In 1983 David Wojnarowicz and Mike Bidlo turned the shed of Pier 34 down at the foot of Canal Street into a decrepit art gallery for a group exhibition of murals, sculptures, and installations. The shed was torn down the following year. Many of the other piers would also be destroyed in the years that followed as part of the waterfront's transformation into today's Hudson River Park.

In 1978 Random House published a novel satirizing the whole scene, with the incendiary title *Faggots*. After growing up middle class in suburban Washington, D.C., Larry Kramer had gone to Yale at his father's insistence and tried to commit suicide there by swallowing two hundred aspirin. He came out at thirty and spent much of the 1960s in London, where he earned an Oscar nomination for adapting D. H. Lawrence's *Women in Love* for the Ken Russell film. He moved to the Village in 1971, just as the scene got rolling. *Faggots* is about a gay man approaching forty (Kramer was forty-three when it came out) and looking for love when everybody else seems just to want sex. It offers a litany of what had become by then the scene's self-imposed clichés and stereotypes: the obsessions with youth, the "ass kerchiefs" and trips to the gym, the rote overindulgence in extreme sex and drugs in the discos and bathhouses, the cruelly

rigorous and supercilious way gay society enforced caste and class in its ranks. Many gay men were scandalized. The Oscar Wilde Bookshop declined to shelve it. Kramer's grocer on Fire Island refused to serve him. "People would literally turn their backs when I walked by," he later told *The New Yorker*. The orgy rolled on.

VILLAGE LESBIANS HAD THEIR OWN ISSUES AND INTERESTS IN THE post-Stonewall years. They found gay men at least as condescending and obsessed with their penises as the rest of male society, were disgusted by all the public sex, and refused to serve as "the ladies auxiliary of the gay movement." Withdrawing from groups like the GAA, they formed their own "womyn's" organizations, such as Lesbian Feminist Liberation and Radicalesbians. At first, mainstream feminist organizations like NOW were as wary of lesbians as gay pride organizers were of street queens. They called them the "lavender menace." Lesbians instantly printed the words on T-shirts they wore to rallies. Rita Mae Brown was 86'ed from the organization. Betty Friedan "went so far as to tell the *New York Times* in 1973 that lesbians were sent to infiltrate the women's movement by the CIA as a plot to discredit feminism." Some lesbians joined conservatives in opposing pornography and S&M, while others defended it. Some became radical separatists, advocating, in language not much different from the SCUM *Manifesto* ("A lesbian is the rage of all women condensed to the point of explosion"), complete withdrawal from American society to create their own "Lesbian Nation," as the *Voice*'s Jill Johnston titled her 1973 book. Johnston, who'd started out straight and writing dance reviews for the paper in 1959, had a nervous breakdown, spent some time in Bellevue in the mid-1960s, and emerged a lesbian. She stopped writing reviews and started handing in unpunctuated, usually inscrutable personal journals that read like E. E. Cummings on LSD. Dan Wolf, characteristically, shrugged and continued to publish her. At a Town Hall debate on feminism in 1971, where she was on a panel that included Germaine Greer and Norman Mailer, she declared that "all women are lesbians except those that don't know it yet," and invited two friends on stage for a group

grope, rolling on the floor as Mailer squirmed and complained, "Come on, Jill, be a lady." She went back to more conventional writing eventually and died in 2010, age eighty-one.

Lesbians had their own Bob Dylan in the Village folksinger Alix Dobkin. She was, like Suze Rotolo, a red-diaper baby, born in the Village in 1940 to parents who were Communists. An uncle was caught and executed by Franco's Fascists during the Spanish Civil War, and her father was a member of the National Maritime Union. He and her mother pushed the infant Alix around the Village waterfront in a baby carriage as they handed out NMU leaflets. After growing up in various places, Dobkin returned to the Village in the early 1960s and dove straight into the folk scene, getting gigs at the Gaslight and elsewhere, becoming friends with Van Ronk, Dylan, and the others. She once brought her father to the Limelight to meet some of them. Afterward, Dobkin's father asked her, "That one with the polka dots, who *is* she?" It was Dylan, entering his mod phase, his hair in a wild 'fro. Dobkin and the Gaslight's Sam Hood got married in his parents' apartment on Seventh Avenue South, had the wedding party at the Dom, and honeymooned in the Gramercy Park Hotel. She left New York with him for Coconut Grove, Florida, where they opened the short-lived Gaslight South Cafe. When they returned to New York toward the end of the 1960s, the Gaslight had changed hands and was now called the Village Gaslight. The big folk and folk-rock acts of that period, Van Morrison and James Taylor and many others, passed through before it closed for good in 1971. Around then, Dobkin discovered the women's movement, left Hood, and came out as a lesbian. Combining tunes as pretty and innocuous as Pete Seeger's with lyrics that occasionally verged on anti-male hate speech, she built a songlist of lesbian-separatist anthems and fight songs—"Living with Lesbians," "Amazon ABC," "The Lesbian Power Authority"—making her a revered cult figure inside the movement.

Lesbians found a poet laureate in Audre Lorde. Born in Harlem to poor immigrants from Grenada in 1934, she was a shy and extremely nearsighted child who turned to poetry to express herself. She immersed herself in the Village lesbian culture of the 1950s, then married a lawyer,

had two daughters, and divorced him in 1970. She found her voice as a self-described "black feminist lesbian mother poet" in the 1960s and '70s. At her best she was a sensitive, angry documenter of the city when it was a darker and harder place than it is now, for example in the poem "New York City 1970" ("There is nothing beautiful left in the streets of this city. / I have come to believe in death and renewal by fire."). At her slightest she wrote political bumper-sticker slogans ("Woman power / is / Black power / is / Human power"), but there was a lot of that being written at the time. When she died of cancer in 1992 she'd moved to St. Croix and adopted an African name, Gambda Adisa, which means Warrior: She Who Makes Her Meaning Known.

# Art in the Junkyard

I N 1969 LANFORD WILSON AND A HANDFUL OF OTHER CINO VET-
erans formed the Off-Off-Broadway company that later came to be
Circle Rep. They started out in an open space above an uptown Thom
McAn shoe store, performing realist plays with social commentary,
most famously Wilson's *The Hot l Baltimore*, set in a seedy residential
hotel. In 1974 Wilson and the company moved back to the Village,
renting out the Sheridan Square Playhouse, former site of the Nut
Club. The company eventually signed a contract with Actors' Equity
to step up to Off-Broadway status and went on to a successful life as
a repertory theater into the 1990s.

The 1970s were good to Off-Off-Broadway. Ruinous production costs,
the decline of Times Square into a seedy porn zone, New York City's
general economic collapse and its abandonment by the middle class and
tourists were all very hard on Broadway and Off-Broadway in the period.
But the bombed-out and abandoned New York landscape left a lot of free
or cheap space for no-budget theater groups, and creative people in all
forms, to colonize. The 1970s may have been a low point for New York

City generally but it was a playground for the creative, remembered by many now as the last hurrah of downtown Manhattan as a culture engine. It was "a junkyard with serious artistic aspirations," Edmund White has written. Along with punk rock, underground filmmaking, hip-hop, and graffiti art, Off-Off-Broadway companies and spaces flourished and spread throughout the city. Where there'd been a scant handful in the Cino-Judson 1960s there were more than three hundred by 1975, with their own Off-Off-Broadway Alliance. Many were short-lived, and many critics complained that the quality declined in direct proportion to the growing numbers. Still, if you wanted to make low-budget, experimental theater it could be a busy and productive time.

"I remember times when we worked an eight o'clock show in one club, a ten o'clock in another, and a midnight show in another," Chris Kapp, actress and director of La MaMa's Coffeehouse Chronicles, says of the time. "We worked our asses off. On drugs. It was a terribly creative time. Tremendous energy, but really very focused and hardworking. Those of us who weren't in the shows would build the sets, hang the lights, write the plays."

In 1972 Kapp moved into the small apartment on Bethune Street, half a block from Westbeth, where she was still living in the 2010s. She got a job waitressing at a place called the Gallery on Christopher Street. She remembers that the northwest corner of the Village was "very gay. Practically everybody I knew was gay." The area was also still dark and desolate at nights, so she was charmed when gay friends would offer to walk her home. "I thought they were being so nice," she recalls with a chuckle. Later she learned they were heading that way anyway, to go have sex on the piers. "I never knew anything about that part of their lives. Didn't want to know."

She was another Village escapee from Long Island. She'd grown up in West Hempstead, where she had "a lousy home life," with an abusive father and alcoholic mother. As an adolescent in the late 1950s she started going into Brooklyn to catch Alan Freed's rock and roll stage shows. "Rock and roll saved my life. I was the kind of kid who would always get backstage. I wasn't a groupie, because I was scared to death of sex. But I

got to meet everybody," including Chuck Berry, Buddy Holly, Jerry Lee Lewis.

At nineteen she got married. It lasted "about a year and a half. Nice Italian guy, nice family, all that. But I did it just to get out of the house. A lot of women did that," she said. By 1965 she was on her own and living on the Upper West Side. Petite and pretty, she modeled clothes for buyers in the garment center during the day, went home for a nap, and headed out later to dance at Ondine. "The Chambers Brothers were the house band. They were fabulous." One night when she was dancing with a friend Mick Jagger cut in. She swears he stole a dance step from her. "He would never say that. He wouldn't remember me. He was just a snotty asshole then." Phil Spector was a regular. "He was a creep. Just looking at him was creepy." And she met Hendrix there. "Jimi was sitting at the bar. I told him I could get some pot. He said, 'You *can*? I'll give you the money.'" She took a cab back to the Upper West Side, scored from her dealer there, and returned to Ondine. They smoked it in the ladies' room. "But I was a little bit wary of Jimi. I wasn't a hip kid. I wasn't a nerd but I was just scared. So I shied away from Jimi."

She started going with Bobby Callender, who worked at the time for the legendary disc jockey Murray the K (Murray Kaufman). "He booked Murray the K's shows. He was the kid who listened to all the records and told Murray what to play." She became a dancer in Murray's live stage shows, "and met everybody." She babysat performers' kids backstage, including a young Whitney Houston, met Otis Redding and Jim Morrison and the Beatles. She was in Murray's car when a crowd surrounded it after the Beatles' second Shea Stadium concert, which he emceed. She was terrified. "I cried, 'Murray, get us out of here!'"

Meanwhile she was coming to the Village to study acting with Bill Hickey at HB studios. That led to her first acting gig, in a pair of one-act plays starring and directed by Al Pacino. "Of course I had a crush on him. I made out with him once. But I was too innocent for Al." She also performed with two very campy East Village–based troupes. She was one of the actual females in the good-naturedly drag-queeny Hot Peaches, alongside Marsha P. Johnson and Agosto Machado, and performed with the

darker Play-House of the Ridiculous. Play-House founders John Vaccaro, who acted and directed, and playwright Ronald Tavel came from backgrounds in Off-Off-Broadway, but their aesthetics were just as reflective of the underground film of the time. Their first evenings of one-acts in the mid-1960s, tossed together with production budgets as low as twenty dollars, were scripts Tavel had originally written for Warhol to film. The filmmaker Jack Smith (*Flaming Creatures*) acted and built costumes for them, and many Factory types participated. Where Harry Koutoukas's plays were camp at its highest, Tavel's were the lowest, loose grab bags of stupid jokes and bad puns and goony smut thrown together in parodies with titles like *Indira Gandhi's Daring Device* (a gigantic dildo) and *Gorilla Queen*. "We have passed beyond the Absurd," Tavel declared. "Our position is absolutely preposterous." The drugs everyone was on added to the anarchic antics. Tavel soon broke with Vaccaro and took his work to the Judson and Cino. In the 1980s Kapp became an assistant to the powerful Broadway producer David Merrick and also got small parts in the soap operas *All My Children* and *One Life to Live* and many more. "Any soap opera that was shot in New York, I was in."

By then she'd gotten a notice that her building was turning into a co-op and she could buy her apartment for seventeen thousand dollars. "Seventeen thousand dollars was not in my vocabulary . . . That was the first sign of change for me." She went to court and won the right to remain a renter, the only one in her building. To this day, whenever new people buy into the building—always wealthy people, she notes—they say, "Oh, you're the renter." (As she speaks, the town house next door has just gone on the market for $12 million.)

Charles Ludlam followed Tavel as the Play-House's chief writer. Like Kapp, he'd come to Manhattan from suburban Long Island, where he'd had a cold and disapproving father but received unconditional love from his mother and sisters. He was already dressing in drag as a child, trick-or-treating as a girl. As an actor at the Play-House he upstaged everyone, and as a writer he out-Taveled Tavel, producing sprawling parodies, including *Conquest of the Universe*, aptly subtitled *When Queens Collide*, a joke-strewn mash-up of old Flash Gordon serials and Christopher Marlowe. Ludlam

and Vaccaro fell out over the staging and Ludlam defected in 1967, form-
ing his own company he dared to name the Ridiculous Theatrical Com-
pany. He was the director, principal playwright, and star, often in drag,
with advice from Minette, who turned down numerous requests to join
the company—she said she could make more money on her back than on
the stage. Early productions were just as chaotic and druggy as Vaccaro's
had been. By the 1970 Bluebeard, a farcical update of The Island of Doctor
Moreau in which the mad scientist wants to create a "third genital," they
were more coherent and structured, though they remained just as wildly
silly.

Bluebeard premiered at La MaMa, then moved to Christopher's End.
Villager and Times critic Mel Gussow became a believer with this show
and would continue to be a cheerleader throughout Ludlam's career. Oth-
ers fell into place more gradually and not always as enthusiastically. Lud-
lam cranked out new plays at a furious pace, grazing the broad landscape
of high, low, and middlebrow culture for his material, with lavishly three-
penny productions that were the ne plus ultra of drag chic. His formula,
he later explained, was "Steal lines. Orchestrate platitudes. Hang them on
some plot you found somewhere else." In Camille he played Marguerite
in hairy-chested drag to great success. Stage Blood, his spoof of Hamlet,
and Der Ring Gott Farblonjet, a lampoon of Wagner, were also mid-1970s
hits. Off to the side he wrote and performed puppet shows for children
and demonstrated his skills as a ventriloquist in the chamber piece The
Ventriloquist's Wife.

In 1972 Ludlam moved from the East Village to an apartment on Mor-
ton Street, where he stayed the rest of his life. The company, however,
bounced around from venue to venue—the East Village, a Times Square
porn theater, a fan's loft—until 1977, when Ludlam was able to rent the old
Cafe Society space in the basement of 1 Sheridan Square. Ludlam was by
then the toast of downtown, yet he bit every hand that petted him with Le
Bourgeois Avant-Garde, his rewrite of Molière's Le Bourgeois Gentilhomme,
making savage fun of the downtown arts scene and its philistine support-
ers. After running through all the movements from Futurism to Post-
postmodernism and back again, his artists invent "the avant-derriére"

movement, so retro it's futuristic. They wear fake buttocks in front for their fans to kneel and kiss.

Harvey Fierstein brought drag and gay camp from the Village to Broadway in 1982 with his highly celebrated *Torch Song Trilogy*, which had begun Off-Broadway at the Actors' Playhouse just below Sheridan Square. The following year he collaborated with Jerry Herman—who'd started out satirizing Village life in revues like *Parade*—on the Broadway hit *La Cage aux Folles*. Fiercely envious, Ludlam responded with his most traditional play, *The Mystery of Irma Vep*, a tour de farce for two actors playing multiple roles, originally starring Ludlam and his lover Everett Quinton, whom he'd met in the mid-1970s cruising on Christopher Street. *Irma Vep* ran for two years at Sheridan Square, went to Off-Broadway, and has gone on to be Ludlam's most successful and widely produced work. He continued to write, direct, and act at a great clip until a few months before he was taken to St. Vincent's, where he died of AIDS in May 1987, just past his forty-fourth birthday. Quinton took over as artistic director of the company, which continued performing Ludlam's works and new plays by Quinton until 1997.

LIKE MARKY IANNELLO AND DERMOT MCEVOY IN THE 1950S AND '60s, George Tabb, music writer and founder of the punk rock band Furious George, saw the Village of the 1960s and '70s through a child's and teen's eyes. He was born in Brooklyn in 1961, and after his parents broke up he and his two brothers spent weekends, summers, school holidays with his mother and his stepfather, the photographer Nick Gurwitz, in Greenwich Village. He moved there himself in 1980. In the 2010s he was living on Bank Street, across from Westbeth.

Through most of Tabb's youth his mother and Gurwitz had the basement apartment at 243 West Fourth Street, between West Tenth and Charles Streets. They slept in the back, the kids in the front room by the street. Tabb's mother was a friend of the author Lee Israel, who wrote the landmark biography *Miss Tallulah Bankhead*. "Lee was a big woman, tough, like a truck driver." He puts on a deep, manly growl. " 'Hey George, how ya doin?' Cussing, this and that. She went to the dyke bars in Sheridan

Square. One night at like four in the morning there's this pounding on the door. It's Lee. 'I have to come in. You have to close the door and hide me.' There's a little blood on her face. Lee had gotten into a fight at one of the dyke bars, which was not uncommon. She punched some woman through a window. When she told my mom, my mom said, 'That's the third time!' They were looking for her on the street, so she slept with us that night."

Tabb recalls being taken to the Tiffany Diner on Sheridan Square in the wee hours. "It was all transvestites, hookers, gay men, cops, mob guys, everybody, in the middle of the night. It was a wild scene. It was fun to see all these wild people dressed up. So when the Village People happened after that I thought it was so cool, because people *did* dress up like that in the Village. I didn't understand that they were gay. They were just, you know, Village people." Tabb was sixteen when the Village People put out their first single, "San Francisco," in 1977. Morali and Belolo had intended the group to appeal to a gay audience, but disco had gone so mainstream by then that songs like "Macho Man" and "YMCA" made fans of many kids like Tabb, on whom the campy gay subtext was lost. "One morning I hear all this noise outside. They're filming the movie *Can't Stop the Music* right in front of my mother's apartment! The Village People are all sitting on our stoop—the Indian, the Cowboy, all of them. 'Mom! Mom! The Village People are on the stoop!' " She offered them something to drink and let them use the bathroom. "So all the Village People are coming in our basement apartment, using the bathroom. I talked to them all. Randy Jones, the Cowboy, became my favorite."

Tabb also offers a unique take on the origins of punk fashion, arguing that it began in the Village and initially had nothing to do with punk rock. "People got it all wrong about punk. People started dressing for punk rock because of *Rocky Horror*," he insists. *The Rocky Horror Picture Show* originally bombed when released in the United States in 1975. It owed its global cult following to a long Friday and Saturday midnight run that started in April 1976 at the Waverly Theater on Sixth Avenue, by the busy West Fourth Street subway station. (In 2005 it became the IFC Center.) After almost two years at the Waverly it moved to the Eighth Street

Playhouse. Early in the Waverly run fans began talking back and dressing up like the characters, complete with props. In the spring of 1977 Sal Piro, a former seminarian from New Jersey, founded the movie's fan club and became the host of the raucous "floor show" in which the costumed audience performed along with the film. Tabb, still an innocent, went to one of these shows with his mom and Nick, "and I was scared shitless. I was petrified. I did not know what was going on. But it was exciting in a way. Also, girls were there changing their clothes in the aisles, getting completely naked. Wow!" Tabb soon joined the cult, becoming a regular at the Waverly midnight shows.

Meanwhile, he discovered another great love, the Ramones, whom he first heard at CBGB. Tabb insists that *Rocky Horror* and punk rock fused to form a single cultural moment. "After *Rocky Horror*, we'd walk over to CBGB's or Max's Kansas City, as a group, in these wild outfits—fishnets, safety pins, leather jacket with buttons all over it and chains like Frank-N-Furter wore in *Rocky Horror*, the girls in wild makeup. We'd walk over to these clubs where bands like Blondie were playing, all dressed up, and that became the punk rock look. To this day people don't know that. It all came from *Rocky Horror*. That's also why places like CBGB got popular. There'd be nobody there until two in the morning, when *Rocky Horror* got out and we went there. The best band slot would be two-thirty in the morning. There'd be huge crowds."

# The 1980s and AIDS

B Y 1977 ED KOCH, STILL A VILLAGER, HAD RISEN FROM DISTRICT leader to city councilman to the U.S. Congress. But what he really wanted was to be mayor. He'd made an unsuccessful run at it in 1973, and now, after four years of Abe Beame—whom Pete Hamill would later characterize as "a clubhouse mediocrity" and "a kind of still life"—Koch and a crowded field that included Mario Cuomo and Koch's fellow Villager Bella Abzug announced their candidacies. Even Barry Farber, the radio talk-show host, ran as the Conservative Party candidate. (He would get fifty-eight thousand votes, not bad for a conservative nonpolitician in 1970s New York City.)

They all claimed they could drag the city out of the dysfunctional mess it had fallen into under Beame's caretaker government. Koch tacked to the right. As racial tensions mounted between blacks and whites and blacks and Jews, Koch, who'd participated in civil rights marches in the South back in the 1960s, sided with the whites and Jews, scandalizing many of his Village friends. They included Jack Newfield, a *Village Voice* muckraker, who started out Koch's supporter and became one of his most

dogged critics. When Son of Sam terrorized the city, Koch came out for the death penalty, styling himself as the tough guy the city needed. Meanwhile he cut deals, sometimes secretly, with the sort of old-school machine bosses he had always railed against, including Carmine DeSapio's counterparts in the other boroughs. It would come back to haunt him.

The race came down to a fight between Koch and Cuomo, and it turned ugly. Bess Myerson, America's first Jewish Miss America, had constantly been at Koch's elbow to ward off the gay question. Then some "Vote for Cuomo, Not the Homo" signs appeared, and Cuomo added an insinuation or two of his own, forcing Koch to deny in public, for the last time, that he was gay. To help keep the volatile Koch from blowing his cool, his team got his old pal Dan Wolf to stay at his side in the last weeks before the election, counseling calm. Koch prevailed.

Modeling his mayoralty on his hero La Guardia, Koch was the hardest working man in the city, on the job before and after everyone else. He rode the bus to his inauguration and took the subway to work. He outdid even La Guardia in his ubiquity and in his love of the media, and for a long time the media loved him back. He was the city's—and his own—most ebullient promoter, sometimes its wackiest clown, sometimes its nastiest scold. Hamill writes that he was like "some mad public combination of a Lindy's waiter, Coney Island barker, Catskill comedian, irritated school principal, eccentric uncle." There was something a little desperate in his constantly asking New Yorkers "How'm I doing?" If you answered "Not so hot," he was likely to lash back with a brusque insult. He hadn't actually been asking for your opinion, just your approval.

The austerity measures Beame's economic advisers had imposed in 1975 had dragged the city back from the precipice by the time Koch took office. He and his team won a new round of loans from Washington, with the proviso that they balance the city budget in four years. Koch earned the nickname Dr. No as he cut more spending, jobs, and services. He faced down transit workers and firemen and tried to abolish the woefully crony-packed Board of Education. He enjoyed a reputation as one white liberal who could say no to black leaders' demands and shrug off charges of racism. The city beat the four-year deadline by a full year. By the mid-

1980s it had gone from a miserable deficit to showing a budget surplus. The city would be back in the red by the end of Koch's long reign, but for a few years there he looked, and acted, like a miracle worker.

Saving the public sector from ruin helped create a setting for a private-sector resurgence. Developers like Donald Trump went on a skyscraper and high-rise building spree the likes of which hadn't been seen since the 1920s. The new commercial spaces they built in the 1980s equaled the total commercial square footage of Boston and San Francisco combined. Koch's administration helped by offering sweetheart tax abatements and cutting miles of red tape. Meanwhile it was greed-is-good boom times on Wall Street. The terms "yuppie" and "masters of the universe" gained currency. Financial institutions, including more than three hundred foreign banks, brought two hundred thousand white-collar workers back to Manhattan in the first half of the decade—but not necessarily as residents. Many still commuted from the suburbs. The tourists started coming back, though Koch still warned them to avoid Times Square. (The Koch administration's plans for the rebirth of Times Square, like the construction of a new West Side Highway, barely got off the ground in his time, leaving his successors to complete and take credit for the projects.)

Inevitably, not all New Yorkers benefited equally from the boom. Those with vested interests in the new city they were creating profited handsomely but little trickled down to workers and the poor. In fact, the gulf between the very well-off and the terribly poor yawned again as wide as it had in the Gilded Age. Homeless people, many of them unwed mothers and their children, others deinstitutionalized mental patients, appeared in record numbers on the sidewalks, in the parks and subways, in the welfare hotels. In the outer boroughs, in Harlem, and on the Lower East Side there were still acres of bombed-out buildings and rubble-strewn lots. Koch was slow to commit to the redevelopment of housing in those areas, and the Reagan administration offered no federal help. Neighborhood and church groups began their own grassroots rebuilding campaigns. In his third term, considering a run for a fourth, Koch finally pitched in with billions of dollars in city support.

While Koch was developing what some analysts called his "corporatist-

pluralist" regime, his support in the Village plummeted. Although he won reelection by a landslide in 1981, the Village Independent Democrats endorsed an opponent, a Brooklyn liberal named Frank Barbaro, who, tellingly, was "the first serious citywide candidate to campaign in gay male bars and clubs." And in his second term Koch made mortal enemies in the Village over his response, or perceived lack of response, to AIDS.

IN 1981 THE FIRST REPORTS CAME OUT OF GAY MEN WITH THE RARE cancer Kaposi's sarcoma, usually seen only in the elderly; or with *Pneumocystis carinii* pneumonia (PCP), a form of pneumonia suggesting immunity deficiencies; or cytomegalovirus (CMV), a form of herpes that also attacks the immune system. By the end of the year almost three hundred cases of severe immunity deficiency had been reported, mostly in New York City and San Francisco, the two largest gay communities in the country. Nearly half the cases were fatal. The gay periodical *New York Native* was the first newspaper to report the story, in 1981. Names suggested for this new syndrome included GRID (Gay-Related Immune Deficiency) and CAID (Community Acquired Immune Deficiency) before it came to be known as AIDS in 1982.

Gay men had been getting sick all through the 1970s. The high levels of sexual activity in their relatively closed communities created an excellent environment for the spreading of opportunistic and infectious diseases. In the Village the Gay Men's Health Project clinic had opened in 1971 to treat men with STDs. Through the decade the clinic treated many cases of gonorrhea, syphilis, hepatitis, herpes, mononucleosis, urethritis, a range of intestinal parasites, scabies, venereal warts, and various other infections. "People were continually sick, low-grade fevers and what have you, and in denial," Agosto remembers. "People said, 'Sex was created by God. Why would he curse us in this way? It can't be sex.' " Men would go to the clinic, get their antibiotics, and continue partying.

In 1982 a group of gay men in the Village met in Larry Kramer's apartment and formed the grassroots Gay Men's Health Crisis (GMHC), the first volunteer AIDS organization in the country. In its first newsletter

that year, GMHC counseled against panic in language that showed how closely sexual freedom and gay liberation had become associated in many men's minds. "Wherever we gather—at our gyms, in bars, at parties—clone banter is switching from the four D's (disco, drugs, dicks and dish) to who is the latest victim . . . All this talk has produced a toxic side effect. We are overcome by hysteria." Kramer, who believed that gay men should in fact be very frightened, fell out with GMHC and in 1987 founded the extremely militant ACT UP (AIDS Coalition to Unleash Power).

Politically, AIDS could not have appeared at a worse time. Ronald Reagan had entered the White House in 1981. Exhausted after two extremely unsettled decades of revolution and rebellion, of political violence and economic dysfunction and, many believed, moral decay, mainstream America needed a break. Many Americans were ready to retreat to a neo-fifties conservatism, with a new edge of right-wing militancy and Christian fundamentalism. Political and religious leaders who spoke about AIDS at all in the early 1980s tended to declare it a gay plague and God's retribution on perverts. President Reagan would not say the word "AIDS" in public until 1987, two years after the world was shocked by Rock Hudson's death from the disease. Like most gay Hollywood movie stars, Hudson had kept his sexuality a secret. The year after Hudson died, Bob Hope was in New York for centenary festivities at the Statue of Liberty. He joked, "I just heard that the Statue of Liberty has AIDS, but she doesn't know if she got it from the mouth of the Hudson or the Staten Island Fairy."

Added to that was the terror of AIDS that spread outside the gay community. Straight people feared that any sort of contact might be deadly— toilet seats, kissing, handshakes, a trip to the disco or the dentist, eating in restaurants where infected people might work. The mainstream media fanned the fears with articles like the Associated Press report in 1987 forecasting that AIDS could be worse than the Black Death, with tens of millions of AIDS deaths over the coming decade.

It all contributed to a context in which a gay man who suggested a link between a decade of sexual promiscuity and this new disease risked being accused of self-hatred and aiding the homophobes. Even after the

National Cancer Institute reported in 1982 that "the median number of lifetime sexual partners for gay AIDS victims being studied is 1,160," just using the word "promiscuity" was anathematized. Early on, doctors at the Gay Men's Health Project suspected that no single new virus would be found as the cause of AIDS but that rather it was caused by a breakdown of the immune system after a decade of STDs, other infectious illnesses, drug abuse, and serial use of antibiotics. When Richard Berkowitz told an AIDS support group in 1982 that on the advice of his doctor at the clinic he intended to "stop fucking around and give my body a chance to heal from years of taking recreational drugs and getting sexually transmitted diseases," he "ignited a firestorm of outrage" and was shouted down. Randy Wicker characteristically positioned himself on the politically incorrect side of the issue as well. "I always tell people the AIDS epidemic happened because if you let a bunch of kids loose in a candy store, what are they gonna do? They're gonna eat too much candy, and they're gonna get sick," he says. "The gay liberation movement doesn't like my opinion. I say we turned liberty into license. It's still divisive." Wicker's live-in lover wasted away from AIDS in their Hoboken apartment, with Marsha P. Johnson nursing him during the days while Wicker went to his Village shop.

Gay men and AIDS activists "were less than eager to pull closely at the threads of AIDS history," Gabriel Rotello writes. "[M]any felt that the stigma of causing an epidemic was so politically damaging that it rendered open discussion of the epidemic's origin extremely unwise." Asked on CNN in 1983 why AIDS first appeared in the gay community Larry Kramer, who had all but forecast a plague in *Faggots*, shrugged and replied, "No idea."

In 1982 Berkowitz and Michael Callen, who had met through their doctor at the clinic, cowrote an article for the *Native* outlining the theory that AIDS was the cumulative result of a decade of abuse to the immune system. They then wrote *How to Have Sex in an Epidemic*, the first "safe sex" pamphlet, advocating the use of condoms. The gay Village was at first highly resistant, even derisive. By the 1980s the Pill had made condoms virtually obsolete among heterosexuals, and gay men of course had

never needed them. Within a few years, however, the practice was univer-
sally advocated for both heteros and homosexuals. Callen went on to be a
leading AIDS activist, a cofounder of the organization People with AIDS
who spoke eloquently before Congress and in the media. He was skepti-
cal when the Centers for Disease Control declared HIV the sole cause of
AIDS in 1984 and held that opinion until he died of the disease in 1993.
By then such skepticism was condemned as heretical and branded "AIDS
denialism." Nevertheless, Callen is remembered for his work in raising
public awareness of the epidemic. The Callen-Lorde Community Health
Center for gays and lesbians, located in Chelsea, was named for him and
Audre Lorde.

As the 1980s progressed AIDS ravaged the gay Village. Survivors of
the decade remember when they seemed to be visiting a sick friend or
attending another friend's funeral every day. "I probably lost sixty to
seventy people to AIDS, easily," Chris Kapp says. "Just about everyone.
I mean they were dropping like flies." St. Vincent's saw some of the first
AIDS patients in the city and opened the first and largest AIDS wing
in the Northeast. Beds overflowed, until even the corridors were com-
mandeered, with masking tape on the floor designating "rooms." It would
be likened to a military hospital in a war zone and be referred to as the
ground zero of AIDS.

In 1983 Larry Kramer wrote a jeremiad in the Native in which he ac-
cused the Centers for Disease Control, the National Institutes of Health,
other health care facilities, and Mayor Ed Koch of dragging their feet on
AIDS. Kramer and other activists believed that Koch had two reasons
for skirting the issue: first, because he was in the closet, and second, be-
cause he didn't want to scare away the tourists who were just then return-
ing to the city. Kramer went on to pillory Koch in his plays The Normal
Heart, produced at the Public Theater in 1985, and Just Say No three years
later. In the former, the Kramer-surrogate character complains that the
only way to get a message to the mayor would be to "[h]ire a hunky hus-
tler and send him up to Gracie Mansion with our plea tattooed on his
cock." Just Say No was a farce that lampooned political figures including
the Reagans, and portrayed Koch, identified simply as Mayor, as a horny,

power-mad closet queen with lines such as "Oh, Gilbert, just hearing your whiny voice, just looking into your dribbly eyes, just feeling your dumpy body, I've got lover's nuts." Gilbert was apparently a stand-in for a former aide and alleged lover of Koch's from the 1970s, whom Kramer, as well as investigators working for U.S. Attorney Giuliani, tried to convince to go public. In panning the play, the Times's Mel Gussow, who'd seen and enjoyed his share of envelope-pushing farces by then, wrote, "Imagine the worst possible taste, then take it several steps further." In 1989, when Koch appeared in Sheridan Square to proclaim June Lesbian and Gay Pride Month, hundreds of ACT UP hecklers booed and shouted him down.

In another only-in-the-Village coincidence, Koch and Kramer were living by then in the same modern high-rise at 2 Fifth Avenue just above Washington Square Park. The first time Kramer ran into Koch in the lobby, he pointed at him and screamed, "Murderer! No one wants you here!" The building's management warned he'd be evicted if he ever did that again. Later, they encountered each other again at the mailboxes. When Koch bent to pat Kramer's dog, Kramer yanked her away, saying, "No, Molly, that's the man who murdered all of Daddy's friends."

In 1985 the city's Department of Health shut down the Mineshaft, citing activities that could spread AIDS. The Anvil and Hellfire closed voluntarily. The city shut the Everard and St. Mark's Baths and Plato's Retreat as well. Owners of other establishments managed to skirt the law and stay in operation by resurrecting the old mob ruse of becoming quasi-private members clubs. But the era of the far west Village and meatpacking district as a gay sexual playground was drawing to a close.

Reported AIDS cases in the city peaked in 1993 and dropped fairly steadily thereafter. The reported demographics shifted from white gay men to nonwhite drug users. By then AIDS had decimated the Village. As the far west Village where Chris Kapp lived emptied out of gay residents, either because they died or because they moved out of what had become a death zone, "that's when the straight people moved in. It was weird . . . All these little apartments got bought up and the rich started

moving in." Where most of her neighbors had once been gay, she says, now it was "yuppie families."

Plague had played a significant role in the development of Greenwich Village in the early nineteenth century. Now another plague contributed to its transformation at the end of the twentieth.

# Epilogue

WE WERE ALL SO LUCKY TO BE IN THE VILLAGE WHEN
YOU DIDN'T HAVE TO BE A ONE PERCENTER TO RENT A
PLACE.

—*David Amram*

MARKY IANNELLO SITS IN THE GLOOM OF THE XR BAR AT THE corner of Sullivan and Houston Streets, a couple of blocks from his apartment. It's late on a warm summer afternoon in 2011. Rush-hour traffic booms by on Houston Street. The after-work crowd is just filtering in from the sidewalk. They're mostly young office guys with their ties loosened and their shirtsleeves rolled up, a few young women in summer dresses fiddling with cell phones. Marky turns his back to them and hunches his shoulders. An older guy in work clothes and a ball cap, he doesn't fit in. He hunkers at his end of the bar like a ghost of the Village past.

"The Village is all full of people who are not from New York, who don't give a shit about New York, who are only here to make money," he grumbles. "They don't give a *fuck* about New York. They don't want to be a part

of the community. They only care about their little thing. They're worried about their job. You can get a job in Milwaukee. This is not the New York that I grew up in. They're like carpetbaggers. They're always trying to figure out how to make it ugly and make a buck."

Three young office guys in shirtsleeves and ties enter the bar on cue. Marky glares at them. "Like look at these fuckin' mooks." He shakes his head. "It can't really be the way it used to be. But to see it replaced with people who really don't give a shit, that's what bugs me."

"I think what's changed is its personality more than anything," Suze Rotolo had said of the Village earlier that year. "Physically its core is still there, but the personality has changed. There's no more funky little mom-and-pop shops, funky little restaurants, places that were owned by families for generations, like the little Laundromat I used to go to on West Fourth. People would sit on the benches outside, and we'd always say it would be nice to have an outdoor café here. Well, now there are twelve of them, and the Village is very wealthy. Only wealthy, successful artists can live here. I'm sure they're attracted for the same reasons I was attracted to come here, but it's not the same. It still looks wonderful but it lost its funk. And funk has its good points."

Complaining about newcomers and change is a long tradition in the Village. But there was no denying that the Village of 2011 was a very different place from the one Iannello and Rotolo knew in their youths. The Village's long period as a bohemian enclave, a magnet for misfits, and an engine of culture had ended, maybe for good. Much of it was now an affluent bedroom, shopping, and dining zone; NYU seemed intent on absorbing the rest into an ever-growing campus. In the mid-1990s New York City had embarked on a remarkable program of reinventing itself and carried the Village along with it.

Ed Koch's low standing in the Village hadn't stopped him from being reelected for a third term, from 1986 through 1989, by a stunning 75 percent of the voters. He was a national celebrity. There was much talk of the White House being his next move. But from the start, his last term was a minefield of political scandals. Meanwhile, Wall Street crashed in 1987, and the city, along with the rest of the nation, fell into a recession.

In 1990 his successor Mayor David Dinkins inherited a city slipping back to 1970s levels of depressing dysfunction. When Rudolph Giuliani took office four years later he moved quickly to buff up the city's badly tarnished image, understood as a necessary first step to rebooting Koch's failed redevelopment program. He cracked down on crime across the board, swept the homeless and panhandlers out of Manhattan, cleaned up the graffiti and the rat-infested parks. Under Giuliani the long-planned transformation of Times Square from scummy sin pit to tourist-friendly family amusement center, anchored by Disney no less, was finally realized. Times Square is once again the dazzlingly lit crossroads of the world, thick with entertainments and ringed with new hotels. The city's makeover spread from there, urged forward by both Giuliani and his successor, the billionaire Michael Bloomberg.

A whole new Manhattan had emerged by 2011, clean, safe, brightly lit, family friendly, and packed with new hotels and amenities. The tourists had flocked back in record-breaking numbers—almost fifty million a year now, the city estimates. The new Manhattan also attracted a flood of new white-collar residents. The children of the professionals who had followed their corporate employers out to the suburbs in the city's darker times poured back in, buying up new luxury condominiums as quickly as they could be built. In the 2000s a feeding frenzy for domestic real estate, riding the crest of a nationwide housing bubble, sent prices soaring. Even the shock of 9/11 did little to slow the pace. In 2005 the *average* sale price of an apartment in Manhattan went above $1 million. That year, the average Manhattan renter was paying $2,500 a month. The crash of 2008 brought a momentary pause, but by 2012 prices were well up again, with the average renter in Manhattan paying $3,418 a month.

As sale and rental prices skyrocketed elsewhere on the island, Manhattan developers and realty agents were increasingly able to lure affluent buyers to the relative bargains in the traditionally downmarket and déclassé areas below Fourteenth Street. The old cultural divide Max Gordon wrote about, separating the tony uptown from the bohemian downtown, was obliterated. Downtown has now been uptowned. Tenement buildings on the Lower East Side were converted to luxury condos. The

East Village and Alphabet City, previously considered funky ghettos and a no-man's-land to anyone who could afford to avoid them, were suddenly hot. Real estate there is now pricier than on the Upper East Side, Manhattan's traditional zone of wealth for generations.

The historic landmarking of much of Greenwich Village has relegated new construction primarily to its formerly industrial fringes. West Street, for instance, has sprouted several new glass-and-steel luxury towers. But preserving the quaint, old-fashioned charm of the heart of the Village only makes the real estate there that much more dear. In 2012 one-room studios in the Village sold for half a million to a million dollars; town houses and condominiums went for ten, fifteen, twenty million. Rents on one-bedrooms were now as high as five, six, eight thousand dollars a month.

Not surprisingly, such skyrocketing prices drove resident bohemians and artists out of the Village, and out of downtown Manhattan generally. Few hopeful youngsters have come to replace them. New York's bohemian and art scenes are now fanned out across Brooklyn. (Escalating rents have been chasing them there as well.) Except for Westbeth's tenants and others in rent-controlled apartments, the only creative-sector people who can afford to live below Fourteenth Street now are already successful movie stars, celebrities, fashion giants like Calvin Klein, and such artists as Julian Schnabel, whose Venetian-fantasy Palazzo Chupi on West Eleventh Street near Washington Street riled neighbors as it reared up over the rest of its block in 2007. Schnabel built an eleven-story addition on top of an old stable and garage and painted it a jarring Pepto-Bismol pink. Richard Gere bought one of the five condos in it for $12 million. As the pink exterior weathered to a softer rose, Villagers debated whether Chupi was an ugly intrusion or a fittingly audacious and eccentric addition to the neighborhood.

The journalist Kate Walter, who lives in Westbeth, says she has found it "really dispiriting" that "this whole neighborhood has become full of straight people, lots of people with kids. When the gay bookstore A Different Light became a maternity shop, that for me was one of the most significant changes. And when the Oscar Wilde Bookshop closed, that

for me was heartbreaking. You still sometimes see gay European tourists on Christopher Street with the old guidebooks looking for Oscar Wilde and it isn't there. I feel like I'm in the last holdout for Greenwich Village bohemia, and I'm surrounded by all these wealthy people."

Who cares, her Westbeth neighbor Bob Gruen argues, if people are not making art in downtown Manhattan anymore? "They're pricing people out of Manhattan, which is a shame," he concedes. "The Village used to be a real mecca. There are people who complain about that, 'The Village isn't what it used to be.' Nothing's like it used to be. Nothing will ever be the way it used to be. Things always change. It's too bad it changed in a way that young people can't really come into the Village. I can't imagine being able to come into the Village now on the budget I had. Even Westbeth is ten times what we paid forty years ago. But it's forty years, you know? People say there's nothing going on in the Village, but there doesn't have to be. There's a lot going on in Brooklyn. So what that it's not on the Lower East Side anymore? It didn't disappear. There are still young people and young bands."

All around Westbeth the Village is shiny and new. The city dismantled the crumbling waterfront, knocking down the elevated West Side Highway and the sheds on the piers, prepping for the development of today's Hudson River Park. "For a while in the '80s it was crack dealers out there, and it was kind of a no-man's-land," Bob Gruen recalls. "After the AIDS crisis killed off the gay scene it was really kind of deserted." That period was just a transitional phase. The whole West Side waterfront is now a leafy park, with bike lanes and joggers and young singles walking their dogs and young mothers pushing strollers the size of Volkswagens. They look across a Hudson flecked with sailboats and kayaks at similar parks lining the Jersey side. The occasional transvestite still strolls West Street after dark but she seems a visitor from another time.

The meatpacking district's era as a sexual playground had scarcely ended when an upscale all-night bistro, Florent, opened on Gansevoort Street in 1985. In the 1990s and 2000s the area was completely transformed. Its cobbled streets are now lined with upscale restaurants, new hotels, an Apple store, pricey boutiques. Since Sex and the City featured

the area—Samantha was said to live there—it has attracted large flocks of young Samanthas and Carries with their dates. The High Line that runs through the area, an elevated railway where freight trains once shunted to and through the West Side's industrial buildings (a short section still pierces the flank of Westbeth), is now a park where tourists stroll among small trees, flowering shrubs, and native grasses. The wide intersection where Gansevoort, Little West Twelfth Street, and Ninth Avenue meet is now a pedestrian mall, Gansevoort Plaza. Gruen remembers when "even the butchers wouldn't go up there. It was too dangerous. Now at three in the morning there's literally hundreds or thousands of people staggering around . . . And all the windows open and all the glasses tinkling and all the people laughing and all the music blending." He says it reminds him of Bourbon Street.

In 1990 John Waters bought a one-bedroom apartment in a prewar doorman building in the Village. Since then he has divided his year between Baltimore, the Village, Provincetown in the summer, and being on the road. "I walk around the meatpacking district today, one of my least favorite neighborhoods now, and I see these people eating in these fancy restaurants," he says. "I think, 'If you knew what went on here.' The Toilet is a fancy restaurant. I've seen people *eating* there."

Affluent new residents have attracted upscale shops and restaurants all around the Village, driving out Rotolo's mom-and-pop shops. On and near the western blocks of Bleecker Street, once the heart of the gay Village, landlords doubled and tripled the rents on the old shops to get them out and make way for new, tonier tenants—Marc Jacobs, Jimmy Choo, Ralph Lauren, and, maybe the most ironic of all, Brooks Brothers. Villagers took to calling it Madison Avenue South, and a bright yellow postcard began to appear around the area, declaring "More Jane Jacobs, Less Marc Jacobs." Magnolia Bakery, which opened at the corner of Bleecker and West Eleventh Streets in 1996, was also featured in *Sex and the City*. Tour guides bring the show's fans there.

Seated nearby at the White Horse in 2011, Dermot McEvoy railed against "that fucking cupcake place" and the gentrification of the neighborhood generally. "I had a haircut yesterday, my barber Jim over on Perry

Street, been in the Village for years. He was cutting this guy's hair and he goes, 'In five years there won't be a grocery store to buy a salami sandwich.' 'Well you don't need grocery stores,' the guy in the chair says. 'We eat out every night.' That's nice, fuck you. I can't stand people like that . . . All these people are WASPs. They are all white, they all have money, and they have no imagination. There is no culture here now." He would move out of the Village to Jersey City in 2012.

Over the past quarter century NYU has been on a remarkable program of reinvention itself, metastasizing from a modest commuter school to the largest private university in the country, with forty thousand students, nine out of ten of them now from outside the city. It has been buying and building all over the Village and East Village, its new structures often displaying, the New York Times has commented, "an unfortunate knack for commissioning some of the worst work from big-name architects." The destruction and artificial reproduction of the Poe House was just one of several public relations gaffes that have earned the school many bitterly combative enemies in the Village, even among its own students and faculty. In 2010 the usually pro-development New York magazine dubbed NYU "The School That Ate New York." For neighborhood preservationists, the magazine noted, fighting to keep the school from turning the Village into one giant campus has been the twenty-first-century echo of the historic battle to keep Robert Moses from paving it all over.

A SHARP RENT HIKE FORCED ART D'LUGOFF TO CLOSE THE VILLAGE Gate in 1993. At his death in 2009, aged eighty-five, he was still planning a comeback. A hip new music club, Le Poisson Rouge, took over some of the space. Across the street, Kenny's Castaways, the site of the former Slide, closed in 2012.

Ed Koch died on February 1, 2013. He was eighty-eight and, despite failing health in the last few years, feisty, argumentative, and politically engaged to the end.

Robert Delford Brown continued to hold grand openings at the Crack-Up until 1997, when he sold the building and left the city. After some moving around he settled in Wilmington, North Carolina, on the banks

of the Cape Fear River, in 2007. In 2009 his body was found in the river. He'd been planning an event in which he'd float a raft made of flip-flops downstream and evidently he slipped in and drowned. The Crack-Up is now offices. No goofy signs hang from it. It blends in perfectly with its surroundings and gives no hint of its arty past.

In the late 1990s Randy Wicker was back in the news with a new cause. Shortly after the cloning of the sheep Dolly was announced in 1997 Wicker, then fifty-nine, started proselytizing for human cloning rights. As an older gay man he wanted to reproduce—have not just a child but a sort of identical twin, only younger. He founded a group he called Clone Rights United Front, printed up literature, made posters and buttons with sayings like "Clone Jesus." "I actually hired ten homeless people and had a demonstration in Sheridan Square." Local news covered it, which got him in *Time* and on many national news broadcasts, and he played along good-naturedly in a segment of *The Daily Show* shot at and around his Hudson Street shop in 2001. He closed the shop in 2003.

St. Vincent's Hospital closed in 2010. As the AIDS epidemic receded, so did much of the Catholic charity–run hospital's funding. In 2012 neighborhood groups were hotly contesting a developer's plan to replace the main hospital building with yet another luxury housing complex, while the old NMU hall would become an emergency care facility; the nearby triangle where Seventh Avenue, Greenwich Avenue, and West Twelfth Street converge would become an AIDS memorial park.

Reflecting on all the changes, Paul Foster recalls that when he was at NYU law school he walked by the Provincetown Playhouse every day. "All this historicity, all this inbreeding of talent, I don't know where else in the world you would have found that. Civilization has its zeitgeist. There is a ghost of the time. But it doesn't stay where it's not welcome. Ancient Athens, there was a geist there. The geist was surely in that part of the world, then it jumped away. It went to Italy for the Renaissance, it went to Elizabethan England, it went to Paris and Berlin. It's the combination of the right energies from the right people getting together at the right time. And I don't know of a single example of when it's come back

again. When the geist moves, it never comes back to its old neighborhood."

Lucian Truscott left the Village decades ago, to go to Los Angeles and be a screenwriter, then to the rural South. He keeps up with McEvoy and his other Lion's Head friends via e-mail now.

"I guess every generation goes through this same sort of geezer stage, when there are fewer and fewer people around who remember the good old, or bad old, days," he says. "It's the natural order of things. I remember one Saturday years and years ago, back in the late '80s, after I had moved out of New York. I was back for a couple of days staying with a friend in the Village, and I was walking down one of those nice little streets over there west of Seventh Avenue, and I saw this young woman walking down the street toward me. She was in her early twenties, and dressed real cool, and she was gorgeous, and she was going somewhere important to do something important, almost bent forward with the energy of youth and great expectations. It came to me that she was exactly like the young women I lusted after when I was her age. We were all gorgeous and dressed real cool and headed someplace fast to see someone important or do something important, filled with great expectations that would come true, damn it, or we would die tryin'. All of a sudden I realized that we had been replaced. That the little studio apartments all around me were no longer filled with my friends and acquaintances but hers. The street was hers now. The energy was hers. The important people she was going to see were her important people, not mine, and the important things she was going to do were different than our important things. The only things that remained pretty much the same were the street and her gorgeousness and great expectations."

# ACKNOWLEDGMENTS

A LOT OF PEOPLE HELPED IN MYRIAD WAYS TO MAKE THIS BOOK happen. I am indebted to them all.

First, thanks to everyone who agreed to be interviewed for this book. They shared not only their stories, but their ideas, contacts, guidance, and encouragement. Some are people I have known for years, but many were new acquaintances when they graciously agreed to talk with me. Sadly, a few have passed on since.

Thanks to Sashweight, Arne Svenson, Daniel Drasin, Al Leslie, John Gilman, Jim Linderman, and Christine Walker for providing photographs, production stills, and other illustration material. And to Christine as well for her invaluable help in photo research.

A number of other people shared their wisdom and knowledge, loaned me reading material, suggested topics to explore and people to contact, read draft segments, published excerpts, transcribed interviews, accompanied me on some of my endless walks around the Village, and much more. Thanks to each and every one of you: Lincoln Anderson at the *Villager*; Jan Benzel at the *New York Times*; Brian Berger; Andrew Berman and the staff at the Greenwich Village Society for Historic Preservation; Lauri Bortz; William Bryk; Chris Calhoun; Irwin Chusid; Celia Farber; Joan Fleur; Michael Gentile; Christopher George and Claartje van Dijk at the International Center of Photography; Giorgio Gomelsky; Nora Griffin; Andrew Jacobson; Joe E. Jeffreys at NYU; Tanisha Jones at the New York Public Library; Lisa Kearns; Jim Knipfel; Laura Lindgren; Laurie Liss; Don McLeod; Sina Najafi at *Cabinet*; Clayton Patterson; Diane

Ramo; Rasha Refaie; Daniel Riccuito at the *Chiseler*; Todd Robbins; Jeffrey Roth at the *New York Times*; David Schroeder at NYU's Jazz Studies department; Michael Sgouros at the Players Theatre; Kenneth Swezey; Scott Veale at the *New York Times*; and Matt Weiland.

Many thanks, of course, to Dan Halpern, publisher of Ecco, and to my magnificent and wise editors Hilary Redmon and Shanna Milkey, and to Libby Edelson and everyone else at Ecco and HarperCollins. Thanks to Donald Kennison for his excellent copyediting.

# NOTES

## INTRODUCTION

vii   "America was one thing": Sukenick, Ronald. Down and In, p. 15.
vii   "You could sit on a bar stool . . .": Dylan, Bob. Chronicles, p. 47.
xi    "What happens when . . .": Burroughs, William. Junky, Queer, Naked Lunch, p. 275.

## 1. BOSSEN BOUWERIE

3     "the motliest assortment . . .": Burrows, Edwin G., and Mike Wallace. Gotham, p. 31.
3     The first Jews: Ibid., p. 60.
3     Predominantly male: Caldwell, Mark. New York Night, pp. 12–13.
4     Wouter Van Twiller: Jackson, Kenneth T., ed. The Encyclopedia of New York City, p. 506.
4     His farmhouse: Boyer, Christine. "Straight Down Christopher Street," in Greenwich Village: Culture and Counterculture, Rick Beard and Leslie Cohen Berlowitz, eds. pp. 36–37.
4     A native settlement: Geismar, Joan H. "The Village Underground," in Greenwich Village, p. 55.
4     In 1644 the first black residents: Foote, Thelma Wills. "Crossroads or Settlement?" in Beard and Berlowitz, pp. 120–22.
5     Kieft and his cohort: Caldwell, pp. 17–18.
6     The following year: Lepore, Jill. New York Burning, pp. 53–58.
6     As a result: Foote, p. 123.
6     The stone Great Dock: Buttenwieser, Ann L. Manhattan Water-Bound, pp. 29–34.
7     "As late as 1820 . . .": Haswell, Charles Haynes. Reminiscences of New York by an Octogenarian (1816 to 1860), p. 35.
8     From the day it was published: Gray, Christopher. "Are Manhattan's Right Angles Wrong?" New York Times, October 23, 2005.

8      "*The magnificent opportunity . . .*": Janvier, Thomas Allibone. "The Evolu-
       tion of New York," *Harper's New Monthly Magazine*, June 1893.

## 2. A MAGNET FOR MISFITS

10     *In the 1650s:* Janvier, Thomas Allibone. *In Old New York*, p. 90.

10     *It's mentioned again:* Danckaerts, Jasper. *The Journal of Jasper Danckaerts
       1679–1780*, pp. 66–68.

10     *Because the settlements:* Harris, Luther S. *Around Washington Square*, p. ix.

11     *In the 1740s:* Boyer, Christine. "Straight Down Christopher Street," in
       *Greenwich Village*, Rick Beard and Leslie Cohen Berlowitz, eds. p. 37.

11     *Warren was evidently:* Burrows, Edwin G., and Mike Wallace. *Gotham*, p.
       178.

11     *the three parallel east-west roads:* Moscow, Henry. *The Street Book*, p. 37.

11     *Other wealthy New Yorkers:* Burrows and Wallace, p. 178.

11     *Haswell, in* Reminiscences: Haswell, Charles Haynes. *Reminiscences of
       New York by an Octogenarian (1816 to 1860)*, p. 108.

12     *Abraham Mortier leased:* Burrows and Wallace, p. 178.

12     *George Washington made it:* Dunshee, Kenneth Holcomb. *As You Pass By*,
       p. 213.

13     *John Jacob Astor:* Lockwood, Charles. *Manhattan Moves Uptown*, p. 68.

13     *In 1913, when the city:* "Wreckers Uncover Aaron Burr House," *New York
       Times*, December 11, 1913.

15     "*When President Thomas Jefferson . . .*": Ritchie, Donald A. *American Jour-
       nalists*, p. 25.

15     *In 1808 Paine moved:* Kazin, Alfred. "Greenwich Village Writers," in
       *Greenwich Village*, p. 292.

15     *One of his few obituaries:* Kaplan, James S. "Thomas Paine's America,"
       *Last Exit*, May 20, 2009 (http://lastexitmag.com/article/thomas-paines-
       america).

16     "*deep damp cellars . . .*": Janvier, Thomas Allibone. "The Evolution of New
       York," *Harper's New Monthly Magazine*, June 1893.

16     *the especially virulent epidemic:* Haswell, p. 135.

17     *In one week:* Scherzer, Kenneth A. *The Unbounded Community*, p. 144.

17     *Between 1825 and 1835:* Ware, Caroline F. *Greenwich Village, 1920–1930*, p.
       10.

17     *New York grew and flowed:* Scherzer, p. 25.

17     *Newgate Prison opened:* Boyer, p. 39.

18     *Fulton, a Pennsylvania-born inventor:* Lewis, Tom. *The Hudson*, pp. 155–64.

19     *Over the next thirty years this soggy ground:* Harris, p. 6.

19     "*a great public barbecue . . .*": Bender, Thomas. "Washington Square in the
       Growing City," in Beard and Berlowitz, p. 28.

20     *James was born:* Edmiston, Susan, and Linda D. Cirino. *Literary New York*,
       pp. 39–41.

20      In 1832, the fledgling University: Harris, pp. 18–20.

21      To cut construction costs: Walkowitz, Daniel J. "The Artisans and Builders of Nineteenth-Century New York," in Beard and Berlowitz, pp. 202–3.

21      A long block: Harris, pp. 12–14.

21      The literary historian Sandra Tomc argues: Tomc, Sandra M. "Poe and His Circle," in Kevin J. Hayes, ed. The Cambridge Companion to Edgar Allan Poe, pp. 22–24.

23      Tomc speculates that: Ibid., pp. 26–30.

24      Village lore tenuously connects: Gray, Christopher. "Streetscapes," New York Times, October 10, 1993.

## 3. THE FIRST BOHEMIANS

29      The idea of the individual artistic genius: Wilson, Elizabeth. Bohemians, p. 2.

29      The few insurgent spirits: Hobsbawm, Eric. The Age of Revolution, p. 260.

29      The poet Kenneth Rexroth: Rexroth, Kenneth. World Outside the Window, p. 58.

29      "required furniture, ceramics . . .": Wilson, pp. 16–17.

30      "left to cast his soul . . .": Hobsbawm, p. 261.

30      "essentially an oppositional fraction . . .": Wilson, p. 22.

30      "acting out the conflicts . . .": Seigel, Jerrold. Bohemian Paris, p. 11.

31      Malcolm Cowley points out: Cowley, Malcolm. Exile's Return, p. 55.

32      The country's economic boom ended: Huston, James L. The Panic of 1857 and the Coming of the Civil War, pp. 14–34.

33      in the cellar of the Coleman House: Harris, Luther S. Around Washington Square, p. 52.

33      Next door to Coleman House: Ibid., pp. 34–40.

33      As the city surged up toward: Lockwood, Charles. Manhattan Moves Uptown, pp. 125–35.

34      In the evenings Broadway: Schmidgall, Gary. Walt Whitman, p. 98.

34      Upwards of a hundred brothels: Gilfoyle, Timothy J. City of Eros, pp. 120–23.

35      In its 1890 obituary: "Death of Charles I. Pfaff," New York Times, April 26, 1890.

35      "Far from a pack of . . .": Stansell, Christine. "Whitman at Pfaff's: Commercial Culture, Literary Life and New York Bohemia at Mid-Century," Walt Whitman Quarterly Review 10 (Winter 1993).

35      By January 1858 the New York Times: "Bohemia in New-York," New York Times, January 6, 1858.

36      According to legend Clapp: Wilson, p. 141.

36      When the Nation appeared: Parry, Albert. Garrets and Pretenders, pp. 44–45.

37      Stansell points out: Stansell, Christine. American Moderns, pp. 111–12.

37      "I have finished reading 'Beulah' . . .": Clare, Ada. "Thoughts and Things," Saturday Press, November 12, 1859. Scanned issues of the Saturday Press

are archived at the excellent website The Vault at Pfaff's (http://digital
.lib.lehigh.edu/pfaffs/).

38      *where developers had been building:* Lockwood, pp. 249–50.

38      *According to another actress:* Eytinge, Rose. *The Memories of Rose Eytinge,*
         pp. 21–22.

38      *"When I say that I am a Bohemian . . .":* O'Brien, Fitz-James. *The Poems and
         Stories of Fitz-James O'Brien,* pp. 286–87.

39      *"sitting out the long period . . .":* Stansell, "Whitman at Pfaff's."

41      *As a young newspaperman:* Loving, Jerome. "A Newly Discovered Whit-
         man Poem," *Walt Whitman Quarterly Review* 11, no. 3 (Winter 1994).

42      *He and Clapp were kindred spirits:* Gailey, Amanda. "Walt Whitman and
         the King of Bohemia," *Walt Whitman Quarterly Review* 25, no. 4 (Spring
         2008).

42      Vanity Fair, *begun in 1859:* Scholnick, Robert J. "An Unusually Active
         Market for Calamus," *Walt Whitman Quarterly Review* 19, no. 34 (Win-
         ter/Spring 2002).

44      *In cities like New York:* Chauncey, George. *Gay New York,* pp. 76–86.

44      *"the well-dressed male clerks . . .":* Scholnick.

45      *In February 1874:* " 'Ada Clare' Bitten by a Pet Dog," *New York Times,* Feb-
         ruary 20, 1874.

45      *Pfaff and Clapp tried:* Parry, p. 61.

## 4. THE RESTLESS NINETIES

50      *"a passably good-looking street . . .":* McCabe, James D., Jr. *Lights and Shadows
         of New York Life,* pp. 386–89.

52      *Before the Civil War, Fourteenth Street:* Lockwood, Charles. *Manhattan
         Moves Uptown,* pp. 167–70.

52      *The area was also well known:* Gilfoyle, Timothy J. *City of Eros,* pp. 210–12.

55      *"We entered the resort . . .":* Gardner, Charles W. *The Doctor and the Devil,*
         p. 52.

55      *a* New York Times *report on his death:* "Murray Hall Fooled Many Shrewd
         Men," *New York Times,* January 19, 1901.

56      *The Tenth Street Studio:* Gray, Christopher. "Remembering an 1858 Green-
         wich Village Atelier," *New York Times,* May 25, 1997.

57      *Tourists in the know:* Parry, Albert. *Garrets and Pretenders,* pp. 64–66.

58      *a venerable tavern called the Grapevine:* "Passing of the Old Grapevine,"
         *New York Times,* July 18, 1915.

59      *The new woman appeared:* Stansell, Christine. *American Moderns,* pp. 27–28.

## 5. THE BOHEMIANS' NEIGHBORS

64      *Working-class Irish families:* Ware, Caroline F. *Greenwich Village, 1920–
         1930,* pp. 203–4.

64    Ninety-five percent of the longshoremen: Fisher, James T. On the Irish Water-front, pp. 6–7.

66    As other productions followed: Bean, Annemarie, James V. Hatch, and Brooks McNamara, eds. Inside the Minstrel Mask, p. 260.

66    The seating policy at the African Grove: Edmiston, Susan, and Linda D. Cirino. Literary New York, p. 48.

67    White workers organized: Sacks, Marcy S. Before Harlem, pp. 127–30.

67    "The Czar of all the Russias . . .": Riis, Jacob. How the Other Half Lives, p. 156.

68    In his 1896 article: Crane, Stephen. Tales, Sketches, and Reports, pp. 399–406.

68    The crackdown Crane mentions: McFarland, Gerald W. Inside Greenwich Village, pp. 12–13.

69    To whites, the most notorious: Sacks, pp. 47–62.

69    Writing about Little Africa: Riis, pp. 156–58.

70    Bostin Crummell was captured: Gates, Henry Louis, and Evelyn Brooks Higginbotham, African American Lives, p. 198.

70    Samuel Eli Cornish: Penn, I. Garland. The Afro-American Press, and Its Editors, p. 28.

70    Henry Highland Garnet: Gates and Higginbotham, pp. 324–25.

71    According to an article: "For an Ex-Slave's Fortune," New York Times, June 8, 1890.

72    In 1912, Mary Kingsbury Simkhovitch: Simkhovitch, Mary Kingsbury. Neighborhood, p. 112.

72    The one-block Gay Street: Miller, Terry. Greenwich Village and How It Got That Way, pp. 44–45.

72    After the Civil War: McFarland, p. 85.

73    In his book Black Manhattan: Johnson, James Weldon. Black Manhattan, p. 58.

73    Visiting New York in 1904–5: James, Henry. In The Greenwich Village Reader, June Skinner Sawyers, ed., pp. 84–85.

74    Across narrow Greene Street: Argersinger, Jo Ann E. The Triangle Fire, pp. 1–43.

76    Ironically, the strike provided: Sacks, pp. 129–30.

77    This huge demonstration: Argersinger, pp. 21–33.

## 6. THE "GOLDEN AGE" BEGINS

80    "Greenwich Village was not only a place . . .": Cowley, Malcolm. Exile's Return, pp. 59–60.

80    One of the magnets: Stansell, Christine. American Moderns, pp. 79–80.

81    "a respectable, well-meaning . . .": Dell, Floyd. Love in Greenwich Village, p. 18.

81    Where lectures and polite conversation: Stansell, pp. 80–81.

81    Havel was a small: Churchill, Allen. The Improper Bohemians, pp. 21–24.

| 81 | *According to one Villager:* Hapgood, Hutchins. *A Victorian in the Modern World,* pp. 198–99. |
| 82 | *"a carrier of ideas . . .":* Green, Martin. *New York 1913,* p. 50. |
| 82 | *"I felt I was made . . .":* Luhan, Mabel Dodge. *Intimate Memories,* p. 81. |
| 83 | *"Gertrude Stein was prodigious . . .":* Ibid., p. 89. |
| 84 | *as their ship pulled into:* Ibid., pp. 101–2. |
| 84 | *The house, which no longer stands:* Green, pp. 52–53. |
| 84 | *"He had nice brown eyes . . .":* Luhan, p. 108. |
| 85 | *"I preferred for many years . . .":* Hapgood, pp. 325–26. |
| 86 | *"she was completely innocent . . .":* Ibid., p. 347. |
| 86 | *"Socialists, Trade Unionists . . .":* Luhan, p. 124. |
| 87 | *One night, not an Evening:* Hapgood, p. 365. |
| 87 | *"that very rare species . . .":* Ibid., p. 204. |
| 87 | *"Sasha tried to kiss me . . .":* Luhan, p. 115. |
| 88 | *He stayed for a while:* Edmiston, Susan, and Linda D. Cirino. *Literary New York,* p. 65. |
| 89 | *The restlessly peripatetic Upton Sinclair:* Arthur, Anthony. *Radical Innocent,* pp. 3–137. |
| 90 | *He was so handsome:* May, Henry F. *The End of American Innocence,* p. 315. |
| 90 | *"He was young, big . . .":* Luhan, p. 132. |
| 91 | *"When he came in one night . . .":* Ibid., pp. 137–38. |
| 91 | *Then, too, he may also:* Green, p. 209. |
| 92 | *Haywood had helped to found:* Ibid., pp. 28–31. |
| 92 | *"Socialists could not agree . . .":* May, pp. 177–79. |
| 93 | *the Lafayette's café and restaurant:* Harris, Luther S. *Around Washington Square,* p. 156. |
| 93 | *"procrastinator's paradise . . .":* Powell, Dawn. *The Wicked Pavilion,* pp. 32–33. |
| 94 | *In her landmark study:* Ware, Caroline F. *Greenwich Village, 1920–1930,* pp. 105–6. |
| 95 | *"In 1906, Washington Square . . .":* Lewis, Edith. *Willa Cather Living,* pp. xii–xiii. |
| 95 | *The two of them moved:* Ibid., pp. 86–87. |
| 95 | *Cather wrote that her Greenwich Village:* Jewell, Andrew. "Willa Cather's Greenwich Village," *Studies in American Fiction* 32, no. 1 (Spring 2004). |

## 7. 1913

| 98 | *Max Eastman was vacationing:* O'Neill, William L. *Echoes of Revolt,* p. 17. |
| 98 | *Chicago's own bohemian scene:* Stansell, Christine. *American Moderns,* p. 53. |
| 99 | "A MAGAZINE WITH A SENSE": O'Neill, p. 29. |
| 100 | *In fact the book's author:* Chauncey, George. *Gay New York,* pp. 230–31. |
| 101 | *"For Americans an artist . . .":* Ashton, Dore. *The New York School,* pp. 6–31. |

102     *In 1910 some artists*: Green, Martin. *New York 1913*, pp. 131–35.

103     *"The thing is pathological! . . .":* "Cubists and Futurists Are Making Insanity Pay," *New York Times*, March 16, 1913.

104     *"There's a war in Paterson . . .":* O'Neill, p. 143.

104     *Kemp was dismayed:* Kemp, Harry. *More Miles*, pp. 406–7.

105     *On the morning of June 7:* Green, pp. 195–205.

106     *"at last I learned . . .":* Luhan, Mabel Dodge. *Intimate Memories*, p. 132.

106     *And, as Flynn had predicted:* Green, pp. 208–15.

## 8. THE PROVINCETOWN PLAYERS

107     *American theater in the 1910s:* McNamara, Brooks. "Something Glorious," in *Greenwich Village*, Rick Beard and Leslie Cohen Berlowitz, eds. p. 309.

107     *Susan Glaspell, a founder:* Heller, Adele. "The New Theatre," in *1915, the Cultural Moment*, Adele Heller and Lois Rudnick, eds. pp. 217–23.

108     *Soon-to-be Villagers:* Murphy, Brenda. *The Provincetown Players and the Culture of Modernity*, pp. 3–5.

108     *Much the same could be said:* McNamara, p. 310.

109     *"a social register . . .":* Churchill, Allen. *The Improper Bohemians*, p. 136.

110     *"The young O'Neill was dressed . . .":* Ibid., p. 139.

111     *The young redhead:* Milford, Nancy. *Savage Beauty*, pp. 17–142.

112     *"sat darning socks . . .":* Ibid., pp. 161–62.

112     *Another young woman:* Herring, Philip. *Djuna*, pp. 1–58.

113     *"In those days Greenwich Village . . .":* Barnes, Djuna. "The Days of Jig Cook," *Theater Guild Magazine*, January 1939.

114     *"my upper lip . . .":* Herring, p. 94.

115     *as the Brooklyn Daily News quipped:* "All God's Chillun Got Wings," *Brooklyn Daily News*, May 16, 1924.

## 9. THE GOLDEN AGE WANES

118     *"Then came yells and hoofs . . .":* Reed, John. *Insurgent Mexico*, pp. 88–89.

119     *It was there that Willa Cather:* Lewis, Edith. *Willa Cather Living*, pp. 141–43.

119     *Upton Sinclair heard:* Arthur, Anthony. *Radical Innocent*, pp. 149–53.

119     *"I avowed revolutionary principles . . .":* Kemp, Harry. *More Miles*, pp. 272–73.

120     *Emma Goldman, who'd worked:* Stansell, Christine. *American Moderns*, pp. 116–17.

121     *The judge summarily excused:* Churchill, Allen. *The Improper Bohemians*, pp. 97–102.

122     *"too Thirteenth Street":* Miller, Terry. *Greenwich Village and How It Got That Way*, p. 141.

122     *In the spring and summer:* Taylor, Nick. *American-Made*, pp. 39–40.

123   *"all forms of government . . .":* Goldman, Emma. *Anarchism and Other Essays,* p. 56.

124   *One harbinger of the future:* Ramirez, Jan Seilder. "The Tourist Trade Takes Hold," in *Greenwich Village,* Rick Beard and Leslie Cohen Berlowitz, eds. p. 376.

124   *In 1915 he took:* Harris, Luther S. *Around Washington Square,* pp. 192–93.

125   *"the layman's dream . . .":* Churchill, p. 105.

125   *P. G. Wodehouse:* McCrum, Robert. *Wodehouse,* pp. 68–104.

125   *"Quite ordinary people . . .":* Groce, Nancy. *New York: Songs of the City,* p. 63.

125   *So did Sadakichi Hartmann:* Bryk, William. "King of the Bohemians," *New York Sun,* January 26, 2005.

126   *Once, when he was:* Schulman, Robert. *Romany Marie,* pp. 148–49.

128   *"Having fled from Dubuque . . .":* Cowley, Malcolm. *Exile's Return,* p. 59.

128   *Village women opened tearooms:* Ramirez, p. 382.

128   *"Romany" Marie Marchand:* Schulman, pp. 38–115.

130   *By 1917 boutiques sprouted:* Ramirez, pp. 379–83.

131   *"potent in its appeal . . .":* Dell, Floyd. *Love in Greenwich Village,* p. 299.

132   *These early balls launched:* Churchill, pp. 172–73.

132   *"we had something . . .":* Dell, p. 290.

132   *From 1914 to 1918:* Miller, pp. 28–29.

134   *In 1915 the New York Times:* "New Homes in Old Greenwich Village," *New York Times,* May 23, 1915.

135   *So many of the newcomers:* Andrew Dolkart, in a lecture sponsored by the Greenwich Village Society for Historic Preservation, 2011.

135   *By 1922 the Times:* "Artists to Migrate to Warehouse Tops," *New York Times,* September 19, 1922.

136   *The sociologist Caroline Ware:* Ware, Caroline F. *Greenwich Village, 1920–1930,* pp. 235–50.

137   *Even in Greenwich Village:* Miller, pp. 210–13.

## 10. THE NEXT WAVE

140   *"There were two sorts of people . . .":* Cowley, Malcolm. *Exile's Return,* p. 43.

140   *"After college and the war . . .":* Ibid., p. 48.

141   *"I came to think of them . . .":* Ibid., pp. 69–73.

142   *"I heard Emma Goldman lecture . . .":* Anderson, Margaret C. *My Thirty Years' War,* pp. 54–154.

144   *Villagers flocked to the courtroom:* Churchill, Allen. *The Improper Bohemians,* p. 130.

144   *"The sweet corners . . .":* Anderson, Margaret C., ed. *The Little Review Anthology,* p. 189.

145   *She was born Else Plötz:* Gammel, Irene. *Baroness Elsa,* pp. 58–76.

146   *At a reception for:* Anderson, *My Thirty Years' War,* pp. 194–95.

147   *Her heart broken:* Ibid., p. 211.

147    "Joe Gould was an odd . . .": Mitchell, Joseph. *Up in the Old Hotel*, p. 623.

148    *Dawn Powell arrived in Manhattan:* Page, Tim. *Dawn Powell*, pp. 1–101.

149    *"gave her a fine philanthropic reputation . . .":* Powell, Dawn. *The Wicked Pavilion*, p. 43.

151    *"Djuna Barnes was caught . . .":* Herring, Philip. *Djuna*, p. 242.

151    *Djuna Barnes once told:* Wilson, Edmund. *The Twenties*, pp. 66–67.

152    *"Our mission was accomplished . . .":* The Little Review Anthology, pp. 349–56.

## 11. THE PROHIBITION YEARS

155    *In 1929, when the mayor:* Lerner, Michael A. *Dry Manhattan*, p. 1.

156    *It was all the culmination:* Okrent, Daniel. *Last Call*, pp. 7–52.

156    *Twenty-six states were:* Merz, Charles. *The Dry Decade*, pp. 1–25.

156    *There was so much smuggling:* Okrent, p. 107.

156    *drinking in fact declined:* Kyvig, David E., ed. *Law, Alcohol, and Order*, pp. 3–16.

157    *labor leaders threatened:* Drescher, Nuala McGann. "Labor and Prohibition," in Kyvig, pp. 41–42.

157    *In the Village, the Brevoort:* Churchill, Allen. *The Improper Bohemians*, pp. 220–21.

157    *On the very first day:* Ibid., pp. 221–23.

158    *"the principal industry of the Village . . .":* Ware, Caroline F. *Greenwich Village, 1920–1930*, p. 55.

158    *Data suggest that:* Merz, pp. 54–70.

158    *Periodically through the 1920s:* Lerner, p. 259.

159    *"In the fall of the year . . .":* Ware, pp. 57–58.

159    *John Sloan commented:* Churchill, p. 214.

159    *"stowed away with utmost secrecy . . .":* Ware, pp. 56–57.

159    *Poisoning from bad alcohol:* Lerner, p. 260.

160    *In Plexus Miller writes:* Miller, Henry. *Plexus*, pp. 392–93.

160    *"On the kitchen wall . . .":* Ibid., p. 480.

161    *Mary Louise Cecilia Guinan:* Trachtenberg, Leo. "Texas Guinan: Queen of the Night," *City Journal* (Spring 1998).

162    *Max Gordon, later the founder:* Gordon, Max. *Live at the Village Vanguard*, p. 17.

162    *"The Village had indeed deteriorated . . .":* Miller, pp. 197–98.

163    *New Yorkers of all strata:* Lerner, pp. 127–47.

164    *Gangsters built their own breweries:* Kessner, Thomas. *Fiorello H. La Guardia and the Making of Modern New York*, pp. 358–59.

164    *His father, William Walker:* Walsh, George. *Gentleman Jimmy Walker*, pp. 12–17.

165    *"often a saloonkeeper . . .":* Jackson, Kenneth T., ed. *The Encyclopedia of New York City*, pp. 1236–37.

165   *"because the voting rolls . . .":* Browne, Arthur, Dan Collins, and Michael Goodwin. I, Koch, p. 59.

165   *Jimmy grew up affable:* Walsh, pp. 21–70.

166   *When critics complained:* Kessner, p. 162.

168   *Gene was quiet, polite:* Tunney, Jay R. The Prizefighter and the Playwright, pp. 15–62.

169   *New York City House of Detention for Women:* Harris, Sara. Hellhole, pp. 38–66.

170   *In 1957 Dorothy Day:* "Jail Pickets Back 10 Pacifists Inside," New York Times, July 21, 1957.

170   *"we would often . . .":* Paley, Grace. Just As I Thought, p. 29.

## 12. THE CONEY ISLAND OF THE SOUL

173   *"A den of iniquity . . .":* Sutton, Willie, with Edward Linn. Where the Money Was, pp. 60–61.

174   *"more disliked, derided . . .":* Hecht, Ben. Letters from Bohemia, p. 107.

174   *According to Allen Churchill:* Churchill, Allen. The Improper Bohemians, pp. 123–24.

175   *Hecht records that:* Hecht, p. 122.

175   *When the Society:* Wetzsteon, Ross. Republic of Dreams, pp. 384–86.

176   *Aimee Cortez:* Churchill, pp. 216–33.

177   *"tottering drunkenly to sleep . . .":* Hecht, p. 108.

177   *Bodenheim still attracted:* Wetzsteon, pp. 389–90.

178   *"A ragged drunk approaches . . .":* Malina, Judith. The Diaries of Judith Malina 1947–1957, pp. 183–211.

178   *"Do we not idolize Maxwell Bodenheim . . .":* Ibid., p. 226.

178   *In 1953 Ruth Bodenheim:* Wetzsteon, pp. 389–92.

180   *"the nose in the air attitude . . .":* Dos Passos, John. The Best Times, p. 135.

180   *"The ride in the paddywagon . . .":* Ibid., pp. 172–73.

181   *"the man in the iron necktie":* Meyers, Jeffrey. Edmund Wilson, p. 45.

181   *"a cold fishy leprous person . . .":* Wilson, Edmund. The Thirties, p. 236.

181   *He returned to the Village:* Meyers, p. 43.

182   *"many of the hazards of sex . . .":* Wilson, Edmund. The Twenties, p. 15.

182   *"ignited for me . . .":* Ibid., pp. 54–55.

182   *"one of the great literary fornicators . . .":* Meyers, pp. 64–65.

183   *He took a room:* Pollock, Thomas Clark, and Oscar Cargill. Thomas Wolfe at Washington Square, pp. 20–21.

184   *"the proud and potent Jewesses . . .":* Wetzsteon, p. 397.

184   *his own personal erotic Jewess:* Pollock and Cargill, pp. 41–52.

185   *"Oh Boston girls how about it . . .":* Page, Tim. Dawn Powell, p. 145.

186   *In 1938 Wolfe was diagnosed:* Wetzsteon, pp. 406–15.

186   *Contrary to later myths:* Oja, Carol J. Making Modern Music, pp. 25–44.

187   *Frederick Kiesler:* Harris, Luther S. Around Washington Square, pp. 222–24.

## 13. THE RED DECADE

189     *Greenwich House's Mary Simkhovich recorded:* Simkhovitch, Mary Kingsbury. *Neighborhood,* pp. 216–22.

190     *In 1932 Gertrude Whitney:* Harris, Luther S. *Around Washington Square,* pp. 227–28.

191     *As Kenneth Rexroth later japed:* Rexroth, Kenneth. "The Neglected Henry Miller," in *A View of the Nation,* Henry M. Christman, ed., p. 31.

191     *Those who were CPUSA members:* Gorman, Paul R. *Left Intellectuals & Popular Culture in Twentieth-Century America,* pp. 108–34.

192     *Workers Music Alliance:* Wilentz, Sean. *Bob Dylan in America,* pp. 18–22.

192     *"From Spirituals to Swing":* Goldsmith, Peter D. *Making People's Music,* pp. 83–85.

195     *Delmore Schwartz:* Atlas, James. *Delmore Schwartz: The Life of an American Poet,* pp. 3–26.

195     *"Don't do it . . .":* Schwartz, Delmore. *The World Is a Wedding,* p. 194.

196     *"an attic loft . . .":* Atlas, p. 104.

196     *"O the whole of history . . .":* Schwartz, Delmore. *Shenandoah,* p. 27.

197     *James Agee:* Bergreen, Laurence. *James Agee,* pp. 5–64.

198     *governor Franklin D. Roosevelt:* Taylor, Nick. *American-Made,* pp. 95–101.

200     *"represented . . . a meshing . . .":* Ashton, Dore. *The New York School,* pp. 118–22.

## 14. THE WRONG PLACE FOR THE RIGHT PEOPLE

201     *On one of those triangle-shaped lots:* Kahn, Ashley. "After 70 Years, the Village Vanguard Is Still in the Jazz Swing," *Wall Street Journal,* February 8, 2005.

201     *"People looked whiter . . .":* Wilson, Edmund. *The Thirties,* pp. 156–57.

202     *"Romany Marie's, the Gypsy Tavern . . .":* Gordon, Max. *Live at the Village Vanguard,* p. 15.

202     *The poet Eli Siegel:* Ibid., pp. 26–30.

204     *his tangled skein of wordplay:* Knipfel, Jim. "Protocol Takes Precedence Over Procedure," Chiseler.org.

205     *"Village people might . . .":* Sukenick, Ronald. *Down and In,* p. 15.

205     *"Black patent leather walls . . .":* Gordon, p. 66.

205     *She'd grown up a jazz fanatic:* Gordon, Lorraine. *Alive at the Village Vanguard,* pp. 15–96.

206     *"I learned about prejudice . . .":* Miller, Terry. *Greenwich Village and How It Got That Way,* p. 34.

206     *It was an odd shape:* Silvester, Peter J. *The Story of Boogie-Woogie,* pp. 170–75.

208     *"the greatest mayor . . .":* Kessner, Thomas. *Fiorello H. La Guardia and the Making of Modern New York,* pp. 3–5.

208   *When he was three:* Ibid., pp. 7–56.

209   *judge Martin Manton:* Reppetto, Thomas. *American Mafia,* p. 157.

210   *a global narcotics network:* Schneider, Eric C. *Smack,* pp. 4–6.

210   *half of all the junkies:* Ibid., p. 10.

211   *"even the presence of homosexuals . . .":* Carter, David. *Stonewall,* p. 18.

211   *"watered-down drinks . . .":* Truscott, Lucian K., IV. "The Real Mob at Stonewall," *New York Times,* June 25, 2009.

211   *"All fairy night clubs . . .":* Lait, Jack, and Lee Mortimer. U.S.A. *Confidential,* p. 45.

212   *In 1938 three gunmen:* "Dewey to Ask Death for Night Club Robbers," Associated Press, April 18, 1938.

212   *"The lezzies used to mix . . .":* Minette. *Recollections of a Part-Time Lady.*

212   *Both clubs were raided:* "Queer Doings Net Suspension for Vill. Clubs," *Variety,* December 2, 1944.

213   *Vincent "Chin" Gigante:* Raab, Selwyn. *Five Families,* pp. 531–44.

## 15. SWAG WAS OUR WELFARE

215   *By midwar New York:* Winkler, Allan M. *Home Front U.S.A.,* pp. 55–58.

215   *The city's clubs, movie houses, and restaurants:* Goldstein, Richard. *Helluva Town,* pp. 178–90.

216   *For Italians in the South Village:* Pozzetta, George E. "My Children Are My Jewels," in *The Home-Front War,* Kenneth Paul O'Brien and Lynn Hudson Parsons, eds., pp. 63–82.

217   *"No community, rich or poor . . .":* Lait, Jack, and Lee Mortimer. U.S.A. *Confidential,* p. 37.

220   *"cheap lunchrooms, tawdry saloons . . .":* WPA *Guide to New York City,* p. 69.

220   *It was a system obviously built:* Fisher, James T. *On the Irish Waterfront,* pp. 18–19.

221   *The whole system was enforced:* Ward, Nathan. *Dark Harbor,* pp. 34–37.

221   *In 1947, Andy Mintz:* Ibid., pp. 45–52.

222   *Dorothy Day's Catholic Worker House:* Fisher, pp. 74–75.

222   *"on a number of occasions . . .":* Harrington, Michael. *Fragments of the Century,* p. 49.

## 16. A REFUGE IN THE AGE OF ANXIETY

228   *"the psychic havoc . . .":* Mailer, Norman. *Advertisements for Myself,* p. 300.

228   *"The war had broken the rhythm . . .":* Broyard, Anatole. *Kafka Was the Rage,* p. 80.

228   *Auden:* Carpenter, Humphrey. *W. H. Auden,* pp. 120–346.

229   *J. R. R. Tolkien:* Broyard, p. 53.

229   *"Of convulsions and vast evil . . .":* Auden, W. H. *Collected Longer Poems,* p. 268.

229      *"Our generation in the fifties . . ."*: Wakefield, Dan. *New York in the Fifties,* p. 121.

230      *The poet Edward Field*: Field, Edward. *The Man Who Would Marry Susan Sontag,* pp. x–xi.

230      *Instead of garter belts*: Jones, Hettie. *How I Became Hettie Jones,* p. 46.

232      *In 1945 Delmore Schwartz*: Atlas, James. *Delmore Schwartz,* pp. 174–376.

235      *a one-room apartment*: Gruen, John. *Callas Kissed Me . . . Lenny Too!,* p. 79.

235      *The other tenants were*: Gruen, John. *The Party's Over Now,* pp. 19–26.

235      *He also met*: Gruen, *Callas,* pp. 89–92.

237      *"a virtuoso of ambiguity . . ."*: Gates, Henry Louis, Jr. *Thirteen Ways of Looking at a Black Man,* p. 181.

237      *"The Village in 1946 . . ."*: Broyard, pp. 8–16.

239      *It started with Ritual*: Holl, Ute. "Moving the Dancers' Souls," in *Maya Deren and the American Avant-Garde,* Bill Nichols, ed., pp. 151–55.

239      *Amos Vogel*: MacDonald, Scott. *Cinema 16,* pp. 1–17.

## 17. THE "NEW YORK SCHOOL"

242      *"Is he the greatest living painter . . ."*: "Jackson Pollock," *Life,* August 9, 1949.

245      *Explaining the downtown scene*: Ashton, Dore. *The New York School,* p. 164.

246      *"that ham-and-eggs school of art"*: "Harry Truman, Critic," *Time,* March 4, 1946.

247      *Larry Rivers describes Hofmann*: Rivers, Larry, with Arnold Weinstein. *What Did I Do?,* pp. 78–79.

247      *The food was lousy*: Harris, Luther S. *Around Washington Square,* pp. 233–34.

248      *The four poets*: Lehman, David. *The Last Avant-Garde,* p. 7.

249      *"nondescript, ill-lit . . ."*: Gruen, John. *Callas Kissed Me . . . Lenny Too!,* p. 101.

249      *"a small, crummy-looking bar . . ."*: Kligman, Ruth. *Love Affair,* p. 27.

249      *"We go there . . ."*: Lehman, p. 66.

249      *Gruen was there one night*: Gruen, John. *The Party's Over Now,* p. 229.

250      *"a loud bar . . ."*: Rivers, pp. 212–13.

250      *"A painter can't turn out . . ."*: Powell, Dawn. *The Golden Spur,* p. 18.

251      *"came storming in . . ."*: Kligman, p. 29.

252      *Larry Rivers*: Rivers, pp. 197–98.

253      *In 1957 Rivers was invited*: Ibid., pp. 323–27.

257      *When Ashbery and O'Hara came*: Lehman, pp. 87–89.

258      *"swishy, surrealist, almost zany . . ."*: Field, Edward. *The Man Who Would Marry Susan Sontag,* p. 73.

## 18. DUCHAMP, CAGE, AND THE THEORY OF PHARBLONGENCE

261    *"There were pretty girls . . .":* Ray, Man. *Self Portrait,* p. 68.

262    *Cage was born in Los Angeles:* Kostelanetz, Richard. *Conversing with Cage,* pp. 1–11.

263    *"stood up part way through . . .":* Cage, John. *Silence,* p. ix.

264    *Cage asked Duchamp:* Lotringer, Sylvere. "Becoming Duchamp," *tout-fait* 1, no. 2 (May 2000).

## 19. BEBOP

272    *"had passed completely into the mainstream . . .":* Jones, LeRoi. *Blues People,* pp. 181–82.

273    *"BeBop. A new language . . .":* Baraka, Amiri. *The Autobiography of LeRoi Jones,* pp. 58–60.

273    *"taking the music apart . . .":* Ibid., p. 176.

273    *"Bob Reisner says . . .":* Reisner, Robert. *Bird,* p. 26.

273    *Charlie Parker knocked on Edgard Varèse's door:* Ibid., pp. 229–30.

274    Life *did a spread on him:* "Bebop," *Life,* October 11, 1948.

274    *"I like the people around here . . .":* Reisner, p. 11.

274    *"He loved the Village . . .":* Ibid., p. 116.

275    *"The Sunday sessions . . .":* Ibid., p. 13.

275    *He had taken up trumpet:* Amram, David. *Vibrations,* pp. 1–43.

276    *Alfred Leslie credits the sculptor David Smith:* Sargeant, Jack. *Naked Lens,* p. 28.

276    *"The Five Spot is darkly lit . . .":* Kerouac, Jack. *Lonesome Traveler,* p. 113.

277    *In* Minor Characters *Joyce Johnson:* Johnson, Joyce. *Minor Characters,* p. 222.

278    *as the jazz critic Nat Hentoff put it:* Panish, Jon. *The Color of Jazz,* pp. 39–40.

279    *Harry Belafonte came to the Village:* Belafonte, Harry. *My Song,* pp. 1–65.

280    *"began to cause some resentment . . .":* Ibid., pp. 91–100.

281    *"It seemed to me part of . . .":* Baraka, p. 142.

281    *According to Hettie:* Jones, Hettie. *How I Became Hettie Jones,* pp. 36–37.

281    *"The boy looked at him . . .":* Baldwin, James. *Another Country,* p. 30.

281    *Sukenick records that:* Sukenick, Ronald. *Down and In,* pp. 105–8.

282    *In the later 1950s Baldwin:* Wakefield, Dan. *New York in the Fifties,* p. 138.

282    *"I do not like bohemia . . .":* Baldwin, James. *Notes of a Native Son,* pp. 8–9.

283    *"You great liberated whore . . .":* Jones, LeRoi. *Dutchman & The Slave,* p. 34.

284    *A couple of weeks later:* Newfield, Jack. "Gig at Gate: Return of the White Liberal Stompers," *Village Voice,* March 18, 1965.

285    *Heroin use exploded:* Schneider, Eric C. *Smack,* pp. 17–28.

285    *By happenstance:* Valentine, Douglas. *The Strength of the Wolf,* pp. 45–47.

286    *In 1953 the CIA:* Ibid., pp. 127–40.

## 20. THE BEAT GENERATION

291    *In December 1943, Allen Ginsberg:* Miles, Barry. "The Beat Generation in Greenwich Village," in *Greenwich Village*, Rick Beard and Leslie Cohen Berlowitz, eds. p. 167.

292    *"and, bleeding badly . . .":* Morgan, Bill. *The Typewriter Is Holy*, p. 5.

293    *"Don't let those bums . . .":* Kerouac, Jack. *Desolation Angels*, pp. 286–87.

293    *Defending Kerouac:* Ginsberg, Allen. "The Dharma Bums," *Village Voice*, November 12, 1958.

293    *"The author claimed to have spent . . .":* Burroughs, William. *Junky, Queer, Naked Lunch*, p. xvi.

294    *"What a crew! Mooches . . .":* Ibid., p. 47.

294    *a citrus farm near the border town:* Johnson, Rob. *The Lost Years of William S. Burroughs*, pp. 7–22.

294    *Meanwhile, his New York friends:* Morgan, pp. 40–41.

297    *"an interesting guy":* Sargeant, Jack. *Naked Lens*, p. 27.

297    *"to see who could hold . . .":* Miles, pp. 170–71.

298    *his girlfriend Joyce Glassman:* Johnson, Joyce. *Minor Characters*, p. 142.

298    *John Clellon Holmes:* Morgan, pp. 37–38.

300    *"teeming as it was with artists . . .":* Weaver, Helen. *The Awakener*, p. 25.

301    *"brown sleek hair . . .":* Kerouac, p. 263.

301    *In a drunk, playful interview:* Balaban, Dan. "3 'Witless Madcaps' Come Home to Roost," *Village Voice*, February 13 1957.

301    *They jammed together:* Amram, David. *Offbeat*, p. ix.

301    *Dan Wakefield met Kerouac:* Wakefield, Dan. *New York in the Fifties*, pp. 160–61.

302    *"I foresaw a new dreariness . . .":* Kerouac, p. 281.

302    *"And just like in New York . . .":* Ibid., p. 320.

303    *Norman Podhoretz:* Podhoretz, Norman. "Where Is the Beat Generation Going?" *Esquire*, December 1958.

303    *"talkers, loafers, passive little con men . . .":* O'Neil, Paul. "The Only Rebellion Around," *Life*, November 30, 1959.

303    *James Baldwin rolled his moist eyes:* Wakefield, pp. 138–39.

304    *"incompetents looking for a fast buck . . .":* McDarrah, Fred, ed. *Kerouac and Friends*, p. 41.

304    *In an interview in the* Voice: Schleifer, Marc D. "Kenneth Patchen on the 'Brat' Generation," *Village Voice*, March 18, 1959.

304    *Even Romany Marie piled on:* Klein, Edward. "The Wreckers Close In on the Last Bohemians," New York *Daily News*, February 20, 1958.

305    *"he seemed bewildered . . .":* Jones, Hettie. *How I Became Hettie Jones*, p. 47.

305    *Amram has always insisted:* Amram, p. xvii.

305    *Brooklyn College:* Breslin, Jimmy. "The Day Kerouac Almost, But Not Quite, Took Flatbush," *Village Voice*, March 5, 1958.

305    *Dan Wakefield, covering the show:* Wakefield, pp. 49–53.

306    *Howard Smith saw a very different show:* Ibid., pp. 55–56.
306    *Kerouac and his friends:* Hamill, Pete. *A Drinking Life,* p. 210.
306    *"tattered, forlorn young man . . .":* Wallace, Mike. "Mike Wallace Asks Jack Kerouac: What Is the Beat Generation?" in *Conversations with Jack Kerouac,* p. 6.

21. PULL MY DAISY

312    *Amram recalls the shoot:* Amram, David. *Offbeat,* pp. 48–63.
315    *"We eased our way through . . .":* Ibid., p. 67.
316    *Timothy Leary:* Conners, Peter. *White Hand Society,* p. 97.
317    *he told a reporter:* McDarrah, Fred, ed. *Kerouac and Friends,* pp. 249–54.

22. VILLAGE VOICES

320    *Theodore Gottlieb was not:* Martin, Douglas. "Theodore Gottlieb, Dark Comedian, Dies at 94," *New York Times,* April 6, 2001.
321    *"Do you realize how . . .":* Bergmann, Eugene B. *Excelsior, You Fathead!* pp. 162–63.
323    *As a final comeuppance:* Ibid., p. 318.
324    *One Saturday in May of 1957:* Bodian, Alan. "Jean Shepherd's Rally," *Village Voice,* May 8, 1957.
324    *The original owner, Helen Gee:* Gee, Helen. *Limelight,* pp. 3–27.
325    *"The only time I see . . .":* McDarrah, Fred, ed. *Kerouac and Friends,* p. 171.
326    *In 1961, facing mounting bills:* Ibid., pp. 281–88.
326    *By the time Shepherd started:* Bergmann, pp. 447–48.
328    *Mailer, in his early thirties:* McAuliffe, Kevin Michael. *The Great American Newspaper,* pp. 13–14.
329    *"the empty winds of a postpartum gloom":* Mailer, Norman. *Advertisements for Myself,* p. 244.
330    *"different ideas of how . . .":* Ibid., p. 245.
332    *"Very inarticulate people . . .":* Jordan, Ken. "Barney Rosset, The Art of Publishing No. 2," *Paris Review* 145 (Winter 1997).
334    *Godot went on to sell:* Carroll, Kent. "Grove in the '70s," in *The Grove Press Reader 1951–2001,* S. E. Gontarski, ed., p. 283.
336    *"What we want from Grove Press . . .":* See the documentary film *Obscene,* Double O Film Production, 2007.

23. STANDING UP TO MOSES AND THE MACHINE

337    *Born Jane Butzner in Scranton:* Alexiou, Alice Sparberg. *Jane Jacobs,* pp. 9–27.
338    *"an immense laboratory . . .":* Jacobs, Jane. *The Death and Life of Great American Cities,* pp. 3–15.

339    *Two new prestige institutions:* Caro, Robert A. *The Power Broker,* pp. 771–75.

339    *Closer to home for Jacobs:* McAuliffe, Kevin Michael. *The Great American Newspaper,* p. 95.

340    *"the attack on Washington Square . . .":* Ibid., p. 97.

341    *The so-called Twain House:* Fehrman, Craig. "The Fall of the House of Twain," *New York Press,* April 23, 2010.

342    *"Where would they go . . .":* Powell, Dawn. *The Wicked Pavilion,* p. 276.

342    *They had to leave their duplex:* Page, Tim. *Dawn Powell,* pp. 241–312.

344    *the Tamawa Club:* Browne, Arthur, Dan Collins, and Michael Goodwin. *I, Koch,* pp. 57–61.

344    *"A New Kind of Tiger":* "A New Kind of Tiger," *Time,* August 22, 1955.

344    *No one backed Stevenson more vociferously:* Browne et al., pp. 19–56.

345    *"DeSapio was the boss of bosses . . .":* Koch, Edward I. *Mayor,* p. 4.

345    *Wolf meanwhile was writing:* McAuliffe, pp. 100–106.

## 24. OFF-OFF-BROADWAY

351    *In 1949 Broadway and Actors' Equity:* Bottoms, Stephen J. *Playing Underground,* pp. 19–20.

353    *A scoffing reviewer for* Billboard: McDonald, Dennis. "An Evening of Bohemian Theater," *Billboard,* March 15, 1952.

353    *"reflected the avant-garde conceits":* Rivers, Larry, with Arnold Weinstein. *What Did I Do?,* pp. 352–53.

355    *Shortly after birth in 1928:* Gussow, Mel. *Edward Albee,* pp. 22–76.

355    *"They were deeply bigoted . . .":* Albee, Edward. "Home Free," *Time,* September 25, 2002.

356    *"It had a kind of artistic . . .":* Heide, Robert, and John Gilman. *Greenwich Village,* pp. 12–13.

357    *The Zoo Story didn't premiere:* Gussow, pp. 90–128.

358    *a dinner party he and his wife gave:* Ibid., pp. 383–84.

358    *Off-Broadway theaters sprang up:* Bottoms, p. 83.

358    *"greedy landlords, union demands . . .":* Ibid., p. 83.

358    *"It seems to me . . .":* Kolin, Philip C., ed. *Conversations with Edward Albee,* p. 55.

359    *"abundant, humanistic . . .":* Heide and Gilman, pp. 18–19.

360    *Frank Thompson:* McDonough, Jimmy. *The Ghastly One,* p. 30.

362    *"incense burning . : .":* Bottoms, p. 45.

363    *"Must you always gather . . .":* Susoyev, Steve, and George Birimisa, eds. *Return to the Caffe Cino,* p. 309.

363    *In an interview he asked:* Grimes, William. "H. M. Koutoukas, Author of Surrealist Plays, Dies at 72," *New York Times,* March 18, 2010.

363    *As Jimmy McDonough relates:* McDonough, pp. 5–56.

365    *Wilson had come to New York:* Bottoms, pp. 52–53.

366    *In States of Desire:* White, Edmund. *States of Desire,* pp. 254–55.

368    "What's life like . . .": Susoyev and Birimisa, p. 135.
369    Hector played at Cherry Lane: Stone, Wendell C. Caffe Cino, pp. 104–5.
371    Patrick later recalled: Bottoms, p. 261.
373    Writing for Esquire: Ibid., p. 67.
374    She'd grown up in the Bronx: Yau, John. "Rosalyn Drexler with John Yau," Brooklyn Rail, July–August, 2007.

## 25. THE FOLK MUSIC SCENE

378    when a thirteen-year-old Joan Baez: Hajdu, David. Positively 4th Street, pp. 7–9.
378    Caricature, a tiny place: Van Ronk, Dave, with Elijah Wald. The Mayor of MacDougal Street, p. 48.
378    He was born in Brooklyn: Ibid., pp. 2–55.
380    the Gaslight Cafe: Ibid., pp. 143–48.
380    Among the folk, blues, and comedy: Dobkin, Alix. My Red Blood, pp. 153–54.
381    The Allan Block Sandal Shop: Hajdu, p. 35.
382    "like an ancient chapel . . .": Dylan, Bob. Chronicles, p. 18.
382    Gerde's, an Italian restaurant: Hajdu, pp. 50–51.
382    The journalist John A. Williams: Panish, Jon. The Color of Jazz, pp. 35–36.
383    "sing and play from two . . .": Van Ronk, p. 41.
386    That enraged Commissioner Kennedy: "A Card Game with the Cops," Life, December 5, 1960.
386    Moses "Moe" Asch's Folkways Records: Goldsmith, Peter D. Making People's Music, pp. 13–80.
390    After Suze's father died: Rotolo, Suze. A Freewheelin' Time, p. 146.
391    Rotolo learned his: Ibid., p. 106.
391    The day he arrived: Dylan, p. 12.
391    Dylan met Hammond Sr.: Hajdu, p. 95.
392    Vanguard producers were making: Ibid., p. 87.
393    Joan Baez first heard him: Ibid., pp. 76–78.
393    In Positively 4th Street: Ibid., pp. 36–37.
394    "a bright new face . . .": Shelton, Robert. "Bob Dylan: A Distinctive Folk-Song Stylist," New York Times, September 29, 1961.
394    The day Shelton's article appeared: Hajdu, pp. 102–4.
395    "She was the most erotic thing . . .": Dylan, p. 265.
395    Dylan writes in Chronicles: Ibid., pp. 268–76.
397    "Their convergence was predictable . . .": Rotolo, pp. 232–59.

## 26. FROM FOLK TO ROCK

401    Bill Reed: Reed, Bill. Early Plastic, pp. 99–100.
401    By 1950, after a mighty struggle: Herring, Philip. Djuna, p. 309.
402    Al Aronowitz: Wilentz, Sean. Bob Dylan in America, p. 69.

405  *She came from New England aristocracy:* Scherman, Tony, and David Dalton. *Pop*, pp. 245–59.

406  *After three minutes of fidgeting:* Ibid., pp. 297–300.

408  *Weaver had previously:* Reed, p. 81.

411  *Named Johnny Allen Hendrix:* Hopkins, Jerry. *The Jimi Hendrix Experience*, pp. 19–71.

411  *when he moved to:* Kilgannon, Corey. "Limbo King Finds a New Home and an Old, Familiar Face," *New York Times*, March 12, 2010.

412  *"I teased him . . .":* Hopkins, p. 72.

412  *In the summer of 1966:* Ibid., pp. 78–114.

413  *Without doubt the strangest story:* Ibid., pp. 229–31.

414  *Jimi left Salvation:* Ibid., pp. 232–38. See also Shapiro, Harry, and Caesar Glebbeek, *Jimi Hendrix*, pp. 395–96.

## 27. LENNY BRUCE AND VALERIE SOLANAS

417  *Born Leonard Alfred Schneider:* Bruce, Lenny. *How to Talk Dirty and Influence People*, pp. 22–72.

418  *he worked as a comic and emcee:* Collins, Ronald K. L., and David M. Skover. *The Trials of Lenny Bruce*, p. 15.

418  *In 1957 he moved:* Ibid., p. 17.

419  *"Constant, abrasive irritation . . .":* Bruce, p. xi.

421  *The Manhattan district attorney:* Ibid., pp. 198–99.

421  *Helen Elliott and Helen Weaver:* Weaver, Helen. *The Awakener*, pp. 132–45.

423  *It got so bad:* " 'Village' Cafe Area Is Barred to Autos," *New York Times*, March 19, 1966.

424  *"At no time . . .":* " 'Village' Is Tense as Police Shift Clean-Up Tactics," *New York Times*, March 20, 1966.

424  *Meanwhile the long block:* Whelton, Clark. "8th Street: A Walk on the Wild Sidewalk," *Village Voice*, December 10, 1970.

424  *"most of Greenwich Village . . .":* Petronius. *New York Unexpurgated*, pp. 17–18.

425  *its own alternative to the Voice:* McAuliffe, Kevin Michael. *The Great American Newspaper*, pp. 232–36.

425  *Carol Greitzer and Ed Koch:* Perlmutter, Emanuel. " 'Villagers' Seek Clean-up of Park," *New York Times*, September 27, 1964.

425  *The park also filled up with:* Rosenbaum, Ron. "Positively MacDougal Street," *Village Voice*, May 27, 1971.

426  *Judson House was operating:* Lerner, Steve. "The Judson House Gang," *Village Voice*, December 5, 1968.

427  *"Life in this society being . . .":* Solanas, Valerie. *SCUM Manifesto*, p. 1.

429  *In 1968 she approached:* Scherman, Tony, and David Dalton. *Pop*, pp. 420–28.

431  *It wasn't until 2000:* Coburn, Judith. "Solanas Lost and Found," *Village Voice*, January 11, 2000.

## 28. THE RADICAL '60S

434      *On Saturday, February 20, 1965:* Harris, Sara. *Hellhole*, pp. 15–56.

435      *"He thought I was old enough . . .":* Paley, Grace. *Just As I Thought*, p. 24.

435      *"It was my life . . .":* Perry, Ruth. "Grace Paley," in *Women Writers Talking*, Janet Todd, ed., p. 46.

436      *Born in 1945:* Wilkerson, Cathy. *Flying Close to the Sun*, pp. 5–101.

437      *"Now it seems fantastic . . .":* Ibid., p. 323.

437      *"more effective tools . . .":* Ibid., pp. 262–63.

439      *The theater critic Mel Gussow also lived:* Gussow, Mel. "The House on West 11th Street," *New York Times*, March 5, 2000.

439      *A neighbor let Wilkerson:* Wilkerson, pp. 332–48.

440      *NYU students occupied: The Disruptions at Loeb, Courant and Kimball*. New York: News Bureau of New York University, 1970.

441      *The 1970 explosions and fire:* Miller, Terry. *Greenwich Village and How It Got That Way*, p. 137.

442      *James Merrill wrote a poem:* Merrill, James. *Selected Poems 1946–1985*, p. 204.

443      *Before the FBI arrested her:* Charlton, Linda. "F.B.I. Seizes Angela Davis in Motel Here," *New York Times*, October 14, 1970.

## 29. THE LION'S HEAD

448      *"the body of his murdered dockworker father . . .":* McAuliffe, Kevin Michael. *The Great American Newspaper*, pp. 189–97.

450      *Announcing his candidacy:* "Norman Mailer for Mayor?" *Village Voice*, April 3, 1969.

450      *"a day set aside . . .":* Pilati, Joe. "Norman Mailer Wins a Pulitzer, But Gets No Respect from the Press," *Village Voice*, May 8, 1969.

450      *When John Lindsay was elected mayor:* Cannato, Vincent J. *The Ungovernable City*, pp. 302–11.

451      *His biggest gaffe:* Flaherty, Joe. *Managing Mailer*, pp. 107–25.

## 30. PRELUDE TO THE STONEWALL UPRISING

455      *"Sheridan Square this weekend . . .":* Truscott, Lucian K., IV. "Gay Power Comes to Sheridan Square," *Village Voice*, July 3, 1969.

457      *There was no gay pride:* White, Edmund. *City Boy*, p. 24.

462      *"scraping the sickly barrel-bottom . . .":* O'Brian, Jack. "Jack O'Brian Says," *New York Journal-American*, July 9, 1962.

463      *Mattachine staged a demonstration:* Duberman, Martin. *Stonewall*, p. 115.

464      *Desperate, they appealed:* Carter, David. *Stonewall*, pp. 49–51.

464      *By the 1960s the Mafia involvement:* See the blog Friends of Ours, with a cache of documentation on mob involvement in gay establishments,

at http://bitterqueen.typepad.com/friends_of_ours/umbertos-clam-house/.

464    *David Carter explains:* Carter, p. 8–80.

471    *"You must remember . . .":* Rivera, Sylvia. "Sylvia Rivera's Talk at LGMNY, June 2001," CENTRO *Journal,* Spring 2007.

## 31. STONEWALL

473    *Deputy Inspector Seymour Pine:* Carter, David. *Stonewall,* pp. 100–103.

475    *A candidate favored:* Fernandez, Manny. "A Stonewall Veteran, 89, Misses the Parade," *New York Times,* June 27, 2010.

475    *Dave Van Ronk was celebrating:* Carter, pp. 155–58.

478    *"You know, the guys there . . .":* Truscott, Lucian K., IV. "Gay Power Comes to Sheridan Square," *Village Voice,* July 3, 1969.

478    *On July 6 the Daily News:* Lisker, Jerry. "Homo Nest Raided, Queen Bees Are Stinging Mad," *New York Daily News,* July 6, 1969.

478    *By ten o'clock Wednesday night:* Carter, pp. 200–205.

479    *Ginsberg, who had:* Ibid., p. 199.

482    *Skull Murphy went on:* Ibid., pp. 252–53.

482    *For a brief time:* Bell, Arthur. "STAR Trek," *Village Voice,* July 15, 1971.

483    *A few years later Sylvia:* "Still Here: Sylvia, Who Survived Stonewall, Time and the River," *New York Times,* May 24, 1995.

## 32. VILLAGE CELEBRITIES OF THE 1970S

485    *"When we first moved here . . .":* See the documentary film *The U.S. vs. John Lennon,* Lionsgate, 2006.

486    *The city government was borrowing:* Newfield, Jack, and Wayne Barrett. *City for Sale,* p. 3.

487    *his heroin use was confirmed:* Jones, Rebecca. "Dylan Tapes Reveal Heroin Addiction," BBC News, May 23, 2011.

489    *After one class Weberman:* See the documentary film *The Ballad of* A. J. *Weberman,* 2006.

490    *For Dylan's thirtieth birthday:* Rosenbaum, Ron. "Positively MacDougal Street," *Village Voice,* May 27, 1971.

491    *Truscott wrote:* Truscott, Lucian. "Nights at the End," *The New Yorker,* July 28, 1975.

491    *Smith recalls the first time:* Smith, Patti. *Just Kids,* p. 59.

491    *The original plan was for Westbeth:* Hartocollis, Anemona. "An Enclave of Artists, Reluctant to Leave," *New York Times,* November 21, 2011.

497    *Her roots in the Village:* Bosworth, Patricia. *Diane Arbus,* pp. 1–34.

499    *After ten years apart:* Ibid., p. 236.

501    *A reporter for the magazine* Show: Sarlin, Bob. "Robert Downey Goes to the Dogs," *Show,* June 1970.

502 *The eight-story, mansard-roofed:* Lewis, Emory. "Hotel's Fall Was a Cultural Disaster," *Sunday Record,* August 19, 1973.

502 *drug addicts, drunks, hookers and thieves:* Perlez, Jane. "From Riches to Rags," *New York Post,* August 4, 1973.

503 *"the closest thing yet . . .":* Phillips, McCandlish. "Mercer Stages Are a Supermarket," *New York Times,* November 2, 1971.

504 *In the ensuing city investigations:* McCarthy, Philip, and Henry Lee. "Eye Illegal Work on Fallen Hotel," New York *Daily News,* August 5, 1973.

## 33. AFTER STONEWALL

508 *The Voice's Arthur Bell:* Bell, Arthur. "Littlejohn & the Mob," *Village Voice,* August 31, 1972.

508 *Wojtowicz later wrote:* Wojtowicz, John. "Real Dog Day Hero Tells His Story," *Jump Cut,* Number 15, 1977.

510 *On a Sunday afternoon:* Wicker, Randy. "On the Day of His Castration," *Gay,* March 26, 1973.

511 *"He wasn't mean or anything . . .":* Katz, Celeste. " 'Dog Day's' Journey into Legend," New York *Daily News,* April 23, 2006.

512 *but it's uncontested fact:* Aletti, Vince. "Soho vs. Disco," *Village Voice,* June 16, 1975.

513 *In States of Desire:* White, Edmund. *States of Desire,* p. 270.

514 *Gabriel Rotello has written:* Rotello, Gabriel. *Sexual Ecology,* pp. 55–56.

515 *"Gay liberation began about . . .":* See the documentary film *Sex Positive,* 2008.

515 *"It wasn't about changing . . .":* See the documentary film *After Stonewall,* 1999.

515 *Berkowitz's friend Michael Callen:* Berkowitz, Richard. *Stayin' Alive,* p. 132.

515 *Berkowitz writes that:* Ibid., pp. 7–62.

516 *In 1971 the* Voice's *Mary Perot Nichols:* Nichols, Mary Perot. "Colombo Linked to Village," *Village Voice,* July 1, 1971.

517 *a joint organized crime task force:* Nichols, Mary Perot. "Hitting Where It Hurts," *Village Voice,* July 22, 1971.

517 *"pranced up and down the bars . . .":* White, p. 275.

519 *"ugly, bearded, painted . . .":* Colacello, Bob. *Holy Terror,* p. 183.

520 *Crispo had allegedly:* Glueck, Grace. "There Was Something Creepy About the Gallery," *New York Times,* June 21, 1992.

521 *LeGeros, still in prison:* Shram, Jamie. "'80s Fiend in Tug of Love," *New York Post,* November 9, 2007.

523 *Many gay men were scandalized:* Specter, Michael. "Public Nuisance," *The New Yorker,* May 13, 2002.

523 *Village lesbians had their own issues:* Faderman, Lillian. *Odd Girls and Twilight Lovers,* pp. 211–13.

523 *Johnston, who'd started out:* McAuliffe, Kevin Michael. *The Great American Newspaper,* pp. 268–70.

523    *At a Town Hall debate:* Grimes, William. "Jill Johnston, Critic Who Wrote 'Lesbian Nation,' Dies at 81," *New York Times*, September 21, 2010.

524    *She was, like Suze Rotolo:* Dobkin, Alix. *My Red Blood*, pp. 1–166.

## 34. ART IN THE JUNKYARD

527    *In 1969 Lanford Wilson:* Olsen, Christopher. *Off-Off Broadway*, pp. 237–44.

528    *a Junkyard:* White, Edmund. *City Boy*, p. 3.

528    *Off-Off-Broadway companies and spaces:* Bottoms, Stephen J. *Playing Underground*, pp. 344–45.

530    *Charles Ludlam followed:* Kaufman, David. *Ridiculous!*, pp. 1–17.

531    *"Steal lines . . .":* Ibid., p. 450.

531    *In 1972 Ludlam moved:* Ibid., pp. 363–66.

## 35. THE 1980S AND AIDS

536    *When Son of Sam terrorized:* Newfield, Jack, and Wayne Barrett. *City for Sale*, pp. 131–46.

536    *The race came down to:* Browne, Arthur, Dan Collins, and Michael Goodwin. I, *Koch*, pp. 119–61.

536    *Hamill writes that:* Hamill, Pete. "Personality with a Point," in *New York Comes Back*, Michael Goodwin, ed., p. 39.

536    *The austerity measures:* Brigham, James R., Jr., and Alair Townsend. "The Fiscal Crisis," in Goodwin, pp. 29–36.

538    *Frank Barbaro:* Bailey, Robert W. *Gay Politics, Urban Politics*, pp. 160–61.

538    *Through the decade the clinic:* Berkowitz, Richard. *Stayin' Alive*, p. 133.

539    *"Wherever we gather . . .":* Ibid., pp. 97–98.

539    *Bob Hope was in New York:* "AIDS in New York: A Biography," *New York*, May 28, 2006.

539    *the Associated Press report:* "AIDS May Dwarf the Plague," Associated Press, January 30, 1987.

540    *When Richard Berkowitz told:* Berkowitz, p. 108.

540    *Gay men and AIDS activists:* Rotello, Gabriel. *Sexual Ecology*, p. 25.

541    *"[h]ire a hunky hustler . . .":* Kramer, Larry. *The Normal Heart and The Destiny of Me*, p. 81.

542    *"Oh, Gilbert . . .":* Kramer, Larry. *Just Say No*, p. 88.

542    *In panning the play:* Gussow, Mel. "Skewers for the Political in Kramer's 'Just Say No,' " *New York Times*, October 21, 1988.

542    *when Koch appeared:* "Koch Heckled at Event for Gay Pride Month," *New York Times*, June 2, 1989.

542    *Koch and Kramer were living:* Gross, Ken. "Larry Kramer," *People*, July 9, 1990.

542    *In 1985 the city's Department of Health:* Purnick, Joyce. "City Closes Bar Frequented by Homosexuals, Citing Sexual Activity Linked to AIDS," *New York Times*, November 8, 1985.

542    *Owners of other establishments:* Dangerous Bedfellows, eds. *Policing Public Sex,* p. 26.

## EPILOGUE

547    *The crash of 2008:* Wotapka, Dawn, and Laura Kusisto. "Rents Record in Manhattan," *Wall Street Journal,* April 11, 2012.

551    *"an unfortunate knack . . .":* Kimmelman, Michael. "It Riles a Village," *New York Times,* March 22, 2012.

551    New York *magazine:* Sherman, Gabriel. "The School That Ate New York," *New York,* November 4, 2010.

# BIBLIOGRAPHY

"A Card Game with the Cops." *Life*, December 5, 1960.

" 'Ada Clare' Bitten by a Pet Dog." *New York Times*, February 20, 1874.

"AIDS in New York: A Biography." *New York*, May 28, 2006.

Albee, Edward. "Home Free." *Time*, September 25, 2002.

Aletti, Vince. "Soho vs. Disco." *Village Voice*, June 16, 1975.

Alexiou, Alice Sparberg. *Jane Jacobs*. New Brunswick, NJ: Rutgers University Press, 2006.

"All God's Chillun Got Wings." *Brooklyn Daily News*, May 16, 1924.

Amram, David. *Offbeat*. New York: Thunder's Mouth Press, 2002.

———. *Vibrations*. New York: Macmillan, 1968.

Anderson, Margaret C. *My Thirty Years' War*. New York: Horizon House, 1969.

———, ed. *The Little Review Anthology*. New York: Hermitage House, 1953.

"A New Kind of Tiger." *Time*, August 22, 1955.

Argersinger, Jo Ann E. *The Triangle Fire*. Boston: Bedford/St. Martin's, 2009.

Arthur, Anthony. *Radical Innocent*. New York: Random House, 2006.

"Artists to Migrate to Warehouse Tops." *New York Times*, September 19, 1922.

Ashton, Dore. *The New York School*. New York: Viking, 1973.

Atlas, James. *Delmore Schwartz*. New York: Farrar, Straus and Giroux, 1977.

Auden, W. H. *Collected Longer Poems*. New York: Random House, 1969.

Bailey, Robert W. *Gay Politics, Urban Politics*. New York: Columbia University Press, 1999.

Balaban, Dan. "3 'Witless Madcaps' Come Home to Roost." *Village Voice*, February 13, 1957.

Baldwin, James. *Another Country*. New York: Dial Press, 1962.

———. *Notes of a Native Son*. Boston: Beacon Press, 1955.

Baraka, Amiri. *The Autobiography of LeRoi Jones*. New York: Freundlich Books, 1984.

Barnes, Djuna. "The Days of Jig Cook." *Theater Guild Magazine*, January 1939.

Bean, Annemarie, James V. Hatch, and Brooks McNamara, eds. *Inside the Minstrel Mask*. Middletown, CT: Wesleyan University Press, 1996.

Beard, Rick, and Leslie Cohen Berlowitz, eds. *Greenwich Village: Culture and Counterculture*. New Brunswick, NJ: Rutgers University Press, 1993.

"Bebop." *Life*, October 11, 1948.

Belafonte, Harry. *My Song*. New York: Alfred A. Knopf, 2011.

Bell, Arthur. "Littlejohn & the Mob." *Village Voice*, August 31, 1972.

——. "STAR Trek." *Village Voice*, July 15, 1971.

Bergmann, Eugene B. *Excelsior, You Fathead!* New York: Applause Books, 2005.

Bergreen, Laurence. *James Agee*. New York: E. P. Dutton, 1984.

Berkowitz, Richard. *Stayin' Alive*. New York: Basic Books, 2003.

Bodenheim, Maxwell. *My Life and Loves in Greenwich Village*. New York: Bridgehead Books, 1954.

Bodian, Alan. "Jean Shepherd's Rally." *Village Voice*, May 8, 1957.

"Bohemia in New-York." *New York Times*, January 6, 1858.

Bosworth, Patricia. *Diane Arbus*. New York: W. W. Norton, 1984.

Bottoms, Stephen J. *Playing Underground*. Ann Arbor: University of Michigan Press, 2004.

Breslin, Jimmy. "The Day Kerouac Almost, But Not Quite, Took Flatbush." *Village Voice*, March 5, 1958.

Browne, Arthur, Dan Collins, and Michael Goodwin. *I, Koch*. New York: Dodd Mead, 1988.

Broyard, Anatole. *Kafka Was the Rage*. New York: Carol Southern Books, 1993.

Bruce, Lenny. *How to Talk Dirty and Influence People*. Chicago: Playboy Press, 1965.

Bryk, William. "King of the Bohemians." *New York Sun*, January 26, 2005.

Burroughs, William. *Junky, Queer, Naked Lunch*. New York: Quality Paperback Book Club, 1995.

Burrows, Edwin G., and Mike Wallace. *Gotham*. New York: Oxford University Press, 1998.

Buttenwieser, Ann L. *Manhattan Water-Bound*, 2nd edition. Syracuse, NY: Syracuse University Press, 1999.

Cage, John. *Silence*. Middletown, CT: Wesleyan University Press, 1961.

Cannato, Vincent J. *The Ungovernable City*. New York: Basic Books, 2002.

Caro, Robert A. *The Power Broker*. New York: Alfred A. Knopf, 1974.

Carpenter, Humphrey. *W. H. Auden*. Boston: Houghton Mifflin, 1981.

Carter, David. *Stonewall*. New York: St. Martin's Press, 2004.

Charlton, Linda. "F.B.I. Seizes Angela Davis in Motel Here." *New York Times*, October 14, 1970.

Chauncey, George. *Gay New York*. New York: Basic Books, 1994.

Christman, Henry M., ed. *A View of the Nation*. New York: Ayer Publishing, 1970.

Churchill, Allen. *The Improper Bohemians*. New York: E. P. Dutton, 1959.

Coburn, Judith. "Solanas Lost and Found." *Village Voice*, January 11, 2000.

Colacello, Bob. *Holy Terror*. New York: HarperCollins, 1990.

Collins, Ronald K. L., and David M. Skover. *The Trials of Lenny Bruce*. Naperville, IL: Sourcebooks, 2002.

Conners, Peter. *White Hand Society*. San Francisco: City Lights Books, 2010.

Cowley, Malcolm. *Exile's Return*. New York: W. W. Norton, 1934.

Crane, Stephen. *Tales, Sketches, and Reports*. Edited by Fredson Bowers. Charlottesville: University Press of Virginia, 1973.

"Cubists and Futurists Are Making Insanity Pay." *New York Times*, March 16, 1913.

Danckaerts, Jasper. *The Journal of Jasper Danckaerts 1679–1780*. Edited by Bartlett Burleigh James and J. Franklin Jameson. New York: Charles Scribner's Sons, 1913.

Dangerous Bedfellows, eds. *Policing Public Sex*. Boston: South End Press, 1996.

"Death of Charles I. Pfaff." *New York Times*, April 26, 1890.

Dell, Floyd. *Love in Greenwich Village*. New York: George H. Doran, 1926.

"Dewey to Ask Death for Night Club Robbers," Associated Press, April 18, 1938.

Dobkin, Alix. *My Red Blood*. New York: Alyson Books, 2009.

Dodson, Howard, Christopher Moore, and Roberta Yancy. *The Black New Yorkers*. New York: John Wiley and Sons, 2000.

Dos Passos, John. *The Best Times*. New York: New American Library, 1966.

Duberman, Martin. *Stonewall*. New York: E. P. Dutton, 1993.

Dunshee, Kenneth Holcomb. *As You Pass By*. New York: Hastings House, 1952.

Dylan, Bob. *Chronicles*. New York: Simon and Schuster, 2004.

Edmiston, Susan, and Linda D. Cirino. *Literary New York*. Boston: Houghton Mifflin, 1976.

Eytinge, Rose. *The Memories of Rose Eytinge*. New York: Frederick A. Stokes, 1905.

Faderman, Lillian. *Odd Girls and Twilight Lovers*. New York: Columbia University Press, 1991.

Fehrman, Craig. "The Fall of the House of Twain." *New York Press*, April 23, 2010.

Fernandez, Manny. "A Stonewall Veteran, 89, Misses the Parade." *New York Times*, June 27, 2010.

Field, Edward. *The Man Who Would Marry Susan Sontag*. Madison: University of Wisconsin Press, 2005.

Fisher, James T. *On the Irish Waterfront*. Ithaca, NY: Cornell University Press, 2009.

Flaherty, Joe. *Managing Mailer*. New York: Coward-McCann, 1970.

"For an Ex-Slave's Fortune." *New York Times*, June 8, 1890.

Gailey, Amanda. "Walt Whitman and the King of Bohemia." *Walt Whitman Quarterly Review* 25, no. 4 (Spring 2008).

Gammel, Irene. *Baroness Elsa*. Cambridge, MA: MIT Press, 2002.

Gardner, Charles W. *The Doctor and the Devil*. New York: Gardner, 1894.

Gates, Henry Louis, and Evelyn Brooks Higginbotham, eds. *African American Lives*. New York: Oxford University Press, 2006.

Gates, Henry Louis, Jr. *Thirteen Ways of Looking at a Black Man*. New York: Random House, 1997.

Gee, Helen. *Limelight*. Albuquerque: University of New Mexico Press, 1997.

Gilfoyle, Timothy J. *City of Eros*. New York: W. W. Norton, 1992.

Ginsberg, Allen. *Howl and Other Poems*. San Francisco: City Lights Books, 1956.

———. "The Dharma Bums." *Village Voice*, November 12, 1958.

Glueck, Grace. "There Was Something Creepy About the Gallery." *New York Times*, June 21, 1992.

Goldman, Emma. *Anarchism and Other Essays*. New York: Mother East Publishing Association, 1911.

Goldsmith, Peter D. *Making People's Music*. Washington, DC: Smithsonian, 1998.

Goldstein, Richard. *Helluva Town*. New York: Free Press, 2010.

Gontarski, S. E., ed. *The Grove Press Reader 1951–2001*. New York: Grove Press, 2001.

Goodwin, Michael, ed. *New York Comes Back*. New York: powerHouse Books, 2006.

Gordon, Lorraine. *Alive at the Village Vanguard*. Milwaukee, WI: Hal Leonard Corporation, 2006.

Gordon, Max. *Live at the Village Vanguard*. Cambridge, MA: Da Capo Press, 1982.

Gorman, Paul R. *Left Intellectuals & Popular Culture in Twentieth-Century America*. Chapel Hill: University of North Carolina Press, 1996.

Gray, Christopher. "Are Manhattan's Right Angles Wrong?" *New York Times*, October 23, 2005.

——. "Remembering an 1858 Greenwich Village Atelier." *New York Times*, May 25, 1997.

——. "Streetscapes." *New York Times*, October 10, 1993.

Green, Martin. *New York 1913*. New York: Macmillan, 1988.

"Greenwich Village Too Costly Now for Artists to Live There." *Christian Science Monitor*, August 29, 1927.

Grimes, William. "H. M. Koutoukas, Author of Surrealist Plays, Dies at 72." *New York Times*, March 18, 2010.

——. "Jill Johnston, Critic Who Wrote 'Lesbian Nation,' Dies at 81." *New York Times*, September 21, 2010.

Groce, Nancy. *New York: Songs of the City*. New York: Watson-Guptill, 1999.

Gross, Ken. "Larry Kramer." *People*, July 9, 1990.

Gruen, John. *Callas Kissed Me . . . Lenny Too!* New York: powerHouse Books, 2008.

——. *The Party's Over Now*. New York: Viking Press, 1972.

Gussow, Mel. *Edward Albee*. New York: Applause Books, 2000.

——. "Skewers for the Political in Kramer's 'Just Say No.'" *New York Times*, October 21, 1988.

——. "The House on West 11th Street." *New York Times*, March 5, 2000.

Hajdu, David. *Positively 4th Street*. New York: Farrar, Straus and Giroux, 2001.

Hamill, Pete. *A Drinking Life*. New York: Little, Brown, 1994.

Hapgood, Hutchins. *A Victorian in the Modern World*. New York: Harcourt, Brace, 1939.

Harrington, Michael. *Fragments of the Century*. New York: Saturday Review Press, 1973.

Harris, Luther S. *Around Washington Square*. Baltimore: Johns Hopkins University Press, 2003.

Harris, Sara. *Hellhole*. New York: E. P. Dutton, 1967.

"Harry Truman, Critic." *Time*, March 4, 1946.

Hartocollis, Anemona. "An Enclave of Artists, Reluctant to Leave." *New York Times*, November 21, 2011.

Haswell, Charles Haynes. *Reminiscences of New York by an Octogenarian (1816 to 1860)*. New York: Harper and Bros., 1896.

Hayes, Kevin J., ed. *The Cambridge Companion to Edgar Allan Poe*. Cambridge, UK: Cambridge University Press, 2002.

——. *Conversations with Jack Kerouac*. Jackson: University Press of Mississippi, 2005.

Hecht, Ben. *Letters from Bohemia*. New York: Doubleday, 1964.

Heide, Robert, and John Gilman. *Greenwich Village*. New York: St. Martin's Press, 1995.

Heller, Adele, and Lois Rudnick, eds. *1915. The Cultural Moment*. New Brunswick, NJ: Rutgers University Press, 1991.

Herring, Philip. *Djuna*. New York: Viking Penguin, 1995.

Hobsbawm, Eric. *The Age of Revolution*. London: Weidenfeld and Nicholson, 1962.

Homberger, Eric. *The Historical Atlas of New York City*. New York: Henry Holt, 2005.

——. "Lucien Carr." *The Guardian*, February 9, 2005.

Hopkins, Jerry. *The Jimi Hendrix Experience*. New York: Arcade, 1996.

Huston, James L. *The Panic of 1857 and the Coming of the Civil War*. Baton Rouge: Louisiana State University Press, 1987.

Jackson, Kenneth T., ed. *The Encyclopedia of New York City*. New Haven, CT: Yale University Press, 1995.

Jacobs, Jaap. *New Netherland*. Boston: Brill Leiden, 2005.

Jacobs, Jane. *The Death and Life of Great American Cities*. New York: Random House, 1961.

"Jackson Pollock." *Life*, August 9, 1949.

"Jail Pickets Back 10 Pacifists Inside." *New York Times*, July 21, 1957.

Janvier, Thomas Allibone. *In Old New York*. New York: Harper and Brothers, 1894.

——. "The Evolution of New York." *Harper's New Monthly Magazine*, June 1893.

Jewell, Andrew. "Willa Cather's Greenwich Village." *Studies in American Fiction* 32, no. 1 (Spring 2004).

Johnson, James Weldon. *Black Manhattan*. New York: Da Capo Press, 1991.

Johnson, Joyce. *Minor Characters*. New York: Penguin, 1999.

Johnson, Rob. *The Lost Years of William S. Burroughs*. College Station: Texas A&M University Press, 2006.

Jones, Hettie. *How I Became Hettie Jones*. New York: E. P. Dutton, 1990.

Jones, LeRoi. *Blues People*. New York: William Morrow, 1963.

——. *Dutchman & The Slave*. New York: William Morrow, 1964.

Jones, Rebecca. "Dylan Tapes Reveal Heroin Addiction." BBC News, May 23, 2011.

Jordan, Ken. "Barney Rosset, the Art of Publishing No. 2." *Paris Review* 145 (Winter 1997).

Kahn, Ashley. "After 70 Years, the Village Vanguard Is Still in the Jazz Swing." *Wall Street Journal*, February 8, 2005.

Kaplan, James S. "Thomas Paine's America." *Last Exit*, May 20, 2009.

Kaufman, David. *Ridiculous!* New York: Applause Books, 2005.

Kemp, Harry. *More Miles.* New York: Boni and Liveright, 1926.

Kerouac, Jack. *Desolation Angels.* New York: Coward McCann, 1965.

———. *Lonesome Traveler.* New York: McGraw-Hill, 1960.

Kessner, Thomas. *Fiorello H. La Guardia and the Making of Modern New York.* New York: McGraw-Hill, 1989.

Kilgannon, Corey. "Limbo King Finds a New Home and an Old, Familiar Face." *New York Times,* March 12, 2010.

Kimmelman, Michael. "It Riles a Village." *New York Times,* March 22, 2012.

Klein, Edward. "The Wreckers Close In on the Last Bohemians." New York *Daily News,* February 20, 1958.

Kligman, Ruth. *Love Affair.* New York: William Morrow, 1974.

Knipfel, Jim. "Protocol Takes Precedence Over Procedure." Chiseler.org.

Koch, Edward I. *Mayor.* New York: Simon and Schuster, 1984.

"Koch Heckled at Event for Gay Pride Month." *New York Times,* June 2, 1989.

Kolin, Philip C., ed. *Conversations with Edward Albee.* Jackson: University Press of Mississippi, 1988.

Kostelanetz, Richard. *Conversing with Cage.* New York: Routledge, 2003.

Kramer, Larry. *Faggots.* New York: Warner Books, 1979.

———. *Just Say No.* New York: St. Martin's Press, 1989.

———. *The Normal Heart and The Destiny of Me.* New York: Grove Press, 2000.

Kyvig, David E., ed. *Law, Alcohol, and Order.* Westport, CT: Greenwood Press, 1985.

Lait, Jack, and Lee Mortimer. *U.S.A. Confidential.* New York: Crown, 1952.

Lehman, David. *The Last Avant-Garde.* New York: Doubleday, 1998.

Lepore, Jill. *New York Burning.* New York: Alfred A. Knopf, 2005.

Lerner, Michael A. *Dry Manhattan.* Cambridge, MA: Harvard University Press. 2007.

Lerner, Steve. "The Judson House Gang." *Village Voice,* December 5, 1968.

Leslie, Alfred, ed. *The Hasty Papers.* Austin, TX: Host Publications, 1999.

Lewis, Edith. *Willa Cather Living.* Lincoln: University of Nebraska Press, 2000.

Lewis, Emory. "Hotel's Fall Was a Cultural Disaster." *Sunday Record,* August 19, 1973.

Lewis, Tom. *The Hudson.* New Haven, CT: Yale University Press. 2005.

Lisker, Jerry. "Homo Nest Raided, Queen Bees Are Stinging Mad." New York *Daily News,* July 6, 1969.

Lockwood, Charles. *Manhattan Moves Uptown*. New York: Barnes and Noble Books, 1995.

Lotringer, Sylvere. "Becoming Duchamp." *tout-fait* 1, no. 2, May 2000.

Loving, Jerome. "A Newly Discovered Whitman Poem." *Walt Whitman Quarterly Review* 11, no. 3 (Winter 1994).

Luhan, Mabel Dodge. *Intimate Memories*. Edited by Lois Palken Rudnick. Albuquerque: University of New Mexico Press, 1999.

Mailer, Norman. *Advertisements for Myself*. New York: G. P. Putnam's Sons, 1959.

Malina, Judith. *The Diaries of Judith Malina 1947–1957*. New York: Grove Press, 1984.

Martin, Douglas. "Theodore Gottlieb, Dark Comedian, Dies at 94." *New York Times*, April 6, 2001.

May, Henry F. *The End of American Innocence*. New York: Alfred A. Knopf, 1959.

McAuliffe, Kevin Michael. *The Great American Newspaper*. New York: Charles Scribner's Sons, 1978.

McCabe, James D., Jr. *Lights and Shadows of New York Life*. Philadelphia: National Publishing Company, 1872.

McCarthy, Philip, and Henry Lee. "Eye Illegal Work on Fallen Hotel." New York *Daily News*, August 5, 1973.

McCrum, Robert. *Wodehouse*. London: Viking, 2004.

McDarrah, Fred, with Timothy McDarrah, eds. *Kerouac and Friends*. New York: Thunder's Mouth Press, 2002.

McDonald, Dennis. "An Evening of Bohemian Theater." *Billboard*, March 15, 1952.

MacDonald, Scott. *Cinema 16*. Philadelphia: Temple University Press, 2002.

McDonough, Jimmy. *The Ghastly One*. Chicago: A Capella Books, 2001.

McFarland, Gerald W. *Inside Greenwich Village*. Amherst: University of Massachusetts Press, 2001.

Merrill, James. *Selected Poems 1946–1985*. New York: Alfred A. Knopf, 1992.

Merz, Charles. *The Dry Decade*. Garden City, NY: Doubleday, Doran, 1931.

Meyers, Jeffrey. *Edmund Wilson*. New York: Houghton Mifflin, 1995.

Milford, Nancy. *Savage Beauty*. New York: Random House, 2001.

Miller, Henry. *Plexus*. New York: Grove Press, 1965.

Miller, Terry. *Greenwich Village and How It Got That Way*. New York: Crown, 1990.

Minette. *Recollections of a Part-Time Lady*. New York: Flower-Beneath-the-Foot Press, 1979.

Mitchell, Joseph. *Up in the Old Hotel*. New York: Pantheon, 1992.

Morgan, Bill. *The Typewriter Is Holy*. New York: Free Press, 2010.

Moscow, Henry. *The Street Book*. New York: Fordham University Press, 1978.

Murphy, Brenda. *The Provincetown Players and the Culture of Modernity*. Cambridge, UK: Cambridge University Press, 2005.

Newfield, Jack. "Gig at Gate: Return of the White Liberal Stompers." *Village Voice*, March 18, 1965.

Newfield, Jack, and Wayne Barrett. *City for Sale*. New York: HarperCollins, 1988.

"New Homes in Old Greenwich Village." *New York Times*, May 23, 1915.

"New York's Spreading Upper Bohemia." *Esquire*, July 1957.

Nichols, Bill, ed. *Maya Deren and the American Avant-Garde*. Berkeley: University of California Press, 2001.

Nichols, Mary Perot. "Colombo Linked to Village." *Village Voice*, July 1, 1971.

———. "Hitting Where It Hurts." *Village Voice*, July 22, 1971.

"Norman Mailer for Mayor?" *Village Voice*, April 3, 1969.

O'Brian, Jack. "Jack O'Brian Says." *New York Journal-American*, July 9, 1962.

O'Brien, Fitz-James. *The Poems and Stories of Fitz-James O'Brien*. Whitefish, MT: Kessinger Publishing, 2007.

O'Brien, Kenneth Paul, and Lynn Hudson Parsons, eds. *The Home-Front War*. Westport, CT: Greenwood Press, 1995.

Oja, Carol J. *Making Modern Music*. New York: Oxford University Press, 2004.

Okrent, Daniel. *Last Call*. New York: Scribner, 2010.

Olsen, Christopher. *Off-Off Broadway*. Self-published, 2011.

O'Neil, Paul. "The Only Rebellion Around." *Life*, November 30, 1959.

O'Neill, William L. *Echoes of Revolt*. Chicago: Quadrangle Books, 1966.

Page, Tim. *Dawn Powell*. New York: Henry Holt, 1998.

Paley, Grace. *Collected Stories*. New York: Farrar, Straus and Giroux, 1994.

———. *Just As I Thought*. New York: Farrar, Straus and Giroux, 1998.

Panish, Jon. *The Color of Jazz*. Jackson: University of Mississippi Press, 1997.

Parry, Albert. *Garrets and Pretenders*, 2nd edition. New York: Dover, 1960.

"Passing of the Old Grapevine." *New York Times*, July 18, 1915.

Penn, I. Garland. *The Afro-American Press, and Its Editors*. Springfield, MA.: Willey and Co., 1891.

Perlez, Jane. "From Riches to Rags." *New York Post*, August 4, 1973.

Perlmutter, Emanuel. " 'Villagers' Seek Clean-up of Park." *New York Times*, September 27, 1964.

Petronius. *New York Unexpurgated*. New York: Matrix House, 1966.

Phillips, McCandlish. "Mercer Stages Are a Supermarket." *New York Times*, November 2, 1971.

Pilati, Joe. "Norman Mailer Wins a Pulitzer, But Gets No Respect from the Press." *Village Voice*, May 8, 1969.

Podhoretz, Norman. "Where Is the Beat Generation Going?" *Esquire*, December 1958.

Pollock, Thomas Clark, and Oscar Cargill. *Thomas Wolfe at Washington Square*. New York: New York University Press, 1954.

Powell, Dawn. *The Golden Spur*. New York: Viking, 1962.

——. *The Wicked Pavilion*. Boston: Houghton Mifflin, 1954.

Purnick, Joyce. "City Closes Bar Frequented by Homosexuals, Citing Sexual Activity Linked to AIDS." *New York Times*, November 8, 1985.

"Queer Doings Net Suspension for Vill. Clubs," *Variety*, December 2, 1944.

Raab, Selwyn. *Five Families*. New York: St. Martin's Press, 2005.

Ray, Man. *Self Portrait*. New York: Little, Brown, 1963.

Reed, Bill. *Early Plastic*. Los Angeles: Cellar Door Books, 2000.

Reed, John. *Insurgent Mexico*. New York: D. Appleton and Company, 1914.

Reisner, Robert. *Bird*. New York: Citadel Press, 1962.

Reppetto, Thomas. *American Mafia*. New York: Henry Holt, 2004.

Rexroth, Kenneth. *World Outside the Window*. Edited by Bradford Morrow. New York: New Directions, 1987.

Riis, Jacob. *How the Other Half Lives*. New York: Charles Scribner's Sons, 1890.

Ritchie, Donald A. *American Journalists*. New York: Oxford University Press, 1997.

Rivera, Sylvia. "Sylvia Rivera's Talk at LGMNY, June 2001." CENTRO Journal (Spring 2007).

Rivers, Larry, with Arnold Weinstein. *What Did I Do?* New York: HarperCollins, 1992.

Rosenbaum, Ron. "Positively MacDougal Street." *Village Voice*, May 27, 1971.

Rotello, Gabriel. *Sexual Ecology*. New York: E. P. Dutton, 1997.

Rotolo, Suze. *A Freewheelin' Time*. New York: Broadway Books, 2008.

"Round Table on Modern Art." *Life*, October 11, 1948.

Sacks, Marcy S. *Before Harlem*. Philadelphia: University of Pennsylvania Press, 2006.

Sargeant, Jack. *Naked Lens*. New York: Soft Skull Press, 2009.

Sarlin, Bob. "Robert Downey Goes to the Dogs." *Show*, June 1970.

Sawyers, June Skinner, ed. *The Greenwich Village Reader*. New York: Cooper Square Press, 2001.

Scherman, Tony, and David Dalton. *Pop*. New York: HarperCollins, 2009.

Scherzer, Kenneth A. *The Unbounded Community*. Durham, NC: Duke University Press, 1992.

Schleifer, Marc D. "Kenneth Patchen on the 'Brat' Generation." *Village Voice*, March 18, 1959.

Schmidgall, Gary. *Walt Whitman*. New York: E. P. Dutton, 1997.

Schneider, Eric C. *Smack*. Philadelphia: University of Pennsylvania Press, 2008.

Scholnick, Robert J. "An Unusually Active Market for Calamus." *Walt Whitman Quarterly Review* 19, no. 34 (Winter/Spring 2002).

Schulman, Robert. *Romany Marie*. Lousville, KY: Butler Books, 2006.

Schwartz, Delmore. *Shenandoah*. Norfolk, CT: New Directions, 1941.

———. *The World Is a Wedding*. Norfolk, CT: New Directions, 1948.

Seigel, Jerrold. *Bohemian Paris*. Baltimore: Johns Hopkins University Press, 1999.

Shapiro, Harry, and Caesar Glebbeek. *Jimi Hendrix*. New York: St. Martin's Press, 1995.

Shelton, Robert. "Bob Dylan: A Distinctive Folk-Song Stylist." *New York Times*, September 29, 1961.

Sherman, Gabriel. "The School That Ate New York." *New York*, November 4, 2010.

Shram, Jamie. "'80s Fiend in Tug of Love." *New York Post*, November 9, 2007.

Silvester, Peter J. *The Story of Boogie-Woogie*. Lanham, MD: Scarecrow Press, 2009.

Simkhovitch, Mary Kingsbury. *Neighborhood*. New York: W. W. Norton, 1938.

Smith, Patti. *Just Kids*. New York: Ecco, 2010.

Solanas, Valerie. *SCUM Manifesto*. San Francisco: AK Press, 1996.

Specter, Michael. "Public Nuisance." *The New Yorker*, May 13, 2002.

Stansell, Christine. *American Moderns*. New York: Metropolitan Books, 2000.

———. "Whitman at Pfaff's: Commercial Culture, Literary Life and New York Bohemia at Mid-Century." *Walt Whitman Quarterly Review* 10 (Winter 1993).

"Still Here: Sylvia, Who Survived Stonewall, Time and the River." *New York Times*, May 24, 1995.

Stone, Wendell C. *Caffe Cino*. Carbondale: Southern Illinois University Press, 2005.

Sukenick, Ronald. *Down and In*. New York: Macmillan, 1987.

Susoyev, Steve, and George Birimisa, eds. *Return to the Caffe Cino*. San Francisco: Moving Finger Press, 2007.

Sutton, Willie, with Edward Linn. *Where the Money Was*. New York: Viking, 1976.

Taylor, Nick. *American-Made*. New York: Bantam, 2008.

*The Disruptions at Loeb, Courant and Kimball*. New York: News Bureau of New York University, 1970.

Todd, Janet, ed. *Women Writers Talking*. New York: Holmes and Meier, 1983.

Trachtenberg, Leo. "Texas Guinan: Queen of the Night." *City Journal* (Spring 1998).

Truscott, Lucian K., IV. "Gay Power Comes to Sheridan Square." *Village Voice*, July 3, 1969.

——. "Nights at the End." *The New Yorker*, July 28, 1975.

——. "The Real Mob at Stonewall." *New York Times*, June 25, 2009.

Tunney, Jay R. *The Prizefighter and the Playwright*. Buffalo, NY: Firefly Books, 2010.

Valentine, Douglas. *The Strength of the Wolf*. New York: Verso Books, 2004.

Van Ronk, Dave, with Elijah Wald. *The Mayor of MacDougal Street*. Cambridge, MA: Da Capo Press, 2005.

" 'Village' Cafe Area Is Barred to Autos." *New York Times*, March 19, 1966.

" 'Village' Is Tense as Police Shift Clean-up Tactics." *New York Times*, March 20, 1966.

Wakefield, Dan. *New York in the Fifties*. New York: Houghton Mifflin, 1992.

Walsh, George. *Gentleman Jimmy Walker*. New York: Prager, 1974.

Ward, Nathan. *Dark Harbor*. New York: Farrar, Straus and Giroux, 2010.

Ware, Caroline F. *Greenwich Village, 1920–1930*. New York: Houghton Mifflin, 1935.

Weaver, Helen. *The Awakener*. San Francisco: City Lights, 2009.

Werther, Ralph. *Autobiography of an Androgyne*. New Brunswick, NJ: Rutgers University Press, 2008.

Wetzsteon, Ross. *Republic of Dreams*. New York: Simon and Schuster, 2002.

Whelton, Clark. "8th Street: A Walk on the Wild Sidewalk." *Village Voice*, December 10, 1970.

White, Edmund. *City Boy*. New York: Bloomsbury, 2009.

——. *States of Desire*. New York: E. P. Dutton, 1980.

Wicker, Randy. "On the Day of His Castration." *Gay*, March 26, 1973.

Wilentz, Sean. *Bob Dylan in America*. New York: Doubleday, 2010.

Wilkerson, Cathy. *Flying Close to the Sun*. New York: Seven Stories Press, 2007.

Wilson, Edmund. *The Thirties*. New York: Farrar, Straus and Giroux, 1980.

———. *The Twenties*. New York: Farrar, Straus and Giroux, 1975.

Wilson, Elizabeth. *Bohemians*. New Brunswick, NJ: Rutgers University Press, 2000.

Wilson, Rufus Rockwell. *New York: Old & New*, 2nd edition. Philadelphia: J. B. Lippincott, 1903.

Winkler, Allan M. *Home Front U.S.A.* Wheeling, IL: Harlan Davidson, 2000.

Wojtowicz, John. "Real Dog Day Hero Tells His Story." *Jump Cut* 15 (1977).

Wotapka, Dawn, and Laura Kusisto. "Rents Record in Manhattan." *Wall Street Journal*, April 11, 2012.

WPA *Guide to New York City*. New York: Random House, 1982 (reprint).

"Wreckers Uncover Aaron Burr House." *New York Times*, December 11, 1913.

Yau, John. "Rosalyn Drexler with John Yau." *Brooklyn Rail*, July–August 2007.

# INDEX

Frank, Robert, 309–16, 326
Frank E. Campbell Funeral Chapel, 386
Frankenthaler, Helen, 245, 248
Franklin, Benjamin, 14
*Franklin Evans; or The Inebriate* (Whitman), 41–42
Fraser, Brenda, 205
Freas, Kelly, 323
Fred Gray Association, 43
Freed, Alan, 528
*Freedom's Journal*, 70
free love, 30, 81, 109, 230
*Freewheelin' Bob Dylan, The* (album), 389, 397, 399
*Freewheelin' Time, A* (Rotolo), 389
Freilicher, Jane, 245, 253, 256
French Box Revue, 459
French Revolution, 14–15, 29
French Roast, 58
Frenchtown, 56
Freud, Sigmund, 59–60, 81
Freytag-Loringhoven, Elsa von, 144–47, 152
Freytag-Loringhoven, Leo von, 146
Frick, Henry Clay, 87
Friedan, Betty, 523
Friedlander, Lee, 499
Fromm, Erich, 200, 237
*From the Fire* (oratorio), 78
Frost, Robert, 234
*Fuck You: A Magazine of the Arts*, 408
Fugazzi's, 295
Fugs, the, 401, 408–10, 480
Fuller, Buckminster, 129
Fulton, Robert, 18–19
Fulton Ferry, 18–19
Fulton Fish Market, 213–14
*Funny Girl* (movie), 313
Furious George, 532
Furman Hall, 23–24

Gable, Clark, 366
Gaddis, William, 296, 297
Gallagher, William C., 56
Gallant, Barney, 157–58
Gammel, Irene, 145
Gansevoort Market, 466
Gansevoort Plaza, 550
Gansevoort Street, 4, 218, 466, 549
Garbo, Greta, 235

Gardner, Charles, 54–55
Garfunkel, Art, 404
Garnet, Henry Highland, 70–71
Gaslight Cafe, 314, 380–81, 405, 524
Gates, Henry Louis, Jr., 237
Gautier, Théophile, 32
Gay Activists Alliance, 481
Gay Liberation Front, 480–81
Gay Men's Health Crisis (GMHC), 538–39
Gay Street, 72–73
Gee, Helen, 324–27
Geer, Will, 194
Gelber, Jack, 352, 353
Gellert, Hugo, 100
Generation Club, 413
Genet, Jean, 334, 364
*"Genius," The* (Dreiser), 89
Genovese, Vito, 213–14, 464
gentrification, 134–36
George's Corner, 418
*Georgie May* (Bodenheim), 175
Gerde's Folk City, 382, 391, 393, 394
Gere, Richard, 137
Gerrit (guide), 10
Gershwin, Ira, 166
Getty, Ann, 336
*Ghastly One, The* (McDonough), 363–64
GI Bill, 230, 232, 237, 254, 258, 279, 327
Gibran, Kahlil, 57
Gifford, Sanford, 57
Gigante, Vincent "Chin," xi, 213–14
Gilded Age, 48
Gillespie, Dizzy, 272, 274, 278, 382, 386
Gilman, Coburn "Coby," 149
Gilman, Richard, 375
Gilmore, John, 369
Ginsberg, Allen, 291–92, 295–96, 298–300
  background of, 291–92
  Bruce and, 421, 422
  Dylan and, 400, 402
  "Howl," 289, 295, 300, 334, 419
  Huncke and, 294–95
  "Kaddish," 291, 409
  Kerouac and, 293, 298, 302, 306, 311–12
  Patchen and, 304
  *Pull My Daisy* (movie), 311–12
  Smith and, 492
  Stonewall Uprising and, 478, 479